Pre-Raphaelite Art

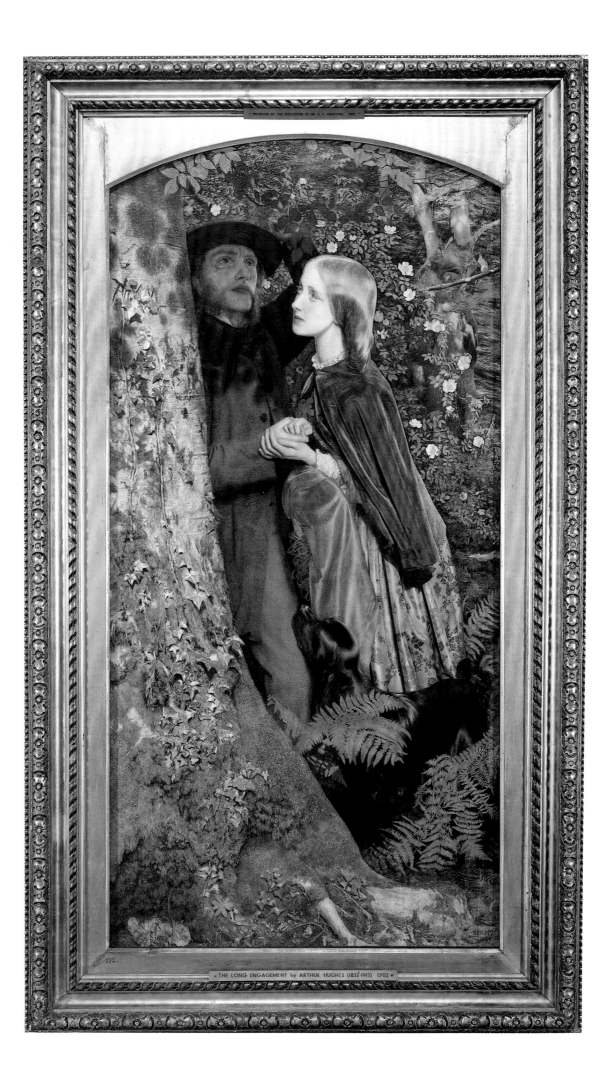

192.

THE LONG ENGAGEMENT by ARTHUR HUGHES (1832-1915) 1902

Visions of Love and Life

PRE-RAPHAELITE ART FROM
BIRMINGHAM MUSEUMS AND ART GALLERY

STEPHEN WILDMAN

WITH ESSAYS BY
JAN MARSH AND JOHN CHRISTIAN

ART SERVICES INTERNATIONAL
ALEXANDRIA, VIRGINIA
1995

This exhibition is organised and circulated by
Art Services International, Alexandria, Virginia.

Dedicated to the memory of John Woodward (1921–1988),
Keeper of Art at Birmingham from 1956 to 1964

Copyright © 1995 by Art Services International
All rights reserved

Library of Congress Cataloging-in-Publication Data

Wildman, Stephen.
 Visions of love and life: Pre-Raphaelite art from the Birmingham
collection, England / Stephen Wildman, with essays by Jan Marsh
and John Christian.
 p. cm.
 Catalog of the exhibition shown at the Seattle Art Museum, and
elsewhere, organized and circulated by Art Services International.
 Includes bibliographical references.
 ISBN 0–88397–113–5
 1. Preraphaelitism--Great Britain--Exhibitions. 2. Art, Modern--
19th century--Great Britain--Exhibitions. 3. Art--England--
Birmingham--Exhibitions. 4. Birmingham Museums and Art
Gallery--Exhibitions. 5. Preraphaelites--England--Biography.
I. Marsh, Jan, 1942– . II. Christian, John, 1942– . III. Art
Services International. IV. Title.
N6767.5.P7W55 1995
759.2'09'03407473--dc20 94-49716
 CIP

Editor: Nancy Eickel
Designer: Marc Zaref Design, New York
Photographer: David Bailey
Printer: Balding + Mansell, Peterborough

Printed and bound in England

ISBN 0–88397–113–5

Cover: Detail of *Morgan le Fay* by Frederick Sandys (cat. no. 77)
Frontispiece: *The Long Engagement* by Arthur Hughes (cat. no. 48)

Contents

Exhibition Tour

SEATTLE ART MUSEUM
Seattle, Washington

THE CLEVELAND MUSEUM OF ART
Cleveland, Ohio

DELAWARE ART MUSEUM
Wilmington, Delaware

THE MUSEUM OF FINE ARTS, HOUSTON
Houston, Texas

HIGH MUSEUM OF ART
Atlanta, Georgia

BIRMINGHAM MUSEUMS AND ART GALLERY
Birmingham, England

Acknowledgements

Since its inception in the mid-nineteenth century, the Pre-Raphaelite Brotherhood has commanded attention and admiration for its distinctive style and unique approach to art. United in the single pursuit of returning to a simpler time in art, to an adherence to nature and to the standards of perfection demonstrated by Raphael and his predecessors, this group of ambitious young men soon came to dominate the British art world. Members of the Pre-Raphaelite Brotherhood, under the guidance and inspirational leadership of Dante Gabriel Rossetti, William Holman Hunt, and John Everett Millais, attracted an ever-widening circle of practitioners and enthusiasts. Famed critic John Ruskin championed the Brotherhood, and renowned designer William Morris combined creative forces with many of these artists to generate a decorative style that is still widely appreciated today. Collectors throughout England acquired their works, and this fervour extended to Birmingham, where its industrial philanthropists, motivated in part by the success of native son Edward Burne-Jones, formed one of the strongest holdings of Pre-Raphaelite art in the country. Having continued to build upon this foundation, Birmingham Museums and Art Gallery ranks among the world's truly outstanding collections of Pre-Raphaelite paintings and drawings. Never before have these works travelled to the United States, and it is with extreme pride that Art Services International presents these treasures to audiences in America. We are greatly indebted to Dr Evelyn Silber, Head of Central Museums in Birmingham, and to Michael Diamond, who is responsible for museums and the arts for Birmingham City Council, for bestowing this honour upon us. It has been our great pleasure to collaborate with them.

Working closely with us on this momentous project has been Stephen Wildman, Curator of Prints and Drawings at Birmingham Museums and Art Gallery, who has lent his expertise as Guest Curator of the exhibition. Mr Wildman's keen interest in the Pre-Raphaelites' association with the city of Birmingham is obvious in his enlightening essay, and his intensive research into the Birmingham collection is quite evident in the catalogue of works. His close attention to detail, strong artistic sense, and good humour have made this collaboration particularly enjoyable, and we thank him for the wonderful experience.

Also making further contributions to our understanding of the evolution of the Pre-Raphaelite movement and to the unique personalities associated with that period of British art are John Christian and Dr Jan Marsh, both leading scholars and art historians on the Pre-Raphaelites. Their continuing interest in the art and society of late nineteenth-century England has resulted in intriguing findings and new perspectives on the Pre-Raphaelites and their circle, and we are grateful to them for sharing their expertise with us.

It is an additional privilege that His Excellency Sir Robin Renwick, Ambassador of Great Britain, and Councillor Sir Richard Knowles, Lord Mayor of Birmingham, have agreed to serve as Honorary Patrons of *Visions of Love and Life*. Their gracious consent is warmly acknowledged, and we thank them for the honour.

Among those who have lent support to this international endeavour are David Evans, Cultural Counsellor at the British Embassy, and Joanna C. Tudge, Cultural Affairs Officer at the British Council. At the National Endowment for the Arts, Jane Alexander, Chairman, Alice Whelihan, Indemnity Administrator, Museum Program, and Ben Glenn II and David Bancroft, Museum Program Specialists, have demonstrated their interest in this beautiful and enlightening exhibition and have helped to make its tour possible. Also instrumental to the success of this project have been Martin Beisley and Andrew Clayton-Payne, both at Christie's, London, to whom we send our thanks.

We wish to extend our congratulations to our numerous colleagues at Birmingham Museums and Art Gallery who aided us throughout the development of this project. We are particularly indebted to Richard Lockett, Jane Farrington, Elizabeth Smallwood, Glennys Wild, Richard Clarke, Haydn Roberts, and George Brown. It is also a pleasure to offer our personal thanks to Marcia Early Brocklebank, our representative in England, who encouraged this project from the outset and secured a new group of friends for Art Services International.

As always, this presentation would not have been possible without the confidence and enthusiasm of our colleagues in the museum community. We are proud to extend our warmest regards to Dr Mary Gardner Neill, Director, and Dr Chiyo Ishikawa, Assistant Curator of European Painting, at the Seattle Art Museum; Dr Robert P. Bergman, Director, and Dr William S. Talbot, Deputy Director, at The Cleveland Museum of Art; Stephen T. Bruni, Executive Director, and Jenine Culligan, Associate Curator for Exhibitions, at the Delaware Art Museum; Dr Peter C. Marzio, Director, and Dr George T.M. Shackelford, Curator of European Painting and Sculpture, at The Museum of Fine Arts, Houston; Ned Rifkin, Director, at the High Museum of Art in Atlanta; and once again to Dr Evelyn Silber and Stephen Wildman in Birmingham, England. Without their endorsement of this project, *Visions of Love and Life* would not be available for the benefit of American and British viewers. We are greatly indebted to each of them.

The creative endeavours and collaboration of our editor Nancy Eickel with the design firm of Marc Zaref Design and the printing firm of Balding + Mansell have produced a visually exciting volume that beautifully reflects the Pre-Raphaelite sensibility. Their careful melding of image and text has resulted in a handsome book that admirably complements *Visions of Love and Life*.

We direct a special word of acknowledgement to the staff of Art Services International. Ana Maria Lim, Douglas Shawn, Anne Breckenridge, Kirsten Simmons, Patti Bruch, Betty Kahler, and Sally Thomas have demonstrated their professionalism in seeing this magnificent exhibition to completion, and we thank them for their effort and dedication.

LYNN K. ROGERSON
Director

JOSEPH W. SAUNDERS
Chief Executive Officer

ART SERVICES INTERNATIONAL

Board of Trustees of Art Services International

Foreword

Birmingham, with its central position in the heart of England, has long been a catalyst for cultural and industrial activity. It is Shakespeare's England, located only a few miles from Stratford-upon-Avon. Ironbridge, nearby in Shropshire, and the Soho Manufactory of Matthew Boulton and James Watt in Birmingham were seminal sites for the Industrial Revolution of the eighteenth century. The intellectual luminaries of the Lunar Society met at Boulton's home, Soho House (which is opening as a museum this year). Traditions of craftsmanship, ingenuity and business acumen developed and reached their peak during the nineteenth century, when Birmingham was world renowned as 'the city of 1,000 trades' and 'the workshop of the world'.

The creation of the City's Museum and Art Gallery was born out of the prosperity of that period; it was motivated by a belief that industrialists and designers needed to have examples of great art and design from throughout the world as an inspiration to their own labours. So it is appropriate that the best collection of work by Pre-Raphaelite artists should be at home here. Their engagement with some of the pressing social issues of the day, their fidelity to nature, their craftsmanship, their interest in the applied arts and their fascination with the romance of medieval and Elizabethan literature evoked a reciprocal enthusiasm from industrial Midlanders.

I am proud to introduce this collection to American audiences for the first time. Birmingham has now taken its place among the great European cities. Celebrated for its cultural vitality and above all for its Symphony Orchestra, led by Sir Simon Rattle, the City is visited for business, conventions and trade fairs at the International Convention Centre and National Exhibition Centre. We are pleased to show you a small part of the City's outstanding art collections, and we hope that this enjoyable exhibition will encourage you to explore the distinctive character of Birmingham for yourself.

COUNCILLOR SIR RICHARD KNOWLES
Lord Mayor of Birmingham

Introduction

Visions of Love and Life is devoted to one of the most significant movements in the history of British art, and indeed one of the most remarkable episodes in art history. In 1848 a group of seven very young artists, all barely more than students and none older than twenty-three, banded together under the title of the Pre-Raphaelite Brotherhood. Dissatisfied with the standards of painting and teaching at the Royal Academy, they looked back to early Italian art ('Pre-Raphael') for inspiration, and hoped to counter the grandiosity of contemporary history painting and the sentimentality of genre pictures by drawing and painting images they thought to be true to nature and honest in spirit. Following the advice of the writer John Ruskin in his influential book *Modern Painters* (initially conceived as a defence of J.M.W. Turner against ill-informed criticism), these 'earnest' young artists set a bold course to change the essence of British art. John Christian's lucid essay charts the path of their almost immediate success and subsequent varied careers as creative artists.

The Brotherhood was also conceived in the spirit of adolescent companionship and youthful enthusiasm. Literature – especially romantic literature – was vitally important from the first, particularly to the group's prime mover, Dante Gabriel Rossetti, already a practised poet by the age of twenty. The stimulus of powerful emotion was crucial to the success of such a passionate venture, and the extraordinary intermingling of art and life, as occurred in the tragic relationship of Rossetti and Elizabeth Siddal, is documented by Jan Marsh in her revealing account of the Pre-Raphaelites' lives and loves. Few of the paintings and drawings illustrated in these pages lack the strong personal associations which make the work of the Pre-Raphaelites so exceptional and so intriguing.

Birmingham Museum and Art Gallery has acquired its unique Pre-Raphaelite collection by rather oblique means. Although an important painting by Ford Madox Brown, the slightly older mentor to the Brotherhood and a painter closely allied to its cause, was shown at the Birmingham Society of Artists as early as 1849, the city could not boast of local patrons to match the cultivated 'merchant princes' of London, Manchester and Liverpool, where some of the other great Pre-Raphaelite collections may be found. It was through Edward Burne-Jones, born in Birmingham in 1833 and the leading member of the 'second generation' of Pre-Raphaelites, that serious interest in the movement developed. In his catalogue essay, Stephen Wildman has, for the first time, given a detailed account of the burgeoning taste for Pre-Raphaelitism that led eventually to the creation of Birmingham's celebrated collection.

Our first major works – a late seascape by John Brett and two unfinished oils by Rossetti, bought from the artist's studio sale – were acquired before the opening of the new Museum and Art Gallery in 1885. The purchase within the next few years of several masterpieces, including Hunt's *Valentine rescuing Sylvia from Proteus* (cat. no. 17) and Brown's *The Last of England* (fig. 30), together with the commission from Burne-

Fig. 1 FORD MADOX BROWN, *An English Autumn Afternoon*, 1852–1855; oil on canvas, 28 1/4 x 53 in. (71.7 x 134.6 cm.). Birmingham Museums and Art Gallery (25'16).

Jones of the large watercolour *The Star of Bethlehem* (fig. 15), showed the serious intentions of the Corporation (later the City) authorities to build a Pre-Raphaelite collection. A major loan exhibition in 1891 was followed by the astonishing coup, aided by the generous support of local benefactors, of purchasing nearly a thousand drawings from the collector and dealer Charles Fairfax Murray. By this single far-sighted stroke, Birmingham was established as the greatest single repository of Pre-Raphaelite art, a position it has never relinquished.

Surprisingly few opportunities have arisen to share the treasures of this collection with a wider audience on any substantial scale, and this is the first time they will be seen in the United States. In the winter of 1911–1912, a selection of ninety-three items (including four loans) was shown at the Tate Gallery in London; their return coincided with the opening of the Museum and Art Gallery's extension (the Feeney Picture Galleries), where for many years a rotating display from the cream of the Murray purchase could be seen. The impending centenary of the Brotherhood instigated a number of celebratory events, and Birmingham hosted the largest exhibition of Pre-Raphaelite art ever held, contributing more than a third of the three hundred works shown in the summer of 1947. From 1964 onwards, beginning with the exhibition *Ford Madox Brown* at Liverpool, the Birmingham collection has consistently provided loans to the series of seminal monographic exhibitions which have restored the reputations of each major Pre-Raphaelite painter as a British master. To the culminating exhibition of *The Pre-Raphaelites* at the Tate Gallery in 1984, Birmingham sent twenty-three important paintings and drawings (making us the largest lender after the Tate itself).

The present selection is altogether more ambitious and wide-ranging, and it is hoped that this catalogue will remain of lasting value as an introduction to the collection. All the major paintings that are fit to travel have been included. The significant exceptions, on sound conservation grounds, are regrettable: Hunt's *Finding of the Saviour in the Temple* (fig. 37), Brown's *Last of England* (fig. 30), and not least the same artist's *English Autumn Afternoon* (fig. 1), which formed part of the pioneering exhibition of Pre-Raphaelite painting which toured America in 1857–1858. Burne-Jones's *Phyllis and Demophoön* (fig. 11), which suffers like many of that painter's contemporary watercolours from an overworked and now fragile surface, sadly has also failed its fitness test.

What follows, however, is still an extraordinary collection of works, all arguably masterpieces in their context. They illuminate every aspect of Pre-Raphaelitism. Important drawings recall the earliest days of the Brotherhood, none more evocatively than the highly finished pen and ink designs which were mutual gifts between Rossetti and Millais (cat. nos. 12, 13). Hunt's *Valentine rescuing Sylvia from Proteus* (cat. no. 17) was among the mould-breaking canvases shown at the Royal Academy in 1851, which attracted Ruskin's attention and sparked off a national controversy. Millais's wonderful pencil study for *Ophelia* (cat. no. 22) introduces Elizabeth Siddal, and his *Blind Girl* (cat. no. 38) is one of the perennially memorable images of British painting. Brown's *Pretty Baa-Lambs* (cat. no. 18) is no less significant as a landscape undertaken wholly out of doors, perhaps the first ever – a neglected fact which roused the critic R.A.M. Stevenson to declare that "the whole history of modern art begins with that picture!" *The Stonebreaker* by Henry Wallis (cat. no. 40) and *The Long Engagement* by Arthur Hughes (cat. no. 48) are among the fine works that demonstrate the immediate influence of the movement on younger artists, and the contribution of the 'second generation' Pre-Raphaelites, headed by Burne-Jones, is copiously represented. All the artist members of the original Brotherhood are here, even James Collinson, although nothing by the sculptor Thomas Woolner is included. (The collection contains no major pieces by him.) Alexander Munro's *Paolo and Francesca* (cat. no. 19) acts as ample compensation, being the one universally acknowledged masterpiece of Pre-Raphaelite sculpture.

Some of the minor masters, such as James Campbell and J.W. Inchbold, are represented through oils, and others, notably W.H. Deverell, Frederick Sandys, Simeon Solomon and John Brett, by both paintings and drawings. William Morris played such a major role in the creation of a style of decorative art that can justly be called Pre-Raphaelite that it was decided to add the Museum's five panels of stained glass from his firm's *Story of St George*, a series designed by Rossetti (cat. nos. 60–64). Birmingham's great strength in the decorative arts could have been drawn on much further, but such an endeavour must await another opportunity.

It only remains to thank the many people who have contributed to the preparation of the exhibition, above all Stephen Wildman, to whose expertise so many students of nineteenth-century British art have been indebted over the years during which he has looked after Birmingham's great collection of drawings and watercolours. Important contributions have also been made by other members of the staff of Birmingham Museum and Art Gallery: Jane Farrington, Glennys Wild, Elizabeth Smallwood, Richard Clarke, Haydn Roberts, Gill Casson, Guy Maxted, Lee Handley, Carl Turner, Ann Parker-Moule, David Bailey and Brian Walkeden. The exhibition project has been developed by Evelyn Silber and Richard Lockett, with the constant encouragement, support and patience of Lynn K. Rogerson and Joseph W. Saunders and their colleagues at Art Services International.

MICHAEL DIAMOND
Assistant Director, Museums and Arts, Birmingham City Council

Life, Literature, Art: The Social and Cultural Context of the Pre-Raphaelite Circle

JAN MARSH

The lives and loves of the Pre-Raphaelites is a fascinating tale, re-told as each generation discovers not only this historical epoch in British art but also its contemporary resonances. In our late industrial society, we struggle with the same issues and hopes – the balance between love and work, security and freedom, the pleasures of art and the needs of the world. Questions of social equity and sexual politics are still matters of experience and debate. Sometimes, the pictorial landscapes and imagery of Pre-Raphaelite art seems far removed from present-day concerns – an archaic and imaginary realm of knights and ladies. As in every age, however, the myths and the art of the past engage with present desires and fears.

Carefully studied, Pre-Raphaelite images reflect perennial concerns – about sex and love, friendship and betrayal, social class and national identity, desire and loss. And the Pre-Raphaelite world is rendered doubly engaging by our knowledge of the artists' lives and those of their models, mistresses, lovers and wives (or husbands, as the occasional case may be).

In 1848 the young painters who founded the Pre-Raphaelite Brotherhood and their companions of the palette whose works are represented in the Birmingham collection, were at the outset of their careers, young men ready to make their way in the world. Art was an uncertain profession compared to law or business. It still strove for status in the emerging Victorian society based on money and merit rather than rank, but it held out the promise of glittering prizes and the personal rewards of creativity. It was also a competitive arena. "Without the love of fame, you can never do anything excellent", wrote Sir Joshua Reynolds in his renowned *Discourses*, aimed at students of the Royal Academy Schools. He added: "Though he who precedes you has had the advantage of starting before you, you may always propose to overtake him . . . you need not tread in his footsteps; and you certainly have a right to outstrip him if you can".[1] With this instruction, the P.R.B.s were committed to the pursuit of excellence, however much they might mock 'Sir Sloshua' in their studios.

So the young painters were ambitious, coming as they did from relatively modest backgrounds. Neither impoverished nor wealthy, they were also honourable and idealistic, for their families were pious or at least churchgoing, in the English Evangelical mode of the time. Accustomed to daily Bible reading, often from illustrated editions such as that of John Martin and Robert Westall, they naturally turned to sacred stories when choosing pictorial subjects, as a shared frame of references with clients and critics.

Then, as interest in early Renaissance art developed, other sacred imagery, of the Blessed Virgin and the Saints, was re-introduced into British art (see cat. no. 14, for example). Though many of the painters followed the age in relinquishing formal religion, both the cultural framework of piety and the moral teaching persisted. So did the pursuit of excellence, with the same idealism that informed both the P.R.B. and the 'second wave' of painters around Edward Burne-Jones and William Morris. Only in the late 1860s did ideas of 'art for art's sake' and the pursuit of sensuousness for beauty's sake begin to displace the ideal of art with uplifting aim. To the end of his life William Holman Hunt remained true to original principles, as did James Collinson, whose post-P.R.B. career has largely been lost to view, but who in the 1860s and 1870s continued to paint meticulous scenes of religious devotion, both in London and Brittany, showing Catholic sisters caring for the poor. Specifically Jewish themes featured in the work of Simeon Solomon (cat. no. 52), although Ford Madox Brown also showed a preference for Old Testament scenes (cat. no. 75).

English literature was the other main source of inspiration, from Chaucer and Shakespeare to John Keats, Walter Scott and the Poet Laureate Alfred, Lord Tennyson (cat. nos. 2, 7, 11, 17, 22, 36). Many Pre-Raphaelite canvases had literary texts appended to them or even inscribed on the frame; every picture told a story, and most were already familiar to the audience. This use of sources reflected a shift from the classical subjects of post-Renaissance art and was allied to the rise of English nationalism in the nineteenth century, when 'England' came to stand, metonymically, for the whole of Great Britain and even, in some configurations, for the British Empire. Under Queen Victoria, English and indeed 'Saxon' history was promoted in honour of the Prince Consort's origins; in this context Millais's *Elgiva seized by order of Odo, Archbishop of Canterbury* (cat. no. 3) depicts an historical Anglo-Saxon heroine.

There were other authors, too, including the cult figures of Edgar Allan Poe (cat. no. 10) and Thomas Malory, whose *Morte d'Arthur* was used, together with Tennyson, to bring the Arthurian myths (cat. nos. 50, 58, 59) to the centre of literary and pictorial culture, with effects that still influence our movies and computer games – Merlin and Mordred live! Medievalism, in this respect, had a distinctly modern impact. Not surprisingly, the Pre-Raphaelites helped re-invent St George, patron saint of England, who destroyed the dragon and saved the princess (cat. nos. 60–64, 80). They also followed the footsteps of earlier artists in depicting the particular beauties of the English countryside and its seasons (cat. nos. 82, 109).

At the same time, however, they looked further afield. The National Gallery in London was already a treasure house of European art, and although by and large the Pre-Raphaelite painters did not study in Paris or Rome, then the leading European centres of art training, they did travel, taking advantage of railways, peace and improved facilities in Europe, and trade links with the wider world, including Australia and the Middle East. Hunt's reputation was largely built on his paintings of Egypt and Palestine, which offered authentically observed landscapes for familiar biblical scenes. His *Scapegoat* (fig. 2) – one of the most startling of all Pre-Raphaelite pictures – brings together religious symbolism and topographical witness, as it incorporates a covert contemporary message that draws attention to the need to expiate the sins of the modern world. Other artists who travelled in the Eastern Mediterranean included Edward Lear (1812–1888), Thomas Seddon (1821–1856) and Henry Wallis. Of those represented here,

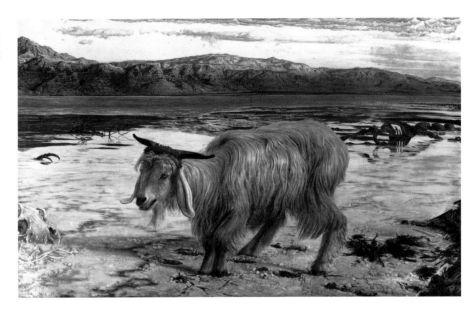

Fig. 2 WILLIAM HOLMAN HUNT, *The Scapegoat*, 1854–1855; oil on canvas, 33 3/4 x 54 1/2 in. (85.7 x 138.5 cm.). Lady Lever Art Gallery, Port Sunlight (National Museums and Galleries on Merseyside).

none visited North America – except by proxy, when works by Brown, Hunt, Arthur Hughes, John Brett and J.W. Inchbold were included in the exhibition of British art that visited the East Coast in 1857–1858. Pre-Raphaelitism as an avant-garde style was promoted by the New York magazine *The Crayon*. "We do not think any other school appeals so strongly to American sympathies", wrote editor W.J. Stillman optimistically.[2] A few years later, the Civil War made a noticeable impact on British painting, refracted in Pre-Raphaelite images of slavery such as Brown's *Joseph and the coat of many colours* (1865–1866; Walker Art Gallery, Liverpool). In this context, William Dyce's *Christ and the Woman of Samaria* (cat. no. 76) may also be read as a comment on racial antagonism, using Christ's example to point a contemporary moral – another instance of archaic subject with modern meaning.

As well as being the 'Year of Revolutions' in Europe, 1848 was the year of the last great Chartist demonstration in London, in support of political democracy and a wider franchise, at which Hunt and Millais were sympathetic observers. Generally speaking, with the exception of famine-devastated Ireland, the 1850s and 1860s were years of economic prosperity and reform in Britain. Nevertheless, poverty and social problems persisted, and the plight of the poor, represented by the beggar children depicted in Millais's *The Blind Girl* (cat. no. 38) or the pauper in Wallis's *Stonebreaker* (cat. no. 40), aroused the compassion of the Pre-Raphaelites and their clients. Brown's *Work* (cat. no. 74) is the key painting here, its canvas crowded with figures representing the range of economic activity in production and consumption. Emigration, to North America or Australasia, was regarded as one solution to economic need; hence the topicality of *The Last of England* (cat. nos. 20, 21).

Prostitution was another social problem, reflected in pictures such as Dante Gabriel Rossetti's *Found* (cat. no. 34) and Hunt's *Awakening Conscience* of 1854 (Tate Gallery, London). This topic was linked to the other pressing issue of the day, that of the position of women and relations between the sexes. The 1850s saw the emergence of the first modern women's movement in Britain, with its focus on education, employment and more egalitarian marriage. These questions underpin or are obliquely present in many of the images of women in Pre-Raphaelite art, as the artists and their society

struggled with changing ideas of the feminine and the masculine. Though it may not be immediately visible, the Pre-Raphaelites should be regarded as generally progressive on gender issues.

Women feature largely in their pictures. Indeed, the term 'Pre-Raphaelite' now denotes a particular feminine look, with cascades of rippling hair, a long neck and soulful eyes. The role of Woman as Muse to the Pre-Raphaelite imagination is well established and explored. What of the women's experience in real life? How did women fare in the Pre-Raphaelite circle? Thanks to the wealth of biographical information – unusual for women in most phases of art and history – we know a good deal about Pre-Raphaelite private life, and the connections and contrasts between art and reality. It is important not to confuse the two, nor to read biography into or from pictures; even in portraiture, the distance between art and life is always significant. Nevertheless, the lives of the artists and their families, as well as their pictures, reflect many of the preoccupations of the age, and also help to illustrate why the Pre-Raphaelite circle is of abiding interest today, for in the women's and men's lives were played out perennial themes.

Several of the Pre-Raphaelite painters were raised in unusually egalitarian families, where brothers and sisters shared artistic interests. Hunt's sister Emily was an aspiring artist; Joanna Boyce studied in Paris and encouraged her brother George in his career; Rosa Brett painted as well as kept house for her brother John. Simeon Solomon

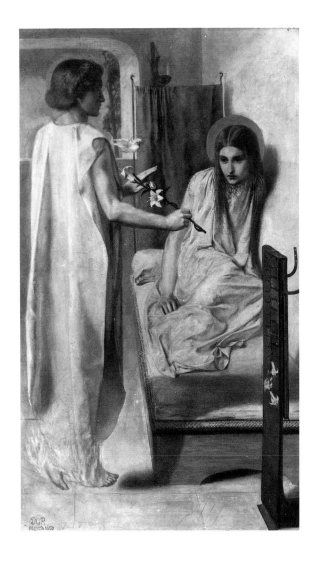

Fig. 3 DANTE GABRIEL ROSSETTI, *Ecce Ancilla Domini!*, 1849–1850; oil on canvas, mounted on wood panel, 28 7/8 x 16 1/2 in. (72.6 x 41.9 cm.). Tate Gallery, London.

was close to his brother Abraham and sister Rebecca, themselves accomplished painters, and both Frederick Sandys and his sister Emma were taught by their artist father. In this post-Romantic period, however, artistic genius was widely regarded as an exclusively male attribute. Many went as far as John Ruskin to claim that 'no woman could paint' in the sense of producing great works (though Rosa Bonheur's undoubted achievement revised a few such judgements in the 1850s).[3] For this reason amongst others, women's work seldom made its way into public collections. But the Pre-Raphaelite group was notable for its encouragement of women's artistic achievement; indeed, a whole 'sisterhood' of female contemporaries, whose work is only now being rediscovered, existed alongside the male painters. Brown in particular was responsible for training a generation of talented artists, including both his daughters.

Perhaps the most famous sister was not a painter but a poet. Christina Rossetti (1830–1894) became engaged to James Collinson around the same time as the Brotherhood was formed, and was swept up in its excitement. She sat for the figure of the Virgin in her brother Gabriel's *Girlhood of Mary Virgin* (1849; Tate Gallery, London) and *Ecce Ancilla Domini!* (1850; Tate Gallery, London; fig. 3) and was involved with Collinson in researching the life of St Elizabeth. Though the female heads in Collinson's picture *St Elizabeth of Hungary* (cat. no. 14) are somewhat stylised, it is possible to discern Christina's features in those of the kneeling Elizabeth. She also contributed to the P.R.B. magazine *The Germ* (1850) and chronicled the Brotherhood's dissolution in two poems whose humour does not quite conceal her own regret at its demise. In 1853, the year of Collinson's defection from the group, Thomas Woolner's departure for Australia, Hunt's announcement of his planned journey to the Holy Land, and Millais's election to the Royal Academy, Christina wrote:

> The two Rossettis (brothers they)
> And Holman Hunt and John Millais,
> With Stephens chivalrous and bland,
> And Woolner in a distant land –
> In these six men I awestruck see
> Embodied the great P.R.B.
>
> The P.R.B. is in its decadence:
> For Woolner in Australia cooks his chops,
> And Hunt is yearning for the land of Cheops;
> D.G. Rossetti shuns the vulgar optic . . .
> And he at last the champion, great Millais,
> Attaining academic opulence,
> Winds up his signature with A.R.A.
> So rivers merge in the perpetual sea;
> So luscious fruit must fall when over-ripe;
> And so the consummated P.R.B.[4]

A few months later Christina wrote a sparkling story set in Renaissance Venice, which was published in *The Crayon*, the magazine devoted to the fine arts in general and Pre-Raphaelitism in particular.[5] Here she partly re-created the rivalry among the three leading members of the Brotherhood in her invocation of the triumphant Titian (Millais was sometimes called the Titian of his time) and his fictional companions, one who is successful but always second, and a third "who had promised everything and fulfilled

nothing" – rather reminiscent of Gabriel Rossetti, who seemed at this date to be falling behind in the race and declined to exhibit publicly.

Through the first half the nineteenth century romantic love gradually replaced heroic history painting as the most popular pictorial subject. This reflected the growing importance of individual affection and the role of art in bourgeois life, where easel paintings were purchased for the drawing-room rather than the grand salon or chamber of state. By mid-century, courtship and marriage were in a period of transition. According to convention, men should postpone marriage until able to support a family – with the result depicted in Hughes's *The Long Engagement* (cat. no. 48). But the young men of the P.R.B. were also impelled by romantic desire, as well as by the need for models who would conform to their pictorial needs, in which emotional and spiritual qualities were as important as social class or physical beauty. A number of Pre-Raphaelite works commented directly on marriage across barriers of wealth, religion, class or ancestral enmity. Such marriages were increasingly frequent, though often still made in the face of family opposition. This explains in part the appeal of subjects such as Romeo and Juliet (cat. no. 11), or Keats's "Eve of St Agnes", in which Porphyro and Madeline overcome all obstacles to their love-match.

Elizabeth Siddal, daughter of an ironmonger, was first 'discovered' by Walter Deverell (as legend has it, in a milliner's shop). She then sat to Hunt for the figure of Sylvia (cat. no. 17); to Millais for the world-famous *Ophelia* (cat. no. 22) and finally to Rossetti for the figure of Delia (cat. no. 27). And, not surprisingly, Rossetti fell in love with Lizzie.

He also responded to her artistic aspirations, encouraging Lizzie's sadly short-lived career. *Love's Mirror* (cat. no. 16) is a historicised rendering of this relationship. Siddal's literary and biblical subjects mirrored those of others in the group (though where Millais chose Ophelia, she picked Lady Macbeth), and the various studies for her depiction of *Jephtha's Daughter* (cat. no. 43 and fig. 4) illustrate her serious intentions. The course of true love did not run smooth, however. Rossetti was not ready for responsibility, and refused to make good his promise of marriage; they separated and then came together again in 1860, when Lizzie was sick, perhaps dying. Marriage and a stillborn daughter were followed by Lizzie's death from an opium overdose. As in all the best romances, the heroine dies young, and her lover is tormented by remorse. *Beata Beatrix* (cat. no. 104) was Rossetti's memorial to their love, with himself cast as the grieving Dante.

Ford Madox Brown, whose first wife died young, took up with Emma Hill, the young model whose features are seen in *The Pretty Baa-Lambs* (cat. no. 18) and *The Last of England* (cat. nos. 20, 21) as well as in *Convalescent* (cat. no. 97). She was an uneducated girl who in other times and other circles would have been used and discarded, but after the birth of their daughter Cathy in 1850, Brown maintained Emma and sent her to school. In 1853 they were married, and Emma was introduced to Brown's friends. She and Lizzie became close, and Brown dreamed of establishing an artists' commune, where each family would live in neighbourly proximity. In 1860 he was instrumental in enabling Burne-Jones to marry his sweetheart, Georgiana Macdonald. The romantic mood of this period is caught in Burne-Jones's *Green Summer*, drawn from Georgie and her sisters (cat. no. 68). Despite later tribulations, Georgie remained his standard of goodness and truth, whose image was included, twenty years on, in the great *King Cophetua and the Beggar Maid*, now in the Tate Gallery, London (fig. 5), which is in

Fig. 4 ELIZABETH SIDDAL, *Study for "Jephtha's Daughter"*, circa 1855–1857; pencil, size and location unknown. (Photograph in Ashmolean Museum, Oxford).

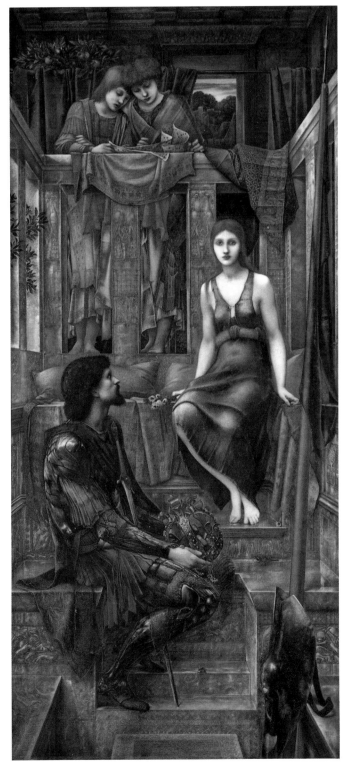

Fig. 5 EDWARD BURNE-JONES, *King Cophetua and the Beggar Maid*, 1884; oil on canvas, 115 1/2 x 53 1/2 in. (293.4 x 135.9 cm). Tate Gallery, London.

part an affirmation of romantic constancy. The popular image of the Pre-Raphaelites is of Bohemian artists roaming the streets in search of 'stunners'; the truth is that most were attentively uxorious, with occasional lapses.

And chivalrous. John Millais also married for love, rescuing his wife Effie from an unhappy and unconsummated union with critic John Ruskin after a joint painting holiday in Scotland. Despite the risks to Millais's career, Effie left her husband, sued for annulment, married the painter and lived happily ever after. At a time when divorce left the taint of scandal, Millais's action was deemed courageous as well as loving.

Hunt's own rescue mission encountered different problems. He departed for the Middle East, leaving his 'stunner' Annie Miller to be turned into a lady. She sat to several of his friends – including Millais, it was once thought, for the little picture called *Waiting* (cat. no. 31) – and predictably developed 'ideas above her station' with a greater liking for amusements than Hunt approved. Some years later he married the eminently respectable Fanny Waugh, Woolner's sister-in-law; then, after Fanny's tragic death in childbirth, Hunt married her younger sister Edith – in defiance of then current English law.

During his estrangement from Lizzie in 1858–1859, and again after her death, Rossetti took up with Fanny Cornforth, who first sat for the figure of the distraught prostitute in *Found* (cat. no. 35) – appropriately so, since this was Fanny's own profession. Her features are seen in many paintings of the early 1860s, especially those depicting 'fallen' or sensuous women. Frederick Sandys, for instance, used Fanny as the model for *If* (cat. no. 83).

Gender relations in the Pre-Raphaelite circle were thus interestingly unconventional, in Victorian terms, at a time when it was common for men to maintain a respectable bourgeois position with an 'official' wife and family, and another household hidden from public view. Sandys's private life was the most irregular in this regard: married in 1853, he moved to London a few years later and in 1867 ran off with his own 'stunner', actress Mary Jones, having earlier (or concurrently) enjoyed a relationship with a Gipsy woman known only as Keomi. Of the artists represented here, all were heterosexual, as far as is known, with the exception of Simeon Solomon, who inevitably suffered under the climate of the time. Perhaps in a more tolerant age his career would not have been cut short by scandal.

Within the group, artistic friendships were close and enduring, and when at the end of the century their numbers were depleted, survivors such as Hunt and Georgie Burne-Jones felt themselves the last remnants of a golden fraternity. The many mutual portrait sketches that survive from the early years testify to the youthful camaraderie of the Brotherhood, which was succeeded by the short-lived Hogarth Club in 1858, and replaced in the early 1860s with two new overlapping groups. One was based in Chelsea, where Rossetti's house in Cheyne Walk, with its erratic menagerie of exotic beasts in the garden (see cat. no. 118), was a gathering place for artists and writers, including James McNeill Whistler, Sandys, George Meredith and most notoriously Algernon Swinburne, whose alcoholic excesses alarmed even his friends. This group, in particular, was responsible for some of the Bohemian tales, and also partly for the increase in sensuous easel subjects. Close links were forged between poetry and painting: drawings by Solomon, for instance, inspired two poems by Swinburne, who also dedicated *Poems and Ballads* to Burne-Jones, whose languorous *Laus Veneris* (1873–1875; Laing Art Gallery, Newcastle upon Tyne) seems in turn to have been inspired by Swinburne's poem of the

same name. Rossetti, in these later years, developed a poetic career to rival his pictorial one. "There is a budding morrow in midnight", he wrote, quoting Keats, in a poem to accompany *Found* (cat. no. 34).

> And here, as lamps across the bridge turn pale
> In London's smokeless resurrection-light,
> Dark breaks to dawn. But o'er the deadly blight
> Of Love deflowered and sorrow of one avail,
> Which makes this man grasp and this woman quail,
> Can day from darkness ever again take light?

The other grouping centred on the families of Rossetti, Brown, Burne-Jones and Morris (see cat. nos. 54, 55), who together with Philip Webb and two others, founded the firm that later became known as Morris and Company, establishing the 'Morris Style' of interior design across the English-speaking world. Their design work is represented here by Morris's *Ascension* (cat. no. 56), Hughes's *Birth of Tristram* (cat. no. 58), the stained-glass sequence showing the story of St George (cat. nos. 60–64), and Webb's design for a window at Brasenose College (cat. no. 65). This commercial enterprise was very much a 'family firm' in a special sense: wives, sisters and friends were involved in decorating and embroidery projects. Jane Morris, William's wife, was responsible, with her sister Elizabeth Burden, for managing the firm's embroidery department, a task later taken over by Jane's daughter May.

Jane Morris was another working-class girl lifted Cinderella-like from a life of drudgery by her association with the Pre-Raphaelites. Rossetti first saw her in Oxford, during the decoration of the Union Debating Chamber. Morris painted her as *La Belle Iseult* at the height of his passion for Malory (see cat. no. 51 and fig. 6) and the couple

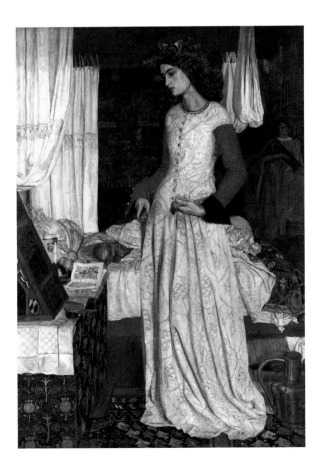

Fig. 6 WILLIAM MORRIS, *La Belle Iseult*, 1858; oil on canvas, 28 1/8 x 20 in. (71.0 x 50.0 cm). Tate Gallery, London.

was married in 1859. When, ten years later, Jane and the now-widowed Rossetti had an intense, romantic but (as I believe) chaste affair (see cat. no. 95: the pansy was Jane's emblem of love), Morris did not prevent their relationship, behaving honourably and generously despite his distress. In this period he moved closer to Georgie Burne-Jones, whose own marriage was under strain owing to her husband's infatuation with Maria Zambaco. In 1872, Rossetti suffered a severe nervous collapse, triggered by a critical attack on his 'immoral' verses and perhaps partly by the triangular tension of loving the wife of his partner and friend. This ended all hope of a life together, but Jane's image haunted his work for the rest of his life, and remains one of the main icons of Pre-Raphaelite art (see cat. nos. 110, 111).

The subjects of Pre-Raphaelite art thus often reflect both personal and general pre-occupations. Not surprisingly, romantic love featured largely on the young P.R.B. easels – Romeo and Juliet, Dante and Beatrice, Delia and Tibullus (cat. nos. 11, 13, 27). Domestic affection is expressed in many of Brown's studies, such as *The Young Mother* and *King René's Honeymoon* (cat. nos. 9, 57), while the unseen child's hand beneath the woman's cloak in *The Last of England* (cat. no. 20) is a characteristic hint of tenderness. Illicit and adulterous passion – a Victorian 'problem' owing to the virtual impossibility of divorce – is seen in the depictions of Paolo and Francesca, Lancelot and Guinevere, Tristram and Iseult (cat. nos. 19, 42, 51). Womanly self-sacrifice is honoured in *Jephtha's Daughter* (cat. no. 43) and the many versions of the Annunciation.

Woman as Muse – the great artistic myth of the nineteenth century – is given full expression in Burne-Jones's *Pygmalion* series (cat. nos. 105–108). One of the oddest, but most compelling, images is that of Rossetti's *The Question* (cat. no. 102), in which the riddle posed by the blind Sphinx confronts Man in youth, maturity and old age. Sandys was particularly fascinated, as were Rossetti and Burne-Jones, by the image of Woman as temptress or witch (see cat. nos. 77, 84, 88, 117), a configuration closely linked to the portrayal of the same archetype in Swinburne's decadent, lascivious verses. The popularity of sorceresses in the later Pre-Raphaelite period obliquely reflects sexual anxiety, and pre-figures the *femmes fatales* of the 1890s and early cinema.

Youthful radicalism often stiffens into middle-aged conservatism. William Morris, as is well known, became more radical as he grew older, emerging in the 1880s as a leader of the Socialist movement in Britain, protesting against unemployment, exploitation and imperial conquest. Brown remained true to his republican principles. Less is known of the other artists' political views, but of those represented here, none except Millais pursued fame or fortune as 'Establishment' artists who painted portraits or official scenes for court or state. In making this choice, they forfeited many of the material rewards and honours available to artists. Millais became a Baronet in 1885, Burne-Jones accepted the same honour in 1894, and in 1905 Hunt received the more prestigious Order of Merit, awarded for intellectual and artistic eminence. At the other end of the scale came Simeon Solomon, his career destroyed by his conviction for homosexual offences in 1873 and a subsequent decline into alcoholism, of which *Bacchus* (cat. no. 86) seems an eloquent premonition. He spent the last twenty years of his life on welfare, occasionally visited by one or two old friends, and died destitute. Other artists such as Hughes, Boyce and Brett went on to respectable but not outstanding achievement. Walter Deverell and Elizabeth Siddal died young, as did Joanna Boyce (1831–

1861), whose work promised as much as any of the men and who may be regarded as the greatest 'lost Pre-Raphaelite'.

Like other human activities, painting and drawing take place in a social, cultural and personal context. The economic and political circumstances of its production are part of art's story. With the Pre-Raphaelites we are lucky enough to have information on many aspects of their lives. It is not necessary to know about an artist to appreciate a painting, but it is illuminating to understand the world in which he or she worked. In their paintings and drawings, these artists believed they were creating imaginary worlds such as were "never seen on land or sea", in Burne-Jones's words,[6] but to us the links are transparently clear, even at the distance of so many years. As Swinburne, the most Pre-Raphaelite poet of all, wrote in *A Forsaken Garden*:

The sun burns sere and the rain dishevels
 One gaunt pink blossom of scentless breath.
Only the wind here hovers and revels
 In a round where life seems as barren as death.
Here there was laughing of old, there was weeping,
 Haply, of lovers none will ever know,
Whose eye went seaward a hundred sleeping
 Years ago.[7]

1. Joshua Reynolds, *Discourses on Art*, edited by Robert R. Wark, New Haven and London, 1975, pp. 89, 101.
2. *The Crayon*, New York (August/September 1857), quoted in Casteras, 1990, p. 47. This travelling exhibition was largely promoted by Captain A.A. Ruxton, whose brother George Ruxton had enthralled British readers with his tales of the Wild West, as published in *Adventures in Mexico and the Rocky Mountains* (1847) and *Life in the Far West* (1849).
3. See Ruskin, *Works*, 1908, vol. 33, no. 19, p. 280. For the gendered construction of genius, see Christine Battersby, *Gender and Genius*, London, 1989, and Jan Marsh and Pamela Garrish Nunn, *Women Artists and the Pre-Raphaelite Movement*, London, 1989.
4. *Complete Poems of Christina Rossetti*, edited by R.W. Crump, Baton Rouge and London, 1979–1990, vol. 3, pp. 223–332.
5. Christina G. Rossetti, "The Lost Titian", *Commonplace and Other Short Stories* (London, 1870), pp. 145 ff., reprinted in Christina Rossetti, *Poems and Prose*, edited by Jan Marsh, London, 1994.
6. Dante Gabriel Rossetti, "Found", *Poetical Works*, edited by W.M. Rossetti, London, 1891, p. 363.
7. Algernon Charles Swinburne, "A Forsaken Garden", *Collected Poetical Works*, London, 1927, pp. 318–321.

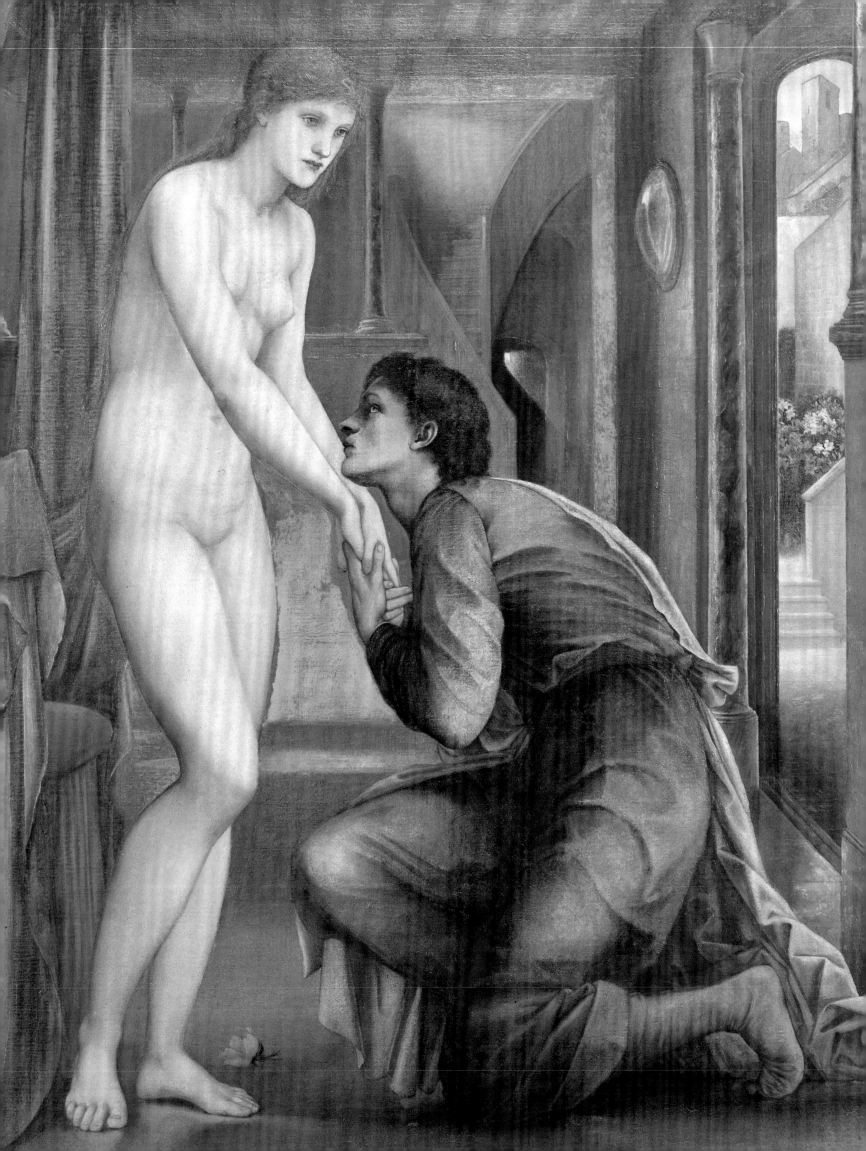

"The souls of earnest men laid open": Pre-Raphaelitism in England, 1848–1898

JOHN CHRISTIAN

When it comes to a sense of excitement, to making the heart beat faster, Pre-Raphaelitism ranks high among cultural phenomena and certainly has no equal in Victorian art. We may argue about the merits of individual artists, or dislike their work intensely – they have always been adept at arousing violent reactions; but no-one can deny the movement's vitality and astonishing powers of renewal. It is a story with a strong element of romance, of youthful enthusiasm, opposition overcome, success beyond the wildest dreams of the original exponents. A charismatic message is abroad, transforming the lives of those strong enough to receive it, while enabling less hardy and adventurous spirits to experience a brief transcendence. It is a story, too, of ever-widening circles, ideas developing dramatically, transition from rather narrow nationalistic concerns to values of international significance. And since, after years of eclipse, the subject now enjoys a revival of almost industrial proportions, it is a story in which we ourselves are inextricably involved. The heady mixture of beauty, poetry, intellectual challenge and personal magnetism appeals today every bit as powerfully as it did during the movement's ascendancy, with the added edge that only nostalgia for a vanished age can give.

The young men who, in John Ruskin's words, "took the unfortunate and somewhat ludicrous name of 'Pre-Raphaelite Brethren',"[1] numbered seven. William Holman Hunt (1827–1910), who was twenty-one, John Everett Millais (1829–1896), who was nineteen, and Dante Gabriel Rossetti (1828–1882), who was twenty, had all recently been students at the Royal Academy Schools. They also belonged to a short-lived sketching club called the Cyclographic Society, in which many of their ideas were formed. Hunt and Millais had been close friends as students; Rossetti joined them when, having admired Hunt's picture *The Eve of St Agnes* (Guildhall Art Gallery, London) at the Royal Academy exhibition of 1848, he asked to share his studio. There he and Hunt discussed their hopes and ambitions, and before long Rossetti had recruited three allies: his own younger brother William Michael (1829–1919), Thomas Woolner (1825–1892), a young sculptor, and another R.A. student, James Collinson (1825–1881). Finally, Hunt produced a seventh supporter, his friend F.G. Stephens (1828–1907). The Brotherhood's inaugural meeting took place in Millais's studio at 83 Gower Street, Bloomsbury, in September 1848.

All seven members were to make some contribution to Pre-Raphaelitism. William Michael Rossetti, though he never had any ambition to become an artist and by profession was a civil servant in the Inland Revenue, played an important part as the

EDWARD BURNE-JONES, *Pygmalion and the Image: IV The Soul Attains* (detail of cat. no. 108)

financial and emotional mainstay of his family and a man of letters who appointed himself one of the chief chroniclers of the movement. F.G. Stephens painted one or two Pre-Raphaelite pictures but soon abandoned his brush for art-criticism; for forty years (1861–1901) he wrote reviews of exhibitions, descriptions of collections and miscellaneous art-gossip for the *Athenaeum* magazine, thus bequeathing us a mine of information about Victorian taste. James Collinson painted briefly in the Pre-Raphaelite style (cat. no. 14) before reverting to what he had been previously, a conventional genre painter. He is also remembered for the fact that he was engaged briefly to the Rossettis' sister Christina, who later achieved fame as a poet. As for Woolner, he and Alexander Munro (cat. no. 19) are the chief representatives of the sculptural dimension to Pre-Raphaelitism, a subject that has recently received much attention.[2] Inadvertently he also inspired one of the most famous Pre-Raphaelite paintings, Ford Madox Brown's *The Last of England* (cat. nos. 20, 21), when he temporarily left England for Australia in 1852, hoping to make his fortune in the gold rush.

From the outset, however, Hunt (cat. no. 6), Millais, and Rossetti (cat. nos. 27, 54), were the central figures and the artists of real significance. Millais, who came from a prosperous Jersey family and possessed striking good looks and an engaging personality, was technically the most accomplished. Precociously gifted and encouraged by ambitious parents, he had entered the R.A. Schools at the age of eleven, their youngest student ever, and was soon carrying off all the prizes. He had no great intellectual capacity, but his brilliant technique, allied to a keen appreciation of public taste, would do much to gain the movement recognition and acceptance.

Although Hunt and Millais were close friends, it was an attraction of opposites, for in circumstances and temperament they could hardly have been more different. The son of a warehouse manager in the City of London, Hunt had had to overcome strong parental opposition to his choice of career. Nor was he a fluent practitioner, gaining admission to the R.A. Schools only at the third attempt and never being an outstanding student. These early setbacks hardened an innate puritanism, and he was to pursue his career in a spirit of moral fervour and dogged determination. Indeed it is hardly too much to say that the element of struggle was essential to Hunt, just as other artists need the stimulus of a particular landscape or model.

D.G. Rossetti was different again. His father, Gabriele Rossetti, was an Italian refugee and a Dante scholar who made a meagre living as Professor of Italian at King's College, London; his mother, Frances Polidori, was also half Italian. If Millais was the brilliant professional and Hunt the fanatical seeker after truth, then Rossetti was the inspired bohemian, the man of imagination and vision. Although bored and frustrated by the technicalities of art, he had steeped himself from childhood in Shakespeare and the Romantics, and his mind teemed with ideas that he longed to paint. He was also a poet himself, and had already drafted some of the poems for which he later became well known, including "The Blessed Damozel", "My Sister's Sleep" and "Jenny". These intellectual qualities, together with an exceptionally powerful personality, made him a natural leader, and there is little doubt that he was the crucial leavening agent in the composition of the P.R.B. Millais's professionalism and Hunt's earnestness were vital to the movement's credibility, but Rossetti supplied that indefinable element of inspirational genius that ultimately made it take wing and ensured its phenomenal influence. It was he who suggested the romantic name of Brotherhood, perhaps partly a reflection

of the atmosphere of conspiracy surrounding his exiled father, just as it was he who organised the P.R.B.'s short-lived journal and mouthpiece, *The Germ*. Nor did Hunt and Millais ever achieve work of greater intensity than in the early years when they were in close touch with Rossetti.

The Brothers were inspired by the spirit of revolution that swept Europe in 1848, and nearer home by the Chartist movement of that year. Millais and Hunt attended the great meeting that was held on Kennington Common on 10 April. There was always an undercurrent of social awareness in Pre-Raphaelitism, leading Rossetti and Brown, for instance, to teach gratis at the Working Men's College, and reaching a climax in the socialism of William Morris.

For the time being, however, the Brothers were combating evils that were essentially artistic, even if Hunt, characteristically, gave them a moral dimension when he came to write his autobiography, *Pre-Raphaelitism and the Pre-Raphaelite Brotherhood* (1905). The first evil he identified as "the frivolous art of the day".[3] This was not a sweeping condemnation. He was at pains to be fair about the art of the late 1840s, acknowledging the merits of such notable exponents as William Etty, William Mulready, C.R. Leslie, Augustus Egg and William Dyce. He bemoaned the fact that so many of J.M.W. Turner's pictures were "shut up in their possessors' galleries, unknown to us younger men",[4] while other fine artists were so preoccupied with murals in the new Houses of Parliament that they had virtually withdrawn from the arena of public exhibitions. Nonetheless, he wrote, "the greater number were trite and affected; their most frequent offence in my eyes was the substitution of inane prettiness for beauty. . . . Pictured waxworks playing the part of human beings provoked me, and hackneyed conventionality often turned me from masters whose powers I valued otherwise".[5] Among the chief objects of his scorn were 'Books of Beauty', the currently fashionable albums of engravings after paintings of simpering models, often in the guise of historical or literary heroines, and "'Monkeyana' ideas", a reference to the monkey subjects popularised by Sir Edwin Landseer and his brother Thomas, whose book *Monkeyana, or Men in Miniature* had appeared in 1828.

For Hunt and his fellow Brethren, the root of the trouble lay in the academic system that had developed in Western art since the time of Raphael. The great Renaissance master was universally regarded as having established an inviolable standard of perfection, and in almost every capital in Europe academies had sprung up to teach and perpetuate pictorial values based on his achievement. The Royal Academy of Arts in London, where so many of the Brothers and their associates were trained, was one of the last to be founded, in 1768. Hunt was as scrupulous in his comments on Raphael as in those on living artists, recalling his youthful self and Millais standing in admiration before the tapestry cartoons, and even citing "the dandelion clock in the 'St. Catherine'" as an "edifying example" of the "patient self-restraint" which he admired in the Old Masters.[6] Yet by 1847 Hunt had come to believe that Raphael's *Transfiguration* in the Vatican, left unfinished at the master's death and completed by his assistants, marked "a signal step in the decadence of Italian art", with "its grandiose disregard of the simplicity of truth, the pompous posturing of the Apostles, and the unspiritual attitudinising of the Saviour".[7] And this was only the start. "I here venture to repeat", his account continues, "what we said in the days of our youth, that the traditions that went on through the Bolognese Academy, which were introduced at the foundation of all later schools and

enforced by Le Brun, Du Fresnoy, Raphael Mengs, and Sir Joshua Reynolds, to our own time, were lethal in their influence, tending to stifle the breath of design".[8]

The Brothers were young, and their comments at the time were less measured than this, or even downright silly. They called Reynolds, the first President of the Royal Academy, whose *Discourses*, delivered to the students between 1769 and 1790, were the classic statement in England of the academic position, 'Sir Sloshua'; and Rossetti wrote 'spit here' against the name of Rubens wherever he found it in Mrs Jameson's *Sacred and Legendary Art*. Nor do any of them seem to have considered that, for all their criticism of academies and academic artists, it was the R.A. that consistently hung their pictures, and hung them well. Nonetheless, their basic analysis was valid. Much British art in the 1840s had become the slave of convention, and was hackneyed and trite as a result. It was time for artists to return to first principles, to concern themselves with serious, thought-provoking subjects, and seek to express them in an honest and meaningful form.

In rejecting Raphaelesque conventions, the Pre-Raphaelites naturally looked back to artists who had practised before Raphael's time. Hence, of course, their name, which was given to them by fellow R.A. students when their intentions became known. At their inaugural meeting they studied a volume of Carlo Lasinio's engravings after the frescoes in the Campo Santo in Pisa, one of the great treasure-houses of early Italian art, determining, according to Hunt, that "a kindred simplicity should regulate our own ambition".[9] Dante, Boccaccio, Ghiberti, Fra Angelico and Bellini were on the list of 'Immortals' which they drew up at about this time.[10] Hunt loved "the newly acquired Van Eyck" in the National Gallery,[11] and in the autumn of 1849 he and Rossetti made a continental tour during which they bought "three stunning etchings by Albert Dürer", saw "the miraculous works of Memling and Van Eyck" at Bruges,[12] and were thrilled to discover Fra Angelico's *Coronation of the Virgin* in the Louvre, a picture, Hunt recalled, "of peerless grace and sweetness in the eyes of us both".[13] Other works in this collection by Mantegna and Giorgione inspired Rossetti to write sonnets, as did two of the Memlings. All four poems were published the following year in *The Germ*, which also included an article by F.G. Stephens on "The Purpose and Tendency of Early Italian Art" and Rossetti's "Hand and Soul". This is a tale about an imaginary *trecento* artist, Chiaro dell'Erma, who paints his soul as it appears to him in the guise of a beautiful woman – an obvious metaphor for Pre-Raphaelite sincerity.

None of this was startlingly original; rebels always appeal to antiquity and rebel artists to nature, and on neither count were the Pre-Raphaelites exceptions. They may have been crucial to the development of British painting, but they were merely a wave in a tide of reaction to the old academic consensus. Indeed there was often a link with earlier manifestations. William Hogarth, the most articulate critic of academic values in eighteenth-century England, was greatly revered by the Pre-Raphaelites, appearing on the list of 'Immortals' and lending his name to the Hogarth Club (cat. no. 44). The fact that Hogarth was rampantly xenophobic and generally regarded as the founder of the British school of painting strengthened their sense of identification since there was a strong element of nationalism in Pre-Raphaelitism itself. Another of their heroes was William Blake, Reynolds's bitterest opponent. Rossetti was the proud possessor of the visionary artist's manuscript notebook, acquired when he was still a student from an attendant at the British Museum, and the two Rossetti brothers helped Mrs Gilchrist

to complete her husband's *Life of William Blake*, published in 1863. As for the 'Ancients', the group of young artists who gathered round the elderly Blake in the 1820s, they in many ways prefigured the P.R.B., being intensely idealistic and seeking inspiration in nature and the early masters. A more recent forerunner was 'The Clique', a coterie of R.A. students – Richard Dadd, W.P. Frith, Henry O'Neil, John Phillip and Augustus Egg – who banded together in 1837 with the intention of subverting the Academy. Nothing much came of this, but Egg was to be a staunch supporter of the P.R.B., while an associate of the group, William Bell Scott (1811–1890), became an important member of the Pre-Raphaelite circle.

In the wider European context, neo-classicism had appealed to antiquity as the key to a more honest, naturalistic style than the frivolous Rococo. The Pre-Raphaelites shared the universal admiration for John Flaxman, another of their 'Immortals' (cat. no. 3), while Rossetti wrote two more early sonnets on a painting by Ingres, and was much excited by the frescoes by that master's pupil, Flandrin, in Saint-Germain-des-Prés. Far more substantial, however, was the link with Romanticism; indeed Pre-Raphaelitism was essentially a late phase of the Romantic movement. Ruskin championed Turner, adored the novels of Sir Walter Scott, and quoted Wordsworth on the title-page of every volume of *Modern Painters*. Rossetti was steeped in Goethe's *Faust*, fascinated by Poe (cat. no. 10) and Meinhold, and admired not only Blake but Géricault, Delacroix and "that great painter Von Holst".[14] Brown was a devotee of Byron (cat. nos. 2, 37), whose doctor, John Polidori, was Rossetti's maternal uncle. Every Pre-Raphaelite loved Keats (yet another 'Immortal', together with Byron, Wordsworth, Poe and Shelley); and the movement enjoyed a complex relationship with the Nazarene tradition.

The group of young German artists who launched the Nazarene movement in Rome in the second decade of the nineteenth century had much in common with the P.R.B., seeking to regenerate the art of their country by going back for inspiration to the early masters, and even calling themselves a Brotherhood. They were greatly admired in England, notably by the Anglo-Catholics, for whom their pietism and archaising style had an obvious appeal. A number of British artists felt their influence, and two in particular are relevant here. The Aberdonian William Dyce (1806–1864), himself a prominent figure in High Church circles, had encountered the leaders of the movement, Peter Cornelius and Friedrich Overbeck, in Rome in the 1820s. In 1844, recommended by Cornelius and actively supported by Prince Albert, Chairman of the Royal Commission in charge and, of course, a German, he began the arduous task of painting murals in the new Palace of Westminster, which was to occupy him until his death twenty years later. Dyce was one of the first to appreciate the Pre-Raphaelites, and was influenced by them in turn. A late example of his work, in which Nazarene and Pre-Raphaelite elements are blended, is included here (cat. no. 76).

Ford Madox Brown (1821–1893) plays a much larger part in the story. He began his career painting in a lush international romantic style which reflects his training under Baron Wappers in Antwerp and the experience of living in Paris in the early 1840s (cat. nos. 1, 2). In 1844 he settled in London to work on cartoons for the Westminster Hall competitions. The historical and allegorical subjects are treated with appropriate grandeur (cat. nos. 4, 5), although even here he was unable to resist those bizarre touches which are so characteristic of his manner (cat. no. 37). It was Hunt who noted how, in painting *The Body of Harold brought before William the Conqueror* (cat. no. 4), Brown

"adopted a glaringly unreasonable reading of the fact that William went into battle with the bones of the saints round his neck. . . . Instead of painting a reliquary, he had hung femur, tibia, humerus, and other large bones dangling loose on the hero's breast, surely a formidable encumbrance both to riding and fighting".[15] By the late 1840s Brown's style had changed again. A visit to Rome for the sake of his wife's health in 1845–1846 enabled him to see the work of the Nazarenes, and this led him to develop what he called an "early Christian" style, applying it to English literary and historical subjects (cat. nos. 7, 8). It was at this point, in March 1848, that D.G. Rossetti wrote to him, professing profound admiration for his work (so profound that the suspicious Brown thought it must be a joke), and asking to become his pupil. Rossetti stayed in Brown's studio for only a few weeks before moving on to Hunt, but they became friends for life.

How was the Pre-Raphaelites' enthusiasm for 'pre-Raphaelite' values to be given concrete expression? In view of the diversity of temperament within the Brotherhood, it is not surprising that the answers varied widely.

Hunt had been reading Ruskin's *Modern Painters*, of which the first two volumes had appeared in 1843 and 1846. He was only able to borrow the book overnight, but he immediately grasped that it might have been "written expressly" for himself.[16] To someone disgusted with the inanity of much modern art, it was thrilling to find an author who took the subject so seriously, to read, for instance, that "every picture [should] be painted with earnest intention of impressing on the spectator some elevated emotion, and exhibiting to him some one particular, but exalted, beauty".[17] He was profoundly impressed by Ruskin's analysis of the Old Masters' use of typological symbolism as a means of endowing a realistic account of a subject with spiritual significance; and he took deeply to heart his famous injunction to artists at the end of the first volume, to "go to Nature in all singleness of heart, . . . rejecting nothing, selecting nothing, and scorning nothing; believing all things to be right and good, and rejoicing always in the truth".[18] These ideas, focusing and articulating his own, provided a theoretical framework for Hunt's future career. Choosing subjects which were meaningful in themselves, he would express them in terms of a realism rich in symbolic reference, achieving this by that "childlike submission to Nature"[19] which was, he believed, for all their technical immaturity, characteristic of artists before Raphael. Millais accepted this programme and for several years the friends adhered to it faithfully, carefully selecting their subjects, whether from modern life, the Bible, or the great writers of the past and present – Shakespeare, Keats, Tennyson (cat. no. 36), Patmore; aiming to see them without the preconceptions which had, in their view, bedevilled post-Raphaelite art; and painting every detail direct from life. The results were the classic masterpieces of Pre-Raphaelitism that we know so well. Several works represent them in the exhibition. Hunt's *Valentine rescuing Sylvia from Proteus* (cat. no. 17), exhibited at the Royal Academy in 1851, may not be one of the religious subjects that epitomise his approach, but it explores powerful human emotions – lust, jealousy, unrequited love, forgiveness and reconciliation; while his horror of convention is revealed in the searching analysis of psychological relationships, the acute and sympathetic observation of nature, and the total honesty of the handling of the paint itself. The effect is deeply impressive; indeed this is Hunt at his very best, achieving a powerful intensity, but with that wonderful spring-like freshness which marks early Pre-Raphaelite painting, and none of the hectoring

didacticism which (to us today, if not to contemporaries) disfigures his later painting. The two examples by Millais are slighter as statements of principle, but one is a study for *Ophelia* (cat. no. 22), perhaps his most famous Pre-Raphaelite painting, while *The Blind Girl* of 1856 (cat. no. 38) combines pathos of subject with extreme sensitivity to landscape in an image of heartbreaking poignancy.

But the question of realisation was not quite as simple as Hunt later maintained. In his book *Pre-Raphaelitism* he would insist that the P.R.B. was not revivalist in the same sense as the Nazarenes, who sought to re-invoke both the spirit and form of early Italian and German art. As he summed it up, "Pre-Raphaelitism [was] not Pre-Raphaelism".[20] Nonetheless, both he and Millais were susceptible to outward forms. Their determination to shun convention often led them into what an American critic in 1856 described as "quaintness, stiffness, and gratuitous deformity",[21] and this was accentuated by a hard linear drawing style that was dictated by their distaste for visual compromise but in practise owed much to the Campo Santo engravings and to archaising modern German artists such as Moritz Retzsch and Josef Führich, who are both mentioned in Hunt's account. The exhibition contains two major examples of this style by Millais (cat. nos. 11, 12), both 'stiff' and 'quaint' to a degree that goes far beyond 'truth to nature' and comes to represent a new form of mannerism. Moreover, several early pictures by Hunt and Millais employ symbolism of an Anglo-Catholic character,

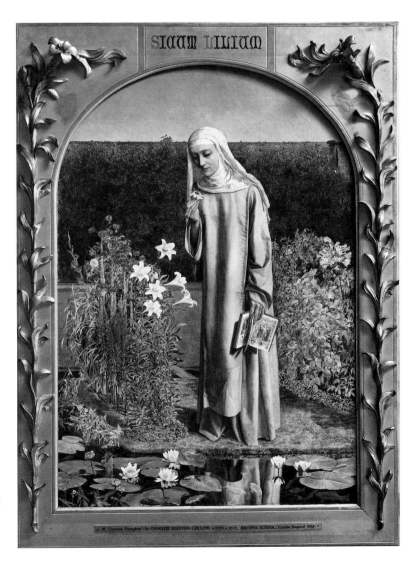

Fig. 7 CHARLES ALLSTON COLLINS, *Convent Thoughts*, 1850–1851; oil on canvas, arched top, 32 1/2 x 22 3/4 in. (82.6 x 57.8 cm.). Ashmolean Museum, Oxford.

and, as we saw, it was the Anglo-Catholics who favoured the Nazarenes, just as they loved Sir Walter Scott's historical novels and espoused the Gothic Revival. This tendency in Hunt and Millais was encouraged by their patron Thomas Combe, Printer to the University of Oxford and a leading figure in Tractarian circles, numbering John Keble and John Henry Newman (who conducted Combe's marriage) among his friends. 'The Early Christian', as the Pre-Raphaelites called him, acquired such important works as Hunt's *Light of the World* (1853; Keble College, Oxford), Millais's *Return of the Dove to the Ark* (1851; Ashmolean Museum, Oxford), and that most overtly Anglo-Catholic of Pre-Raphaelite paintings, C.A. Collins's *Convent Thoughts* (1851; Ashmolean Museum, Oxford; fig. 7).

But the real break in the ranks came with Rossetti. Under Hunt's influence he acknowledged for a time the need to paint direct from nature, and made gallant efforts to do so in two major early pictures, *The Girlhood of Mary Virgin* (1849) and *The Annunciation* (1850; both Tate Gallery, London). But it is significant that these were subjects closely associated with early art. The purist approach never really appealed to Rossetti. Constant reference to observed truth proved irksome, while his highly impressionable temperament responded eagerly to the externals of 'primitive' painting, the pietism of its subject matter, its naive and decorative expression. If Hunt admired the "innocent spirit" of the Campo Santo paintings, Rossetti found Hans Memling "wonderfully mystic and poetical".[22] The exhibition contains a drawing of circa 1848 (cat. no. 10) which is clearly indebted to early Flemish painting, together with a magnificent essay in the taut, wiry 'engraving' style already encountered in Millais (cat. no. 13). Needless to say, Rossetti's friendship with Brown encouraged him to think in revivalist terms. Hunt thought *The Girlhood of Mary Virgin* "most Overbeckian in manner",[23] and remonstrated with Rossetti for adopting Brown's neo-Nazarene term of 'early Christian'.

When the Pre-Raphaelites began to exhibit their paintings, the first reaction was one of outrage. The sheer brilliance of their colour, achieved by working in semi-transparent paint on a pure white canvas, was shocking to eyes used to the 'old mastery' tones of most contemporary painting, while the awkward gestures, serious subjects and hints of abstruse symbolism disconcerted and embarrassed a public used to a diet of platitudes. The most famous attack was that of Charles Dickens on Millais's *Christ in the House of his Parents* (Tate Gallery, London; fig. 8), published in *Household Words* when the picture was exhibited at the Royal Academy in 1850. The Christ child, he wrote, was

> a hideous, wry-necked, blubbering, red-haired boy in a night-gown, who appears to have received a poke playing in an adjacent gutter, and to be holding it up for the contemplation of a kneeling woman, so horrible in her ugliness that (supposing it were possible for any human creature to exist for a moment with that dislocated throat) she would stand out from the rest of the company as a monster in the vilest cabaret in France or in the lowest gin-shop in England.[24]

The critics' hostility was redoubled when, as a result of a 'leak' by Rossetti, they learnt the meaning of the initials 'P.R.B.' which the artists added to their signatures, and it became clear that these presumptuous youths were flouting the most hallowed artistic conventions.

From the first, however, the Brothers commanded respect in informed circles. Among their earliest admirers was Dyce, and he brought them to the notice of John

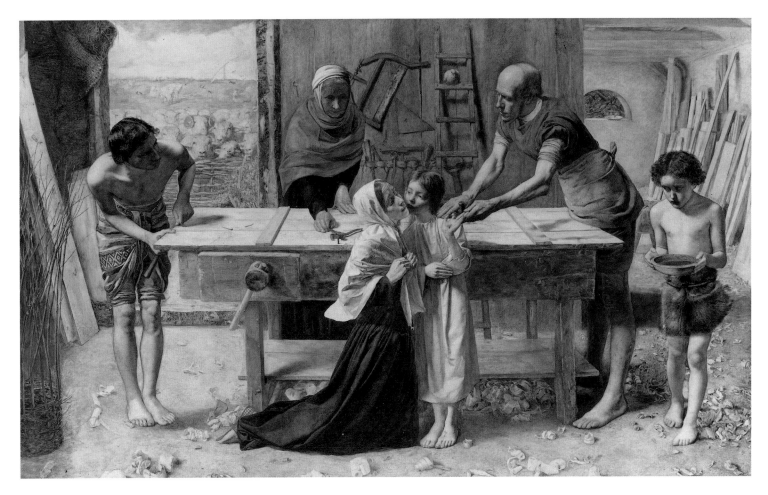

Fig. 8 JOHN EVERETT MILLAIS, *Christ in the House of his Parents*, 1849–1850; oil on canvas, 34 x 55 in. (86.5 x 139.7 cm.). Tate Gallery, London.

Ruskin (1819–1900), the most influential critic of the day. Ruskin had not been particularly impressed by their work when he first saw it, but on examining it more carefully he decided that it did indeed correspond to the principals of *Modern Painters*, and in May 1851 he came to their defence in two letters to the *Times*, which had just published a vitriolic attack on their pictures at that year's Academy. From then on he lost no opportunity of calling attention to their merits, publishing the pamphlet *Pre-Raphaelitism* in 1851, alluding to them in later volumes of *Modern Painters* and in *The Stones of Venice*, and devoting one of his Edinburgh Lectures to them in 1853. Soon, as he predicted, many were following their example; it is the commonest occurrence to find artists exhibiting Pre-Raphaelite influence in the 1850s, even if for many it was only a passing phase.

We have already seen that Dyce himself reached an accommodation with Pre-Raphaelitism, and Brown, the other 'father figure' with Nazarene connections, was influenced by the young trendsetters. Indeed, through his friendship with Rossetti, Brown became a leading member of the Pre-Raphaelite circle, although he did not join the Brotherhood. Moreover, unlike Dyce, who never entirely outgrew the Nazarene experience, he embraced Pre-Raphaelite values with all the ardour of his forceful personality, going to as great lengths as Hunt to paint his pictures direct from nature. As he recorded, *The Pretty Baa-Lambs* (cat. no. 18), begun in 1851, "was painted almost entirely in sunlight which twice gave me a fever while painting. I used to take the lay figure out every morning & bring it in at night or if it rained. . . . The lambs & sheep used to be brought every morning from Clappam [*sic*] Common in a truck. One of them eat [*sic*] up all the flowers one morning in the garden where they used to behave very ill".[25]

Yet for all its truth to objective reality, the picture is not Pre-Raphaelite in one vital respect, having no moral or symbolical meaning. "The only intention", Brown wrote later, "[was] to render [the] effect [of sunlight] as well as my powers in a first attempt of this kind would allow".[26] It is not surprising that the critics were puzzled when the picture appeared at the Academy in 1852, the *Art Journal* summing up reactions by observing that "such [was] the general animus of the work that it [was] impossible to apprehend its bent".[27] Nor did Brown succeed in selling it until 1859. Divorced from its didactic purpose, Pre-Raphaelitism was anticipating Impressionism by a decade.

A more fully Pre-Raphaelite work was *The Last of England*, often regarded as Brown's masterpiece, which he began in 1852 and completed three years later (cat. nos. 20, 21). This again, as he noted, was carried out in the most rigorous circumstances. "To ensure the peculiar look of *light all round*, which objects have on a dull day at sea, it was painted for the most part in the open air on dull days, and when the flesh was being painted, on cold days". But this time there was an ulterior motive, serious enough to satisfy Ruskin himself, although in fact Ruskin never cared for Brown's work and, to Brown's annoyance, did nothing to promote it. The account continues:

> This picture is in the strictest sense historical. It treats of the great emigration movement which attained its culminating point in 1852. . . . I have, . . . in order to present the parting scene in its fullest tragic development, singled out a couple from the middle classes, high enough, through education and refinement, to appreciate all they are now giving up, and yet depressed enough in means to have to put up with the discomforts and humiliations incident to a vessel "all one class". . . . The minuteness of detail which would be visible under . . . conditions of broad daylight, I have thought necessary to imitate, as bringing the pathos of the subject more home to the beholder.[28]

Brown's Pre-Raphaelite work all tends to oscillate between the poles of pure observation and moral homily; he painted many straightforward landscapes but in 1852 embarked on *Work* (cat. no. 74), that great sermon in paint, Hogarthian yet quintessentially Victorian, which only reveals its full meaning when 'read' like a many layered and richly textured book.

Among younger artists, the first to be closely associated with the movement was the handsome and tragically short-lived Walter Howell Deverell (1827–1854) (cat. no. 23). Born of English parents in Charlottesville, Virginia, he was taken to England as a child and encountered the P.R.B. as a student at the Royal Academy Schools in the late 1840s. Rossetti, his chief mentor, proposed that he should join the Brotherhood, but he was never actually elected. He is represented here by one of the Shakespearean subjects in which he specialised, the mock marriage of Rosalind and Orlando in *As You Like It* (cat. no. 24). The picture was painted at Combe Wood in Surrey, with the models posed out of doors in the approved Pre-Raphaelite fashion. His sister Margaretta sat for Rosalind and his brother Spencer for Orlando.

Deverell was quickly followed by Charles Allston Collins (1828–1873), the son of the genre painter William Collins and the younger brother of Wilkie Collins, the novelist. A close friend of Hunt and Millais, he too was proposed for membership of the P.R.B. but was rejected on the grounds that he had not yet proved his Pre-Raphaelite credentials – a rather unfair judgement since the same could have been said of more than one of the original Brothers. Apart from the already mentioned *Convent Thoughts* (fig. 7), Collins is best known for *Berengaria's Alarm for the Safety of her*

Husband, Richard Coeur de Lion, Awakened by the Sight of his Girdle Offered for Sale at Rome (Manchester City Art Gallery), which was exhibited at the Royal Academy in 1850. As so often with the work of minor artists, the picture is almost a parody of the style it represents, being full of wilful *gaucheries* and exploring the difficult terrain of typological symbolism with naive abandon. The cumbersome title also raises a smile, although Collins was only following a mid-Victorian fashion to which his friend Hunt, too, subscribed.

Arthur Hughes (1832–1915) was another early follower. Having become interested in Pre-Raphaelitism on reading *The Germ* in 1850, he met the Brothers and was soon developing a very personal style in which religious subjects (cat. nos. 46, 47), domestic scenes (cat. no. 87) and themes of romantic love (cat. nos. 48, 49) were handled with great sensitivity. Millais the painter of star-crossed lovers, notably *A Huguenot* of 1852 (Private Collection), was the chief influence on him. The tendency towards genre evident in Hughes was even more pronounced in R.B. Martineau (1826–1869), a pupil of Hunt. Martineau is best known for *The Last Day in the Old Home* (1862; Tate Gallery, London), in which a well-to-do family is seen on the point of quitting their ancestral mansion because of the feckless father's gambling, but *The Last Chapter* (cat. no. 69) is probably a better, if less ambitious, picture. Martineau came from a professional family, his father and brothers being lawyers. He was the model for the 'gentleman' on horseback in *Work* (cat. no. 74), described by Brown as "very rich, probably a colonel in the army, with a seat in Parliament, and fifteen thousand a year and a pack of hounds".[29]

Henry Wallis (1830–1916) is an example of an artist who was not in the inner Pre-Raphaelite circle but who produced one or two masterpieces under its influence. Like so many of the Brothers and their associates, he attended the R.A. Schools, and then studied under Charles Gleyre and at the Ecole des Beaux-Arts in Paris. It is tempting to imagine that, while in France, he saw Courbet's painting *The Stonebreakers* (1849; formerly Dresden Gallery), and that this had a bearing on his own version of the theme (cat. no. 40). This almost unbearably moving image shocked many but was greatly admired by Ruskin, despite his strong dislike of 'painful' subjects. It is undoubtedly Wallis's masterpiece, as well as a key work in the social-realist tradition that runs so strongly through Victorian art. Wallis's other well-known picture, the slightly earlier *Chatterton* (cat. no. 39), appears stagey and conventional by comparison, although it has been suggested that Wallis saw them as pendants, representing respectively the 'toilworn Craftsmen' and the 'inspired Thinker' whom Thomas Carlyle celebrates in *Sartor Resartus*. The same contrast, underlined by the inclusion in the picture of Carlyle himself, is a central theme of Brown's *Work* (cat. no. 74), which was in progress at the same time.

Wallis's Parisian training tells us something important about the early Pre-Raphaelites. We have seen how Brown also studied abroad, and how Hunt and Rossetti visited Paris and Belgium in 1849. Six years later, in 1855, Hunt and Millais were represented at the Exposition Universelle in Paris, where their work arrested the attention of Delacroix. "Stayed there until midday looking at the paintings by those Englishmen whom I admire so much", he recorded in his journal on 30 June. "I am really astounded by Hunt's sheep".[30] Pre-Raphaelite paintings were also included in the exhibition of British art, largely organised by William Michael Rossetti, that was shown in New York, Philadelphia and Boston in 1857–1858, thus giving Americans their first chance to

see such works at first hand, as distinct from reading about them in the press.[31] On the whole, however, Pre-Raphaelitism remained essentially insular throughout its early development. This is not really surprising, considering it was conceived as a revival of British art on the Hogarthian model, and that neither Millais, pursuing his public, nor Hunt, absorbed in his religious symbolism, was likely to challenge the British prejudice against French artistic values. More might have been expected of Rossetti, the bohemian Italian who had written sonnets on a picture by Ingres and was to become a close friend of the cosmopolitan James McNeill Whistler, but he was more chauvinistic than any. Visiting Paris in 1864, he found Manet's pictures "mere scrawls", Courbet's "not much better", and the "new French school" in general "simple putrescence and decomposition".[32]

Like the ripples of a stone dropped into a pond, Pre-Raphaelitism exerted influence in ever-widening circles. William Bell Scott represented an outpost of the movement in Newcastle, where he was Master of the Government School of Design for twenty years from 1843. In Edinburgh some of Robert Scott Lauder's most talented students at the Trustees' Academy, later to make their name as exponents of a bold 'impressionism', were temporarily influenced by the pictures by Hunt and Millais which were exhibited at the Royal Scottish Academy in the late 1850s. But the most flourishing of these regional centres was Liverpool, where the Pre-Raphaelites found a warm reception among local artists and patrons. The key figure was John Miller, a local tobacco merchant, whose large collection included Millais's *Blind Girl* (cat. no. 38) and Deverell's *Scene from "As You Like It"* (cat. no. 24), purchased through Rossetti after the young artist's death to help his impoverished family. Encouraged by such enthusiasm, Hunt, Millais, Brown and others exhibited their work at the Liverpool Academy in the 1850s, and were consistently awarded the £50 non-member prize. Hunt won it in 1851 with his *Valentine rescuing Sylvia from Proteus* (cat. no. 17) and Millais in 1857 with *The Blind Girl*, while Brown's *Last of England* (cat. nos. 20, 21) and *The Pretty Baa-Lambs* (cat. no. 18) appeared at the Liverpool Academy respectively in 1856 and 1859. The presence of these pictures, together with visits from the artists themselves, had a profound impact, and a distinct Liverpool version of Pre-Raphaelitism emerged. The chief exponents were W.L. Windus (1822–1907), who is known particularly for two pictures – *Burd Helen* (1856; Walker Art Gallery, Liverpool) and *Too Late* (1858; Tate Gallery, London; fig. 9); William Davis (1812–1873), who specialised in landscape; John J. Lee (fl. 1850–1867), the author of a handful of genre subjects of great intensity; and James Campbell (circa 1828–1893), who is represented here (cat. no. 45). Like so many of these painters, Campbell was supported by Miller, although he also enjoyed the patronage of the Birkenhead banker George Rae and the Newcastle industrialist James Leathart. Miller, Rae and Leathart were typical of the self-made men, usually based in the provinces, who formed the most significant collections of Pre-Raphaelite paintings. Although the movement had a few aristocratic patrons, among them Sir Walter and Lady Trevelyan, George Howard, Earl of Carlisle, and the 'Souls' who later bought the work of Edward Burne-Jones, collecting their work was essentially a middle-class activity, quite unlike the aristocratic patronage of portraitists and sporting artists that had dominated British painting in the eighteenth century.

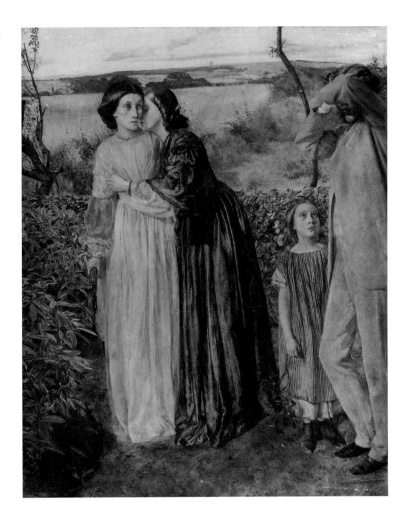

Fig. 9 WILLIAM LINDSAY WINDUS, *Too Late*,
1857–1858; oil on canvas, 37 1/2 x 30 in.
(95.3 x 76.2 cm.). Tate Gallery, London.

Ruskin's success as an apologist for Pre-Raphaelitism owed much to his membership of this professional middle class. He was able to explain the movement in the language of evangelical morality that it knew so well, just as he was able to explain European art and architecture to the new breed of middle-class tourist. He was increasingly involved with the artists concerned. Having come to their defence in 1851 and supported them during their early struggles, he reserved the right to guide and admonish them when he saw room for improvement or thought that standards were slipping. His first protégé was Millais, whom he met in the summer of 1851 as a result of his letters to the *Times*. There was immediately talk of their going together to Switzerland, giving Ruskin the chance to expound his theories in relation to his beloved Alpine scenery; and although this plan fell through, a similarly didactic purpose lay behind the holiday which Millais spent with Ruskin and his wife in the Trossachs in the summer of 1853, when he painted the famous portrait of his patron standing against a waterfall at Glenfinlas (Private Collection). Ruskin's attitude to Millais at this time is reflected in a highly characteristic comment which he made in a letter to his father on 24 July; the artist, he wrote, "is a very interesting study, but I don't know how to manage him".[33]

As is well known, the Scottish trip led to the break-up of Ruskin's marriage and the severance of relations between him and Millais, who married the former Mrs Ruskin two years later. Ruskin, who had an almost pathological need to instruct, might then have turned his attention to Hunt; but in January 1854 Hunt effectively removed himself from Ruskin's sphere of influence by leaving England to paint biblical scenes in

the East. There remained Rossetti, whom Ruskin met in April 1854 and recognised, rightly, as the driving imaginative and intellectual force behind the P.R.B. During the next few years they were in close communication, and Rossetti derived both artistic stimulus and financial benefit from the friendship. But this too was doomed. A dominant personality himself, Rossetti found Ruskin's fussy attempts at supervision increasingly irksome, while Ruskin for his part was more and more disenchanted with Rossetti's artistic development. By the late 1850s he was transferring his attention yet again, this time to Rossetti's pupil Edward Burne-Jones (1833–1898). And here at last he achieved a measure of success. Both on a personal and on an intellectual level, the relationship was to be the most satisfying that Ruskin would ever enjoy with a major practising artist.[34]

In addition to this sequence of attempts to mould the leaders of the movement, Ruskin tried to influence a number of Pre-Raphaelites who were primarily concerned with landscape, lesser figures but ones whose subject matter made them of special interest to a critic whose whole analytical system was based on his championship of Turner. G.P. Boyce (1826–1897), John Brett (1831–1902), J.W. Inchbold (1830–1888) and the American J.W. Stillman (1828–1901) were all recipients of Ruskin's freely given advice in the 1850s. It was a daunting experience, and not everyone could cope. Brett, having attracted Ruskin's attention with his picture *The Stonebreaker* (Walker Art Gallery, Liverpool) of 1858 (comparable in theme to cat. no. 40 but without its social commitment), not only found himself painting a Ruskinian subject, *The Val d'Aosta* (Private Collection), that summer, but being summoned to Turin to be 'lectured' by the master on how to do it. Ruskin himself admitted that he had reduced the painter to a "completely wretched" state,[35] and it is hardly surprising that the picture was not a total success. Indeed, although Brett was capable of magical evocations of nature as late as the mid-1860s (cat. no. 82), he never quite fulfilled his early promise, and much of his later work is pedestrian (cat. no. 103). Even more disastrous was the impact of Ruskin on Stillman, whose artistic career was literally ruined by his mentor. Visiting London in 1859, Stillman spoilt and subsequently destroyed an important picture as a result of Ruskin's ill-judged advice. But the nadir of their relationship was reached in the summer of 1860 when he suffered an acute crisis of confidence and even temporary blindness while working with Ruskin in Switzerland. Having abandoned painting for a diplomatic career, he later wrote: "Ruskin had dragged me from my old methods, and given me none to replace them. I lost my faith in myself, and in him as a guide to art".[36] His words might have been echoed by the Liverpool figure painter W.L. Windus, who was so discouraged when Ruskin adversely reviewed his picture *Too Late* (1858; Tate Gallery, London; fig. 9) that he virtually gave up painting.

But although Ruskin could be thoughtless to the point of cruelty, even in these extreme cases he was perhaps ultimately no more than a contributory factor. Pre-Raphaelitism made such demands on an artist that it was almost impossible to maintain an unswerving loyalty to the original principles. As we have seen, one of the Brothers, F.G. Stephens, turned to journalism, while another, James Collinson, reverted to conventional genre subjects. Outside the P.R.B. the same pattern occurs. Charles Allston Collins gave up painting for literature, a move perhaps not unconnected with his marriage to Dickens's daughter in 1860. Wallis put an increasing amount of energy into travel, excavation and collecting, interests which find a reflection in his *Corner of an Eastern Courtyard* (cat. no. 92), which dates from the 1870s. J.W. Inchbold and G.P. Boyce survived the

Ruskinian onslaught and continued to paint pictures of integrity and charm to the end of their lives (cat. nos. 91, 109). Yet in both cases their later work represents a compromise in terms of either a freer technique or a more conventional vision.

The major figure painters show a similar development. All were forced to abandon a programme conceived in a mood of youthful idealism but hardly sustainable in later years, when they were subject to the economic pressures of family life. Time and again we see the extreme delicacy of early Pre-Raphaelite practice give way to a broader and coarser touch, while the original notion of painting everything direct from nature is replaced by more traditional 'studio' methods. Inevitably, mannerisms emerged. The sensitivity which distinguishes the early work of Arthur Hughes tended to degenerate into a rather cloying sentimentality. Brown's style, on the other hand, became progressively quirkier, appearing at its most bizarre in the murals illustrating scenes from local history which he was commissioned to paint in Manchester Town Hall in 1878, and completed just before his death fifteen years later. In these highly eccentric but strangely compelling paintings he finally fulfilled the role of monumental history painter which he had assumed in the 1840s when he embarked on designs for murals in the new Houses of Parliament, and which to some extent had coloured his whole career.

When we talk of the Pre-Raphaelites compromising their artistic vision, the name that leaps to mind is that of Millais. To the end, when he put his mind to it, he could be an interesting artist, and like many others in the circle, including Brown (cat. no. 75), Hunt, Rossetti, Hughes, Burne-Jones, Solomon and Sandys (cat. nos. 83, 84), he made a significant contribution to the revival of book and periodical illustration which is such a notable feature of English art in the third quarter of the nineteenth century (cat. nos. 41, 53). From the start, however, he had known how to charm the public, and by the early 1860s he was well on the way to becoming the most successful artist of his day, painting scenes of ill-fated love and sentimental studies of children which enjoyed enormous popularity. His style broadened under the influence of the Old Masters, especially Velazquez and Frans Hals, and he identified closely with the Royal Academy, an institution which, for all his youthful rebellion, was his true spiritual home. As early as 1853 he was elected an Associate member; ten years later he became a full Academician, and he was President for a brief period before his death in 1896. In 1885 he was created a baronet, the first British artist to be accorded this honour.

Hunt is invariably seen as the Brother who remained most faithful to the original tenets. He certainly saw himself in this light, and Evelyn Waugh, who was related to him by marriage, went so far as to call him "the only Pre-Raphaelite".[37] It is true that he took Pre-Raphaelite values to their logical conclusion, paying a series of visits to the Holy Land to paint biblical events on the very spot where they had occurred. Yet even his style broadened and coarsened in time, while his work lost something of its early tension and insight (cat. no. 114). Perhaps the very fervour of his pursuit of truth was to blame. It is interesting that Ruskin did not approve of him going to the East, fearing that it would inhibit the free play of his imagination.

The first visit took place in 1854–1855 (cat. nos. 28–30), and produced that tormented masterpiece *The Scapegoat* (Lady Lever Art Gallery, Port Sunlight; fig. 2), as well as seeing the beginning of *The Finding of the Saviour in the Temple* (cat. no. 29), finally completed in 1860. Other visits followed in 1869–1872, 1875–1878 and 1892, each resulting in some great religious work that expressed the concept of symbolic realism

which he had long since absorbed from his reading of *Modern Painters*. Unlike Millais, Hunt was never an establishment figure. Ceasing to exhibit at the Royal Academy after 1874, he preferred to show his work at dealers' galleries or at the Grosvenor Gallery in Bond Street, which opened in 1877 as a liberal alternative to the Academy and quickly established itself as a forum of artistic innovation and the flagship of the Aesthetic movement. This did not mean, however, that he lacked worldly success. His painstaking reconstructions of biblical events sold for enormous prices: Ernest Gambart paid £5,500 for *The Finding of the Saviour*, and Agnew's no less than £10,500 for *The Shadow of Death* (1870–1873; Manchester City Art Gallery). He also received official recognition, being awarded the newly instituted Order of Merit and the Oxford degree of D.C.L. in 1905. The same year, by then indisputably the grand old man of the movement, he published the autobiography that has so often been quoted in this article, a massive two-volume apologia, biased and self-justificatory, but in its way brilliantly written and still an indispensable source for the scholar. He died five years later, outlived by only one other member of the Brotherhood, William Michael Rossetti.

If Millais's artistic destiny carried him to the heart of the Royal Academy and Hunt's to the bandit-infested shores of the Dead Sea, then Rossetti's career was also the ineluctable fulfilment of an artistic personality clearly defined from the start. His two early illustrations to the life of the Virgin were followed by one more attempt to paint a picture in oils from nature, a modern subject of social and psychological import, *Found* (cat. nos. 34, 35). But it was never completed and he soon gave up trying to work in this way, turning to the less demanding medium of watercolour and giving free rein to the imaginative faculty in which his true strength as an artist lay. The watercolours he painted in the 1850s – the earlier ones biblical or Dantesque in theme (cat. no. 33), the later chivalric or Arthurian (cat. no. 50) – are by common consent his greatest artistic achievement. Technically they are often awkward and unsure, but the very struggle for expression lends them a piercing intensity which a more polished performance could never convey.

The muse of Rossetti's Dantesque phase was Elizabeth Siddal (1829–1862), the enigmatic red-haired girl whom Deverell is said to have 'discovered' working as a milliner's assistant near Leicester Square in 1849. Rossetti painted and drew her obsessively throughout the 1850s (cat. nos. 16, 27, 33), and in 1860, after a long and tortuous engagement, they married. Two years later she died in tragic circumstances, and he left their bohemian 'crib' overlooking the Thames at Blackfriars, settling in a large romantic house up river in Cheyne Walk, Chelsea. About the same time his style changed dramatically. Returning once again to oils, and working on a much larger scale than hitherto, he began to paint the female half-lengths for which he is probably best known, basing them on a series of glamorous models and often giving them fanciful Italian titles (cat. no. 110). In the 1860s the model who dominated his work was Fanny Cornforth, his housekeeper and mistress (cat. nos. 78, 89, 90). Just as the virginal Lizzie had inspired his Dantesque designs, so Fanny's coarse good looks and golden hair corresponded to a voluptuous and consciously 'Venetian' quality which he cultivated at this period. The 1870s saw his work change in mood yet again, becoming soulful and melancholy, with strong hints of symbolic meaning (cat. no. 102). Once more the development was associated with a model with whom he was closely involved emotionally, this time Jane Morris, whom he had encountered as early as 1857 and fallen in love with after she was

married to William Morris (1834-1896), his follower and partner in business (cat. nos. 42, 95, 110, 111). Morbidly sensitive to criticism, Rossetti virtually ceased to exhibit after 1850,[38] selling his work privately and living an increasingly reclusive existence. This did not, however, harm his reputation. On the contrary, it created the legend of a withdrawn and eccentric genius, and his pictures were eagerly sought by devoted patrons, among whom William Graham, a wealthy businessman and Member of Parliament for Glasgow, and the Liverpool shipowner F.R. Leyland were prominent. Rossetti's reputation as a poet was also established by the publication of his *Poems* in 1870. Nonetheless there remains an aura of failure about this great and fascinating man. His life was increasingly clouded by illness and melancholia, and when he died in 1882 at the age of fifty-three he had hardly realised the full potential of his exceptional mental powers.

We have seen how Rossetti's intellectual gifts and force of character were crucial to the initial success of the Brotherhood. It is therefore not surprising that while Hunt and Millais had the occasional follower, Rossetti continued to exercise a potent influence which largely determined how the movement later developed. In the case of Lizzie Siddal, he played an almost Svengalian role, and her drawings and watercolours are a touching echo of his (cat. no. 43). All Rossetti's work has an autobiographical element, but nowhere is this more apparent than in the drawing *Love's Mirror* of circa 1850 (cat. no. 16), in which he shows himself in the guise of a Renaissance artist helping Lizzie to paint her portrait, both their heads being reflected in a mirror. Lizzie in fact was only one of a number of women artists within the Pre-Raphaelite orbit, most of whom were related in some way to the male practitioners, as sisters, daughters, mistresses or wives. Others were Rosa Brett, Joanna Boyce, Lucy and Catherine Brown, Alice Boyd, Marie Stillman, Rebecca Solomon, May Morris and Evelyn De Morgan. They fail to appear in the exhibition only because they are so poorly represented at Birmingham.

It would be simplistic to describe Alexander Munro's *Paolo and Francesca* of 1852 (cat. no. 19) as an expression of Rossetti's influence. This well-known sculpture and Rossetti's contemporary drawings on the same theme are essentially twin expressions of the same idea; influence is mutual, and the composition in both cases goes back to Flaxman. On the other hand, the later and more florid style of Brown (cat. no. 97) undoubtedly owed much to his close friendship with Rossetti. The art of Frederick Sandys also betrays the fact that he belonged to Rossetti's circle (cat. nos. 77, 83–85, 88, 98), although the resemblance between the two artists is superficial. Indeed Sandys's technically brilliant but heartless work exactly reverses the elements found in Rossetti, powerful emotion often expressed in terms of an inadequate technique.

But the greatest monument to Rossetti's powers of inspiration is the development associated with Edward Burne-Jones and William Morris (cat. no. 55), a whole new wave of the movement that carried it into realms unimaginable in 1848, even if, with the benefit of historical hindsight, we can see that certain seeds were present. These two youths had gone up to Oxford in 1853, differing considerably in social background but united in their love of all things medieval and their identification with the Tractarian movement. They were determined to enter the Church, but to their bitter disappointment they found that the religious fervour they had expected to encounter had evaporated (Newman had seceded a full eight years before), and they began to seek new outlets for their devotional enthusiasm. Carlyle's theory of hero-worship encouraged them

to look for heroes, and they found them in Alfred Tennyson (cat. no. 36), Charles Kingsley, and Carlyle himself. But the really significant discovery was Ruskin, who not only thrilled them with his magnificent prose and descriptions of gothic architecture, but convinced them, by his concept of the prophetic nature of art, that here was a vehicle for their idealism no less valid than the Church. Burne-Jones had drawn prolifically from an early age, but without much sense of direction. Under Ruskin's guidance he began to cultivate the gift, and, together with Morris, to seek out the work of the Pre-Raphaelites whom they had read about in *Modern Painters* and the Edinburgh Lectures. They visited the Royal Academy, but their main source was the collection formed in Oxford by Thomas Combe. Although this, as we have seen, contained major works by Hunt and Millais, their "greatest wonder and delight"[39] was reserved for Rossetti's watercolour *Dante Drawing an Angel on the Anniversary of the Death of Beatrice* (1853–1854; Ashmolean Museum, Oxford; fig. 10 [cat. no. 13 is an earlier version]). The picture's intensely poetic evocation of the Middle Ages perfectly reflected their own ardent romanticism, and they were captivated by the powerful personality behind it.

Returning from a tour of the cathedrals of northern France in the Long Vacation of 1855, they finally decided to devote themselves to art, Burne-Jones as a painter, Morris as an architect. In January 1856 Burne-Jones contrived to meet Rossetti, and by May he was launched on his career under his hero's supervision in London. He was soon joined by Morris, whom Rossetti declared must also become a painter (cat. no. 51). It was the perfect marriage of minds and needs. Rossetti was the ideal hero the friends had long been seeking; they offered him scope for his powers of leadership; and both brought to the union a passion for the Middle Ages. The upshot was the emergence of a self-conscious clique devoted to a cult of medievalism, with the *Morte d'Arthur* assuming the status of a sacred text. They revelled in far-fetched literary conceits, and indulged,

Fig. 10 DANTE GABRIEL ROSSETTI, *Dante Drawing an Angel on the Anniversary of the Death of Beatrice*, 1853–1854; watercolour, 16 1/2 x 24 in. (42 x 61 cm.). Ashmolean Museum, Oxford.

half tongue-in-cheek, in quaint pictorial effects; Rossetti admitted that he adopted some of his most eccentric details "to puzzle fools".[40] Historically, the outstanding product of this phase was the murals which the trio and their associates painted in the Oxford Union in 1857 (cat. no. 42), all illustrating scenes from Malory. As is well known, however, the artists approached their work with more enthusiasm than knowledge, and the paintings soon faded to shadows. Fortunately Rossetti, Morris and Burne-Jones all left more durable expressions of their medievalism, Morris his first volume of poetry, *The Defence of Guenevere* (1858), Rossetti and Burne-Jones a series of intense pen and ink drawings and watercolours. The exhibition contains a watercolour by each which make a fascinating comparison. Rossetti's *Sir Galahad* of 1859 (cat. no. 50) and Burne-Jones's *Merciful Knight* of 1863 (cat. no. 73) are comparable in theme and design, but the interpretation is very different, Rossetti being fundamentally interested in drama, emotion and psychology, Burne-Jones in a fairy-tale dream-like mood and a decorative effect. Whatever the superficial resemblances, this essential dualism runs throughout their work.

From the outset Burne-Jones's decorative approach found its logical expression in applied design. He excelled at designing stained glass, and soon found himself working with such leading exponents of the Gothic Revival as William Butterfield, G.F. Bodley and William Burges. Morris also discovered that his talent lay in decorative art, and in 1861 he launched the firm of Morris, Marshall, Faulkner and Company, "fine art workmen", which was to have such a phenomenal impact on later Victorian taste. In addition to Morris himself (cat. no. 56), the partners included Burne-Jones (cat. nos. 59, 66, 100), Rossetti (cat. nos. 60–64), Brown (cat. no. 57), and the architect Philip Webb (1831–1915) (cat. no. 65), whom Morris had met when they were both working in the office of G.E. Street. Other artists were employed from time to time, including Arthur Hughes (cat. no. 58), who had already contributed to the Union murals, and Simeon Solomon (1840–1905), a brilliant young Jewish artist, fresh from the Royal Academy Schools, who joined Rossetti's circle in the late 1850s.

Solomon's work, with its unique blend of Hebraic (cat. no. 52), Anglo-Catholic, homoerotic (cat. no. 94) and mystical elements, brings us to yet another stage in the development of Pre-Raphaelitism, the point at which, having outgrown its medievalist excesses, it shades imperceptibly into the Aesthetic movement. "Since Pre-Raphaelitism has gone out of fashion", the *Art Journal* observed in its review of the Royal Academy exhibition of 1871, "a new [and] select . . . school has been formed by a few choice spirits. . . . The brotherhood cherish in common reverence for the antique [and] affection for . . . Italy; they affect southern climes . . . [and] a certain *dolce far niente* style, with a general Sybarite state of mind which rests in Art and aestheticism as the be-all and end-all of existence".[41] This passage is a useful point of reference since it not only recognises the emergence of 'aestheticism' but identifies its salient characteristics: dependence on classical and Italian art and a belief in beauty as an end in itself, not as a handmaid to morality. No-one did more to formulate a theory of the movement than the Oxford don Walter Pater (1839–1894), whose book *The Renaissance* (1873) contains the famous dictum that "all art constantly aspires towards the condition of music", that is to say is essentially abstract in nature and concerned with formal values. Solomon was a close friend of Pater, who particularly admired his *Bacchus* (cat. no. 86). Similar ideas were expressed by Algernon Charles Swinburne (1837–1909), who had joined the Rossetti

circle at the time of the Union 'campaign', and, unlike Pater, wrote about modern art. In a review of the Royal Academy exhibition of 1868, for instance, he described the work of Albert Moore (1841–1893) as being "to artists what the verse of Théophile Gautier is to poets, the faultless and secure expression of an exclusive worship of things formally beautiful".[42]

Moore was typical of the 'new and select school'. A member of a York family of artists, he studied at the R.A. Schools and experimented with Pre-Raphaelite natural-ism at the outset of his career. Following a stay of some months in Rome in 1862–1863, however, he developed a highly personal style in which groups of figures representing formal designs and colour harmonies rather than narrative subjects betray the influence both of classical sculpture and Japanese prints. Moore was one of a number of artists who settled in London in the late 1850s and early 1860s, following a period of foreign travel or study abroad. Frederic Leighton (1830–1896) returned to England in 1859 after an exhaustive continental training; Edward Poynter (1836–1919), Thomas Armstrong (1835–1911) and the American James McNeill Whistler (1834–1903) all made London their home after studying in Paris with the 'gang' later immortalised by George du Maurier in *Trilby* (1894). Firmly grounded in the European academic tradition, these artists had very different priorities to the Pre-Raphaelites, even if some experienced a passing Pre-Raphaelite phase. They thought naturally in terms of the antique, classical subjects and the nude, areas which none of the Pre-Raphaelites had really touched. They saw their pictures as structured compositions based on form, colour and design, not as aggregations of details studied piecemeal from nature. And since 'nature' in the Pre-Raphaelite sense, art before Raphael, and the personalities of Ruskin and Hunt did not seriously enter their scheme of things, neither did morality. These pictorial and conceptual concerns had wider implications. With their strong sense of tradition, they were more inclined than the Pre-Raphaelites to identify with the Royal Academy; it is no accident that Leighton and Poynter both in due course became President. Yet if they were essentially conservative, they were by no means inward looking; on the contrary, they had a cosmopolitan outlook that underlines the insularity of the Pre-Raphaelites. We have only to think of Leighton's 'continental' style and relentless travelling, Poynter's introduction of French methods into English art education, or the way in which Whistler always seemed to have one foot in London and the other in Paris.

'Aestheticism' was the product of a creative friction between this group and the indigenous Pre-Raphaelites. They worked together on such projects as William Burges's painted furniture, the decoration of Waltham Abbey and Lyndhurst Church in the New Forest, and the Dalziel brothers' illustrated Bible; Albert Moore worked briefly for William Morris in 1864.[43] Artists from both groups lived in Bloomsbury, the bohemi-an quarter of the day. They belonged to the Hogarth Club and met at Little Holland House, where Mrs Prinsep's resident genius, G.F. Watts (1817–1904), kept a fatherly eye on the younger practitioners and urged them to study the Elgin Marbles. Whistler struck up a friendship with his fellow bohemian, Rossetti; Poynter became Burne-Jones's brother-in-law in 1866.

Most Pre-Raphaelites were touched by 'aestheticism', even such a student of character as Brown and the moralising Hunt. The early 1860s saw Hunt painting *Il Dolce far Niente* (FORBES Magazine Collection, New York), a "work", as he put it, "which had not any didactic purpose";[44] and, as we have seen, he became a supporter

of that bastion of 'aesthetic' values, the Grosvenor Gallery. Far more significant is the strong decorative tendency in Rossetti's later painting. He described the sumptuous *Monna Vanna* (1866; Tate Gallery, London) as "probably the most effective [picture] as a room decoration which I have ever painted",[45] and *Veronica Veronese* (1872; Samuel and Mary Bancroft Collection, Wilmington, Delaware) as "a study of varied greens".[46] This was one of his many later works commissioned by F.R. Leyland, whose mansion at 49 Prince's Gate was one of the 'aesthetic' sights of London.

But it was Rossetti's followers, closer in age to the newcomers and therefore better able to identify with them, who entered most completely into the 'aesthetic' spirit. Morris's contribution to the movement, as designer and purveyor of every feature of interior design, can hardly be overstressed. Burne-Jones, who, like Rossetti, was extensively patronised by Leyland, made many essays in the 'aesthetic' style; single figures or groups of an almost 'subjectless' nature, strongly influenced by the antique sculpture he was studying in the British Museum and with clearly defined colour harmonies, they come remarkably close to Moore, or even Whistler in his Moore-like phase of the late 1860s. Other exponents were Simeon Solomon and his friend Henry Holiday (1839–1927), both of whom had known Moore in the R.A. Schools, where they belonged to a sketching club, and a slightly younger group – Walter Crane (1845–1915), Robert Bateman (1842–1922), Edward Clifford (1844–1907) and others – who were inspired by the pictures that Burne-Jones exhibited at the Old Water Colour Society, to which he was elected in 1864. Dubbed by critics the "Poetry without Grammar School", these artists tended to exhibit at the Dudley Gallery in Piccadilly, which was launched in 1865 and forestalled the Grosvenor in supporting 'aesthetic' values.

As so often in the Pre-Raphaelite context, literary parallels are not lacking. Swinburne's *Atalanta in Calydon* (1865) and *Poems and Ballads* (1866) and Morris's *Life and Death of Jason* (1867) and *The Earthly Paradise* (1868–1870) all represent a reaction against the medievalism of the late 1850s in favour of classical themes and forms. *Poems and Ballads* was dedicated to Burne-Jones, and he produced numerous designs for a lavishly illustrated edition of *The Earthly Paradise*. The scheme itself fell through, but the designs provided a bank of compositional ideas on which he drew for easel pictures until the end of his life (cat. nos. 99, 105–108). Yet another correspondence exists in the developing field of art history. In his early work Burne-Jones had reflected what Ruskin was saying about the Italian 'primitives' and the great Venetian masters. He had actually travelled with his mentor in northern Italy in 1862, copying pictures that Ruskin felt would be "best for [his] own work".[47] During the next few years, however, he took an increasing interest in the Renaissance masters – Botticelli, Mantegna, Raphael, Michelangelo, and others. This related closely to Swinburne's pioneering article on Florentine drawings, published in the *Fortnightly Review* in July 1868, and to the chapters on Botticelli, Leonardo and Michelangelo in Pater's *Renaissance*.

Out of the state of flux of the 1860s the pattern that was to characterise idealist painting in England in the last quarter of the nineteenth century gradually emerged. Only Moore remained entirely faithful to the 'aesthetic' ideal. Leighton and Poynter embraced a more narrative form of classicism. Rossetti moved into a hermetic world dominated by Jane Morris, while Whistler developed his 'nocturnes' and turned to portraiture. There had always been elements of danger in 'aestheticism' for someone of

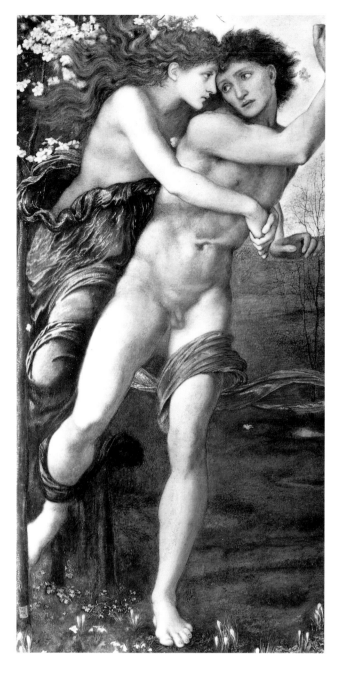

Fig. 11 EDWARD BURNE-JONES, *Phyllis and Demophoön*, 1870; watercolour and bodycolour, 36 x 18 in. (91.5 x 45.8 cm.). Birmingham Museums and Art Gallery.

Solomon's temperament, and in 1873 his career collapsed when he was arrested for homosexual offences. He seems to have accepted cheerfully enough the role of social outcast, but his work changed, becoming the vehicle for a lush and soulful symbolism (cat. no. 113).

As for Burne-Jones, by the early 1870s he was suffering from an acute sense of artistic isolation. In 1870 he resigned from the Old Water Colour Society when objections were raised to the nude male figure in *Phyllis and Demophoön* (Birmingham Museums and Art Gallery; fig. 11). A year later he was distressed to find himself at loggerheads with Ruskin who, as Slade Professor at Oxford, delivered a lecture attacking Michelangelo, now one of his own greatest heroes. His friendship with Rossetti declined after Rossetti's nervous breakdown in June 1872, and even with Morris there was less sympathy than formerly. His troubles were compounded by his affair with the Greek beauty Maria Zambaco, which reached a dramatic climax early in 1869 but dragged on for another two or three years.

Assailed by a 'miserable feeling' that he had lost his way as an artist,[48] Burne-Jones paid two more visits to Italy in 1871 and 1873. These brought him reassurance, and his work was never more Italianate than at this time. Then in 1877 came the turning point of his career. For seven years following his resignation from the Old Water Colour Society he had hardly exhibited a picture, but to the opening exhibition of the Grosvenor Gallery he sent eight large works, and this sudden unveiling of his mature powers caused a sensation. Overnight he was famous, the 'star' of the Grosvenor, and the doyen of 'aestheticism' in its later, popular, phase. A generation of young women modelled themselves on the damsels descending *The Golden Stairs* (1880; Tate Gallery, London), for which the sitters included his daughter Margaret, Morris's daughter May, and several well-connected girls in his circle who would soon be leaders of the social set known as the 'Souls'. The picture was reputedly a source of inspiration for Gilbert and Sullivan's satire on the 'aesthetic' craze, the comic opera *Patience*, which was first staged in 1881. Burne-Jones continued to support the Grosvenor until 1887, and thereafter its successor, the New Gallery, exhibiting a series of large oils and watercolours which had usually been developed slowly over many years. The *Pygmalion* series (cat. nos. 105–108), shown at the Grosvenor in 1879, represent them in the exhibition, which also includes some of the preparatory drawings which were such a notable feature of his studio practice (cat. nos. 79–81, 115–117). It need hardly be said that his pictures by this date represent a reversal of the early Pre-Raphaelite approach. In 1886 Henry James described Burne-Jones's art as the product of "a complete *studio* existence, with doors and windows closed",[49] and the artist himself, "to a friend who urged some piece of realism in his work, . . . answered: 'I don't want to pretend that this isn't a picture'."[50] Even the most objective transcript from nature demands a high degree of artistry, but there is a sense in which "pretending that this isn't a picture" is precisely what Hunt and Millais were doing in their early works.

In addition to his prolific output as a painter of figure subjects – drawn from the Bible, classical mythology and romantic literature, or simply the product of his teeming imagination – Burne-Jones continued to be deeply involved in many forms of decorative art. Although he had distinct reservations about the socialism to which Morris was led by his experience as a craftsman, he supported his old friend loyally in all his decorative projects, supplying him with a seemingly endless series of stained-glass cartoons (approximately one a week in the 1870s), as well as numerous designs for tiles, needlework and tapestry and hundreds of illustrations, not only for *The Earthly Paradise* in the 1860s but for the Kelmscott Press which Morris launched in 1890. Nor was all his decorative work connected with Morris. In 1881 he was commissioned to design mosaics for G.E. Street's new American Episcopal Church in Rome, an enormous task which caused a Byzantine element to enter his work in general during the next decade. Not surprisingly, he found it necessary to employ assistants, building up a busy studio on the Renaissance model. The first to join him, in 1866, was Charles Fairfax Murray (1849–1919), who is represented here (cat. no. 93) not only as an interesting if minor artist but as the source, in his later persona as a dealer, of the bulk of the Pre-Raphaelite drawings in the Birmingham collection.

Burne-Jones's career was at its height in the 1880s, with two particular peaks: the exhibition of *King Cophetua and the Beggar Maid* (Tate Gallery, London; fig. 5) at the Grosvenor in 1884 ("not only the finest work that Mr Burne-Jones has ever painted,

but . . . one of the finest pictures ever painted by an Englishman", the art critic of the *Times* declared, voicing "universal opinion"[51]), and of *The Briar Rose* series (Buscot Park, Oxfordshire) (cat. no. 115) at Agnew's, his dealer, in 1890. Such was his prestige that an attempt was made to harness him to the Royal Academy, of which he reluctantly became an Associate in 1889. True to Pre-Raphaelite tradition, however, he was never happy in this ambience, and having exhibited only one picture on the Academy's walls, he resigned in 1893. In 1892 a retrospective exhibition of his work was held at the New Gallery, and in 1894 he accepted a baronetcy from his old friend, Gladstone.

During the last decade of his life Burne-Jones also acquired a European reputation. His work was first seen abroad in 1878 when he showed *The Beguiling of Merlin* (Lady Lever Art Gallery, Port Sunlight) at the Exposition Universelle in Paris. It made little impression, but at the Exposition Universelle of 1889 *King Cophetua* was received with great enthusiasm, earning him a gold medal and the cross of the Légion d'Honneur at the insistence of Gustave Moreau, who was on the jury. He continued to exhibit in Paris until 1896, corresponding with Puvis de Chavannes and being much admired in advanced intellectual circles.[52] No English artist had enjoyed such popularity in France since John Constable scored his great success in 1824. Burne-Jones was also acclaimed in Belgium, Germany, Spain, America, and even Russia. The Belgian symbolist Fernand Khnopff visited him in London, and they exchanged drawings.[53] His *St George* series (cat. no. 80) won a gold medal at the Munich International Exhibition of 1897. Picasso was inspired by reproductions of his work in Barcelona, and even toyed with the idea of going to London to see the paintings themselves. It is true that he refused to exhibit with the 'Sâr' Péladan's self-indulgent Salon de la Rose + Croix, but his contribution to European Symbolism is now widely recognised, as is the influence of his sinuous line on international Art Nouveau.

Burne-Jones's death in 1898, exactly fifty years after the launching of the P.R.B., was not of course the end of the Pre-Raphaelite movement. He had many followers, not least a whole school which sprang up in the 1890s in his native Birmingham, and traces of Pre-Raphaelite feeling can be found in British art right up to the Second World War. But the exhibition stops with the demise of the movement's last great representative, and indeed the range of works encompassed may already seem daunting enough. When all the linear connections and stylistic developments have been traced, can any common underlying principle be discerned in, say, Brett's account of a spring day in the Isle of Wight (cat. no. 82) and Rossetti's evocation of the 'Lady of the Window' in Dante's *Vita Nuova* (cat. no. 110)?

Purists sometimes argue that the term 'Pre-Raphaelite' should only be used of those paintings which were produced in the first few years of the Brotherhood's existence, when the ideas of the Brothers and their associates had at least some homogeneity. Tangential or later developments, they suggest, would be better identified as 'Ruskinian', 'medievalist', 'Post-Pre-Raphaelite', 'Aesthetic', 'Symbolist', or expressions of the Arts and Crafts movement. Such terms may indeed indicate additional and meaningful contexts, but the fact remains that images which fall outside the purist canon are commonly referred to as 'Pre-Raphaelite', and were so described from the outset, not only in general parlance (represented for us today largely by comment in the contemporary press), but by those who were close to the movement. In 1869, for

instance, we find Charles Eliot Norton, a habitué of Pre-Raphaelite circles and later Professor of the History of Art at Harvard University, referring to an early pen and ink drawing by Burne-Jones as "in the extreme Pre-Raphaelite manner",[54] even though it had only the most superficial connection with the early work of Hunt or Millais. Again, in 1878, Ruskin published an article entitled *The Three Colours of Pre-Raphaelitism* in which he discussed *The Blind Girl* by Millais (cat. no. 38) and Rossetti's *Annunciation* of 1850 (Tate Gallery, London), two pictures, it is true, that are Pre-Raphaelite enough to satisfy the most stringent purist, but also *The King's Wedding* by Burne-Jones (Clemens-Sels-Museum, Neuss), a watercolour of 1870 which makes not the slightest concession to the original principles of the Brotherhood.

Yet Ruskin's article also suggests a way out of the dilemma, since it was precisely his purpose to show that there is a "common and sympathetic impulse" behind such disparate works. The Burne-Jones may appear very different from the Millais and the Rossetti "insomuch that while *they* with all their strength avouch realities, *this* with simplest confession dwells upon a dream", but the only real discrepancy is that the Burne-Jones "reach[es] beyond [the others] to the more perfect truth of things, not only that once were, – not only that now are, – but which are the same yesterday, today, and for ever".[55] In other words, the Millais and the Rossetti aim to convey physical truth, the Burne-Jones spiritual reality.

This notion was re-affirmed by Ruskin in his *Art of England* lectures, delivered at Oxford in 1883, in which Rossetti and Hunt are characterised as belonging to the "Realistic Schools of Painting" and Burne-Jones to the "Mythic Schools". These "schools", he asserts, "must be thought of as absolutely one", the only difference being that "as the dramatic painters seek to show you the substantial truth of persons, so the mythic school seeks to teach you the spiritual truth of myths. Truth is the vital power of the entire school".[56] Ruskin was being wholly consistent here since the idea went back to the passage at the end of the first volume of *Modern Painters*, in which he had urged artists to "go to Nature in all singleness of heart, . . . rejecting nothing, selecting nothing, and scorning nothing; . . . and rejoicing always in the truth". As we have seen, this was the inspiration for the meticulous renderings of nature so typical of the early years of the movement, but we should not forget that it was only part of Ruskin's programme. "Then", the passage continues, "when their memories are stored, and their imaginations fed, and their hands firm, let them take up the scarlet and the gold, give the reins to their fancy, and show us what their heads are made of".[57] If an artist was incapable of going this further lap in the creative process, so be it; an honest transcript from nature was to Ruskin infinitely more precious than an insincere attempt at some higher mode of art. But his ideal was always a thorough understanding of natural phenomena used as a springboard for flights of imagination, whether to make sublime statements about the beneficence of God as revealed in the natural world, as in the case of Turner (always for Ruskin a Pre-Raphaelite *avant la lettre*); to paint religious subjects of an unprecedented veracity and replete with meaningful symbolism, as in the case of Hunt and Rossetti; or to "teach the spiritual truth of myths", as in the case of Burne-Jones.

Ruskin never failed to castigate what he saw as lapses from his ideal. Millais's *Sir Isumbras* (1857; Lady Lever Art Gallery, Port Sunlight) – "not merely fall [but] catastrophe"[58] – is the example that leaps to mind. Although we are not likely to be so fastidious, the premise that a zeal for truth, whether physical or spiritual, is the authentic note

of the movement, may be accepted; and certainly it was this earnestness of purpose that appealed to contemporaries on both sides of the Atlantic, with their nonconformist consciences and firmly entrenched work-ethic. Dr Susan Casteras has recently stressed this element in the American response to the movement. In 1855 the New York *Evening Post* lectured its readers on the attitude they should adopt to Pre-Raphaelite paintings: "*Dislike* them if you will, it is your right; but do not jest with the souls of earnest men laid open in their work to the world".[59] Three years later the *Knickerbocker, or New-York Monthly Magazine* complained of all the "maudlin talk there has been of Earnestness and Earnest men".[60] Echoes of this are still heard in Henry James's assessment of the Pre-Raphaelites in relation to the Impressionists, written in 1876.

> When the English realists "went in", as the phrase is, for hard truth and stern fact, an irresistible instinct of righteousness caused them to try and purchase forgiveness for their infidelity to the old more or less moral proprieties and conventionalities, by an exquisite, patient, virtuous manipulation – by being above all things laborious. But the Impressionists, who, I think, are more consistent, abjure virtue altogether, and declare that a subject which has been crudely chosen shall be loosely treated. . . . The Englishmen, in a word, were pedants, and the Frenchmen are cynics.[61]

Whether or not 'pedants' is quite the right word for the Pre-Raphaelites, they were certainly not 'cynics'; indeed a cynical Pre-Raphaelite is a contradiction in terms. When such a being did arise in Aubrey Beardsley illustrating the *Morte d'Arthur* (1893–1894), Burne-Jones and Morris were horrified. Burne-Jones had even lost his abundant sense of humour when George du Maurier published his parodies of the Pre-Raphaelite style in *Punch* in 1866, their friendship cooling for the best part of thirty years. It is by no means certain that he would have appreciated Max Beerbohm's caricatures of the Pre-Raphaelites (cat. no. 118), especially the best of them – Benjamin Jowett asking "And what were they going to do with the Grail when they found it, Mr Rossetti?"[62] – which pokes fun at the legend he regarded as more "beautiful" than "anything in the world", and "an explanation of life".[63]

Earnestness is not always welcome, even when it comes in the "pointless", "irresponsible" and "delightfully amusing" form represented, according to Henry James, by the later work of Burne-Jones.[64] By the 1890s the vogue for literary subjects was waning, killed off by French realism as interpreted by the New English Art Club (founded 1886) and the Newlyn School. Burne-Jones saw his last major picture, the Chaucerian *Love Leading the Pilgrim* (1897; Tate Gallery, London), return from exhibition unsold, and admitted philosophically that "the rage for me is over".[65] His response was to paint more and more for himself, exploring an uncompromising personal vision that makes no concessions to popular taste. In this he was following a pattern common to many artists at the end of their lives. Michelangelo, Poussin, Turner, Beethoven and Henry James offer other well-known examples.

Great success breeds great reaction, and the 'rage' was to be 'over' for a long time. "The Burne-Jones attitude", wrote Walter Richard Sickert in 1914, "is almost intolerable to the present generation, though it certainly charmed a great many people thirty years ago".[66] In 1927 the Bloomsbury critic Clive Bell dismissed the Pre-Raphaelites as having "utter insignificance in the history of European culture",[67] illustrating his point with a reproduction of *The Golden Stairs*; and in 1933 R.H. Wilenski described *King Cophetua* as "the silliest possible still-life record of two models posing in fancy dress on

a heap of Wardour Street bric-à-brac".[68] The Pre-Raphaelites themselves were long since dead, but those who still adhered to the tradition were dismayed and alienated by the reversal of taste. Charles Ricketts wrote to W.B. Yeats in 1922: "I know I am a quite useless survival from another age, and because the future has no use for me I look at it like a sheep in a railway truck".[69] W. Graham Robertson, once a young member of the Burne-Jones circle, wrote in 1942:

> I have lived for long, happy years . . . in a lovely land of art and literature where men strove earnestly and, I think, nobly to create and perpetuate beauty. Now that land has been invaded and overrun by a rabble rout, who have profaned its innermost sanctuaries and polluted them with ugliness and obscenity . . . I am sorry that I ever tried to be a painter and bitterly ashamed of my late profession.[70]

Ricketts and Robertson would be amazed if they could see how matters stand today. The Pre-Raphaelite revival has been with us for some thirty years, and we have witnessed every manifestation – from exhibitions, books, articles, journals and societies, to soaring saleroom prices and popular culture. If England has inevitably taken the lead, vital contributions have been made in Europe, America, Canada, Australia and Japan. The present exhibition significantly adds to the process in being the first to be seen in America which is entirely drawn from one of the greatest public collections of Pre-Raphaelite art in Britain. To this extent it opens a new chapter in the capricious posthumous fortunes of these 'earnest men'.

1. Ruskin, *Works*, 1904, vol. 12, p. 134 (4th Edinburgh Lecture on *Pre-Raphaelitism*, delivered 18 November 1853).
2. See London and Birmingham, 1991–1992.
3. Hunt, 1905, vol. 1, p. 142.
4. Ibid., p. 51.
5. Ibid., p. 48.
6. Ibid., p.54. A reference to Raphael's painting of *St Catherine of Alexandria* in the National Gallery, London (no. 168). It had been bought in 1839 and was the first work by Raphael to enter the collection.
7. Ibid., pp. 100–101.
8. Ibid., p. 137.
9. Ibid., p. 130.
10. Ibid., p. 159.
11. Ibid., p. 54. This was the famous *Marriage Portrait of Giovanni Arnolfini and Giovanna Cenami* (no. 186), purchased in 1842. Hunt borrowed the motif of the circular mirror surrounded by scenes of the Passion for his composition of *The Lady of Shalott*, conceived in 1850 (see Liverpool and London, 1969, cat. no. 119).
12. Doughty and Wahl, 1965–1967, vol. 1, pp. 72, 84.
13. Hunt, 1905, vol. 1, p. 190.
14. Doughty and Wahl, 1965–1967, vol. 1, p. 36. The relationship between Holst and the Pre-Raphaelites is explored in the catalogue of the exhibition *The Romantic Art of Theodor von Holst*, Hazlitt, Gooden & Fox Ltd., London, and Cheltenham Art Gallery and Museum, 1994.
15. Hunt, 1905, vol. 1, p. 120.
16. Ibid., p. 73.
17. Ruskin, *Works*, 1903, vol. 3, pp. 626–627.
18. Ibid., p. 624.
19. Hunt, 1905, vol. 1, p. 132.
20. Ibid., p. 135.
21. In a review in the *Eclectic Magazine*, quoted in "The English Pre-Raphaelites", *The Crayon*, vol. 3, March 1856, p. 96. See Casteras, 1990, pp. 33 and 193, note 9.
22. Hunt, 1905, vol. 1, p. 130, and Doughty and Wahl, 1965–1967, vol. 1, p. 85.
23. Hunt, 1905, vol. 1, p. 174.

24. *Household Words*, 15 June 1850; quoted in London, Tate, 1984, cat. p. 78, under no. 26.

25. Surtees, 1981, p. 76.

26. Catalogue of his one-man exhibition at 191 Piccadilly in 1865; quoted in Liverpool, 1964, cat. p. 17, under no. 21.

27. *Art Journal*, London, 1852, p. 175.

28. Catalogue of his one-man exhibition, 1865; quoted in London, Tate, 1984, cat. p. 124, under no. 62.

29. Ibid.; quoted in Hueffer, 1896, p. 193.

30. Hubert Wellington (ed.), *The Journal of Eugène Delacroix*, London, 1951, p. 286. "Hunt's sheep" refers to *Our English Coasts, 1852* (otherwise known as *Strayed Sheep*), now in the Tate Gallery, London. Delacroix also admired Millais's *Order of Release* (Tate Gallery), comparing it favourably with the archaising work of Ingres and his followers (Wellington, 1951, p. 280). Both pictures had been exhibited at the Royal Academy in 1853.

31. For a full account, see Casteras, 1990, ch. 3.

32. Doughty and Wahl, 1965–1967, vol. 2 (1965), p. 527.

33. Ruskin, *Works*, 1904, vol. 12, p. xxiii.

34. For a fuller account, see John Christian, "'A Serious Talk': Ruskin's Place in Burne-Jones's Artistic Development", in Parris (ed.), 1984, pp. 184–205.

35. Ruskin, *Works*, 1904, vol. 14, pp. xxiii–xxiv.

36. W.J Stillman, *The Autobiography of a Journalist*, London, 1901, vol. 1, p. 270. See also Casteras, 1990, pp. 24–25.

37. The title of his review of Diana Holman-Hunt's book *My Grandmothers and I* (1960) in the *Spectator*, vol. 205, no. 6903, 14 October 1960, p. 567.

38. Unlike Hunt and Millais, Rossetti never exhibited at the Royal Academy, showing *The Girlhood of Mary Virgin* at the Free Exhibition in 1849 and *The Annunciation* at the National Institution in 1850. The only other exhibitions to which he contributed during his lifetime tended to be semi-private affairs, such as the exhibition of Pre-Raphaelite works held at 4 Russell Place, Fitzroy Square, in 1857, and the Hogarth Club exhibition of 1859. He was not represented in the exhibition of British pictures seen in America in 1857–1858.

39. Burne-Jones, *Memorials*, 1904, vol. 1, p. 110.

40. W. Graham Robertson, *Time Was*, London, 1931, p. 88.

41. *Art Journal*, London, 1871, p. 176. The significance of this passage was first noticed by Allen Staley in the introduction to the catalogue of the exhibition *Victorian High Renaissance*, held at the Manchester City Art Gallery, the Minneapolis Institute of Arts, and the Brooklyn Museum, 1978–1979, p. 13.

42. William Michael Rossetti and Algernon C. Swinburne, *Notes on the Royal Academy Exhibition, 1868*, London, 1868, p. 32.

43. His cartoon for a figure of Christ as Salvator Mundi, used in the south window of the chancel in Bradford Cathedral, is in Birmingham Museums and Art Gallery (189'00).

44. Hunt, 1905, vol. 2, p. 203. The picture was exhibited at the Royal Academy in 1867.

45. Doughty and Wahl, 1965–1967, vol. 2 (1965), p. 606.

46. Letter to F.R. Leyland, 25 January 1872, published in the *Art Journal*, 1892, p. 250, and quoted in Surtees, 1971, vol. 1, p. 128, under no. 228.

47. Burne-Jones, *Memorials*, 1904, vol. 1, p. 247. For further information, see John Christian, "Burne-Jones's Second Italian Journey", *Apollo*, vol. 102, no. 165, November 1975, pp. 334–337.

48. Burne-Jones, *Memorials*, 1904, vol. 2, p. 23.

49. Percy Lubbock (ed.), *The Letters of Henry James*, London, 1920, vol. 1, p. 126.

50. Burne-Jones, *Memorials*, 1904, vol. 2, p. 261.

51. *Times*, 1 May 1884, p. 6.

52. For further information, see Claude Allemand-Cosneau, "La Fortune Critique de Burne-Jones en France", in the catalogue of the exhibition *Burne-Jones: Dessins du Fitzwilliam Museum de Cambridge*, shown at Nantes, Charleroi and Nancy, 1992, pp. 69–81.

53. See Laurent Busine, "From Edward Burne-Jones to Fernand Khnopff", in the same catalogue, pp. 59–67.

54. Sara Norton and M.A. DeWolfe Howe, *Letters of Charles Eliot Norton*, London, 1913, vol. 1, p. 342.

55. Ruskin, *Works*, 1908, vol. 34, pp. 155–156.

56. Ibid., 1908, vol. 33, p. 294.

57. Ibid., 1903, vol. 3, p. 624.

58. Ibid., 1904, vol. 14, p. 107.

59. Quoted in Casteras, 1990, p. 36. As Dr Casteras has kindly pointed out, the sentence was quoted in a further article in the *Evening Post*, 14 November 1857, p. 2.

60. Ibid.

61. From an article entitled "Parisian Festivity", published in the *New York Tribune*, 13 May 1876, and reprinted in John L. Sweeney (ed.), *The Painter's Eye: Notes and Essays on the Pictorial Arts by Henry James*, London, 1956, p. 115.

62. Max Beerbohm, *Rossetti and his Circle*, London, 1922, pl. 4.

63. Burne-Jones, *Memorials*, 1904, vol. 2, p. 333.

64. From a review of the Grosvenor Gallery exhibition of 1882, published as part of an article entitled "London Pictures and London Plays" in the *Atlantic Monthly*, August 1882, and reprinted in Sweeney (ed.), *The Painter's Eye*, 1956, p. 208.

65. From the notes of conversation in Burne-Jones's studio in the last few years of his life, kept by his assistant T.M. Rooke (copy in the National Art Library, Victoria and Albert Museum, London). The passage does not occur in the selection edited by Mary Lago as *Burne-Jones Talking*, London, 1982.

66. *The New Age*, 28 May 1914, reprinted in Osbert Sitwell (ed.), *A Free House! . . . The Writings of Walter Richard Sickert*, London, 1947, p. 280.

67. Clive Bell, *Landmarks in Nineteenth-Century Painting*, London, 1927, p. 111.

68. R.H. Wilenski, *English Painting*, London, 1933, p. 225.

69. Cecil Lewis (ed.), *Self-Portrait. Taken from the Letters and Journals of Charles Ricketts, RA*, London, 1939, p. 343.

70. Kerrison Preston (ed.), *Letters from Graham Robertson*, London, 1953, p. 488.

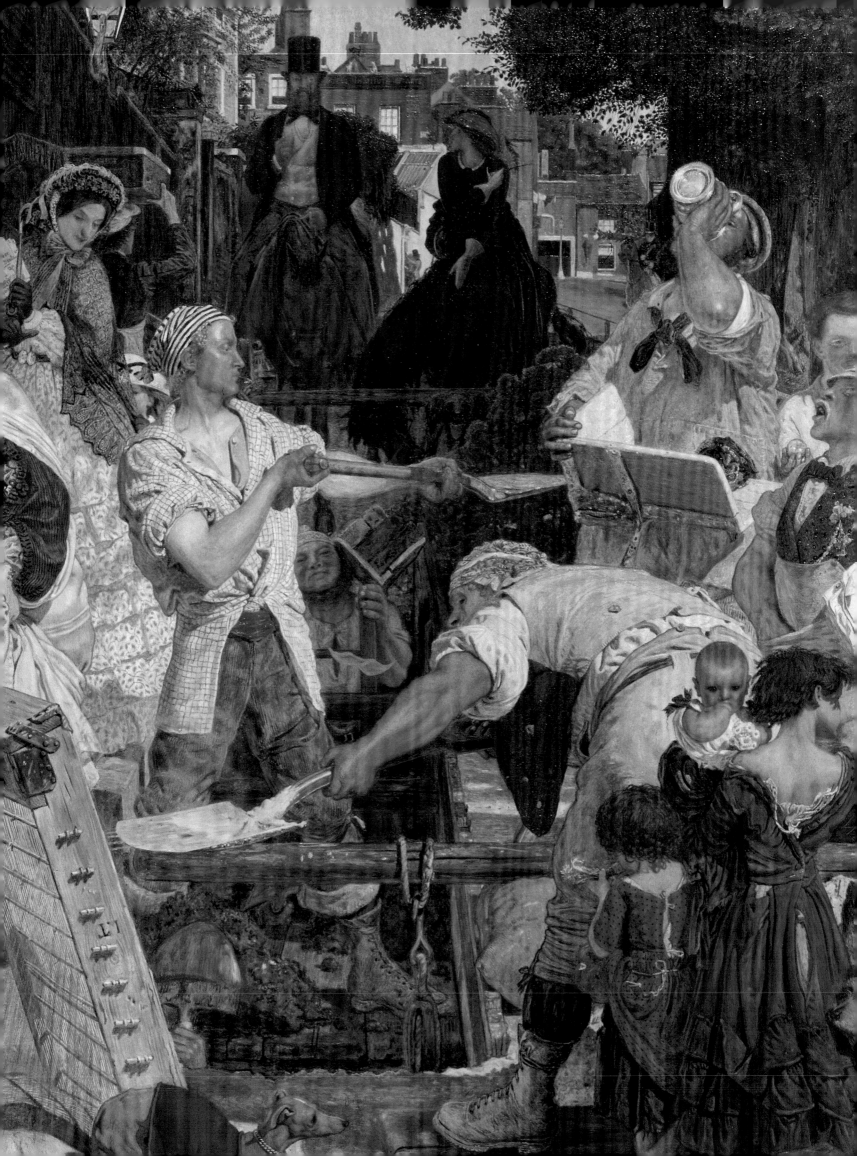

Opportunity and Philanthropy: The Pre-Raphaelites as seen and collected in Birmingham

STEPHEN WILDMAN

Birmingham nurtured two great painters of the nineteenth century – David Cox (1783–1859) and Edward Burne-Jones (1833–1898). For twelve years, both were living in Birmingham. Cox, having tired of London, returned to his roots in 1841, at the age of fifty-eight.[1] Fifty years younger, Burne-Jones was at that very time showing the same precocious talent for drawing as Cox had earlier done, but he was to have far greater opportunities for encouragement. Apart from daily contact with the pictures coming into his father's framing shop in Bennett's Hill (Cox was brought up in a smithy), Burne-Jones had the chance to attend classes at the School of Design under Thomas Clarke, the same drawing-master that he had at King Edward VI School.[2] Burne-Jones left Birmingham for Oxford University in 1853, six years before Cox's death, and though he paid frequent visits to his father, he would never again live in the city.[3] Before leaving, he might well have visited the Birmingham Society of Artists. From 1842, its annual exhibitions of contemporary painting grew in size and importance, affording the town a vital focus of artistic activity, and it was at these that Burne-Jones could have seen his first Pre-Raphaelite pictures.[4]

The first appearance of a Pre-Raphaelite painting in Birmingham was that of Ford Madox Brown's *Wycliffe reading his Translation of the New Testament* (Bradford Art Galleries and Museums; see cat. no. 8, fig. 21). Shown in London at the Free Exhibition of 1848 and later in the year at the Liverpool Academy, it appeared at the Birmingham Society of Artists' autumn exhibition in 1849.[5] Dissatisfied with its hanging at Liverpool, Brown stopped off in Birmingham on his way home in November 1848, possibly to lobby for kinder treatment.[6] Although no price is given in the catalogue for that exhibition, the painting was presumably for sale, as it did not find a buyer until about 1851.[7] Its size alone ought to have attracted attention, but the artist's name would have been unfamiliar to a Birmingham audience, certainly in comparison with W.C.T. Dobson (the first Head Master of the Birmingham School of Design), William Etty, W.P. Frith and C.R. Leslie, among the other exhibitors of figure painting. (Clarkson Stanfield and J.M.W. Turner, as well a host of local artists, were represented by major landscapes.)

During the three years that elapsed before the showing of John Everett Millais's *Ophelia* (Tate Gallery, London; see cat. no. 22, fig. 32) at the Society in 1852, there is little evidence in Birmingham of any active interest in the work of the Pre-Raphaelites.[8] Millais had been directly solicited, however, according to William Michael Rossetti's entry in the *P.R.B. Journal* for 13–15 May 1851: "Millais has had another request . . . for his *Dove in the Ark;* and a particular invitation from the Birmingham exhibition for him

to send it thither".[9] *Ophelia* was doubtless a more than acceptable substitute, coming straight from the walls of the Royal Academy of Arts. The public support of John Ruskin (1819–1900), together with prolonged discussion in magazines such as the *Art Journal*, must have brought the general aims of the Brotherhood to local attention. A critic in the *Birmingham Journal*, toeing the Ruskinian line on the "conscientious fidelity to nature", wondered at "the erratic genius and the acute sense of observation and power of imitation manifest in the picture of 'Ophelia'," and felt sure that "many who come to scoff will remain to wonder and admire".[10]

Already sold to the dealer Henry Farrer long before it was finished, *Ophelia* was the first of a small but important group of major Pre-Raphaelite paintings sent to the Birmingham exhibitions presumably in the hope of capitalising on favourable public response in Liverpool. A smaller number of pictures was also sent to the annual exhibitions of the Manchester Institution (after 1859, taken over by the Manchester Academy of Fine Arts). In 1851, William Holman Hunt had received the Liverpool Academy's £50 prize for *Valentine rescuing Sylvia from Proteus* (cat. no. 17), a feat matched by Millais in 1852 with his *Huguenot* (Huntington Hartford Collection, New York). Indeed, for the next five years the Liverpool prize was to go to an artist within the Pre-Raphaelite circle, which engendered so much local hostility that a group of artists established a rival exhibiting society and brought about the Academy's demise in 1867.[11] Hunt did win the £60 prize at Birmingham with his *Strayed Sheep (Our English Coasts)* (Tate Gallery, London) in 1853, but this started no similar trend, even though the *Birmingham Journal* was again generous in its praise, calling it "one of the most perfect works in the exhibition . . . marvellous for its literal truth, its subtle atmosphere and its artistic expression".[12]

The 1854 Birmingham exhibition included *Valentine rescuing Sylvia*, by now the property of the Belfast shipper Francis MacCracken. Although this picture's sale had benefited from its exposure in Liverpool – MacCracken was an eccentric collector who bought many works before he had actually seen them – it was not until 1856, when Brown and Hunt met John Miller of Liverpool, that the Pre-Raphaelites began to make personal contact with the Northern industrialists who were to become some of their leading patrons. That year's Birmingham exhibition witnessed the last notable early appearance of Pre-Raphaelite masterpieces. Significantly, both already belonged to 'merchant princes': Millais's *The Blind Girl* (cat. no. 38) was on its way to Miller from the London dealer Gambart, while Hunt's *Awakening Conscience* (Tate Gallery, London) had been commissioned by Thomas Fairbairn of Manchester, and completed before Hunt's departure for the Holy Land early in 1854.

Sadly, no Birmingham names can be added to the roll-call of progressively minded merchant and businessman collectors which includes Thomas Plint of Leeds, James Leathart of Newcastle and F.R. Leyland of Liverpool. Doubtless there were those who, as Hunt records Fairbairn telling him of Manchester people, "are disposed to admire individual examples, but the term [Pre-Raphaelite] has to them become of such confirmed ridicule that they cannot accept it calmly".[13] Certainly others matched Brown's well-known description of Miller as "a jolly, kind old man" with a "house full of pictures, even to the kitchen", but among them only the "splendid Linnells, a fine Constable, & good Turners" being particularly noteworthy, "plus a host of good pictures by Liverpool artists".[14] In this category of taste, Charles Birch of Metchley Abbey,

Harborne; Edwin Bullock (1787–1870) of Hawthorn House, Handsworth; and Joseph Gillott (1799–1872) were very much Miller's Birmingham equivalents. All were patrons of Cox and other local landscape painters, but they also pursued the bigger names of the Royal Academy. In the period from 1849 to 1854 alone, the Pre-Raphaelites' occasional submissions would have hung alongside proud loans made by Birch of paintings by J.R. Herbert, John Linnell, Daniel Maclise and Turner (including *The Burning of the House of Lords and Commons*, 1834; now in the Philadelphia Museum of Art); Charles Lock Eastlake's *Ruth and Boaz;* several works by C.R. Leslie sent by Bullock; and major canvases by William Etty, David Wilkie, Edwin Landseer and Turner from the constantly fluid but very important collection of Gillott, the millionaire pen manufacturer.[15]

None, alas, seems to have been seduced by Pre-Raphaelitism, and nor were their immediate successors, despite an increase in the number of Pre-Raphaelite pictures sent to the Society of Artists after 1860, far more of which were for sale. An English Civil War subject by Henry Wallis, *Back from Marston Moor*, could have been bought for £200 in 1860, and *The Stonebreaker* (cat. no. 40) was also apparently available when shown the following year.[16] James Campbell asked 60 guineas for *Driving a Bargain* in 1863 and 100 guineas in 1864 for *The Debutante*, while Hunt's *The Lantern-Maker's Courtship* (fig. 36) appeared at 550 guineas in 1863 (this would find a Birmingham buyer, but not until 1891). From 1865 to 1867, an unusually large number of Pre-Raphaelite pictures were featured in the Society's exhibitions, including loans of such now well-known paintings as Hunt's *The Hireling Shepherd* (Manchester City Art Gallery) in 1865, then belonging to James Leathart, alongside Millais's *Christ in the House of His Parents* (Tate Gallery, London) and *The Black Brunswicker* (Lady Lever Art Gallery, Port Sunlight), both owned by Albert Grant, Member of Parliament for Kidderminster. Fulfilling a long-standing promise, Millais persuaded Thomas Combe of Oxford to lend *The Return of the Dove to the Ark* (Ashmolean Museum, Oxford) in 1867.

This seemingly deliberate campaign of solicitation conducted by the Society of Artists was probably connected with its launch in 1866 of an additional spring exhibition of watercolours and sketches, following the successful example set by the Old Water Colour Society the previous year. For this inauguration, both Hunt and John Brett sent watercolours, with the latter submitting a pair entitled *February in the Isle of Wight* and *November in the Isle of Wight*. They both re-appeared in the Birmingham Museum's 1891 Pre-Raphaelite exhibition, this time lent by William Martin (perhaps the architect and former partner of John Henry Chamberlain) who possibly purchased them in 1866: *February* (cat. no. 82) was donated to the permanent collection by Herbert Martin in 1919. Two paintings by Robert Braithwaite Martineau were exhibited in the autumn exhibition of 1867, *The Last Chapter* (cat. no. 69) and *The Princess with the Golden Ball*. The fact that Martineau had influential relatives in Birmingham (including a second cousin, Thomas, who went on to become Mayor in 1884 and sit on the Museum and School of Art Committee) may not be entirely coincidental.

It was at this time that the first moves were made to establish a public Museum and Art Gallery in Birmingham. A civic art collection which had begun to be formed in the 1850s was opened to the public in August 1867, in a room in the Free Library. Once funds from local rates alone proved insufficient, it was through the efforts of philanthropic patrons following the 'Civic Gospel' of politician Joseph Chamberlain that a new Art Gallery was eventually erected, opening in 1885 (fig. 12).[17] The foundation collection

then unveiled was unsurprisingly rich in landscapes by David Cox, including many from the 1882 bequest of Joseph Nettlefold. Thanks to the generosity of the brothers Richard and George Tangye, who offered £10,000 for purchases,[18] and the energies of the first Keeper, Whitworth Wallis (1855–1927), the collection also boasted two oils by Dante Gabriel Rossetti. Both were unfinished works – *La Donna della Finestra* (cat. no. 110), and *The Boat of Love* – which were purchased directly from the artist's studio sale in 1883. This token of intent to acquire works by the Pre-Raphaelites significantly coincided with an influential series of lectures presented by John Ruskin on "The Art of England", which may be said to have established the artists' status as modern 'Old Masters'.[19]

A new generation of patrons and collectors, prepared to embrace Pre-Raphaelitism in its more established guise, emerged in Birmingham in the 1870s. A

Fig. 12 Chamberlain Square, Birmingham, circa 1914. On right: Museum and Art Gallery (H. Yeoville Thomason, 1881–1885); centre: Council House Extension, including Feeney Picture Galleries (Ashley and Newman, 1911–1912).

Public Picture Gallery Fund (happily, still active) had been initiated in 1871 by a gift of £3,000 from the glass manufacturer Thomas Clarkson Osler, and its Trustees made the first purchases two years later: *A Condottiere* by Frederic Leighton (1830–1896) and Brett's *A North-West Gale off the Longships Lighthouse* (fig. 90).[20] The latter was bought from the walls of the Royal Birmingham Society of Artists (which made a £100 donation), to which Brett loyally continued to send paintings well into the 1890s; in more than twenty years, from 1873 to 1894, Brett missed only two years – 1884 and 1889. One of the founding Trustees of the Fund was William Kenrick (1831–1919) of the West Bromwich iron-founding firm of Archibald Kenrick & Sons. Married to Joseph Chamberlain's sister Mary, Kenrick was a central figure in the city's political and social circles, serving as

Mayor in 1877 and as Member of Parliament for North Birmingham from 1885 to 1899, when he was appointed a Privy Councillor. An amateur painter, he oversaw the early development of the Art Gallery, serving as Chairman of the Museum and School of Art Committee from 1884 until 1914.

A notebook survives detailing the growth and scope of Kenrick's collection, which began in 1863 with a ten-guinea picture bought directly from the Birmingham-born landscape painter Elijah Walton (1832–1880).[21] Conservative purchases followed of watercolours by Samuel Prout, Thomas Collier and (again from the artist) Alfred William Hunt, with the more substantial expense of £800 in 1875 for John Linnell's *"Piping down the valleys wild"*. *Apples* by Albert Moore (1841–1893) followed in 1876, but it was not for another ten years that Kenrick was able to acquire *The Feast of Peleus* by Burne-Jones, paying 990 guineas through Agnew's at the William Graham sale in 1886. (This painting was donated to the Museum and Art Gallery by the Kenrick family, in his honour, in 1956.) The year 1891 saw his purchase of *The Ransom* by Millais (Private Collection) and *The Lantern-Maker's Courtship* by Hunt (which was presented by the Kenrick family in 1962), and in the next year he made the outstanding gesture of buying Millais's *The Blind Girl* (cat. no. 38) as an immediate gift to the Birmingham collection.

John Throgmorton Middlemore (1844–1925) was a City Councillor from 1883 to 1892, and succeeded Kenrick as M.P. in 1899, a position he held until 1918 (the following year he was created a Baronet). Middlemore's great benefaction came in 1896 with the gift of Hunt's *The Finding of the Saviour in the Temple* (see cat. no. 29, fig. 37). It had been sold to the dealer Gambart in 1860 for £5,500 (including copyright), the highest sum paid to a living artist during the whole of the nineteenth century, and the work was acquired by Middlemore from Agnew's after the Matthews sale at Christie's in 1891. Recently discovered letters from Hunt express the artist's "relief at the escape of all the dangers of an uncertain future" for the picture, which he had told Ruskin in 1857 was "to me . . . as important [as] Da Vinci's last supper was to him".[22] Praising Middlemore's generosity, Hunt wrote: "I trust that you as the donor will be remembered as the benefactor more than myself, for your act was a voluntary choice: mine as the painter was an act of necessity".[23] Middlemore went on to buy the smaller version of Hunt's *The Shadow of Death* (Private Collection) to add to the replica of *The Triumph of the Innocents* (Tate Gallery, London), which was already on loan to Birmingham.[24] To mark his election as a Trustee of the Public Picture Gallery Fund in 1903 (and as a gesture of respect to fellow benefactors), Middlemore donated the *Pygmalion* series by Burne-Jones (cat. nos. 105–108); other pictures remained on loan after his death, and it eventually proved possible to acquire *The Merciful Knight* (cat. no. 73), Burne-Jones's most important early work, when the residue of Middlemore's collection was dispersed in 1973.

The brewer John Charles Holder (1838–1923), created Baronet in 1898, was much more of a magpie collector, not only of pictures but also of local committee chairmanships, chiefly of schools and hospitals. A 1911 catalogue of the paintings and sculpture in Pitmaston, his house in the Birmingham suburb of Moseley, details an amazingly eclectic collection, even allowing for the varied donations already made to the Art Gallery (these range from Lemuel Abbott's portrait of Matthew Boulton to a splendid Gustave Doré watercolour, *Le Chant du Départ*, given in 1884). Holder owned no fewer than six oils by the Belgian history painter Willem Geets (1838–1919); Kenrick shared

this enthusiasm, buying *A Martyr in the Sixteenth Century* at the Royal Birmingham Society of Artists for the city's collection in 1884. In a very crowded gallery at Pitmaston, Holder displayed major canvases by Lawrence Alma-Tadema, Edwin Landseer, Vicat Cole, Henry Moore, Edwin Long and Joseph Farquharson.[25] Birmingham painters were also included, from Cox and F.H. Henshaw to W.J. Wainwright and Walter Langley, whose masterpiece in watercolour, *Disaster* (1889), happily formed part of a choice group of works bequeathed in 1923. Holder clearly bought Brett's large Scottish landscape *An Argyle Eden* from the Society's exhibition in 1886, while Rossetti's late oil *The Salutation of Beatrice* (The Toledo Museum of Art, Toledo, Ohio) came from F.R. Leyland's sale at Christie's in 1892. Unfortunately, it was the crayon *Rosa Triplex*, patently a copy (perhaps by Rossetti's studio assistant Henry Treffry Dunn), which Holder presented to the Museum in 1912. Burne-Jones's last major painting, *The Wizard*, was a gift of the same date. By far his best Pre-Raphaelite work, the watercolour of *The Backgammon Players* which Burne-Jones had painted in 1862, was presented in his memory by Lady Holder and her family in 1923.[26]

William Kenrick's efforts on behalf of the arts in Birmingham were complemented by those of the architect John Henry Chamberlain (1831–1883) and Edward Richard Taylor (1838–1912), the Head Master of the School of Art from 1877. Chamberlain, no relation of the politician Joseph, had been inspired by Ruskin's *Stones of Venice* to visit Italy and study Venetian Gothic architecture, and in partnership with William Martin he designed some of the most distinguished public buildings in the city. He succeeded Thomas Martineau as Honorary Secretary of the Birmingham and Midland Institute in 1865, and energetically revitalised it as a centre for debate on art, design and education. A frequent speaker himself – he lectured on a range of topics, from *Pre-Raphaelitism* in 1859 to his last in 1883 on *Exotic Art*, immediately after which he suddenly died – Chamberlain invited a panoply of great names to give the Institute's celebrated Monday Evening Lectures. In this respect, William Michael Rossetti and Ford Madox Brown were in the remarkable company of F.D. Maurice, J.A. Froude, T.H. Huxley, Edward Whymper, Anthony Trollope, Matthew Arnold and Walter Pater, among many others.[27] Brown gave two pairs of lectures, the first in February 1874 (*The Latest Phase of Modern Art, Style and Realism* and *Style in Painting*) and the second in February 1878 (*Idea in Art* and *The Connection between the Fine Arts*).[28]

William Morris spoke on 13 November 1879, in the early days of his career on the lecture platform, on behalf of the campaign to persuade the Italian government to halt the restoration of mosaics in St Mark's, Venice.[29] Morris was no stranger to Birmingham, having visited Burne-Jones during at least one vacation from Oxford in 1855, when he was also entertained by Cormell (Crom) Price, another fellow undergraduate, at his home in Spon Lane, West Bromwich. It was apparently in a Birmingham bookshop that Burne-Jones found, and Morris bought, Robert Southey's edition of Malory's *Morte d'Arthur*, which sparked off the Arthurian revival central to the second phase of the Pre-Raphaelite movement.[30]

Morris's four subsequent lectures at the Midland Institute included *Some of the Minor Arts of Life*, delivered on 23 January 1882 in support of the Society for the Protection of Ancient Buildings. This was published as *The Lesser Arts of Life* (not to be confused with an earlier lecture on *The Lesser Arts*) and contains some important theoretical principles. Every design, in Morris's view, "must have a distinct idea in it; some

beautiful piece of nature must have pressed itself on our notice so forcibly that we are quite full of it, and can, by submitting ourselves to the rule of art, express our pleasure to others, and give them some of the keen delight that we ourselves have felt".[31] This Arts and Crafts ethic was shared by E.R. Taylor, who had recruited Morris to act as President of the Birmingham School of Art, for which a new building was being planned. Designed in 1883, and fittingly if sadly Chamberlain's last important work, the now Municipal School of Art in Margaret Street, close to the new Museum and Art Gallery, was opened in 1885. With its combination of Venetian Gothic detail (including Salviati mosaic) and naturalistic ornament, especially in the spectacular blind rose window in buff terracotta, the School of Art is often cited as an exemplum of Ruskinian architecture (fig. 13).[32] Chamberlain was certainly a disciple of Ruskin, serving as a Trustee and Councilman of the Guild of St George and proudly exhibiting his collection of Ruskin's writings at a conversazione in 1879. It is disappointing, to say the least, that Ruskin was unable to reciprocate this enthusiasm. His only visit to Birmingham, in July 1877, consisted of a two-day stay with George Baker, then Mayor (immediately preceding William Kenrick), at Bellefield, his house on the rural outskirts. A delegation of civic dignitaries was brought to him, since Ruskin was sufficiently upset by seeing the encroachment of urban sprawl that he had no wish to venture further into the town.[33] Chamberlain's untimely death at least spared him the anguish likely to have been caused by Ruskin's subsequent use of the phrase 'Birmingham Gothic' as a term of disparaging criticism.

No coolness on the great man's part, however, could dampen the ardour of Ruskin's followers in Birmingham. Baker's attempts to persuade Ruskin to select a local site for his artisans' museum, a major part of the Guild of St George, went as far as a gift of land at Bewdley in Worcestershire (astonishingly, it is still known as Ruskin's Land) and the preparation in 1884 of architectural designs by Baker's nephew Joseph Southall (1861–1944).[34] Southall, the Birmingham School tempera painter, was a budding architect when he was summoned to Brantwood (Ruskin's home at Coniston in

Fig. 13 EDMUND HORT NEW (1871–1931), *The Birmingham School of Art,* 1894; pen and ink, 8 1/4 x 6 3/4 in. (20.8 x 17.0 cm.). Birmingham Museums and Art Gallery.

the Lake District) in December 1885 to discuss the plans. The Guild's eventual decision, made at the time of Ruskin's failing health in 1889, to accept premises at Meersbrook Hall in Sheffield was a blow to Southall: "My chances as an architect vanished and years of obscurity [not] without a little bitterness of soul followed".[35] Happily, he recovered, not least after encouragement by both Morris and Burne-Jones.

It is perhaps not generally realised that the sustained interest in Ruskin's writings and philosophy – as well as the establishment of the Ruskin Galleries at Bembridge, Isle of Wight, which at present still houses the largest single collection of his manuscripts, books and drawings – is due to the efforts of a Birmingham man, J. Howard Whitehouse (1873–1955). Founder of the Ruskin Society of Birmingham in 1896 (and two years later, of its magazine *St George*), he started Bembridge School in 1919 and became an assiduous collector of Ruskin material, even acquiring Brantwood itself in 1932 and opening it to the public in 1934.[36] In Birmingham, a unique and rather noble memorial to Ruskin had already got underway in 1893. Sydney Cockerell (1867–1962), a close associate of both Ruskin and Morris, conceived the idea of commissioning Thomas Matthews Rooke (1842–1942), Burne-Jones's studio assistant and a capable painter in his own right, to make records in watercolour of the great Gothic cathedrals of France and Italy, so dear to Ruskin's heart and increasingly vulnerable to insensitive restoration. For the next thirty years, Rooke faithfully delivered to the Museum and Art Gallery one splendid watercolour annually from his travels, done, in Ruskin's own words, "for love and mere journeyman's wages".[37]

Burne-Jones's celebrated week-long visit to his native city in October 1885 (as far as is known, his last) was thus in many respects a culmination of much activity on the part of others. The enormous rise in his reputation as an artist following his success at the Grosvenor Gallery exhibitions in London from 1877 led to a first approach in 1880 from the Royal Birmingham Society of Artists to accept its Presidency. This he refused, sending to J.H. Chamberlain, the Society's Vice-President, a letter supporting Birmingham's campaigns for a new Museum and School of Art.

> Without a Museum, a School of Art is impossible – how can students work properly without some high standards of art before their eyes, some visible authority to which reference can be made? [An] Art Museum is as essential for a student of art as a library is to the student of letters. . . . [Let] us see if anything can be done to get an Art Museum for Birmingham.[38]

With the establishment of both School and Museum, Burne-Jones could hardly turn down a second invitation five years later. He accepted the Presidency of the Society only on condition that he did not have to make speeches or give lectures. His worry was unfounded, as the title was quite honorary, and had already been awarded to Millais in 1881–1882 and to Alma-Tadema in 1883–1884. "But", he wrote in acceptance, "if it were thought desirable that I should visit the Schools of Design, or meet the artists or pupils in some quiet way, without pomp or circumstance, it would be a delight to me".[39] Burne-Jones stayed at William Kenrick's house in Harborne, The Grove, which had been remodelled after 1876 in Ruskinian Gothic by Martin and Chamberlain. The house was demolished in 1963, although the sumptuous panelled ante-room is preserved in the Victoria and Albert Museum.[40]

No contemporary account is known that would amplify Lady Burne-Jones's record that "one whole day was spent in looking over the work of the most advanced

students of the School of Art, and in giving them advice", but he must have met Arthur Gaskin (1862–1928), Henry Payne (1868–1940) and Sidney Meteyard (1868–1947). The encounter can only have strengthened the Pre-Raphaelite influence on their work as independent artists, its Burne-Jonesian focus evident in examples ranging from Gaskin's early drawing of 1888, *The Lady of Shalott*, to Meteyard's oil painting of *Hope Comforting Love in Bondage*, shown at the Royal Academy in 1901 and included by Percy Bate in his book of that year, *The English Pre-Raphaelite Painters*.[41] As he was neither student nor staff member, Joseph Southall is unlikely to have been present in 1885, but on Gaskin's advice he visited Burne-Jones in 1893 and 1894, taking some early paintings which won warm approval.[42] The wood-engraver Bernard Sleigh (1872–1954), a younger pupil and then teacher at Margaret Street, was an even more fervent devotee: he recalled (in an unpublished autobiography) visiting the Art Gallery to lay flowers before *The Star of Bethlehem* on Burne-Jones's birthday. A reminder that this lingering Pre-Raphaelite influence was not wholly welcome, however, is offered in a remark made by Edward Samuel Harper (1854–1941), teacher of the Life Class from 1885, on his retirement in 1920. In his view, Burne-Jones's visit "altered the current of the School's work, and for a time wrested the control of that current almost entirely out of Mr. Taylor's hands; . . . we had a large number of students working in the Burne-Jones style, though most of them recovered their individuality after a while".[43]

The influence of William Morris on the Birmingham School, in contrast, was entirely welcome, not least since the main purpose of the School of Art was to train designers and craftsmen rather than easel painters. The impact of the Kelmscott Press is particularly evident on the first books of 'black and white' illustration, produced by School of Art staff and students under Gaskin's direction: *A Book of Pictured Carols* (1893) and *A Book of Nursery Songs and Rhymes* (1895). *Good King Wenceslas*, published by the Birmingham Guild of Handicraft in 1895, was entirely designed by Gaskin, who managed to complete the illustrations for one Kelmscott Press book, *The Shepheards Calender* (fig. 14), and see it published just before Morris's death in 1896.[44]

It seems that Burne-Jones may only have seen one of the four works by which he is best remembered in Birmingham: the huge stained-glass windows in St Philip's

Fig. 14 EDMUND SPENSER, *The Shepheards Calender*, Kelmscott Press, 1896; initials and twelve illustrations by Arthur Joseph Gaskin (1862–1928).

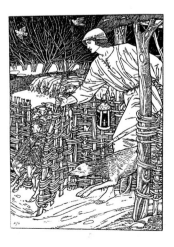

church (since 1905, the Cathedral). The first, an *Ascension* in the Chancel east window, was finished in 1885; the *Nativity* and *Crucifixion*, on either side, followed in 1888 (Morris, we know from letters, did see these installed). The great *Last Judgement* at the west end was not completed until 1897.[45] Burne-Jones went to some trouble over these large and spectacular designs – generally acknowledged as being among the best late Morris and Company glass – and penned two long ironic notes in his Account Book, doubtless for Morris's eyes, in which he humorously but genuinely expressed the feeling that he had been underpaid:

> Connected now for ever in my memory with this noble theme is a base offer of a flagrantly inadequate sum [£200] by way of payment. Was it hoped that in the absorption & rapture of composition I might be exploited unwarily? or because my sympathies were enlisted by the associations of youth was it hoped that I should be satisfied, clothed & fed with the glow of early memories?[46]

A £2,000 commission from the Corporation of Birmingham in 1887, for a work by which Burne-Jones might be properly represented in the Art Gallery's permanent collection, may have restored the strength of his affections. *The Star of Bethlehem* was completed in 1890, and shown at the New Gallery in London in 1891 before being brought up to Birmingham. It is among Burne-Jones's largest works, and is very possibly the largest watercolour in the world.[47] It formed the centrepiece of the Museum and Art Gallery's celebratory exhibition of Pre-Raphaelite painting (fig. 15), which was opened with an address by William Morris on Friday, 2 October. Two surviving members of the Brotherhood, William Holman Hunt and F.G. Stephens, were in the audience.[48] Nineteen works by Brown, five by Hunt, ten by Millais and eight by Rossetti were among the seventy-three paintings and drawings that made up what one critic called "the most comprehensive view of the movement and its productions that has yet been presented to the public".[49] Another four major oils had been purchased by this time – Hunt's *Valentine rescuing Sylvia from Proteus* (cat. no. 17), Brown's *Last of England*, Millais's *The Widow's Mite* and Rossetti's second replica of *Beata Beatrix* (cat. no. 104) – and the foundations had been laid for what was to become a great collection.

Fig. 15 Pre-Raphaelite Loan Exhibition, Birmingham Museum and Art Gallery, 1891. In centre: Edward Burne-Jones, *The Star of Bethlehem*, 1887–1890; watercolour, 101 x 152 in. (256.5 x 386.0 cm.).

A further coup was effected early in the new century, which transformed Birmingham's Pre-Raphaelite collection into one unrivalled anywhere in the world. Although he was not a lender in 1891, contact must have been made with Charles Fairfax Murray (1849–1919) between 1898 and 1900, when the Public Picture Gallery Fund bought *St George and the Dragon*, the watercolour copy after Carpaccio that Murray presumably had made for Ruskin.[50] A competent artist (see cat. no. 93), Murray became Rossetti's studio assistant in the winter of 1866–1867, and later worked for Morris and Company on translating Burne-Jones's designs for stained glass into working cartoons.[51] With Rossetti's encouragement, he developed into a formidable connoisseur, collector and dealer, especially in the field of Old Master drawings (his clients included the American financier J. Pierpont Morgan). Murray amassed over eight hundred Pre-Raphaelite drawings, shrewdly accumulating them chiefly through numerous minor lots at studio sales after the artists' deaths. He agreed to sell them *en bloc* to Birmingham in 1903. With purchase funds exhausted, Whitworth Wallis had to rally two groups of subscribers in 1904 and 1906 in order to raise funds to meet the asking price, believed to have been £10,000.[52] William Kenrick headed the list, which included several familiar Birmingham names: Feeney, Colmore, Cadbury, Dixon and Pinsent.[53] Another subscriber was James Richardson Holliday (1840–1927), a Birmingham solicitor with a twin passion for Pre-Raphaelitism and British drawings. A Trustee of the Public Picture Gallery Fund from 1893, he bequeathed his collection to the nation, and through his executor Sydney Cockerell a large portion of it came to the Museum and Art Gallery, including numerous Pre-Raphaelite drawings, cartoons for stained glass and Brown's smaller version of *Work* (cat. no. 74).

Many further acquisitions have been added to the Birmingham collection over the years. Its importance attracted numerous gifts not only from local and national collectors but also from artists' families, including those of Millais, Burne-Jones, Arthur Hughes (cat. no. 49) and Martineau (cat. nos. 69–70). Occasional important purchases have been possible, not least during the post-war period which saw a decline of interest in Victorian art. The acquisition of two masterpieces – Brown's *The Pretty Baa-Lambs* (cat. no. 18) and Munro's sculpture of *Paolo and Francesca* (cat. no. 19) – resulted from this perspicacity. The applied arts have not been overlooked as a vital component of second-generation Pre-Raphaelitism. In addition to a good group of Morris and Company stained glass (see cat. nos. 60–64), the collection now also holds the most complete set of the firm's celebrated *Holy Grail* tapestries (*The Summons* having been purchased as recently as 1980).[54] Even complementary light relief has been added, in the form of a Burne-Jones self-caricature, *Unpainted Masterpieces*, and Sir Max Beerbohm's teasing homage to the movement (cat. no. 118). In such small but useful ways do we try to sustain the vision and purpose expressed by Sir John Middlemore in his gift of *The Finding of the Saviour in the Temple* in 1896: "I am glad to be able to offer a Pre-Raphaelite work, as our City is becoming – possibly has already become – the best centre in the world in which to study this distinctively English school of art".[55]

1. See Nathaniel Neal Solly, *Memoir of the Life of David Cox*, 1873 (reprinted 1973) and Stephen Wildman, et al., *David Cox 1783–1859*, Birmingham, 1983.

2. In a letter of 8 October 1848 to his cousin Maria Choyce, Burne-Jones stated that his "leisure hours . . . are few, as I go to the School of Design 3 evenings pr. wk." (Burne-Jones, *Memorials*, 1904, vol. 1, p. 26).

3. Burne-Jones's mother, Elizabeth, had died giving birth; his father, Edward Richard Jones, died in Birmingham in 1889.

4. A schism had developed in 1842 between the Society of Arts in New Street, which housed the School of Design and occasionally displayed Old Masters, and the Society of Artists, who decamped to the Athenaeum building in Temple Row (now demolished) to hold exhibitions of modern work. The rift was healed in 1858, when the School of Design was subsumed by the Midland Institute and the artists returned to New Street. Burne-Jones's unhelpful retrospective comments about his childhood tastes at least reveal some exposure to pictures: "I quite hated painting when I was little . . . until I saw Rossetti's work and Fra Angelico's, I never supposed that I liked painting. I hated the kind of stuff that was going on then" (Burne-Jones, *Memorials*, 1904, vol. 1, p. 48).

5. No. 311, under the title *Chaucer, Gower, Wickliff, and John of Gaunt*.

6. Diary entries for 6 November 1848 ("by rail to Liverpool saw my Wicliff there up high, looked damned bad") and 7 November 1848 ("to Chester thence to Birmingham saw Exn."); Surtees, 1981, pp. 47–48.

7. See London, Tate, 1984, p. 56.

8. John Gibbons (1777–1851) was only technically a Birmingham collector; the owner of a large local iron foundry, he had moved to London four years before purchasing Hunt's *Rienzi* in 1849, on the advice of Augustus Egg. Even then, he could hardly be described as an enthusiast: Hunt states in his autobiography that "the gentleman never valued the work, but hid it away in a closet, and at his death the family sold it without distributing his general collection" (Hunt, 1905, vol. 1, p. 183).

9. Fredeman, 1975, p. 95.

10. *Birmingham Journal*, 11 September 1852. This and the following notice cited were brought to light by Roy Hartnell in "The Pre-Raphaelites and Birmingham: The Early Years", *Pre-Raphaelite Society* [newsletter], no. 6, Autumn 1990.

11. See Mary Bennett, "The Pre-Raphaelites and the Liverpool Prize", *Apollo*, vol. 77, December 1962, pp. 748–753, and "A Check List of Pre-Raphaelite Pictures exhibited at Liverpool 1846-67, and some of their Northern Collectors", *Burlington Magazine*, vol. 105, November 1963, pp. 486–493.

12. *Birmingham Journal*, 1 October and 15 October 1853.

13. Hunt, 1905, vol. 2, p. 162; quoted by Dianne Sachko Macleod, "Avant-Garde Patronage in the North East", in Newcastle upon Tyne, 1989–1990, p. 12.

14. Surtees, 1981, p. 189 (diary entry for 25 September 1856).

15. For more information on Gillott see Jeannie Chapel, "The Turner Collector: Joseph Gillott, 1799–1872", *Turner Studies*, vol. 6, no. 2, Winter 1986, pp. 43–50.

16. Wallis's *The Stonebreaker* was exhibited at the Birmingham Society of Artists in 1860 under its subtitle "Now is done thy long day's work", the first line of Tennyson's poem "A Dirge".

17. See Stuart Davies, *By the Gains of Industry: Birmingham Museums and Art Gallery 1885–1985*, Birmingham, 1985, pp. 14–15. Designed in 1881 by H. Yeoville Thomason as an extension to his Council House of 1874–1879, the new building was opened on 28 November 1885 by the Prince of Wales (the future Edward VII).

18. Owners of a Birmingham engineering firm, the Tangye brothers gave £5,000 in 1880 for the purchase of works of art and, if equalled, a further £5,000 to be invested for future acquisitions; this Purchase Fund was finally exhausted in 1899. The Tangyes also presented their outstanding collection of Wedgwood ceramics to the Museum and Art Gallery.

19. The first lecture, *Realistic Schools of Painting: D.G. Rossetti and W. Holman Hunt*, was given in Oxford on 9 March 1883, after Ruskin's re-election as Slade Professor of Fine Art; the second, *Mythic Schools of Painting: E. Burne-Jones and G.F. Watts*, followed on 12 May. Printed in parts from May onwards, the lectures were published in 1884 as the single volume *The Art of England* (Ruskin, *Works*, 1908, vol. 33).

20. The early history of this body is given in Eric W. Vincent, *Notable Pictures: The Contribution of the Public Picture Gallery Fund to the Birmingham Art Gallery*, Birmingham, 1949.

21. I am grateful to Mr John Kenrick for access to the manuscript and permission to publish these details.

22. Quoted in London, Tate, 1984, p. 160.

23. Letter to Middlemore, 1 June 1896; this and eighteen other letters from Hunt to his Birmingham patron have been presented to the Museum and Art Gallery by Middlemore's granddaughter, Mrs Rosemary Smith. Hunt sent a long account of the genesis and execution of *The Finding of the Saviour in the Temple* to the *Birmingham Daily Post* on 15 June 1896; the manuscript draft of this is also in the permanent collection.

24. Middlemore had intended this as an additional gift to Birmingham, but only "if our city will build what I consider a suitable gallery for the proper display of the works of art which it possesses, and hopes to possess" (quoted in Davies, *By the Gains of Industry*, 1985, pp. 33–34). By 1898, when he wrote this, the Museum's original building was seriously overcrowded (there were only four galleries). A substantial extension was built in 1911–1912, by which time Middlemore's offer of the picture had been withdrawn.

25. *Catalogue of Pictures and Statuary*, Pitmaston, 1911 (privately printed).

26. Holder had acquired *The Backgammon Players* by 1898, when he lent it to the Burne-Jones memorial exhibition at the New Gallery, London, from December 1898 to April 1899; see Birmingham, *Paintings &c.*, [1930], p. 36 (146'23).

27. See Rachel E. Waterhouse, *The Birmingham and Midland Institute 1854–1954*, Birmingham, 1954, p. 45. "By the time that the lecture theatre in the new buildings opened in 1881 J.H. Chamberlain could rightly claim that no lecture was delivered on any subject in which the lecturer was not an acknowledged master: 'The Institute has in

fact induced many eminent men to break away from the privacy of their own lecture rooms and class rooms, to address in Birmingham a public audience for the first time'."

28. Hueffer, 1896, pp. 282, 324. "In the first [of 1874], I propose to show that the so-called innovations of myself and others are nothing more than is the rule at present with all leading European artists. In the second, I wish to call attention to the difference between historic (*so-called*), that is, *elevated* and *elevating* art, and the commonplace so affected by our blessed English public, plebeian and patrician".

29. Details of all of Morris's fifteen speaking engagements in Birmingham between 1879 and 1894 are given in Eugene D. Lemire (ed.), *The Unpublished Lectures of William Morris*, Detroit, 1969, Appendix I: "A Calendar of William Morris's Platform Career".

30. Burne-Jones, *Memorials*, 1904, vol. 1, p. 117.

31. Quoted in Philip Henderson, *William Morris: His Life, Work and Friends*, London, 1967, p. 156.

32. See Michael W. Brooks, *John Ruskin and Victorian Architecture*, London, 1989, especially ch. 11, "John Ruskin, John Henry Chamberlain and the Civic Gospel".

33. Number 90 of *Fors Clavigera*, Ruskin's open letters to the "Workmen and Labourers of Great Britain", was written while staying at Bellefield, "watching the workmen on the new Gothic school, which is fast blocking out the once pretty view from my window" (Ruskin, *Works*, 1907, vol. 29, p. 170).

34. See Peter Wardle and Cedric Quayle, *Ruskin and Bewdley*, St Albans, 1989, ch. 1, "John Ruskin, George Baker and the Guild of St George".

35. Quoted in the catalogue (by George Breeze) to the exhibition *Joseph Southall 1861–1944: Artist-Craftsman*, Fine Art Society, Birmingham and London, 1980, p. 6.

36. See James S. Dearden, "The Ruskin Galleries at Bembridge School, Isle of Wight", *Bulletin of the John Rylands Library, Manchester*, vol. 51, no. 2, Spring 1969, pp. 310–319.

37. See Janet Barnes and Stephen Wildman, *"Faithful and Able": Works by Thomas Matthews Rooke 1842–1942 in the Collections of Birmingham Museums and Art Gallery and the Ruskin Gallery, Sheffield*, Birmingham and Sheffield, 1993.

38. Burne-Jones, *Memorials*, 1904, vol. 2, pp. 99–100.

39. Burne-Jones, *Memorials*, 1904, vol. 2, p. 155.

40. See Barbara Morris, "The Harborne Room", *Victoria and Albert Museum Bulletin*, vol. 4, no. 3, July 1968, pp. 82–95.

41. Both works are now in the Birmingham Museums and Art Gallery collection; see Stephen Wildman, *The Birmingham School*, Birmingham, 1990, nos. 45, 51. Burne-Jones's influence is also discussed in Alan Crawford (ed.), *By Hammer and Hand: the Arts and Crafts Movement in Birmingham*, Birmingham, 1984 (George Breeze, "Decorative Painting", pp. 61–83).

42. *Joseph Southall*, exhibition catalogue, Birmingham and London, 1980, p. 12.

43. *Birmingham Mail*, 9 January 1920.

44. See the catalogue to the exhibition *Arthur & Georgie Gaskin*, Fine Art Society, Birmingham and London, 1982, particularly the section on illustration by Niky Rathbone and George Breeze.

45. See Sewter, 1975, pp. 19–20. A note in Burne-Jones's account book for 1887, printed here by Sewter, states that during his 1885 visit he had been "struck with admiration at one of my works in St Philip's Church". Morris wrote to his daughter Jenny from Malvern on 18 August 1888: "Yesterday I went to Birmingham all by myself to see the new window: my work was over there in five minutes, for it was quite satisfactory; it was rather a long journey for so short a piece of work" (Mackail, 1899, vol. 2, p. 209).

46. Quoted in Sewter, 1975, p. 19.

47. See Birmingham, *Paintings &c.*, [1930], p. 27 (75'91); it measures 101 x 152 inches (256.5 x 386.0 cm.), dwarfing even the large tapestries, usually called *The Adoration of the Magi*, which were made from the same subject at Morris's Merton Abbey works.

48. The presence of Hunt and Stephens was recorded in *The Academy*, 10 October 1891, p. 317. The rather meandering nature of Morris's speech, printed in pamphlet form as an *Address on the Collection of Paintings of the English Pre-Raphaelite School*, was explained by his biographer: "It perhaps expresses his views not the less exactly because it was spoken on the spur of the moment and was the imperfect but immediate offerance of his habitual feelings. The curiously halting sentences and inconclusive termination are accounted for very simply. He had meant to think out what he would say on the journey down to Birmingham, but fell asleep in the train and arrived with nothing prepared" (Mackail, 1899, vol. 2, p. 270).

49. *The Academy*, 10 October 1891, p. 316.

50. Birmingham, *Paintings &c.*, [1930], p. 144 (18'00); Manchester, Bath and London, 1989, (138, repr.).

51. See Carole Cable, "Charles Fairfax Murray, Assistant to Dante Gabriel Rossetti", *Library Chronicle of the University of Texas at Austin*, n.s., no. 10, 1978, pp. 81–89.

52. In the interim, Murray made a number of individual gifts, including important works by Brown, Rossetti, Sandys (cat. no. 98) and Boyce (cat. no. 109).

53. The subscribers were these: in 1903 (for drawings by Burne-Jones and Rossetti), Cregoe Colmore, John Feeney, J.R. Holliday, William Kenrick and C.A. Smith-Ryland; and in 1906 (for drawings by Brown, Millais, Sandys and others), William A. Cadbury, J. Palmer Phillips, F.W.V. Mitchell, Sir G.H. Kenrick, G. Hookham, Mrs Charles Dixon, R.A. Pinsent and an anonymous donor.

54. See Oliver Fairclough and Emmeline Leary, *Textiles by William Morris & Co. 1861–1940*, Birmingham, 1981, and Emmeline Leary, *The Holy Grail Tapestries designed by Edward Burne-Jones for Morris & Co*, Birmingham, 1985.

55. Quoted in Davies, *By The Gains of Industry*, 1985, pp. 31–32.

Author's Note

Among my predecessors at Birmingham who have done much valuable work on the Pre-Raphaelite collection, special acknowledgement should be made to Richard Ormond, Andrea Rose, and the late John Woodward, former Keeper of Art, to whom this catalogue is dedicated. In addition to re-iterating the thanks due to my present colleagues – especially to Ann Parker-Moule, who fed a seemingly endless manuscript into the word processor with unceasing good humour – I should like to acknowledge the debt all succeeding writers owe to those scholars whose work on the Pre-Raphaelites appears in monographic books, articles and catalogues. I salute Mary Bennett, Judith Bronkhurst, Susan Casteras, John Christian, David Cordingly, Peter Cormack, Betty and Rowland Elzea, William Fredeman, the late John Gere, Alastair Grieve, Robin Hamlyn, Lionel Lambourne, Mary Lutyens, Katharine Macdonald, Jan Marsh, Christopher Newall, Ron Parkinson, Leslie Parris, Benedict Read, Leonard Roberts, the late Charles Sewter, Allen Staley, Virginia Surtees, Julian Treuherz, Malcolm Warner and Ray Watkinson, and thank all among them who have never failed to answer the tedious and time-consuming queries generated by this kind of publication.

It has been a particular pleasure to collaborate on this occasion with John Christian and Jan Marsh, both long-standing friends of Birmingham Museum and Art Gallery. Louise Hazel, a post-graduate student at the University of Essex who hails from Birmingham, has kindly prepared the chronology. I am grateful to John Baskett, John Kenrick and Denis Martineau for providing useful information, and would like to thank the curators and photographers of those museums and galleries which have provided complementary illustrations, as well as the staffs of Birmingham Central Reference Library, Cambridge University Library, the Yale Center for British Art, Christie's and Sotheby's. Perhaps the greatest debt of gratitude goes to my editor Nancy Eickel at Art Services International, who has consistently honed and improved a most unwieldy text.

STEPHEN WILDMAN
January 1995

Notes to the Catalogue

All the catalogue entries and the artists' biographies were written by Stephen Wildman, Curator of Prints and Drawings at Birmingham Museum and Art Gallery. Works are arranged in chronological order; the assignment of conjectural dates necessary for some of the drawings is explained in the text. An index of works arranged by artist has been incorporated within the biographical section (pages 335–346).

Measurements, which have all been newly checked and corrected, are given in inches and centimetres, height before width. Unless otherwise specified, the drawings are on white paper.

The opportunity has been taken to illustate some of the more important works in their frames, especially those known to be original and, in a number of cases, to be of the artist's own design.

As complete a provenance as possible is given, including the circumstances of acquisition by Birmingham Museum and Art Gallery. Under 'Exhibited' are listed only those instances of public display of a work within the artist's lifetime; a fuller exhibition history of a work can be found in the most recent catalogues cited in the 'References' section. Unless otherwise stated, cited auctions took place in London.

In all cases, reference has been made to existing catalogues of the Birmingham collection: the 1960 *Paintings* catalogue, the 1939 *Drawings* volume and, for watercolours and chalk drawings only, the 1930 *Paintings* catalogue, which included coloured works on paper not cited subsequently. Otherwise, references have been confined to literature containing specific discussion of each individual work, including the most important recent exhibition catalogues. Shortened references in the text and footnotes are elaborated in the extensive bibliography that concludes the book. In all bibliographical references, the place of publication is London unless otherwise stated.

Catalogue of Works

1

FORD MADOX BROWN

Head of a Page Boy (?)

1837 (?)
Oil on canvas
14 x 12 in.; 35.5 x 30.6 cm.
Presented by L.M. Angus-Butterworth, through the
National Art Collections Fund, in memory of his father,
Walter Butterworth, 1960 (P25'60)

PROVENANCE: Henry Boddington, by 1911

REFERENCES: Hueffer, 1896, p. 432; Birmingham, *Paintings*,
1960, p. 16

This sprightly oil study is usually placed amongst Brown's earliest works, including a number of portraits, produced after he had settled as a student at the Antwerp Academy in 1836. The best of those which survive are of his father Ford Brown (1837; Private Collection); F.H.S. Pendleton, a student at Ghent University who taught him the violin (1837; Manchester City Art Gallery); and an unidentified head of a girl (1840; Tate Gallery, London).[1]

A possible identification is with a *Head of Page* dated to 1837 in "A list of Madox Brown's more important works", which forms Appendix B of Ford Madox Hueffer's biography of 1896. This might help to explain the otherwise puzzling heart-shaped emblem on the boy's clothing, which could be part of an institutional or historical costume. A young page features as one of the attendants in Brown's first major history painting, *The Execution of Mary, Queen of Scots* (1840–1841; Whitworth Art Gallery, University of Manchester).[2]

Brown retained an affection for these boldly coloured, strongly modelled early oils. In retrospective mood, he recorded in a diary entry of 6 January 1856, "At this time when I first began art seriatiom [*sic*] & before I fell into any kind of mannerism, many of my studies are better than I was able to do for many years afterwards".[3]

1. All reproduced in Newman and Watkinson, 1991, pls. 8–10.
2. Reproduced in Newman and Watkinson, 1991, pl. 2.
3. Surtees, 1981, p. 162.

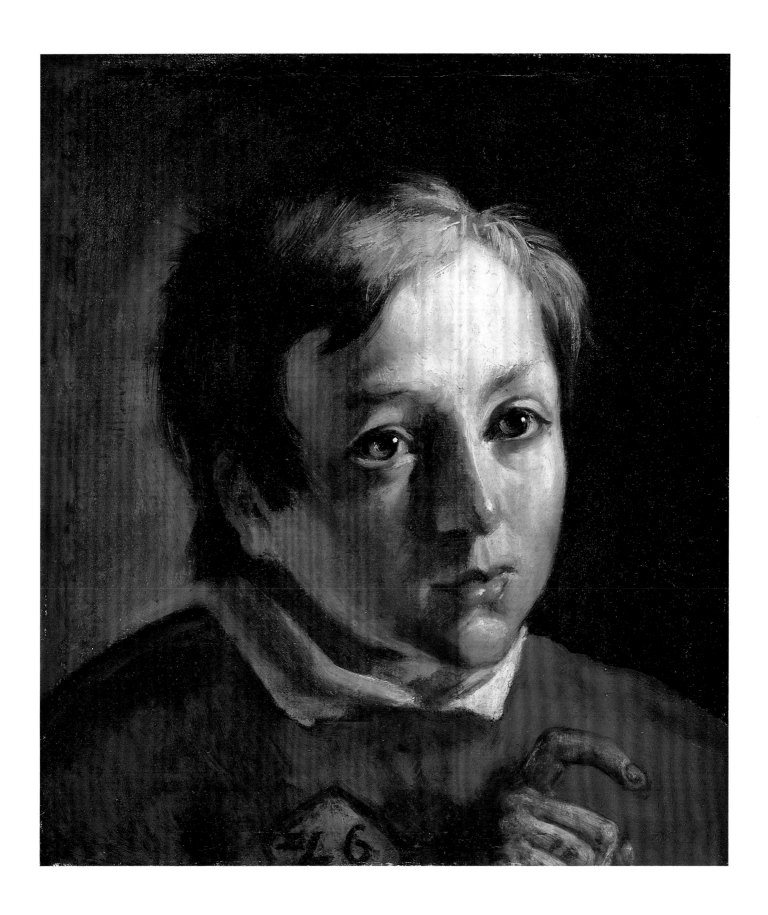

FORD MADOX BROWN

Parisina's Sleep: study for the head of Parisina

1842
Black chalk, heightened with white chalk, on grey paper
12 5/8 x 11 3/4 in.; 32.0 x 29.8 cm.
Signed and dated in brown ink, bottom right: Ford M
Brown 1842 (Paris)
Presented by subscribers, 1906 (717'06)

PROVENANCE: Charles Fairfax Murray

REFERENCES: Birmingham, *Drawings*, 1939, p. 27; Newman
and Watkinson, 1991, pl. 20

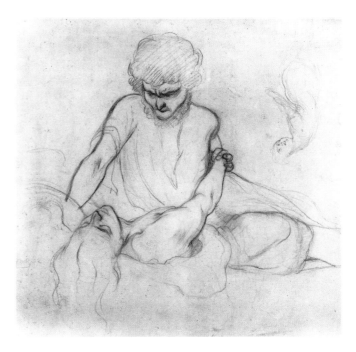

Fig. 16 FORD MADOX BROWN, *Parisinia's Sleep: study for the composition*, circa 1842; black chalk on buff paper, 16 1/4 x 16 1/2 in. (41.3 x 41.8 cm.). Birmingham Museums and Art Gallery (355'27).

*I*n the course of what he called his 'art studentship' in Paris, Brown culled subjects from many literary sources. The poetry of Byron was to remain a lifelong inspiration (see cat. no. 37), and gave rise to three early oil paintings: *Manfred on the Jungfrau* (1840–1841, re-worked 1861) and *The Prisoner of Chillon* (1843), both now at Manchester City Art Gallery, and *Parisina's Sleep* (1842). Last exhibited in 1911,[1] this painting is now lost, although its two-figure composition is recorded in a preparatory study which is also at Birmingham (fig. 16).[2]

Byron's poem "Parisina", published in 1816, takes its subject from Edward Gibbon's *Antiquities of the House of Brunswick:*

> Under the reign of Nicholas III, Ferrara was polluted with a domestic tragedy. By the testimony of an attendant, and his own observation, the Marquis of Este discovered the incestuous loves of his wife Parisina and Hugo his bastard son, a beautiful and valiant youth. They were beheaded in the castle by the sentence of a father and husband, who published his shame, and survived their execution.[3]

Brown fixes on a moment of dramatic tension, as the husband (called Azo in the poem) contemplates the murder of his wife in her sleep:

> He could not slay a thing so fair –
> At least not smiling – sleeping there

An equally powerful drawing, in the same medium and again at Birmingham,[4] shows the head of Prince Azo bearing a fiendish expression, precisely according with Byron's lines:

> he did not wake her then,
> But gazed upon her with a glance
> Which, had she roused her from her trance
> Had frozen her sense to sleep again. . . .

Writing in 1865, Brown recalled that the painting was not, as a viewer might easily assume, influenced by contemporary French romantic art, but rather "had its origin in the Spanish pictures [i.e., Velazquez] and in Rembrandt".[5]

1. Manchester, 1911 (59, lent by Henry Boddington).
2. Birmingham, *Drawings*, 1939, p. 26 (716'06); Newman and Watkinson, 1991, pl. 19.
3. William Michael Rossetti (ed.), *The Poetical Works of Lord Byron*, 1870, p. 129.
4. Birmingham, *Drawings*, 1939, p. 27 (355'27); Newman and Watkinson, 1991, pl. 21.
5. London, Piccadilly, 1865 (37, p. 17).

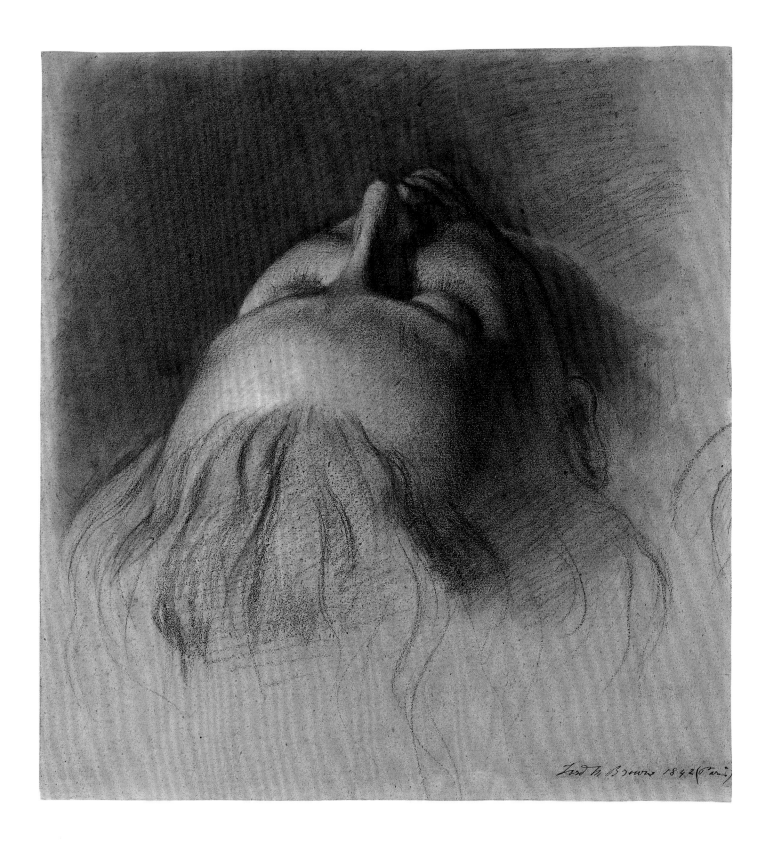

3

JOHN EVERETT MILLAIS

Elgiva seized by order of Odo, Archbishop of Canterbury

1843
Pen and brown ink, laid onto card
8 x 11 7/8 in.; 20.5 x 30.2 cm.
Signed and dated in brown ink, bottom right: J. E. Millais /
1843
Inscribed in pencil, on mount above image, top left: A.D. 955
Top right: Edwy
Inscribed in pencil, on mount below image: Elgiva seized by
the orders of Odo Archbishop of Canterbury
Purchased (through John Feeney Charitable Trust), 1967
(P47'67)

PROVENANCE: D.T. White; Christie's, 20 April 1868, part of
lot 355; Christie's, 7 December 1945, part of lot 30; Sotheby's,
13 October 1965, lot 64; Leger Galleries, London

REFERENCES: London and Liverpool, 1967 (197, lent by Leger
Galleries); Arts Council, 1979, p. 18

*P*recociously gifted, Millais entered the schools of the Royal
Academy of Arts in July 1840, at the age of eleven their youngest
student ever. Six years later he exhibited at the Royal Academy
his first large oil painting, *Pizarro seizing the Inca of Peru* (Victoria
and Albert Museum, London). By then he had produced a sub-
stantial body of drawings, strongly weighted towards subjects
from British history: he was awarded a 'silver palette' in 1841
by the Society of Arts for a sepia drawing, *News of the Defeat
of the Royalists* (Royal Academy of Arts, London).[1]

Millais also entered a competition organised by the Art
Union of London, which was announced in October 1842 and
closed on 25 March 1843. The competition called for a set of
ten outline drawings illustrating a theme from English history
or literature, and carried a prize of £60; the winning entry
would be engraved and included in a series of increasingly
popular folios. With typical enthusiasm, Millais seems to have
produced sixteen pen and ink drawings of subjects from
Anglo-Saxon history.[2]

Malcolm Warner has suggested that Sharon Turner's *History
of the Anglo-Saxons* (1828) may have been one of Millais's sources.
The artist also certainly used David Hume's *History of England*
(1754–1757), offering this quotation to accompany the exhibi-
tion of a large oil of *Elgiva* at the Royal Academy in 1847:[3]

> Archbishop Odo, to avenge the banishment of Dunstan,
> dissolved Edwy's marriage with Elgiva, on the plea of
> kinship, and sent a party of soldiers into the palace, who
> seized the Queen, and, after branding her face, in order
> to destroy that fatal beauty which had seduced Edwy,
> forcibly conveyed her to Ireland.

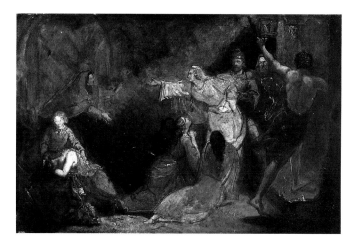

Fig. 17 JOHN EVERETT MILLAIS, *Elgiva seized by order of Odo, Archbishop
of Canterbury*, circa 1846; oil on millboard, 12 1/8 x 18 1/2 in. (31.0 x
46.9 cm.). Birmingham Museums and Art Gallery (P127'80).

It is commonly observed that the 'outline' style so fash-
ionable at this period owes much to a familiarity both with
John Flaxman's engraved illustrations of Homer and Dante
(1793; first fully published in London in 1805–1807) and with
the German engraver Moritz Retzsch's *Outlines to Shakespeare*,
which was available with English text by the late 1830s.[4] The
young Millais's re-interpretation of these sources, which offers
a greater directness and sense of involvement in the human
action of a scene such as Elgiva's humiliation, must be con-
sidered an important contribution to the Pre-Raphaelite
Brotherhood's earliest common style.

1. Arts Council, 1979 (2).
2. Arts Council, 1979, discussed in detail under no. 5, pp. 18–19; a fur-
ther drawing in the series, *The Danes committing barbarous Ravages on
the Coast of England*, appeared at Christie's, 4 February 1986, lot 244.
3. Arts Council, 1979 (35, p. 25); a preliminary oil sketch, formerly on
loan to the museum, was purchased for the Birmingham permanent
collection in 1980 (fig. 17).
4. This is most fully explored in Vaughan, 1979, ch. 4, "F.A.M.
Retzsch and the Outline Style".

4

FORD MADOX BROWN

The Body of Harold brought before William the Conqueror: sheet of studies

Circa 1843–1844
Pencil, pen and brown ink
17 1/4 x 22 3/8 in.; 43.8 x 56.8 cm.
Verso: Unidentified eighteenth-century costume subject (possibly from Laurence Sterne's *Sentimental Journey*)
Pencil, pen and brown ink
Signed and dated, bottom right: Ford M Brown Paris / 42
Presented by subscribers, 1906 (797'06)

PROVENANCE: Charles Fairfax Murray

REFERENCE: Birmingham, *Drawings*, 1939, p. 48 (studies mentioned but not identified)

*T*his sheet has not hitherto been recognised as containing an important series of studies for one of the subjects submitted by Brown in the competition to decorate the new Houses of Parliament.

Following the fire of 1834 and the rebuilding of the Palace of Westminster by Charles Barry and A.W.N. Pugin, a Commission was established, which decided to hold competitions for new painted and sculptural decoration. Cartoons were invited "executed in chalk or charcoal, not less than ten nor more than fifteen feet in their longest dimension; the figures to be not less than the size of life, illustrating subjects from British History, or from the works of Spenser, Shakespeare or Milton".[1] After the entries were exhibited in 1843, 1844 and

1845, prizes were awarded and eventually sites for frescoes were allotted to William Dyce, C.W. Cope, J.C. Horsley and Daniel Maclise.

Brown's cartoons for *Adam and Eve*, *The Body of Harold* (both shown in 1844) and *The Spirit of Justice* (in the 1845 exhibition) attracted some attention, but failed to win him a commission. He later worked up an oil sketch of *Harold* into a finished painting, which was sold in 1861 to the collector Thomas Plint under the title *Wilhelmus Conquistator* (now at Manchester City Art Gallery; fig. 18).[2] Such a subdued, although moving, image of the Battle of Hastings would certainly have provided a contrast to the more heroic subjects submitted to the Westminster competitions. Its effectiveness as a composition, however, is a reminder of what Brown had to offer the Pre-Raphaelites in practice as well as in theory (his essay "On the Mechanism of a Historical Picture" was printed in the second issue of *The Germ*). Hunt's *Rienzi vowing to obtain Justice for the Death of his Young Brother* (1848–1849; Private Collection) contains several echoes of *The Body of Harold*, which had greatly impressed the younger artist.[3]

In addition to a compositional sketch and other figures fairly close to their final form, two studies on this sheet for a group show a dead or wounded man being helped from his horse – possibly an early idea for depicting the delivery of Harold's body. Perhaps consciously, the juxtaposition of so many studies gives the sheet a rather 'Old Master' feel; comparable sheets from the early years of the Brotherhood include several by Hunt, filled with studies for *The Flight of Madeline and Porphyro* (1848; Guildhall Art Gallery, Corporation of London).[4]

1. From the Commissioners' *1st Report*, 1842, quoted in T.S.R. Boase, "The Decoration of the New Palace of Westminster, 1841–1863", *Journal of the Warburg and Courtauld Institutes*, vol. 17, 1954, pp. 319–358; abridged in M.H. Port (ed.), *The Houses of Parliament*, New Haven and London, 1976, pp. 268–281.
2. Liverpool, 1964 (6).
3. Hunt, 1905, vol. 1, p. 120.
4. Sotheby's, 10 October 1985 (including the Burt Collection of Holman Hunt Drawings), lots 2–4; lot 3 is now at the Fitzwilliam Museum, Cambridge, and lot 4 is at Liverpool (Bennett, 1988, pp. 67–69).

Fig. 18 FORD MADOX BROWN, *The Body of Harold brought before William the Conqueror (Wilhelmus Conquistator)*, 1844–1861; oil on canvas, 41 1/4 x 48 3/8 in. (105.0 x 123.1 cm.). Manchester City Art Gallery.

5

FORD MADOX BROWN

The Spirit of Justice: study for the head of a Counsellor

Circa 1844–1845
Black chalk
17 7/8 x 12 3/8 in.; 45.5 x 31.5 cm.
Presented by Harold Hartley, 1905 (21'05)
REFERENCE: Birmingham, *Drawings*, 1939, p. 28

*S*ix arched compartments on the end walls of the new House of Lords in the Palace of Westminster were reserved for frescoes of Religion, Justice and Chivalry, allegories representing "the functions of the House of Lords and the relation in which it stands to the Sovereign".[1] Brown's cartoon, shown in the 1845 exhibition (see cat. no. 4), had as its subject "a widow, whose husband has been murdered by a knight, appealing to the Spirit of Justice, who, blind and seated on high with scales and sword, is surrounded by revered counsellors";[2] a coloured design survives in Manchester City Art Gallery (fig. 19).[3] The commission for *The Spirit of Justice* was awarded to Daniel Maclise.

Of the ten studies in Birmingham for the cartoon, four are large heads of the knight and widow, and of the two counsellors on the left. These powerful drawings are among a group of eight presented to the museum in 1905 by the collector Harold Hartley (1851–1943).[4]

1. T.S.R. Boase, *Journal of the Warburg and Courtauld Institutes*, vol. 17, 1954, p. 332.
2. Hueffer, 1896, p. 35.
3. Treuherz, 1980, pp. 26–27.
4. A connoisseur and professional organiser of exhibitions, Harold Hartley's abiding interest was in book illustration of the 1860s, a passion chronicled in his engaging autobiography, *Eighty-eight Not Out* (1939). His own extensive collection was purchased by the Museum of Fine Arts in Boston in 1955; see Sarah Hamilton Phelps, "The Hartley Collection of Victorian Illustration", *Bulletin: Museum of Fine Arts, Boston*, vol. 71, no. 360, 1973, pp. 52–67.

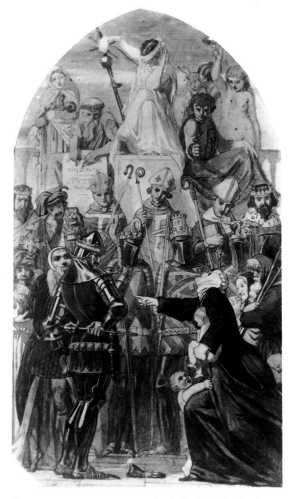

Fig. 19 FORD MADOX BROWN, *Study for "The Spirit of Justice"*, 1845; pencil, watercolour and bodycolour, 29 3/4 x 20 3/8 in. (75.7 x 51.7 cm.). Manchester City Art Gallery.

81

6

WILLIAM HOLMAN HUNT

Self-Portrait

1845
Oil on canvas
18 x 15 1/2 in.; 45.7 x 39.3 cm.
Signed and dated, at left: WHH / 1845
Purchased, from the bequest of W.T. Wiggins-Davies, to
commemorate the services of Alderman W. Byng Kenrick to
the City of Birmingham, 1961 (P32'61)

PROVENANCE: The artist, and by descent to Mrs Elizabeth Burt

REFERENCES: ?Fine Art Society, 1886 (1); Hunt, 1905, vol. 1,
p. 55, repr.; Liverpool and London, 1969 (4, pl. 1)

*T*his canvas was painted early in 1845, if the caption 'Aged
17' which accompanies its reproduction in Hunt's autobiog-
raphy is accurate. In January of that year Hunt had entered
the Royal Academy Schools as a student, where he later met
Rossetti and continued an acquaintance already made with
Millais. This is one of three early self-portraits: another, paint-
ed at the age of fourteen, is in the Ashmolean Museum,
Oxford. Richard Ormond has observed that "it reveals Hunt's
overwhelming self-confidence and something of the dogmatic
cast of his character".[1]

A handwritten note, presumably by a member of the
family, was formerly attached to the frame:

> This portrait was painted when WHH could not afford
> a new canvas. He therefore used one that he had used
> for a picture of his little sister called "Hark!" which was
> exhibited at the R.A. in 1846. The original picture was
> not properly reprimed. At the time WHH thought he
> bore a striking resemblance to Hogarth, & he sought to
> emphasise the likeness in this painting.[2]

1. Ormond, 1965.
2. From a transcription in the files of the Birmingham Museums and
Art Gallery.

7

FORD MADOX BROWN

Chaucer at the Court of Edward III: compositional design

1845
Pencil, with shape of frame indicated in brown ink
12 7/8 x 9 3/8 in.; 32.9 x 23.8 cm.
Signed and dated in brown ink, bottom left: F M Brown
Rome / 45
Presented by subscribers, 1906 (681'06)

PROVENANCE: Charles Fairfax Murray

REFERENCES: Hueffer, 1896, repr. following p. 447;
Birmingham, *Drawings*, 1939, p. 31; Liverpool, 1964 (51);
Andrews, 1964, p. 81, repr. pl. 72b; Newman and
Watkinson, 1991, pl. 41

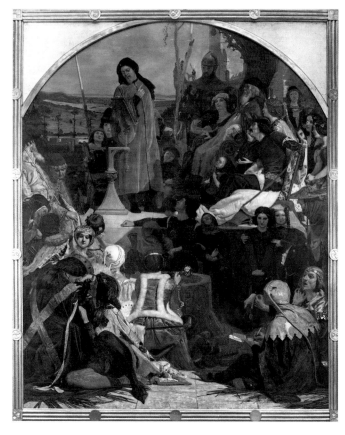

Fig. 20 FORD MADOX BROWN, *Chaucer at the Court of Edward III*,
1845–1851; oil on canvas, 146 1/2 x 116 1/2 in. (372.0 x 296.0 cm.). Art
Gallery of New South Wales, Sydney, Australia.

1. Liverpool, 1964 (11, pl. 2) and London, Tate, 1984 (7, repr.), respectively.
2. Liverpool, 1964 (12); London, Tate, 1984 (6, repr.).
3. Liverpool, 1964 (50); repr. Newman and Watkinson, 1991, pl. 40.
4. London, Piccadilly, 1865 (1, p. 4).

*I*n the autumn of 1845, Brown took his wife Elisabeth to
the warmer climate of Italy. Terminally ill with tuberculosis,
she survived the winter but died in Paris on the return jour-
ney in June 1846. While in Rome, Brown began work on his
first ambitious easel painting, of an imaginary scene, set at a
date of 1375, showing the poet Geoffrey Chaucer (1340?–
1400) reading aloud to Edward III and his court.

Two paintings developed from this idea. A huge oil (12 x
10 feet; 3.5 x 3 metres), which is generally known as *Chaucer at
the Court of Edward III*, was exhibited at the Royal Academy
in 1851, and was bought in 1876 by the Art Gallery of New
South Wales, Sydney (fig. 20; a smaller replica of 1867–1868 is
in the Tate Gallery, London).[1] The other, which now exists
only in the form of an elaborate oil sketch (Ashmolean
Museum, Oxford), shows a similar central panel flanked by
figures from literary history: on the left Milton, Spenser and
Shakespeare, and on the right Byron, Pope and Burns. Under
the grander title *The Seeds and Fruits of English Poetry*, this
was exhibited at the Liverpool Academy in 1853.[2]

The present sheet seems to be the second in sequence of
two such designs in the Birmingham collection: the other,
which is smaller (9 7/8 x 7 1/2 in.; 25.1 x 19.1 cm.; 680'06), also
in pencil and inscribed 'Ford M Brown Rome', differs only in
minor detail. Another pencil drawing, inscribed 'Roma 1845',
shows the first idea of a triptych format (Cecil Higgins Art
Gallery, Bedford).[3] Apart from the poet, the main figures in
the upper group are John of Gaunt, Chaucer's patron, "repre-
sented in full armour, to indicate that active measures now
devolve upon him", and the grey-bearded Edward III, seated
next to Edward the Black Prince who, "now in his fortieth
year, emaciated by sickness, leans on the lap of his wife
Joanna, surnamed the Fair Maid of Kent".[4]

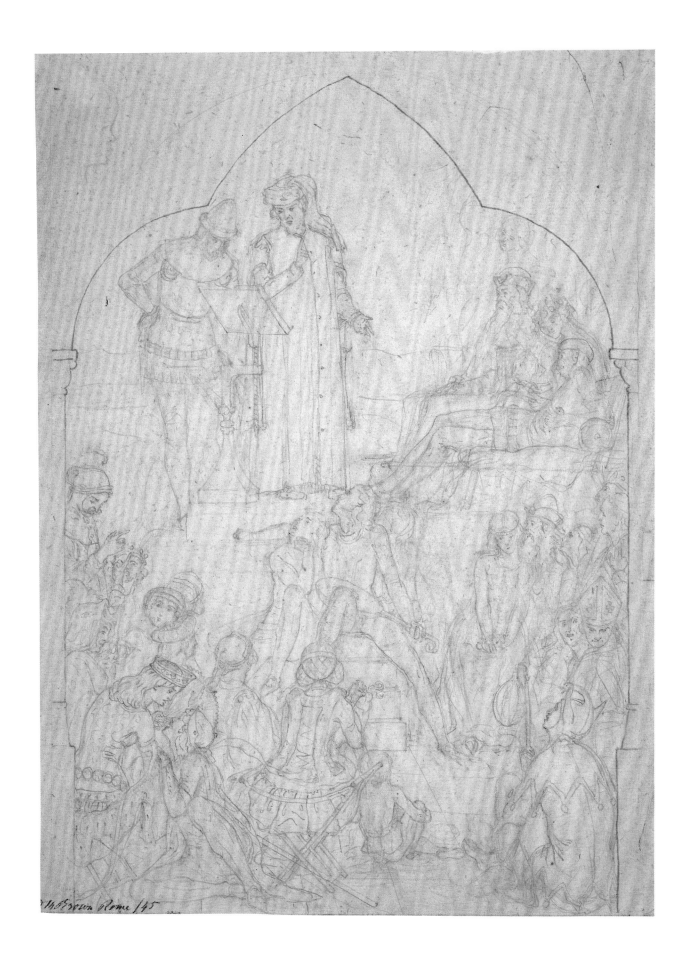

M.ᵉ Brown Rome /45

FORD MADOX BROWN

The First Translation of the Bible into English – Wycliffe reading his Translation of the New Testament: study of a Monk, representing Catholic Faith

1848
Black chalk, with pen and black ink
10 3/4 in.; 27.5 cm., diameter (trimmed to a circle)
Signed and dated in brown ink, bottom right: Ford M. Brown 1848 London
Presented by subscribers, 1906 (703'06)

PROVENANCE: Charles Fairfax Murray

REFERENCES: Birmingham, *Drawings*, 1939, p. 40; Liverpool, 1964 (59)

*D*uring work on the larger Chaucer oil (see cat. no. 7), Brown had another idea for a related composition. His diary entry for 29 November 1847 records how, on the way from Kent into London, he "thought of a subject as I went along. Wycliffe reading his translation of the bible to John of Gaunt, Chaucer & Gower Present – arranged it in my mind".[1] He set to work on the painting with unusual speed, his diary recording daily labour at the various details of figure, costume and furniture. A large oil (now at Bradford; fig. 21), it was completed in time to show at the Free Exhibition (a juryless alternative to the Royal Academy) in 1848.[2]

In the top corners of the picture, accommodated within an arched frame, Brown placed half-length figures symbolising Catholic and Protestant Faith. His diary entry for 28 February 1848 notes the completion of the latter (a girl holding a palm leaf and open book), then: "after dinner composed the other figure, of the Romish Faith; a figure holding a chained-up bible and a torch, with a hood (like the penitents at catholic funerals) showing only the eyes, with burning fagots [*sic*] & a wheel of fortune for accessories".[3] This study shows a slightly sober modification of that rather melodramatic image.

1. Surtees, 1981, p. 17.
2. London, Tate, 1984 (8, repr.).
3. Surtees, 1981, p. 32; a similar study for the girl (Protestant Faith) is also at Birmingham (704'06; Newman and Watkinson, 1991, pl. 39).

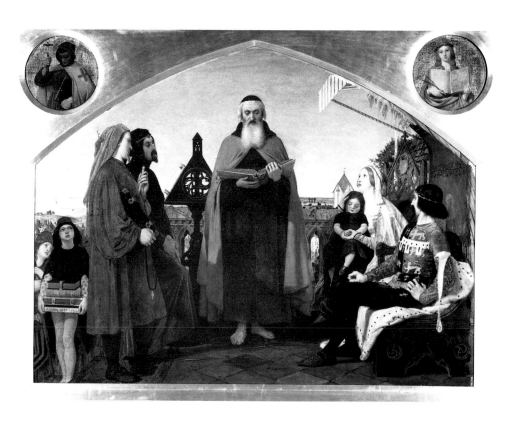

Fig. 21 FORD MADOX BROWN, *Wycliffe reading his Translation of the New Testament*, 1847–1848, 1859–1861; oil on canvas, 47 x 60 1/2 in. (119.5 x 153.5 cm.). Bradford Art Galleries and Museums.

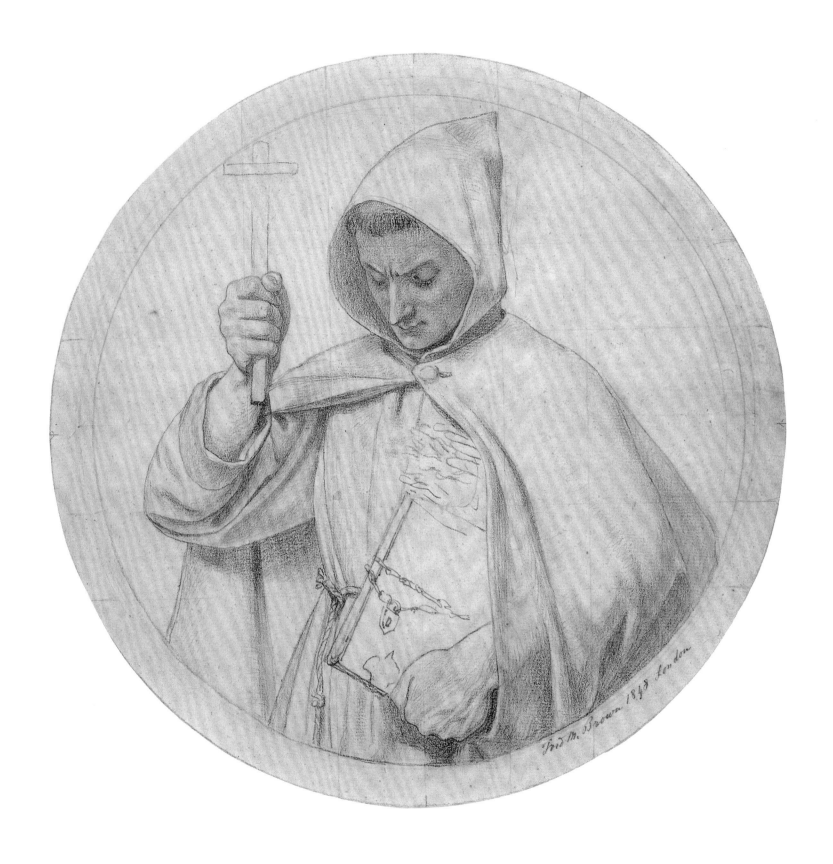

87

9

FORD MADOX BROWN

The Young Mother: sheet of studies

1848
Black and white chalk
9 7/8 x 6 7/8 in.; 25.1 x 17.5 cm.
Signed and dated in brown ink, bottom right: Ford M
Brown London / 48
Presented by subscribers, 1906 (679'06)

PROVENANCE: Charles Fairfax Murray

REFERENCES: Wallis, 1925, pl. X; Birmingham, *Drawings*,
1939, p. 45

A small, intimate oil painting of a mother and child,
accompanied by a dog, was variously called *The Infant's Repast*,
Mother and Child or, as exhibited at the British Institution in
1851, *The Young Mother*. This picture is now unlocated, but a
replica exists (fig. 22) at Wightwick Manor, Wolverhampton
(The National Trust).[1]

Two delightful drawings for the oil are in the
Birmingham collection: a quick but vivid full-length sketch
in black and white chalk (680'06),[2] and this more careful but
equally tender sheet of studies. These were presumably made
on 13 October 1848, when Brown recorded in his diary: "sent
for Mrs. Ashley and child, and began a sketch of them for a
little picture of a mother and child".[3]

1. Surtees, 1981, pl. 5.
2. Birmingham, *Drawings*, 1939, repr. p. 428; Liverpool, 1964 (60).
3. Surtees, 1981, p. 48.

Fig. 22 FORD MADOX BROWN, *The Young Mother*, circa 1848–1851; oil
on canvas, 8 x 5 7/8 in. (20.3 x 15.0 cm.). Wightwick Manor,
Wolverhampton (The National Trust).

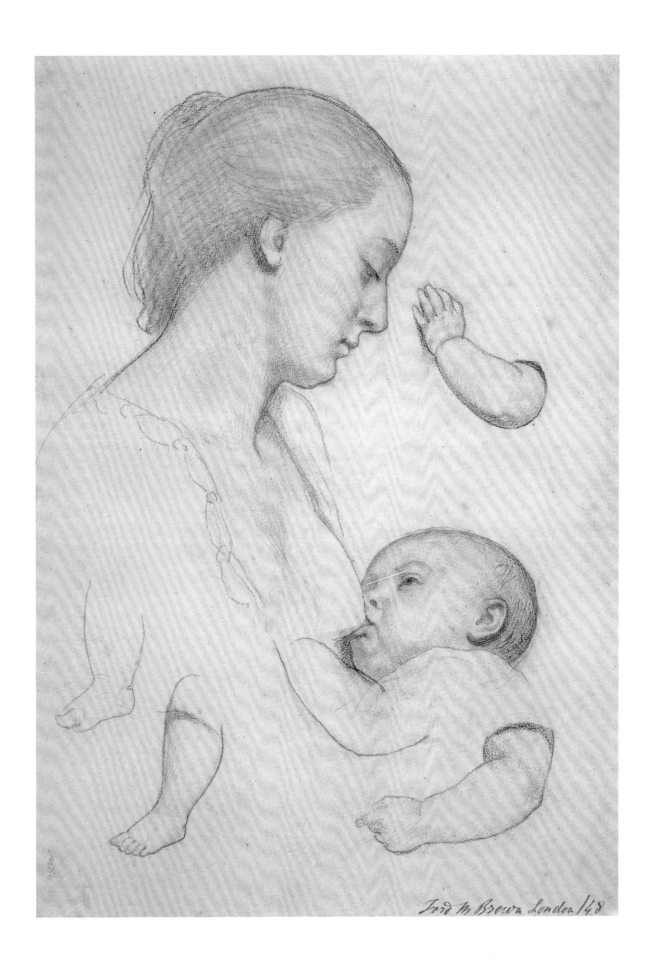

Ford M Brown London /48

10

DANTE GABRIEL ROSSETTI

Ulalume

Circa 1848
Pen and black and brown ink over pencil on green paper
8 1/8 x 7 3/4 in.; 20.6 x 19.7 cm.
Presented by subscribers, 1904 (269'04)

PROVENANCE: Lowes Cato Dickinson; sold at Foster's, London,
1888, under the title *Welcome;* Charles Fairfax Murray

REFERENCES: Birmingham, *Drawings,* 1939, p. 311; Surtees,
1971, no. 30, pl. 16; London and Birmingham, 1973 (29);
Grieve, 1973A, p. 15, pl. 15; Grieve, 1973B, p. 145, fig. 8;
London, Tate, 1984 (161, repr.); Grieve, 1984, pp. 39–40, pl. 12

*M*ost of Rossetti's earliest drawings take their subject
either from the works of Dante, which remained a lifelong
obsession, or from romantic literature, such as Goethe's *Faust,*
old English ballads and the poems of Sir Walter Scott. He
delighted in the poetry of Edgar Allan Poe (1809–1849), to
which he may have been introduced by an American student
named Charley Ware.[1] By 1846 Rossetti had drawn a scene
inspired by "The Raven", and a little later produced a whole
group of drawings based on Poe subjects, which may be dated
to 1847–1848: four further versions of "The Raven", plus "The
Sleeper" (British Museum, London) and "Ulalume".[2]

Along with Emerson and Longfellow, Poe was included
in the "List of Immortals" compiled by Hunt and Rossetti
shortly before the creation of the Pre-Raphaelite Brotherhood.[3]
For Rossetti, the recurrence in Poe's verses of images of super-
natural forces bridging the divide between life and death
struck an exact chord with his own visual and poetic imagi-
nation. In "Ulalume", the narrator encounters his own soul in
the form of a winged angel and is re-united with his dead
lover, walking together into a 'ghoul-haunted woodland' on
the anniversary of her death. Rossetti relished such poetic
moments of psychological tension (see also cat. nos. 13, 16,
33); he could also see their absurd side, however, and his
brother William Michael recorded in the *P.R.B. Journal* for 30
November 1850 that "Gabriel finished, all but the last verse,
his parody on 'Ulalume'."[4]

1. Alastair Grieve, in London, Tate, 1984, p. 243.
2. Surtees, 1971, nos. 19–19C, 29 and 30.
3. Fredeman, 1975, p. 107.
4. Fredeman, 1975, p. 83.

JOHN EVERETT MILLAIS

The Death of Romeo and Juliet

1848
Pen and black ink
8 1/2 x 14 1/2 in.; 21.4 x 36.1 cm.
Signed and dated in black ink, bottom left: JEM 1848
(initials in monogram)
Presented by subscribers, 1906 (646'06)

PROVENANCE: J.R. Clayton, by 1886; Charles Fairfax Murray

REFERENCES: London, Grosvenor, 1886 (136); Wallis, 1925, pl. XI; Birmingham, *Drawings*, 1939, p. 263; London and Liverpool, 1967 (228); Vaughan, 1979, p. 154, pl. 84; Treuherz, 1993, p. 19, fig. v

A comparison of this drawing with Millais's earlier study of *Elgiva* (cat. no. 3) demonstrates the emergence of a distinct Pre-Raphaelite drawing style during the year 1848. As Mary Bennett has pointed out, the composition clearly derives from a plate in *Romeo and Juliet* by Moritz Retzsch, published in 1836, one of the 'outline' drawing books which were such an important inspiration for the young group of artists.[1] The alterations to the composition are instructive: clearly, Hunt was not alone in finding Retzsch's illustrations 'artificial',[2] and Millais has made the scene at once both more medieval in atmosphere and yet more realistic in appearance.

The Death of Romeo and Juliet typifies the point of the term 'Pre-Raphaelite': by drawing on the style and spirit of pre-Renaissance art, a direct simplicity of action and emotion could be expressed, uncluttered by academic rules of draughtsmanship and design. Retzsch's composition, with figures dressed in vaguely sixteenth-century costume, is symmetrical and focuses on the balanced groups of Montagues and Capulets which are theatrically united over the almost forgotten bodies of Romeo and Juliet. Millais instead evokes the release of pathos and anguish at the very moment of discovering the lovers' deaths, with the untidy but telling groups of figures frozen into a tableau that more closely resembles an actual event than a stage performance.

A tiny but undeniable element of comic exaggeration appears here, as in most of Millais's early Pre-Raphaelite ink drawings. On the left, a soldier blows out his (albeit symbolic) candle, while opposite him an attendant solemnly holds up the phial of poison to the interest of a dandified youth standing on tiptoe at the door; the figures – and their costumes – are stiffened and elongated throughout. It should be remembered that Millais had long proved himself an accomplished academic draughtsman, and was at that time deliberately adopting a less sophisticated manner. As a man with a mischievous sense of humour, it would be surprising if he had not shown signs of taking the new Pre-Raphaelite style just a little less seriously than the others. Traces of this disconcerting self-parody may be found in the crisp outline studies for *Isabella* (1848; Fitzwilliam Museum, Cambridge), *Christ in the House of His Parents* (circa 1849; Tate Gallery, London) and *The Eve of the Deluge* (1850–1851; British Museum, London),[3] but reach their height in the extraordinary drawing of *The Disentombment of Queen Matilda of Flanders* (1849; Tate Gallery, London). William Michael Rossetti solemnly recorded of this last work in the *P.R.B. Journal* for 17 May 1849 that Millais "has put in some fat men, finding his general tendency towards thin ones".[4]

A much simplified oil sketch, smaller than the drawing and with fewer figures and far less detail, is now at Manchester City Art Gallery (fig. 23). Millais made sketches for a depiction of the balcony scene in *Romeo and Juliet,* but seems to have taken them no further.

1. Bennett, 1967, p. 51, fig. 28.
2. The comment appeared in one of the three surviving criticism sheets of the Cyclographic Society, dated 27 July 1848; Fredeman, 1975, p. 110.
3. All are reproduced in Grieve, 1984, pls. 5, 6 and 17.
4. Quoted by Malcolm Warner in London, Tate, 1984, p. 257.

Fig. 23 JOHN EVERETT MILLAIS, *The Death of Romeo and Juliet,* circa 1848; oil on millboard, 6 1/4 x 10 5/8 in. (16.1 x 26.9 cm.). Manchester City Art Gallery.

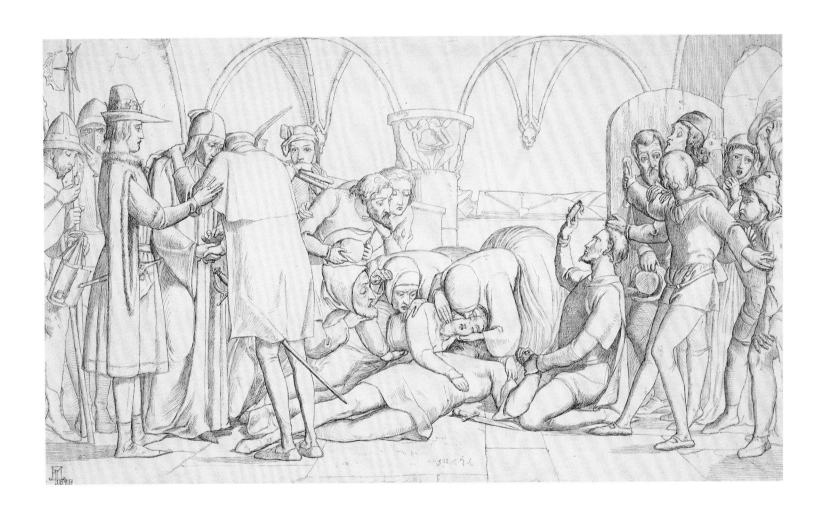

12

JOHN EVERETT MILLAIS

"My Beautiful Lady" (Lovers by a Rosebush)

1848
Pen and black ink, within ink border, over traces of pencil
10 x 6 1/2 in.; 25.4 x 16.5 cm.
Signed and dated in black ink, bottom right: J E Millais 1848
Inscribed in brown ink, bottom left: PRB (as monogram)
Inscribed in brown ink, below image, bottom right: John E Millais to his PRB (as monogram) / brother Dante Gabriel Rossetti
Purchased, 1920 (12'20)

PROVENANCE: Given by the artist to D. G. Rossetti; his sale, Christie's, 5–7 July 1882 (341R, wrongly described as for Keats's *Isabella*); anonymous sale, Christie's, 3 June 1898, lot 44 (bought Tregaskis)

REFERENCES: Birmingham, *Drawings*, 1939, pp. 265–266; London and Liverpool, 1967 (242); Smith, 1973, p. 33, repr.; Arts Council, 1979 (12, repr.); London, Tate, 1984 (158, repr.)

This precise but gentle drawing – Timothy Hilton aptly calls it "beautifully sweet and sharp" – offers further evidence of Millais's commitment to the Pre-Raphaelite Brotherhood. Its angularity and flattened perspective were not done for serio-comic purpose, but are nevertheless very effective in creating an atmosphere of medieval courtly romance. *Lovers by a Rosebush* is an adaptation of the figures in *Youth*, a design probably of 1847, and one of a set of six decorative lunettes commissioned by John Atkinson, a Leeds solicitor.[1] The image also invites inescapable comparison with a passage in Thomas Woolner's poem "My Beautiful Lady", which begins the first issue of *The Germ*, published in January 1850:

> We thread a copse where frequent bramble spray
> With loose obtrusion from the side roots stray,
> (Forcing sweet pauses on our walk):
> I'll lift one with my foot and talk
> About its leaves and stalk.
>
> Or may be that the prickles of some stem
> Will hold a prisoner her long garment's hem;
> To disentangle it I'll kneel,
> Oft wounding more than I can heal;
> It makes her laugh, my zeal.

As the drawing is dated 1848, and Woolner is known to have been still at work on his poem in May 1849, the drawing may have instead inspired the verse, as Malcolm Warner has suggested.[2] If this is the sheet included in the Grosvenor Gallery's *Millais* exhibition in 1886 (152, lent by Frances Austen but given the date 1849), it was then called *The Path of True Love*

Never Did Run Smooth, which could conceivably have been its original title. Previous identification of the drawing as an illustration to Keats's *Isabella* is misleading; it doubtless derives from the coincidental prominence of a greyhound in the foreground of Millais's oil painting *Isabella* (1848–1849; Walker Art Gallery, Liverpool).

It is not known exactly when Millais presented the drawing to Rossetti, but the gift probably preceded Rossetti's reciprocal gesture (see cat. no. 13): the very first entry in the *P.R.B. Journal* recounts a meeting on Tuesday, 15 May 1849: "At Millais's; Hunt, Stephens, Collinson, Gabriel [Dante Gabriel Rossetti] and myself [William Michael Rossetti]. Gabriel brought with him his design of *Dante Drawing the Figure of an Angel* on the first anniversary of Beatrice's death, which he completed in the course of the day and intends for Millais".[3] This is a rare and poignant benchmark of comradeship between two young artists of utterly different background and character, who were united for a moment in a common artistic cause. Much later Millais told his son (and biographer) that

> because in my early days I saw a good deal of Rossetti – the mysterious and un-English Rossetti – they [the art press] assume that my Pre-Raphaelite impulses in pursuit of light and truth were due to him. All nonsense! My pictures would have been exactly the same if I had never seen or heard of Rossetti. I liked him very much when we first met, believing him to be (as perhaps he was) sincere in his desire to further our aims – Hunt's and mine – but I always liked his brother William much better. D. G. Rossetti, you must understand, was a queer fellow, and impossible as a boon companion – so dogmatic and so irritable when opposed.[4]

1. Arts Council, 1979. pp. 20, 26.
2. Arts Council, 1979, p. 20.
3. Fredeman, 1975, p. 3.
4. Millais, 1899, vol. 1, p. 52.

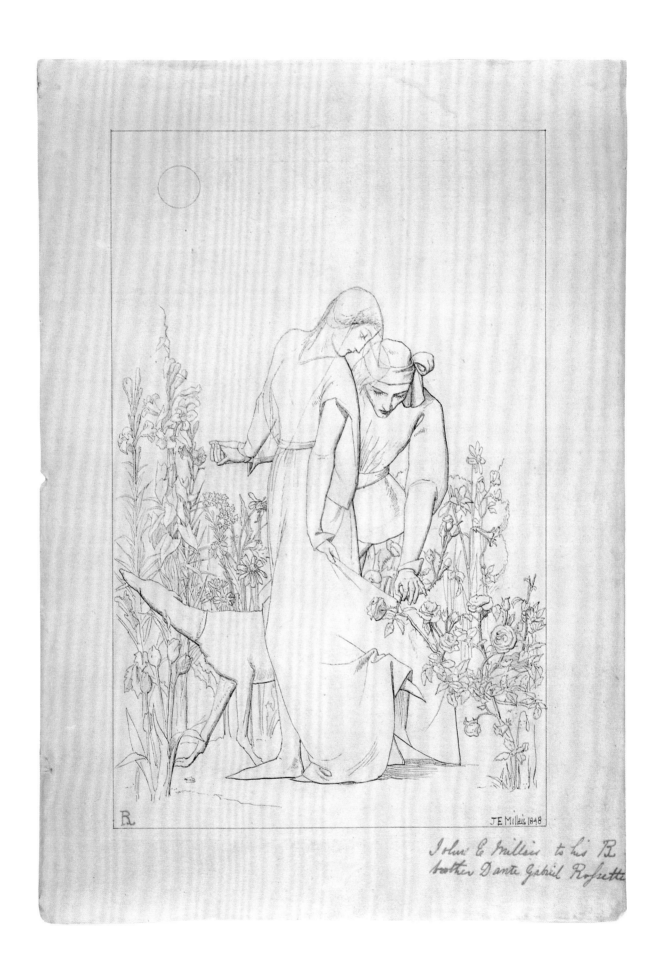

R.

J.E. Millais 1848

John E. Millais to his B... brother Dante Gabriel Rossetti

13

DANTE GABRIEL ROSSETTI

The First Anniversary of the Death of Beatrice

1849
Pen and black ink, within ink border (curved top)
15 3/4 x 12 7/8 in.; 39.8 x 32.0 cm.
Signed and dated in black ink, bottom left: Dante G.
Rossetti / P.R.B. 1849
Inscribed in brown ink, top right: Dante G. Rossetti / to his
P R Brother / John E. Millais
Above image, in brown ink: Florence, 9th June, 1291: The
first anniversary of the death of Beatrice
Below image, in brown ink: "On that day on which a whole
year was completed since my lady had been born into / the
life eternal, - remembering me of her as I sat alone, I betook
myself / to draw the resemblance of an Angel upon certain
tablets. And while I did / alas, chancing to turn my head, I
perceived that some were standing beside / me to whom I
should have given courteous welcome, and that they were /
observing what I did: also I learned afterwards that they had
been there / a while before I perceived them. Perceiving
whom, I arose for salvation, / and said: "Another was with
me." / see Dante's "Autobiography of his early life."
Presented by subscribers, 1904 (485'04)

PROVENANCE: Sir John Everett Millais; his sale, Christie's,
2 July 1898, lot 6; Charles Fairfax Murray

REFERENCES: Toynbee, 1912, pp. 137–138 (1); Birmingham,
Drawings, 1939, p. 340; Surtees, 1971, no. 42, pl. 27; London
and Birmingham, 1973 (85); Grieve, 1973A, pp. 15–16, fig.
16; Smith, 1973, pp. 31–32, repr.; London, Tate, 1984 (162,
repr.); Grieve, 1984, p. 39, pl. 11

conveying an image of medieval Florence. As Roger Smith has pointed out, the costume of Dante's visitor (presumably intended to represent his fellow poet Guido Cavalcanti) comes directly from a plate in Camille Bonnard's *Costume Historique* (Paris, 1829–1830), and Rossetti carefully chose costumes of the right date, culling them from a Florentine fresco.[4]

Probably under the influence of Millais, Rossetti injected just a little of the mannerism that gives early Pre-Raphaelite drawings their particular piquancy: an almost disembodied head peers from behind Dante himself, and the young page on the right scratches his leg in an awkward pose that bends the point of his absurdly elongated shoe. At the same time, some delightful details have been added to the furniture of the room, including a statuette of St Reparata, the patron saint of Florence, and a graffito on the window embrasure recording the date of Beatrice's death.

1. Surtees, 1971, no. 42B.
2. The translation appeared in Rossetti's first major published work, *The Early Italian Poets from Ciullo d'Alcamo to Dante Alighieri (1100–1200–1300) in the Original Metres, together with Dante's Vita Nuova*, London, 1861.
3. See Toynbee, 1912.
4. Smith, 1973, p. 32, who cites an undated letter from Rossetti to F.G. Stephens (Bodleian Library, Oxford), recording his purchase of a copy of Bonnard; since the earlier drawing does not show this Florentine costume, it may be assumed that Rossetti acquired the book between September 1848 and May 1849.

The drawing which Rossetti finished at the P.R.B. meeting of 15 May 1849 and gave to Millais in return for *Lovers by a Rosebush* (see cat. no. 12) is a much elaborated version of a design dated September 1848 (fig. 24).[1] It was at this time that Rossetti completed his translation of Dante's autobiographical prose poem *Vita Nuova*, and he may have intended this all-embracing image as an illustration that could be engraved, perhaps for a frontispiece.[2] Inheriting from his father, a literary scholar, a lifelong passion for the works of the medieval poet after whom he was named, Rossetti was to return to Dante more than twenty times for inspiration, but would rarely recapture the intensity of this first subject.[3]

His physical love for Beatrice unrequited, the poet is interrupted at the moment of spiritual consummation – exactly the kind of understated human drama that appealed to the young Pre-Raphaelites. With the historical setting being literally 'Pre-Raphaelite', the subject could hardly have been more suitable for an exercise in the group's chosen drawing style. While the 1848 design betrays much of the generally stiff and tentative nature of Rossetti's draughtsmanship, the flattened angularity of the finished drawing seems quite appropriate as a way of

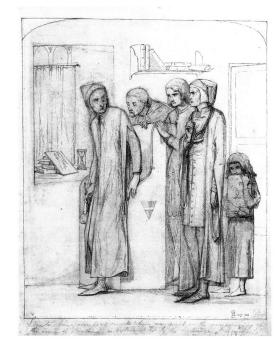

Fig. 24 DANTE GABRIEL ROSSETTI, *The First Anniversary of the Death of Beatrice*, 1848; pencil, pen and ink, 11 x 9 1/8 in. (28.0 x 23.0 cm.). Royal Institute of British Architects, London (on permanent loan from the Architectural Association).

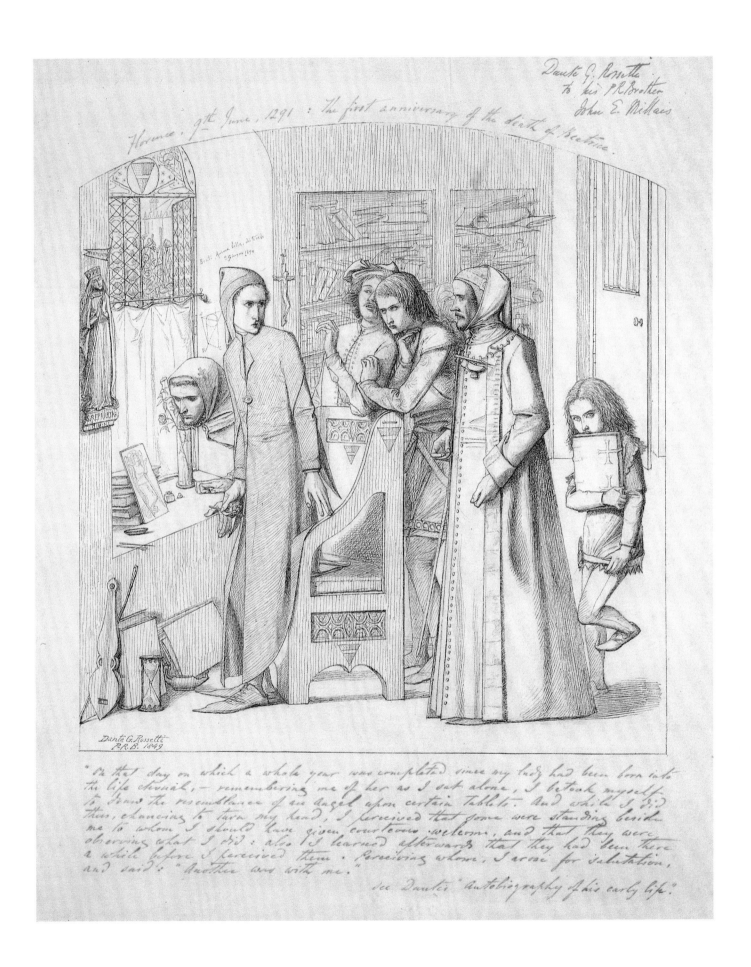

JAMES COLLINSON

An Incident in the Life of St Elizabeth of Hungary

1850
Pen and black and brown ink over traces of pencil, within brown ink border
15 3/4 x 21 1/2 in.; 40.0 x 54.6 cm.
Signed and dated in brown ink, bottom left: J C 1850 (monogram incorporates cross and anchor)
Purchased (Christina Feeney Bequest Fund), 1929 (38'29)

PROVENANCE: Randall Davies, from whom purchased

REFERENCES: Birmingham, *Drawings*, 1939, p. 154; Grieve, 1969, p. 293, fig. 37; Grieve, 1973A, pp. 26–27, fig. 27; Smith, 1973, pp. 36-37, repr.; London, Tate, 1984 (169, repr.); Grieve, 1984, p. 38, pl. 8; Parkinson, 1984, p. 72

*T*he most important surviving drawing by James Collinson, this sheet shares many of the characteristics of early Brotherhood draughtsmanship, and it was also used as a detailed study for an oil painting which was first exhibited in London at the Portland Gallery in 1851 as *An Incident in the Life of St Elizabeth of Hungary* (now in Johannesburg Art Gallery, South Africa; fig. 25).[1] The *P.R.B. Journal* refers twice to Collinson's idea for the picture: first, on 10 December 1849, "After he shall have finished his paintings for this year, he means to set to work on the subject of St Elizabeth of Hungary taking off her crown before the crucifix"; and then, on 7 April 1850, "The idea of painting for next year the subject of Saint Elizabeth before the Altar is again strong upon him".[2]

The subject has two sources: Collinson provided the painting with an explanatory extract from the Count de Montalembert's *Chronicle of the Life of St Elizabeth of Hungary*,

translated into English in 1839, but he must also have been familiar with Charles Kingsley's more popular book *The Saint's Tragedy*, published in 1848.[3] The latter has an anti-Catholic slant, however, and it may be that Collinson, who converted to Catholicism for the second time in 1850, wished to make a more emphatic statement of faith. The painting shows Elizabeth, the devout daughter of the Landgrave of Thuringia and future Queen of Hungary in the thirteenth century, who has been taken by her mother to Mass, where she humbles herself before the crucifix to the consternation of her sister Agnes.

This act of humility, which preceded the saint's later renunciation of worldly goods, has led to a confusion of title for Collinson's subject. Shown subsequently at the Liverpool Academy in 1854 as *The Humility of St Elizabeth*, the painting appeared in the 1891 Pre-Raphaelite exhibition at Birmingham as *The Renunciation of St Elizabeth of Hungary*, a misunderstanding of the scene which has remained current.

As with the ink drawings that Millais converted into large paintings, the extreme severity of Collinson's penmanship is softened in the final oil painting, although the placement of the figures is slightly altered. Certain amendments, however, are instructive: the impossibly stiff armour and pointed shoes of the courtier on the right (copied from a plate in Bonnard's *Costume Historique*) are made plausible, and the discarded coronet is given less prominence, perhaps to avoid a confusion of identity with the prostrate worshipper on the left. It has been noted that while he retained the layout of the architectural background, Collinson converted its details into those of the interior of St Barnabas, Pimlico, an important Gothic Revival church by the architect Thomas Cundy.[4] Consecrated on 11 June 1850, it became a centre of controversy over Anglo-Catholic ritual under the ministry of W.J.E. Bennett: Collinson could hardly have been unaware that this association would inevitably encourage those critics who discerned 'Popish' tendencies in such Pre-Raphaelite paintings as Millais's *Christ in the House of His Parents*, shown at the Royal Academy in 1850.[5]

1. Reproduced in Wood, 1981, p. 20.
2. Fredeman, 1975, pp. 30, 69.
3. See Grieve, 1969, p. 293.
4. Grieve, 1973A, p. 27.
5. In 1850 the Papal Bull was issued establishing the Roman Catholic hierarchy in England, and was met by much public hostility. "There were riots at St Barnabas, and Lord Shaftesbury did not help matters by proclaiming that he 'would rather worship with Lydia on the banks of the river than with a hundred surpliced priests in the gorgeous temple of St Barnabas'" (Basil Clarke, *Parish Churches of London*, London, 1966, p. 186).

Fig. 25 JAMES COLLINSON, *An Incident in the Life of St Elizabeth of Hungary*, 1850; oil on canvas, 48 x 72 3/8 in. (122.0 x 184.0 cm.). Johannesburg Art Gallery, South Africa.

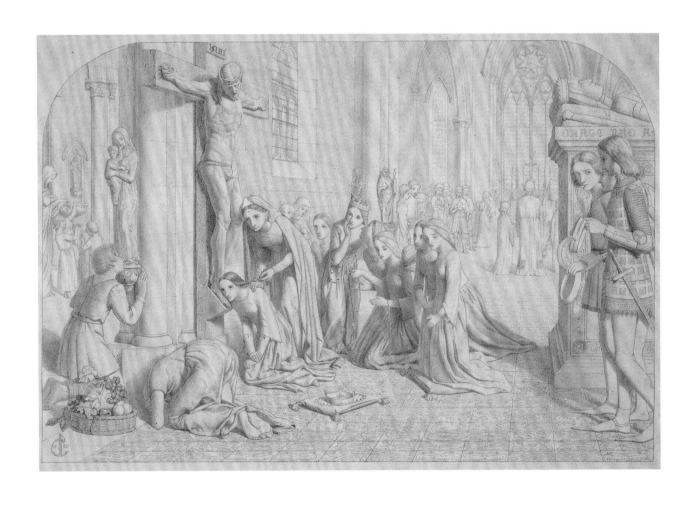

15

WALTER HOWELL DEVERELL

James II robbed by Fishermen while escaping from England

1850
Pen and black ink, with ink wash, over traces of pencil
11 1/4 x 15 3/8 in.; 28.5 x 39.0 cm.
Inscribed in pencil, bottom left: [W.H. De] verell to / [his
P.R. Bro] ther Dante Rossetti [corner of sheet is missing]
Presented by subscribers, 1906 (794'06)

PROVENANCE: Dante Gabriel Rossetti; his sale, Christie's,
12 May 1883; Charles Fairfax Murray

REFERENCES: Wallis, 1925, pl. XII; Birmingham, *Drawings*,
1939, pp. 172–173; Lutyens, 1984, pp. 82, 245, pl. 36

*W*alter Howell Deverell effectively became a member of the Pre-Raphaelite Brotherhood in the summer of 1850, as William Michael Rossetti noted: "Deverell has worthily filled up the place left vacant by Collinson",[1] who had resigned in May on a point of religious principle.[2] The same *P.R.B. Journal* entry describes a number of works which Deverell had in hand:

> He hopes to exhibit two pictures next year: Rosalind witnessing the encounter of Jaques and Orlando in the forest, – which is pretty nearly finished; and the ordering of Hamlet's departure for England, of which Gabriel [Dante Gabriel Rossetti] has seen an uncompleted design. Other recent designs of his are the converse of Laertes and Ophelia, Claude du Val dancing with a lady of quality after attacking her carriage (in the possession of Stephens), James 2 in his flight overhauled, and his person rifled by Fishermen (given to Gabriel), and the flight of an Egyptian ibis.

Nearly all of this motley assortment of subjects can be identified, with two of the 'designs' (i.e., drawings) having come into the Birmingham collection.[3] Both are peculiar scenes from modern rather than medieval history. *Claude Duval and the Lady* (fig. 26) depicts the eighteenth-century highwayman gallantly levying a dance from one of his victims, Lady Aurora Sydney.[4] Also used by W.P. Frith for an oil painting of 1860 (Manchester City Art Gallery), this anecdote appears in Thomas Macaulay's *History of England*, which is presumably also the source for the present drawing.[5]

With his supporters defecting to William of Orange, who landed in Devon on 5 November 1688, James II made secret arrangements to flee the country, and on 11 December travelled to the coast at Sheerness, in Kent. Delayed by bad weather, his boat was boarded by fishermen; having been "roughly handled", the King was escorted by "seamen and

rabble" to Faversham, then back to London. He was allowed to sail into permanent exile in France on Christmas Day 1688. Roy Strong has observed how, in Victorian history painting,

> imprisonments, executions, the sad fate of exile and defeat in battle are recounted again and again in the persons of Mary Queen of Scots, Lady Jane Grey, Henrietta Maria, Charles I, Charles II, James II and Bonnie Prince Charlie. Perhaps through these figures, comfortably far distant in time, it was possible to meditate on the kind of disaster which was still happening on the mainland of Europe.[6]

The year 1848, which saw the foundation of the Pre-Raphaelite Brotherhood, was of course also a year of revolution and political turmoil throughout Europe.

The Brotherhood's quirky sense of humour comes out strongly both in this and in the drawing of Claude Duval (which was also a gift from the artist to F.G. Stephens). Deverell has used a fine brush to complement the austere line of the pen nib, throwing the central figures into strangely surreal relief, and highlighting bizarre details such as the King's bent sword scabbard and the puzzled delight expressed by those who study his watch chain.

1. Fredeman, 1975, p. 72.
2. See Parkinson, 1984, p. 71.
3. See Lutyens, 1984, p. 245.
4. Birmingham, *Drawings*, 1939, p. 173 (40'29; from the collection of Randall Davies, as is the Collinson drawing, cat. no. 14).
5. The first two volumes of Macaulay's *History of England, from the Accession of James II* had just been published in 1849. Deverell might well have seen, at the 1850 Royal Academy exhibition, E.M. Ward's painting *James II in his Palace of Whitehall, receiving the news of the landing of the Prince of Orange in 1688*; this was accompanied in the catalogue by an extract from Sir John Dalrymple's *Memoirs of Great Britain and Ireland* (1771–1788).
6. Roy Strong, *And when did you last see your father?: The Victorian Painter and British History*, London, 1978, p. 44.

Fig. 26 WALTER HOWELL DEVERELL, *Claude Duval and the Lady*, 1850; pencil, pen and ink, 14 x 18 1/2 in. (35.5 x 47.0 cm.). Birmingham Museums and Art Gallery (40'29).

16

DANTE GABRIEL ROSSETTI

A Parable of Love (Love's Mirror)

1849–1850
Pen and black ink with ink wash
7 5/8 x 6 7/8 in.; 19.3 x 17.5 cm.
Presented by subscribers, 1904 (491'04)

PROVENANCE: Coventry Patmore; his sale, Christie's, 6 April 1898, lot 10 (as *Love's Mirror*); Charles Fairfax Murray

REFERENCES: London, Royal Academy, 1883 (330, as *Love's Mirror*, lent by Coventry Patmore); Birmingham, *Drawings*, 1939, p. 366 (as *Love's Mirror*); Surtees, 1971, no. 668 (as *A Parable of Love*); Grieve, 1978, p. 60, fig. 57; Marsh, 1985, p. 44; Marsh, 1989, repr. following p. 84

The simple message of the 'parable' is that while the young man assists his beloved with her self-portrait, the mirror ('love's mirror') improves on art by reflecting an image of the two lovers together. Little attention has been paid to this charming drawing, except as a romanticised image of Elizabeth Siddal in the dual role of Rossetti's model and pupil. However, if the features of the young woman are indeed to be accepted as hers, this is arguably Rossetti's first drawing of his future wife – and certainly his first use of her as a model in a finished design.[1]

There seems to be no contemporary reference to this drawing whatsoever. A conjectural date of circa 1850 has never been doubted, and the heavily shaded pen and brush work is entirely consistent with the drawing *"To caper nimbly in a lady's chamber"*, which is of almost exactly the same size and is signed and dated 1850 (also in the Birmingham collection).[2] It is possible that Rossetti may have given it to Coventry Patmore (1823–1896), the young poet who was an intimate associate of the Pre-Raphaelites from the first; the two were introduced on 7 November 1849 at Thomas Woolner's studio, when Patmore praised Woolner's poetry.[3] According to Marillier, the head of the young man is a portrait of Woolner, which invites the possibility that the whole image might refer to an idea or poem of his, akin to "My Beautiful Lady" (see cat. no. 12) but with a more overtly medieval setting.

A further clue to its date is offered in an amusing sketch by Millais (fig. 27), which appears to caricature the central part of Rossetti's design. This is clearly an addition, quickly drawn in pencil, to one of the five sheets of head studies for his oil painting *Isabella* (Walker Art Gallery, Liverpool).[4] These must have been drawn in early 1849 (one is dated) before the painting's completion in time for that year's Royal Academy exhibition. It is quite plausible that Millais could have found in his studio just such a recently used sheet of

paper on which to dash off a comic sketch, but this is unlikely to have happened much later than the winter of 1849–1850.

1. Although it is clear that Deverell introduced Elizabeth Siddal to the Pre-Raphaelite circle towards the end of 1849, it is not certain when she and Rossetti first met. A pencil study of her head has been tentatively dated only to circa 1850 (Surtees, 1971, no. 457, pl. 421), while the watercolour *Rossovestita*, signed and dated 1850 (Surtees, 1971, no. 45, pl. 43), probably does not represent her but another red-haired model named Miss Mead (see Marsh, 1985, p. 162).
2. Surtees, 1971, no. 47, pl. 36 (478'04).
3. Fredeman, 1975, p. 23; a contributor to *The Germ*, Patmore is mentioned often in the *P.R.B. Journal*, and was acting as host for meetings early in 1851. It was he who persuaded John Ruskin to write to the *Times* on 13 May 1851 in defence of the Pre-Raphaelites (Fredeman, 1975, pp. 92–93).
4. Birmingham, *Drawings*, 1939, p. 264 (651'06).

Fig. 27 JOHN EVERETT MILLAIS, *Study for "Isabella"*, 1849; pencil, 9 3/4 x 13 5/8 in (24.8 x 35.4 cm.). Birmingham Museums and Art Gallery (651'06).

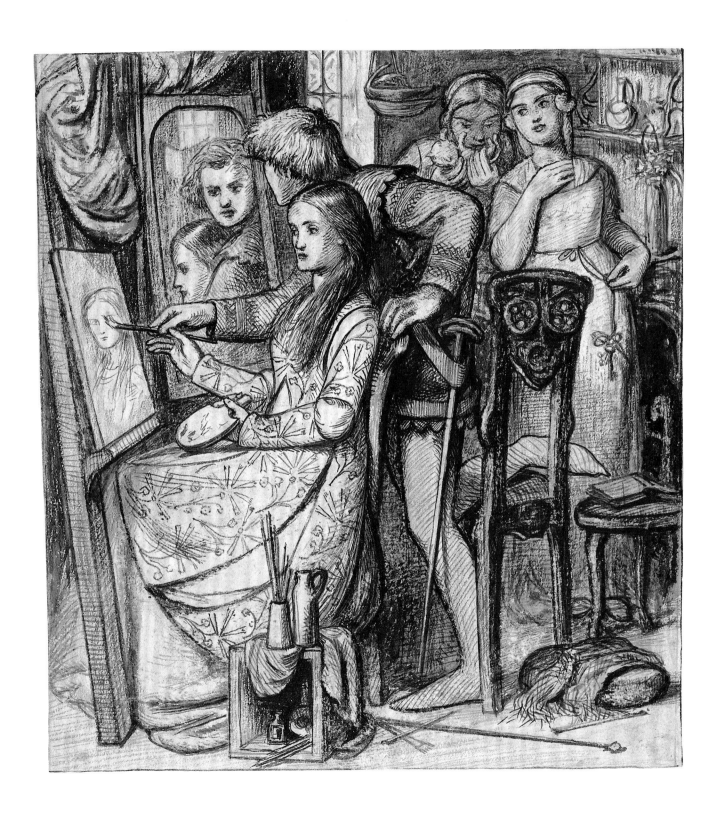

17

WILLIAM HOLMAN HUNT

Valentine rescuing Sylvia from Proteus

1850–1851
Oil on canvas, arched top
38 3/4 x 52 1/2 in.; 98.5 x 133.3 cm.
Signed and dated, bottom left: W. HOLMAN HUNT 1851. Kent
In original frame
Purchased, 1887 (953'87)

PROVENANCE: Bought by Francis MacCracken, 1851; his sale, Christie's, 17 June 1854, lot 97; Thomas Fairbairn, by 1855; his sale, Christie's, 7 May 1887, lot 142, bought by Birmingham Corporation

REFERENCES: London, Royal Academy, 1851 (594); Liverpool Academy, 1851 (32); Manchester, Art Treasures Exhibition, 1857 (115); London, Hogarth Club, 1859; London, International Exhibition, 1862 (728); Hunt, 1886, pp. 487–488, 747–749; "Holman Hunt's 'Two Gentlemen of Verona'," *Birmingham Daily Post*, 23 May 1887; Birmingham, 1891 (170, repr.); Birmingham, *Paintings*, 1960, p. 78; Liverpool and London, 1969 (19, repr.); Staley, 1973, pp. 11–13, pl. 1b; London, Tate, 1984 (36)

The subject is taken from act V, scene iv, of Shakespeare's *Two Gentlemen of Verona*. As so often occurred in the Pre-Raphaelites' choice of theme, the moment is one of dramatic tension engendered by romantic passion. Valentine, a banished suitor, intervenes just in time to prevent Sylvia, with whom he is in love, being ravished by Proteus, his best friend. It is a double betrayal of trust in that the scene is witnessed by Julia, disguised as a page, who has previously been the subject of Proteus's attentions (she looks on, apprehensively fingering her faithless lover's ring behind her back). Sylvia's father, the Duke of Milan, is among the group of figures in the background, whose arrival presages reconciliation and a happy ending to the play.

The Corporation of Birmingham paid 1,000 guineas for this picture in 1887.[1] Following *The Boat of Love* by Rossetti, which was bought at the artist's studio sale in 1883, it was the next Pre-Raphaelite work to enter the Birmingham collection, and it has remained its most important painting from the years of the Brotherhood. Hunt's fourth successive annual submission of a major painting to the Royal Academy – after *The Eve of St Agnes* in 1848, *Rienzi* in 1849 and *Druids* in 1850 – it was poorly hung, yet it was still targeted for hostile criticism. Along with Brown's *Chaucer* (see no. cat. 7), Charles Collins's *Convent Thoughts* and three paintings by Millais – *Mariana, The Woodman's Daughter* and *The Return of the Dove to the Ark* – it was the subject of such abuse in the *Times* that Ruskin was moved to write two letters to the newspaper, published on 13 and 30 May 1851, in support of the artists and their work.

The *Times's* critic condemned the Pre-Raphaelites'

"cramped style, false perspective and crude colour".[2] *Valentine and Sylvia* is instructive in demonstrating exactly why the Brotherhood's new ideas about composition and technique elicited this kind of response. Hunt has allowed the figures to fill the canvas space (even eliminating the top corners of the composition, which provided additional room on the frame for the accompanying text), and thus brought the viewer into direct involvement with the action. This well-established Pre-Raphaelite device permitted the more realistic interpretation of a literary or historical subject – in Ruskin's helpful words, giving "what they [the Pre-Raphaelites] suppose might have been the actual facts of the scene they desire to represent".[3] With a slightly heightened viewpoint, the distant background is deliberately curtailed, allowing greater concentration on the dappled sunlight, and on the details of leaves and grass as well as of figure and costume. Hunt's use of colour was indeed extraordinary, and of all the Pre-Raphaelites he revelled most in the brilliant modern pigments (notably, as here, pinks and mauves) which were newly available in the 1840s.[4] This striking new palette at once paid homage to the primary dazzle of the medieval world, and also served to distinguish the work of the Brotherhood from the generally more drab, conventional tonal range of contemporary painting.

A smaller two-figure subject from *Measure for Measure (Claudio and Isabella)* (Tate Gallery, London) was Hunt's first painting on a Shakespearean theme: this was begun in 1850, but set aside in favour of a larger work. A thumbnail pencil sketch (Private Collection) together with a detailed but rather stiff pen drawing (British Museum, London)[5] show that Hunt had worked out the composition of *Valentine rescuing Sylvia from Proteus* before travelling to Knole Park, near Sevenoaks in Kent, in October 1850. In the rather unlikely company of Rossetti (making a noble but unsuccessful attempt at outdoor painting), Hunt worked diligently at landscape details throughout November, in spite of bad weather. Woolner paid a visit, and reported him "progressing well, painting the ground all covered with the red Autumn-leaves".[6]

The figures would have been added in the studio over the winter, and in the details of faces and costume Hunt employed considerable technical innovation. He and Millais had previously experimented with a 'wet white' ground, painting on top of an area still wet to give added translucence to the upper layer of colour. Hunt later recalled that "the heads of Valentine and of Proteus, the hands of these figures, and the brighter costumes in the same painting had been executed in this way".[7] He also devised a method of re-creating the effect of localised shadow on brightly coloured drapery by using semi-transparent colours within a double layer of varnish: this he called "locking up" fugitive pigments.[8] Ruskin was sufficiently impressed with the finished results to assert that "as

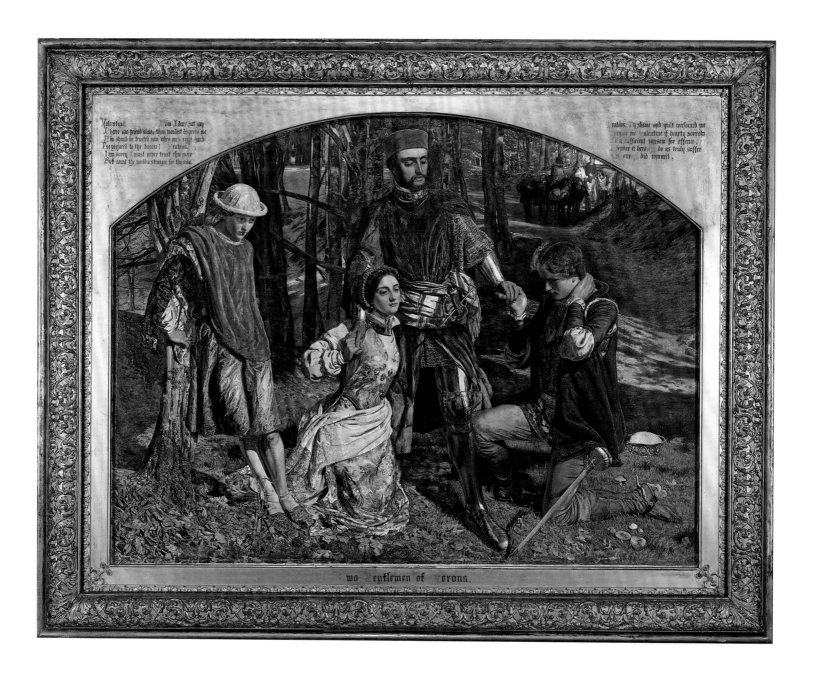

studies both of drapery and of every minor detail, there has been nothing in art so earnest or so complete as these pictures [Hunt's and Millais's] since the days of Albert Dürer".[9] Quite surprisingly, the handling of detail, in the leaves for instance, is bold and vigorous, and Hunt clearly concentrated on luminosity rather than scientific accuracy. The background is quite freely painted, creating the simple illusion of space: Woolner thought Hunt had "given the effect of a large forest in a small space better than I ever remember to have seen it done before".[10]

In March 1851, Hunt found a sitter for the head of Valentine in James Lennox Hannay, a young barrister; a fellow lawyer, James Aspinal, initially sat for Proteus. "For Julia", Hunt recalled, "I had the services of a very excellent young lassie. I was at no loss for Sylvia; the beauty and grace of Miss Siddal would make her of perfect type for the duke's daughter, but I had not seen her for several months. I wrote doubtingly as to her ability to come, but one morning in the spring the young lady appeared".[11] The head study proved unsatisfactory, however (Ruskin found it the one jarring note in the picture), and Hunt was obliged to repaint it, although retaining Lizzie's features, in August 1851. Immediately thereafter the painting was sent to the Liverpool Academy exhibition where, after some lobbying, it was awarded the £50 prize – the first significant public approbation of Pre-Raphaelitism. This success also produced a buyer for the picture, a Belfast shipping agent named Francis MacCracken, "who had never seen the work, but who was interested from what he had read of it".[12] MacCracken went on to purchase Rossetti's *Ecce Ancilla Domini!* (Tate Gallery, London; fig. 3) in 1853.

1. Thomas Fairbairn, who was forced to sell part of his collection in 1887 to raise capital, wanted £1200, "but on learning that the bid of £1000 was from the Birmingham Art Gallery he at once reduced the price, which otherwise he would not have done" (letter from Hunt, 1 June 1887, quoted in Bronkhurst, 1983, p. 595).
2. *The Times*, 7 May 1851, quoted in Ruskin, *Works*, 1904, vol. 12, p. 319.
3. Ruskin, *Works*, 1904, vol. 12, p. 322.
4. Hunt's devotion to a bright palette is evident also in his watercolours (see cat. no. 30), and lasted well beyond the years of the Brotherhood. Reviewing *The Apple Harvest – Valley of the Rhine, Ragaz* (Birmingham collection, 145'35) at the Old Water Colour Society exhibition of 1885, one critic drew attention to "that high pitch of colour which is peculiar to Mr Hunt", and noted that "time has not diminished Mr Hunt's passion for strong colours" (*The Athenaeum*, 2 May 1885, p. 574).
5. Liverpool and London, 1969, (115, 116; pls.27, 28).
6. Fredeman, 1975, p. 78.
7. Hunt, 1905, vol. 1, p. 276.
8. Liverpool and London, 1969, no. 19, p. 27.
9. Ruskin, *Works*, 1904, vol. 12, p. 323.
10. Liverpool and London, 1969, no. 19, p. 27.
11. Hunt, 1905, vol. 1, pp. 237–238. He also recalled that "Mr W.P. Frith kindly lent me some armour, which the 'slavey' in my lodging announced as a 'tin waistcoat and trousers'." Roger Smith, however, has pointed out a strong similarity between Valentine's hat and leg armour and a plate from Bonnard's *Costume Historique* (Smith, 1973, p. 35). Hunt claimed to have made most of the costume himself: "The dress

of Julia, to wit, I made out of materials bought at a modern mercer's, and I embroidered the sleeve in gold thread with my own hand. The hat I also made myself, and the dress of Proteus was painted from my own tailoring" (Hunt, 1905, vol. 2, p. 349).
12. Hunt, 1886, p. 749.

18

FORD MADOX BROWN

The Pretty Baa-Lambs

1851, 1852–1853, 1859
Oil on wood panel
24 x 30 in.; 61.0 x 76.2 cm.
Inscribed, bottom right: F. MADOX BROWN 1851–59
Purchased, 1956 (P9'56)

PROVENANCE: Bought by James Leathart in 1859, and still his in 1896; H. Yates Thompson; Mrs E. M. Thompson, sold Sotheby's, 27 June 1956, lot 81; purchased from Messrs. Colnaghi, London

REFERENCES: London, Royal Academy, 1852 (1291); Newcastle upon Tyne, Academy of Arts, *Works by Living Artists*, 1852; Glasgow, St Enoch's Hall, *Works of Modern Artists*, 1854–1855 (241); Liverpool Academy, 1859 (39); London, Piccadilly, 1865 (11); Hueffer, 1896, pp. 84–85, 162–163, 436 (list); Birmingham, *Paintings*, 1960, p. 16; Liverpool, 1964 (21, pl. 5); Staley, 1973, pp. 26–30, pl. 8; London, Tate, 1984 (38, repr.); Newcastle upon Tyne, 1989–1990 (10, repr.); Newman and Watkinson, 1991, pp. 59–61, pl. 108

The Pretty Baa-Lambs is one of three major Pre-Raphaelite paintings begun in the summer of 1851 and exhibited at the Royal Academy in 1852. Hunt and Millais worked together at Ewell in Surrey on the landscape backgrounds of, respectively, *The Hireling Shepherd* (Manchester City Art Gallery) and *Ophelia* (Tate Gallery, London), while Brown was happy with Clapham Common, near his home in Stockwell, South London. A passage in his diary, retrospectively covering 1851, succinctly sums up "five months of Hard Labour":

> The baa lamb picture was painted almost entirely in sunlight which twice gave me a fever while painting. I used to take the lay figure out every morning & bring it in at night or if it rained. My painting room being on a level with the garden, Emma [Brown's future wife] sat for the lady & Kate [his daughter] for the child. The lambs & sheep used to be brought every morning from Clappam [*sic*] common in a truck. One of them eat [*sic*] up all the flowers one morning in the garden where they used to behave very ill. The back ground was painted on the common.[1]

Unlike Hunt and Millais, therefore, who worked on their figures exclusively indoors (see cat. no. 22), Brown was attempting a unified treatment of the whole scene. Not content with only a realistic background painted from nature, he wanted to convey the effects of sunshine and shadow on the figure group as well. "This picture", he wrote in the catalogue to his 1865 one-man exhibition, "was painted out in the sunlight; the only intention being to render that effect as well as my

powers in a first attempt of this kind would allow".[2]

This was indeed a revolutionary idea. While other artists, including John Constable and David Cox, had sketched in oils out of doors, none had tried to produce a finished picture that captured the true appearance of a subject set in bright daylight. Brown's infinite patience and perseverance were rewarded with entirely new observations as to the effects of light and shade on local colour: that sunlight, for instance, bleaches skin tone to a high, flat contrast, or that deep shadow gives a blueish cast to white material, while green grass takes on a darker shade of its own hue rather than blue or black.[3] Such realisations would become commonplace for the succeeding generation of *plein-air* painters, including the Impressionists, but were quite novel in 1851. It was for this reason that R.A.M. Stevenson, the Francophile critic who 're-discovered' Velazquez, was moved to offer Brown's grandson the famous statement: "By God! the whole history of modern art begins with that picture. Corot, Manet, the Marises, all the Fontainebleau School, all the Impressionists, never did anything but imitate that picture".[4]

Despite the painting's childlike title, and its poor placement in the Royal Academy's undesirable Octagon Room, it was impossible for spectators not to read some narrative or hidden meaning in the subject. "Few people I trust", Brown was later to disclaim, "will seek any meaning beyond the obvious one, that is – a lady, a baby, two lambs, a servant maid, and some grass",[5] but this disingenuousness could not hope to supplant an obvious religious interpretation, as a Madonna and Child, with the sheep as a symbolic flock. Hunt's *Hireling Shepherd*, although exhibited with a bucolic quotation from *King Lear*, was also seen from the first to have a "doctrinal import",[6] and Brown's other work in the 1852 exhibition was *Jesus washing Peter's Feet* (Tate Gallery, London). Brown urged, however, that

> in all cases pictures must be judged first as pictures – a deep philosophical intention will not make a fine picture, such being rather given in excess of the bargain; and although all epic works of art have this excess, yet I should be much inclined to doubt the genuineness of that artist's ideas, who never painted from love of the mere look of things, whose mind was always on the stretch for a moral.[7]

Dissatisfied with the picture's compositional balance, Brown made alterations in 1852 and more substantially in 1853, adding the distant view of an estuary which has been plausibly identified as Canvey Bay in Essex, and was probably copied from a small landscape (now lost) begun during a stay in Southend in 1846.[8] Under the less awkward title of *Summer Heat*, it was then offered to the Pre-Raphaelites' new

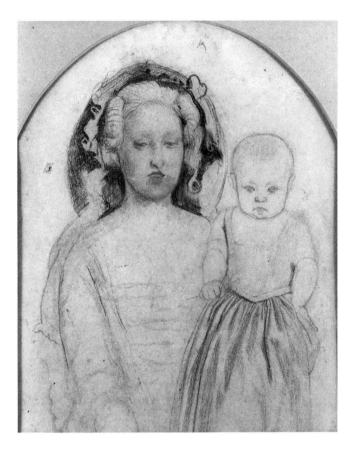

Fig. 28 FORD MADOX BROWN, *The Pretty Baa-Lambs: study for Mother and Child*, 1851; black and sepia chalk, 8 1/2 x 6 3/4 in. (21.3 x 17.2 cm.). Walker Art Gallery, Liverpool (National Museums and Galleries on Merseyside).

1. Surtees, 1981, pp. 74, 76.
2. London, Piccadilly, 1865, p. 7.
3. This is discussed in greater detail in Staley, 1973, pp. 28–29.
4. Ford Madox Hueffer, *Ancient Lights and Certain New Reflections*, 1911, p. 207.
5. London, Piccadilly, 1865, p. 7.
6. *British Quarterly Review*, August 1852, quoted by Judith Bronkhurst in London, Tate, 1984, p. 95.
7. London, Piccadilly, 1865, p. 7.
8. Suggestion made in Staley, 1973, p. 27 and expanded in Bennett, 1973, p. 78.
9. Brown family papers, quoted by Mary Bennett in London, Tate, 1984, p. 94.
10. Bennett, 1988, p. 28, repr.
11. Dated 1852, this is also on panel (7 3/4 x 10 in.; 19.7 x 25.4 cm.); reproduced in Newman and Watkinson, 1991, pl. 109.

patron Francis MacCracken, who thought it "beautiful", despite querying the over-animated sheep ("never did lambs in this country make such a bound"),[9] but did not buy it. A purchaser was finally found in James Leathart, a Newcastle industrialist whose taste as a collector was expanding in the late 1850s to include Pre-Raphaelitism. In 1859 he bought Rossetti's watercolour *Sir Galahad at the Ruined Chapel* (cat. no. 50) as well as *The Pretty Baa-Lambs*, and commissioned from Brown the replica of *Work* (cat. no. 74); in 1864 he was also to buy Burne-Jones's *The Merciful Knight* (cat. no. 73).

A chalk study of Emma and baby Catherine (born in November 1850) is now in the Walker Art Gallery, Liverpool (fig. 28),[10] and a small replica in oil that shows the original composition with a lower horizon is in the Ashmolean Museum, Oxford.[11]

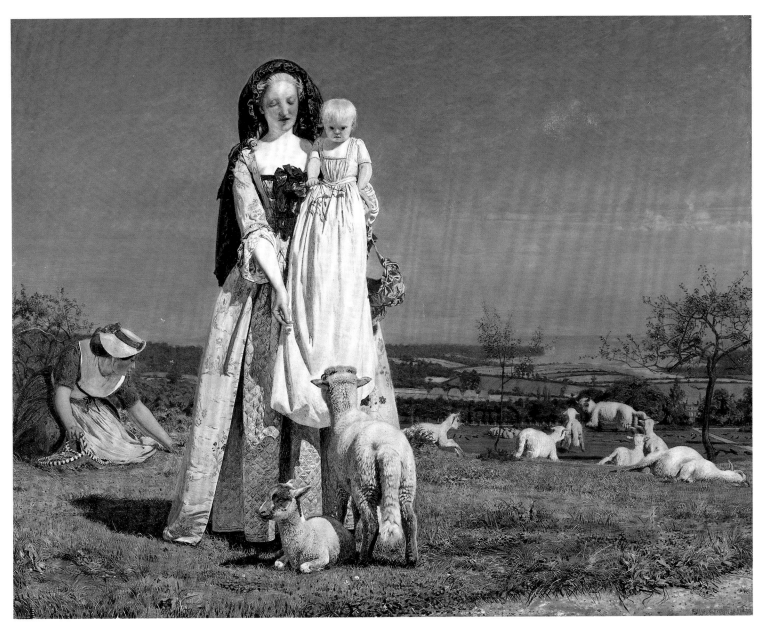

Cat. no. 18

19

ALEXANDER MUNRO

Paolo and Francesca

1852
Marble
26 x 26 1/2 x 21 in.; 66.0 x 67.5 x 53.5 cm.
Signed, on seat at right: ALEX. MUNRO. / Sc. 1852.
Inscribed, in relief along foot of base: "Quel giorno più non vi leggemmo avante."
Purchased, 1960 (P29'60)

PROVENANCE: Commissioned by W.E. Gladstone, 1851; succeeding whereabouts unknown until 1960, when discovered by John Gere in Beckwith's Antiques, Hertford, Hertfordshire

REFERENCES: London, Royal Academy, 1852 (1340); Paris, Exposition Universelle, 1855 (1158); Manchester, Art Treasures Exhibition, 1857 (1158); London, International Exhibition, 1862; Gere, 1963, pp. 509–510, fig. 44; London and Birmingham, 1973 (100); London, Tate, 1984 (44, repr.); Birmingham, *Sculpture*, 1987, p. 70, no. 216, repr. p. 71; London and Birmingham, 1991–1992 (21, repr.)

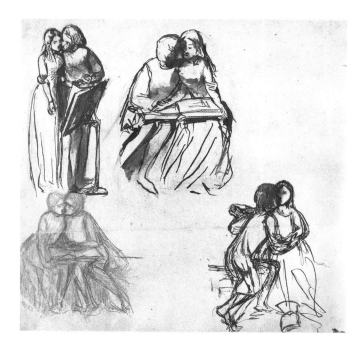

Fig. 29 DANTE GABRIEL ROSSETTI, *Paolo and Francesca da Rimini: sheet of studies*, circa 1849; pencil, pen and ink wash, 7 3/4 x 8 in. (19.5 x 20.2 cm.). Private Collection.

*I*n answer to the question, "Was there Pre-Raphaelite sculpture?",[1] Alexander Munro's *Paolo and Francesca* is invariably cited as positive proof that there was. Although the Brotherhood included the sculptor Thomas Woolner (1825–1892) among its seven members, and could count three others – John Hancock (1825–1869), Bernhard Smith (1820–1885) and John Lucas Tupper (circa 1823–1879) – as close associates, their combined output fails to match Munro's imaginative work in terms of a substantial equivalent to Pre-Raphaelite painting.[2]

Paolo and Francesca resembles a three-dimensional Pre-Raphaelite drawing, and indeed much discussion has focused on its relationship to a series of drawings by Rossetti which dates from no later than November 1849.[3] One sheet in particular (fig. 29) contains, in the upper central sketch, a resolution of the figure group very close to the sculpture.[4] By then Munro, who had entered the Royal Academy Schools as a student in 1847, was a part of the Pre-Raphaelite circle; the *P.R.B. Journal* records his visit to the Rossetti household on 22 May 1849,[5] and William Michael Rossetti later confided in his own diary that his brother "never had a more admiring or attached friend than Munro".[6] While the gift of these drawings to Munro might suggest a debt of gratitude on Rossetti's part for a refinement of the composition (which bore fruit in the left-hand compartment of a *Paolo and Francesca* watercolour of 1855, now in the Tate Gallery, London),[7] it may simply reflect the two artists' common interest in a subject more likely to have been suggested by Rossetti.

In any case, there are other strikingly similar images of

Dante's ill-fated lovers, all seemingly derived from a line engraving by John Flaxman titled *The Lovers Surprised*, one of his illustrations to Dante, first published in 1793.[8] It is unlikely that either Munro or Rossetti could have known the two drawings by Joseph Anton Koch (circa 1805), a watercolour by Delacroix (1826) or any of the seven versions of the subject by Ingres (1814 *et seq*), although the large oil painting *Francesca da Rimini* by William Dyce (1837; National Gallery of Scotland, Edinburgh) was closer to home, if rather inaccessibly in Scotland.[9]

The scene is a recollection by Francesca, whom Dante meets during his sad tour of Hell, of the incident which awakens her love for Paolo Malatesta, her brother-in-law. On discovering the adultery, her husband Gianciotto kills them both.

> One day
> For our delight, we read of Lancelot,
> How him love thralled. Alone we were, and no
> Suspicion near us. Oft-times by that reading
> Our eyes were drawn together, and the love
> Fled from our alter'd cheek. But at one point
> Alone we fell. When of that smile we read,
> The wished smile, so rapturously kiss'd
> By one so deep in love, then he, who ne'er
> From me shall separate, at once my lips
> All trembling kiss'd. The book and writer both
> Were love's purveyors. In its leaves that day
> We read no more.[10]

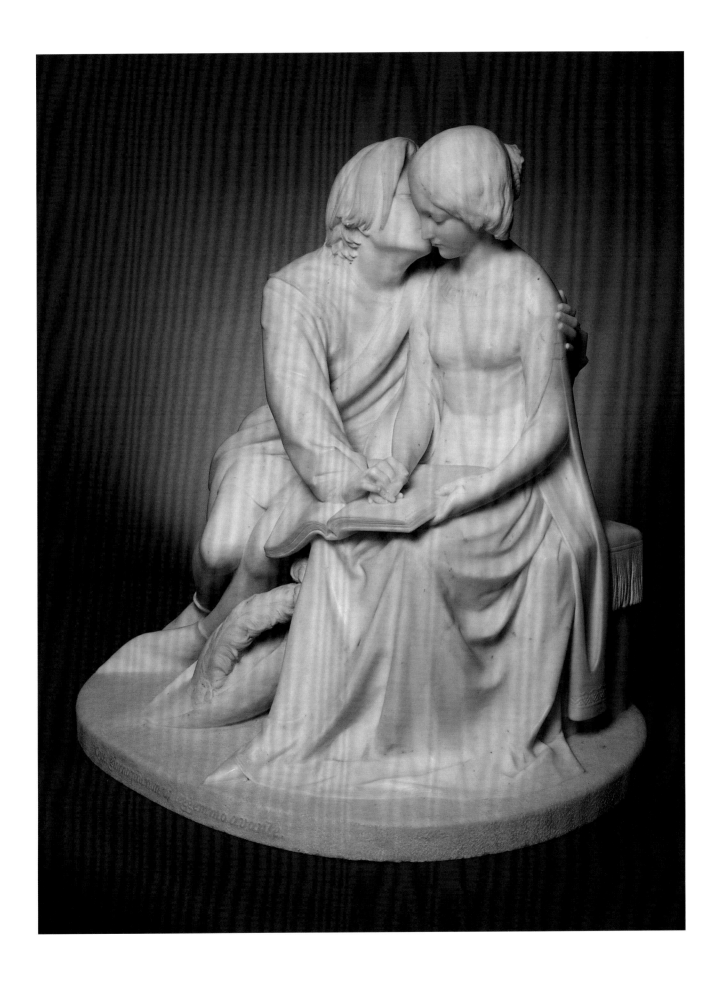

Munro's smooth, rounded treatment of the figures – obligatory pointed footwear notwithstanding – is hardly comparable with either the angularity of early Brotherhood draughtsmanship or the naturalism of contemporary figure painting, but it does convey the passionate romanticism that Rossetti especially brought to the movement and which was most evident in its literary works. The *Spectator* magazine in 1852 discerned "a burning tenderness in Paolo, a yielding sweetness in Francesca, worth any amount of those merely classical and respectable traditions with which we are so familiar".[11]

Munro completed the work in plaster for inclusion in the Great Exhibition of 1851, where it attracted a good deal of notice. A woodcut of it appeared in Cassell's *Illustrated Exhibitor*, and it received a paragraph in Tallis's *History and Description of the Crystal Palace*, albeit with the caveat that "to express the idea of strong emotion as conveyed through the eyes is a thing not to be attempted in the plastic art".[12] The work so impressed W.E. Gladstone, then Member of Parliament for Oxford University, that he commissioned its translation into stone, relying on the sculptor's assurance "that the freshness of the idea which is very well expressed in the clay can be reproduced without loss in the marble".[13] Gladstone willingly lent the sculpture to the great succession of exhibitions in 1855, 1857 and 1862 (by which time he was Chancellor of the Exchequer), but when and how it left the politician's collection is not known.[14]

The plaster itself was purchased by Sir Walter and Lady Pauline Trevelyan, notable patrons of the Pre-Raphaelites in the north-east, and it may still be seen in the hall of their remarkable country house, Wallington (now administered by The National Trust).[15] Munro gave another plaster cast to Rossetti around 1852–1853, which remained in the painter's studio throughout his life (but is now unlocated).

1. Asked in Read, 1984, and answered in London and Birmingham, 1991–1992.
2. As well as a plaster of Munro's *Repose: study of a Babe* (1857; 263I'85), the Birmingham collection also includes two roundel portraits by Woolner: *Robert Browning* (bronze, 1856; P97'47) and *Dorothy* (marble, 1882; P51'48). A bronze version of Hancock's *Beatrice* (1854) was acquired in 1992 (1992 P 10).
3. Surtees, 1971, nos.75A–C and 75E, pls. 89–91; see Gere, 1963, and Benedict Read in London, Tate, 1984, p. 102.
4. Surtees, 1971, no. 75D, pl. 92; this sheet seems not to have been included in the gift to Munro, although interestingly the standing figure group (upper left) bears a remarkable similarity to Munro's later sculpture *Lovers' Walk* (Royal Academy, 1855, now lost; reproduced in Macdonald, 1982, fig. 5).
5. Fredeman, 1973, p. 5.
6. Bornand, 1977, p. 39.
7. Surtees, 1971, no. 75, pl. 87.
8. London, Tate, 1984, p. 102.
9. Andrews, 1964, pl. 47b (by Koch); Corrado Gizzi (ed.), *Koch e Dante*, Torre de' Passeri, 1988, no. 10, p. 293, repr.; Emilio Radius (ed.), *L'opera completa di Ingres*, 1968, nos.79 (a–d), 139 (a–c), repr.; Pointon,

1979, pp. 40–41, pl. 113. The Delacroix watercolour is reproduced (fig. 8) in Henning Bock, "'Freundespaar' und 'Liebespaar'," *Jahrbuch der Hamburger Kunstsammlungen*, vol. 12, 1967, pp. 85–96, which discusses a further sculptural re-working of the composition by Adolf von Hildebrand (*Lovers*, circa 1909).
10. *The Divine Comedy: Inferno*, canto V (in H.F. Cary's translation, published in 1805).
11. Quoted by Martin Greenwood in London and Birmingham, 1991–1992, p. 112.
12. John Tallis, *History and Description of the Crystal Palace, and the Exhibition of the World's Industry in 1851*, London and New York, 1851, p. 125.
13. Letter to Munro, 18 July 1851 (from transcript in the Birmingham Museums files).
14. Perhaps significantly, Gladstone was a friend and patron of William Dyce; as an enthusiast for Dante's poetry, he went on to commission from Dyce a painting of *Beatrice* (1859; Aberdeen Art Gallery). See Marcia Pointon, "W.E. Gladstone as a Patron and Collector', *Victorian Studies*, vol. 9, no. 1, September 1975.
15. Newcastle upon Tyne, 1989–1990, no. 84, repr.

20

FORD MADOX BROWN

The Last of England: compositional design

1852, re-touched 1855?
Pencil, image edged with brown ink
17 x 15 3/8 in.; 43.1 x 39.0 cm. (sheet); 16 1/8 x 14 3/8 in.;
41.0 x 36.5 cm. (image)
Inscribed, bottom right: F. MADOX BROWN. 1852.
Presented by subscribers, 1906 (795'06)

PROVENANCE: D.T. White; B.G. Windus; his sale?, Christie's,
14 February, 1868 (205), bought Rowbottom; Frederic
Shields?; Harold Rathbone by 1897 (said to be from the
artist's sale, 1894); Charles Fairfax Murray

REFERENCES: London, Piccadilly, 1865 (71, "Pencil study for
the 'Last of England'"); Birmingham, *Drawings*, 1939, p. 42;
Liverpool, 1964 (71); Surtees, 1981, p. 80, pl. 13; London,
Tate, 1984 (178); Newman and Watkinson, 1991, pl. 59

*T*his is one of the most elaborate and detailed of all
Brown's surviving drawings. The artist moved to Hampstead
in June 1852, and without domestic distractions (Emma and
baby Catherine were spending the summer in Dover) he
began two major paintings – *Work* (see cat. no. 74), set in
Hampstead High Street, and *An English Autumn Afternoon*
(fig. 1). Progress on the former was slow, while he had to
abandon work on the landscape when the room he was using
for the view was requisitioned by the landlady. "Having given
this up about the End of Octr", Brown wrote in his diary, "&
decided that I should not have time to finish the 'Work' for
the next acady Exhn [Royal Academy exhibition] I designed
the subject of 'The Last of England', at the colored [*sic*] sketch
& cartoon of which I worked till Xmas".[1] Fresh in his mind
would have been the emigration of Thomas Woolner to
Australia on 15 July 1852; although there is no supporting evi-
dence, Brown may have seen his friend off from Gravesend,
where Brown's elder daughter Lucy lived with her aunt.

This is presumably the 'cartoon'; the 'colored sketch',
probably a watercolour, is unlocated. Brown's dealer, D.T.
White, bought this drawing in September 1855 (for £7), along
with the finished painting, for which he gave £150.[2] White
had already paid £10 for the coloured sketch, and sold all
three works to the collector B.G. Windus,[3] who lent seven
works to Brown's one-man exhibition in 1865, though not the
oil itself, which he had sold in 1859.[4]

All the essential elements of the composition are fully
worked out in this design, although Brown was to refine sev-
eral details when he resumed work on the painting (fig. 30)
in September 1854. The chief amendments would be the addi-
tion of a small child (modelled after Catherine) on the left,
and a row of cabbages on the taffrail in the foreground. The

lifeboat is here prosaically lettered "WHITE HORSE LINE OF
AUSTRALIA"; in the oil it bears the legend "ELDORADO", pun-
ningly underlining both the emigrants' hopes (striking it
lucky in the gold fields) and their slim chances of success.

1. Surtees, 1981, pp. 78–80.
2. Surtees, 1981, pp. 152–153 (entry for 5 September 1855).
3. Benjamin Godfrey Windus (1790–1867), the owner of a firm of
coachbuilders, lived in Tottenham, North London. His celebrated col-
lection of watercolours by J.M.W. Turner (of which he had acquired
some two hundred by the late 1830s) was memorialised in a water-
colour view of his library painted in 1835 by John Scarlett Davis
(1804–1844), that is now in the British Museum, London.
4. It was bought twice by the dealer Ernest Gambart – once from
Windus's sale at Christie's on 26 March 1859 (lot 45) and then from the
late T.E. Plint's sale in the same rooms on 8 March 1862 (lot 329).
Passing to John Crossley (who lent it to Brown's 1865 exhibition) and
then C.J. Pooley, the work was eventually purchased for the
Birmingham collection in 1891.

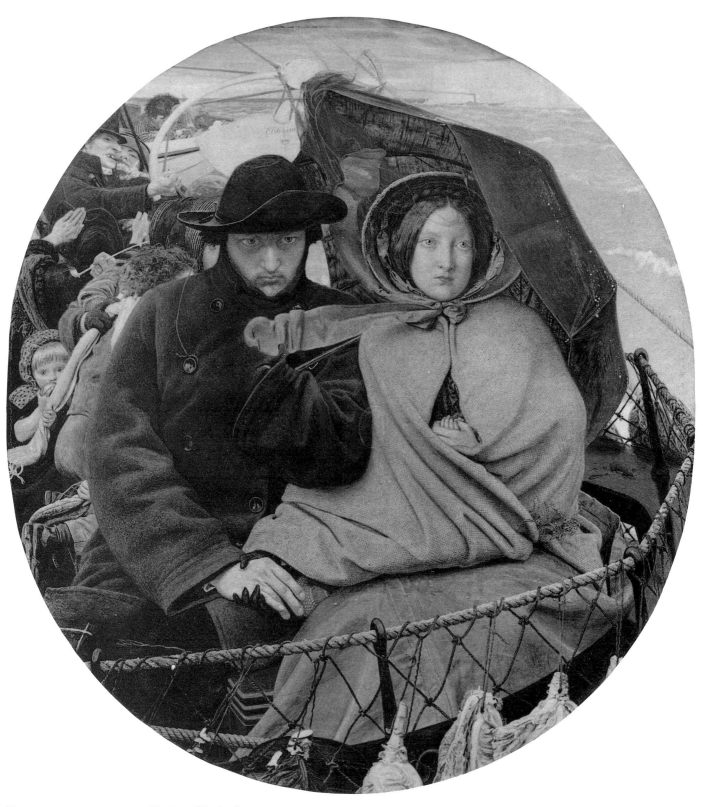

Fig. 30 FORD MADOX BROWN, *The Last of England*, 1852–1855;
oil on wood panel, oval, 32 1/2 x 29 1/2 in. (82.5 x 75.0 cm.).
Birmingham Museums and Art Gallery (24'91).

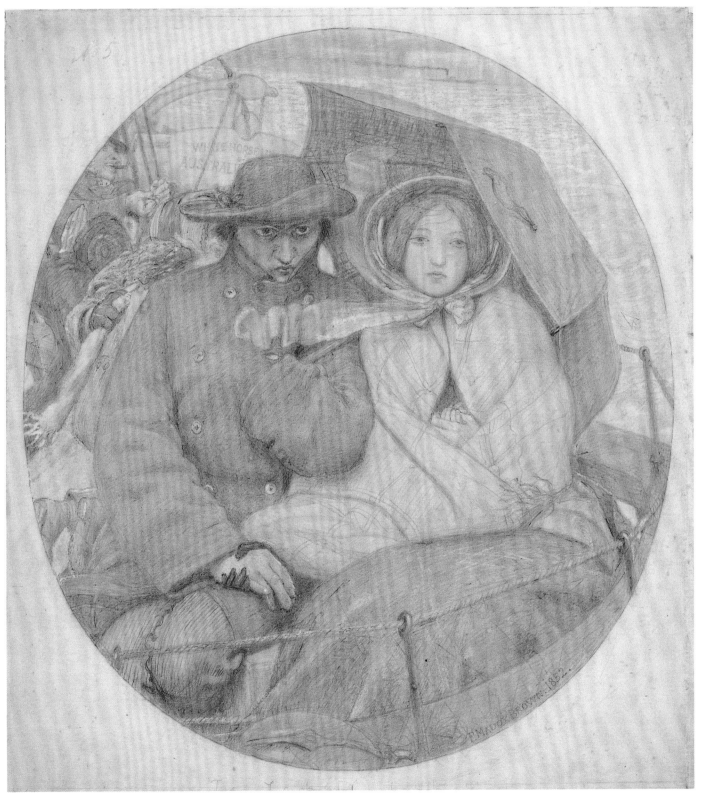

Cat. no. 20

21

FORD MADOX BROWN

Emma Hill: study for "The Last of England"

1852
Black chalk, with wash
6 1/2 x 7 in.; 16.5 x 17.8 cm.
Signed and dated in chalk, bottom left: FMB Decr / 52
(initials in monogram)
Presented by subscribers, 1906 (791'06)

PROVENANCE: See cat. no. 20; Charles Fairfax Murray

REFERENCES: Birmingham, *Drawings*, 1939, p. 42; Liverpool, 1964 (61); Rose, 1981, p. 21, repr.; London, Tate, 1984 (179, repr.)

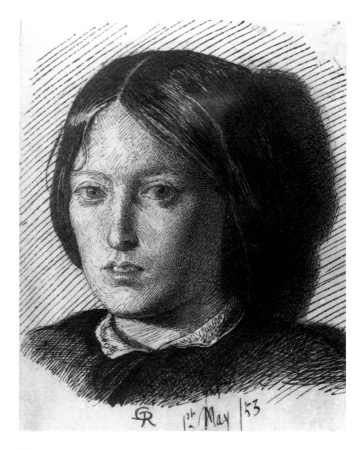

Fig. 31 DANTE GABRIEL ROSSETTI, *Emma Brown*, 1853; pen and brown ink, 5 x 3 7/8 in. (12.7 x 7.6 cm.). Birmingham Museums and Art Gallery (447'04).

One of the most direct and appealing of all Pre-Raphaelite portrait drawings, this study of Brown's future wife remained an important focus for continued work on *The Last of England*. Having endured the heat of summer to model for *The Pretty Baa-Lambs* (see cat. no. 18), Emma nobly endured freezing cold in the winter of 1852–1853, "coming to sit to me in the most inhuman weather from Highgate. This work representing an out door without sun light I painted at it chiefly out of doors when the snow was lieing [sic] on the ground".[1] Re-touching in 1855 included work on "Emma's head, [using] the drawing I made at Hampstead when I began the picture. Emma would not sit so I worked from feeling".[2] When the finished painting was shown for the first time in London, at the Pre-Raphaelites' Russell Place exhibition in 1857, the critic of the *Saturday Review* rewarded Brown's perseverance by calling the woman's face "the chief charm of the picture".[3]

The first evidence of Brown having met Matilda Hill (who was always known as Emma) is provided by a tender portrait drawing dated 'Xmas 48' (Birmingham collection, 789'06; reproduced in Newman and Watkinson, 1991, pl. 47). She was then nineteen, the daughter of a poor farmer who had migrated to London during the agricultural depression of the 1830s. William Michael Rossetti recalled her as having "a pink complexion, regular features, and a fine abundance of beautiful yellow hair, the tint of harvest corn".[4] Although a daughter, Catherine, was born on 11 November 1850, Emma and Brown did not marry until 1853. They had little money, and Brown was embarrassed both by his own insecurity and by Emma's lack of formal education. By early 1853 she was apparently attending a school for young ladies in Highgate, in the hope of attaining some of the accomplishments that would be expected of a wife in the event of Brown achieving success as a painter.

From 1851–1852 onwards, when Brown was sharing a studio with Rossetti in Newman Street, Emma enjoyed the occa-sional company of Elizabeth Siddal, who was by then Rossetti's model and mistress. Finding themselves in a similar social limbo, the two young women became firm friends (rather to Rossetti's annoyance, since Emma seemed to encourage Lizzie's independence). Rossetti was a witness at the marriage on 5 April 1853, and he made a drawing of Emma in pen and ink – doubtless a wedding gift – which remained in Brown's possession for the rest of his life (fig. 31).[5]

1. Surtees, 1981, p. 80.
2. Surtees, 1981, p. 132.
3. *Saturday Review*, 4 July 1857, quoted by Mary Bennett in London, Tate, 1984, p. 256.
4. *Rossetti*, 1906, vol. 1, p. 137.
5. Surtees, 1971, no. 272, pl. 395.

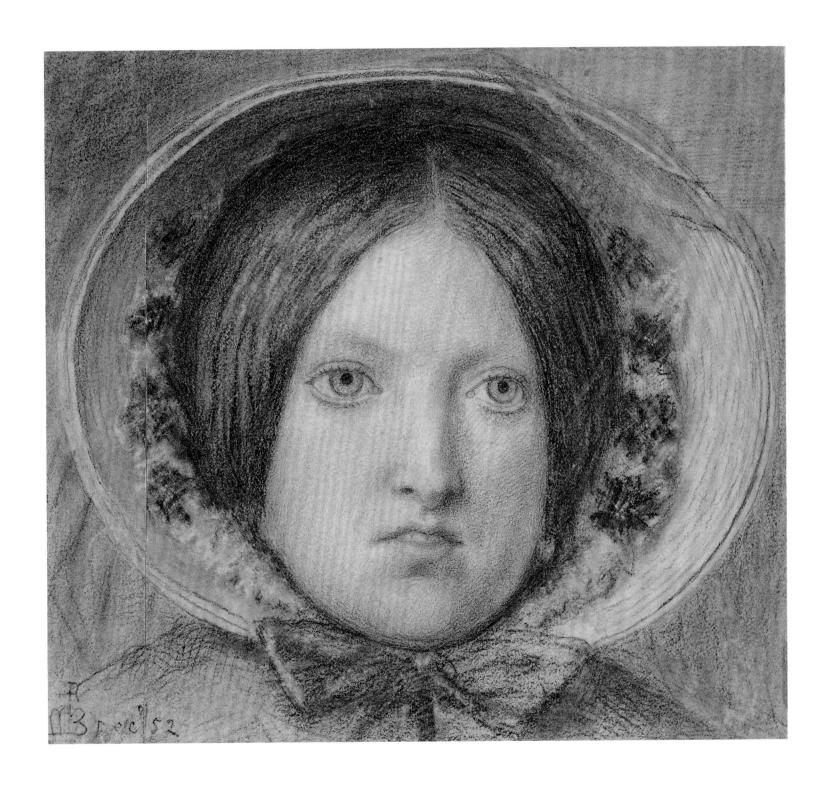

117

22

JOHN EVERETT MILLAIS

Elizabeth Siddal: study for "Ophelia"

1852
Pencil
7 1/2 x 10 1/2 in.; 23.2 x 30.7 cm.
Presented by subscribers, 1906 (664'06)

PROVENANCE: Sir William Bowman, Bart., by 1886; Charles
Fairfax Murray

REFERENCES: Birmingham, *Drawings*, 1939, p. 268, repr. p. 435;
London and Liverpool, 1967 (272); Rose, 1981, p. 76, repr.;
London, Tate, 1984, p. 98, no. 40

*R*eturning on 6 December 1851 from a painting trip with
Hunt (see cat. no. 18), Millais was in need of a model to com-
plete his painting of *Ophelia* (Tate Gallery, London; fig. 32).
He approached Elizabeth Siddal, who had already sat for
Hunt (see cat. no. 17) and Deverell (see cat. no. 24). Delayed
by the terminal illness of her brother Charles, she was finally
available at the end of January 1852, and Millais could set up
his now famous studio arrangement. In a truly Pre-Raphaelite
spirit of truth to nature, Millais was eager to re-create as far as
possible the image of Ophelia's death by drowning, as report-
ed by Queen Gertrude in this passage from act IV, scene vii
of *Hamlet:*

> When down her weedy trophies and herself
> Fell in the weeping brook. Her clothes spread wide,
> And, mermaid-like, awhile they bore her up;
> Which time she chanted snatches of old lauds,
> As one incapable of her own distress,
> Or like a creature native and indued
> Unto that element; but long it could not be
> Till that her garments, heavy with their drink,
> Pull'd the poor wretch from her melodious lay
> To muddy death.

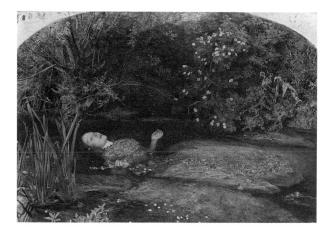

Lizzie Siddal's sacrifice in the cause of veracity is recorded by
Millais's son:

> In order that the artist might get the proper set of the
> garments in water and the right atmosphere and aqueous
> effects, she had to lie in a large bath filled with water,
> which was kept at an even temperature by lamps placed
> beneath. One day, just as the picture was nearly finished,
> the lamps went out unnoticed by the artist, who was so
> intensely absorbed in his work that he thought of nothing
> else, and the poor lady was kept floating in the cold
> water till she was quite benumbed. She herself never com-
> plained of this, but the result was that she contracted a
> severe cold, and her father wrote to Millais, threatening
> him with an action for £50 damages for his carelessness.
> Eventually the matter was satisfactorily compromised.
> Millais paid the doctor's bill; and Miss Siddal, quickly
> recovering, was none the worse for her cold bath.[1]

Unsurprisingly, she never sat for Millais again, and it is fortu-
nate that he made this memorably beautiful drawing, pre-
sumably at the beginning of her ordeal. In the tilt of the head,
with its heavy-lidded eyes and half-open mouth, is a hint of
recollection of a pencil drawing made by Millais at the age of
eight: the head of the swooning Virgin Mary, copied from
Correggio's *Ecce Homo* in the National Gallery (Birmingham
collection, 17'16). A letter of 6 March 1852 records his having
finished painting the head, while in another of the same
month he told his patron Thomas Combe that "I have pur-
chased a really splendid lady's ancient dress – all flowered over
in silver embroidery – and I am going to paint it for
'Ophelia'."[2] This would have provided details for the finish-
ing touches to the picture, which was submitted to the Royal
Academy in April.

Along with *A Huguenot* (Makins Collection), *Ophelia* was
quite well received; even the critic in *Punch*, despite carping at
the "needless elaboration" of Millais's carefully detailed foliage,
could see "only that face of poor drowning Ophelia. My eye
goes to that, and rests on that, and sees nothing else".[3] Marion
Spielmann, the artist's first independent commentator, also
felt that "despite . . . the brilliancy of colour, diligence of micro-
scopic research, and masterly handling, it is Ophelia's face that
holds the spectator, rivets his attentions, and . . . his emotion".[4]

1. Millais, 1899, vol. 1, p. 144.
2. Millais, 1899, vol. 1, pp. 160–162.
3. Quoted by Mary Bennett in London and Liverpool, 1967, p. 33,
no. 34.
4. Quoted in Millais, 1899, vol. 1, p. 145.

Fig. 32 JOHN EVERETT MILLAIS, *Ophelia*, 1851–1852; oil on
canvas, 30 x 44 in. (76.2 x 111.8 cm.). Tate Gallery, London.

118

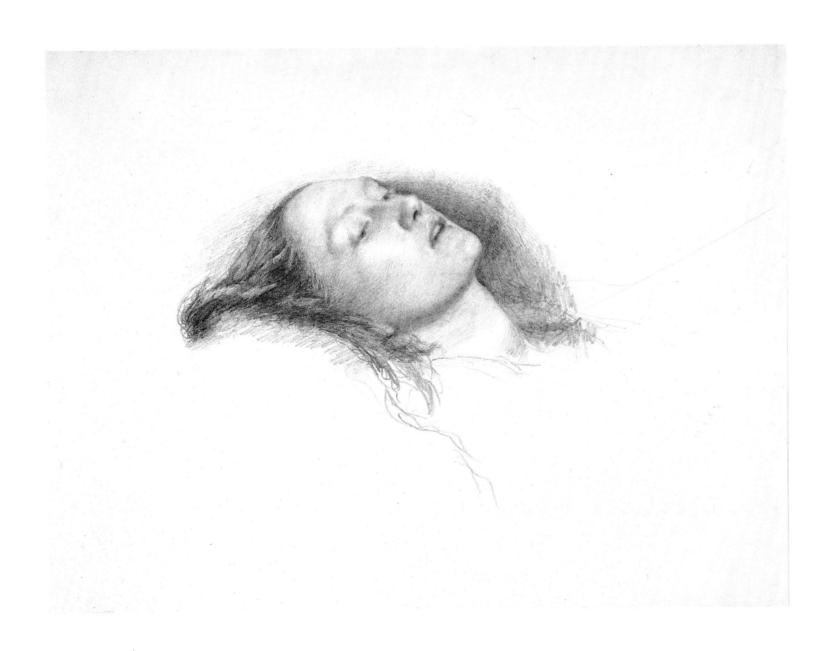

23

WILLIAM HOLMAN HUNT

Walter Howell Deverell

1853
Black and red chalk, with wash
14 x 10 1/4 in.; 35.5 x 26.0 cm.
Signed and dated, in black chalk, bottom left: Whh 1853.
(initials in monogram)
Presented by the artist, 1907 (134'07)

PROVENANCE: William Holman Hunt

REFERENCES: Birmingham, *Drawings*, 1939, p. 238; Liverpool
and London, 1969 (129, pl. 21); Rose, 1981, p. 54, repr.;
London, Tate, 1984, p. 31, repr.

Walter Howell Deverell was already very ill when this portrait drawing was made, at about the time of his twenty-sixth birthday in the autumn of 1853. He had contracted Bright's Disease, possibly through an earlier bout of scarlet fever, and did not survive the winter, dying on 2 February 1854. Popular with all the members of the Pre-Raphaelite Brotherhood, he maintained a cheerful disposition in spite of much adversity: his paintings received little recognition, and he inherited heavy family responsibilities on the death of his father (a difficult man who was Secretary of the Government School of Design) in the summer of 1853.

Hunt and Millais provided financial assistance by purchasing Deverell's painting *A Pet* (Tate Gallery, London) from the Liverpool Academy exhibition.[1] It was on a visit to bring this good news that Hunt drew this portrait.[2] It captures the vivacity of Deverell's character, almost undimmed by illness, as well as his good looks. William Michael Rossetti thought him "one of the handsomest young men I have known; belonging to a type not properly to be termed feminine, but which might rather be dubbed 'troubadourish'."[3]

1. London, Tate, 1984 (54, repr.); the only painting sold in his lifetime, *A Pet* was later sold to the dealer D.T. White and afterwards belonged to Burne-Jones.
2. Hunt, 1905, vol. 1, p. 362; Hunt left for Egypt in January 1854, and received the news of Deverell's death only when mail reached him at Cairo in March: "God help poor Deverell! I was prepared for the fatal news, but not the less affected by it" (Hunt, 1905, vol. 1, p. 380).
3. Rossetti, 1906, vol. 1, p. 148.

1853.

WALTER HOWELL DEVERELL

A Scene from "As You Like It" (The Mock Marriage of Orlando and Rosalind)

1853
Oil on canvas
23 1/2 x 19 3/4 in.; 59.7 x 50.2 cm.
Signed, bottom left: WHD
Presented by J.R. Holliday, 1912 (19'12)

PROVENANCE: John Miller, Liverpool; his sale?, Christie's, 20–22 May 1858; Edwin Bullock, Birmingham; sale "at an hotel in Birmingham", circa 1911, where bought by J.R. Holliday

EXHIBITED: London, Royal Academy, 1853 (1244, as *The Marriage of Orlando and Rosalind*)

REFERENCES: Birmingham, *Paintings*, 1960, p. 45; Staley, 1973, pp. 83–84; Lutyens, 1984, p. 88, pl. 35

Out of only fifteen recorded oil paintings by Deverell (two of which were left unfinished at his death), two are known to have been destroyed and three are unlocated.[1] His most important group of oils consists of three subjects from Shakespeare – one of *Twelfth Night* and two of *As You Like It*. *Twelfth Night* (FORBES Magazine Collection, New York)[2] was his first attempt at a work in the Pre-Raphaelite manner and was exhibited in 1850 at the National Institution of Fine Arts (at the Portland Gallery, Langham Place, London), in the company of Rossetti's *Ecce Ancilla Domini!* (see fig. 3). Begun in the autumn of 1849, this large, colourful but rather awkward composition remains of great interest for its depiction of Rossetti as the jester Feste and Elizabeth Siddal as Viola. This was Lizzie's first appearance in a Pre-Raphaelite painting, and Hunt recalled Deverell telling him (in Rossetti's company) how "I got my mother to persuade the miraculous creature to sit for me for my Viola in 'Twelfth Night', and to-day I have been trying to paint her; but I have made a mess of my beginning".[3] Hunt then states that Rossetti went to Deverell's studio the following day – possibly effecting his first meeting with Lizzie – and it is likely that this accords with the reference in the *P.R.B. Journal* of 14 December 1849 to Rossetti having "painted the hair in Deverell's picture".[4]

The *P.R.B. Journal* records that the first *As You Like It* picture was "pretty nearly finished" in October 1850.[5] Described as "Rosalind witnessing the encounter of Jacques and Orlando in the forest", this is accepted to be the oil on panel now at the Shipley Art Gallery, Gateshead (fig. 33);[6] although it appears to be in a finished state, it seems never to have been exhibited. Certainly, Deverell suffered much disruption at the end of the year: his mother, a helpful supporter of his artistic ambitions, died on 21 October and in December he moved to rooms at 17 Red Lion Square, sharing the studio with Rossetti. These he was obliged to give up after only six months when Rossetti left to share studio space with Brown instead.

Perhaps dissatisfied with the uneasy balance of figure and landscape in his first attempt, Deverell took up the second subject from *As You Like It* on a much smaller scale. Also set in the Forest of Arden, this depicts the 'mock marriage' of Orlando and Rosalind, with Celia acting as 'priest' (act IV, scene i). The artist was now living with his father and family at Heathfield House, Kew Green, and he persuaded his elder sister Margaretta to go with him to Combe Wood, beyond Richmond, "where she was expected to pose as Rosalind regardless of weather. A special dress was made for her for this picture – a grey tunic. Sometimes Walter continued to paint under an umbrella in spite of his sister's remonstrance".[7] Deverell's brother Spencer sat for the head of Orlando: a small but strong pencil study is in the Tate Gallery (fig. 34).

Deverell would undoubtedly have seen Hunt's *Valentine rescuing Sylvia from Proteus* (see cat. no. 17) at the Royal Academy in 1851: there are distinct echoes of that composition, as well as a similarity in treatment of the scene as a dramatic tableau. Although lacking the quality of execution of a major oil by Hunt, Millais or Brown, it was clearly a painting on which Deverell had set high hopes: only two of the five oils he submitted to the Academy in 1853 were accepted, and this one was to suffer the same fate as Brown's *Pretty Baa-Lambs* in the previous year: "The Marriage of Orlando and Rosalind was disgracefully hung – the most insulting position in the Octagon Room – so all my hopes and labours of the preceding year were overthrown at one fell swoop!"[8]

Rossetti apparently re-touched the face of Celia; taking charge of Deverell's unsold paintings after his death in the hope of raising money for the family, Rossetti found an immediate buyer for the picture in John Miller, a Liverpool merchant and collector, who paid fifty guineas for it at the end of March 1854. "Victoria!", Rossetti wrote to Miss Deverell (presumably Margaretta) on 27 March, "Miller of Liverpool has just sent me a cheque for 50 guineas for the *As you like it* which it seems is as he likes it".[9]

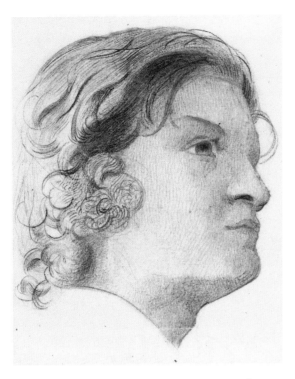

Fig. 34 WALTER HOWELL DEVERELL, *Spencer Deverell (study for "A Scene from 'As You Like It'")*, circa 1853; pencil, 3 1/2 x 2 3/4 in. (9.2 x 7.3 cm.). Tate Gallery, London.

1. See Jeffrey, 1986, pp. 87–89.
2. London, Tate, 1984 (23, repr.).
3. Hunt, 1905, vol. 1, pp. 198–199.
4. Fredeman, 1975, p. 31; this suggestion is made in Lutyens, 1984, p. 80.
5. Fredeman, 1975, p. 72.
6. Poulson, 1980, p. 246, gives the descriptive title *Rosalind and Celia as Ganymede and Aliena in the Forest of Arden* (act III, scene ii).
7. From the unpublished memoir of Deverell (with a preface and annotations by William Michael Rossetti, 1899) in the Huntington Library, Art Collections, and Botanical Gardens, San Marino, California; quoted in Lutyens, 1984, p. 88. An unidentified typescript in the Birmingham Museum files quotes Deverell's diary for March 1853: "Commenced on picture for 'As You Like It', redesigned and painted an entirely new figure for Rosalind; this making the fourth figure, having erased three. . . . Altogether I am more pleased with this picture than with anything I have yet done". Lutyens states that since the diary or journal itself was destroyed, only certain passages were quoted in the memoir (Lutyens, 1984, p. 244, note 4).
8. Lutyens, 1984, p. 90.
9. Doughty and Wahl, 1965–1967, vol. 1, p. 182. Miller later bought paintings by Brown, Wallis and Millais, including *The Blind Girl* (see cat. no. 38); see Bennett, 1963, p. 489.

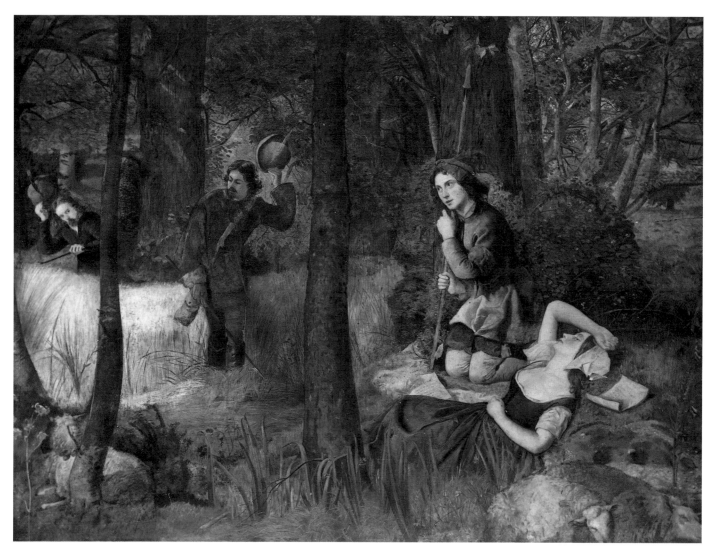

Fig. 33 WALTER HOWELL DEVERELL, *Rosalind and Celia as Ganymede and Aliena in the Forest of Arden ("As You Like It")*, circa 1850; oil on wood panel, 27 3/4 x 36 in. (70.5 x 92.0 cm.). Shipley Art Gallery, Gateshead (Tyne and Wear Museums).

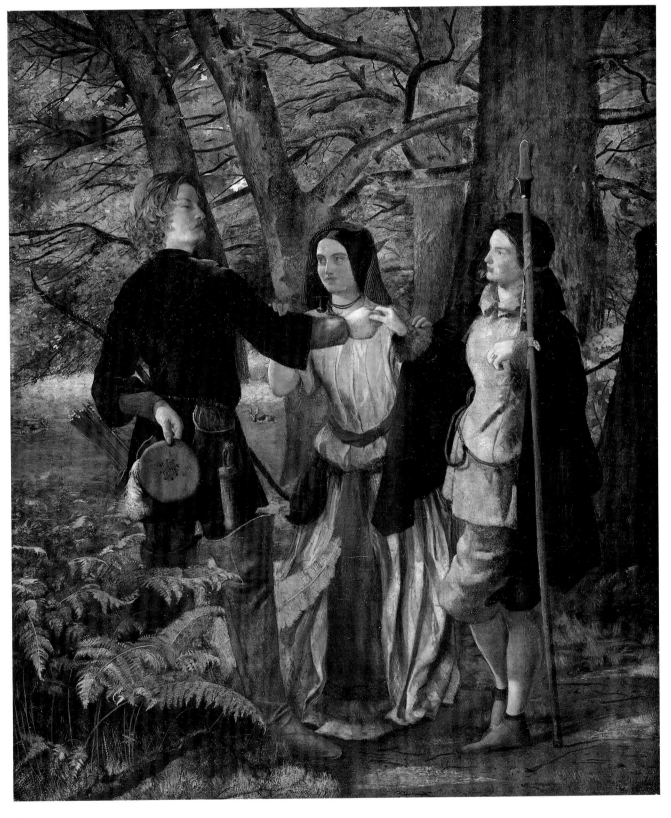

Cat. no. 24

25

WALTER HOWELL DEVERELL

Heads of two Women, one kissing the other

1853
Pencil and black chalk
14 x 10 in.; 35.5 x 25.5 cm.
Verso, in pencil: Two slight drawings of sheep and a thumbnail sketch of a cricket match; also, in pencil: Mr Turvey(?) / 8 Stafford Place / Pimlico and 10 Norfolk St / Middlesex Hospital
Dated, in pencil, bottom left: May 9 / 1853
Inscribed in red crayon, bottom right: by – / Walter Howell Deverell / given me by his Sisters / Feb. 1854 / F.G.S.
Presented by M.B. Walker, 1920 (711'20)

PROVENANCE: Frederic George Stephens

REFERENCES: Birmingham, *Drawings*, 1939, p. 173; Lutyens, 1984, p. 245, note 24

*T*his charming sheet is the most delicate of Deverell's few surviving drawings.[1] Its technique invites comparison both with Millais's crisp use of the sharply poised pencil and with Rossetti's preference for softer pencil and chalk (especially in the shading and the outlining of limbs).

The inscription reveals it as a gift by the artist's sisters to F.G. Stephens (who attended Deverell's funeral at Brompton parish church on 7 February 1854, along with Rossetti, Munro and Brown),[2] and it is possibly a portrait of them. The younger girl looks just old enough to be Maria, who was born on 16 April 1841, while Margaretta would have been about eighteen in May 1853 (her exact date of birth is not known).[3]

Equally, this may be a preliminary study for a painting either never begun or lost without trace. In 1853 Deverell had completed and exhibited four oil paintings of female figures, including the double portrait *Miss Margaretta and Miss Jessie Bird*, shown at the Royal Academy.[4] *A Pet* (see cat. no. 23, note 1) was sent to the Liverpool Academy, while *The Grey Parrot* (National Gallery of Victoria, Melbourne) and *Eustatia* (Tate Gallery, London) were hung, albeit unsympathetically, at the Society of British Artists in Suffolk Street.[5] The model for these pictures, identified as Eustatia Davy, can be said to bear some resemblance to the woman at the left in the present drawing.

1. The checklist in Jeffrey, 1986, pp. 88–89, records just thirteen identified drawings, with a possible further seven of unknown whereabouts.
2. Doughty and Wahl, 1965, vol. 1, p. 174 (letter from Rossetti to Woolner in Australia).
3. See Lutyens, 1984, pp. 77, 244 (note 3). A third sister, Jemima, had died of consumption in 1846, aged fourteen.
4. A fragment, of one of the heads only, is in a private collection (Lutyens, 1984, repr. pl. 38).
5. Lutyens, 1984, repr. pls. 37, 39. William Michael Rossetti, writing in the *Spectator*, complained that these, "the two best and most pleasing single pictures . . . are shabbily banished to the Watercolour Room" (quoted in Lutyens, 1984, p. 90).

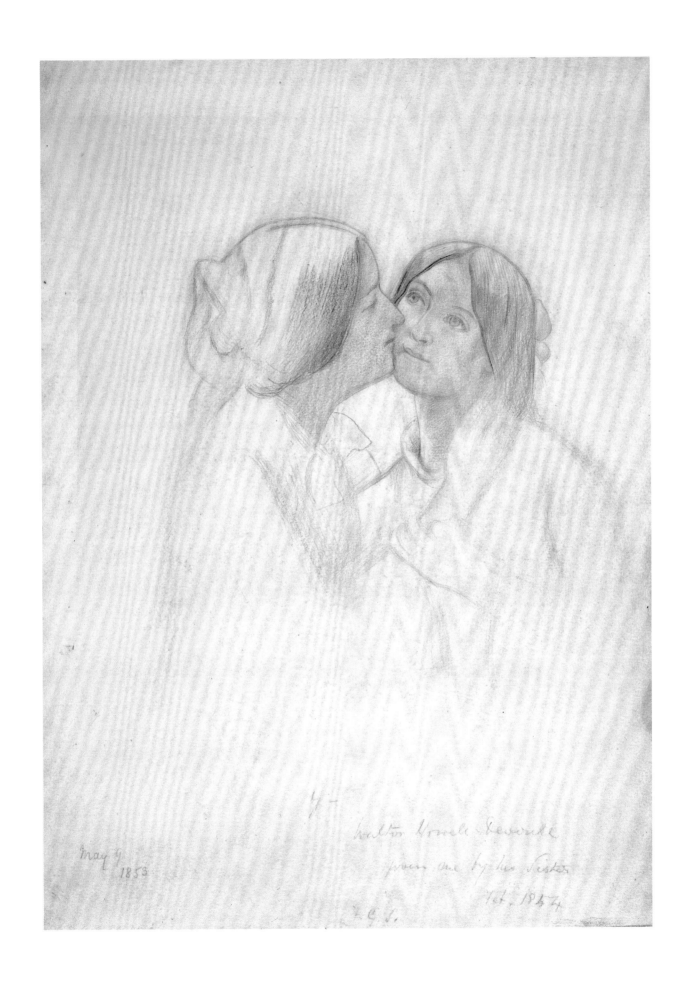

May 9
1853

Walter Howell Deverell
from me by his Sister
Feb. 1854

F.G.S.

26

WILLIAM HOLMAN HUNT

Dante Gabriel Rossetti

1882–1883, replica of a drawing made in 1853
Oil on wood panel
11 7/8 x 9 in.; 30.2 x 22.9 cm. (image within oval shape)
Signed and dated, lower right: 18 Whh 53 (initials in monogram)
In original frame, bearing the label of W.A. Smith, Carver and Gilder, 20 & 22 Mortimer Street, London W. Purchased, from the bequest of H.T. Wiggins-Davies, to commemorate the services of Alderman W. Byng Kenrick to the City of Birmingham, 1961 (P33'61)

PROVENANCE: The artist, and by descent to Mrs Elizabeth Burt, from whom purchased

EXHIBITED: Liverpool, Walker Art Gallery, *Autumn Exhibition*, 1883 (533)

REFERENCES: Ormond, 1967, p. 26, fig. 6; Liverpool and London, 1969 (56, pl. 90); Rose, 1981, p. 53, repr.; London, Tate, 1984, pp. 259–260.

Six months after Woolner's emigration in July 1852, Rossetti conceived a plan for the remaining members of the Brotherhood to make portrait drawings of each other to be sent to their friend in Australia.[1] Eventually, on 12 April 1853, the five remaining Pre-Raphaelites (Collinson having by then resigned) met for breakfast in Millais's studio to carry out the task; Brown had also been invited, but he declined. By chance, Munro called on Millais during the day, and his portrait was quickly taken (although it is not certain that it was forwarded with the five others to Woolner). This enterprise outdates by several months the last entry in the *P.R.B. Journal* (29 January 1853), and is generally recognised as the last concerted effort of the Brotherhood.

Remarkably, all six drawings have survived.[2] With Stephens soon giving up an attempt to draw Millais, and William Michael Rossetti demurring, the others were left to undertake two subjects each. Millais's study of Stephens is disappointingly sketchy, although the former was unwell and the latter a late arrival at the breakfast meeting. After Rossetti had drawn his brother, and Hunt had made, in the chalk portrait of Millais, by far the best drawing of the series, the two artists then drew each other. Rossetti's pencil study of Hunt is decidedly stiff and overworked, and demonstrates some of the deficiencies of his technique when working under pressure; the sitter thought it made him look twenty years older, while William Michael Rossetti fancied it resembled "Rush, the notorious murderer of the day".[3]

Hunt's coloured chalk drawing of Rossetti, however, has always been considered a splendid likeness, conveying much of his compelling appearance and charismatic personality. In his autobiography, Hunt describes the young Rossetti's "southern" [i.e., Italian] features with "grey eyes, looking directly only when arrested by external interest".[4] It is likely that Rossetti was constantly looking up at Hunt from work on the reciprocal portrait, which would explain his brother's comment in this description of the image:

> The face seems somewhat long – longer than Rossetti's was: I think that is due to the peculiar lighting, which, falling from above downwards, makes the face look like a long one partially foreshortened, whereas it is in fact full-fronting, and not fore-shortened at all. . . . The total expression of the face is somewhat more strained and set than was usual with Rossetti, one of the last men to "make up" a visage for any purpose of effect; apart from this, there is little that needs to be allowed for in this remarkable revision of his aspect at the age of twenty-five.[5]

Woolner hung the portraits in his Melbourne studio, and brought them all back on his return to England in 1854. He set particular store by Hunt's drawing, "one of the best things he ever did",[6] and generously gave it to William Michael Rossetti in 1882, shortly after his brother's death. Hunt then approached William, seeking to make a copy: the suggestion that the surface of the drawing (now in Manchester City Art Gallery) had become damaged by rubbing was probably a pretext for Hunt wanting simply "to reproduce the portrait of Gabriel by me as a representation of what he was when still youth and its hunger of inspiration was glowing in his face".[7]

This version in oils, which is the same size as the drawing, was the result. Ever the opportunist, Hunt may have expected that Rossetti's recent death might have raised an interest in such a portrait among collectors: the picture was originally offered for 200 guineas but seems not to have found a buyer. The commanding frame was designed by Hunt; a preparatory sketch for it exists.[8]

1. Ormond, 1967, offers an excellent account of this scheme.
2. Millais's of Stephens and Hunt's of Millais are in the National Portrait Gallery, London; Millais's of Munro is in the William Morris Gallery, Walthamstow, London; Rossetti's of Hunt is in the Birmingham collection, and Hunt's chalk drawing of Rossetti (the basis for the present oil) is in Manchester City Art Gallery. All are reproduced in Ormond, 1967, figs. 1–5. Rossetti's drawing of his brother William Michael was re-discovered in 1974, sold at Christie's, 16 October 1981 (lot 20, repr.), and purchased by the National Portrait Gallery, London.
3. Hunt, 1905, vol. 1, p. 341.
4. Hunt, 1905, vol. 1, p. 144.
5. Rossetti, 1889, p. 57.
6. Letter to William Michael Rossetti, 21 July 1882, quoted by Judith Bronkhurst in London, Tate, 1984, p. 260.
7. Letter to William Michael Rossetti, 19 November 1882, quoted by Judith Bronkhurst in London, Tate, 1984, p. 260.
8. Bennett, 1970, p. 61, fig. 24.

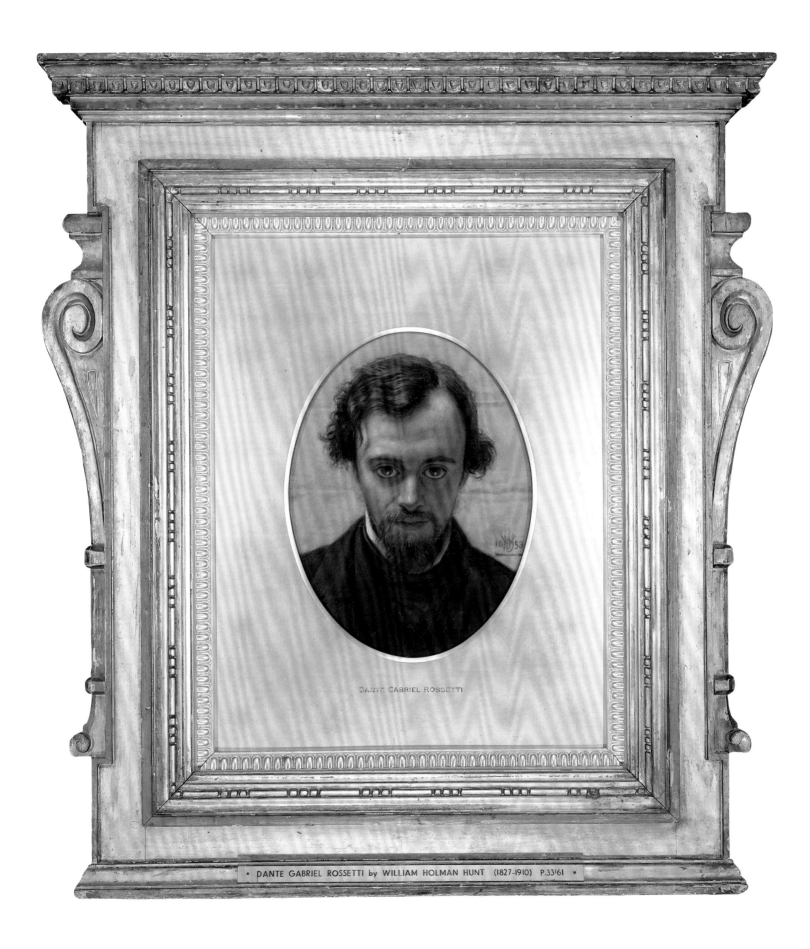

DANTE GABRIEL ROSSETTI

• DANTE GABRIEL ROSSETTI by WILLIAM HOLMAN HUNT (1827-1910) P.33ʹ61 •

DANTE GABRIEL ROSSETTI

The Return of Tibullus to Delia: study for Delia

Circa 1853-1855
Pencil, touched with pen and brown ink
16 1/8 x 12 5/8 in.; 41.0 x 32.2 cm. (right side of sheet cut off diagonally)
Formerly inscribed on verso of mount in the handwriting of G.P. Boyce: Study made (probably 1855) from his wife (née Elizabeth Eleanor Siddal) whom he married in 1860, for the "Delia" in the "Tibullus' Return to Delia", by Dante G. Rossetti. The action of the head of Delia is different in this drawing from that in the subsequent watercolour drawing. The gift of the artist to G.P. Boyce, December 6th, 1868.[1]
Presented by subscribers, 1904 (403'04)

PROVENANCE: George Price Boyce; Charles Fairfax Murray

REFERENCES: Birmingham, *Drawings*, 1939, p. 313; Surtees, 1971, no. 62D, pl. 60; London and Birmingham, 1973, no. 60; Grieve, 1978, p. 57, pl. 53; Surtees, 1991, no. 8, repr.

In 1851, Rossetti began a watercolour based on lines from the *Elegies* of the classical Roman poet Tibullus. In place of Dante's unrequited love for Beatrice, Rossetti depicts the rapturous moment in the Third Elegy in which Tibullus longs to end their separation and return to consummate his passion for Delia. A first small design in watercolour (fig. 35) shows Tibullus bursting into the room where Delia sits on a day-bed, listening to music played by an old servant woman, and distractedly sucks on a strand of her long hair.[2] Rossetti appended these lines, in his own translation, to the composition:

> Live chaste, dear love; and while I'm far away,
> Be some old dame thy guardian night and day.
> She'll sing thee songs, and when the lamp is lit,
> Fly the full rock and draw long threads from it,
> So, unannounced, shall I come suddenly,
> As 'twere a presence sent from heaven to thee.
> Then as thou art, all long and loose thy hair,
> Run to me, Delia, run with thy feet bare.

Seven pencil studies survive for the figure of Delia sucking at her hair, one of the most erotic images in Pre-Raphaelite art.[3] One of the earliest, dated November 1851, seems to depict Emma Hill, posing rather uncomfortably in day clothes and teasing a necklace in her mouth (her hair being respectably tidy). The others, however, are of Elizabeth Siddal, with two pairs of small studies again bearing the date 1851.[4]

The two strongest and most heavily worked drawings are probably later in date, when Lizzie would have resumed her pose while in a far more romantic relationship with Rossetti. The present sheet remains close to the watercolour, although

Delia holds a shortened distaff, or rock (hence "Fly the full rock"). The equally languid study now in the Fitzwilliam Museum, Cambridge, is of head and shoulders only, without the right arm raised.[5]

In addition to the inscription on the back of the Birmingham drawing, G.P. Boyce recorded in his diary for 10 March 1867 the occasion of its acquisition: "I am also to have a pencil study (touched with pen and ink) for the sorrowing Lady on the bed in the Tibullus. At his request I wrote my name on the back".[6] Boyce had discovered his friend at work on the first of two larger watercolour versions of the subject, Rossetti finally having been motivated by a commission from the Manchester collector Frederick Craven.[7] In these, however, a more subdued figure of Delia is shown in slumber, based on drawings that were probably modelled by Alexa Wilding.

1. From a transcript in the Birmingham Museum files; also quoted in Surtees, 1971, p. 24.
2. Surtees, 1971, no. 62, pl. 56; sold at Sotheby's, Belgravia, 14 February 1978 (lot 37, repr.).
3. The motif was later used by Frederick Sandys in his chalk drawing *Proud Maisie* (circa 1867; Victoria and Albert Museum, London); Brighton and Sheffield, 1974, no. 142, pl. 102, and also appears in the design for *If* (see cat. no. 83).
4. Surtees, 1971, nos. 62A–C, pls. 57–59 (Emma Hill and one pair of drawings, all in the Birmingham collection); the other pair is in the Ulster Museum, Belfast (not in Surtees; reproduced in Grieve, 1978, figs. 51, 54).
5. Surtees, 1971, no. 62E, pl. 61.
6. Surtees, 1980, p. 46.
7. Surtees, 1971, nos. 62.R.1 and 62.R.2 (last sold at Christie's, 11 June 1993, lot 82, and Sotheby's, 12 November 1992, lot 148, respectively).

Fig. 35 DANTE GABRIEL ROSSETTI, *The Return of Tibullus to Delia*, 1851; watercolour and bodycolour, 9 x 11 1/2 in. (23.0 x 29.0 cm.). Private Collection.

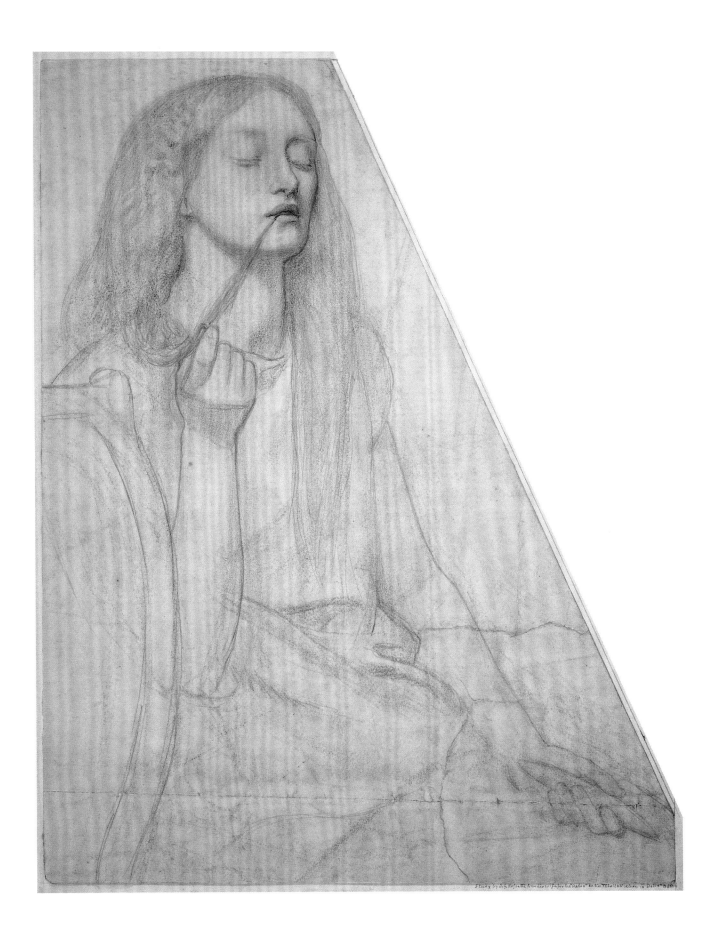

28

WILLIAM HOLMAN HUNT

A Street Scene in Cairo

1854
Pencil on cream paper
13 1/2 x 9 3/4 in.; 34.3 x 24.8 cm.
Inscribed in pencil, bottom left: Cairo. March 30 W Holman
Hunt / 1854 [this year probably a later addition]
Verso, in pencil: No 1
Presented by Barrow Cadbury, 1946 (P18'46)

PROVENANCE: Barrow Cadbury, by whom presented

REFERENCES: Birmingham, *Paintings &c.*, [1930],
Supplement III, 1951, p. 39; Liverpool and London, 1969,
no. 132, pl. 53; London, Tate, 1984, p. 161

Hunt had been planning his "Eastern project" for two
or three years before setting off for Egypt on 16 January 1854,
travelling via Paris and Marseilles to Alexandria. Combining
strong religious convictions with the Pre-Raphaelite belief in
'truth to nature', he had decided that the biblical subjects he
wanted to paint would have to be begun in the Holy Land.
His resolve was strengthened by the support of friends and
patrons such as Millais and Thomas Combe; by the immedi-
ate offer from the art dealer Thomas Agnew of 500 guineas
for the first picture produced (as it transpired, wisely declined
by Hunt); and by meeting former travellers to Egypt, includ-
ing Edward Lear (1812–1888) and the archaeologist Austen
Henry Layard (1817–1894).[1]

He arrived in Cairo in February, where he made a planned
rendezvous with the painter Thomas Seddon (1821–1856).
Hunt was instantly enthralled by the sights and sounds of the
city, finding sleep difficult on his first night:

> The noise of life was like the ringing bells of a festa,
> and it was impossible to turn one's eyes from the open
> window, where each minute brought forward a new
> scene, each scene being one of the perennial dramas of
> the East, heard of, imagined often, but hitherto cut off
> from me by the intervening leagues of sea.[2]

As well as working on small watercolours of the Pyramids,
usually in Seddon's company, Hunt began sketches for a fig-
ure subject set in the streets of Cairo. This would become *The
Lantern-Maker's Courtship* (Birmingham collection; fig. 36),
which was finished back in England and finally exhibited at
the Royal Academy in 1861.[3] Its title refers to the young man's
surreptitious, but prohibited, attempt to glimpse his future
bride's face.

A study for the shop doorway in this painting, now unlo-
cated, bears the date 2 March 1854.[4] The present sheet
approximates the finished form of the righthand background,
even to the indication of a heavily laden camel almost filling
the narrow thoroughfare. Missing, however, is the curious
overhead wooden superstructure that spans the street; Hunt
may have remembered what must have been a temporary
arrangement for the celebrations of the betrothal of the Pasha
of Egypt's son to the Sultan of Turkey's daughter. In a letter of
12–13 March 1854 to Rossetti, he describes returning

> from a walk around the town every space is filled as at a
> fair but the impression it renders is very different all the
> narrow streets covered in above with trellis work and
> matting [which] have lamps suspended in various devices
> throughout while the little square openings (which serve
> as shops but which are more like cupboards), are occu-
> pied by the proprietor and his friends all smoking in
> sphynx-like regard in front of the richest hangings
> which the shop can produce.[5]

1. Hunt, 1905, vol. 1, pp. 328–334, 344, 346; Lear paid his second visit
to Egypt in December 1853, hoping to travel with Hunt on his arrival,
but their travel plans coincided for only a week in Cairo during March
1854, at which time Lear had to return to England (Lutyens, 1974, p. 58).
2. Lutyens, 1974, p. 373.
3. London, Tate, 1984 (86, repr.).
4. Last exhibited in London at Millbank, 1923, no. 291; reproduced in
Gazette des Beaux-Arts, vol. 36, 1887, p. 403.
5. Lutyens, 1974, pp. 55–56.

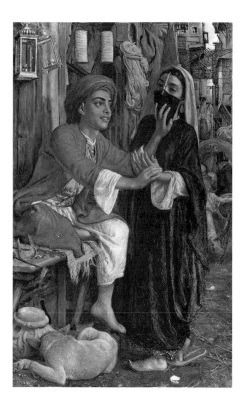

Fig. 36 WILLIAM HOLMAN HUNT, *A Street Scene in Cairo: The Lantern-Maker's Courtship*, 1854–1856, 1860–1861; oil on canvas, 21 1/2 x 13 3/4 in. (54.6 x 35.0 cm.). Birmingham Museums and Art Gallery (P68'62).

Cairo, March 30. W Holman Hunt
1854

133

29

WILLIAM HOLMAN HUNT

*The Finding of the Saviour in the Temple:
study for the Holy Family*

1854
Pencil
10 x 8 in.; 25.5 x 20.5 cm.
Inscribed in pencil, verso, by Gladys Holman Hunt:
First Study for Finding of Christ in the Temple
Presented by Association of Friends of Birmingham
Museums and Art Gallery, 1985 (1985 P 64)

PROVENANCE: The artist, by descent to Mrs Elizabeth Burt; her
sale, Sotheby's, 10 October 1985, lot 21 (repr.), where purchased

REFERENCES: Liverpool and London, 1969 (154)

In a long letter of 16 March to Millais, Hunt bemoaned
the difficulty he encountered in Cairo in obtaining models to
sit for him, both due to the constraints of oriental society and
from the uncertainty of knowing what features might lie be-
neath the veil. He found less trouble with children than with
adults, making many quick sketches and finally finding one
sitter who posed long enough to inspire a single-figure painting,
The Afterglow in Egypt (Southampton Art Gallery), completed
in 1863: "I prevailed upon the friends of a full-grown damsel to
allow her to sit to me for an oil picture, but I had to undertake
my work in an open cave under the plateau of the Pyramids,
at times convenient for the girl, and at short notice".[1]

Such informal sketches must have been pressed into ser-
vice when Hunt had to leave Cairo. Seddon managed to
arrange passage to Jaffa and the Holy Land, and it was on the
boat ride down the eastern branch of the Nile to Damietta
that Hunt turned his thoughts to preparation for a more
important painting:

> I had already decided on the subject of "The Finding of
> Christ in the Temple" as that to which I should devote
> myself on my arrival in Jerusalem. The working out of
> the design was a most appropriate occasion for the
> leisure of life on a boat, going down the stream with no
> disturbance but that of the morning swim and the
> hour's constitutional on the banks after luncheon, when
> an occasional shot secured supplies for the cook.[2]

This design for the figure group of the Holy Family in
The Finding of the Saviour in the Temple (Birmingham collec-
tion; fig. 37)[3] was probably a product of the boat trip, as the
head of the Christ child is similar to studies of Egyptian boys
made during a break in the journey at Seminood on 14 May.
It is unusual among Pre-Raphaelite drawings in showing the
artist's progressive changes of mind about the stance of the
figures; such 'working' sheets were more usually consigned to
destruction. Hunt was adamant, however, even in such

adverse circumstances, about "the very important advantage
of studying positions from the nude".[4]

Two additional studies incorporating these figures, which
were further refined as a more tightly knit group in which
Christ steps forward with his left foot, must have been made
after Hunt's arrival in Jerusalem on 3 June.[5] Both studies show
the row of seated rabbis which would remain essentially
unchanged over the long gestation of the painting, although
again Hunt found it difficult to obtain sitters. He recalled
later that "for the principal figures I cautiously made separate
studies to determine the racial type, knowing that the discov-
ery that my picture was more than an assemblage of Jewish
Rabbis – which I had truly explained it as being – would, in
the temper then existing, prevent any other Israelites from sit-
ting to me then or on future visits".[6]

In his memoirs, Hunt records having begun work on the
canvas itself in Jerusalem, laying in the perspective and outlines
of the figures, based on those life drawings he had managed to
make. On his return to England in February 1856, he immedi-
ately found new models in boys from Jewish schools in London,
but he did not continuously work on the painting, completing
it only in 1860. His patience was rewarded with its hugely suc-
cessful exhibition that year at the German Gallery in Bond
Street, and its sale to the dealer Ernest Gambart for £5,500 (or
more probably, 5,500 guineas), which was to remain the high-
est sum paid to a living artist in the nineteenth century.

1. Hunt, 1905, vol. 1, p. 382.
2. Hunt, 1905, vol. 1, p. 391.
3. Birmingham, *Paintings*, 1960, pp. 78–79; London, Tate, 1984, no.
85, repr.
4. Hunt, 1905, vol. 1, p. 408.
5. Sotheby's, 10 October 1985, lots 33 (repr.) and 34; the latter was also
purchased for the Birmingham collection (1985 P 65).
6. Hunt, 1886, p. 218.

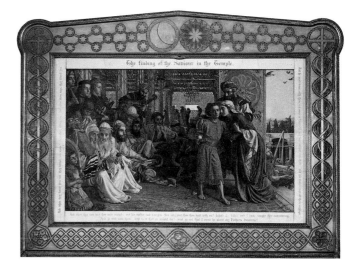

Fig. 37 WILLIAM HOLMAN HUNT, *The Finding of the Saviour in the
Temple*, 1854–1860; oil on canvas, 33 3/4 x 55 1/2 in. (85.7 x 141.0 cm.),
in frame designed by the artist. Birmingham Museums and Art
Gallery (80'96).

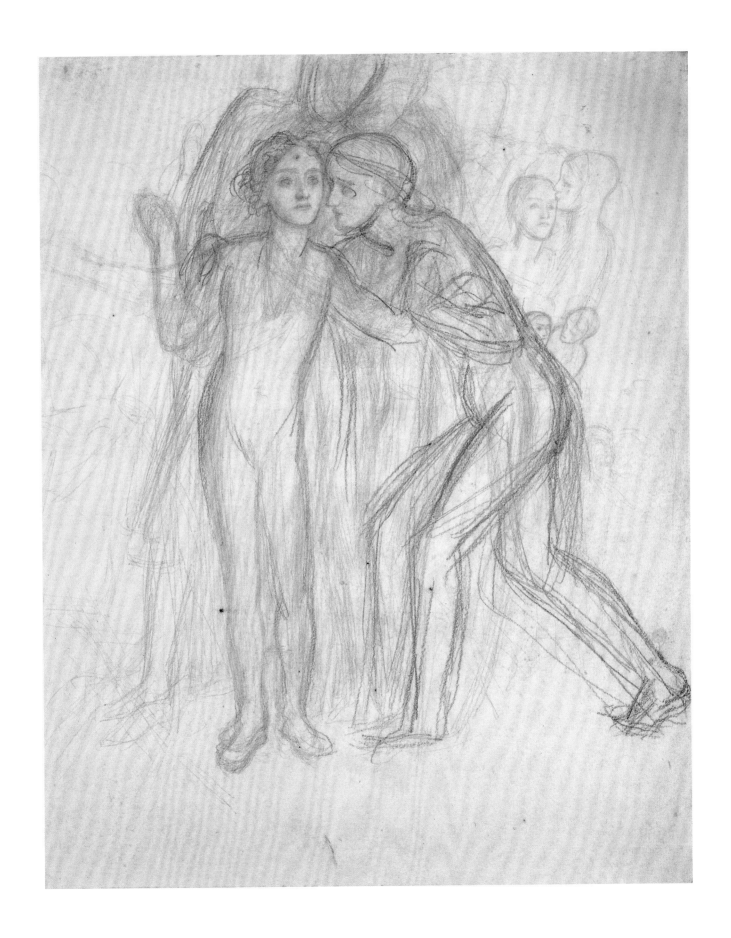

30

WILLIAM HOLMAN HUNT

The Dead Sea from Siloam

1854–1855
Watercolour and bodycolour over pencil
9 3/4 x 13 3/4 in.; 24.8 x 34.8 cm.
In original frame, designed by the artist
Presented by Edward Morse, through the National Art
Collections Fund, 1948 (P13'48)

PROVENANCE: T.E. Plint; his sale, Christie's, 7 March 1862
(lot 194), bought Moore (63 guineas); James Leathart, by
1873; his sale, Christie's, 19 June 1897 (lot 5), bought Leggatt;
Sydney Morse, by 1905

EXHIBITED: London, Royal Academy, 1856 (873), as *View
from the Mount of Offence looking towards the Dead Sea and
the Mountains of Moab – Morning;* German Gallery, 168
New Bond Street, London, 1861; Liverpool Academy, 1862
(681); Old Water Colour Society, 1883 (268)

REFERENCES: Birmingham, *Paintings &c.,* [1930],
Supplement III, 1951, p. 39; Liverpool and London, 1969, no.
163; New Haven, Cleveland and Birmingham, 1992–1993
(24, repr.)

In the winters of 1854 and 1855, Hunt embarked on a series of watercolours of Jerusalem and its surrounding landscape, working up initial pencil sketches into brilliantly coloured finished pictures. He first visited the Dead Sea in the company of the Reverend W.J. Beaumont, arriving there on 24 October 1854. This subject must have been begun then, for in a letter of 7 September 1855 to Thomas Combe, Hunt wrote that "tomorrow I am to rise ere the sun, to go out to finish a sketch which I commenced on the mount of Offence, the hill above Siloam, last year about this time".[1]

This reference seems to confirm that the work was shown at the Royal Academy in 1856, along with two other watercolours – *Jerusalem by Moonlight* (Whitworth Art Gallery, University of Manchester) and *The Sphinx, Gizeh* (Harris Museum and Art Gallery, Preston) – and the oil painting *The Scapegoat* (Lady Lever Art Gallery, Port Sunlight; fig. 2). Hunt's second visit to the Dead Sea was primarily to work on *The Scapegoat:* he spent almost two weeks of November 1854, in dangerous and uncomfortable conditions, painting from a live goat on the salt-caked shore at Oosdoom.

As Judith Bronkhurst has pointed out, it is likely that Hunt eventually conceived five of his Holy Land watercolours as a sequence, illustrating the vividly contrasting light conditions which he encountered in Egypt and Palestine.[2] While *The Dead Sea from Siloam* captures early morning light, the four others – all now in the Whitworth Art Gallery, University of Manchester – depict daylight, twilight, sunset and moonlight: respectively, *Nazareth, The Plain of Rephaim*

from Mount Zion, Cairo: Sunset on the Gebel Mokattum and *Jerusalem by Moonlight (The Mosque As Sakrah, Jerusalem, during Ramazan).* Uniformly framed according to the artist's own design, with arabesque and Islamic geometrical patterning, the five watercolours were shown together in 1861 to complement the continuing exhibition of *The Finding of the Saviour in the Temple* at the German Gallery in Bond Street, in an adjoining room. The Leeds collector Thomas E. Plint bought all five, for a sum variously cited as 700 guineas and £1,250.[3]

Attempting to convey the dazzling effect of unshaded sunlight on a rocky landscape, Hunt contrived a method of juxtaposing small touches of very bright colour, leaving much of the white paper exposed for contrast, with a few touches of opaque bodycolour in the foreground (especially on the figure, which is almost invisible at first glance). Reviewing the 1861 exhibition, the critic of the *Athenaeum* was struck by this watercolour's "purple shadows and zones of light", especially admiring the effect of "a bar of faintest white in the mid-distance indicating the Dead Sea, show mist intervenes like a trembling veil between us". A subsequent notice in the same magazine, when the work was shown at the Old Water Colour Society in 1883, called it "absolutely grand in its simplicity and searching draughtsmanship, but more like a mosaic than a picture. Accepted as a sketch produced with energy and concentration of the artist's powers of observation, it is on that account very remarkable".[4]

1. Quoted by Mary Bennett in Liverpool and London, 1969, no. 163, p. 77.
2. London, Tate, 1984, no. 201, p. 269.
3. London, Tate, 1984, p. 269.
4. Quoted by Mary Bennett in Liverpool and London, 1969, no. 163, p. 77.

THE DEAD SEA FROM SILOAM.

WILLIAM HOLMAN HUNT. O.M.
1827 — 1910.

P.13·48

31

JOHN EVERETT MILLAIS

Waiting

1854
Oil on wood panel
12 3/4 x 9 3/4 in.; 32.4 x 24.8 cm.
Signed and dated, bottom right: JM 1854 (initials in monogram)
Presented by Mrs Edward Nettlefold, 1909 (62'09)

PROVENANCE: Joseph Arden; his sale, Christie's, 24 April 1879, lot 29, as *Landscape with a girl at a stile*; bought Tooth; Edward Nettlefold

REFERENCES: Birmingham, *Paintings*, 1960, p. 100; London and Liverpool, 1967 (43); Staley, 1973, p. 53, pl. 22; London, Tate, 1984 (59, repr.)

*M*illais did not submit a picture to the Royal Academy's exhibition of 1854. Determined to complete the portrait of John Ruskin, which he had begun during their celebrated sojourn at Glenfinlas the previous summer, Millais returned to the Scottish Highlands in May to finish the landscape background. The painting (now in a private collection) was delivered in December to the critic's father, who had commissioned it.[1]

At Glenfinlas, Millais had also painted a small oil on panel of Ruskin's wife Effie seated on rocks a little further downstream from the site of her husband's portrait.[2] Such smaller paintings, known as 'cabinet pictures', found a ready market among collectors: under the title of *The Waterfall*, that example was sold immediately to Benjamin Windus (see cat. no. 20), who already owned *The Bridesmaid*, another small panel by Millais (1851; Fitzwilliam Museum, Cambridge). It has been suggested that *Waiting* is also a study of Effie, but there is no supporting evidence for this.[3] Millais and Effie, who were to marry in 1855 after the annulment of her marriage to Ruskin, had little opportunity to meet during 1854, and the spring-like landscape suggests that the painting was done by the time the artist left for Scotland.

Although it carries all the brilliant colour of Millais's earlier landscapes, *Waiting* contains less of the precise detailing of nature that is associated with Ruskinian Pre-Raphaelitism. The foreground is a summary exercise in shades of green, with only random suggestions of individual blades of grass, and the stone wall is distinctly lacking in the geological precision urged on Millais by Ruskin at Glenfinlas. While the very small scale of the panel is a factor in determining the degree of detail, its presentation as a finished work did lead contemporary critics to comment on an apparent relaxation of effort. In an article of 1857 on the collection of Joseph Arden, the painting's first owner, the *Art Journal* noted in

Waiting "greater breadth of manipulation than is generally found in Millais's works".[4]

Alternatively, as Allen Staley has pointed out, it can be argued that Millais is beginning here to demonstrate signs of an independence from slavish observation of natural detail, pursuing instead a more effective visual and emotional suggestion of atmosphere and mood. There seems to be no narrative attached to *Waiting* (a title first used in M.H. Spielmann's catalogue on Millais's work in 1898; the painting was previously called simply *The Stile*). Its subject nonetheless achieves a harmony between the depiction of young womanhood and the beauty of nature, which indeed largely depends on a treatment deliberately or unconsciously lacking intellectual purpose.

1. London and Liverpool, 1967 (42, repr.), and London, Tate, 1984 (56, repr.).
2. Delaware Art Museum, Wilmington (Samuel Bancroft Collection); see Elzea, 1984, pp. 72–73 (repr.) and London, Tate, 1984 (55, repr.).
3. Elzea, 1984, p. 74, in discussing *The Highland Lassie*, also at Wilmington, adds that the picture was once erroneously suggested as a study for *Waiting*. Annie Miller, Hunt's protégée, has also been proposed as the model, but without any supporting evidence.
4. Quoted in Staley, 1973, p. 53.

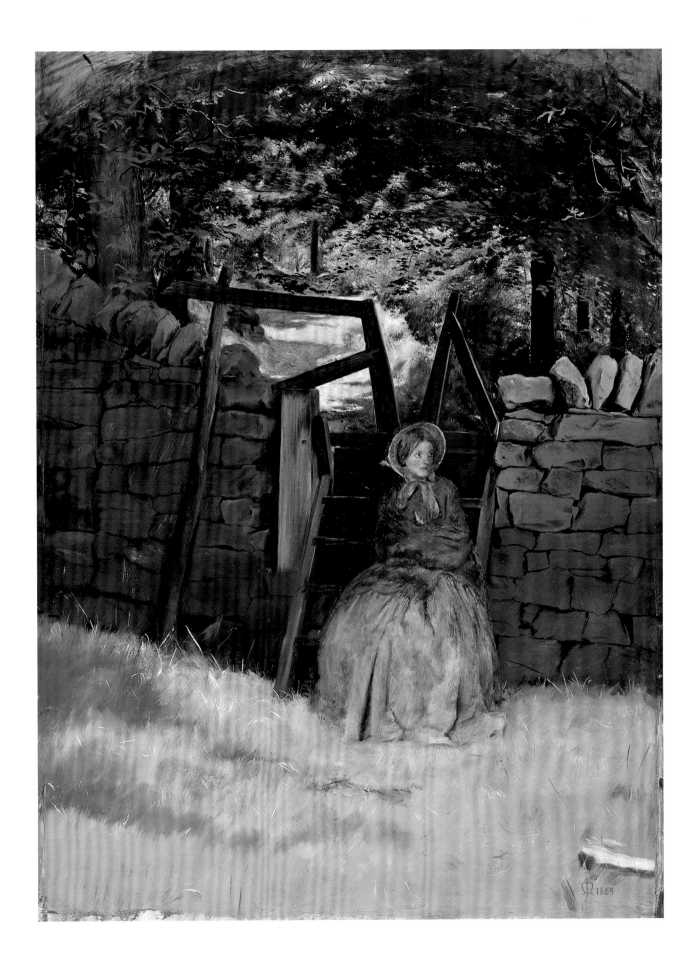

JOHN EVERETT MILLAIS

The Rescue: preliminary cartoon

1855
Pencil, charcoal, red and brown chalk
39 3/8 x 28 1/4 in.; 99.9 x 71.8 cm.
Presented by Edward Nettlefold, 1901 (41'01)

EXHIBITED: London, Grosvenor Gallery, 1886 (149, lent by
D. Bates)

REFERENCES: Birmingham, *Drawings*, 1939, p. 270; London,
Tate, 1984, p. 133; Robyn Cooper, "Millais's *The Rescue:*
A Painting of a 'Dreadful Interruption of Domestic Peace',"
Art History, vol. 9, no. 4, December 1986, p. 482, pl. 52.

The Rescue (National Gallery of Victoria, Melbourne; fig.
38) was one of two paintings of modern-life subjects that were
begun by Millais in 1854 and were the first he had attempted.
Conceived late in the year after a good deal of work on *The
Blind Girl* (see cat. no. 38), it was rapidly completed just in
time for submission to the Royal Academy in April 1855. In
the company of his brother William, the artist had witnessed
the fighting of a fire near Meux's brewery, close to Tottenham
Court Road in central London: "We went home", recalled
William, "much impressed with what we had seen, and my
brother said, 'Soldiers and sailors have been praised on canvas
a thousand times. My next picture shall be of the fireman'."[1]

Fires were common occurrences in Victorian London,
and Millais had the opportunity to visit several others, even
being interrupted at dinner by a friendly fire brigade captain
in order to catch "a first-class blaze".[2] On beginning the pic-
ture, however, he did not ask a real fireman to pose, but
instead employed a professional studio model named Baker,
according to the detailed testimony of his artist friend
Frederick Barwell, whose studio Millais used:

> After several rough pencil sketches had been made, and
> the composition determined upon, a full-sized cartoon
> was drawn from nature. Baker, a stalwart model, was the
> fireman, and he had to hold three children in the proper
> attitudes and bear their weight as long as he could, whilst
> the children were encouraged and constrained to do their
> part to the utmost. The strain could never be kept up for
> long, and the acrobatic feat had to be repeated over and
> over again for more than one sitting, till Millais had secured
> the action and proportion of the various figures. When
> sufficiently satisfied with the cartoon, it was traced onto
> a perfectly white canvas, and the painting commenced.[3]

In his *Academy Notes* for 1855, Ruskin – who had little
cause to be kind to Millais personally – generously described

The Rescue as "the only *great* picture exhibited this year; but
this is very great. The immortal element is in it to the full",
even acknowledging "a true sympathy between the impetu-
ousness of execution and the haste of the action".[4] Other crit-
ics found the whole subject implausible as an interior scene.
Then, as now, a civilian, albeit a frantic mother, would hard-
ly be allowed to remain in a burning building, and critics
thought the fireman curiously lacking in expression. Baker's
stoicism as a model may have contributed to this, although
the *Critic*'s reviewer discerned how "the firm tread of the fire-
man and his placid expression of countenance, mark
admirably the lofty fortitude of the real hero".[5]

This splendidly vigorous cartoon is a rare example, within
Pre-Raphaelite practice at least, of a full-scale preparatory design;
such work would normally have been done, in simpler form,
on the canvas itself and subsequently obliterated. Ironically, in
this instance Charles Fairfax Murray owned the painting (al-
though not until after 1909) rather than this cartoon, which was
the first Millais drawing to enter the Birmingham collection.

1. Millais, 1899, vol. 1, p. 248.
2. Millais, 1899, vol. 1, p. 257.
3. Millais, 1899, vol. 1, p. 250. Two pencil sketches of the figure group,
of essentially the same composition, are in the Courtauld Institute
Galleries, London (reproduced in Cooper, *Art History*, vol. 9, no. 4,
December 1986, pls. 50, 51).
4. Ruskin, *Works*, 1904, vol. 14, pp. 22–23.
5. *Critic*, 15 May 1855, p. 241; quoted in Cooper, *Art History*, vol. 9,
no. 4, December 1986, p. 479.

Fig. 38 JOHN EVERETT MILLAIS, *The Rescue*, 1855; oil on
canvas, 47 3/4 x 32 7/8 in. (121.3 x 83.5 cm.). National
Gallery of Victoria, Melbourne (Felton Bequest, 1924).

33

DANTE GABRIEL ROSSETTI

*Elizabeth Siddal: study for "Dante's Vision of
Rachel and Leah"*

Circa 1855
Pencil
12 5/8 x 6 1/2 in.; 32.0 x 16.6 cm.
Presented by subscribers, 1904 (262'04)

PROVENANCE: Christie's, Rossetti sale, 12 May 1883, lot 133
(6 guineas); Charles Fairfax Murray

REFERENCES: Birmingham, *Drawings*, 1939, p. 342; Surtees,
1971, no. 74A, pl. 83; London and Birmingham, 1973 (93);
Surtees, 1991 (28, repr.)

The romantic relationship between Rossetti and Elizabeth
Siddal was at its strongest between 1852 and 1855, and gave rise
to a remarkable series of beautiful, intimate portrait drawings.
On two visits to Rossetti, Brown was offered a rare glimpse of
these studies, which were certainly never intended for public
scrutiny. On 7 October 1854, Brown discovered Rossetti, who
should have been at work on *Found* (see cat. no. 34), drawing
"one after an other each one a fresh charm each one stamped
with immortality", and almost a year later, on 6 August 1855,
he was shown "a drawer full . . . God knows how many, but
not bad work I should say for the six years he had known her.

It is like a monomania with him. Many of them are match-
less in beauty however & one day will be worth large sums".[1]

A dozen or more of the existing drawings were made at
Hastings in the summer of 1854, where Lizzie was recuperat-
ing from her recurring neurotic illness. In 1855 both her health
and her work as an artist attracted the solicitous attention of
John Ruskin. He not only bought as many of her drawings as
he could, but he also covered the cost of her further conva-
lescence in the south of France by commissioning five water-
colours from Rossetti, who made unusually strenuous efforts
to complete them in time to join Lizzie in Paris in October.
There he also kept a rendezvous with Munro as well as with
Robert and Elizabeth Browning.

Two of these watercolours were *Dante's Vision of Matilda
gathering Flowers* (now unlocated) and *Dante's Vision of Rachel
and Leah* (Tate Gallery, London; fig. 39), both subjects from
the *Purgatorio*.[2] Clearly the present drawing was used for the
figure of Rachel, but it may not necessarily have been con-
ceived as a study: the inclusion of the half-open card table and
the need to alter the disposition of Rachel's arms rather sug-
gest that Rossetti was making use of a drawing already done
simply as a portrait. This artifice would also explain Ruskin's
sole doubt about the composition, expressed in a letter to his
friend Ellen Heaton, to whom he gave the watercolour: "It is
only *imperfect* because Rachel does not sit easily – but stiffly,
in a Pre-Raphaelite way".[3]

1. Surtees, 1981, pp. 101, 148, respectively.
2. Surtees, 1971, nos. 72, 74.
3. Quoted in Surtees, 1971, p. 35.

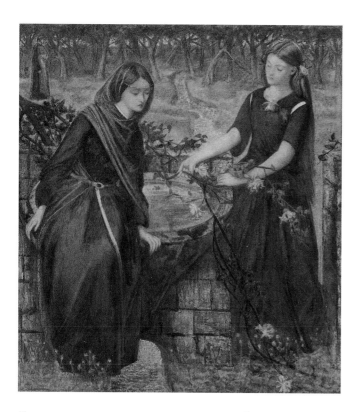

Fig. 39 DANTE GABRIEL ROSSETTI, *Dante's Vision of Rachel and Leah*,
1855; watercolour, 14 x 12 1/2 in. (35.2 x 31.4 cm.). Tate Gallery, London.

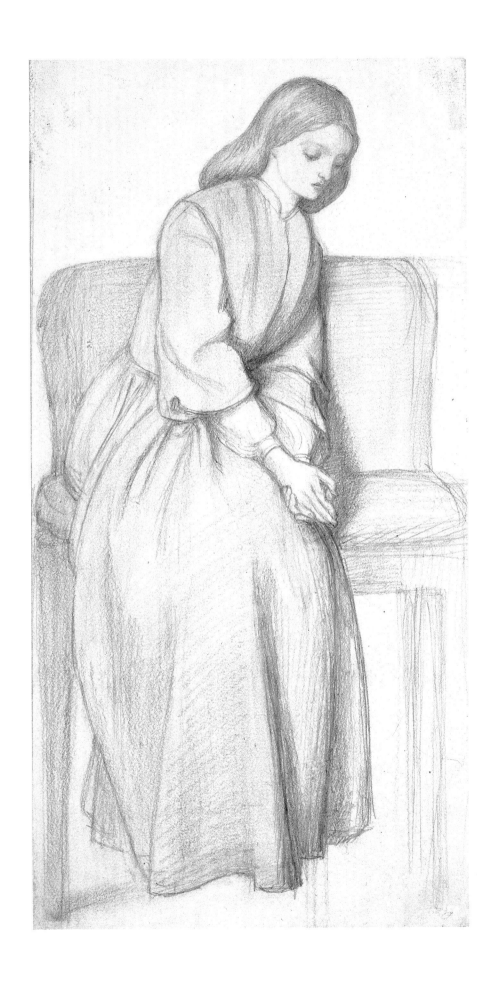

34

DANTE GABRIEL ROSSETTI
Found: compositional design

Circa 1854–1855
Pen and black ink
9 1/4 x 8 5/8 in.; 23.5 x 21.8 cm.
Signed, bottom right: DGR (initials in monogram)
Inscribed in ink, below image: "I remember thee; the kindness of thy youth, the love of thy betrothal". Jerem.II.2. / Found
Presented by subscribers, 1904 (232'04)

PROVENANCE: Christie's, Rossetti sale, 12 May 1883, lot 57 (58 guineas); Charles Fairfax Murray

REFERENCES: Birmingham, *Drawings*, 1939, p. 314, repr. p. 436; Surtees, 1971, no. 64A, pl. 66; London and Birmingham, 1973 (75); Grieve, 1976, p. 3; Oberhausen, 1976, pp. 36–37, fig. 17

Found (Delaware Art Museum, Wilmington; fig. 40) was the only oil painting undertaken by Rossetti of a subject drawn from modern life and with a moral message. Although the image he conceived is forceful and effective, if a little simplistic, he encountered great difficulties in trying to paint directly from nature, in the true spirit of Pre-Raphaelitism, and was obliged to leave the picture incomplete for long periods while he worked more happily on drawings and watercolours. Rossetti's own account of the subject, given in a letter of 30 January 1855 to Hunt (then in Jerusalem), is worth quoting at length:

> The picture represents a London street at dawn, with the lamps still lighted along a bridge which forms the distant background. A drover has left his cart standing in the middle of the road (in which, i.e. the cart, stands baa-ing a calf tied on its way to market), and has run a little way after a girl who has passed him, wandering in the streets. He had just come up with her and she, recognising him, has sunk under her shame upon her knees, against the wall of a raised churchyard in the foreground, while he stands holding her hands as he seized them, half in bewilderment and half guarding her from doing herself a hurt. These are the chief things in the picture which is to be called "Found" and for which my sister Maria has found me a most lovely motto from Jeremiah: "I remember Thee, the kindness of thy youth, the love of thine espousals". Is not this happily applicable?[1]

The same letter includes a disclaimer of any influence by Hunt's *The Awakening Conscience* (Tate Gallery, London), which had been shown at the Royal Academy in 1854. Rossetti reminded Hunt (perhaps with an eye to posterity) that "as you know I had long had in view subjects taking the same direction as my present one", and stated that "the subject had

been sometime designed before you left England". A detailed design in pen and ink, now in the British Museum, London, bears the date 1853.[2] While this is stylistically possible, it would seem to predate by many months the definite commission for an oil painting from the Belfast collector Francis MacCracken, to which Rossetti refers in a letter written in the autumn of 1854.[3] It must have been after this that he made the present revised design, and began the small oil painting on panel now at Carlisle Museum and Art Gallery in England.[4] This was abandoned with only the calf in the cart, the woman's head, and the churchyard wall put in – the latter representing what he told William Allingham was "hateful, mechanical brick-painting".[5]

The complete history of the picture and the relationships among its many preparatory studies, beginning with several simple sketches of the figure group, are fully discussed by both Alastair Grieve and Judith Oberhausen.

1. Quoted in Surtees, 1971, p. 28. Most commentators, from Hunt onwards, have recognised Rossetti's undoubted familiarity with William Bell Scott's poem *Rosabell* (later retitled *Maryanne*), "which contrasted the wholesomeness of the country with the illness and depravity of the city" (Elzea, 1984, p. 98).
2. Surtees, 1971, no. 64B, pl. 67.
3. Doughty and Wahl, 1965–1967, vol. I, p. 219.
4. Surtees, 1971, nos. 64M, 64Q.
5. Doughty and Wahl, 1965–1967, vol. I, p. 227 (letter of 15 October 1854).

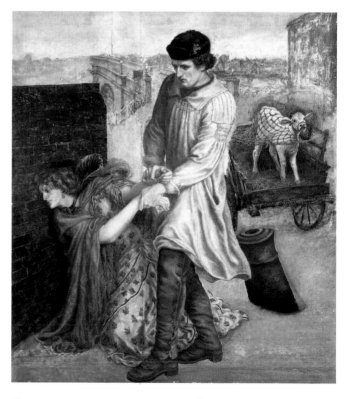

Fig. 40 DANTE GABRIEL ROSSETTI, *Found*, begun 1854; oil on canvas, 36 x 31 1/2 in. (91.4 x 80.0 cm.). Delaware Art Museum, Wilmington (Samuel and Mary R. Bancroft Memorial).

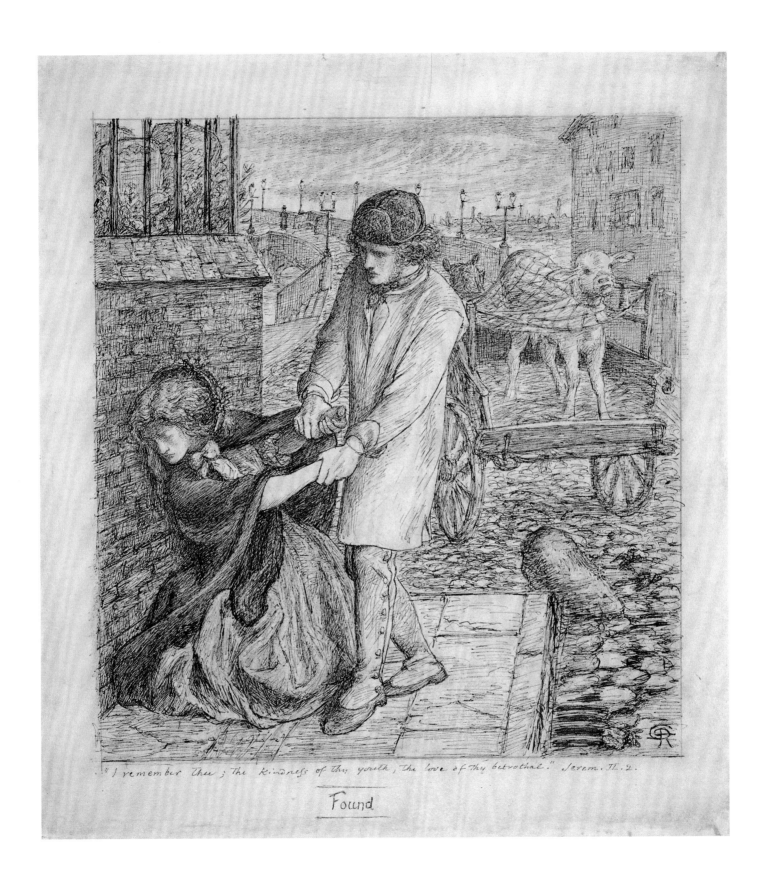

"I remember Thee; the kindness of thy youth, the love of thy betrothal." *Jerem. II. 2.*

Found

35

DANTE GABRIEL ROSSETTI

Fanny Cornforth: study for "Found"

Circa 1859–1861
Pen and black ink, with ink wash
7 x 7 3/4 in.; 17.8 x 19.7 cm.
Presented by subscribers, 1904 (488'04)

PROVENANCE: Fanny Cornforth; Charles Fairfax Murray

REFERENCES: Birmingham, *Drawings*, 1939, p. 315; Surtees,
1971, 64N, pl. 17; London and Birmingham, 1973 (82, pl. IVb);
Grieve, 1976, p. 6, fig. 5; Oberhausen, 1976, p. 38, fig. 20

1. Letter of 27 May 1867 to James Leathart, quoted in Surtees, 1971,
p. 28.
2. See Elzea, 1984, pp. 101–103.
3. See Marsh, 1987, pp. 142, 377–378, for the origins of this anecdote.
4. Surtees, 1981, p. 200 (27 January 1858: "Called on Rossetti . . . then
on with him to Jones'. Saw there, Fanny, their model").
5. See Marsh, 1987, pp. 139–140 and p. 377 for a review of the previously suggested birthdate of 3 January 1824 (given in Baum, 1940).

After the commission from his patron Francis MacCracken (see cat. no. 34) lapsed in 1855, Rossetti abandoned work on *Found* for several years, taking an interest in it again only in 1859 on the offer of 350 guineas from the Newcastle collector James Leathart. The immediate results, however, seem to have been a number of studies in pen and ink of the heads of the man and woman, including this sheet. There is no clear evidence that Rossetti made any attempt to start a new canvas, and in 1867 he was obliged to return advance payments received from Leathart, admitting that the picture had been "untouched and unseen for years".[1] Surprisingly, Rossetti renewed the commission in 1869, this time with William Graham, but he too was destined to be disappointed. Tinkering with it throughout the 1870s, Rossetti did bring the painting close to completion early in 1881, but a good deal of the background was left unfinished at his death in the following year.[2]

The combination in this drawing of precise detail and rough suggestion is very appealing, and must reflect Rossetti's great pleasure in having a new model. Exactly when he met Fanny Cornforth is unclear, but the story of their encounter is plausible enough: walking in the Royal Surrey Gardens with Brown and Burne-Jones, he was attracted by her magnificent golden hair, and contrived to release its cascading tresses.[3] This was probably in late 1857, for Brown's diary records her sitting as a model to both Burne-Jones and Rossetti in January of the following year.[4]

The present sheet would appear to be Rossetti's earliest surviving drawing of her. Barely literate, rather coarse, but full of vitality, she was a natural choice to model for the fallen woman in *Found*, and then in 1859 for *Bocca Baciata* (Museum of Fine Arts, Boston), Rossetti's first attempt at a sensual single-figure female subject. Although her origins remain obscure, she was probably born in the mid-1830s under the name Sarah Cox.[5]

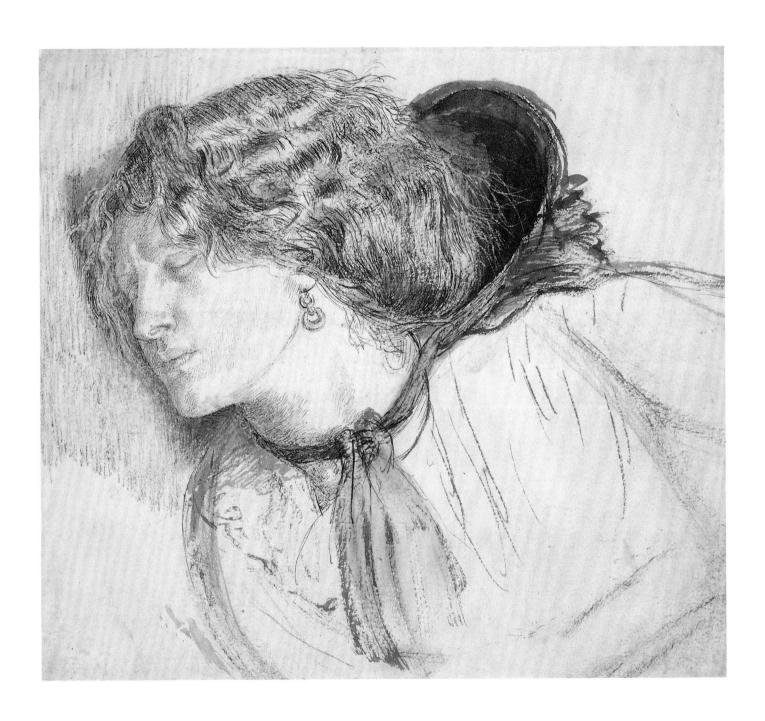

36

DANTE GABRIEL ROSSETTI

Tennyson reading "Maud"

1855
Pen with brown and black ink and brown ink wash
8 1/4 x 6 1/8 in.; 20.7 x 15.5 cm.
Inscribed in brown ink, bottom right: "Maud" / 1855
Presented by subscribers, 1904 (495'04)

PROVENANCE: William Sharp?; William Cosmo Monkhouse, by 1883; his sale, Christie's, 25 November 1901, lot 113 (30 guineas); Charles Fairfax Murray

REFERENCES: Birmingham, *Drawings*, 1939, pp. 352–353, repr. p. 428; Fredeman, 1963, pp. 117–118, fig. 25; Surtees, 1971, 526.R.2, pl. 420; London and Birmingham, 1973 (47, pl. IVb).

At a social gathering in the home of Robert and Elizabeth Barrett Browning on the evening of 27 September 1855, Rossetti made an impromptu sketch of Alfred Tennyson (1809–1892) reading one of his favourite poems, "Maud".[1] The drawing was offered to his host as a gift, but presumably not until Rossetti had made at least the first of two copies of it, similar but not quite identical in detail and technique. One was done for Elizabeth Siddal, then in Paris. This is the second replica, possibly made quite some time after the event, but arguably the strongest drawing and certainly the best known, especially as the 'Browning' and 'Siddal' versions are currently unlocated.[2]

According to a note by William Michael Rossetti, "The Poet Laureate neither saw what [Rossetti] was doing, nor knew of it afterwards. His deep grand voice, with slightly changing intonation, was a noble vehicle for the perusal of mighty verse. On it rolled, sonorous and emotional. . . . Truly a night of the gods, not to be remembered without pride and pang".[3] Elizabeth Browning was similarly captivated by Tennyson's curious combination of confidence and naïveté: "Think of his stopping in 'Maud' every now and then. 'There's a wonderful touch! That's very tender! How beautiful that is!' Yes, it was wonderful, tender and beautiful, and he read exquisitely in a voice like an organ, rather music than speech".[4]

In common with other Pre-Raphaelites, Rossetti was an enthusiast for the early poetry of Tennyson, which gained him a place in the Brotherhood's 'List of Immortals', drawn up in 1848 (he even received a star, although Browning got two!). The rather grand persona which Tennyson adopted after becoming Poet Laureate in 1850 clearly lessened Rossetti's respect, albeit with the admission that he remained "quite as glorious in his way as Browning in his, and perhaps of the two even more impressive on the whole personally".[5] *Maud*, a collection of short poems published in 1855, initially received mixed reviews, and Rossetti's own opinion of the

book was equivocal. Writing to William Allingham in August 1855, he recorded his disappointment: "Of course much is lovely – especially the garden scene [in "Maud"] – but much is surely artificial, and some very like rubbish . . . after all this abuse one mustn't miss saying how glorious some of the poetry is, and how admirable in its way the "Brook" is throughout. The other poems seem not quite up to T.'s mark. . . ."[6]

1. According to Virginia Surtees, this was in lodgings at 13 Dorset Street, Manchester Square, London; see London and Birmingham, 1973, p. 26.
2. Fredeman, 1963, gives a full account of the history of all three drawings, and reproduces the two others from old photographs.
3. Quoted in Surtees, 1971, p. 199.
4. Quoted in Grasmere and Lincoln, 1992, p. 67.
5. Doughty and Wahl, 1965–1967, vol. 1, p. 282 (to William Allingham, 25 November 1855).
6. Doughty and Wahl, 1965–1967, vol. 1, pp. 266–267.

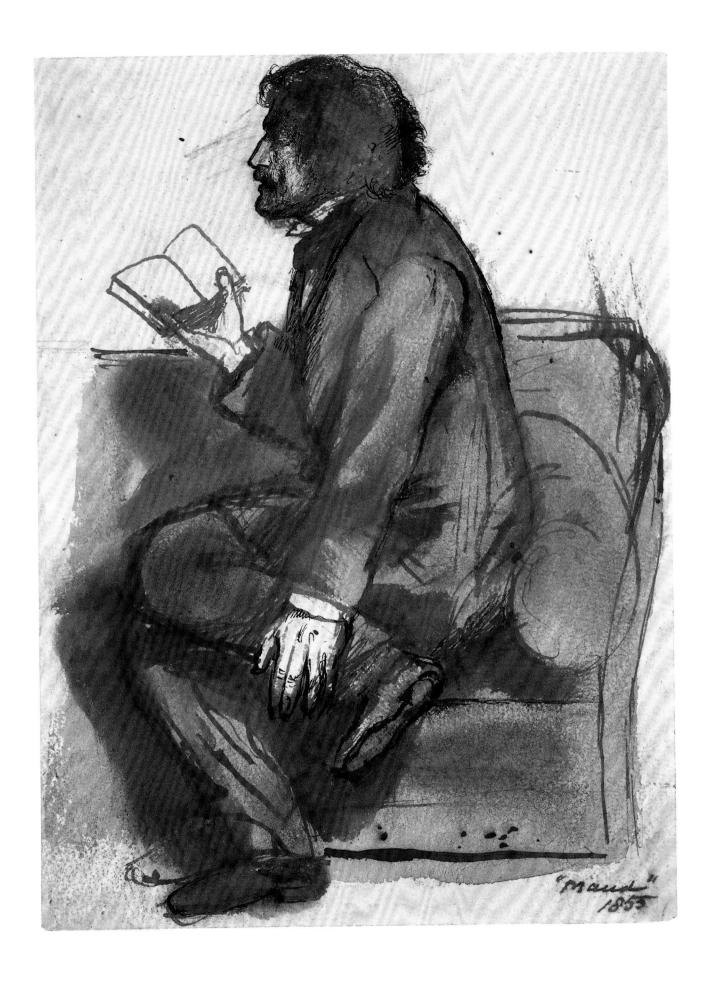

"Maud"
1855

37

FORD MADOX BROWN

The Prisoner of Chillon: study of a corpse

1856
Pencil
6 1/2 x 11 in.; 16.5 x 28.0 cm.
Inscribed, bottom right: FMB University Hospital / Study
for prisoner of / Chillon / from Corpse FMB
Verso: Decorative designs of, or for, the moulding of a frame
Bequeathed by J.R. Holliday, 1927 (000'27)

REFERENCES: Birmingham, *Drawings*, 1939, p. 42; Liverpool,
1964 (78); Brighton, Museum and Art Gallery, *Death,
Heaven and the Victorians*, 1970 (47); London, Victoria and
Albert Museum, *Byron*, 1974 (S25, pl. 81)

*B*rown's diary for 4 March 1856 records how he "came
home & found Dalziel here with a note from Rossetti, wants
me to do him a Prisoner of Chilon [*sic*] on Wood".[1] This piece
of disinterested patronage from Rossetti introduced Brown to
the art of reproductive wood engraving, which as practised by
the brothers George and Edward Dalziel became an impor-
tant sphere of Pre-Raphaelite activity in the late 1850s.[2]

The specific request was for an illustration to Byron's poem
"The Prisoner of Chillon", in a compilation entitled *The Poets*

of the Nineteenth Century, selected and edited by the Reverend
Robert Willmott (fig. 41). Published in 1857, it was also to
include two designs by Millais. Brown negotiated a fee of £8,
and typically spent the best part of a fortnight on the design:
a compositional study was also bequeathed to Birmingham by
J.R. Holliday (353'27), and another is in the British Museum,
London. Never one to waste effort, however, Brown made a
watercolour version which was bought by the collector
Thomas Plint (Yale Center for British Art, New Haven).

Brown was a lifelong admirer of Byron's poetry, and had
already been inspired by the romantic gloom of "The Prisoner
of Chillon", in an albeit unsatisfactory oil painting of 1843
(Manchester City Art Gallery).[3] The stoical hero of the poem
is imprisoned in a dungeon with his two brothers, each
chained to a column, and is forced to watch both die.

In a rather macabre pursuit of Pre-Raphaelite truth to
nature, Brown asked his friend John Marshall, an assistant
surgeon at University College Hospital, London, and later
Professor of Anatomy to the Royal Academy, to arrange access
to a real corpse. Brown recorded in his diary for 13 March 1856:

> It was in the vaults under the dissecting room. When I
> saw it first, what with the dim light, the brown &
> parchment like appearance of it & the shaven head, I
> took it for a wooden [s]imulation of the thing. Often as
> I have seen horrors I really did not remember how
> hideous the shell of a poor creature may remain when
> the substance contained is fled. Yet we both in our joy
> at the obtainment of what we sought declared it to be
> lovely & a splendid corps[e].[4]

1. Surtees, 1981, p. 165.
2. See *The Brothers Dalziel: A Record of Work 1840–1890*, 1901, and
Casteras (ed.), 1991.
3. Treuherz, 1993, pp. 11–12, pl. 3.
4. Surtees, 1981, p. 167.

Fig. 41 BROTHERS DALZIEL, after FORD MADOX BROWN,
The Prisoner of Chillon, 1857; wood engraving, 4 7/8 x 3 3/4
in. (12.5 x 9.5 cm.). The Reverend R. Willmott, *The Poets
of the Nineteenth Century*, London, 1857, p. 111.

JOHN EVERETT MILLAIS

The Blind Girl

1854–1856
Oil on canvas
32 1/2 x 24 1/2 in.; 82.6 x 62.2 cm.
Signed and dated, bottom right: J Millais / 1856 (initials in monogram)
In contemporary frame
Presented by William Kenrick, 1892 (3'92)

PROVENANCE: Bought by Ernest Gambart, 1856; John Miller, Liverpool, by 1857; sold Christie's, 21 May 1858, lot 171 (300 guineas); David Currie, by 1861; William Graham; his sale, Christie's, 2 April 1886, lot 89 (830 guineas); Albert Wood, by 1891; bought from him by William Kenrick

EXHIBITED: London, Royal Academy, 1856 (586); Birmingham, Society of Artists, 1856 (113); Edinburgh, Royal Scottish Academy, 1856 (89); Liverpool Academy, 1857 (124); Birmingham, 1891 (189)

REFERENCES: Birmingham, *Paintings*, 1960, p. 100; Bennett, 1962, pp. 749–750, pl. II; London and Liverpool, 1967 (51); Staley, 1973, pp. 53–56, pl. 23; London, Tate, 1984 (69, repr.)

The Blind Girl represents Millais's most successful combination of figure and landscape, addressing both a poignant subject of social concern as well as the difficult technical treatment of an elaborate outdoor view under specific weather conditions.

Their rough, stained clothing identifies the two children as vagrants, dependent on charity; the elder girl has, pinned to her dress, a note labelled 'PITY THE BLIND'. The viewer's sympathies are thus simply but directly aroused: William Michael Rossetti considered the composition "a most pathetic thought, treated in a spirit which may be called religious".[1] Interestingly, this was also Ford Madox Brown's reaction on first seeing the work, which he deemed "altogether the finest subject[,] a glorious one[,] a religious picture".[2] While it may indeed offer an echo of Brown's *The Pretty Baa-Lambs* (cat. no. 18), which is more overtly readable as an image of the Madonna and Child, *The Blind Girl* presents a simple narrative through a Ruskinian interpretation of nature as a symbol of divine handiwork. None of the beauty of the landscape, brilliantly illuminated after a passing shower, can the blind girl see. In William Michael Rossetti's description:

> The glory of a double rainbow is in the dark-grey sky; the waving luxuriant meadow-grass is laughing again in bright cool sunshine; crows, sheep, and cattle rejoice in its return, and a butterfly settles on her worn dress. Of all this she knows only what she can *feel* – the mild warmth of the sun, but not its splendour; she only knows

the presence of her sister, who is turning round to gaze upon the rainbow, by holding her hand, and the hare-bells which cluster the bank only by fingering them.[3]

The inadequacy of the sense of hearing which is left to her is underlined by the presence of the concertina – the tool of her trade as a beggar, but one whose harsh sound is implicitly contrasted with the tranquil animation of the countryside.

The background was begun first, and is an accurate view of Winchelsea in Sussex, which Millais had visited in 1852 in the company of William Holman Hunt and Edward Lear. It occupied him from late August to October 1854, when he reported work on the rainbow in a letter to John Leech (the fainter part of the double arc had to be repainted when it was declared inaccurate by a correspondent in the *Art Journal* of August 1856).[4] Staley has rightly observed that this discreet hilltop panorama is not merely one of the most brilliant and appealing passages in all Pre-Raphaelite painting, but it also plays a part in reinforcing the 'message' of the picture, which is to celebrate "the joys inherent in the possibility of sight".[5] In a later description of the painting, not having mentioned it in his *Academy Notes*, Ruskin recognised Millais's faithfulness in detailing what he thought were "entirely uninteresting [houses], but decent, trim, as human dwellings should be, and on the whole inoffensive – not 'cottages', mind you, in any sense, but respectable brick-walled and slated constructions . . . with a pretty little church belonging to them, its window traceries freshly whitewashed by order of the careful wardens".[6]

The middle ground and figures were completed at Perth in Scotland, where Millais took his new bride Effie (formerly Mrs Ruskin) in the summer of 1855. A journal kept by Effie records that initially she modelled for the figure of the blind girl, suffering some discomfort as she sat in full sunlight: "I had a cloth over my forehead [*sic*] and this was a little relief but several times I was as sick as possible".[7] Millais was unhappy with the result, however, and replaced her features with those of Matilda Proudfoot; her friend Isabella Nicol sat for the figure of the sister. These two Perth girls were also used as models in *Autumn Leaves* (Manchester City Art Gallery), which Millais began soon afterwards. The last thing to be painted was the blind girl's amber-coloured petticoat (replacing a striped brown and yellow one, with which Millais was dissatisfied), which Effie borrowed from an old woman she had seen in a shop: "She swore an oath and said what could Mrs Millais want with her old Coat, it was so dirty, but I was welcome. I kept it two days and sent her it back with a shilling and she was quite pleased".[8]

The Blind Girl attracted a certain amount of contemporary criticism, especially when it was awarded the Liverpool Academy's prize of £50. Again according to William Michael

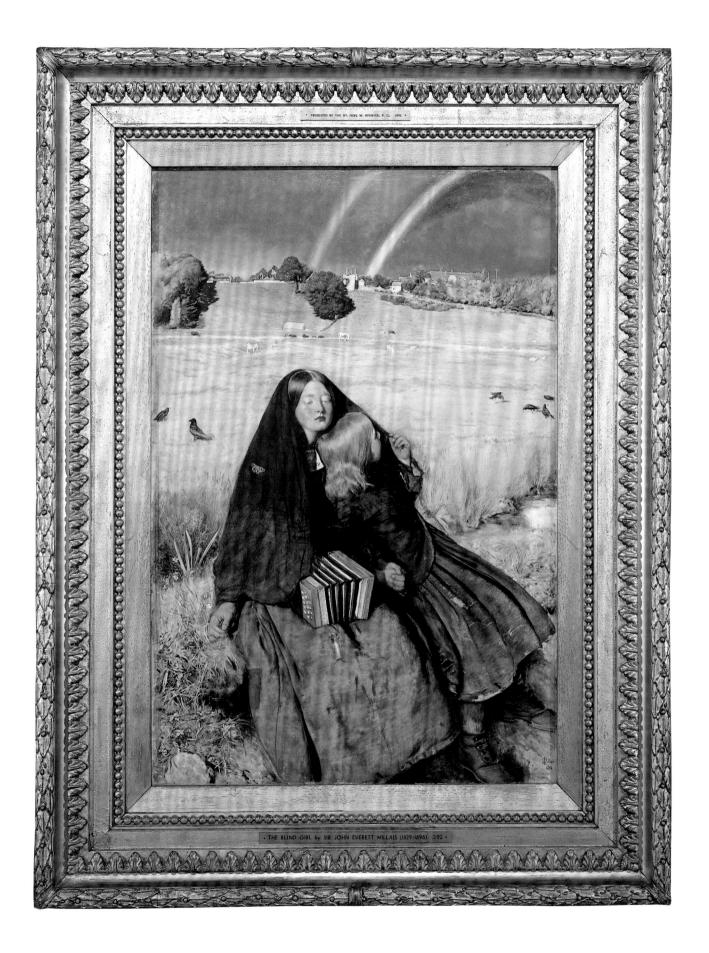

THE BLIND GIRL by SIR JOHN EVERETT MILLAIS (1829-1896) 3'92

Rossetti, it was characterised as "crude", an accusation that referred both to the dirtiness of the figures and to the generalised handling in some passages; Brown also remarked that Millais had "scamped the execution".[9] On a larger scale than *Waiting* (cat. no. 31), Millais's painting does show the same move towards selectivity of detail – Ruskin praised "the weeds at the girl's side as bright as a Byzantine enamel" – balanced against the use of broader brushwork, as in the meadow and the grasses of the stream. The choice of handling, however, is surely deliberate rather than careless, with Millais succeeding admirably in capturing the rather unreal impression of vivid detail seen in the sunshine following a summer storm, a meterological effect which William Michael Rossetti affirmed "peculiarly tends to bring out the remoter lighted objects clearly in form and detail".[10]

1. Rossetti, 1867, p. 219, reprinting a notice first published in the *Spectator*, a London magazine.
2. Surtees, 1981, p. 169 (diary entry for 11 April 1856).
3. Rossetti, 1867, p. 219.
4. Details cited by Malcolm Warner in London, Tate, 1984, pp. 134–135.
5. Staley, 1973, p. 54.
6. "The Three Colours of Pre-Raphaelitism", an essay which appeared in two parts in the magazine *Nineteenth Century*, vol. 4, November/December 1878; Ruskin, *Works*, 1908, vol. 34, p. 150.
7. Quoted by Mary Bennett in London and Liverpool, 1967, p. 39, and by Malcolm Warner in London, Tate, 1984, p. 134.
8. Quoted by Mary Bennett in London and Liverpool, 1967, p. 39, and by Malcolm Warner in London, Tate, 1984, p. 134.
9. Surtees, 1981, p. 169.
10. Rossetti, 1867, p. 221.

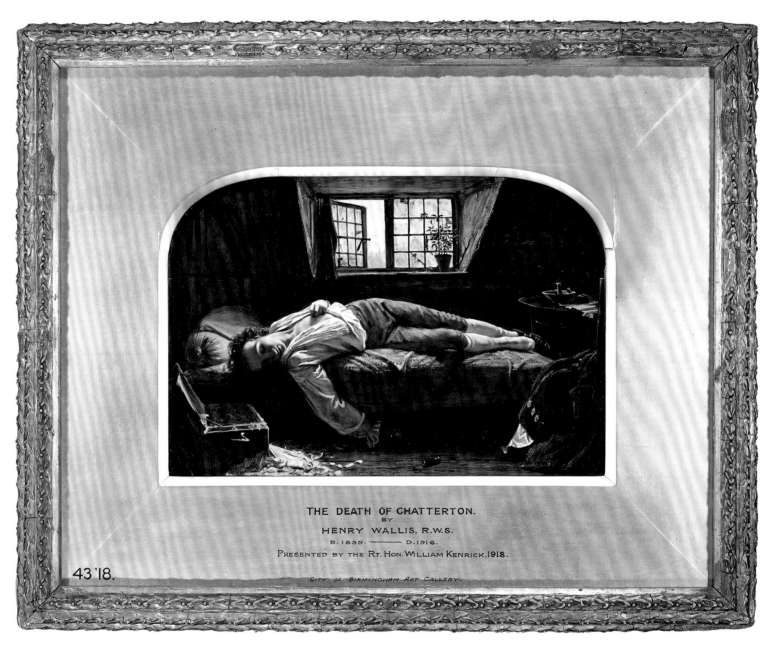

THE DEATH OF CHATTERTON.
BY
HENRY WALLIS, R.W.S.
B. 1839. ——— D. 1916.
PRESENTED BY THE RT. HON. WILLIAM KENRICK, 1918.

CITY OF BIRMINGHAM ART GALLERY.

43 '18.

Cat. no. 39

39

HENRY WALLIS

Chatterton

Circa 1855–1856
Oil on wood panel
6 7/8 x 10 in.; 17.4 x 25.4 cm. (image has curved top corners)
Signed, bottom left: H.W.
Inscribed in ink on label, verso of panel: The Death of
Chatterton / the original painting / Study by H. Wallis / –
"The Marvellous Boy / The sleepless soul, that perished in
his pride" / Wordsworth
In contemporary frame
Presented by William Kenrick, 1918 (43'18)

PROVENANCE: S. Mendel; Christie's, 24 April 1875, lot 384
(260 guineas); Albert Grant; Christie's, 28 April 1877, lot 129
(150 guineas)

REFERENCES: Birmingham, *Paintings*, 1960, p. 149 (as *The
Death of Chatterton*); for premier version see London, Tate,
1984 (75, repr.)

Whether, as the old inscription on the reverse suggests,
this is a 'study' for the large (24 x 36 in.; 61.0 x 91.5 cm.) oil
on canvas now in the Tate Gallery, London, or a later replica,
it is very difficult to tell. It would have accorded with Pre-
Raphaelite practice for Wallis to have begun a small picture
first, in preparation for painting on a larger scale (see cat. nos.
74, 114), allowing the artist to work out details of perspective,
lighting and costume. The question is complicated by the
existence of a second small version (slightly larger than the
Birmingham one, at 8 x 11 3/4 in.; 22.7 x 30.2 cm.), now in
the Yale Center for British Art, New Haven.[1] Some very
minor differences of detail – most noticeable in the angle of
the head, the rooftop view, the disposition of the leaves of the
potted plant and the torn fragments of paper – are found
when comparing the Birmingham version with the two oth-
ers, leading to the conclusion that this is indeed the first
design, and that the Yale oil is a replica.

Although commonly known as *The Death of Chatterton*,
the large oil was exhibited at the Royal Academy in 1856
under the simple title *Chatterton*, and was accompanied in
the catalogue by a couplet from Christopher Marlowe's play
Doctor Faustus, which is also inscribed on the frame:

Cut is the branch that might have grown full straight
And burnèd is Apollo's laurel bough.

It must be assumed that a mid-nineteenth century audi-
ence would have been familiar with the story of Thomas
Chatterton's tragically short life and sad death.[2] Born in
Bristol in 1752, he was a precociously gifted poet who at first
sought attention by producing what he claimed were lost
medieval ballads, but which he himself had written and fab-
ricated on old parchment. Coming to London in 1770, he
met with little encouragement or success as a writer.
Embittered by the greater interest in his fakes than in his orig-
inal verse, he committed suicide by swallowing arsenic.

Wallis's moving tribute to "The Marvellous Boy"
(Wordsworth's phrase, from his poem "Resolution and
Independence") proved extremely popular at the Royal
Academy exhibition, and was praised highly by Ruskin:
"Faultless and wonderful: a most noble example of the great
school. Examine it well inch by inch: it is one of the pictures
which intend and accomplish the entire placing before your
eyes of an actual fact – and that a solemn one. Give it much
time".[3] As in Millais's *Ophelia* (see cat. no. 22), whose format
it shares, there is much symbolic detail: the guttering candle
whose smoke drifts towards an unseen dawn; the single rose
with falling petals; and the rich clothes whose elegant super-
ficiality has been of little use to the aspiring poet.

Chatterton did die his romantic death in a garret, at 39
Brooke Street, Holborn, but it now seems unlikely that Wallis
was attempting to simulate the actual room.[4] The unmistak-
able profile of St Paul's Cathedral fixes the view as one over
the City of London, which is possible from Holborn, but is
perhaps as much a symbolic reference to the heartlessness of
commerce as it is the suggestion of a specific location. The
poet George Meredith (1828–1909) sat as model for the head
of Chatterton, Wallis using his long chestnut-coloured hair
but not the beard he is known to have had; two sketches for
the lying figure (now in the Tate Gallery) were probably taken
from a studio model. Subsequently, Wallis formed a liaison
with Meredith's strong-willed wife Mary Ellen, daughter of
the novelist Thomas Love Peacock.[5]

1. This appeared at Sotheby's, Belgravia, 28 November 1972, lot 50, repr.
2. Wallis's painting seems to have been the first depiction of the sub-
ject: see Robin Hamlyn in London, Tate, 1984, pp. 142–144.
3. *Academy Notes*, 1856; Ruskin, *Works*, vol. 14, 1904, p. 60.
4. See Hamlyn in London, Tate, 1984, pp. 142–144.
5. The common implication that Wallis 'eloped' with Mary Ellen
Meredith is an exaggerated piece of Pre-Raphaelite mythology, as hus-
band and wife had already fallen out: see Diane Johnson, *The True
History of the First Mrs Meredith and Other Lesser Lives*, New York,
1972; London, 1973.

40

HENRY WALLIS

The Stonebreaker

1857
Oil on canvas
25 3/4 x 31 in.; 65.4 x 78.7 cm.
Signed and dated, bottom right: H Wallis 1857 (initials in monogram)
Presented by Charles Aitken, 1936 (506'36)

PROVENANCE: Temple Soames, Tunbridge Wells, in 1880s

EXHIBITED: London, Royal Academy, 1858 (562); Liverpool Academy, 1860 (54); Birmingham, Society of Artists, 1861 (176); Birmingham, 1891 (233)

REFERENCES: Birmingham, *Paintings*, 1960, p. 149; Staley, 1973, p. 88, pl. 43A and col. pl. 5; London, Tate, 1984 (92, repr.); Treuherz, 1987, pp. 36–38, cat. 23, repr.

The Stonebreaker was as successful at the Royal Academy exhibition of 1858 as *Chatterton* had been two years earlier, and it has been plausibly suggested that Wallis may have intended it as a pendant.[1] Instead of a title, a quotation from Thomas Carlyle's *Sartor Resartus* (first published in 1833–1834) was printed in the catalogue:

> Hardly-entreated Brother! For us was thy back so bent, for us were thy straight limbs and fingers so deformed: thou wert our Conscript, on whom the lot fell, and fighting our battles wert so marred. For in thee too lay a god-created Form, but it was not to be unfolded: encrusted must it stand with the thick adhesions and defacements of labour; and thy body, like thy soul, was not to know freedom.

The context of this passage is an identification by Carlyle of two types of honourable men: the "inspired Thinker" or creative artist, of whom Chatterton could be considered representative, and "the toil-worn Craftsman that with earth-made implement laboriously conquers the Earth, and makes her man's".[2]

From a number of clues, the viewer gradually realises that here, too, is an image of death. The day descends into sunset as the man, exhausted by his labour, slumps lifeless amongst the fallen leaves and broken stones, insensible to the attentions of a stoat at his foot. The original frame was apparently inscribed with the symbolic line from Tennyson's poem "A Dirge": "Now is done thy long day's work"; the painting was exhibited under this title at Birmingham in 1861.

Wallis blends precise Pre-Raphaelite detail – brilliantly, in the foliage silhouetted against the sky and its reflection in the distant water – with a broader, but strongly coloured, treatment of the figure and foreground. This combination of handling is something of a hallmark of post-Brotherhood Pre-Raphaelite landscape, and was used to equal effect by Millais, as in *Autumn Leaves* (Manchester City Art Gallery), which Wallis doubtless saw at the Royal Academy in 1856. The painting of the rugged, but less than scientifically detailed, stones recalls Hunt's delineation of leaves in the foreground of *Valentine rescuing Sylvia from Proteus* (see cat. no. 17).[3]

The Stonebreaker struck a strong chord of compassion with spectators and reviewers, in its implied criticism of the harsh Poor Law: crushing stones for use as hardcore in the making of new roads was a common requirement for an able-bodied pauper to qualify for the meagre subsistence provided in a parish workhouse.[4] More than one commentator considered the picture disturbing – the critic for the *Illustrated London News* thought it "shocks the sight and offends the sense" – but most found it a moving image, singling it out (as did Ruskin) as the picture of the year. The *Spectator*'s critic saw "a picture of the sacredness and solemnity which dwell in a human creature, however seared, and in death, however obscure".[5]

That writer was probably William Michael Rossetti; three years later he included the painting in a list of works demonstrating "the advance in style which the British School now presents", and which he considered was "mainly due to the stern and true discipline of Praeraphaelitism [*sic*]".[6] He continued:

> Modern art, to be worthy of the name, must deal with . . . passion, multiform character, real business and action, incident, historic fact. We are by no means destitute of pioneers in these directions. We have had Millais's 'Rescue' of a family from the flames; Hunt's 'Awakening Conscience'; Madox Brown's 'Last of England', the emigrants on their voyage; Wallis's 'Dead Stonebreaker'; Paton's 'Scene from the Indian Mutiny'.

It was this kind of forceful social realism, based on "strong facts, strong conceptions, and solid portrait-like actuality", which Rossetti thought preferable to its French counterpart.

In a review of the Paris Exposition Universelle of 1855 (again, published in the *Spectator*), he described Gustave Courbet's *Stonebreakers* as simply "a couple of men breaking stones, painted on a large scale broadly; and absolutely nothing more . . . it never seems to occur to him that real sincerity in art must be exercised first of all in the invention of the subject; that his function is to translate the sentiment of things as well as to exhibit their conformation".[7] In contrast, Pre-Raphaelite painters such as Wallis and John Brett, whose own *Stonebreaker* (Walker Art Gallery, Liverpool; fig. 42) was also exhibited at the 1858 Royal Academy exhibition, had "remembered these fundamental truths".[8]

A smaller replica of the painting (14 3/4 x 18 in.; 37.5 x 45.7 cm.) was sold at Sotheby's, Belgravia, on 19 March 1979, lot 18 (repr.). Apparently this formerly belonged to Joseph Dixon, who also owned the Yale replica of *Chatterton* (see cat. no. 39).

1. Robin Hamlyn in London, Tate, 1984, p. 167.
2. *Sartor Resartus* [The Tailor Re-clothed], book III, ch. iv.
3. Ruskin considered "the ivy, ferns, &c . . . somewhat hastily painted, but they are lovely in colour, and may pass blameless, as I think it would have been in false taste to elaborate this subject further" (*Academy Notes*, 1858; Ruskin, *Works*, 1904, vol. 14, p. 170).
4. The *Athenaeum*'s critic recognised that "this may be a protest against the Poor Law – against a social system that makes the workhouse or stonebreaking the end of the peasant; but it may also be a mere attempt to excite and to startle by the poetically horrible" (quoted in Treuherz, 1987, p. 38).
5. Quoted in London, Tate, 1984, p. 168.
6. From a review in *Fraser's Magazine* of the Royal Academy exhibition of 1861, reprinted in Rossetti, 1867, p. 7. *In Memoriam* by Joseph Noel Paton (1821–1901), also shown at the Royal Academy in 1858, depicts a group of British women and children awaiting death during the Cawnpore Massacre of 1857; it was sold at Sotheby's, 21 November 1989, lot 24 (repr.).
7. Rossetti, 1867, pp. 112–113.
8. Rossetti, 1867, pp. 112–113. For Brett's *Stonebreaker*, see Bennett, 1988, pp. 16–19. It has often been pointed out that Brett and Wallis had a point of personal contact through membership of the Hogarth Club, as both attended a meeting in May 1858. The remarkable coincidence of subject remains to be explained, although the appealing suggestion that William Michael Rossetti may have been the catalyst in its choice has been put forward by Michael Hickox (in as yet unpublished research).

Fig. 42 JOHN BRETT, *The Stonebreaker*, 1858; oil on canvas, 20 1/4 x 27 in. (51.5 x 68.5 cm.). Walker Art Gallery, Liverpool (National Museums and Galleries on Merseyside).

41

JOHN EVERETT MILLAIS

Dora

Circa 1856
Pencil with blue-grey ink wash
5 1/4 x 6 in.; 13.3 x 15.2 cm. (trimmed to arched top)
Signed in blue-grey ink, bottom left: JM (initials in monogram)
Inscribed in blue-grey ink, bottom centre: DORA
Presented by subscribers, 1906 (647'06)

PROVENANCE: Birmingham, *Drawings*, 1939, p. 271; Grasmere and Lincoln, 1992 (255, repr.)

*T*he edition of Tennyson's *Poems* published in 1857 by Edward Moxon (1801–1858), universally known as the 'Moxon Tennyson', contains fifty-four engraved woodblock illustrations. Twenty-four of these are from designs by artists who were well known to the public as genre and landscape painters as well as illustrators: Thomas Creswick, J.C. Horsley, Daniel Maclise, William Mulready and Clarkson Stanfield. The other illustrations were offered to artists in the Pre-Raphaelite circle: Rossetti took five subjects, Hunt seven, and Millais eighteen. Although now hugely celebrated, the Moxon Tennyson was not a success at the time, as Hunt recalled:

> The book itself was an apple of discord with the public. In trying to please all, the publisher satisfied neither section of book buyers. The greater proportion were in favour of the work done by prominent artists of the old school, and their admirers were scandalised by the incorporation of designs by members of the Pre-Raphaelite Brotherhood; while our fewer appreciators would not buy the book in which the preponderance of work was by artists they did not approve. Thus the unfortunate book never found favour until after Moxon's ruin and death, when it passed into other hands and was sold at a reduced price.[1]

The Birmingham collection holds highly finished pen and ink designs for three of Rossetti's subjects (*Saint Cecilia*, *King Arthur and the Weeping Queens* and *Mariana in the South*) as well as some twenty studies by Millais that range from slight thumbnail sketches for first ideas to more complete compositions, such as the present sheet. The final drawing would have been made on the woodblock itself and printed as a reverse image after being cut by the engraver (fig. 43). Hunt records that the artists received £25 for each illustration (although Rossetti held out for £30).[2] Book illustration suited Millais's natural gifts for precise draughtsmanship and tight figure composition, and he later achieved particular success with his designs for six novels by Anthony Trollope, which were serialised during the 1860s in the *Cornhill Magazine*.[3]

In Tennyson's poem, Dora's cousin William refuses the command of his father, farmer Allan, to marry her (Millais also illustrated this scene). Instead, he weds a labourer's daughter, Mary, who bears him a son. Only after William's death is Dora able to soften the old man's heart: Millais's design shows her comforting Allan as he is reconciled with his daughter-in-law and grandson (the latter dressed, according to Victorian custom, in skirts):

> Then they clung about
> The old man's neck, and kiss'd him many times.
> And all the man was broken with remorse;
> And all his love came back a hundredfold;
> And for three hours he sobb'd o'er William's child,
> Thinking of William.

Millais had received Moxon's commission in 1854, and a letter of 24 August to Tennyson shows the degree of attention he was giving to the project: "I have made many sketches of corn fields for Dora. I hope your boy has not grown too large for the character. Some questions I wish to ask you about the poems I am to illustrate but I will keep them until I see you".[4] Further evidence demonstrates that Millais was still working on the last illustrations in the autumn of 1856.[5]

1. *Some Poems by Alfred Lord Tennyson . . . with a preface by Joseph Pennell treating of the illustrators of the sixties & an introduction by W. Holman Hunt*, London, 1901, pp. xxiii–xxiv.
2. Hunt, 1905, vol. 2, pp. 99–102.
3. See Arts Council, 1979, pp. 36–37.
4. Quoted in Grasmere and Lincoln, 1992, p. 78. In November 1854, Millais visited Tennyson at his home in Farringford, on the Isle of Wight, to discuss the illustrations.
5. Arts Council, 1979, p. 35.

Fig. 43 JOHN THOMPSON (1785–1866), after JOHN EVERETT MILLAIS, *Dora*, 1857; wood engraving, 3 1/2 x 3 1/2 in. (9.0 x 9.0 cm.). Alfred Tennyson, *Poems*, published by Edward Moxon, London, 1857, p. 219.

DORA

42

DANTE GABRIEL ROSSETTI

Sir Launcelot in the Queen's Chamber

1857
Pen and black and brown ink
10 3/8 x 13 7/8 in.; 26.5 x 35.2 cm.
Signed and dated in black ink, bottom right: DGR Oxford /
1857 (initials in monogram)
Presented by subscribers, 1904 (404'04)

PROVENANCE: T.E. Plint, bought in 1859 (30 guineas); J.
Anderson Rose; his sale, Christie's, 5 May 1891, lot 79 (13
guineas); Charles Fairfax Murray

REFERENCES: Birmingham, *Drawings*, 1939, p. 320; Surtees,
1971, no. 95, pl. 127; London and Birmingham, 1973 (141);
Manchester, Whitworth, 1984 (109, repr.)

The original gold frame (alas, now lost) bore an inscription from Sir Thomas Malory's *Morte d'Arthur* (book XX): "How Sir Launcelot was espied in the Queen's Chamber, and how Sir Agravaine and Sir Mordred came with twelve knights to slay him".[1] In one of the most dramatic and fateful episodes in the story of the Round Table, Lancelot visits Guenevere in her chamber while her husband King Arthur is away hunting. Discovered and challenged by the other knights, Lancelot fights and defeats them, despite having only a sword but no armour. Accused of treason, Guenevere is condemned to be burned at the stake, but is dramatically rescued by Lancelot; the ensuing conflict between Arthur and Lancelot leads to the dissolution of the Round Table.

This composition was possibly intended to be one of the ten subjects chosen to decorate the upper walls of the hall of the Oxford Union (now the Library) as part of the 'jovial campaign' that was instigated by Rossetti and carried out in the summer of 1857, along with Morris, Burne-Jones, Hughes and others.[2] Rossetti did complete one mural painting, *Sir Launcelot's Vision of the Sanc Grael*, and made studies for another, *Sir Galahad, Sir Bors and Sir Percival receiving the Sanc Grael*. Although this design could not easily have fitted a compartment with two central circular windows, it might have been begun following an offer from Ruskin to cancel a debt of seventy guineas, "if you like to do another side of the Union".[3]

As Rossetti's most elaborate pen and ink drawing to date, *Sir Launcelot in the Queen's Chamber* is comparable in its tight detail and claustrophobic atmosphere to the remarkable series of highly finished watercolours that were also undertaken (and mostly finished) in his *annus mirabilis* of 1857: *The Blue Closet*, *The Tune of Seven Towers*, both of which were acquired by William Morris, and *The Wedding of St George and the Princess Sabra* (all now in the Tate Gallery, London).[4] The last

was also bought, like the present drawing, by T.E. Plint (for fifty-five guineas), and was described by the painter James Smetham (1821–1889) in terms equally applicable to *Sir Launcelot in the Queen's Chamber*, as having "a sense of secret enclosure in 'palace chambers far apart'; but quaint chambers in quaint palaces".[5]

Guenevere has the features of Jane Burden, the seventeen-year-old daughter of an Oxford groom, who was immediately courted by William Morris; they married in April 1859, by which time Morris had also painted her as *La Belle Iseult* (1858; Tate Gallery, London; see fig. 6). A head and shoulders study by Rossetti, with the same clasped hands as in the finished work and inscribed 'fainting study', is in Manchester City Art Gallery.[6]

1. Recorded in Birmingham, *Drawings*, 1939, p. 320.
2. See John Christian, *The Oxford Union Murals*, Chicago and London, 1981, and Rosalie Mander, "Rossetti and the Oxford Murals, 1857", in Parris (ed.), 1984, pp. 170–183.
3. Quoted in Surtees, 1971, p. 54.
4. Surtees, 1971, nos. 90, 92, 97.
5. Quoted in Surtees, 1971, p. 55 (letter of 25 September 1860).
6. Surtees, 1971, no. 95A, pl. 129; Treuherz, 1993, p. 79, pl. 60.

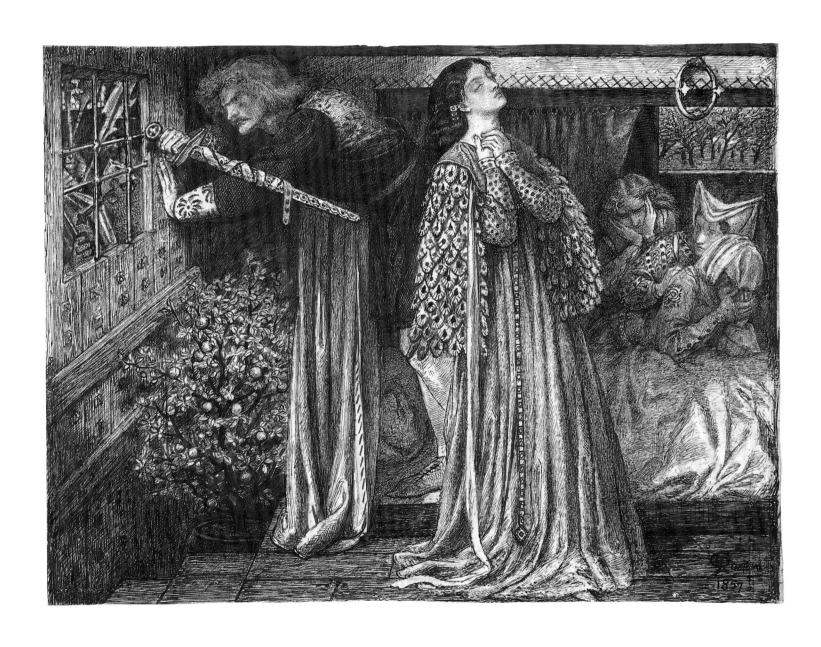

43

ELIZABETH SIDDAL

Jephtha's Daughter: figure study

Circa 1855-1857
Pencil
8 3/4 x 5 3/8 in.; 22.2 x 13.7 cm.
Inscribed in pencil, bottom right: This sketch / by Miss
Siddal [handwriting probably that of Charles Fairfax
Murray]
Verso: Dante Gabriel Rossetti, *Study for "Ballad of Fair Annie"*
Pen and brown ink
Presented by subscribers, 1904 (360'04)

PROVENANCE: Fanny Cornforth; Charles Fairfax Murray

REFERENCES: Birmingham, *Drawings*, 1939, p. 358 (cited in
entry for Rossetti drawing); Surtees, 1971, no. 68A (Siddal
drawing not mentioned); Sheffield, 1991 (23, repr.)

Fig. 44 DANTE GABRIEL ROSSETTI, *Study for "Ballad of Fair
Annie"*, circa 1855; pen and brown ink, 8 3/4 x 5 3/8 in.
(22.2 x 13.7 cm.). Verso of cat. no. 43.

1. Surtees, 1971, no. 68A, pl. 54.
2. Sheffield, 1991 (37, repr.).
3. Sheffield, 1991 (38, repr.).
4. See Sheffield, 1991, nos. 23–26.

*T*his is the only drawing in the Birmingham collection by
Elizabeth Siddal – indeed, it is the only work by any female
associate of the Pre-Raphaelites (discounting such Birmingham
School followers as Kate Bunce). The drawing by Rossetti on
the verso of the sheet (fig. 44) is one of four sketches illustrating
the "Ballad of Fair Annie", which Surtees dates to around 1855
and describes as being "for a projected *Book of Old English
Ballads* in which Elizabeth Siddal was also to collaborate".[1]

One of Siddal's most accomplished works is *The Ladies'
Lament from "Sir Patrick Spens"*, a watercolour of 1856 now in
the Tate Gallery.[2] This must have developed from the idea for
an illustrated book of ballads, which the poet William
Allingham (1824–1889) intended to edit; "Sir Patrick Spens"
was one of the best-known traditional northern poems.
Siddal also took her next major subject, *Clerk Saunders*
(Fitzwilliam Museum, Cambridge), from ballad literature,
completing the watercolour in time for inclusion in the 1857
Pre-Raphaelite exhibition organised by Brown at 4 Russell
Place, Fitzroy Square, London.[3]

It is uncertain whether the seven slight figure sketches
that have been identified as studies for *Jephtha's Daughter* are
of later date, or if they relate to an earlier group of religious
subjects.[4] Three of those drawings, in the Ashmolean
Museum, Oxford, are annotated with this title, and all are
variations on a two-figure composition (see fig. 4). An
Israelite commander who waged war against the Ammonites,
Jephtha vowed to sacrifice to God "whatsoever cometh forth
of the doors of my house to meet me" should he return vic-
torious (Judges 11:31); this proved to be his daughter, his only
child. Siddal's hieratic, angular figures evoke some of the
anguished tension between father and daughter. Millais took
up the subject in *Jephtha*, an oil painting of 1867 (National
Museum of Wales, Cardiff).

44

WILLIAM HOLMAN HUNT

A Porter to the Hogarth Club

Circa 1858–1860
Pen and brown ink with ink wash
18 1/4 x 12 1/2 in.; 46.4 x 31.7 cm.
Inscribed in pencil, lower right: A Porter to the Hogarth
Club / drawn by W. Holman Hunt [handwriting identified
as that of F.G. Stephens]
Presented by John H. Cattell, 1920 (710'20)

PROVENANCE: Frederic George Stephens

REFERENCES: Wallis, 1925, pl. V; Birmingham, *Drawings*,
1939, p. 239, repr., p. 433; Liverpool and London, 1969 (195);
Cherry, 1980, p. 243, fig. 18

Following their reasonably successful exhibition at 4
Russell Place in June 1857, the group of mostly Pre-Raphaelite
artists who had been involved, led by Brown, decided to form
a club that could be both a social meeting-place and an exhi-
bition gallery. "To do homage to the stalwart founder of
Modern English art", as Hunt recalled, it was named the
Hogarth Club.[1] Launched in April 1858, its founder-members
included Thomas Woolner, Henry Wallis, Arthur Hughes
and William Morris, with Brown, William Michael Rossetti,
F.G. Stephens and Edward Burne-Jones on the committee.[2]

Brown saw the club's role as "a central room for sending
one's pictures to at any time, in London", but few pictures
were ever on permanent display in the premises taken at 178
Piccadilly. Two exhibitions were therefore organised, one in
January 1859 and one the following summer; at the second,
Hunt showed *Valentine rescuing Sylvia from Proteus* (cat. no.
17) and Wallis exhibited *The Stonebreaker* (cat. no. 40).
Brown, Burne-Jones, and Dante Gabriel Rossetti were the
most enthusiastic contributors, as none of them was eager to
run the gauntlet of selection and hanging at Royal Academy
exhibitions. J.W. Inchbold also sent works to the first show,
along with David Cox (ever an artist of independent mind)
and the architects G.E. Street and G.F. Bodley, who offered
architectural drawings. This eclectic mix secured its position
in the avant-garde as a body able to effect an exchange of ideas
about art, architecture and design. 'Non-artistic' members
were recruited, including Ruskin, Algernon Swinburne and
William Bell Scott, as well as the collectors John Miller of
Liverpool and Thomas Plint of Leeds.[3]

A third exhibition opened in February 1860, and the
fourth and last in the spring of 1861. Both were held in new
surroundings at 6 Waterloo Place, where there was improved
hanging space and more room for club furniture. Hunt's spir-
ited drawing of a waiter holding a bottle and corkscrew (in a
style comparable with Rossetti's vivid sketch of Tennyson [cat.

no. 36]) evokes the convivial spirit of the enterprise, which
did not suit all tastes: Ruskin is reported to have resigned after
a billiard table was installed.[4] The bureaucratic demands of
running both a club and an exhibition society eventually
proved too much for its founders, and the Hogarth Club was
formally dissolved in December 1861.[5]

1. Quoted in Cherry, 1980, pp. 237–244.
2. Cherry, 1980, p. 238.
3. Cherry, 1980, p. 238.
4. Cherry, 1980, p. 242.
5. Cherry, 1980, p. 242. An amusing anecdote was told by Burne-
Jones: "And then, to do him honour, we elected Carlyle – and after
that we sent him all the rules and reports and notices of meetings and
adjournments of meetings and changes of meetings – till one day, talk-
ing to a friend of his who knew us, he said the communications of the
Hogarth Club had become an afflictive phenomenon. So his friend let
us know of this, and we had another meeting about it. Full of uproari-
ous laughter the meeting was – but though we saw the humour of it
we had to propose and pass resolutions that Carlyle should be exempt-
ed from the affliction for the future. Then some one proposed that a
copy of the resolution be sent to him, and though others said that this
was the very kind of thing that bothers him it had to be done"
(Burne-Jones, *Memorials*, 1904, vol. 1, p. 190).

A Porter to the Hogarth Club,
drawn by W. Holman Hunt.

45

JAMES CAMPBELL

The Wife's Remonstrance

1858
Oil on canvas
29 x 19 1/8 in.; 73.7 x 48.5 cm. (image arched at top)
Presented by the Trustees of the Feeney Charitable Trust,
1958 (P8'58)

PROVENANCE: McLean, Haymarket, 31 January 1885, lot 158;
Sotheby's, 31 July 1957, lot 77 (as by Millais); Colnaghi

EXHIBITED: London, Society of British Artists, 1858 (454)

REFERENCES: Birmingham, *Paintings*, 1960, p. 101, pl. 36A
(as by Millais); London and Liverpool, 1967 (60, as by
Millais); Bennett, 1967, pp. 33–40, fig. 15

On its re-appearance in the saleroom almost a hundred years after it was painted, this picture was thought to be *The Poacher's Wife*, a lost work by Millais that was begun in 1860 but possibly left unfinished. Research by Mary Bennett following the Millais exhibition in 1967, where it looked out of place, revealed its true identity as one of the most important surviving paintings by the Liverpool artist James Campbell.[1] This happy re-attribution has provided the Birmingham collection with its only significant example of provincial Pre-Raphaelitism, as it has nothing else by Campbell's Liverpool contemporaries. William Davis (1812–1873), William Lindsay Windus (1822–1907), Daniel Alexander Williamson (1823–1903) and John Lee (fl. 1850–1870) were all greatly impressed by the Pre-Raphaelite paintings exhibited at the Liverpool Academy.[2] Windus had visited the Royal Academy exhibition in 1851 and lobbied successfully for the £50 non-member prize to be awarded in that year to Hunt for *Valentine rescuing Sylvia from Proteus* (cat. no. 17).[3] Both Campbell and Davis became members of the Hogarth Club (see cat. no. 44).

Campbell began exhibiting at the Liverpool Academy in 1852, becoming an Associate in 1854 and a Member in 1856. In 1857 he showed *Waiting for Legal Advice* (Walker Art Gallery, Liverpool; fig. 45) which, in Mary Bennett's words, typifies his "minute finish, pale tonality and Dickensian characterisation".[4] It is the infusion of genre painting with not only an exceptional attention to detail but also a narrative tension and compositional strength – the figures filling the picture plane, with a construction of foreground and background – which stamps Campbell's work with a Pre-Raphaelite hallmark. Ruskin noted Campbell's painting *Eavesdropping* at the Society of British Artists in 1856, and two years later declared *The Wife's Remonstrance* "by far the best picture in Suffolk Street rooms . . . full of pathos, and true painting".[5] He went on, however, to criticise the artist for falling "unredeemably

under the fatal influence which shortens the power of so many of the Pre-Raphaelites – the fate of loving ugly things better than beautiful ones". This was a common cause of complaint by Ruskin (and other critics) against the Pre-Raphaelites' choice of 'modern moral' subjects.

A longer, if more obscure, review in the *Dublin University Magazine* (possibly by F.G. Stephens) is worth quoting in full:

> J. Campbell of Liverpool has sent a picture to the Society of British Artists' Exhibition, an oasis in a horrid desert of conventional stupidity and trash, which, although mostly offensively careless in execution, displayed, nevertheless, much strong dramatic power. *The Wife's Remonstrance* (454) showed a wife entreating a ruffian poacher to abandon that way of life; there was a fine, rude, eloquent passion on her care-worn and squalid face that remains in one's memory with singular force; the husband, also, was finely conceived – a hard-hearted, stupid brute, whose shame covered itself with indignation at his partner's words to which he could not refuse conviction, although obstinate anger kept him on the old vile course. This was a finely conceived picture, marred by unpardonable sins of bad drawing and want of finish.[6]

Fig. 45 JAMES CAMPBELL, *Waiting for Legal Advice*, 1857; oil on canvas, 31 x 25 in. (78.8 x 63.5 cm.). Walker Art Gallery, Liverpool (National Museums and Galleries on Merseyside).

To judge from his few other identified works, Campbell certainly seemed to have difficulty in marrying figure and landscape, although the moss-covered tree and dry-stone wall are here individually well observed. The wife's dramatic gesture in clutching her husband's arm, reinforced by the child's expression of alarm, is not simply one befitting the role of woman as moral guardian: in the mid-nineteenth century, poaching carried severe penalties, from imprisonment to hanging, the husband's actions thereby jeopardising his family's albeit limited security.

1. Bennett, 1967, pp. 33–40.
2. See H.C. Marillier, *The Liverpool School of Painters*, 1904; also Frank Milner, *The Pre-Raphaelites: Pre-Raphaelite Paintings and Drawings in Merseyside Collections*, Liverpool, second edition, 1988, pp. 101–112.
3. See Bennett, 1962.
4. Bennett, 1967, p. 35.
5. *Academy Notes*, 1858; Ruskin, *Works*, 1904, vol. 14, pp. 187–188.
6. "The Art Year", *Dublin University Magazine*, vol. 53, February 1859, p. 156; quoted in Bennett, 1967, pp. 35, 38, who credits its discovery to Anne d'Harnoncourt.

46

ARTHUR HUGHES

The Annunciation

Circa 1858
Oil on canvas
24 1/8 x 14 1/8 in.; 61.3 x 35.9 cm. (image arched at top)
Signed, bottom right: ARTHUR HUGHES
Inscribed on label, verso of stretcher, in the artist's hand:
The Annunciation – "And in the sixth month the / Angel
Gabriel was sent from God / into a city of Galilee, named
Nazareth. / To a Virgin espoused to a man whose / name
was Joseph of the house of David; / and the Virgin's name
was Mary". / Luke 1.26.27 / Arthur Hughes / Buckland
Terrace / Maidstone / Kent
In original frame
Purchased, 1891 (1'92)

PROVENANCE: James Leathart

EXHIBITED: Birmingham, 1891 (168)

REFERENCES: Birmingham, *Paintings*, 1960, p. 76; Newcastle
upon Tyne, 1968 (43)

*I*nspired both by *The Germ* and by seeing Pre-Raphaelite
paintings while a student at the Royal Academy Schools,
Arthur Hughes had matured quickly as a painter, achieving a
notable success with *April Love* (Tate Gallery, London), which
was admired by Ruskin and bought by William Morris from
the Royal Academy exhibition of 1856. Clearly forming a pair
with *The Nativity* (cat. no. 47), *The Annunciation* was not exhib-
ited with it at the Royal Academy in 1858. Ruskin's remark on
The Nativity, that he knew it to have been "hastily finished",
suggests that its companion picture might have been even less
complete; it would then have been difficult to send such an
obvious pendant to the following year's exhibition.[1]

There are certain uncomfortable features about *The
Annunciation* which make it a less appealing picture than *The
Nativity*. Although the angel is meant to represent an
unearthly figure, the body is stiff and the expression blank,
while its juxtaposition with the foliage is rather contrived, as
is the placement of the angelic heads and dove at the apex of
the image. It is as if Hughes were attempting to combine the
striking composition of Rossetti's Annunciation picture, *Ecce
Ancilla Domini!* (Tate Gallery, London; see fig. 3) with
Millais's observation of natural detail. Ruskin's shrewd criti-
cism of *The King's Orchard*, shown at the Royal Academy in
1859, is equally applicable here: while recognising it to be
"accomplished and delicious in detached passages", Hughes
had been "allowing himself to go astray by indulging too
much in his chief delight of colour".[2]

Nevertheless, Hughes makes telling use of simple ele-
ments to reinforce the symbolic nature of the subject. Lilies
and irises denote the Virgin's purity and innocence, while the
angel hovers at the doorway, which thereby becomes the
threshold between Mary's present humility and future glory.
A similar angelic figure, again separated from earthly witness
by a symbolic tree (representing the Tree of Life), was used by
Hughes in his much later painting *The First Easter*, shown at
the Royal Academy in 1896.[3]

1. *Academy Notes*, 1858; Ruskin, *Works*, 1904, vol. 14, p. 163.
2. *Academy Notes*, 1859; Ruskin, *Works*, 1904, vol. 14, p. 233.
3. *Catalogue of the Memorial Exhibition of some of the works by the late
Arthur Hughes*, Walker's Galleries, London, 1916, no. 24, repr.; *The
First Easter* is now in the William Morris Gallery, Walthamstow,
London.

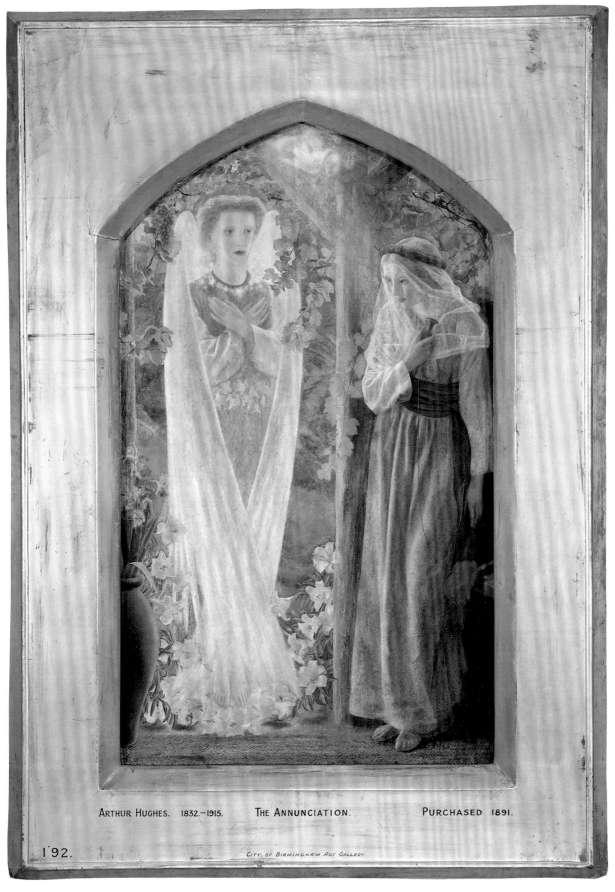

ARTHUR HUGHES. 1832.–1915. THE ANNUNCIATION. PURCHASED 1891.

1·92.

CITY OF BIRMINGHAM ART GALLERY.

Cat. no. 46

172

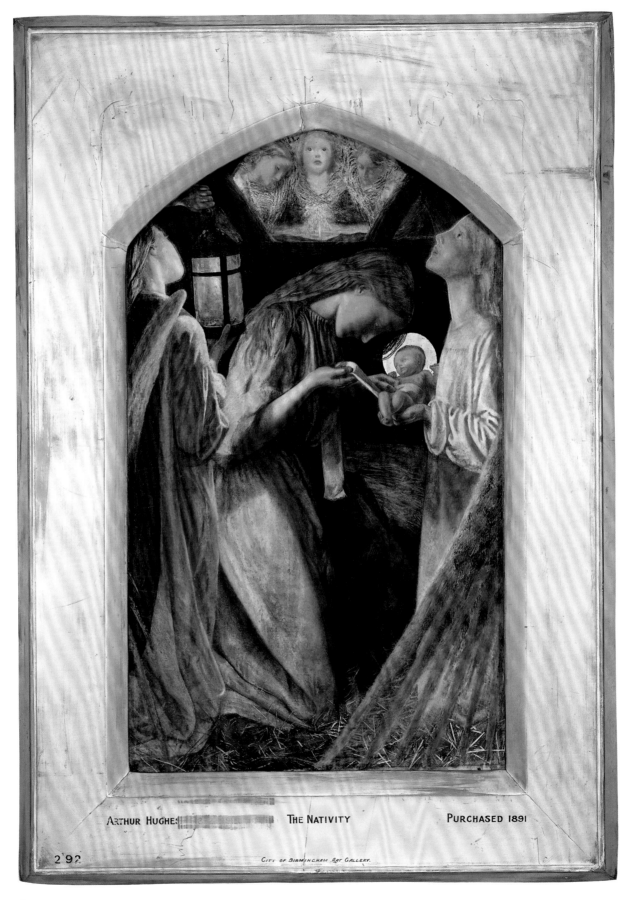

ARTHUR HUGHES THE NATIVITY PURCHASED 1891

2'92 CITY OF BIRMINGHAM ART GALLERY.

Cat. no. 47

47

ARTHUR HUGHES

The Nativity

1858
Oil on canvas
24 1/8 x 14 1/8 in.; 61.2 x 35.8 cm. (image arched at top)
In original frame
Purchased, 1891 (2'92)

PROVENANCE: James Leathart

EXHIBITED: London, Royal Academy, 1858 (284);
Birmingham, 1891 (169)

REFERENCES: Birmingham, *Paintings*, 1960, p. 76; Newcastle
upon Tyne, 1968 (44)

The Nativity impresses the viewer through its freshness of
treatment, simple strength of composition, and subtlety of col-
our. There is little hint of Hughes having followed any med-
ieval or Renaissance precedent; instead he offers in addition
to the Christ child a touching group of young female figures
(at which he excelled) that combines realism with mystery.

"I happen to know that it was hastily finished", Ruskin
wrote in his review of the Royal Academy exhibition, but he
could still declare it "quite beautiful in thought, and indica-
tive of greater colourist's power than anything in the rooms;
there is no other picture so right in manner of work, the
utmost possible value being given to every atom of tint laid
on the canvas".[1] Ruskin was disappointed that no major
works by the leading Pre-Raphaelites were in the exhibition.
In his preamble to *Academy Notes*, he urged a renewed
attempt to paint "the best of Nature", if necessary by lessen-
ing the need to turn pictures "into sermons", as in the case of
Wallis's *The Stonebreaker* (cat. no. 40), which he otherwise
commended. Ruskin reminded his readers that "it is much
easier to be didactic than to be lovely, and . . . it is sometimes
desirable to excite the joy of the spectator as well as his indig-
nation".[2] In that respect, he defended the genuine religious
simplicity of *The Nativity* against those

> thoughtless people [who] may be offended by an angel's
> being set to hold a stable lantern. Everybody is ready to
> repeat verses from Spenser about angels who "watch and
> truly ward", without ever asking themselves what they
> look out for, or what they ward off; . . . they cannot
> conceive that highest of all dignity in the entirely angel-
> ic ministration which would simply do rightly whatever
> needed to be done – great or small – and steady a stable
> lantern if it swung uneasily, just as willingly as drive
> back a thunder-cloud, or helm a ship with a thousand
> souls in it from a lee shore.[3]

The Annunciation and *The Nativity* were among a sub-
stantial group of works by Hughes that was assembled by the
Newcastle industrialist James Leathart (1820–1895), a leading
patron of the Pre-Raphaelites who also owned Brown's *The
Pretty Baa-Lambs* (cat. no. 18) and *The Merciful Knight* by
Burne-Jones (cat. no. 73). From Hughes, Leathart bought
The Rift within the Lute (1859–1862; Carlisle Art Gallery), *The
Woodman's Child* (1860; Tate Gallery, London) and *Home
from Work* (1861; Private Collection), and also commissioned
two family group portraits.[4]

1. *Academy Notes*, 1858; Ruskin, *Works*, 1904, vol. 14, pp. 162–163.
2. *Academy Notes*, 1858; Ruskin, *Works*, 1904, vol. 14, p. 154.
3. *Academy Notes*, 1858; Ruskin, *Works*, 1904, vol. 14, p. 163.
4. See Newcastle upon Tyne, 1968, nos. 44–49, and Newcastle upon
Tyne, 1989–1990, nos. 50–53.

48

ARTHUR HUGHES

The Long Engagement

Circa 1854–1859
Oil on canvas
41 1/2 x 20 1/2 in.; 105.4 x 52.1 cm. (image arched at top)
Signed and dated, bottom right: A.Hughes / 1859
Inscribed on label, verso: No. 1 / "For how myght ever sweetnesse have be known / To hym that never tastyd bitternesse?" / Chaucer / Arthur Hughes / Buckland Terrace / Maidstone / Kent / Painted 1859 / Lent by Mr. Wythes
In contemporary frame
Presented by the executors of the late Dr Edwin T. Griffiths, 1902 (13'02)

PROVENANCE: Mr Wythes?; Edwin Thomas Griffiths

EXHIBITED: London, Royal Academy, 1859 (524)

REFERENCES: Birmingham, *Paintings*, 1960, pp. 76–77, pl. 366; Cardiff and London, 1971 (7); Staley, 1973, pp. 84–85, pl. 41C; New Haven, 1982 (45, repr.); London, Tate, 1984 (95, repr.)

*L*ike Wallis's *The Stonebreaker* (cat. no. 40), this painting was first exhibited without its present title, but with an accompanying quotation, in this case from Chaucer's *Troilus and Criseyde*. The sentiments which Hughes intended to express through this couplet (which puzzled some commentators) were doubtless those of consolation and steadfastness in the face of adversity. The man is recognisable from his clothes as a curate, and is presumably without sufficient financial means to marry – perhaps not even to become formally betrothed, as the young woman's left hand displays no engagement ring. The length of their courtship is indicated by the ivy having grown over her name (Amy), cut long ago into the tree; her unravelled knitting is perhaps also symbolic of plans unfulfilled.

There has been much further discussion of the picture's exact subject and symbolism, but that this has not all been in the context of recent sociological interpretation is demonstrated by a letter to the *Birmingham Daily Mail* from the first decade of this century:

> To my mind, no title could be more appropriate, for the artist with consummate skill depicts, both physically and mentally, a masculine failure; one for whom a woman has waited until nearing middle age, with no immediate hope of wedlock. The wavering look on the face of the man, the limp lines of his figure, denote inability to grasp the essential meaning of life; no spur could goad such an one on to a foremost place in the van of circumstance; and, as usual, the woman pays. Her attitude is symbolical of the ivy which looks on

storms and is never shaken, but her gentleness, kindliness and truth are all inadequate to change the nature of one so unfitted for life's battle. . . . We may surmise that her aged parents have shown disapproval of an attachment so barren of good prospect, but she, deaf to all disloyalty, is willing to wait, no matter how long the engagement.[1]

The Long Engagement apparently evolved out of an unfinished attempt at the Shakespearean subject of *Orlando in the Forest of Arden*, previously treated by Deverell (see cat. no. 24). On a visit to Rossetti's studio on 13 March 1854, G.P. Boyce noted, "A young man of the name of Hughes was painting a picture of Orlando inscribing his mistress' name on

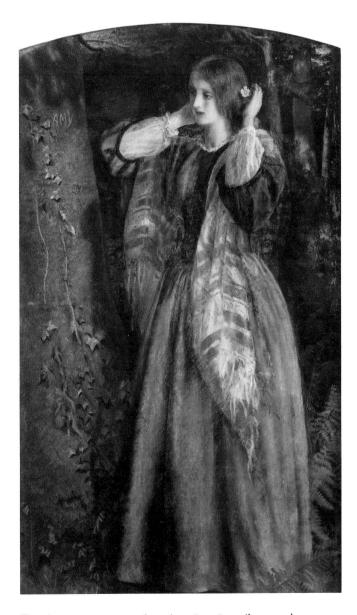

Fig. 46 ARTHUR HUGHES, *Amy*, circa 1857–1859; oil on panel, 12 5/8 x 7 1/4 in. (32.0 x 18.5 cm.). Birmingham Museums and Art Gallery (222'25).

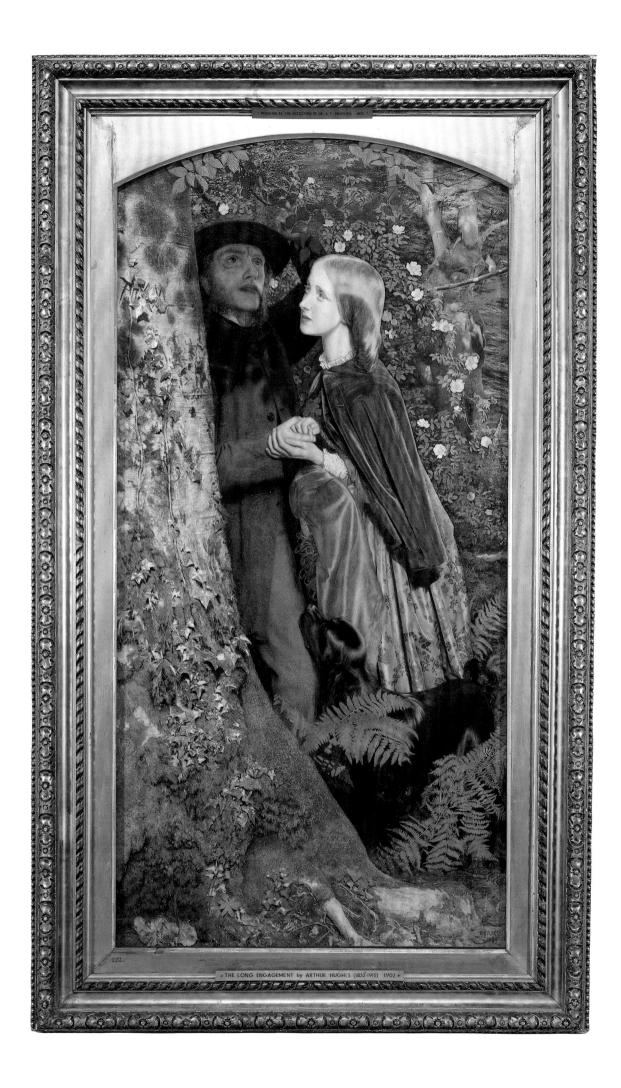

• THE LONG ENGAGEMENT by ARTHUR HUGHES (1837-1915) 1902 •

a tree. Parts nicely painted".[2] In a letter written to William Allingham in the following summer, Hughes described "painting wild roses into 'Orlando'" with the usual practical difficulties of Pre-Raphaelite truth to nature: "One day a great bee exasperated me to a pitch of madness by persisting in attacking me, the perspiration drizzling down my face in three streams the while".[3] Over fifty years later, Hughes stated that he had "painted with much care a background for an 'Orlando and Rosalind', but wiped out the figures before they were completed and substituted modern lovers, and called the picture 'The Long Engagement'."[4] It is plausible to regard the background of the present painting as work of 1854, with much alteration of the rest of the canvas: the two existing preparatory drawings (see cat. no. 49 and fig. 47) illuminate the genesis of the overall design. In any event, Hughes surpassed his previous good work with a bravura demonstration of his ability to capture the complementary textures of foliage, cloth and fur.

A small oil on panel, known as *Amy* (Birmingham collection; fig. 46) is a variation on the theme, and probably precedes the completion of *The Long Engagement*: it is only known that *Amy* was in the collection of Benjamin Windus (see cat. no. 20) before 1862.[5] This may represent the painter's first experiment on the theme of a lovers' tryst in the woods, which Susan Casteras has shown to have been a subject popular at mid-century, and to which Hughes would return with *Aurora Leigh's Dismissal of Romney ('The Tryst')* (1860; Tate Gallery, London).[6] Possibly the choice of name was inspired by Tennyson's poem "Amy", although it was also the name of the artist's mother and of his second child, who was born on 15 December 1857.

1. Letter from 'E.T.' (possibly the painting's former owner), *Birmingham Daily Post*; the undated cutting in the Birmingham Museum files is likely to date from soon after the picture's acquisition in 1902. The benefactor on this occasion, Dr E.T. Griffiths, was a Birmingham surgeon and apothecary who also acted as a City Councillor from 1879 to 1889.
2. Surtees, 1980, p. 12.
3. Letter of 1 August 1854; quoted by Leslie Parris in London, Tate, 1984, p. 170.
4. Written in 1911; London, Tate, 1984, p. 170.
5. Birmingham, *Paintings*, 1960, p. 77; purchased, 1925 (222'25).
6. Susan P. Casteras, "William Maw Egley's 'The Talking Oak'," *Bulletin of the Detroit Institute of Arts*, vol. 65, no. 4, 1990, p. 35. For the Hughes, see London, Tate, 1984 (113, repr.).

49

ARTHUR HUGHES

The Long Engagement: study for composition

Circa 1854–1859
Pencil
10 x 6 7/8 in.; 25.5 x 17.3 cm.
Inscribed on tree, left: AMY
Verso, in pencil: Study of a woman reclining on a sofa, reading a book
Presented by Charles Alexander Munro, 1959 (P11'59)

PROVENANCE: Alexander Munro; by descent

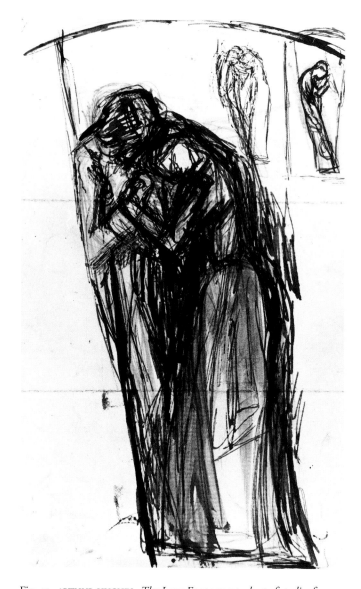

*T*wo preparatory drawings, both now in the Birmingham collection, help to chart the compositional development of *The Long Engagement* (cat. no. 48). The first (fig. 47), a rough sketch in pen and ink, shows the two figures in close embrace; two smaller studies on the same sheet indicate that Hughes was as yet unsure of their placement. Together, these must represent the artist's initial thoughts on converting a Shakespearean set-piece into a more tender image of unfulfilled love.

The present drawing advances closer towards the final design, but also echoes the smaller oil painting *Amy* (fig. 46) in giving prominence to the female figure: the man, already wearing his sober hat, literally emerges from the shadows. A slight sketch at the top of the sheet suggests the artist's next idea of linked hands.

Both drawings belonged to the Pre-Raphaelite sculptor Alexander Munro (see cat. no. 19), with whom Hughes shared a studio at 6 Upper Belgrave Place, London, from 1852 to 1858. According to Katharine Macdonald, Hughes enjoyed "the status of a favourite younger brother. They served as models for each other – notably, Alex Munro in *April Love* and *Benedict in the Arbour*, and his sister Annie in *The Eve of St Agnes*, while Hughes may have been the model for *Paolo and Francesca*".[1] Munro also owned drawings by Rossetti and Millais. The Birmingham drawings were the gift of Munro's great-grandson, who also presented a sheet of pencil studies for *April Love* to the Tate Gallery, London, in 1959.

Fig. 47 ARTHUR HUGHES, *The Long Engagement: sheet of studies for composition*, circa 1854–1859; pen and black ink, 7 1/8 x 4 3/8 in. (18.1 x 11.2 cm.). Birmingham Museums and Art Gallery (P10'59).

1. Katharine Macdonald, "Alexander Munro: Pre-Raphaelite Associate", in London and Birmingham, 1991–1992, p. 47.

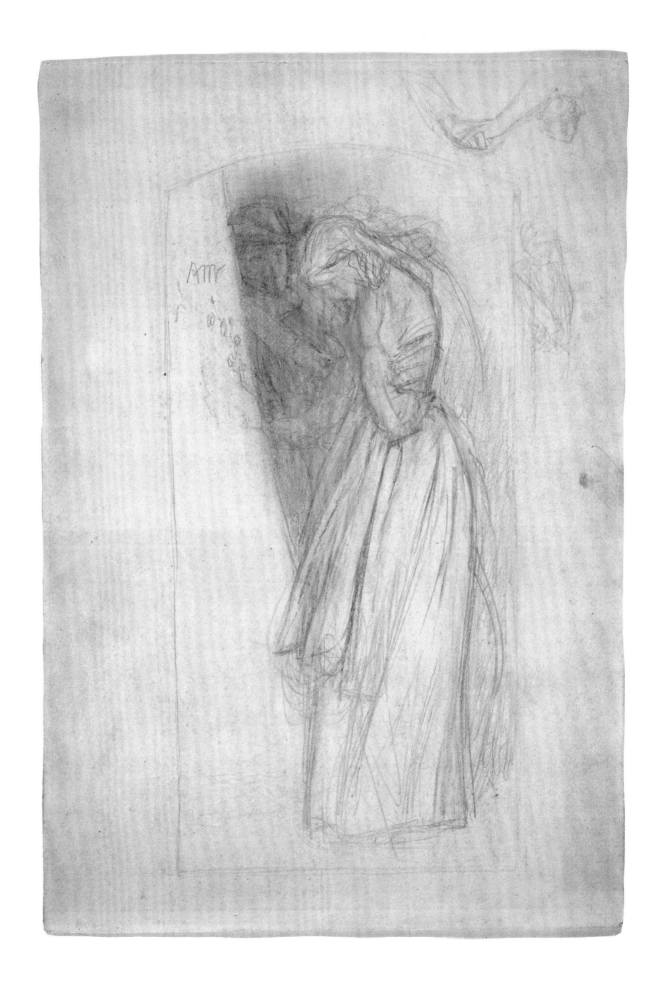

50

DANTE GABRIEL ROSSETTI

Sir Galahad at the Ruined Chapel

1859
Watercolour and bodycolour
11 1/2 x 13 1/2 in.; 29.1 x 34.5 cm.
Signed, bottom centre: DGR (initials in monogram)
Purchased, 1892

PROVENANCE: James Leathart, bought from the artist, 1859;
sold by him to Birmingham, 1892 (150 guineas)

REFERENCES: Birmingham, 1891 (177); Birmingham,
Paintings &c. [1930], p. 175; Surtees, 1971, no. 115, pl. 171;
Manchester, Whitworth, 1984 (112)

This was the last of Rossetti's dozen or more medievalist watercolours, and was probably painted on commission for James Leathart (see cat. no. 47), who paid sixty guineas in the late summer of 1859 for the watercolour *A Christmas Carol* (Fogg Art Museum, Harvard University).[1]

It is an expanded version of one of the five designs Rossetti made for the 'Moxon Tennyson', published in 1857 (fig. 48; see cat. no. 41), and illustrates the poem "Sir Galahad", which first appeared in Tennyson's *Poems* of 1842:

> Between dank stems the forest glows,
> I hear a noise of hymns:
> Then by some secret shrine I ride;
> I hear a voice, but none are there;
> The stalls are void, the doors are wide,
> The tapers burning fair.
> Fair gleams the snowy altar-cloth,
> The silver vessels sparkle clean,
> The shrill bell rings, the censer swings,
> And solemn chants resound between.

In both versions of the design, Rossetti remains faithful to Tennyson's imagery, cleverly incorporating within the composition a group of damsels, unseen by Galahad but providing an agency for the sound of bell and chant. Making more space in the watercolour, Rossetti has refined certain details: the forest setting emerges more clearly, the group of young women (a startling multiple image of Elizabeth Siddal) is given greater prominence, and the chapel's altar becomes a brilliant source of illumination. Contrary to the traditional use of the whiteness of the paper for this purpose, Rossetti uses bright pigments here, paradoxically reserving the translucence of watercolour for the darker background. Undoubtedly, the extraordinary visual impact of this work, which has lost little of its colour to fading, would have been enhanced by a gold frame (with complementary matt), but none has survived.

Rossetti has also changed the vessels on the altar. The engraving shows a chalice and basket of bread, symbolic of Christ's blood and body. These are also carried by the figure in *The Damsel of the Sanct Grael*, a watercolour of 1857 (Tate Gallery, London),[2] and it is likely that Rossetti wished to avoid a possible confusion of the chalice with the Holy Grail. Although it is Sir Galahad – the purest of the Knights of the Round Table, whose celibacy and spirituality are in marked contrast with Sir Lancelot's character – who ultimately achieves the quest for the Grail, Tennyson makes it clear that the chapel in the forest is only a vision, and the poem ends with Galahad still journeying.

1. Surtees, 1971, no. 98, pl. 134.
2. Surtees, 1971, no. 91, pl. 117; this belonged to William Morris.

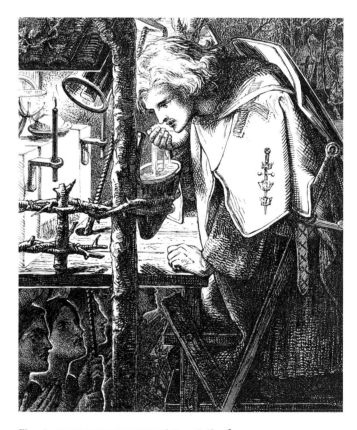

Fig. 48 WILLIAM JAMES LINTON (1812–1898), after DANTE GABRIEL ROSSETTI, *Sir Galahad*, 1857; wood engraving, 3 1/4 x 3 3/4 in. (8.0 x 9.5 cm.). Alfred Tennyson, *Poems*, published by Edward Moxon, London, 1857, p. 305.

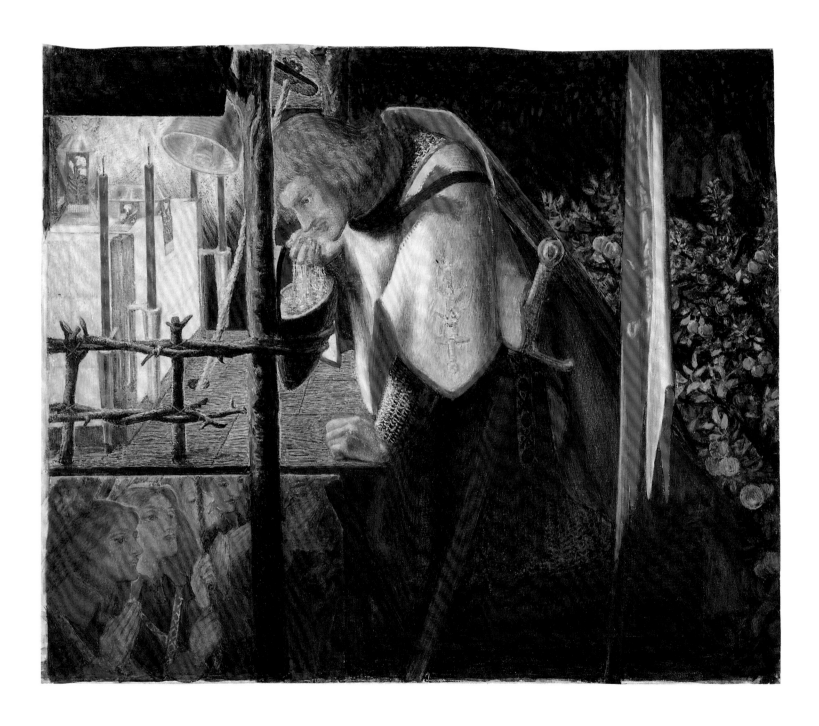

51

WILLIAM MORRIS

Study for composition, possibly "Tristram and Iseult"

Circa 1858–1859
Pencil, with brush and brown ink
10 5/8 x 11 7/8 in.; 27.0 x 30.1 cm.
Inscribed in pencil, verso: by William Morris / C.F.M.
[in handwriting of Charles Fairfax Murray]
Bequeathed by J.R. Holliday, 1927 (913'27)

PROVENANCE: Charles Fairfax Murray?

REFERENCES: Birmingham, *Drawings*, 1939, p. 287

Fig. 49 WILLIAM MORRIS, *Study for "Iseult on the Ship"* (?), 1861; pencil, with brush and brown ink, 18 3/8 x 15 1/2 in. (46.9 x 39.4 cm.). William Morris Gallery, Walthamstow, London.

After abandoning plans both to enter the Church and to become an architect, William Morris was persuaded by Rossetti to take up painting, along with his Oxford friend Edward Burne-Jones. "Rossetti says I ought to paint, he says I shall be able", Morris wrote to former fellow undergraduate Cormell Price in July 1856. "I don't hope much, I must say, yet I will try my best".[1] Sharing a studio and lodgings with Burne-Jones in Red Lion Square, Holborn, he had begun a first painting by June 1857, according to a letter from Rossetti to William Bell Scott: "It is all being done from nature of course, and I believe will turn out capitally".[2]

The subject, *Tristram recognised by Iseult's Dog*, was taken from Malory's *Morte d'Arthur*. While no trace now remains of such a painting, its composition was converted by Morris in 1862 into one of the thirteen panels of stained glass, illustrating the story of Tristram and Iseult, which formed an early commission for his firm of artist-decorators (see cat. nos. 58, 59).[3] A second canvas, usually dated to 1858, was begun after the Oxford Union mural campaign (see cat. no. 42), with Morris's future wife Jane Burden serving as the model; formerly known as *Queen Guenevere*, this painting is now accepted to represent *La Belle Iseult* (Tate Gallery, London; fig.6). A figure study in pencil, concentrating chiefly on the folds of the drapery, is in a private collection.[4]

According to two separate references, Morris accepted a commission for a painting from Thomas Plint early in 1858. Brown noted in his diary on 13 January: "Plint has commissioned Jones [Burne-Jones] for an other picture for 350 gns & bought Topsy's (Morris) for 75, his Tristram & Iseult".[5] This might point to the hopeful purchase of a picture already brought close to completion, possibly Morris's missing first canvas, but it can hardly refer to the single-figure subject of *La Belle Iseult*. Although writing long after the event, Georgiana Burne-Jones also reported that Morris, at the beginning of 1858, was "staying on at Oxford almost permanently now, working at a picture of Tristram and Iseult for which Mr

Plint had given him a commission".[6]

The suggestion, now discounted by Jan Marsh, that Morris may have begun a third easel painting, had previously depended on the otherwise unexplained purpose of an elaborate figure study, tentatively called *Iseult on the Ship* (fig. 49), that is now at the William Morris Gallery, Walthamstow, London. In another study of Jane Burden, the sketchy background suggests that the figure is either within, or about to climb aboard, a sailing vessel. The present drawing from the Birmingham collection has an equally vague background, with a rough group of figures and perhaps the mast and rigging of a ship. Morris's likely subject is the episode from the *Morte d'Arthur* in which Tristram accompanies Iseult on the voyage to Cornwall, where she is to marry King Mark. They mistakenly drink a love potion intended for the royal couple on their wedding night, and fall in love, with fearful consequences.[7] A third figure in the foreground could be the handmaiden Brangwain, who supplies the fateful cup.

The Walthamstow sheet carries a watermark of 1861: although this divorces it from the 1858 commission, an explanation might be provided in a letter of 23 April 1861 from Brown to Plint, who was asking for news of Morris's progress.

183

Brown reported, "His picture is now at my house, and at my suggestion he has so altered it that it is quite a fresh work. There is still a figure in the foreground to be scraped out and another put in its place".[8] Since the type and handling of the draperies in the two drawings have much in common, it is surely a plausible hypothesis that the later single figure of Iseult represents Morris's revision of the composition recorded in the Birmingham drawing, as suggested in Brown's letter. In view of his heavy commitments after the spring of 1861, when the firm of Morris, Marshall, Faulkner and Company was established, Morris could hardly have hoped to continue any serious attempt at painting. He would have been relieved from the demands of the commission, about which nothing else is known, by Plint's death on 11 July 1861.[9]

1. Quoted in Marsh, 1986, p. 571. This otherwise thorough and revealing account of Morris's early career as a painter unfortunately overlooks the Birmingham drawing.
2. Quoted in Marsh, 1986, p. 571.
3. Originally made for Harden Grange, Bingley, the home of the Bradford merchant Walter Dunlop, the panels are now in Bradford City Art Gallery; see Sewter, 1975, pp. 26–27.
4. The drawing is reproduced in Marsh, 1986, fig. 22; for the oil, see London, Tate, 1984 (94, repr., but still titled *Queen Guenevere*).
5. Surtees, 1981, p. 200.
6. Burne-Jones, *Memorials*, 1904, vol. 1, p. 175.
7. This subject was also treated by Rossetti, firstly as a design for the 1862 Bradford stained-glass commission and then in a watercolour dated 1867 (Cecil Higgins Art Gallery, Bedford); see Surtees, 1971, no. 200, pl. 290. It is not impossible that Rossetti may have 'inherited' the idea from Morris.
8. Quoted in Marsh, 1986, p. 574.
9. Brian Lewis, in "Thomas E. Plint: A Patron of Pre-Raphaelite Painters", *Pre-Raphaelite Review*, vol. 3, no. 2, May 1980, pp. 77–101, makes no mention of any subsequent claim by Plint's executors.

52

SIMEON SOLOMON

"Babylon hath been a golden cup"

1859
Pen with black and brown ink, over traces of pencil
10 1/2 x 11 1/8 in.; 26.6 x 28.3 cm.
Signed and dated, in black ink, bottom left: SS/9/59
(initials in monogram)
Purchased (Alfred Leadbeater Bequest Fund), 1925 (452'25)

REFERENCES: Birmingham, *Drawings*, 1939, p. 401 (as *King David*); Reynolds, 1984, p. 11, pl. 16 (as *David playing to King Saul*); Seymour, 1987, pp. 48–50, fig. 48

EXHIBITED: (?) French Gallery, London, *7th Annual Winter Exhibition of Cabinet Pictures, Sketches and Drawings*, 1859 (143)

Simeon Solomon's upbringing probably included the study of sacred Hebrew texts, and his earliest important works are biblical subjects treating Jewish history. Highly finished pen and ink drawings such as *Hagar and Ishmael* (1857; Lionel Lambourne Collection) and *Sacrifice of Isaac* (circa 1858; Ashmolean Museum, Oxford) were followed by *Isaac Offered*, Solomon's first oil painting to be exhibited at the Royal Academy in 1858 (unlocated; watercolour version in a private collection).[1] These and subsequent images produced the comment from the painter William Blake Richmond, a friend of Solomon, that "none but a Jew could have conceived or expressed the depth of national feeling which lay under the strange, remote forms of the archaic people whom he [Solomon] depicted and whose passions he told with a genius entirely unique".[2]

Formerly called *King David*, and tentatively linked to the passage of I Kings 1:1–4 that describes the aged king's comfort by the maiden Abishag, this image has been more plausibly identified by Gayle Seymour as a drawing exhibited at the French Gallery, London, on 12 November 1859.[3] This extract from Jeremiah 51:7 formed part of the catalogue entry: "Babylon hath been a golden cup in the hand of God, which hath made all the earth drunken: the nations have drunken of her wine, therefore all the nations are mad". The context is of Jeremiah's lamentation over the Jewish people's captivity under the kingdom of Babylon, and their gradual acceptance of Babylonian hedonism and immorality. The prophet warns the tribe of Judah of the temptation to "steal, murder, commit adultery, swear falsely, burn incense to Baal, and go after gods you have not known" (Jeremiah 7:9, 10). Symbolic details in Solomon's drawing include not only Baal's incense burner but also a "golden cup" whose spilled contents have stupefied even the heathen sacred leopard. Seymour observes that the harp of the languorous king (whose crown lies dis-

carded on his lap) is decorated with peacock feathers, symbolising vanity, and passion flowers.[4]

It could be presumed that Simeon Solomon intended this drawing as a contribution to the *Bible Gallery*, a hugely ambitious series of wood engravings planned by the brothers Dalziel (see cat. no. 37). The earliest designs date from 1859 – including the present sheet, whose inscription gives its date as September 1859 – but negotiations with contributing artists were still under way in 1865, and work on engraving the wood blocks continued throughout the 1870s.[5] Sixty-two engravings were eventually published in 1881, but with no accompanying text; an expanded commercial edition, with accompanying text, appeared in 1894.[6] In its combination of designs by the Pre-Raphaelites and their academic contemporaries, the *Bible Gallery* stands as an important successor to the Moxon Tennyson (see cat. no. 41), and is a more obvious landmark to the acceptance and absorption of Pre-Raphaelitism within the development of British art. Brown, Hunt, Burne-Jones and Sandys were represented, alongside G.F. Watts, E.J. Poynter and Frederic Leighton (who, by 1881, was President of the Royal Academy). Millais had already achieved popular success

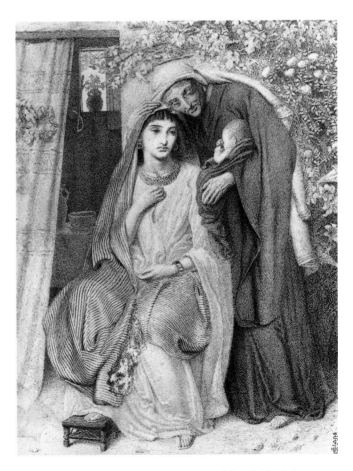

Fig. 50 SIMEON SOLOMON, *Ruth, Naomi, and the Child Obed*, 1860; pen and brown ink over pencil; 11 1/2 x 9 in. (29.2 x 22.9 cm.). Birmingham Museums and Art Gallery (63'11).

in the same field with *The Parables of Our Lord*, first published in 1864.

Solomon had six designs published in the *Bible Gallery*, including *Ruth, Naomi, and the Child Obed*, for which his drawing of 1860 is in the Birmingham collection (fig. 50).[7] It is difficult to believe, however, that he could have imagined this drawing of Babylon to be acceptable for publishing, with its sultry atmosphere, background frieze of half-naked women, and the ambiguous sex of the youth. A more sober depiction of a Jewish musician, under the title *Hosannah*, which did appear in the *Bible Gallery*, shares some decorative details, such as a similar harp. A pen and ink drawing of this subject, dated 1860 and of almost exactly the same size as the present sheet, is in the Huntington Library, Art Collections, and Botanical Gardens, San Marino, California.[8]

1. London and Birmingham, 1985–1986 (37–39, repr.).
2. A.M.W. Stirling, *The Richmond Papers*, London, 1926; quoted in Seymour, 1987, p. 48.
3. Seymour, 1987, p. 48.
4. Seymour, 1987, p. 49.
5. See Dalziel, 1901, pp. 237–260.
6. *Dalziels' Bible Gallery. Illustrations from the Old Testament*, London, 1881; *Art Pictures from the Old Testament*, London, 1894.
7. Birmingham, *Drawings*, 1939, p. 400 (63'11); wrongly identified as *The Virgin Mary with St Anne holding the Infant Christ*.
8. Reproduced in Reynolds, 1984, pl. 21 (as *A Jewish Musician in the Temple*).

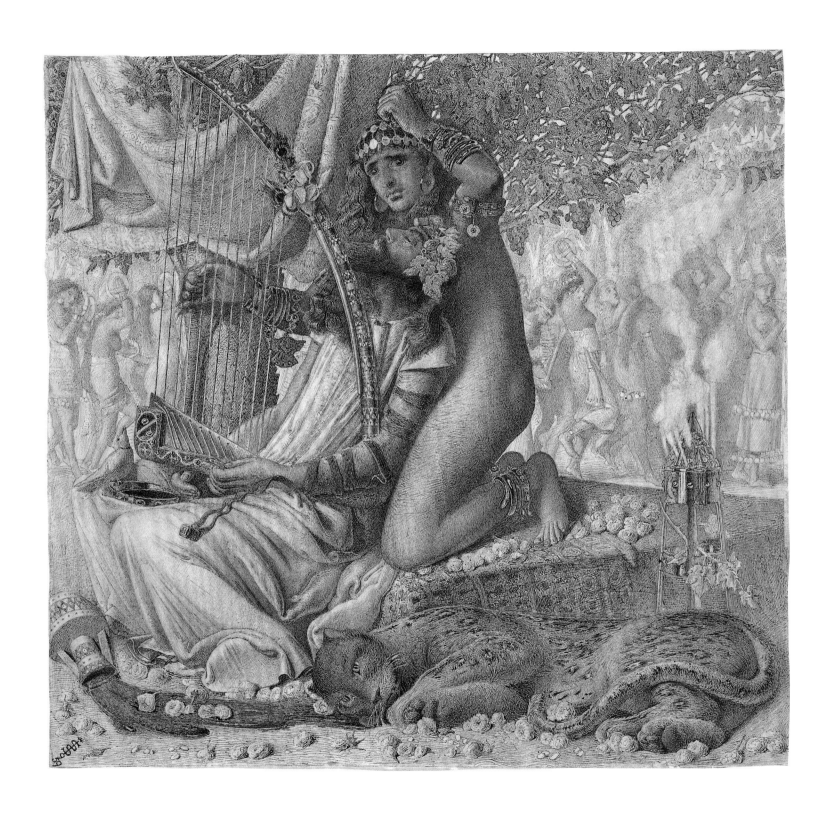

53

JOHN EVERETT MILLAIS

The Seamstress

1860
Watercolour
4 3/8 x 5 3/8 in.; 11.2 x 13.8 cm. (sheet); 4 x 5 in.; 10.1 x 12.8
cm. (image)
Signed, bottom right: JM (initials in monogram)
Presented by subscribers, 1906 (655'06)
PROVENANCE: Myles Birket Foster; Charles Fairfax Murray
REFERENCE: Birmingham, *Paintings &c.* [1930], p. 133

Following his involvement with the Moxon Tennyson (see cat. no. 41) and his commission in 1857 from the brothers Dalziel for *The Parables of Our Lord* (see cat. no. 52), Millais reached a peak of activity as a book illustrator in the early 1860s, making regular contributions to two of the day's leading magazines. In May 1859 he agreed with the publishers Bradbury and Evans to provide designs for the periodical *Once a Week*. He declined a salary of £600 a year, which would have committed him to making one drawing for each weekly issue, considering "upon the whole, as my painting necessitates an uncertainty in the time I can devote to illustration, that I had better make yr. drawings whenever an opportunity presents itself, at 8 g[uineas] a drawing, whether large or small".[1] "The pay is *first rate*", he subsequently reported, "so you can see there are some prospects of making money. I see the estimation I am held in is *tremendously high*".[2] Subsequently, more of his energies were devoted to illustrating six of Anthony Trollope's novels, beginning in 1860 with *Framley Parsonage:* these appeared either in monthly parts or serialised in the *Cornhill Magazine*.[3]

The Seamstress is an illustration to "The Iceberg", a story by J. Stewart Harrison published in *Once a Week* in October 1860. In a slightly more genteel variation on the theme of Rossetti's *Found* (see cat. no. 34), the narrator recalls tracking down a lost love fallen on hard times. Having been "not fairly done by" at the hands of a cad calling himself Montague Fitzjames,

> she was ruined, and had run away. I went nearly mad at this, and set out to find her, and after about three weeks I found her at Manchester. I didn't go in to her place at first, but asked some questions about her in the neighbourhood, and found she'd got a child – a boy – and was working at shirt-making for a living, and was quite a decent woman . . . so I went up and saw her. She was dreadfully thin, and her eyes bright and far back in her head. The baby was lying in a cradle by the fire – such a little bit it hardly kept the room warm.[4]

The plight of such 'fallen women', reduced to piece-work sewing for miserably low pay, was first brought to public attention through Thomas Hood's poem "The Song of the Shirt", published in the 1843 Christmas issue of *Punch*. Richard Redgrave's painting *The Sempstress* (1846; FORBES Magazine Collection, New York) was one of the earliest treatments of an image whose topicality lasted throughout the century.[5]

Millais's original design would have been in pencil. He made many such replicas in watercolour, which proved popular with dealers and collectors, and for which he usually charged fifteen guineas.[6] *The Wife*, another watercolour in the Birmingham collection, is also based on a design for *Once a Week*, and must share the same provenance: it was sold by the dealer Richard Colls to the watercolourist and collector Myles Birket Foster (1825–1899) at some time before July 1863.[7]

1. Quoted by Malcolm Warner in Arts Council, 1979, p. 35.
2. Quoted by Jennifer M. Ullman in Casteras (ed.), 1991, p. 59.
3. See Arts Council, 1979, pp. 36–37.
4. *Once a Week*, vol. 3, 6 October 1860, p. 408.
5. See the catalogue to the exhibition *The Subversive Stitch: Embroidery in Women's Lives 1300–1900*, Whitworth Art Gallery, University of Manchester, 1988.
6. See Casteras (ed.), 1991, p. 59.
7. Birmingham, *Paintings &c.* [1930], p. 133 (656'06); Arts Council, 1979 (75).

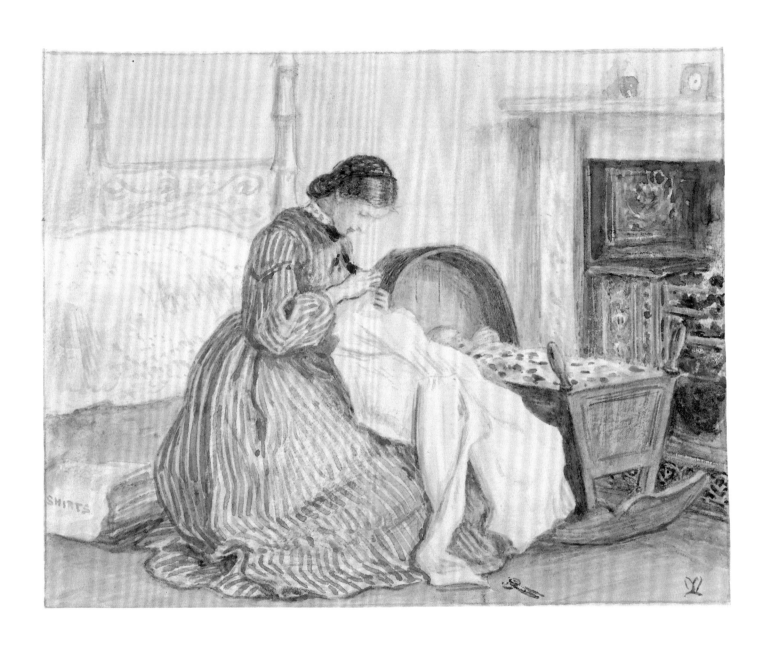

54

DANTE GABRIEL ROSSETTI

Self-Portrait

1861
Pencil
10 x 8 1/2 in.; 25.4 x 21.6 cm.
Signed and dated, lower right: DGR / Oct. 1861 (initials in monogram)
Presented by subscribers, 1904 (479'04)

PROVENANCE: Fanny Cornforth; Charles Fairfax Murray

PEFERENCES: Birmingham, *Drawings*, 1939, p. 352; Surtees, 1971, no. 438, pl. 411; London and Birmingham, 1973 (246, repr.)

*T*his is the largest and most formal of Rossetti's modestly few self-portrait drawings.[1] In 1861 he was aged thirty-three and had been married for a year. In May, Lizzie had given birth to a stillborn baby – a double tragedy, since a child might have provided a focus of stability between two highly emotional people who were in a marriage that was thereafter doomed to failure. Rossetti's career as an artist was gaining pace, however, and with financial assistance from Ruskin he was able to publish his first book in December, verse translations of *The Early Italian Poets and Dante's Vita Nuova*. As a founding partner, he drafted the prospectus and provided early designs for stained glass and decorative work for the firm of Morris, Marshall, Faulkner and Company, which Morris had founded in the spring of 1861.

Contemporary descriptions of the mature Rossetti concentrate on his dark grey eyes and large, round forehead. Henry Treffry Dunn, his studio assistant from 1867 to 1881, wrote that "his face conveyed to me the existence of underlying currents of strong passions impregnated with melancholy",[2] while his last companion Hall Caine "thought his head and face singularly noble, and from the eyes upward full of beauty".[3] This self-portrait shows him dressed in his 'painting coat', which Dunn described as "buttoned close to the throat, descending at least to the knees, and having large perpendicular pockets, in which he kept his hands almost constantly while he walked to and fro".[4] A photograph given to Fanny Cornforth in 1863 (Delaware Art Museum, Wilmington; fig. 51) not only confirms the accuracy of this likeness, but also seems to show Rossetti dressed in this favourite coat.

1. Surtees, 1971, nos. 434–439.
2. Quoted in Pedrick, 1904, p. 18.
3. Hall Caine, *Recollections of Rossetti*, 1928, p. 68.
4. Pedrick, 1904, p. 19.

Fig. 51 UNKNOWN PHOTOGRAPHER, *Dante Gabriel Rossetti*, before 1863; photograph, 7 5/8 x 5 3/4 in. (19.5 x 14.5 cm.). Delaware Art Museum, Wilmington (Helen Farr Sloan Library Archives).

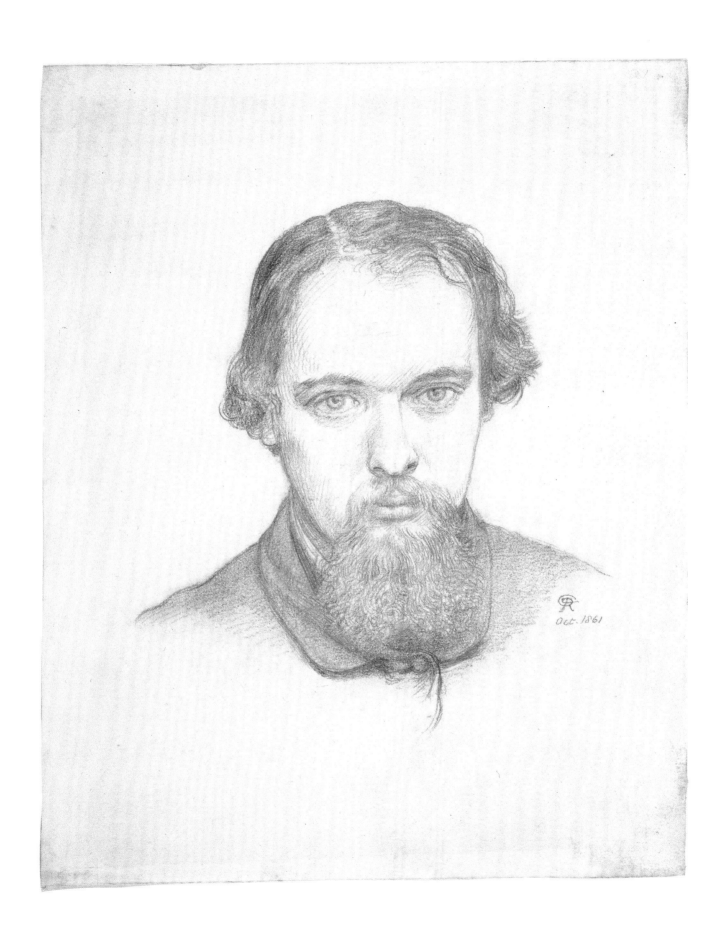

Oct. 1861

DANTE GABRIEL ROSSETTI

The Seed of David: study for David (William Morris)

Circa 1861
Pencil
9 5/8 x 8 3/4 in.; 24.5 x 22.3 cm.
Verso: Male figure in medieval costume
Pen and black ink
Presented by subscribers, 1904 (261'04)

PROVENANCE: William Michael Rossetti; Charles Fairfax Murray

REFERENCES: Birmingham, *Drawings*, 1939, p. 324; Surtees, 1971, no. 105J, pl. 144; Cambridge, 1980 (7, pl. 2)

Through Brown and his friend John Pollard Seddon (1827–1906), architect in charge of restoring Llandaff Cathedral in south Wales, Rossetti obtained in 1856 a commission of £400 to paint a reredos for that building. He conceived of it as a large triptych, *The Seed of David* (fig. 52): "This picture shows Christ sprung from high and low, as united in the person of David who was both Shepherd and King, and worshipped by high and low (by King and Shepherd)".[1] Enthusing over such "a big thing which I shall go into with a howl of delight",[2] Rossetti started work in 1858, and gave it further serious attention in 1861, completing enough of the design to exhibit it fleetingly in London in mid-September. The triptych was effectively finished in 1864, although it was probably re-touched in 1869.

The model for the Christ child was Agnes, the infant daughter of Arthur Hughes; Ruth Herbert, an actress much admired by Rossetti, originally sat for the Virgin. She was replaced by Jane Morris, and two of the three studies taken of her head are dated 1861 (one of them has the additional note of September).[3] It seems likely that this portrait drawing of William Morris, a study for the head of King David in the righthand panel of the triptych, was made at the same time, probably at Red House, where Rossetti was a regular guest.

It is the most striking early portrait extant of the young Morris, who was then twenty-seven. A commentary by his biographer, J.W. Mackail, on a photograph taken in 1857 also matches Rossetti's direct but informal image:

> His hair remained through life of extraordinary beauty, very thick, fine and strong, with a beautiful curl that made it look like exquisitely wrought metal, and with no parting. . . . His general appearance at this time [showed] the massive head, the slightly knitted brow, the narrow eye-slits and heavy underlids, the delicately beautiful mouth and chin only half veiled by the slight beard. . . .[4]

1. Quoted in Surtees, 1971, p. 58.
2. Surtees, 1971, p. 58.
3. Surtees, 1971, p. 59 (nos. 105D–105F; two belong to the Society of Antiquaries in London, one to the Victoria and Albert Museum).
4. Mackail, 1899, vol. 1, p. 104.

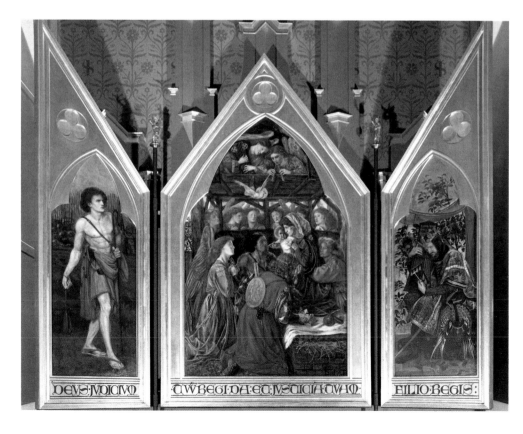

Fig. 52 DANTE GABRIEL ROSSETTI, *The Seed of David*, 1858–1864; oil on canvas, centre compartment 90 x 60 in. (230 x 150 cm.), wings 73 x 24 1/2 in. (185.5 x 62.0 cm.). Llandaff Cathedral, Wales.

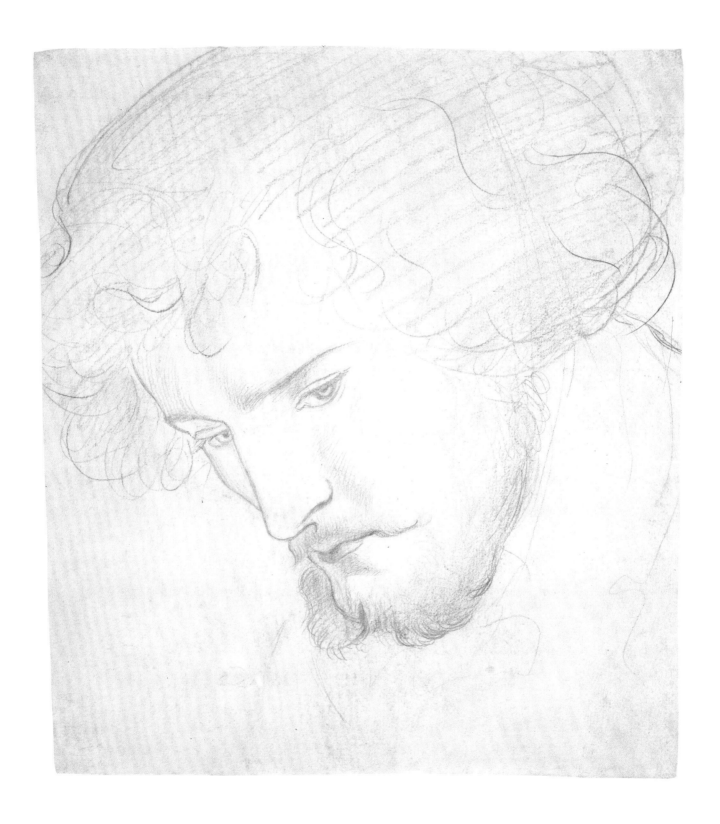

56

WILLIAM MORRIS

The Ascension

Circa 1862
Brush and Indian ink, with brown ink, over pencil
37 1/4 x 23 1/4 in.; 94.5 x 59.2 cm.
Inscribed in pencil, top right: Ascension
Bottom centre: Selsley
Inscribed in ink, verso: S. S. Marling Esqr. / Stanley Park /
Nr Stroud / Gloucestershire [this address crossed out] and:
Messrs. / Morris & Co / 8 Red Lion Square / London /
Book Post
Verso also bears three circular Post Office franking stamps
Presented by Charles Fairfax Murray, 1904 (534'04)

REFERENCES: Birmingham, *Drawings*, 1939, p. 287; Sewter,
1975, *Text*, pp. 171–172, *Plates*, pl. 51; Manchester,
Whitworth, 1984 (91)

*T*he firm of Morris, Marshall, Faulkner and Company, founded in April 1861, made a spectacular beginning with three major schemes for stained glass in new churches by the architect George Frederick Bodley (1827–1907).[1] At St Michael and All Angels, Brighton, four windows were filled, including the whole of the west end, with Burne-Jones's simple but effective two-light *Flight into Egypt* in the chapel at the east end.[2] St Martin's-on-the-Hill, Scarborough, has five windows from the first campaign, with a further fifteen added between 1863 and 1873. The firm also carried out painted decoration, including the pulpit.[3] All Saints, Selsley, near Stroud, is yet more impressive: as Sewter points out, its fifteen windows represent Morris and Company's "only complete scheme of glazing for a church, designed and executed all at the same period, and is thus of outstanding importance as an example of the firm's early work".[4]

Burne-Jones and Morris supplied most of the designs for the Selsley windows, although Brown, Rossetti and Philip Webb also contributed. Burne-Jones's account book with Morris and Company begins with an entry under 1861, which includes 'Christ blessing children' and '2 small heads of apostles' among subjects for the church. The cartoon for these heads of Saints Peter and Paul arguably contains portraits of Morris and Bodley in roundels (fig. 53).[5] Entries for designs intended for Selsley continue until May 1862, as indicated by the date of Morris's cartoon for *The Ascension*. Post Office frankings on the reverse of the sheet reveal that the cartoon was despatched (presumably rolled up) from the firm's offices at Red Lion Square on 27 May 1862 to the church's patron, Sir Samuel Marling of Stanley Hall, and were received in, or returned from, Stroud on 28 May.

Initial studies for the composition, in a notebook now in the British Library, indicate that Morris was directly inspired by medieval illuminated manuscripts, which he both collected and sought out in the British Museum. Sewter illustrates Morris's copy of an Ascension from the fourteenth-century Queen Mary's Psalter, which clearly gave him the idea for the composition of the present cartoon, with only Christ's disappearing feet in sight.[6]

The Ascension is the first of the five windows in the chancel apse at Selsley, each of a single light with a simple circular tracery window above. The main subjects that follow are *The Resurrection* by Burne-Jones, *Christ on the Cross* by Brown, *The Nativity* and *Adoration of the Magi* also by Morris, and *The Visitation* by Rossetti. Strongly leaded, these clear and dramatic designs remain medieval in spirit, and yet share the equally important Pre-Raphaelite characteristics of bold draughtsmanship and uncluttered detail. Early Morris windows such as these contrast with most commercial stained glass of the period, just as the first Pre-Raphaelite Brotherhood canvases do with contemporary painting, and as such they mark a watershed in the development of nineteenth-century ecclesiastical art.

1. See David Verey, "George Frederick Bodley: climax of the Gothic Revival", in Jane Fawcett (ed.), *Seven Victorian Architects*, London, 1976, pp. 87–89.
2. Sewter, 1975, *Text*, pp. 32–33, *Plates*, pls. 54–63.
3. Sewter, 1975, *Text*, pp. 168–171, *Plates*, pls. 64–77.
4. Sewter, 1975, *Text*, pp. 171–173, *Plates*, pls. 28–53.
5. Birmingham, *Drawings*, 1939, p. 136 (numbered 539–540'04, though a single sheet).
6. Sewter, 1975, *Plates*, pl. 50; see also Manchester, Whitworth, 1984, p. 150.

Fig. 53 EDWARD BURNE-JONES, *St Peter and St Paul*, 1861; pencil and brown chalk, with black and brown ink, 15 1/4 x 22 1/4 in. (38.8 x 56.5 cm.). Birmingham Museums and Art Gallery (539–540'04).

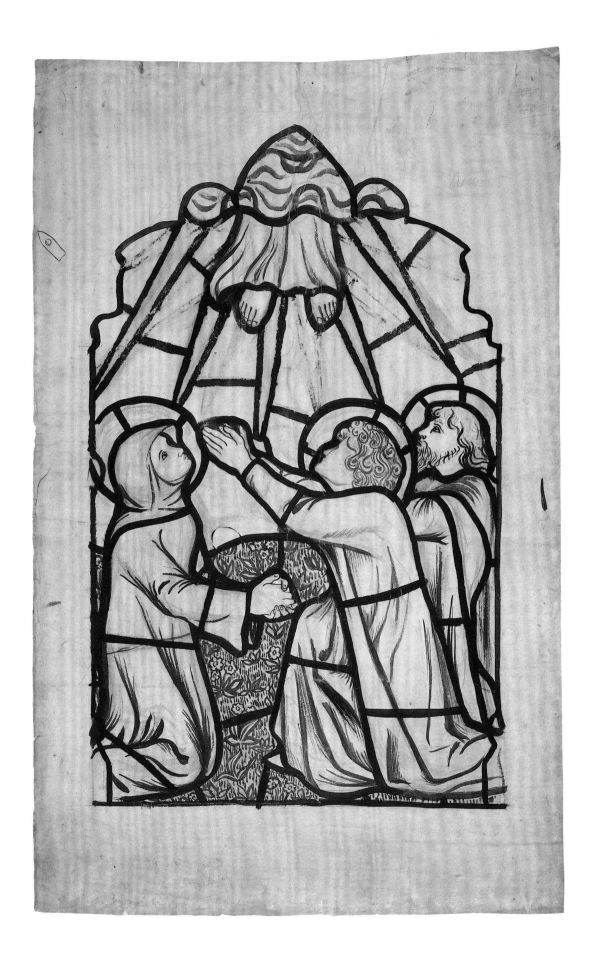

57

FORD MADOX BROWN

King René's Honeymoon: Architecture

1861
Brush and brown ink, with watercolour, over pencil on
buff paper
17 1/2 x 12 1/2 in.; 44.4 x 31.6 cm. (strip 2 5/8 x 12 1/2 in.
[6.6 x 31.6 cm.] added at bottom)
Signed and dated, bottom right: FMB – 61 (initials in
monogram)
Inscribed in pencil, verso: King Rene's Honeymoon
Bequeathed by J.R. Holliday, 1927 (351'27)

REFERENCES: Birmingham, *Drawings*, 1939, p. 44; Liverpool,
1964 (82); Manchester, Whitworth, 1984 (65)

*O*ne of the first of the Morris firm's domestic commissions
was to decorate an oak cabinet designed by J.P. Seddon (see
cat. no. 55) to hold his architectural drawings. Along with
other painted furniture, this was exhibited by Morris in the
Medieval Court of the International Exhibition of 1862, held
at South Kensington. In architecture and the applied arts, the
Gothic Revival style was at the forefront of the avant-garde,
and the kind of 'practical' Pre-Raphaelitism exemplified by
the firm's exhibits attracted much attention.[1]

The cabinet, now in the Victoria and Albert Museum,
was designed with one main panel on each of its four large doors
and six subsidiary panels on the back rail above. Following
Seddon's wish to "realise the unity of the several fine arts and
their accessories", the main subjects illustrate Architecture,
Painting, Sculpture and Music, through a romantic narrative
of "the old spirit of chivalry", based on the story of King René
of Anjou. In a later book describing the cabinet, Seddon cred-
its Brown with this idea, which provides a more flattering
image of the pleasure-loving monarch than that given in Sir
Walter Scott's novel *Anne of Geierstein* (1829).[2] Brown intro-
duces the subject and this first composition thus:

> King René was titular King of Naples, Sicily, Jerusalem,
> and Cyprus; and father of our celebrated and unfortunate
> Margaret, Queen to Henry VI [of England]. He was
> poet, painter, architect, sculptor, and musician; but most
> unfortunate in his political relations. Of course, as soon
> as married, he would build a new house, carve it and
> decorate it himself, and talk nothing but Art all the
> "Honeymoon" (except indeed love). It is twilight when
> the workmen are gone.[3]

Two other panels, *Painting* and *Sculpture* (fig. 54)[4], are both
by Burne-Jones, and the fourth, *Music*, is by Rossetti.

As so often happened, the artist converted this image
into other forms – in this instance, an oil painting and two

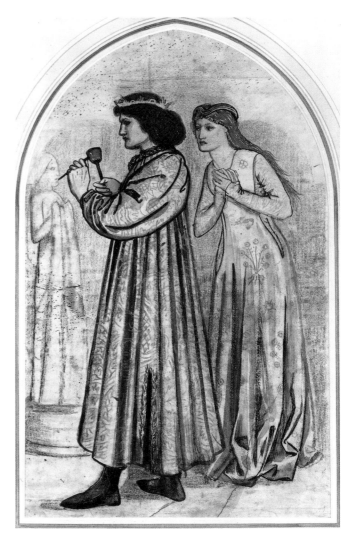

Fig. 54 EDWARD BURNE-JONES, *King René's Honeymoon: Sculpture*,
1861–1862; brush and Indian ink, with coloured chalks and water-
colour, 22 3/4 x 16 5/8 in. (57.8 x 42.2 cm.). Birmingham Museums
and Art Gallery (528'04).

watercolours, all dated 1864.[5] Two similarly detailed cartoons
also exist, one in the British Museum, London, and another
in the Ashmolean Museum, Oxford, which may relate to the
repetition of this and the other three designs as a set of pan-
els of stained glass, each placed within a floral border. That set
of glass, which Sewter suggests could date from as early as
1862, survives in the Victoria and Albert Museum.[6]

1. See Stephen Wildman, "The International Exhibition of 1862: The
Medieval Court", in Manchester, Whitworth, 1984, pp. 124–133.
2. John P. Seddon, *King René's Honeymoon Cabinet*, London, 1898.
3. London, Piccadilly, 1865, p. 13 (reprinted in Seddon, *King René's
Honeymoon Cabinet*, 1898, p. 6).
4. Birmingham, *Drawings*, 1939, p. 53 (528'04).
5. See Liverpool, 1964, under no. 82; one watercolour is in the Tate
Gallery, London, while the other was with Julian Hartnoll, London,
in 1991.
6. Sewter, 1975, *Text*, p. 102, *Plates*, col. pls. IVa–d.

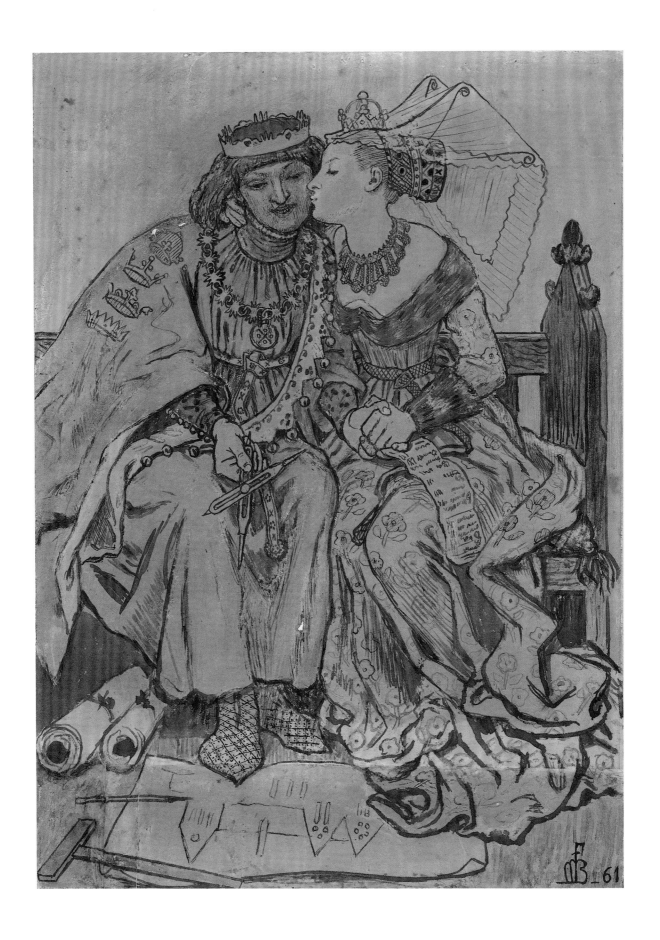

58

ARTHUR HUGHES

The Birth of Tristram

1861–1862
Red chalk, sepia, watercolour and bodycolour
23 x 21 1/2 in.; 58.5 x 54.5 cm.
Presented by Charles Fairfax Murray, 1912 (39'12)

REFERENCES: Birmingham, *Drawings*, 1939, p. 237; Cardiff and London, 1971 (42); Sewter, 1975, *Text*, p. 26, *Plates*, pl. 78

The Birth of Tristram is the first in the series of thirteen panels of stained glass made in 1862 by Morris, Marshall, Faulkner and Company for the Bradford merchant Walter Dunlop (see cat. no. 51). Illustrating the story of Tristram and Isoude (Iseult) from Malory's *Morte d'Arthur*, the glass panels decorated the entrance hall at Harden Grange, near Bingley, Yorkshire, which Dunlop had leased as a country home. On his death in 1903, they passed to the landlord, who sold them to Bradford City Art Gallery in 1916.[1]

The firm's first secular commission for glass, the *Tristram and Isoude* windows are a remarkable translation, into yet another medium, of the romantic Pre-Raphaelitism typified by the Oxford Union mural scheme, the Moxon Tennyson (see cat. no. 41) and Rossetti's medievalist watercolours (cat. no. 50). Similar to the murals at Oxford, the subjects are drawn from Malory, and seem to have been chosen by Morris.[2] After this initial subject of Tristram's birth come *The Fight with Sir Marhaus* by Rossetti; *Sir Tristram leaving Ireland* by Val Prinsep; *The Love Potion* by Rossetti; *The Marriage of Tristram and Isoude, Isoude's attempt to kill herself* (see cat. no. 59) and *The Madness of Sir Tristram*, all by Burne-Jones; *Sir Tristram recognised by Iseult's Dog* and *Tristram and Isoude at Arthur's Court*, both by Morris; *The Death of Sir Tristram* by Brown; *The Tomb of Tristram and Isoude* by Burne-Jones; and two panels depicting *Queen Guenevere and Isoude* and *King Arthur and Sir Lancelot*, both by Morris.

The stained-glass panel of *The Birth of Tristram* has a lettered inscription: "How the father of Sir Tristram de Lyonesse was slain in battle and how his mother fled into the wild woods: there was Sir Tristram born and there his mother died". Before Queen Elizabeth of Lyonesse, the sister of King Mark, dies while on her way to join her already defeated husband King Meliodas, she asks for the baby to the christened Tristram, or 'sorrowful birth'.

A regular visitor to Red House, as well as a welcome member of the Morris and Burne-Jones circle, Arthur Hughes was a natural recruit for the firm, and his name was included on its first prospectus, but he withdrew before the company was formally registered. "I was living far off in the country",

he told Morris's biographer, "while the others were in town, and attending the meetings was inconvenient for me, and also I rather despaired of its establishment, and I wrote asking to be let go. Curiously, my letter was crossed by one from Morris asking me to make a design for a portion of a window, and another for a piece of jewel work. I did the drawing for the window, and it remains my only contribution".[3] This cartoon certainly betrays rather hasty execution, mitigated to a great extent by the unusual medium of red chalk. Hughes regularly turned to the Arthurian legend in his easel paintings, with works such as *The Brave Geraint* (1863; Private Collection), *Sir Galahad* (1870; Walker Art Gallery, Liverpool) and *The Lady of Shalott* (1873; Private Collection).

1. Sewter, 1975, *Text*, p. 26.
2. See Manchester, Whitworth, 1984, p. 182.
3. Mackail, 1899, vol. 1, pp. 147–148.

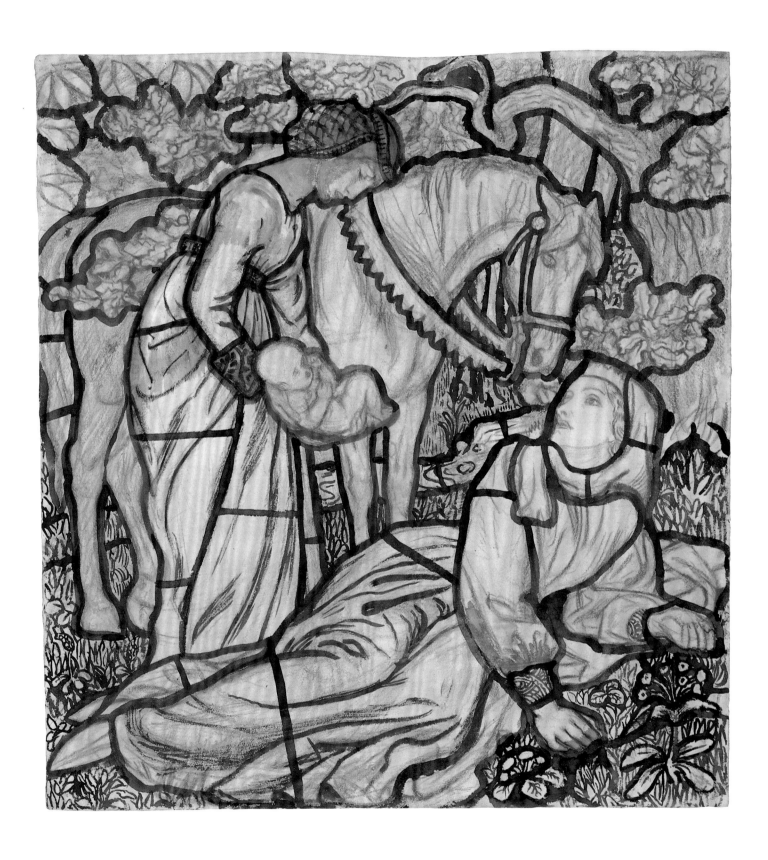

59

EDWARD BURNE-JONES

King Mark and La Belle Iseult

Circa 1862
Watercolour, bodycolour and gum
23 x 21 7/8 in.; 58.5 x 55.5 cm.
Presented by Sir John T. Middlemore, Bart., 1912 (28'12)

PROVENANCE: Charles Fairfax Murray

REFERENCES: Birmingham, *Paintings &c.* [1930], p. 29; Christian, 1973, p. 68, fig. 23; London, Southampton and Birmingham, 1975–1976 (77)

King Mark and La Belle Iseult, as the work is known in this form, is the same image as *Isoude's attempt to kill herself*, the sixth design in the series of thirteen stained-glass panels made by Morris, Marshall, Faulkner and Company in 1862 (see cat. no. 58). The glass (now in Bradford City Art Gallery) bears the inscription: "How Sir Tristram being returned from Brittany into Cornwall, fled again hence and how La Belle Isoude would have slain herself for his sake with the sword had not King Mark been near and prevented her and shut her up in a tower".[1] In a variation on the fatal adulterous passion between Lancelot and Guenevere (see cat. no. 42), Tristram has fallen in love with Isoude, who is promised in marriage to Mark, King of Cornwall (see also cat. no. 51). Separated, Tristram goes mad and Isoude attempts suicide, but after saving the King's life, Tristram is forgiven and eventually takes Isoude to King Arthur's court as his bride. Although apparently reconciled to their union, King Mark treacherously kills Tristram, whereupon Isoude dies of a broken heart.

Also in the Birmingham collection are cartoons by Burne-Jones for *The Madness of Sir Tristram* and *The Tomb of Tristram and Isoude*.[2] Their considerable difference in style – the former is quite detailed in soft pencil, while the latter is boldly painted with brush and ink – is puzzling, but it may be explained by the experimental nature of Burne-Jones's early work for Morris. It has been plausibly suggested that *King Mark and La Belle Iseult* is the original cartoon worked up in watercolour (no other design survives), but this is not necessarily the case, as an independent version of *The Madness of Sir Tristram* exists in watercolour, which presumably could have been completed from the cartoon.[3] Burne-Jones made many preparatory studies for his early decorative work, and again in Birmingham are two drawings for the head of Iseult (fig. 55) and a sheet of studies for her left hand.[4]

As well as the three cartoons presented to Birmingham in 1912, Fairfax Murray also owned this watercolour, but he must have sold it to Sir John Middlemore after 1904 (when it was lent to a Ruskin exhibition in Manchester). He retained

Brown's cartoon for *The Death of Sir Tristram*, presenting it to the Fitzwilliam Museum, Cambridge, in 1917.[5] By then, Birmingham had acquired the version in oil which Brown painted in 1864 (fig. 56).[6]

1. Sewter, 1975, *Text*, p. 26.
2. Birmingham, *Drawings*, 1939, p. 138 (37–38'12); *The Tomb of Tristram and Isoude* is reproduced in Manchester, Whitworth, 1984, p. 184.
3. Jeremy Maas, *Victorian Painters*, London, 1969, repr. p. 158 (Private Collection); it is dated 1862 on a label in the artist's handwriting.
4. Birmingham, *Drawings*, 1939, p. 53 (477–479'27, bequeathed by J.R. Holliday).
5. Cambridge, 1980 (93, pl. 53).
6. Birmingham, *Paintings*, 1960, p. 21 (26'16).

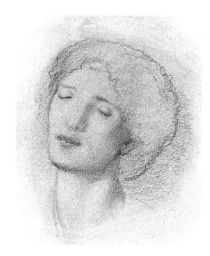

Fig. 55 EDWARD BURNE-JONES, *King Mark and La Belle Iseult: study for the head of Iseult*, circa 1862; pencil, 6 3/8 x 5 3/8 in. (16.1 x 13.7 cm.). Birmingham Museums and Art Gallery (478'27).

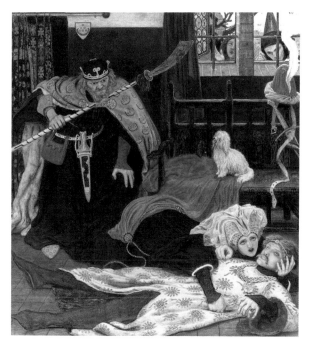

Fig. 56 FORD MADOX BROWN, *The Death of Sir Tristram*, 1864; oil on canvas, 25 1/4 x 23 in. (64.1 x 58.4 cm.). Birmingham Museums and Art Gallery (26'16).

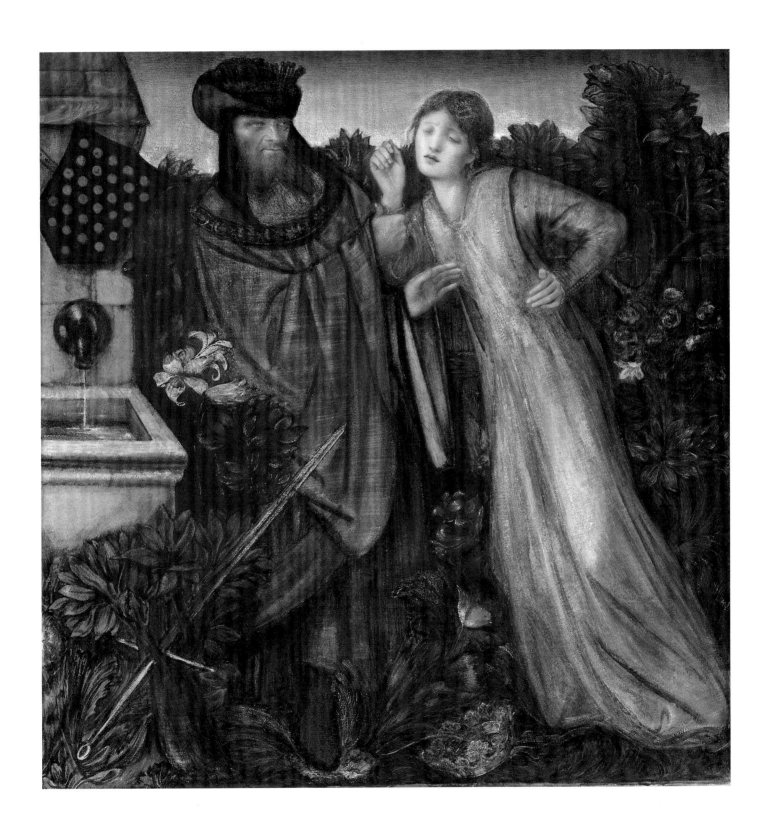

60

DANTE GABRIEL ROSSETTI
for MORRIS, MARSHALL, FAULKNER
AND COMPANY

The Story of St George and the Dragon:
The Skulls brought to the King

Designed circa 1861–1862, executed 1872
Stained glass
37 x 25 1/2 in.; 94.0 x 65.0 cm.
Purchased, 1972 (M77'72)

PROVENANCE: Commissioned by Joseph (later Sir Joseph)
Whitwell Pease, Hutton Hall, Yorkshire

REFERENCES: Tokyo and tour, 1990–1991 (92, repr.); for version
in Victoria and Albert Museum, London, see Sewter, 1975,
Text, p. 103

For the firm's second set of domestic stained glass, Morris turned to Rossetti for designs. No documentation for *The Story of St George and the Dragon* has yet come to light, but the six panels made around 1862 may also have been destined for Walter Dunlop's house, Harden Hall, Bingley, in Yorkshire (see cat. nos. 58, 59).[1] They were eventually acquired by J.R. Holliday, and bequeathed in 1927 to the Victoria and Albert Museum, London. The five stained-glass panels now in Birmingham (cat. nos. 60–64; without the third in the series, *The Princess Sabra taken to the Dragon*), were executed in 1872 for Hutton Hall, near Guisborough, Yorkshire, a mansion

built between 1864 and 1871 and designed by the architect Alfred Waterhouse (1830–1905) for J.W. Pease, M.P.[2]

Capitalising on his experience as a watercolourist, Rossetti fills his designs with much animation and vigorous draughtsmanship, and yet does not lose sight of the essential needs of stained glass in terms of colour and line. All six of his powerful original cartoons, one of them worked over in watercolour (see cat. no. 59), are in the Birmingham collection (fig. 57).[5] A note of grotesque humour runs through the series, notably in the depiction of the dragon. This whimsical element extends to the captions for each subject, which are included in the set belonging to the Victoria and Albert Museum but are absent from the Birmingham panels. The caption of the first subject, *The Skulls brought to the King*, is titled: "How word came to the King of Egypt touching a certain Dragon that ate much folk and must needs be fed with a noble damsel to stay his maw".

1. Sewter, 1975, *Text*, p. 103, *Plates*, pls. 91–96. The suggestion of Harden Hall as the location derives from notes made by H.C. Marillier, the last managing director of Morris and Company.
2. The windows seem to have been installed in a corridor leading to the Billiard Room: payments to Morris, Marshall, Faulkner and Company were made in May 1872 (£93 16s 8d) and August 1872 (£53 11s 0d); information supplied by Colin Cunningham. For Hutton Hall, see Colin Cunningham and Prudence Waterhouse, *Alfred Waterhouse 1830–1905: Biography of a Practice*, Oxford, 1992, p. 222.
3. Surtees, 1971, p. 87 (no. 151).
4. Surtees, 1971, no. 97.
5. Birmingham, *Drawings*, 1939, pp. 367–368 (241–245'04, 494'04); Surtees, 1971, nos. 145–150.

Fig. 57 DANTE GABRIEL ROSSETTI, *Cartoon for "The Skulls brought to the King"*, circa 1861–1862; Indian ink, 19 x 24 in. (48.2 x 61.0 cm.). Birmingham Museums and Art Gallery (241'04).

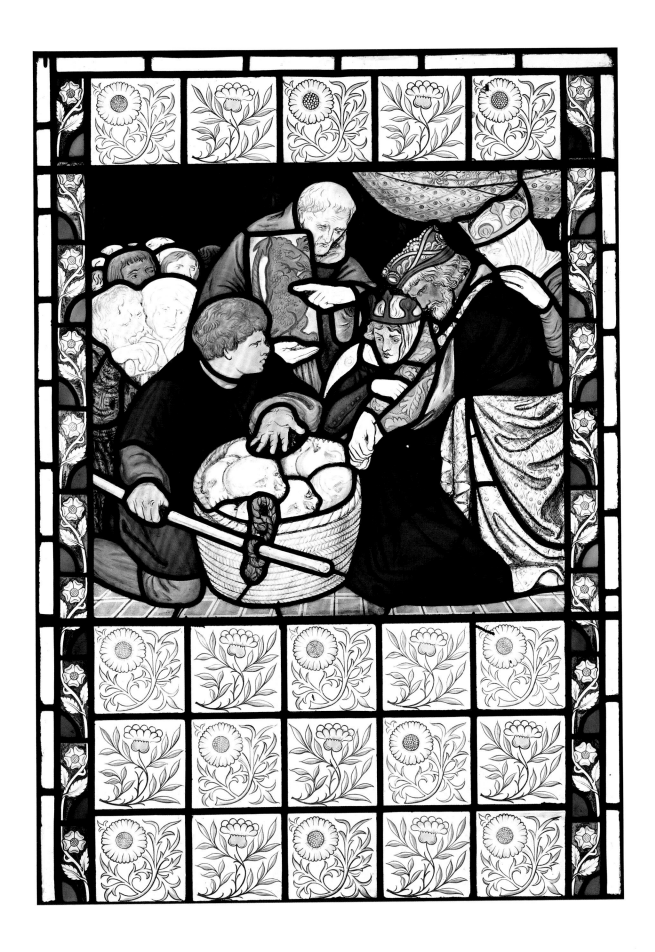

203

61

DANTE GABRIEL ROSSETTI
for MORRIS, MARSHALL, FAULKNER
AND COMPANY

*The Story of St George and the Dragon:
The Princess Sabra drawing the Lot*

Designed circa 1861–1862, executed 1872
Stained glass
37 1/4 x 26 in.; 94.5 x 66.0 cm.
Purchased, 1972 (M78'72)

PROVENANCE: Commissioned by Joseph (later Sir Joseph)
Whitwell Pease, Hutton Hall, Yorkshire

REFERENCES: Tokyo, 1990 (98, repr.); for version in Victoria
and Albert Museum, London, see Sewter, 1975, *Text*, p. 103

𝒯he corresponding stained-glass panel in the Victoria and
Albert Museum (see cat. no. 60) bears the title: "How the
damsels of the court cast lots who should be the Dragon's
meat and how the lot fell to the King's daughter".

A cartoon in brush and ink is missing from the rest of the
series, which is now in Birmingham; in its place is a water-
colour bearing Rossetti's monogram and dated 1868 (fig. 58).[1]
On paper laid onto canvas, and of a heavy and uneven appear-
ance, this may be the cartoon for the stained glass, overlaid
with colour. The head of the Princess Sabra has been altered,
her features now resembling Alexa Wilding, who was indeed

a regular model for Rossetti in 1868. No secure provenance is
known for the watercolour before its purchase from Charles
Fairfax Murray in 1904, although the Birmingham catalogue
(usually dependent on Murray's information) states that it
"changed hands many times, and was once sent to Australia".[2]

1. Surtees, 1971, no. 146, pl. 213.
2. Birmingham, *Drawings*, 1939, p. 368 (494'04).

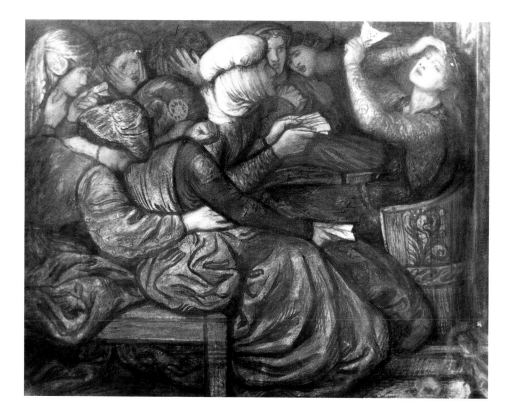

Fig. 58 DANTE GABRIEL ROSSETTI, *The
Princess Sabra drawing the Lot*, 1868; water-
colour and gum, 19 1/2 x 24 5/8 in. (49.5 x
62.5 cm.). Birmingham Museums and Art
Gallery (494'04).

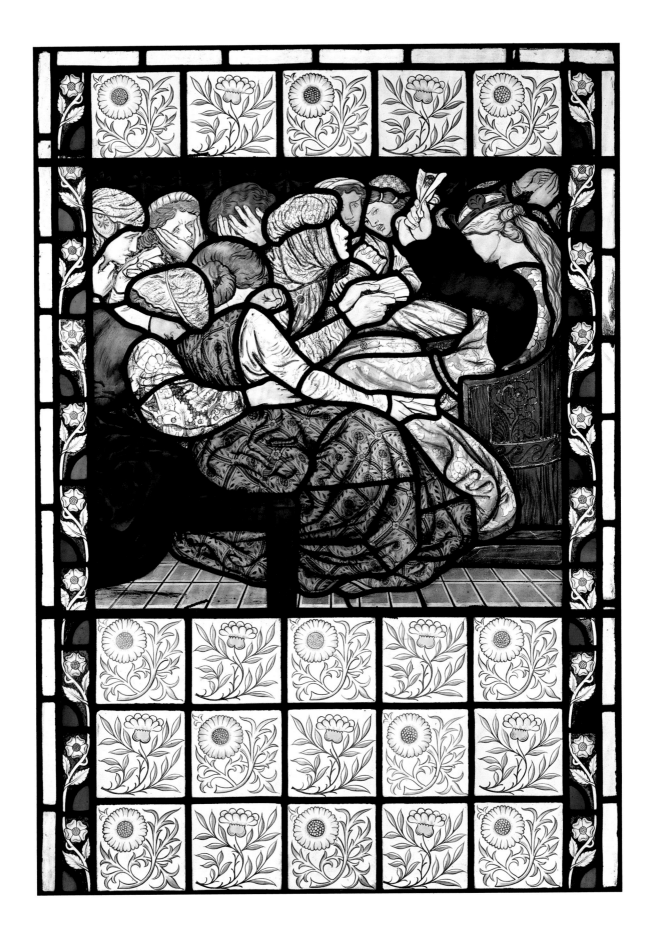

62

DANTE GABRIEL ROSSETTI
for MORRIS, MARSHALL, FAULKNER
AND COMPANY

*The Story of St George and the Dragon:
St George and the Dragon*

Designed circa 1861–1862, executed 1872
Stained glass
37 3/8 x 28 7/8 in.; 95.0 x 73.5 cm.
Purchased, 1972 (M79'72)

PROVENANCE: Commissioned by Joseph (later Sir Joseph)
Whitwell Pease, Hutton Hall, Yorkshire

REFERENCES: Tokyo, 1990 (94, repr.); for version in Victoria
and Albert Museum, London, see Sewter, 1975, *Text*, p. 103

The Birmingham set of windows lacks the third subject
in the series, *The Princess Sabra taken to the Dragon*, although
the Museum does possess the cartoon (fig. 59): "How the
woful Princess was borne to be eaten of the Dragon".

In the panel belonging to the Victoria and Albert
Museum, the next subject is titled: "How the good Knight St
George of England slew the dragon and set the Princess free".
A watercolour replica, signed and dated 1863, is in the
Ashmolean Museum, Oxford.[1] At the Fitzwilliam Museum,
Cambridge, is a small pencil drawing showing many of the
main elements of the composition, but with St George fight-
ing the dragon from his fallen horse: this is the only identified
preliminary study for the whole series.[2]

The head of St George is said to have been modelled from
Charles Augustus Howell (1840?–1890), a figure with a murky
background within the Pre-Raphaelite circle.[3] For a time acting
as Ruskin's secretary, Howell was a flamboyant character who
appears in numerous anecdotes as a rather shady entrepreneur;
one of Rossetti's biographers describes him as "rascally, plaus-
ible, magnificently gracing [an] occasion with his urbane pres-
ence and sparkling wit".[4] It was Howell who acted as Rossetti's
intermediary in arranging the exhumation of Elizabeth
Siddal's coffin in order to rescue a book of manuscript poems.
It is clear that Rossetti lent Howell the set of cartoons for *St
George and the Dragon*, probably with the intention of having
copies made, although he had great difficulty in getting them
back.[5] Four such copies, all in pencil, ink and watercolour,
were presented anonymously to the Birmingham collection in
1905: these are of *The Skulls brought to the King*, *St George and
the Dragon* (fig. 60), *The Return of the Princess*, and *The
Wedding of St George*.[6] They came with an attribution to Rosa
Corder (1853–1893), an associate and mistress of Howell from
1873, and a suspected purveyor of fake Rossetti drawings.[7]
The exact purpose of these copies remains unknown.

1. Surtees, 1971, no. 148.R.1.
2. Surtees, 1971, no. 148A, pl. 218; Cambridge, 1990 (92).
3. According to G.C. Williamson, *Murray Marks and his Friends*,
London, 1919, p. 147. For Howell, see C.L. Cline (ed.), *The Owl and
the Rossettis: Letters of Charles A. Howell and Dante Gabriel, Christina,
and William Michael Rossetti*, Pennsylvania State Press, 1978.
4. Oswald Doughty, *A Victorian Romantic: Dante Gabriel Rossetti*,
London, 1949, p. 333.
5. "You borrowed a set of drawings of St George and the Dragon to
copy – for your own use only. Please return them to Chelsea *at once*"
(letter from Rossetti to Howell, 22 March 1876; Cline, *Owl and
Rossettis*, 1978, letter 461). The demand must have been unsuccessful,
as Rossetti wrote to Theodore Watts-Dunton on 11 February 1878 that
"he [Howell] has of mine five cartoons of *St George*" (Doughty and
Wahl, 1965–1967, vol. 4, p. 1552). According to Henry Treffry Dunn,
Rossetti's studio assistant, "The cartoons of this romance [*St George
and the Dragon*] were framed and used to hang from the staircase wall
[at Tudor House, Cheyne Walk, Chelsea], but three of them having
been removed and turned into water-colours – *The Casting of Lots for
the Victims*, *The Slaying of the Dragon*, and *The Triumphant Entry* – the
rest were taken down and given away or lost" (Pedrick, 1904, pp.
33–34).
6. Birmingham, *Drawings*, 1939, p. 369 (203–206'05).
7. See British Museum, London, *Fake?: The Art of Deception*, London,
1990, no. 239, p. 221.

Fig. 59 DANTE GABRIEL ROSSETTI, *Cartoon for "The Princess Sabra taken to the Dragon"*, circa 1861–1862; Indian ink, 19 x 24 in. (48.2 x 61.0 cm.). Birmingham Museums and Art Gallery (242'04).

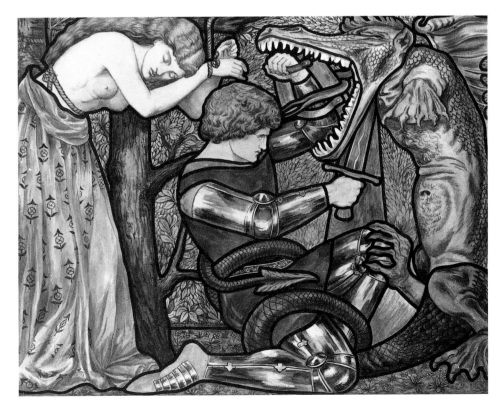

Fig. 60 Attributed to ROSA CORDER, after DANTE GABRIEL ROSSETTI, *St George and the Dragon*, circa 1875?; pencil, Indian ink, watercolour and bodycolour, 19 1/2 x 24 5/8 in. (49.5 x 62.5 cm.). Birmingham Museums and Art Gallery (204'05).

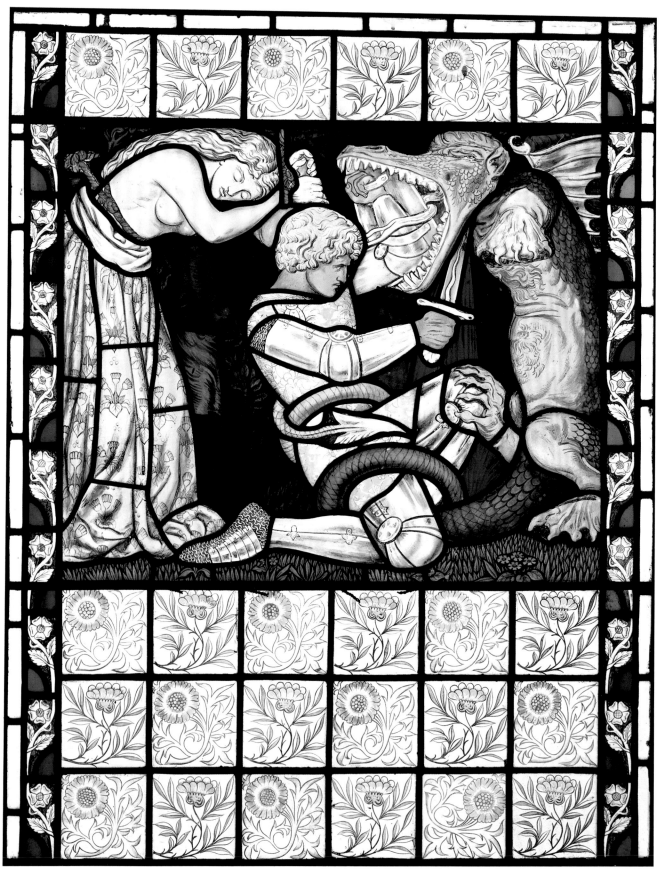

Cat. no. 62

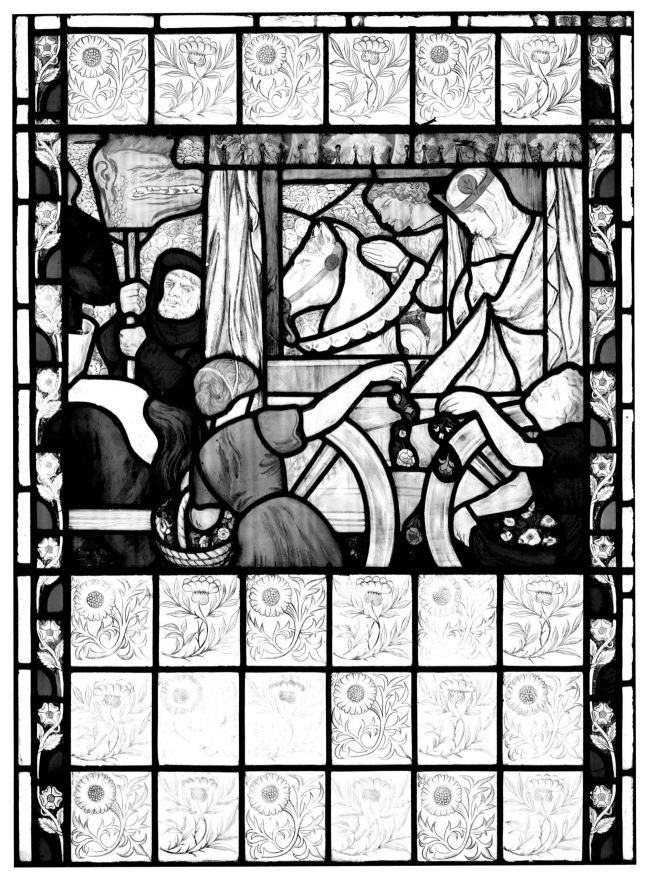

Cat. no. 63

63

DANTE GABRIEL ROSSETTI
for MORRIS, MARSHALL, FAULKNER
AND COMPANY

The Story of St George and the Dragon:
The Return of the Princess

Designed circa 1861–1862, executed 1872
Stained glass
39 x 28 7/8 in.; 99.0 x 73.5 cm.
Purchased, 1972 (M80'72)

PROVENANCE: Commissioned by Joseph (later Sir Joseph)
Whitwell Pease, Hutton Hall, Yorkshire

REFERENCES: Tokyo, 1990 (95, repr.); for version in Victoria
and Albert Museum, London, see Sewter, 1975, *Text*, p. 103

*T*he equivalent panel in the Victoria and Albert Museum
bears the title: "How the joyful Princess was borne home again".

Fig. 61 DANTE GABRIEL ROSSETTI, *Cartoon for "The Return of the Princess"*, circa 1861–1862; Indian ink, 19 x 24 in. (48.2 x 61.0 cm.). Birmingham Museums and Art Gallery (242'05).

64

DANTE GABRIEL ROSSETTI
for MORRIS, MARSHALL, FAULKNER
AND COMPANY

The Story of St George and the Dragon:
The Wedding of St George and the Princess

Designed circa 1861–1862, executed 1872
Stained glass
38 1/8 x 28 1/4 in.; 98.0 x 72.0 cm.
Purchased, 1972 (M81'72)

PROVENANCE: Commissioned by Joseph (later Sir Joseph)
Whitwell Pease, Hutton Hall, Yorkshire

REFERENCES: Tokyo, 1990 (96, repr.); for version in Victoria
and Albert Museum, London, see Sewter, 1975, *Text*, p. 103

1. Surtees, 1971, no. 150.R.1.
2. Indianapolis and New York, 1964 (62, repr.). The further identification of William Michael Rossetti as the King, Christina Rossetti as the Queen, and William Morris as the trumpeter on the right is somewhat more speculative.

The version of this final panel in the Victoria and Albert Museum carries the title: "How great rejoicing was made for the wedding of St George and the Princess".

A smaller replica of the subject in watercolour bears Rossetti's monogram and is dated 1864 (Private Collection).[1] Its former owner, Jerrold Northrop Moore, has made the pleasing suggestion that the head of St George represents Rossetti's self-portrait, with Elizabeth Siddal as the Princess.[2]

Fig. 62 DANTE GABRIEL ROSSETTI, *Cartoon for "The Wedding of St George and the Princess",* circa 1861–1862; Indian ink, 19 x 24 in. (48.2 x 61.0 cm.). Birmingham Museums and Art Gallery (245'04).

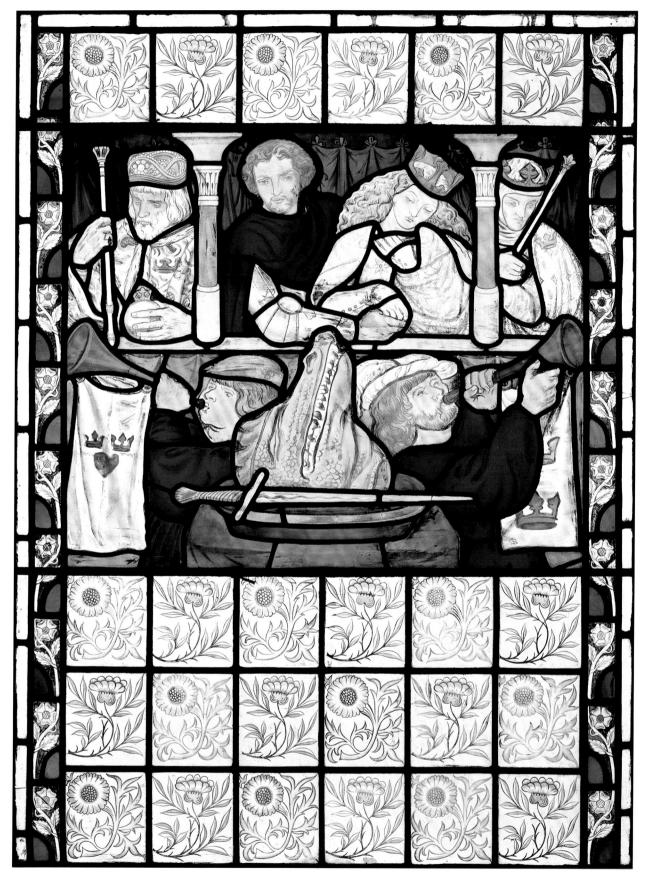

Cat. no. 64

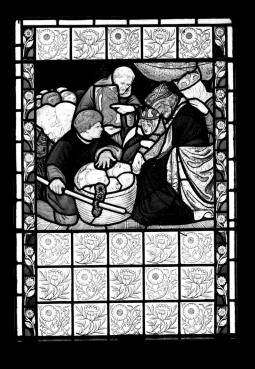
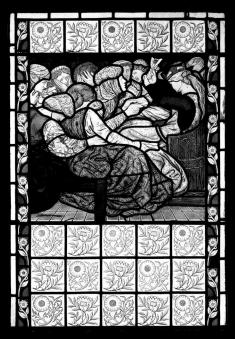
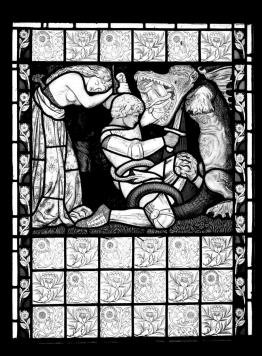
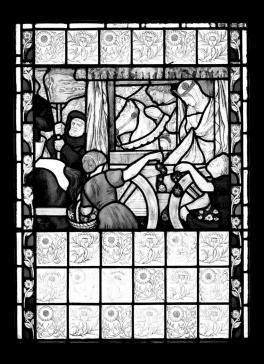
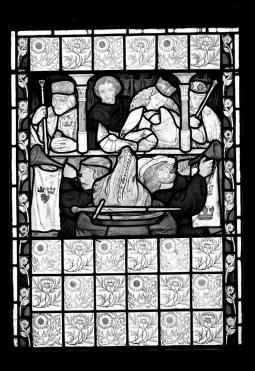

65

PHILIP WEBB

St Paul, with Scenes from his Life

1862
Pencil, black ink and watercolour
21 1/8 x 13 3/4 in.; 53.5 x 35.0 cm.
Titled in ink, below image: Brasenose Coll[ge] Chapel Oxford /
Designs for a Memorial Window / in Memory of the Rev[d]
W. Robertson
Inscribed in pencil, bottom left: 1862
Signed in pencil, bottom right: E. B. Jon[es]
Bequeathed by J.R. Holliday, 1927 (431'27)

REFERENCES: Birmingham, *Drawings*, 1939, p. 144 (as by
Burne-Jones); Sewter, 1975, *Text*, p. 145, *Plates*, pl. 161

*T*his important early sketch-design underlines the credit
due to Philip Webb for the architectural arrangements and
overall appearance of stained glass produced by Morris,
Marshall, Faulkner and Company. Webb worked in the
Oxford office of the architect G.E. Street (1824–1881), becom-
ing his senior assistant before establishing an independent
practice in 1856. In Street's office Webb had met Morris, who
invited him to design Red House in 1859 and then to become
a founding partner in the firm.

The first entry in Webb's account book with Morris is for
the church of All Saints, Selsley: "Scale drawing of arrange-
ment of Nave windows with scheme for whole church".[1] A
sketch-design of this kind, in monochrome pen and wash, for
one complete window in the south aisle at Selsley, is also in
the Birmingham collection (fig. 63).[2] His biographer, W.R.
Lethaby, affirmed that Webb "planned the general layout of
the windows, prepared small coloured sketches, arranged the
disposition of the irons [glazing bars], insisting on thick bars
from the first. . . . He also designed any animals required, and
at first the more ornamental parts".[3]

The present design is also cited in Webb's account book:
"Brazenose [sic] College. Designs, scale drawing of arrange-
ment, coloured 1st design £1:10:0. 2nd design £1.10.0".[4] The
window was never executed, and the implied provision of alter-
native designs may suggest an uneasiness between firm and
client. The geometrical panels are strangely old fashioned, re-
sembling the work of firms such as Wailes or Ward and Hughes
(a window by Wailes of 1844 was already in Brasenose Chapel,
and Morris might have been requested to emulate it). Burne-
Jones certainly supplied the figure subjects: he has approved
the design by signing it, and his account book with the firm
contains a complementary entry, between January and April
1862: "2 designs for window of Brazenose [sic] 6.0.0".[5]

Even in Webb's interpretation, Burne-Jones's designs have
a delightfully simple freshness, with a quirky flavour of medi-

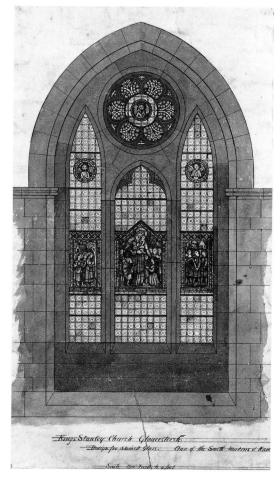

Fig. 63 PHILIP WEBB, *Sketch-design for window, All Saints,
Selsley, Gloucestershire*, 1861; pen and black ink, with ink
wash, 17 7/8 x 10 1/4 in. (45.5 x 26.0 cm.). Birmingham
Museums and Art Gallery (432'27).

eval naïveté. Flanking the central figure are scenes of the con-
version of St Paul, St Paul preaching to the Roman Emperor,
the shipwreck of St Paul, and the martyrdom of St Paul. In
the tracery circle above is a representation of St Paul preach-
ing. None of these designs was ever re-used by Burne-Jones,
but a figure of St Paul ascribed to Morris, holding sword and
open book in much the same way, was used in a window of
1865 at St Giles, Camberwell.[6]

1. Quoted in Sewter, 1975, *Plates*, p. 23. Webb's account book is in the
possession of John Brandon-Jones, and a transcript by J.R. Holliday is
in the Birmingham collection.
2. Birmingham, *Drawings*, 1939, p. 145 (432'27, as by Burne-Jones);
see Sewter, 1975, *Text*, p. 172.
3. Quoted in Sewter, 1975, *Plates*, p. 23.
4. Sewter, 1975, *Text*, p. 145.
5. Burne-Jones's account book is in the library of the Fitzwilliam
Museum, Cambridge, and a transcript by J.R. Holliday is in the
Birmingham collection. This entry was evidently overlooked by Sewter.
6. Sewter, 1975, *Text*, p. 41, *Plates*, pls. 164, 165.

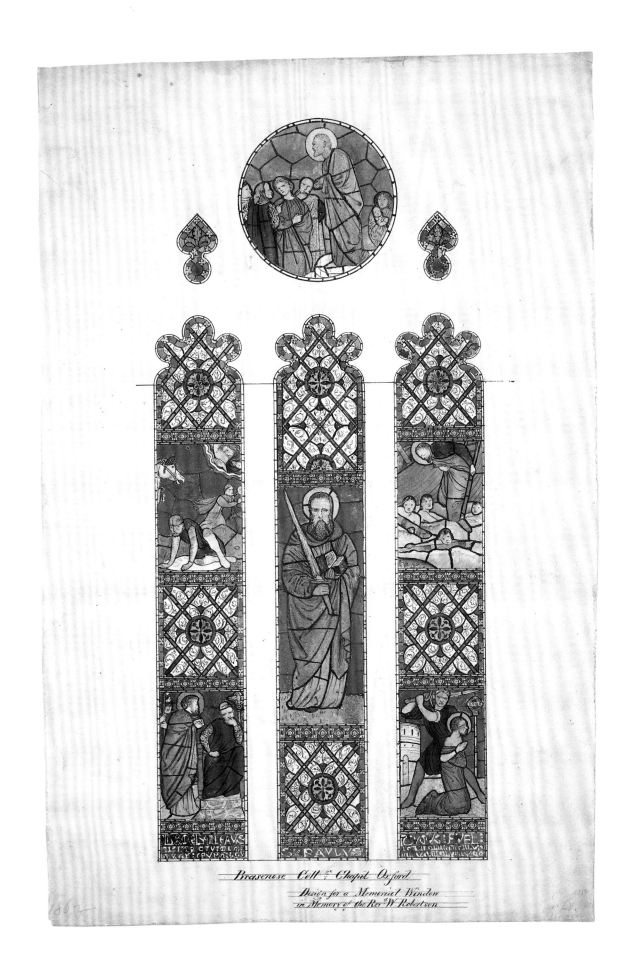

Brasenose Coll^{ge} Chapel Oxford

Design for a Memorial Window
in Memory of the Rev^d W. Robertson

66

EDWARD BURNE-JONES

The Annunciation

Circa 1862
Brush with black and brown ink
29 1/2 x 29 1/2 in.; 75.0 x 75.0 cm.
Lettered, on cartouche, centre: AVE : MARIA: GRATIA : PLENA :
DOMINUS : EST : TECUM [Hail Mary, full of grace, the Lord
is with thee]
Bequeathed by J.R. Holliday, 1927 (64'31)

REFERENCES: Birmingham, *Drawings*, 1939, p. 150; Sewter,
1975, *Text*, p. 169, *Plates*, pl. 70; London, Southampton and
Birmingham, 1975–1976 (73)

This cartoon was adapted as a design for the central circle
in the rose window at the west end of St Martin's-on-the-Hill,
Scarborough, one of the Morris firm's three early stained-glass
commissions from G.F. Bodley (see cat. no. 56). It probably
matches the entry made in Burne-Jones's account book for
October 1862: "large Annunciation for tiles £3:10:0"; the
square format suggests its original design as a large panel of
ceramic tiles, perhaps intended for Scarborough.[1]

The firm's early tiles were hand-painted onto white
blanks, which were imported from Holland and then fired in
the stained-glass kiln at Red Lion Square.[2] Burne-Jones made
designs in 1861 for *The Triumph of Love*, a panel of fifteen
tiles, and followed this with subjects from fairy tales, includ-
ing "Cinderella", "The Sleeping Beauty" and "Beauty and the
Beast".[3] Returning from his trip to Italy with Ruskin in the
summer of 1862, Burne-Jones found many such commissions
waiting, both for tiles and stained glass. As his wife Georgiana
recalled, "His regular habit now and for years afterwards was
to design and draw such things in the evening – the presence
of friends making no difference".[4] Unsurprisingly in these cir-
cumstances, Georgiana appears to have modelled for the
Virgin Mary in the present cartoon.

Although he was to design many others, this was Burne-
Jones's first Annunciation in stained glass for Morris. An ear-
lier design for the firm of Lavers and Barraud around 1860 –
a vertical composition in a three-light window – had proved
less than successful:

> Once, in the ardour of youth, I tried an innovation. It
> was a mistake. I drew an Annunciation with Mary taking
> the Dove to her bosom; and when the architect who
> had commissioned me (he was a very good architect –
> Butterfield it was) objected, I wouldn't alter it. So he
> would never give me anything more to do, and he was
> quite right – and I lost a chance of a lot of work.[5]

1. Sewter, 1975, *Text*, p. 169.
2. See Richard and Hilary Myers, "Morris & Company Ceramic Tiles",
Journal of the Tiles and Architectural Ceramics Society, vol. 1, 1982.
3. London, Southampton and Birmingham, 1975–1976, nos. 68–70.
4. Burne-Jones, *Memorials*, 1904, vol. 1, p. 249.
5. Quoted in Harrison and Waters, 1973, p. 31. For the Lavers and
Barraud *Annunciation* window at St Columba, Topcliffe, Yorkshire, see
Sewter, 1975, *Text*, p. 3, *Plates*, col. pl. II; the cartoon, worked up in
oils, is in the Birmingham collection (406'27), but it is not to be con-
fused with the watercolour of 1861 also at Birmingham (441'27). This,
is turn, is quite different from the watercolour *The Annunciation (The
Flower of God)*, painted in 1863 for the brothers George and Edward
Dalziel (sold Christie's, 12 June 1992, lot 97, repr.).

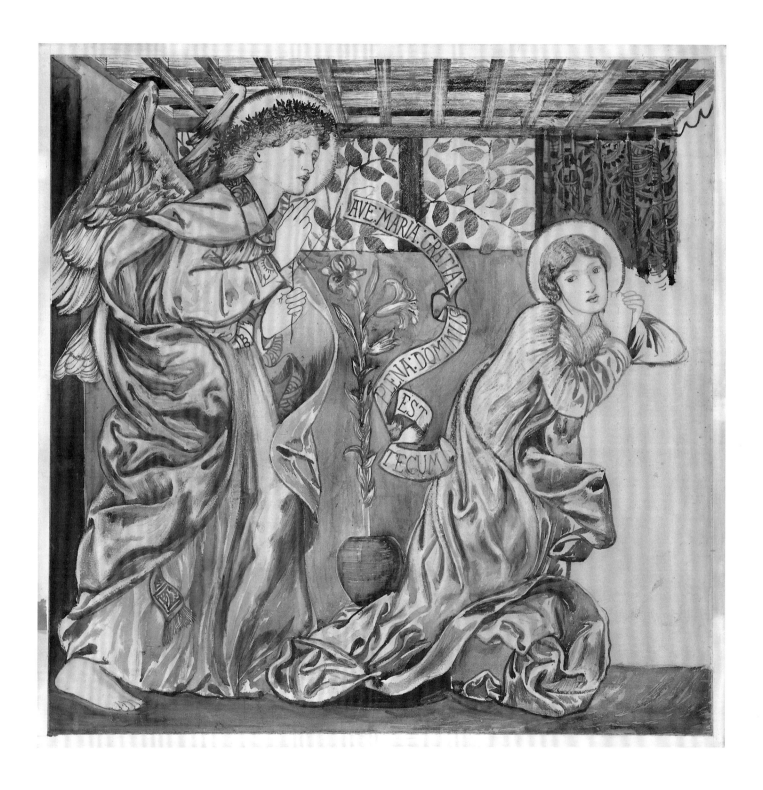

217

67

EDWARD BURNE-JONES

An Idyll: figure study

Circa 1862
Pencil and charcoal
8 3/4 x 13 in.; 22.2 x 33.0 cm.
Presented by subscribers, 1904 (36'04)

PROVENANCE: Charles Fairfax Murray

REFERENCES: Birmingham, *Drawings*, 1939, p. 53, repr. p. 429;
London, Southampton and Birmingham, 1975–1976 (34)

This strong figure study is for the watercolour now known as *An Idyll* (fig. 64), which is also in the Birmingham collection but is too fragile to travel. Signed and dated 1862, the watercolour belonged to the painter George Frederic Watts (1817–1904), who acted as a friendly mentor to Burne-Jones in 1857, when the young artist was undergoing a period of illness and insecurity. The title *An Idyll* cannot be traced further back than the Birmingham catalogue of 1930 (the work was presented by Mrs Watts in 1924), which identifies it as the picture shown under the description of *A Love Scene* at the Burne-Jones memorial exhibition at the New Gallery, London, in 1898.[1] It is undoubtedly the "small watercolour of man and maid kissing in a meadow" in Burne-Jones's retrospective list of his paintings, compiled towards the end of his life.[2]

In combining delicacy and strength, Burne-Jones softens some of the drawing's strongest contours by smudging the charcoal with his finger. An equivalent density is achieved in the watercolour by the liberal use of gum, which darkens and deepens the overall tones of green and red. *An Idyll* is one of a group of works from this period, including *Green Summer* (see cat. no. 68), in which is often detected an echo of Giorgione's mysteriously timeless landscapes. Burne-Jones's first visit to Italy in 1859, in the company of Charles Faulkner and Val Prinsep (another protégé of Watts), had included a long stay in Venice and exposure to paintings of the Venetian Renaissance.

1. Birmingham, *Paintings &c.*, [1930], p. 36 (91'24).
2. Manuscript in the library of the Fitzwilliam Museum, Cambridge; a transcript by J.R. Holliday is in the Birmingham Museum files. Burne-Jones gives a date of 1864, but he must have remembered incorrectly; this is repeated in Bell, 1899, pp. 38, 108.

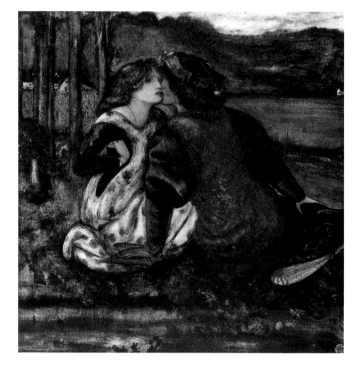

Fig. 64 EDWARD BURNE-JONES, *An Idyll*, 1862; watercolour and gum, 12 x 11 in. (30.5 x 28.0 cm.). Birmingham Museums and Art Gallery (91'24).

68

EDWARD BURNE-JONES

Green Summer: figure study

Circa 1864
Pencil and red chalk
8 x 10 1/4 in.; 20.5 x 26.2 cm.
Presented by subscribers, 1904 (193'04)

PROVENANCE: Charles Fairfax Murray

REFERENCES: Birmingham, *Drawings*, 1939, p. 55; London, Southampton and Birmingham, 1975–1976 (52)

Fig. 65 EDWARD BURNE-JONES, *Green Summer*, 1864; watercolour and gum, 11 3/8 x 19 in. (29.0 x 48.3 cm.). Private Collection.

Fig. 66 EDWARD BURNE-JONES, *Green Summer*, 1868; oil on canvas, 25 1/2 x 41 3/4 in. (64.8 x 106.0 cm.). Private Collection.

*W*riting in the *Athenaeum* in 1864, F.G. Stephens praised Burne-Jones's work for its "romantic feeling, luxury of colour and poetic realisation of a youthful dream".[1] This perfectly describes not only his earlier watercolours, such as *An Idyll* (see cat. no. 67), but also the artist's next major work, *Green Summer* (fig. 65). An even more elaborate harmony in green and red, this was exhibited at the Old Water Colour Society in 1865. Although lacking an overt subject, *Green Summer* has the same languorous romantic atmosphere as his more celebrated composition *Le Chant d'Amour*, inspired by the refrain of an Old French song: "Hélas! je sais un chant d'amour, / Triste ou gai, tour à tour". Both works originated as watercolours but were repeated as oils, with *Green Summer* in 1868 (fig. 66) and *Le Chant d'Amour* in 1878 (The Metropolitan Museum of Art, New York).[3]

Burne-Jones had made some studies from nature in the summer of 1863 (see cat. no. 73), but had given this up by the following year. Georgiana Burne-Jones recalled that *Green Summer* was painted in the studio at Red House, the Morrises' home, since "there seemed little reason for him to torment himself by a struggle with the outer world, and as a rule he painted his backgrounds from notes of nature made here, there, and everywhere, and then dealt with by memory and imagination".[4] Instead, the artist concentrated on figure studies. Although it is exceptionally beautiful, the present sheet is typical of the large number of preparatory studies that became a regular part of Burne-Jones's practice from this date onwards. Such work conveys not only the pleasure he derived from drawing but also its importance to him as a discipline. This was no doubt reinforced by his increased awareness of Old Master draughtsmanship, especially following his second trip to Italy in 1862 (in the company of Ruskin) and subsequent visits made in 1871 and 1873. Also in the Birmingham collection are two further drawings, in the same medium, of other figures for *Green Summer*.[5]

1. *Athenaeum*, 30 April 1864, p. 618.
2. See London, Tate, 1984 (236, repr.).
3. See London, Southampton and Birmingham, 1975–1976 (49, 86).
4. Burne-Jones, *Memorials*, 1904, vol. 1, pp. 280–281. The slight suggestion of distant buildings on the right of this sheet presumably derives from just such a fleeting "note of nature".
5. Birmingham, *Drawings*, 1939, pp. 54–55 (191–192'04).

69

ROBERT BRAITHWAITE MARTINEAU

The Last Chapter

1863
Oil on canvas
28 1/4 x 16 1/2 in.; 71.7 x 41.9 cm.
Signed, bottom right: R. B. MARTINEAU
Presented by Helen Martineau, 1942 (64'42)

PROVENANCE: By descent in the artist's family?; presented by his younger daughter Helen[1]

EXHIBITED: London, Royal Academy, 1863 (568); Birmingham, Society of Artists, 1867 (120)

REFERENCES: Birmingham, *Paintings*, 1960, p. 97; London, Royal Academy, 1968–1969 (381)

*E*ncouraged by the companionship of William Holman Hunt, whom he had met at the Royal Academy Schools and with whom he shared a studio for many years, Robert Braithwaite Martineau participated in many of the Pre-Raphaelites' social and professional activities. He contributed to the 1857 group exhibitions in London and America, and was a member of the Hogarth Club (see cat. no. 44); he was also a regular guest of Lady Holland at Little Holland House, in the company of Hunt, Millais, and Burne-Jones. William Michael Rossetti remembered him with affection and respect as "a very sensible person, not given to much talk, and with a mind rather steady-going than lively, highly trusty and well-principled, and worthy of the utmost regard. He had much taste and some natural gift for music".[2]

The first picture he exhibited, at the Royal Academy in 1852, was *Kit's Writing Lesson* (Tate Gallery, London); the subject of Little Nell helping Christopher Nubbles was taken from Dickens's *Old Curiosity Shop*. It displays a Pre-Raphaelite directness of composition and is full of scrupulously observed incidental detail. These elements were to remain constant throughout Martineau's limited oeuvre (he died at the early age of forty-three), and culminated in his acknowledged masterpiece *The Last Day in the Old Home* (1862; Tate Gallery, London).[3] He showed only eleven paintings at the Royal Academy in sixteen years, and indeed his technique is described by more than one commentator as having been painstaking, if not laborious: Hunt recalled "the incorrigible habit he contracted of painting over and over again his yesterday's work while still wet".[4]

Although it may perhaps have darkened a little over the years, *The Last Chapter* is a very effective rendering of an interior illuminated only by firelight, the source not actually seen but clearly implied by the glow cast on the young woman's face and dress, and on her book.[5] The evening landscape just visible through the window suggests that the reader has become too engrossed in her book to draw the curtain and light a lamp. The subject and experimental effect of light seem to echo Ford Madox Brown's small oil painting *Waiting: An English Fireside of 1854–5* (1855; Walker Art Gallery, Liverpool), which depicts a young woman sewing, with her child asleep on her lap.[6] This was sold to John Miller after having been shown at the Liverpool Academy in 1856, but it was apparently lent by him for exhibition at the Hogarth Club in January 1859, where Martineau is more than likely to have seen it. Middle-class domestic interiors were not uncommon in Victorian genre painting, of course, and Mary Bennett has drawn attention to several other examples (including similar fireside scenes) such as *Prayer Time: Mrs Cope and her daughter Florence* (1854; Harris Museum and Art Gallery, Preston) by Charles West Cope (1811–1890).[7]

1. A puzzling label on the back of the frame is inscribed: 302 *Woman Reading . . .* lent by James Gresham Esq. This reference cannot be identified.
2. Rossetti, 1906, vol. 1, p. 158.
3. *The Last Day in the Old Home* proved so popular when shown in the Picture Galleries of the International Exhibition of 1862 that it later made an individual tour of the country; see Helen Martineau, "A Pre-Raphaelite painter", *Studio*, vol. 87, April 1924, pp. 207–208.
4. Hunt, 1905, vol. 2, p. 309.
5. "It is not often we get firelight so skilfully rendered as Mr Martineau has it here, to an effect that is large and broad, which in ordinary hands becomes spotty and heavy" (*Athenaeum*, 9 May 1863, p. 624).
6. Bennett, 1988, p. 31, repr.
7. Mary Bennett, "'Waiting: An English Fireside of 1854–5': Ford Madox Brown's first modern subject picture", *Burlington Magazine*, vol. 128, December 1986, p. 904.

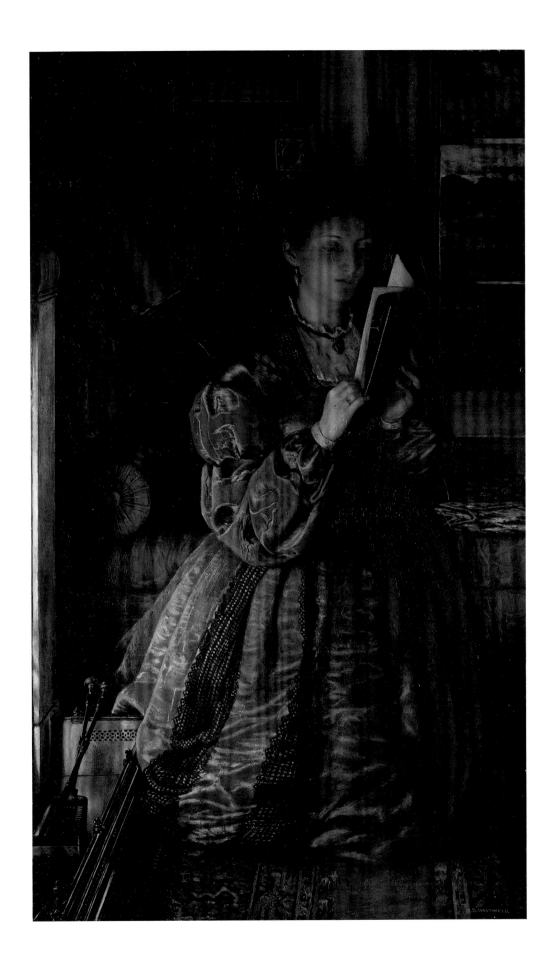

223

70

ROBERT BRAITHWAITE MARTINEAU

The Last Chapter: sheet of studies

Circa 1863
Pencil
10 x 6 3/4 in.; 25.4 x 17.2 cm.
Bequeathed by Helen Martineau, 1951 (P1'51)

PROVENANCE: By descent in the artist's family?; presented by his younger daughter Helen

REFERENCE: London, Leicester Galleries, *The Victorian Romantics*, 1949 (52)

*U*nsurprisingly for artists sharing a studio over a period of years, this simple but engaging sheet shows a stylistic kinship between Martineau's draughtsmanship and that of Hunt in his preparatory figure studies (see cat. no. 29).

Helen Martineau (1868–1950), the artist's younger daughter and the last surviving of his three children, bequeathed a number of drawings and oil studies to public collections, including this one to Birmingham Museum and Art Gallery and others to the Tate Gallery, London, the Ashmolean Museum, Oxford, and Manchester City Art Gallery. Her bequest to Manchester included three fine head studies in pencil and a portrait study in oils of *The Artist's Wife in a Red Cape.*[1]

1. Treuherz, 1993, pp. 69–71, 132, pls. 48–50.

FREDERICK SANDYS
Autumn

Circa 1860–1862
Oil on wood panel
9 3/4 x 14 in.; 24.7 x 35.5 cm.
Presented by George Tangye, 1906 (34'06)

PROVENANCE: Edward Bulmer, Minor Canon of Norwich Cathedral, died 31 January 1900; sold at The Close, Norwich, 28 February 1900, lot 491 (48 guineas, bought Booth)

REFERENCES: Birmingham, *Paintings*, 1960, p. 129; Brighton and Sheffield, 1974 (53, pl. 25)

Frederick Sandys, the son of a Norwich drawing master, came to the attention of the Pre-Raphaelite circle through his remarkable parody of Millais's *A Dream of the Past: Sir Isumbras at the Ford*, published as a zinc engraving in 1857 under the title *A Nightmare*. Although he was living in London from 1851, Sandys made frequent return visits to Norwich, which is the setting for *Autumn*.

Refinements of detail in the much larger oil on canvas (31 1/2 x 43 in.; 80.0 x 109.2 cm.) now at the Castle Museum, Norwich, suggest that this small panel was probably begun first (as is the case of the smaller version of Wallis's *Chatterton* [see cat. no. 39]).[1] In turn, it derives from a fine chalk drawing (fig. 67), one of four preparatory studies also at Birmingham.[2] Two very large pen and ink drawings, *Spring* and *Autumn* (dated 1860, with the same composition), both at Norwich, suggest an unfinished project by Sandys for a series representing the four seasons. *Spring* depicts a group of young children in a garden or woodland setting.[3]

The twilight landscape must be a symbolic complement to the old soldier's retirement from active service. The figures are seated on the bank of the river Wensum, close to Bishop's Bridge, with the unrestored Norwich Castle atop the hill in the background (although this is more imaginary than it appears in reality). The composition echoes Millais's *Sir Isumbras* (1857; Lady Lever Art Gallery, Port Sunlight), a homage which perhaps sought to redress the imbalance caused by Sandys's former parody.

The soldier wears the undress (off-duty) uniform of a sergeant in an infantry battalion, with medal ribbons from the Sikh wars in India (1845–1849). Other ribbons for Long Service and Good Conduct confirm a discharge after twenty-one years' service in the regular Army: this suggests that the sergeant was not in an active Line Battalion but was instead serving in a local militia, which by implication could only be the West Norfolk Militia of the 9th Regiment of Foot, stationed in Norwich between 1858 and 1862.[4] Sandys could

conceivably have borrowed such a uniform, but it is more likely that he would have also used its owner as a model. The recent genealogical research of Dr David Faux has produced the plausible identification of the sitters as Charles Faux, his wife Mary Ann and their three-year-old son Robert.[5] Sgt Faux had served in India with the 62nd Foot (receiving medals for participation in the Sutlej and Punjab campaigns), and was discharged (with Long Service and Good Conduct medals) in 1856, with the stated intention of settling in Norwich, his former home. He is even known to have enlisted with the West Norfolk Militia, serving from 1857 to at least 1867.

1. Brighton and Sheffield, 1974 (52, pl. 24).
2. Birmingham, *Drawings*, 1939, pp. 387–388 (839–840'06, 1020–1021'06); Brighton and Sheffield, 1974 (49–51).
3. Brighton and Sheffield, 1974 (47, 48, pls. 21, 22; 28 x 43 in. [71.1 x 109.2 cm.] and 29 3/4 x 40 7/8 in. [75.5 x 103.8 cm.]); the drawing of *Autumn* was exhibited at the Royal Academy of Arts in 1862 (805).
4. Information supplied by Dr David K. Faux, Hagersville, Ontario, in March 1988. The picture would have commanded topical interest in the years around 1860, which witnessed a considerable national reaction to the possible threat of French military aggression. Hunt, Rossetti and Morris were all (rather ineffective) volunteer members of the Artists' Rifles at that time.
5. Information from Dr Faux; while Sgt Faux would have been forty-six or forty-seven in 1860, prolonged service in India could easily have aged him prematurely.

Fig. 67 FREDERICK SANDYS, *Study for "Autumn"*, circa 1860; black, white and red chalk on grey paper, 10 7/8 x 14 7/8 in. (27.7 x 37.7 cm.). Birmingham Museums and Art Gallery (839'06).

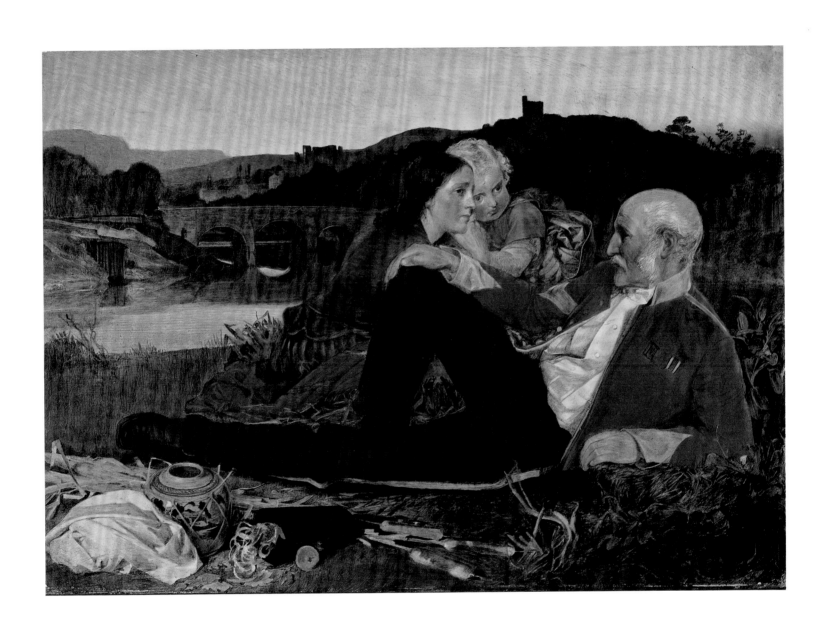

72

FREDERICK SANDYS

Study of Ivy

1863 (?, but possibly 1857)
Pencil and white chalk on grey-brown paper
14 1/8 x 10 1/16 in.; 35.9 x 25.5 cm.
Inscribed in pencil, bottom right: In The Orchard /
Hunworth / March 19th
Presented by subscribers, 1906 (809'06)

PROVENANCE: Charles Fairfax Murray

REFERENCES: Birmingham, *Drawings*, 1939, p. 386; Dale,
1965, p. 251, pl. 50; Brighton and Sheffield, 1974 (89, pl. 58)

*B*y the age of sixteen, Sandys had been introduced to the
Reverend James Bulwer (1793–1879), a clergyman who was
also an amateur artist and a former pupil of John Sell Cotman
(1782–1842). His patronage of Sandys began with illustrations
to his antiquarian researches, and culminated in the commis-
sion of a portrait.

Now in the National Gallery of Canada, Ottawa (fig. 68),
this oil on panel is recognised as a masterpiece of Pre-
Raphaelite portraiture.[1] To the minutely searching precision
of the likeness, Sandys adds a setting that both softens and
illuminates his sitter's character. Bulwer holds a sketchbook and
brush, as if ready to make a study either of the picturesque
foliage in the foreground or of the medieval sculpture behind
him. From 1848 he had been Rector of Stody with Hunworth,
a parish in Norfolk north-west of Norwich, and although
Sandys made studies of the church at Stody, in the portrait he
has painted a detail of the Monks' Door at Ely Cathedral, one
of the finest pieces of Norman carving in East Anglia.[2]

Sandys's diary survives (now also at Ottawa), in which he
details the four weeks' work spent on the portrait during one
March and April.[3] The present study of ivy is one of five relat-
ed drawings in the Birmingham collection.[4] Together with a
lesser study of foliage, it conforms with the diary entries:

Thursday March 19 – drawing Ivy from 9.30 untill 6.
Friday March 20 – drawing Ivy from 10.30 – untill 6 –

As a delicate but powerful piece of observation, it bears
comparison with such striking individual studies as the
famous *Lemon Tree* (1859; pencil) by Frederic Leighton (1830–
1896).[5] It can certainly be classified as a model of Ruskinian
Pre-Raphaelitism, prefiguring a passage in *Praeterita*, in which
Ruskin remembers an incident from 1842:

One day on the road to Norwood, I noticed a bit of ivy
round a thorn stem, which seemed, even to my critical
judgment, not ill "composed"; and proceeded to make a
light and shade pencil study of it in my grey paper

pocket-book, carefully, as if it had been a bit of sculpture,
liking it more and more as I drew. When it was done, I
saw that I had virtually lost all my time since I was twelve
years old, because no one had ever told me to draw
what was really there![6]

This was written in the early 1880s, but Sandys could well
have been mindful of Ruskin's enthusiastic commendation of
ivy as a basis for composition, as stated in the third volume of
Modern Painters, published in 1856.[7]

1. See Dale, 1965.
2. I am grateful to Betty Elzea for pointing out that the source of this
detail is an etching by Cotman, pl. XXI, in his *Fourth Series of
Etchings*, London, 1838.
3. Dale, 1965, p. 251, where it is dated 1863 (the diary carries no year
date). It is Betty Elzea's firm belief, based on prolonged research, that
the portrait is earlier, and that the diary records work of 1857 (the pre-
vious year in which weekday and year coincide); its pages carry a
watermark of 1857. Stylistically, both the painting and the drawings are
acceptable for that date.
4. Birmingham, *Paintings &c.*, [1930], p. 182 (869–870'06) and
Birmingham, *Drawings*, 1939, pp. 386, 391 (809–810'06, 935'06); Dale,
1965, pls. 47–51. Also Brighton and Sheffield, 1974 (88–92, figs. 47–51).
5. Leonée and Richard Ormond, *Lord Leighton*, New Haven and
London, 1975, p. 43, pl. 66 (pencil; 21 x 15 1/2 in. [53.3 x 39.4 cm.];
Private Collection). The drawing was exhibited at the Hogarth Club
in 1859.
6. Ruskin, *Works*, 1908, vol. 35, p. 311.
7. Ruskin, *Works*, 1904, vol. 5, p. 268.

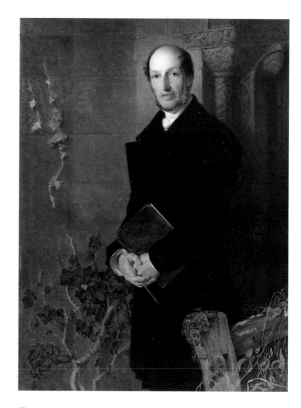

Fig. 68 FREDERICK SANDYS, *Reverend James Bulwer*, 1863?;
oil on wood panel, 29 3/4 x 21 3/4 in. (75.5 x 55.3 cm.).
National Gallery of Canada, Ottawa.

In The Orchard
Hunsworth..
March .19

73

EDWARD BURNE-JONES
The Merciful Knight

1863
Watercolour, bodycolour and gum
39 1/2 x 27 1/4 in.; 100.3 x 69.2 cm.
Signed and dated, bottom right: EDWARD :
BURNE.JONES.1863.
Inner matt of frame bears text: Of a Knight who forgave his
enemy when he might have destroyed him; and how the
image of Christ kissed him in token that his acts had
pleased God
In original frame
Purchased, 1973 (P84'73)

PROVENANCE: Bought from the artist by James Leathart
(180 guineas); his sale, Christie's, 19 June 1897, lot 7; W.
Marchant; Sir John Middlemore; purchased from the
Middlemore Trustees

EXHIBITED: London, Old Water Colour Society, 1864 (215);
London, New Gallery, 1892–1893 (9)

REFERENCES: London, Southampton and Birmingham, 1975
(45); London, Tate, 1984 (234, repr.); Newcastle upon Tyne,
1989–1990 (20, repr.); London, Tate, 1993 (27)

Fig. 69 EDWARD BURNE-JONES, *Study for "The Merciful Knight"*, circa
1863; pencil, 10 x 6 in. (25.4 x 15.2 cm.). Tate Gallery, London.

The Merciful Knight is arguably Burne-Jones's most impor-
tant early work. In the memorial biography of her husband,
Georgiana Burne-Jones stated that it seemed "to sum up and
seal the ten years that had passed since Edward first went to
Oxford".[1] In the first substantial public exhibition of his
work, Burne-Jones showed four major works at the Old Water
Colour Society in 1864. Two were single figure female compo-
sitions – *Cinderella* (Museum of Fine Arts, Boston) and *Fair
Rosamund* (Private Collection) – while two were much more
ambitious religious subjects, *The Annunciation (The Flower of
God)* (Private Collection) and this one, *The Merciful Knight*.[2]
Although Burne-Jones had already been elected an Associate
(along with G.P. Boyce), this kind of Pre-Raphaelite medi-
evalism had never before appeared on the Society's walls, and
the works were given a mixed reception, with considerable
hostility being expressed by his fellow members.[3]

The picture was exhibited under the quotation which
appears on the frame. This text, and the subject itself, derives
from Sir Kenelm Digby's *Broadstone of Honour*, a kind of man-
ual of romantic Christian chivalry that was first published in
1822. Although Burne-Jones was not a religious man in the
conventional sense, he is said to have kept this book by his
bedside throughout his life.[4] In the story, which also appears
in Robert Southey's *Ballads*, the eleventh-century Florentine
knight St John Gualberto is miraculously embraced by a wood-
en figure of Christ, in token of a deed of mercy performed on a
Good Friday. This obscure legend was unlikely to be familiar

to a wide audience, and even F.G. Stephens, writing in the
Athenaeum, thought it a "strange half-mystical picture".[5] The
Art Journal, ever adopting a conservative and high moral tone
on aesthetic as well as religious matters, found Burne-Jones's
drawing deficient and his treatment of such a subject at once
too literal and yet insufficiently reverent, a response that
echoes the reaction to Millais's *Christ in the House of His
Parents* fourteen years earlier. Wondering at the figure of the
knight, "[who] seems to shake in his clattering armour", the
critic for the *Art Journal* continued: "We cannot indeed but
fear that such ultra manifestations of medievalism, however
well meant, must tend inevitably, though of course uncon-
sciously, to bring ridicule upon truths which we all desire to
hold in veneration".[6]

As the summation of a decade of work, *The Merciful
Knight* carries many signs of the artist's Pre-Raphaelite

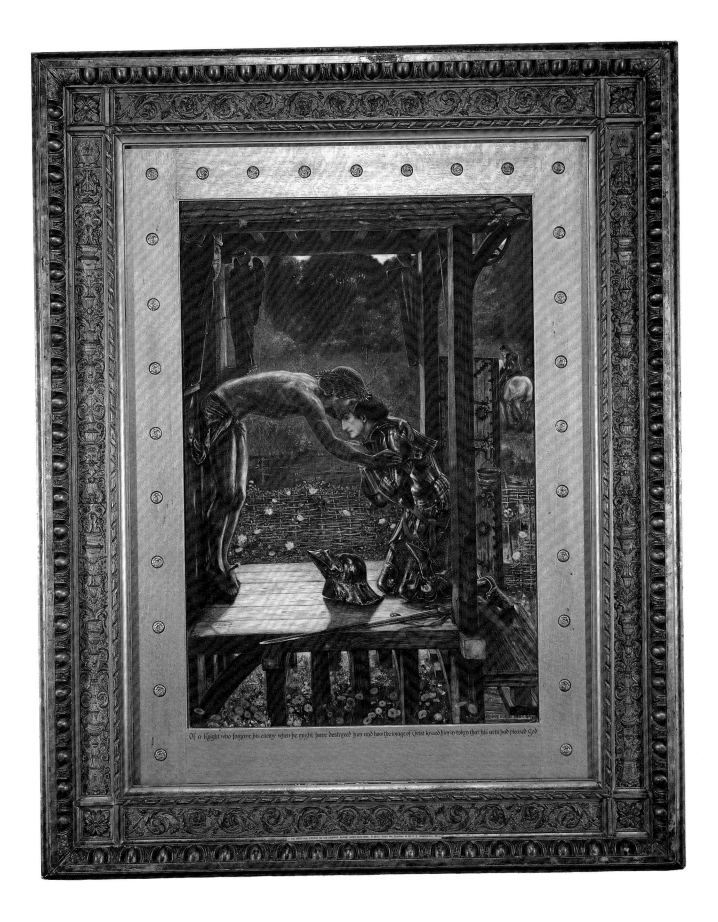

Of a Knight who forgave his enemy when he might have destroyed him and how the image of Christ kissed him in token that his acts had pleased God

THE MERCIFUL KNIGHT by SIR EDWARD BURNE-JONES 1833-1898. F ARTS. From the Original at Sir E. E. WORTHINGTON, RA.

Fig. 70 EDWARD BURNE-JONES, *Study for "The Merciful Knight"*, circa 1863; pencil, 9 1/2 x 4 3/4 in. (24.1 x 12.1 cm.). Tate Gallery, London.

1. Burne-Jones, *Memorials*, 1904, vol. 1, p. 262.
2. For *Cinderella* and *Fair Rosamund*, see London, Southampton and Birmingham, 1975–1976 (39, 40); *The Annunciation (The Flower of God)* was sold at Christie's, 12 June 1992, lot 97 (repr.).
3. Over thirty years later, Burne-Jones told T.M. Rooke, his studio assistant, that "it was stuck right up on top . . . so no one could see it. Some of them were furious with me for sending it, and let me see that they were. They would be talking together when I turned up and let drop remarks about it of a hostile nature for me to overhear" (Lago, 1982, p. 107).
4. See John Christian, in London, Tate, 1984, p. 294.
5. *Athenaeum*, 30 April 1864, p. 618.
6. *Art Journal*, June 1864, p. 170.
7. London, Tate, 1993 (22–24).
8. P60–62'54; London, Southampton and Birmingham, 1975–1976 (246, 247).
9. Burne-Jones, *Memorials*, 1904, vol. 1, pp. 261–262.

apprenticeship. Its clearest debt is to Rossetti's image of *Sir Galahad*, seen praying at a mysterious wayside shrine, which Burne-Jones could have seen both through the Moxon Tennyson engraving of 1857 and in the watercolour of 1859 (see cat. no. 50), which was also in the collection of James Leathart. There is, perhaps, even a distant echo of such celebrated Anglo-Catholic images as Collinson's *Incident in the Life of St Elizabeth of Hungary* (cat. no. 14). In terms of design, technique and expression, however, the picture demonstrates that Burne-Jones had reached the threshold of a new and more personal style. The suffused colour harmonies and rugged handling of pigment – however abhorrent to his water-colourist contemporaries – show an artist ready to tackle elaborate and ambitious canvases as well as further large-scale watercolours and decorative work.

A group of three compositional studies in pencil is in the Tate Gallery, London (figs. 69, 70).[7] Burne-Jones is known to have made studies for the woodland background while staying with the painter J.R. Spencer Stanhope (1829–1908) at Cobham in Surrey during the summer of 1863, and these are identifiable with three watercolours in the Birmingham collection.[8] The marigolds in the foreground came from the 'town-garden' in Russell Square, London, close to Burne-Jones's house opposite the British Museum.[9]

74

FORD MADOX BROWN

Work

1859–1863
Oil on canvas
27 x 39 in.; 68.4 x 99.0 cm. (image arched at top)
Signed and dated, bottom right: F. MADOX BROWN.1863
Inner matt of frame bears text on spandrels (left): NEITHER
DID WE EAT ANY MAN'S BREAD / FOR NOUGHT; BUT
WROUGHT WITH LABOUR / AND TRAVAIL NIGHT AND DAY.
(right): SEES THOU A MAN DILIGENT / IN HIS BUSINESS? HE
SHALL / STAND BEFORE KINGS.
In original frame
Bequeathed by J.R. Holliday, 1927 (349'27)

PROVENANCE: Commissioned from the artist by James
Leathart in November 1859 (300 guineas); Harry Quilter; his
sale, Christie's, 7 April 1906, lot 22, bought by Whitworth
Wallis for J.R. Holliday

EXHIBITED: ?Liverpool Academy, 1866 (544); Newcastle upon
Tyne, Mechanics' Institute, 1866 (30)

REFERENCES: Birmingham, *Paintings*, 1960, pp. 19–20;
Liverpool, 1964 (27); Newcastle upon Tyne, 1968 (20);
Newcastle upon Tyne, 1989–1990 (13, repr.)

*E*ach of the three major oils begun by Brown in 1852 endured
a long period of gestation: *English Autumn Afternoon* (in the
Birmingham collection; see fig. 1) was finished in February
1855 and shown at the British Institution exhibition of that
year, while *The Last of England* (also at Birmingham; see fig.
30) was similarly completed in 1855, and exhibited at the
Liverpool Academy in 1856. Brown took up *Work* again in
November 1856, on receiving a commission from Thomas
Plint, and finished it only in August 1863.[1] All three paintings
were shown at Brown's one-man exhibition at 191 Piccadilly,
London, which ran from 10 March to 10 June 1865. This is a
half-size replica of *Work;* the premier version is in Manchester
City Art Gallery.[2]

Rarely free of financial difficulties, Brown was pleased to
receive in 1859 the commission for this replica from James
Leathart of Newcastle, who had just acquired *The Pretty Baa-
Lambs* (cat. no. 18). The two versions were completed con-
currently, which accounts for the minimal loss of vibrancy,
usually inevitable in later replicas. Plint died suddenly in July
1861, and Leathart attempted to purchase the larger version;
Brown was sympathetic – "I would as soon see it on your
walls as any in England"[3] – but he found himself obliged to
finish it for his initial patron's executors.[4] In September 1863
he travelled to Tynemouth in order to paint Mrs Maria
Leathart's portrait into the replica, including her as the young
woman on the left with the parasol (in place of the features of
the artist's wife Emma). Brown also took with him a canvas

on which to begin a portrait of Leathart, to match Rossetti's
1862 oil of Maria; finished in 1864, this includes in its back-
ground a glimpse of the replica of *Work*, framed and displayed
on an easel.[5]

The setting for *Work* is Heath Street, Hampstead; its
contours and even some of the buildings are still recognisable
today. Brown painted the background on the spot in the sum-
mer of 1852. The picture has often been described as a tract or
a novella in paint, and indeed the artist's own explanation of
its details runs to five pages in the catalogue of his 1865 exhi-
bition, where it appears as the last and culminating item.[6]
Each character or group is of symbolical significance, from
the "British excavator, or *navvy* . . . as the outward and visible
type of *Work*" to the gentleman and his daughter on horse-
back. "These are the *rich*, who have no need to work, – not
at least for bread – the *'bread of life'* being neither here nor
there. The pastry-cook's tray, the symbol of superfluity,
accompanies these". The painter R.B. Martineau (see cat. nos.
69, 70) modelled for the gentleman on horseback. On the left
is the curious figure of a flower- and weed-gatherer for
botanists, a free spirit "who has never been *taught to work*",
while in the centre is a beer-seller, described by the artist as "a
specimen of town pluck and energy contrasted with country
thews and sinews . . . in all matters of taste, vulgar as
Birmingham can make him in the 19th century" (an unfortu-
nate comment given this picture's present ownership). To
complement the main scene, Brown fills the smaller spaces of
distant background with a host of busy figures who are not
seen at first glance – painters, bill-posters, even a policeman
arresting an orange-seller. In the *Athenaeum*, F.G. Stephens
accorded the painting a rapturous review, calling it "in every
respect remarkable. . . . Brilliant, solid, sound, studied with
extraordinary earnestness, elaborate and masterly, the vigour
of *Work* will astonish those who do not know what the artist
has done before".[7]

A moralising tone is added by the biblical texts inscribed
on the frame (from the Book of Proverbs); the Manchester
version carries a third quotation on the centre of the frame: "I
must work while it is day for night cometh when no man can
work". The two figures on the right are also pertinent; Plint,
who was of evangelical tendencies, wrote to Brown on 24
November 1856: "Could you introduce *both* Carlyle and
Kingsley, and change one of the four *fashionable* young ladies
into a *quiet, earnest, holy*-looking one, with a book or two and
tracts? I want *this* put in, for I am much interested in *this*
work myself, and know those who are. . .".[8] Initially, Brown
had placed a single male figure on the right, perhaps repre-
senting himself both as commentator and working artist, but
he complied with Plint's request by adding portraits of
Thomas Carlyle and the Reverend F.D. Maurice (rather than

Charles Kingsley). "These are the brainworkers, who, seeming to be idle, work, and are the cause of well-ordained work and happiness in others".[9] A reference to Carlyle's influential book *Past and Present* (published in 1843) is also made through the placards borne by the procession visible on the extreme right, in support of Bobus, the odious sausage-maker of Houndsditch. The Working Men's College, a Christian Socialist project founded by the Reverend Maurice in 1854, is advertised on a poster at the extreme left. Brown, along with Rossetti and Ruskin, was briefly recruited as a drawing-master at the College in 1858.

1. The tortuous history of the commission is described in detail by Mary Bennett, "The Price of 'Work': the background to its first exhibition, 1865", in Parris (ed.), 1984, pp. 143–152.

2. See London, Tate, 1984 (88, repr.); Treuherz, 1993, pp. 41–51.

3. Letter to Leathart, 21 July 1861; quoted in Newcastle upon Tyne, 1989–1990, p. 61.

4. The painting entered the Manchester collection in 1885.

5. Ford Madox Brown, *James Leathart*, 1863–1864; oil on canvas, 13 1/2 x 11 in. (34.3 x 27.9 cm.), Leathart family collection; Newcastle upon Tyne, 1989–1990 (12, repr.). Ironically, Leathart objected to Brown making a replica of the large watercolour *Our Lady of Good Children* (Tate Gallery, London), another Plint commission of which he did successfully take ownership. This led to Brown's later caustic remark that "collectors never I find object to get duplicates of other collectors' works, *only to their own being repeated*"; quoted in Newcastle upon Tyne, 1968, p. 11.

6. London, Piccadilly, 1865, pp. 27–31, from which the following quotations are taken. Brown also published here a sonnet, dated February 1865, beginning "Work! which beads the brow, and tans the flesh / Of lusty manhood, casting out its devils!"

7. *Athenaeum*, 11 March 1865, p. 353.

8. Quoted in Hueffer, 1896, p. 112.

9. London, Piccadilly, 1865, p. 28.

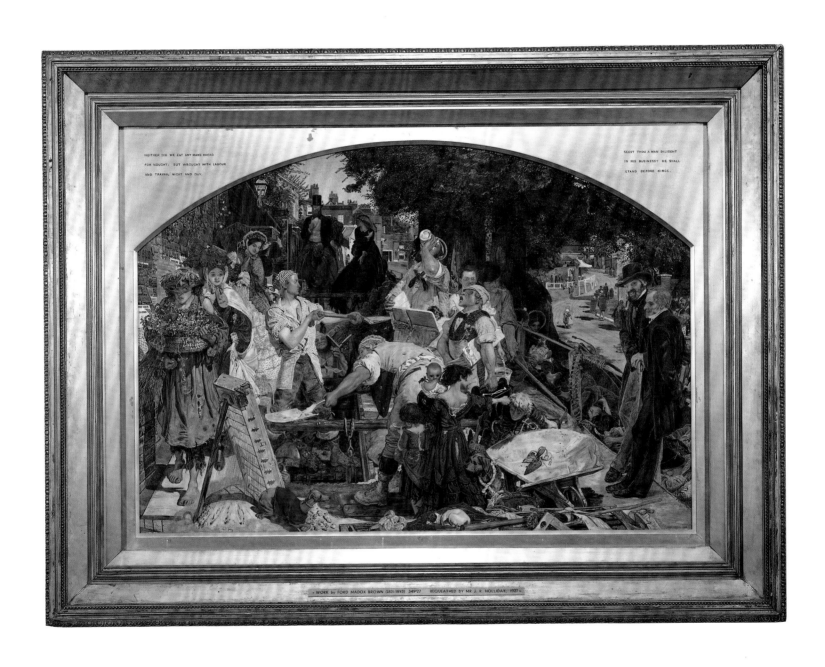

NEITHER DID WE EAT ANY MANS BREAD
FOR NOUGHT; BUT WROUGHT WITH LABOUR
AND TRAVAIL NIGHT AND DAY.

SEEST THOU A MAN DILIGENT
IN HIS BUSINESS? HE SHALL
STAND BEFORE KINGS.

« WORK by FORD MADOX BROWN (1821-1893) 349'27 BEQUEATHED BY MR J. R. HOLLIDAY 1927 »

75

FORD MADOX BROWN

Elijah and the Widow's Son

1864
Oil on wood panel
20 3/4 x 13 1/2 in.; 52.5 x 34.3 cm.
Signed and dated, centre right: FMB / 64 (initials in monogram)
In original frame
Presented by Sir John T. Middlemore, Bart., 1912 (23'12)

PROVENANCE: Commissioned by J.H. Trist; John Bibby; Laurence Hodson; his sale, Christie's, 25 June 1906, lot 142; Sir John Middlemore

EXHIBITED: London, Piccadilly, 1865 (33)

REFERENCES: Birmingham, *Paintings*, 1960, pp. 20–21; London, Tate, 1984 (127, repr.)

This subject, taken from I Kings 17:23, was one of three chosen by Brown for his contributions to Dalziels' *Bible Gallery* (see cat. no. 52); the other two were *Jacob and Joseph's Coat* and *Ehud and Eglon*. All three original pen and ink drawings survive (*Joseph's Coat* is in the British Museum, and the others are in the Victoria and Albert Museum), and were sent by Brown to the Dalziel brothers in 1864 with a clear indication that he intended to turn them into larger pictures.[1] The most important of these is *The Coat of Many Colours* (1864–1866; Walker Art Gallery, Liverpool), a large oil for which George Rae of Birkenhead paid the artist 450 guineas.[2]

Brown converted *Elijah and the Widow's Son* into two watercolours, a small version in 1864 (Private Collection) and a large watercolour of 1868, painted for Frederick Craven of Manchester (Victoria and Albert Museum, London).[3] The present oil painting was a commission (through Arthur Hughes) from John Hamilton Trist, a wine merchant in Brighton, who wanted a pendant for the small painting of *King René's Honeymoon* which he had just acquired (see cat. no. 57). Brown received not only the agreed fee of 100 guineas, but also a gift of wine from a delighted patron.[4]

The incident depicted occurs during Elijah's trial of strength with the followers of Baal. The son of a widow with whom the prophet was lodging has fallen sick and is deemed to be dead; Elijah prays over the body and the boy is restored to life. The widow tells Elijah that "by this I know that thou *art* a man of God, and that the word of the Lord in thy mouth *is* truth". For the catalogue to his 1865 exhibition, Brown gives this description of the painting:

> The child is represented as in his grave-clothes, which have a far-off resemblance to Egyptian funereal trappings; having been laid out with flowers in the palms of

his hands, as is done by women in such cases. Without this, the subject (the coming to life) could not be expressed by the painter's art, and till this view of the subject presented itself to me I could not see my way to make a picture of it. The shadow on the wall projected by a bird out of the picture returning to its nest, (consisting of the bottle which in some countries is inserted in the walls to secure the presence of the swallow good omen), typifies the return of the soul to the body. The Hebrew writing over the door consists of the verse of Deut. vi, 4–9, which the Jews were ordered so to use (possibly suggested to Moses by the Egyptian custom). Probably their dwelling in tents gave rise to the habit of writing the words on parchment placed in a case instead. As is habitual with very poor people, the widow is supposed to have resumed her household duties, little expecting the result of the Prophet's vigil with her dead child. She has therefore been kneading a cake for his dinner. The costume is such as can be devised from the study of Egyptian combined with Assyrian, and other nearly contemporary remains. The effect is vertical sunlight, such as exists in southern latitudes.[5]

1. According to Mary Bennett, in London, Tate, 1984, p. 204.
2. Bennett, 1988, pp. 37–42.
3. See Liverpool, 1964 (85, 86).
4. London, Tate, 1984, p. 204.
5. London, Piccadilly, 1865, p. 15.

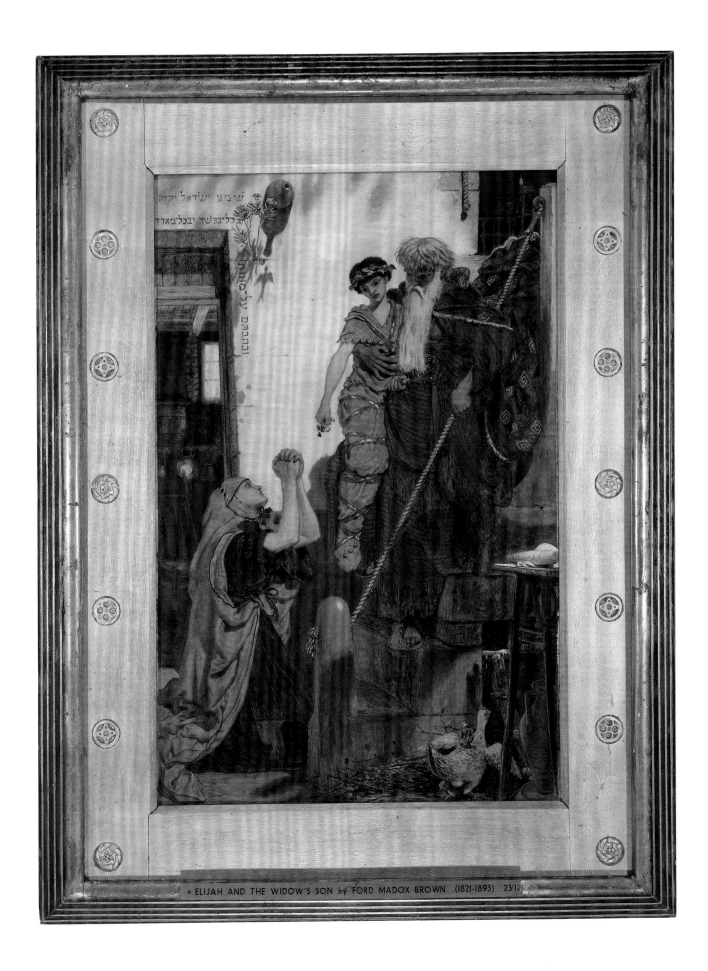

· ELIJAH AND THE WIDOW'S SON by FORD MADOX BROWN (1821-1893) 23/12

76

WILLIAM DYCE
Christ and the Woman of Samaria

Circa 1860
Oil on millboard (label, verso: Geo. Rowney & Co. Mill'd Boards)
13 1/2 x 19 in.; 34.2 x 48.4 cm.
Presented by the Trustees of the Public Picture Gallery Fund, 1897 (8'97)

PROVENANCE: Sir John Pender; his sale, Christie's, 29 May 1897, lot 31

EXHIBITED: Edinburgh, Royal Scottish Academy, 1865 (272)

REFERENCES: Birmingham, *Paintings*, 1960, pp. 47–48, pl. 326; Staley, 1973, pp. 175–176; Pointon, 1979, pp. 163, 195, pl. 81

Although William Dyce had little direct contact with the Pre-Raphaelite Brotherhood, he was sympathetic to its aims and practice, and was instrumental in bringing the young artists' work to the attention of John Ruskin. The critic later admitted that his "real introduction to the whole school", at the Royal Academy exhibition of 1850, was due to Dyce, who "dragged me literally up to the Millais picture of the Carpenter's Shop, which I passed disdainfully, and forced me to look for its merits".[1] Dyce's own work became heavily influenced by Pre-Raphaelite precepts, reaching a climax of natural observation and expressive detail in the painting *Titian preparing to make his First Essay in Colouring* (Aberdeen Art Gallery).[2] When this was shown at the Royal Academy in 1857, Ruskin hailed it as "the only [picture] quite up to the high-water mark of Pre-Raphaelitism this year. . . . Mr Dyce has encountered all discoverable difficulties at once, and chosen a subject involving an immense amount of toil only endurable by the boundless love and patience which are first among the Pre-Raphaelite characteristics".[3]

Christ and the Woman of Samaria belongs to a group of Dyce's small oils on prepared board, depicting biblical figures in a detailed landscape setting. Closest in spirit is *The Man of Sorrows* (1860; National Gallery of Scotland, Edinburgh), showing Christ in a wilderness clearly painted from scenery in the Scottish Highlands.[4] The spirit of universal realism which Dyce presumably intended to convey by this juxtaposition was lost on most critics, however, and even F.G. Stephens, who recognised that "the omnipresence of the typical idea may be well conveyed by thus treating it", considered that "the individuality of the Saviour is lost thereby . . . why – with all this literalness – not be completely loyal, and paint Christ himself in the land where he really lived?"[5] Although thus urged to follow the example of William Holman Hunt, whose *Finding of the Saviour in the Temple* (see cat. no. 29 and

fig. 37) was on exhibition in London during 1860, Dyce here seems instead simply to have diluted the Scottishness of his landscape, importing a few exotic plants to assist the illusion. The other elements of tree, grasses and rocks remain resolutely un-Eastern, and are comparable in disposition and detail to those in another oil of similar size and date, *Henry VI at Towton* (Guildhall Art Gallery, Corporation of London).[6] Pencil studies for the figures of Christ and the woman are at Aberdeen Art Gallery (fig. 71).[7]

The New Testament subject comes from John 4:1–42. Seated by a well in Samaria, Jesus converses with a local woman, in itself a gesture of reconciliation between the Jews and Samaritans, who were long-term enemies. While the woman seeks water as a simple necessity of life, Jesus speaks of the living (flowing) water as a sign of eternal life, emanating from God.

1. Letter of 28 December 1882 to Ernest Chesneau; Ruskin, *Works*, vol. 37, 1909, pp. 427–428.
2. Pointon, 1979, pp. 144–146, pl. III.
3. *Academy Notes*, 1857; Ruskin, *Works*, 1904, vol. 14, p. 98.
4. London, Tate, 1984 (109, repr.).
5. *Athenaeum*, 11 May 1860, p. 653; quoted in Staley, 1973, p. 165.
6. Pointon, 1979, p. 165, pl. 115.
7. Pointon, 1979, p. 208, pls. 82, 83.

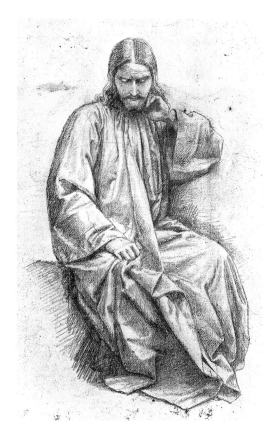

Fig. 71 WILLIAM DYCE, *Christ Seated*, circa 1860; pencil and silverpoint on grey paper, 5 x 8 in. (12.7 x 20.3 cm.). Aberdeen Art Gallery.

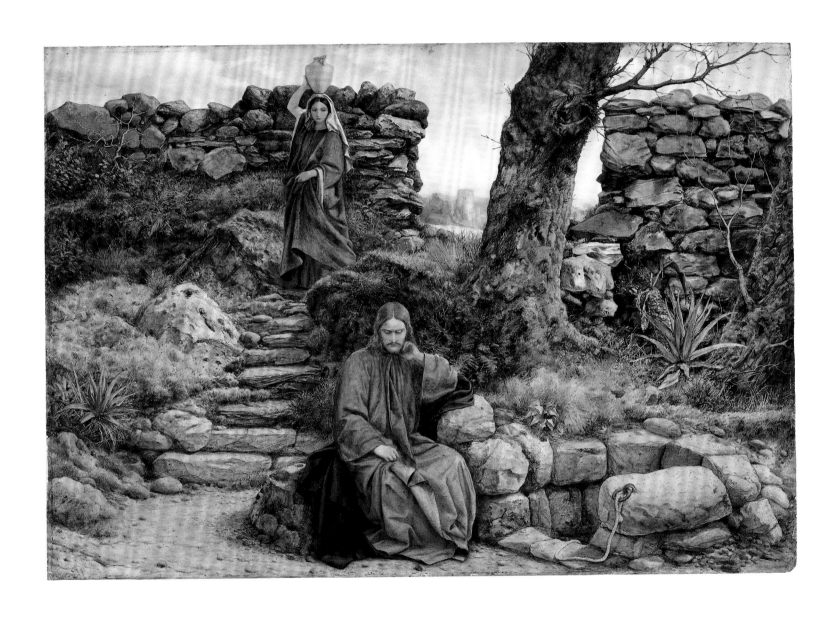

77

FREDERICK SANDYS

Morgan le Fay

1864
Oil on wood panel
24 3/4 x 17 1/2 in.; 63.0 x 44.0 cm.
In original frame
Presented by the Trustees of the Feeney Charitable Fund,
1925 (104'25)

PROVENANCE: W.H. Clabburn, sold 1879, bought by his son-in-law E. Meredith Crosse; by descent to his son E. Mitchell Crosse; his sale, Christie's, 8 May, 1925, lot 73

EXHIBITIONS: London, Royal Academy, 1864 (519)

REFERENCES: Birmingham, *Paintings*, 1960, p. 129; London, Royal Academy of Arts, 1968–1969 (354); Brighton and Sheffield, 1974 (58, pl. 29)

*I*n the Arthurian legend, Morgan le Fay was the half-sister of King Arthur. Increasingly jealous of his high esteem and strong moral character, she made several attempts to disrupt his life and reign, and was instrumental in revealing the adultery of Guenevere with Lancelot (see cat. no. 42). Here, she has turned to sorcery, and passes a lamp of magic fire over a cloak (woven on the loom behind her) intended to consume the King's body.

Sandys may have had knowledge of a large watercolour version of *Morgan le Fay* begun by Burne-Jones in 1862 (Hammersmith Public Libraries, London),[1] but he had already explored other Arthurian subjects, such as the ink drawing *King Pelles's Daughter bearing the Vessel of the Sanc Graal* (1861; Private Collection; exhibited as an oil painting at the Royal Academy in 1862) and the oil painting *Vivien* (1863; Manchester City Art Gallery).[2] A pen and ink drawing of *Morgan le Fay*, of this same size, is in a private collection.[3] Despite the popularity of Tennyson's *Poems* (see cat. no. 50) and *Idylls of the King* (1859), together with publication in 1858 of a modern version of Malory (*La Mort d'Arthure*, edited by Thomas Wright), even the partisan critic F.G. Stephens thought that a narrative picture such as *Morgan le Fay* "ought not to have been presented without explanation to a public hardly enough versed in the Arthurian cycle of legends to recognise its theme at sight".[4] He went on, however, to acknowledge its "strange force of expression and poetic suggestiveness . . . the painting is powerful". In contrast, the critic of the *Art Journal* saw in Morgan's dramatic figure only "a petrified spasm, sensational as a ghost from a grave, and severe as a block cut from stone or wood".[5]

Betty Elzea has suggested that the model for Morgan may have been Keomi, the gypsy girl also used by Rossetti in his painting *The Beloved* (1863–1866; Tate Gallery, London) and

who was for a time the mistress of Sandys.[6] Although facing to the right, a head study in black chalk (Victoria and Albert Museum, London) bears a strong resemblance to the head of Morgan.[7] Stephens commented that "all the accessories have been studied with care", and it has been observed that the designs on the sorceress's own cloak are indeed genuine Pictish symbols, the artist's source probably having been the first volume of *Sculptured Stones of Scotland* by John Stuart, published in Aberdeen in 1856.[8]

1. London, Southampton and Birmingham, 1975–1976 (37).
2. Brighton and Sheffield, 1974 (135 and 63, respectively).
3. Manchester, Whitworth, 1984 (115, repr.).
4. *Athenaeum*, 14 May 1864, p. 682.
5. *Art Journal*, June 1864, p. 161.
6. Brighton and Sheffield, 1974 (58).
7. Brighton and Sheffield, 1974 (59, pl. 30).
8. Information from Trevor Cowie, Department of Archaeology, National Museums of Scotland, Edinburgh; see Joanna Close-Brooks and Robert B.K. Stevenson, *Dark Age Sculpture*, Edinburgh, 1982, pp. 21–22 ("Pictish Symbol Stones").

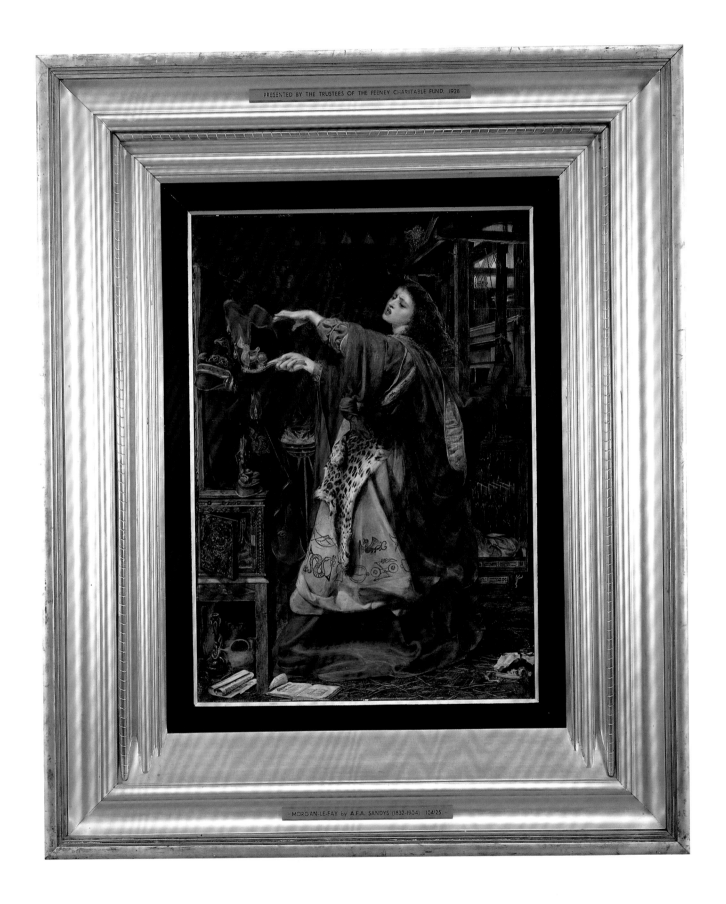

PRESENTED BY THE TRUSTEES OF THE FEENEY CHARITABLE FUND. 1928

MORGAN-LE-FAY by A.F.A. SANDYS (1832-1904) 104'25.

78

DANTE GABRIEL ROSSETTI

Woman combing her Hair

1864
Pencil
15 1/8 x 14 5/8 in.; 38.5 x 37.0 cm.
Signed and dated, bottom left: DGR / 1864 (initials in monogram)
Presented by subscribers, 1904 (416'04)

PROVENANCE: Fanny Cornforth; Charles Fairfax Murray

REFERENCES: Birmingham, *Drawings*, 1939, p. 329 (as study for *Lady Lilith*); Surtees, 1971, no. 174A, pl. 253; Tokyo, 1990 (138, repr.)

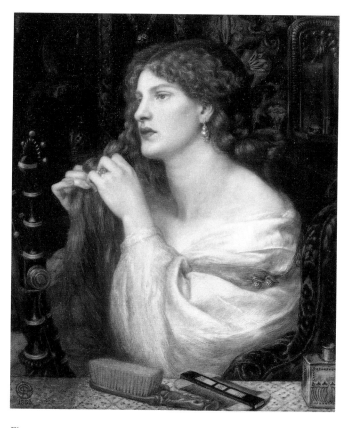

Fig. 72 DANTE GABRIEL ROSSETTI, *Fazio's Mistress (Aurelia)*, 1863; oil on wood panel, 17 x 14 1/2 in. (43.2 x 36.8 cm.). Tate Gallery, London.

*R*ossetti used this composition for a watercolour of the same size (also dated 1864; Private Collection) which has had no title other than the descriptive *Woman combing her Hair*.[1] Of all Rossetti's many half-length female figures beginning with *Bocca Baciata* in 1859 (Museum of Fine Arts, Boston), a number from the period 1863 to 1865 are of women combing or dressing their hair. The most elaborate oil is *Fazio's Mistress*, later called *Aurelia* (1863; Tate Gallery, London; fig. 72). Such titles had little or no significance beyond rendering them more saleable, as Rossetti confessed in this instance that the painting was "chiefly a piece of colour".[2]

The model for both *Fazio's Mistress* and *Woman combing her Hair* was Fanny Cornforth (see cat. no. 35), at this time Rossetti's mistress and housekeeper at Tudor House, Cheyne Walk. She also sat for *Lady Lilith*, a subject begun in 1864 but not completed as an oil painting until 1868 (and later repainted with the features of Alexa Wilding); in this the figure, using comb and mirror, faces to the left.[3] A variant of *Woman combing her Hair*, in watercolour and dated 1865, has appeared recently in the saleroom; this seems to be modelled on Ada Vernon.[4] The present drawing is handled with great vigour and freedom, and demonstrates how Rossetti's technique was constantly widening and improving. As befits their subject, his studies of Fanny have a strength and potency almost equal to the restrained passion evident in his drawings of Elizabeth Siddal made ten years earlier (see cat. no. 33).

Comparison is sometimes made between these compositions and Gustave Courbet's *Portrait de Jo, la belle Irlandaise;* however, this can only date from Courbet's encounter with Whistler and his mistress Joanna Hiffernan at Trouville in 1865.[5] During their trip to Paris in November 1864, Rossetti and Fanny did indeed come into contact with contemporary French painters, although they made rather a poor impression on Rossetti. After meeting Edouard Manet (through Henri de Fantin-Latour) and visiting Courbet's studio (when the artist

was away), Rossetti wrote to his mother that the former's pictures "are for the most part mere scrawls" and the latter's "not much better".[6]

1. Surtees, 1971, no. 174, pl. 252.
2. Letter of 25 October 1863 to Ellen Heaton; quoted in Surtees, 1971, no. 164, pl. 234.
3. Delaware Art Museum, Wilmington (Bancroft Collection); Surtees, 1971, no. 205, pl. 293.
4. Sotheby's, 12 November 1992, lot 150, repr.; not in Surtees, 1971.
5. Of the four versions of the *Portrait de Jo*, the one in the National Museum at Stockholm may be the earliest; for the canvas in the Metropolitan Museum of Art, New York (dated 1866), see Arts Council, *Gustave Courbet 1819–1877*, Royal Academy of Arts, London, 1978 (87, repr.).
6. Letter of 12 November 1864 to Mrs Gabriele Rossetti; Doughty and Wahl, 1965–1967, vol. 2, p. 527.

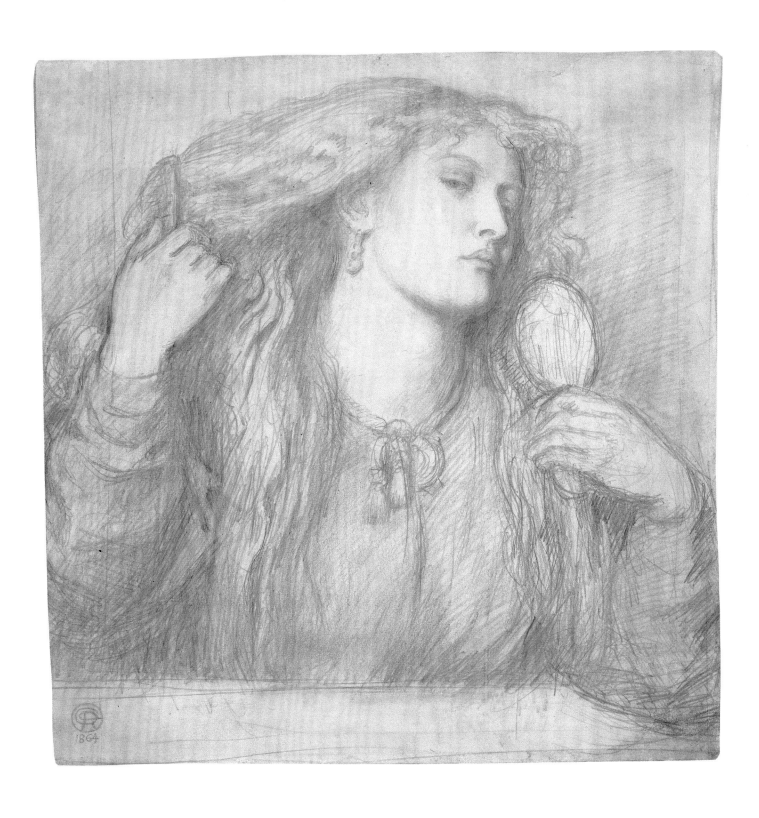

79

EDWARD BURNE-JONES

Two Female Heads

Circa 1865
Black and red chalk, touched with pencil
13 1/2 x 11 5/8 in.; 34.5 x 29.5 cm.
Presented by subscribers, 1904 (188'04)

PROVENANCE: Charles Fairfax Murray

REFERENCES: Birmingham, *Drawings*, 1939, p. 104; Harrison and Waters, 1973, p. 86, fig. 112 (as a study for *The Lament*); Rome, 1986 (12, repr.)

*T*he larger of these two beautiful studies bears some similarities with the head of the left figure in the watercolour *The Lament* (1866; William Morris Gallery, Walthamstow, London), but it is not quite close enough to be regarded as a specific study.[1] The sheet does, however, share the cool lyricism of the watercolour, which is an important milestone in the transition of Burne-Jones's style from the overtly medieval to the more timelessly classical.

Similar drawings from this period include *Amor* (Private Collection, also in red chalk)[2] and a study of a head dated 1866 that has been linked to the image of *Cupid and Psyche*, which is the culminating composition in the series inspired by *The Earthly Paradise* by William Morris.[3] Burne-Jones relished the challenge inherent in every technique of draughtsmanship, and on occasion produced a finished 'presentation' drawing in this style of soft chalk on fairly heavy paper, which gives a rich grainy texture to shadows and background. An example of this is the *Head of a Man in a Renaissance Cap* (also at Birmingham; fig. 73), which declares the artist's interest in, and knowledge of, Renaissance drawing.[4] The combination of red and black chalk in these sheets is itself a further homage to the great Italian masters such as Andrea del Sarto and Raphael.

1. London, Southampton and Birmingham, 1975–1976 (93); reproduced in Harrison and Waters, 1973, pl. 14.
2. Harrison and Waters, 1973, p. 81, fig. 106.
3. Sotheby's, 3 November 1993, lot 193 (as *Study for the Head of Cupid*).
4. Birmingham, *Drawings*, 1939, p. 105 (564'27); reproduced in Rome, 1986, p. 138.

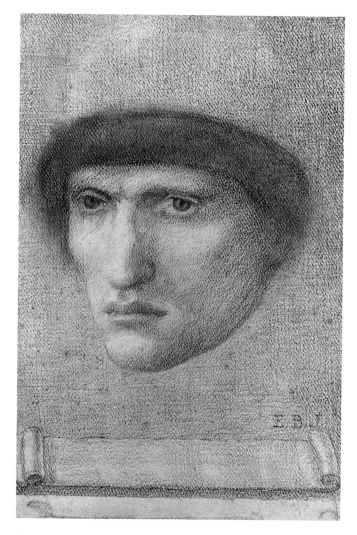

Fig. 73 EDWARD BURNE-JONES, *Head of a Man in a Renaissance Cap*, mid-1860s; red and black chalk, touched with pencil, 14 x 9 1/4 in. (35.7 x 23.5 cm.). Birmingham Museums and Art Gallery (564'27).

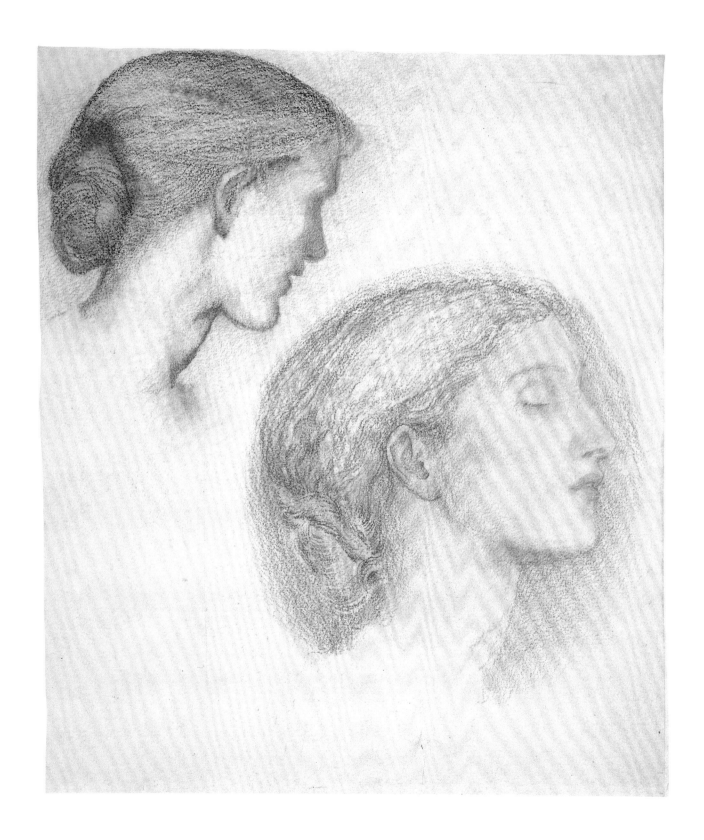

80

EDWARD BURNE-JONES

St George and the Dragon

Circa 1865
Black chalk, heightened with white, on brown paper
Original sheet 14 1/2 x 18 in. (37.0 x 45.8 cm.), joined to
additional sheet extending by 1 3/8 in. (3.5 cm.) at top and
1 1/2 in. (3.8 cm.) at right
Presented by subscribers, 1904 (12'04)

PROVENANCE: Charles Fairfax Murray

REFERENCES: Birmingham, *Drawings*, 1939, p. 72; Harrison
and Waters, 1973, fig. 119; London, Southampton and
Birmingham, 1975–1976 (90)

1. For Birket Foster's commission with Morris, see Sewter, 1975, *Text*, p. 206.
2. Burne-Jones, *Memorials*, 1904, vol. 1, pp. 295, 304.
3. Rome, 1986 (15, repr.); see also London, Southampton and Birmingham, 1975–1976 (88–92).
4. Burne-Jones, *Memorials*, 1904, vol. 1, pp. 296–297, continues: "It was seldom that his own family asked him any questions about his work as he did it, for we saw how little he liked to talk of a thing before it was done, and realised what would be the irksomeness to him of anything like a running commentary on it".

For the decoration of his new house The Hill, at Witley in Surrey, completed in 1863, the watercolourist Myles Birket Foster (1825–1899) turned to his friends and fellow artists. He commissioned a good deal of work from Morris, Marshall, Faulkner and Company, including a tile panel of *The Sleeping Beauty* and a set of seven stained-glass windows on the theme of Chaucer's *Legend of Good Women*.[1] These were all designed by Burne-Jones, who was also asked to provide seven canvases illustrating the story of St George to hang in the dining room. By the end of 1865, Burne-Jones had finished three of the paintings, but the others took an additional two years to complete, even with the assistance of Charles Fairfax Murray.[2] The episodes were essentially the same as those chosen by Rossetti for his stained-glass designs of 1861–1862 (see cat. nos. 60–64), although Burne-Jones began his sequence with *The King's Daughter*, showing a carefree Princess Sabra walking in a garden while reading a book.

St George Slaying the Dragon is certainly the most animated design in the series and one which passed through a number of compositional alterations. This powerful drawing – one of fifteen studies for this subject alone in the Birmingham collection (out of some sixty-four for the whole series) – must have been an early idea, as Burne-Jones reversed the figures of the saint and the dragon in the final painting (now in the Art Gallery of New South Wales, Sydney).[3] The figure of the Princess remained on the right, as faintly suggested here. On seeing the works again at Christie's in 1894, when Birket Foster's collection was sold, Georgiana Burne-Jones was

> surprised by their dramatic character. . . . I spoke of this to Edward afterwards, asking him whether he had not purposely suppressed the dramatic element in his later work, and he said yes, that was so – for no one can get every quality into a picture, and there were others that he desired more than the dramatic.[4]

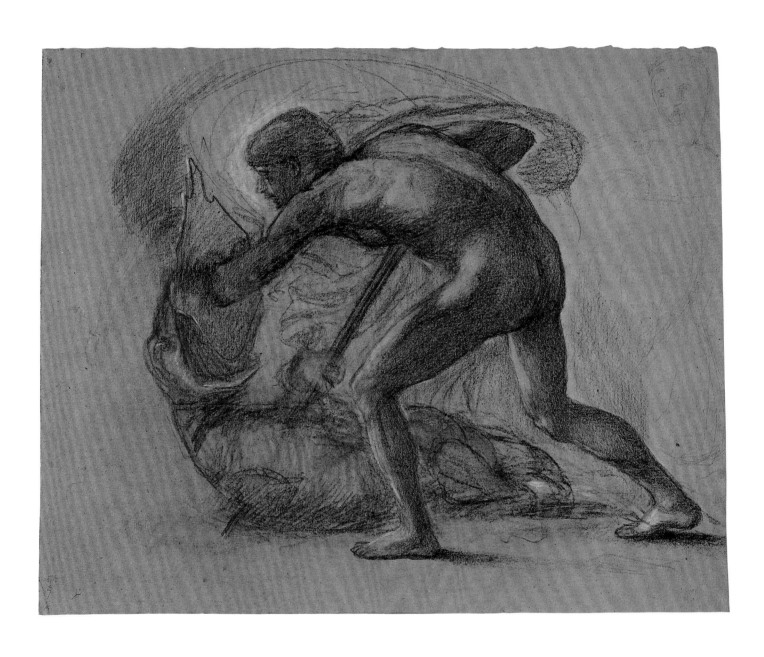

81

EDWARD BURNE-JONES

The Fates: study for Clotho (?)

Circa 1865
Black chalk
21 x 13 3/8 in.; 53.3 x 34.0 cm.
Presented by subscribers, 1904 (6'04)

PROVENANCE: Charles Fairfax Murray

REFERENCE: Birmingham, *Drawings*, 1939, p. 62

Fig. 74 EDWARD BURNE-JONES, *The Fates: study for composition*, circa 1865; brush drawing in sepia, with white chalk, on brown paper, 12 1/2 x 7 in. (31.8 x 17.8 cm.). Birmingham Museums and Art Gallery (1'04).

*V*olumetric studies such as this show Burne-Jones's acquaintance with classical, especially Greek, sculpture and its assimilation into his painting style of the late 1860s. From 1861 he lived opposite the British Museum, and is known to have made studies in the sculpture galleries: a similar chalk drawing (also in the Birmingham collection) has been identified as closely inspired by the figure of Aves in the Elgin Marbles.[1] Writing in 1880, in response to the proposal to establish a proper Museum and Art Gallery in Birmingham, Burne-Jones considered such firsthand exposure to classical art vital for the aspiring artist: "I know if there had been one cast from ancient Greek sculpture or one faithful copy of a great Italian picture to be seen in Birmingham when I was a boy, I should have begun to paint ten years before I did".[2]

Ruskin's wish to lure Burne-Jones ever further from what he saw as the stultifying influence of Rossettian medievalism had included a commission in 1863 for a series of mythological figures to illustrate the critic's serial essay on political economy, *Munera Pulveris* ("Gifts of the Dust"). Soon after this, Burne-Jones embarked on a number of classical subjects, including *The Lament* (see cat. no. 79), *The Hours*, *The Fates* and the first of many treatments of the story of Cupid and Psyche (see cat. no. 99). *The Fates* was never completed, and its appearance is known only through composition and figure studies, mostly at Birmingham. A sprightly early design (fig. 74) depicts the Fates, or Parcae of Greek myth, hieratically seated behind the figures of two lovers, whose lives they symbolically determine.[3] Clotho, youngest of the sisters, presides over the moment of human birth (in this drawing by Burne-Jones [cat. no. 81] she is perhaps poring over the book of life); Lachesis spins out the events and actions of life; and Atropos, the eldest of the three, cuts the vital thread with a pair of scissors.

1. John Christian, in London and Birmingham, 1991–1992, p. 81 (drawing reproduced, fig. 47). An even closer study of a female figure in this same pose was with Peter Nahum in 1989 (*Burne-Jones, the Pre-Raphaelites and their Century*, London, 1989, no. 48, pl. 32).
2. Burne-Jones, *Memorials*, 1904, vol. 2, p. 100.
3. Birmingham, *Drawings*, 1939, p. 62 (1'04).

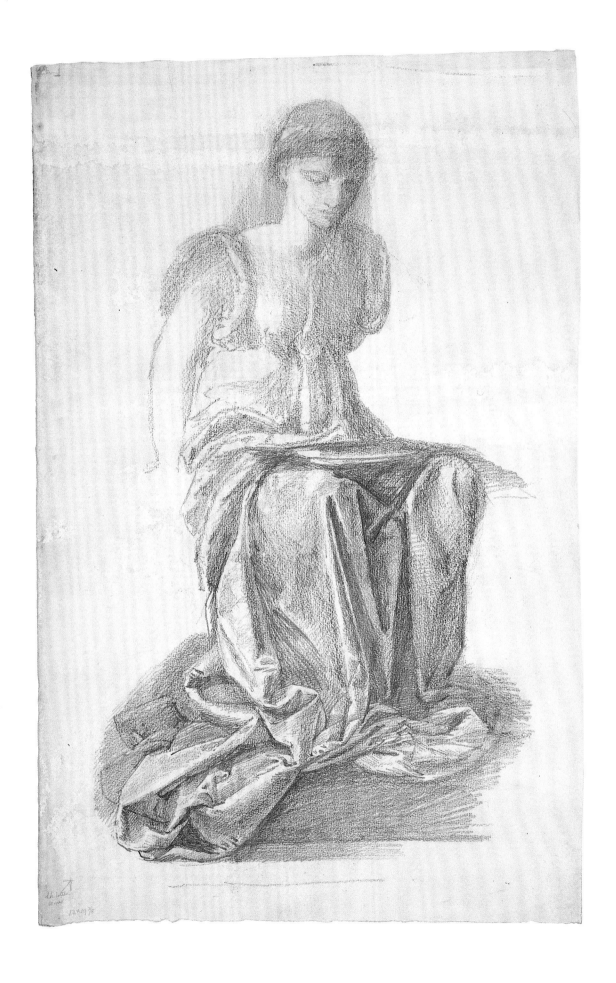

JOHN BRETT

February in the Isle of Wight

1866
Watercolour, bodycolour and gum
18 1/8 x 14 in.; 46.0 x 35.4 cm.
Signed and dated, bottom right: John Brett / 1866
Presented by Herbert Martin, 1919 (70'19)

PROVENANCE: William Martin, by 1891

EXHIBITED: Birmingham, Society of Artists, Spring 1866
(87); Birmingham, 1891 (216)

REFERENCES: Birmingham, *Paintings &c.*, [1930], p. 20;
Staley, 1973, p. 135; New Haven, Cleveland and
Birmingham, 1992–1993 (64, repr.)

After encountering J.W. Inchbold (see cat. no. 91) in
the Alps during the summer of 1856, John Brett soon entered
the Pre-Raphaelite circle, and contributed to the 1857 exhibi-
tion held at Russell Place. His oil of *The Stonebreaker* (Walker
Art Gallery, Liverpool) appeared in the same Royal Academy
exhibition of 1858 as the rendering of the subject by Henry
Wallis (see cat. no. 40), and the remarkable painting *Val
d'Aosta* (Private Collection), shown the following year,
attracted one of Ruskin's longest individual reviews in all his
Academy Notes.[1]

In this, Ruskin applauded the apparent arrival of what he
termed "historical landscape . . . landscape painting with a
meaning and a use".[2] Not only was the scene one of a sublime
view worth painting – Ruskin had been particularly puzzled
by Brown's choice of unglamorous subject matter in his land-
scapes – but the viewer was offered, "by help of art, the power
of visiting a place, reasoning about it, and knowing it, just as
if we were there . . . standing before this picture is just as good
as standing on that spot in Val d'Aosta, so far as gaining of
knowledge is concerned".[3] He went on, however, to define a
central weakness in Brett's painting, a lack of emotion or
"absence of sentiment", in this case "peculiarly indicated by
the feeble anger of the sky . . . there is no majesty in the
clouds". Without this Ruskin considered, in a phrase that has
dogged judgement on Brett's work ever since: "I never saw the
mirror so held up to Nature; but it is Mirror's work, not
Man's".[4] Despite his disappointment, Ruskin then bought
the picture, perhaps feeling some responsibility for its failure
to find another purchaser.

Brett was also a skilful watercolourist, but only a few
works were exhibited. One, under the title *"A Bank whereon
the Wild Thyme grows"*, was included in the American
Exhibition of British Art in 1857, and at least two were shown
at the Royal Academy, in 1862 and 1869.[5] Several resulted

from trips to Italy during the winters of 1861–1862, 1863–1864
and 1864–1865. The crisp but coolly remote coastal view *Near
Sorrento*, stemming from the 1863 trip, is also in the
Birmingham collection.[6]

As well as a good deal of 'mirror's work', an expressive use
of tone and colour is also evident in Brett's watercolours of
the late 1860s (he seems largely to have abandoned the medi-
um after 1870). For *February in the Isle of Wight*, Brett pro-
duces a brilliant evocation of a chilly landscape touched by a
presage of spring, with wonderfully delicate handling of the
tree branches. Rather than the unexplained presence of the
two children and the almost ghostly ship, it is the suffused
light bathing the whole vista which gives this work its strik-
ing character. The watercolour was shown in the Birmingham
Society of Artists' inaugural spring exhibition of watercolours
and sketches in 1866, when it was priced at £45. *November in
the Isle of Wight*, although presumably a pendant, may have
been larger, as it commanded £75. They re-appeared together
in the Birmingham Pre-Raphaelite exhibition of 1891, when
both were lent by William Martin (probably the local archi-
tect of that name, who died in 1899), but *November* (then
called *Autumn in the Isle of Wight*) cannot now be located.

1. Brett's career is admirably detailed in Staley, 1973, pp. 124–137.
2. *Academy Notes*, 1859; Ruskin, *Works*, 1904, vol. 14, p. 234.
3. *Academy Notes*, 1859; Ruskin, *Works*, 1904, vol. 14, p. 234.
4. *Academy Notes*, 1859; Ruskin, *Works*, 1904, vol. 14, p. 237; "holding
a mirror up to Nature" is a quotation from Shakespeare's *Hamlet* (act
III, scene ii).
5. Allen Staley, "Some Water-Colours by John Brett", *Burlington
Magazine*, vol. 115, February 1973, p. 89.
6. Birmingham, *Paintings &c.*, [1930], p. 20 (34'17); New Haven,
Cleveland and Birmingham, 1992–1993 (54, repr.).

83

FREDERICK SANDYS

If

1866
Pen and black ink over pencil
7 1/4 x 5 3/8 in.; 18.4 x 13.7 cm. (sheet); 6 1/4 x 4 5/8 in.;
15.9 x 11.7 cm. (image)
Presented by subscribers, 1906 (844'06)

PROVENANCE: James Anderson Rose; Charles Fairfax Murray

REFERENCES: Birmingham, *Drawings*, 1939, p. 382, repr. p.
439; Brighton and Sheffield, 1974 (276, pl. 167); London,
Tate, 1984 (241, repr.)

Sandys gratefully accepted the opportunities offered by the
burgeoning demand for book and magazine illustration in the
1860s, and quickly established a reputation that lasted through-
out the century. In an article of 1898, Gleeson White singled
out Sandys as "A Great English Illustrator", whose individual
designs were "masterpieces" rivalling any in the British Museum
Print Room.[1] Of his dozen or more really memorable images,
the most celebrated are *The Old Chartist* (for *Once a Week*,
1862; Joseph Pennell thought this "might have been done by
Dürer")[2]; *Manoli* (*Cornhill Magazine*, 1862); *Until her Death*
(*Good Words*, 1862); *Amor Mundi* (*Shilling Magazine*, 1865) and
If (*The Argosy*, March 1866).[3] Painstakingly conscientious about
these commissions, Sandys made many preparatory studies
(see cat. no. 84), a large number of which passed from the
Fairfax Murray collection to Birmingham.[4]

Amor Mundi and *If* both illustrate poems by Christina
Rossetti (1830–1894). The former depicts two lovers whose
idyll ends abruptly with the discovery of a corpse – a dark and
disturbing image in the spirit of Dante Gabriel Rossetti's ear-
lier *doppelgänger* subjects, which brilliantly matches the poet's
more abstract but no less powerful verse.[5] For "If" (a poem
later re-titled "Hope against Hope"), Sandys sets a lone female
figure against an elemental landscape, brooding on the absence
of her lover:

> If he would come to-day, to-day, to-day
> Oh what a day to-day would be!

Also at Birmingham is a chalk study for the billowing dra-
pery, while for the background Sandys made use of a drawing
done in 1858 at Weybourne Cliff, near Sheringham in Norfolk
(Victoria and Albert Museum, London).[6] The pose of the fig-
ure is effectively a repetition of *Until her Death* of 1862, but
with the added tension of the woman sucking at her hair, a
motif used by Rossetti several years earlier (see cat. no. 27) and
refined by Sandys in his picture of circa 1867, *Proud Maisie*.[7]

As with earlier Pre-Raphaelite designs for book illustra-
tions, it has been assumed that the artist's final drawing

should have been made onto a wood block, to be cut by the
engraver, in this case Joseph Swain (fig. 75). By the mid-1860s,
however, it seems that photography was in widespread use for
transferring the finished design onto the block, thus sparing
drawings such as this. From as early as 1859–1860, Sandys was
in the habit of making tracings for this purpose.[8]

1. Gleeson White, "A Great English Illustrator – Frederick Sandys",
Pall Mall Magazine, vol. 16, November 1898, pp. 328–338.
2. Joseph Pennell, "An English Illustrator", *Quarto*, 1896, p. 36.
3. See Brighton and Sheffield, 1974, section 10, Illustrations. The fin-
ished design for *Manoli* was sold at Sotheby's on 30 March 1994 (lot
197, repr.); that for *Until her Death* is in the National Gallery of South
Australia, Adelaide; and the design for *Amor Mundi* is in the National
Gallery of Canada, Ottawa.
4. Birmingham, *Drawings*, 1939, pp. 375–385.
5. See Douglas E. Schoenherr, "Frederick Sandys's 'Amor Mundi',"
Apollo, vol. 127, May 1988, pp. 311–318.
6. Brighton and Sheffield, 1974 (277–278).
7. There are as many as twelve chalk drawings of *Proud Maisie* – two
of circa 1867 (both in the Victoria and Albert Museum, London) and
one of 1902 (National Gallery of Canada, Ottawa) – as well as an
unfinished oil on panel, circa 1868 (Private Collection); Brighton and
Sheffield, 1974 (69, 142, 143, 158).
8. Information supplied by Betty Elzea.

Fig. 75 JOSEPH SWAIN (1820–1909), after FREDERICK SANDYS, *If*,
1866; wood engraving (proof), 6 1/4 x 4 1/2 in. (15.9 x 11.5 cm.).
Birmingham Museums and Art Gallery (846'06).

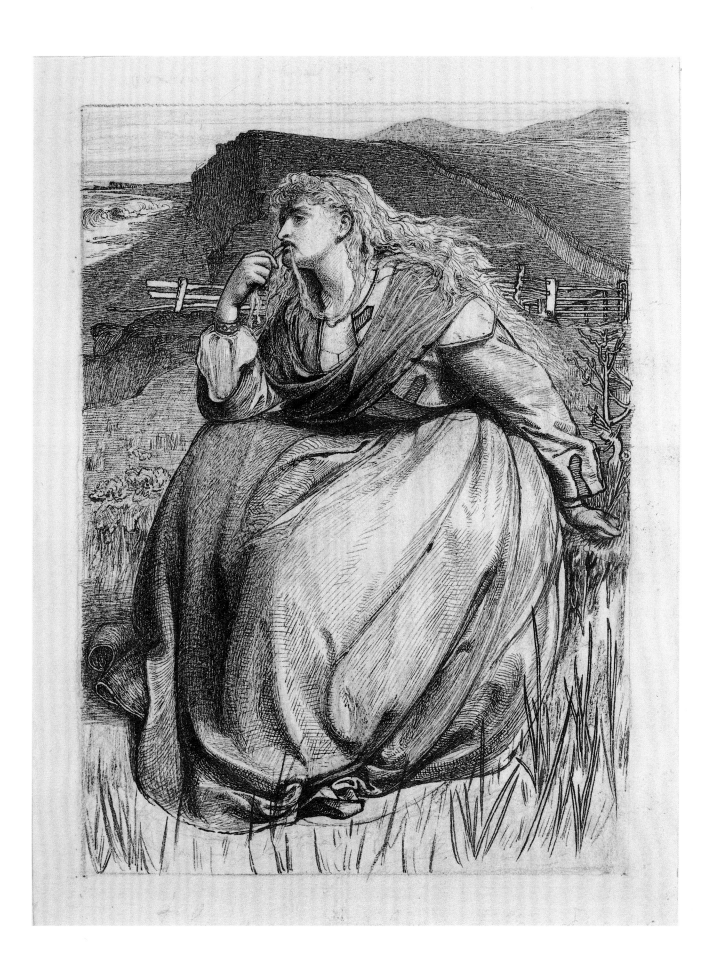

84

FREDERICK SANDYS

Helen and Cassandra: study of drapery

1866
Black chalk, touched with white and red, within pencil
border, on grey-green paper
8 1/2 x 6 1/4 in.; 21.5 x 15.7 cm.
Presented by subscribers, 1906 (880'06)

PROVENANCE: James Anderson Rose; Charles Fairfax Murray

REFERENCES: Birmingham, *Drawings*, 1939, p. 381; Brighton
and Sheffield, 1974 (273)

A fondness for classical subject matter developed even
more quickly in Sandys's work than it did for Burne-Jones.
He showed two oil paintings at the Royal Academy in 1865 –
Gentle Spring (Ashmolean Museum, Oxford; begun in 1863)
and *Cassandra* (Ulster Museum, Belfast).[1] Apparently using the
same model as *Vivien* (1863; Manchester City Art Gallery),
Cassandra is also of the head-and-shoulders format preferred
by Rossetti, but disconcertingly it shows the Trojan soothsayer
uttering an anguished shriek. It is possible that Sandys might
have known Rossetti's highly finished ink drawing *Cassandra*
(1861; British Museum, London), and their mutual inspir-
ation was probably George Meredith's poem of the same
eponymous title.[2]

Unlike his Pre-Raphaelite mentors, Sandys retained a love
of academic life drawing; there is evidence of his attending the
Langham Sketch Club and sharing models with other artists
such as Simeon Solomon.[3] The solid basis he derived from
such studies underlies most of his full-length figurative work,
even on the small scale demanded by book illustration. *Helen
and Cassandra* appeared in the magazine *Once a Week* for 28
April 1866, alongside verses written by Alfred B. Richards to
accompany the engraving. The prophetess Cassandra chastises
a sulky Helen (again shown tensely chewing a strand of hair),
whose actions have led to the burning of Troy. Four drawings
at Birmingham show Sandys's meticulous development of the
image, from a nude study (fig. 76) to the final design in pen
and ink (fig. 77), which adds linear animation to the weight of
the figures.[4] Two drapery studies were done in between, one
left incomplete and the other (cat. no. 84) a wonderful piece
of draughtsmanship, both elaborate and subtle in execution.

1. Brighton and Sheffield, 1974 (65, 66, pls. 36, 37).
2. Surtees, 1971, no. 127, pl. 196.
3. Information supplied by Betty Elzea.
4. Birmingham, *Drawings*, 1939, p. 381 (878, 879, 881'06).

Fig. 76 FREDERICK SANDYS, *Helen and Cassandra: nude
study*, 1866; black chalk, touched with white, 7 1/2 x
5 1/4 in. (19.0 x 13.3 cm.). Birmingham Museums and
Art Gallery (879'06).

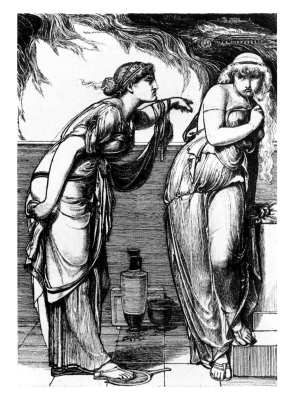

Fig. 77 FREDERICK SANDYS, *Helen and Cassandra: finished
design*, 1866; pen and brush with black ink, 7 3/4 x 5 5/8
in. (19.7 x 14.2 cm.). Birmingham Museums and Art
Gallery (878'06).

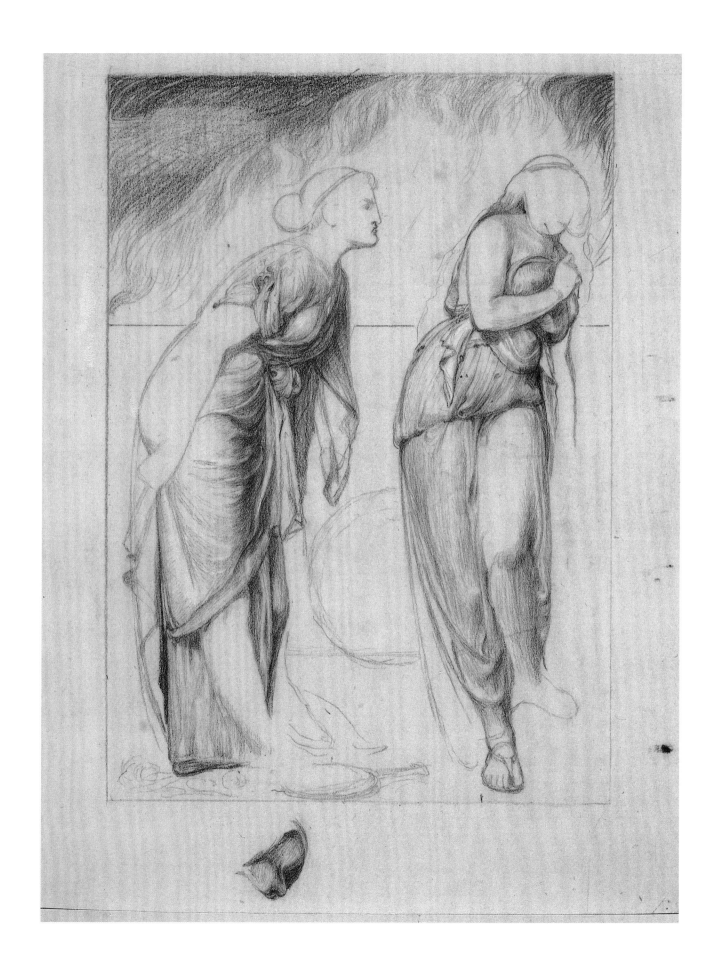

85

FREDERICK SANDYS

Helen of Troy

Circa 1867
Black, red and white chalk on buff paper
15 1/8 x 14 3/8 in.; 38.5 x 36.5 cm.
Presented by subscribers, 1906 (859'06)

PROVENANCE: Charles Fairfax Murray

REFERENCES: Birmingham, *Drawings*, 1939, p. 381; Brighton and Sheffield, 1974 (67, pl. 38)

*T*his dramatic study holds an intermediate place between the illustration *Helen and Cassandra* (see cat. no. 84) and the panel painting *Helen of Troy*, now at the Walker Art Gallery, Liverpool (fig. 78), which is the same size as the present sheet.[1] In what must be the artist's first idea for enlarging the figure of Helen, the position of the head remains virtually unchanged, and he has made even greater play with the swirling smoke of burning Troy. In the painting, however, Sandys switches Helen's sultry stare from right to left, and gives fuller prominence to her cascading tresses, all but eliminating any background. Her classical origins are suggested only by the rich archaic jewellery. Possibly Sandys made these changes in order to avoid invidious comparison with a small

oil on panel by Rossetti, also titled *Helen of Troy* (1863; Kunsthalle, Hamburg), which has a stylised background of the burning city.[2] Rossetti's painting was certainly known to the poet Algernon Swinburne (1837–1909), a close associate of Sandys, who described Helen's "Parian face and mouth of ardent blossom, a keen red flower-bud of fire, framed in broad gold of wide-spread locks".[3]

Sandys's Helen certainly has no "sweet sharp smile of power" (Swinburne's phrase), but is a full-blooded *femme fatale* of a type with which he was to become increasingly associated in the public mind, especially after the appearance of *Medea* (cat. no. 88) at the Royal Academy in 1869. Writing in 1896, the critic Esther Wood summed up the popular conception of his work:

> For the most part, Sandys is stern towards the beauty of women. . . . He has found most of his dramatic inspirations in the more treacherous and vengeful figures of history and romance. With few exceptions, his models have been women of commanding brilliancy and power rather than loveliness or grace. These severer qualities have undoubtedly made for the exclusion of everything trivial and flippant in his subjects; they are unflinchingly serious, and even intense. No modern artist has portrayed so fearlessly the malignant aspects of womanhood. From the great warrior-wives of Greece and Rome to the witch-like enchantresses of medieval lore, he covers the whole gamut of unscrupulous passion, and paints the traitress, the seducer, and the murderess in every phase of jealousy, fury, and desperate revenge. . . . One looks in vain for the more near and familiar realities of womanhood: its best and its worst are shown us, but we miss the "little human woman" of every day.[4]

1. Nottingham, 1994 (57, repr.).
2. Surtees, 1971, no. 163, pl. 232.
3. Quoted in Surtees, 1971, p. 92.
4. Esther Wood, "A Consideration of the Art of Frederick Sandys", *Artist*, vol. 18, November 1896, p. 24; quoted in Kestner, 1989, p. 170.

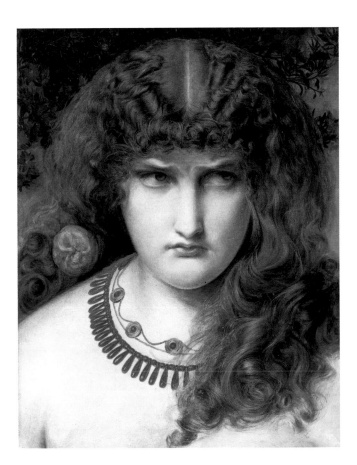

Fig. 78 FREDERICK SANDYS, *Helen of Troy*, circa 1867 (unfinished?); oil on wood panel, 15 1/8 x 12 in. (38.4 x 30.5 cm.). Walker Art Gallery, Liverpool (National Museums and Galleries on Merseyside).

86

SIMEON SOLOMON

Bacchus

1867
Oil on wood panel
20 x 14 3/4 in.; 50.8 x 37.5 cm.
Signed and dated, bottom left: SS / 3 67 [i.e., March 1867]
(initials in monogram)
In original frame
Bequeathed by Katharine Elizabeth Lewis, 1961 (P52'61)

EXHIBITED: London, Royal Academy, 1867 (113)

REFERENCES: Reynolds, 1984, p. 19, pl. 2; London and
Birmingham, 1985–1986 (56, repr.)

\mathscr{S}imeon Solomon spent the winter of 1866–1867 in Rome,
where he began two pictures of *Bacchus*, this oil and a water-
colour of almost identical size but different composition of a
three-quarter-length figure clad only in a loin cloth and leo-
pard skin (fig. 79).[1] While the oil was shown at the Royal
Academy, the watercolour was sent to the Dudley Gallery
exhibition of 1868. Outside Solomon's own circle of friends,
the works attracted the attention of Sidney Colvin, who
found "admirable . . . two of the Dionysiac kind, one quite
early and one more recent, in which solid richness of execu-
tion and intensity of sentiment . . . have been carried about
as far as they could go".[2]

This sensual portrait, undoubtedly modelled from a
young Italian boy, encapsulates many of Solomon's interests
and tastes. He shared with his friends Algernon Swinburne
and Walter Pater (1839–1894) a passion for more purely aes-
thetic Renaissance and Mannerist painting: Botticelli and
Leonardo were favourites, and Solomon may have been
inspired by a portrait by the fifteenth-century Sienese artist
Sodoma, which Swinburne had seen in the Uffizi, Florence,
in 1864 and recommended.[3]

Solomon was actively homosexual, at a time when such a
predilection could not have been publicly expressed (the term
itself was coined only in 1869, and was not in general use in
England for many years), but could be shared with a like-
minded audience of artists and writers.[4] The writings on aes-
thetics by Pater, an Oxford don, were particularly important
in establishing a climate of tacit acceptance for alternative
mores, as expressed in this passage from one of his earliest
essays on the German art critic Johann Winckelmann (also a
homosexual): "The beauty of the Greek statues was a sexless
beauty; the statues of the gods had the least traces of sex. Here
there is a moral sexlessness, a kind of ineffectual wholeness of
nature, yet with a true beauty and significance of its own".[5]

Bacchus was seen and admired by Pater at the Royal

Academy in 1867, and he introduced a description of it into
his essay "A Study of Dionysus" for the *Fortnightly Review* in
December 1876 (and subsequently published in *Greek Studies*
in 1895). Mindful of the scandal of 1873, when Solomon was
arrested for public indecency, Pater referred only to "a young
Hebrew painter" (an allusion likely to have been recognised
by many readers), but was full of praise for this "complete and
very fascinating realisation". For Pater, this was not the bucol-
ic Roman Bacchus, but the "melancholy and sorrowing"
Dionysus of the Greeks. Perhaps subconsciously identifying
the picture with its creator, Pater discerned in this image "the
god of the bitterness of wine, 'of things too sweet', the sea-
water of the Lesbian grape become somewhat brackish in the
cup . . . an emblem or ideal of chastening and purification,
and of final victory through suffering".[6]

1. London and Birmingham, 1985–1986 (56, repr.); sold at Christie's,
11 June 1993, lot 91. An earlier *Bacchus* subject, apparently dated 1865,
is known from a reference in a letter to Swinburne of 1871, but
remains unlocated.
2. "English Painters of the Present Day IV: Simeon Solomon",
Portfolio, March 1870, p. 34.
3. See London and Birmingham, p. 72; a *Narcissus* by the Milanese
painter Boltraffio, a pupil of Leonardo, also in the Uffizi, has been
proposed by Steven Kolsteren as another likely source (*Journal of Pre-
Raphaelite Studies*, vol. 7, no. 1, November 1986, p. 95).
4. See Emmanuel Cooper, "A Vision of Love: Homosexual and
Androgynous Themes in Simeon Solomon's Work after 1873", in
London and Birmingham, 1985–1986, pp. 31–35.
5. Quoted by Lionel Lambourne in London and Birmingham,
1985–1986, p. 27.
6. Quoted by Lambourne in London and Birmingham, 1985–1986, p. 72.

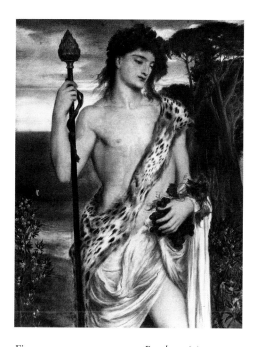

Fig. 79 SIMEON SOLOMON, *Bacchus*, 1867; water-
colour and bodycolour, 19 3/4 x 14 3/4 in. (50.2 x
37.5 cm.). Private Collection.

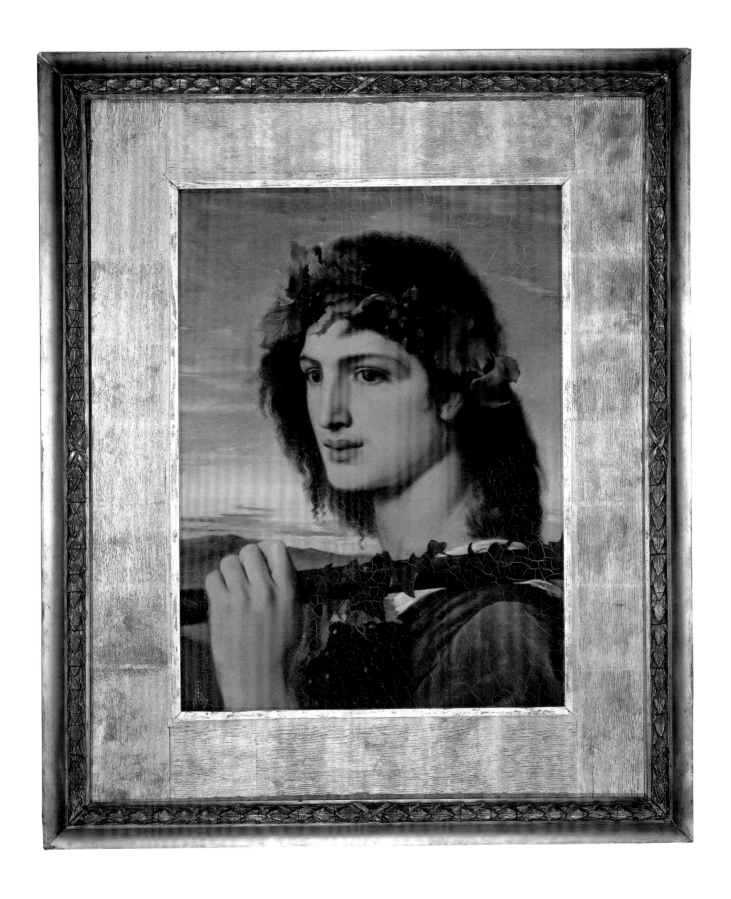

87

ARTHUR HUGHES

The Lost Child

Circa 1867
Oil on wood panel
20 3/4 x 13 3/4 in.; 52.7 x 35.0 cm.
Signed, bottom left: ARTHUR HUGHES
Presented by Mr and Mrs Cotterill Deykin, in memory of
their son Llewellyn, 1926 (3'26)

REFERENCE: Birmingham, *Paintings*, 1960, p. 77

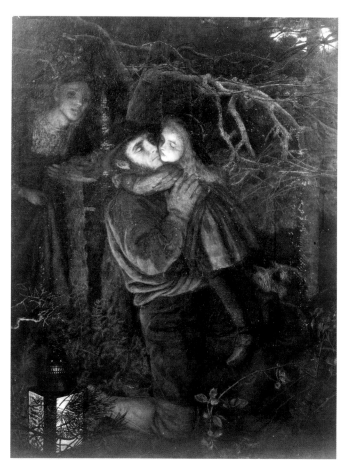

Fig. 80 ARTHUR HUGHES, *The Lost Child (L'enfant perdu)*, 1867; oil on canvas, 38 x 29 1/2 in. (96.5 x 75.0 cm.). Private Collection.

This is a reduced and altered version of a painting exhibited under the title *L'enfant perdu* at the Royal Academy in 1867 (fig. 80).[1] The review by F.G. Stephens in the *Athenaeum* is worth quoting in full:

> Mr Hughes was never more fortunate in sentiment or in execution than in his *L'Enfant Perdu*, – the somewhat whimsical title of a picture which represents the finding of a lost child. The effect is that of twilight in a wood; moonbeams lie in the foliage, and struggle to reach the depths of the branch and trunk shadows. The little one, whose nestling and but half-fearful expression is one of the most delicately rendered points of Nature in the Exhibition, has come to its kneeling father's arms; he, with the rough tenderness of a man, takes up the child; the figure of the mother advances from the background of gloom, just as the light of a lamp falls upon her person, or misses it to penetrate the upper shadows of the place. This is a very fine and powerfully painted picture, as broad in effect as it is subtle in expression and careful in working. The lighting should be studied with recognition of the painter's ability to bring that element of his work to the aid of his purpose and the illustrations of his theme.[2]

Hughes has made several changes in the Birmingham version, notably eliminating the figure of the mother. Even more 'broadly' handled overall, the picture's foreground has been simplified, and greater focus given to the girl, who has now lost a shoe. An inquisitive squirrel has appeared in the tree, echoing those in the background of *The Long Engagement* (cat. no. 48). The artist was fond of rural domestic subjects: among these, both *The Woodman's Child* (1860; Tate Gallery, London) and *Bedtime* (1862; Harris Museum and Art Gallery, Preston) have a Pre-Raphaelite intensity, but do not attempt to offer any profound moral or social message.[3]

The larger oil of *The Lost Child* belonged to the novelist Evelyn Waugh (1903–1966). One of the first modern writers to show serious interest in the Pre-Raphaelites (stimulated by his connection with William Holman Hunt, who married into the Waugh family), he assembled an important collection of Victorian paintings, including Hunt's *Oriana* and one of the rare canvases by the Pre-Raphaelite associate Michael Halliday (1822–1869).[4] This enthusiasm prompted him to arrange a family excursion to Birmingham City Art Gallery on 19 August 1955: they were led "to the cellarage where, in the manner of modern museums, the gems were hidden".[5]

1. Sold at Christie's, 21 June 1985, lot 82, repr.
2. *Athenaeum*, 11 May 1867, p. 629.
3. Cardiff and London, 1971 (8 and 10); for a smaller version of *Bedtime*, see Newcastle upon Tyne, 1989–1990 (53, repr.).
4. See Christopher Wood, "Evelyn Waugh: A Pioneer Collector", *Connoisseur*, vol. 208, September 1981, pp. 30–34.
5. Michael Davie (ed.), *The Diaries of Evelyn Waugh*, 1976, p. 738.

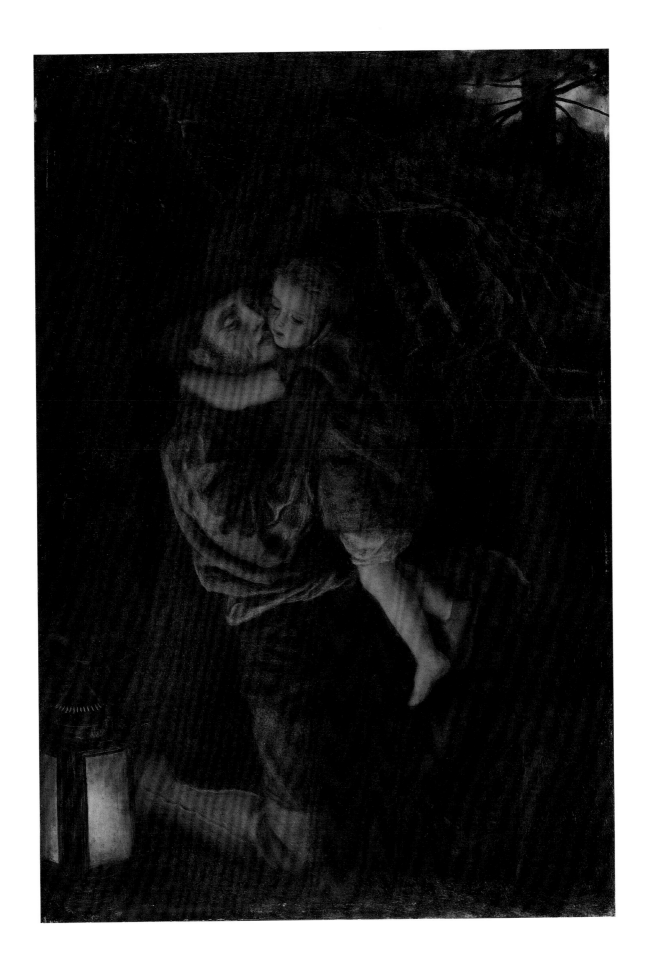

FREDERICK SANDYS

Medea

1866–1868
Oil on wood panel
24 1/2 x 18 1/4 in.; 62.2 x 46.3 cm.
In original frame
Presented by the Trustees of the Public Picture Gallery
Fund, 1925 (105'25)

PROVENANCE: W.H. Clabburn; sold 1879, bought by his son-in-law E. Meredith Crosse; by descent to his son E. Mitchell Crosse; his sale, Christie's, 8 May 1925, lot 74

EXHIBITED: London, Royal Academy, 1869 (99); Paris, Exposition Universelle, 1878; London, Grafton Gallery, *Fair Women*, 1894 (123)

REFERENCES: Birmingham, *Paintings*, 1960, p. 130; Brighton and Sheffield, 1974 (72, pl. 43)

*S*aid to be the artist's favourite among his paintings,[1] *Medea* is in many respects a pendant to *Morgan le Fay* (cat. no. 77): the works are of the same size, are uniformly presented in boldly designed frames (probably by Joseph Green, Rossetti's frame-maker), and had both been in the same family collection until 1925.

Medea is also the classical equivalent to Morgan as a sorceress and (to an even greater extent) a wreaker of revenge on her enemies. When Jason arrived in Colchis during his quest for the golden fleece, Medea, the daughter of King Aetes, fell in love with him and through her magic assisted the safe passage of the Argonauts (whose boat is depicted on the wall behind her, together with the fleece). She returned with Jason to his native Iolchos, and thereafter went with him to Corinth. When Jason abandoned her in favour of Glauce, daughter of King Creon of Corinth, Medea took her revenge by preparing a poisoned garment (as Morgan le Fay did for Arthur) which consumed Glauce's body by fire. Sandys's image is of the distracted Medea treating the threads of this cloth with fiery poison. She went on to kill two of her children in their father's presence, escaping the wrath of Jason on a flying chariot drawn by winged dragons. In order to purge the memory of these shocking events, the Corinthians engaged Euripides to write his tragedy, *Medea*.

The painting was accepted for the Royal Academy exhibition of 1868 but was not hung, creating a great furore in the art press and occasioning a correspondence in the London *Times*. The *Morning Post* protested that the painting's exclusion "is simply disgraceful. To set aside any picture by Mr Sandys in favour of such as form the average of this exhibition would under any circumstances be an act of egregious stupidity or iniquity, but as it happens the *Medea* is not only fully worthy

of its author, but is positively the finest work he has yet produced".[2] It was shown in the following year, to similar acclaim; even the *Art Journal*, which found the subject "repellant" and the treatment of the flesh "waxy", declared that it "certainly stands alone".[3] F.G. Stephens, in the *Athenaeum*, thought it "vigorous and expressive":

> Her expression is terrible and horrible, and lies in the withered, ivory-like look of her skin and the deep, hard anger and woe of her eyes; the ruthless, parted lips; – expression that deepens in force with the observer because of the beauty of the features, which are transformed but not debased. The student will not fail to notice the beautiful execution here, as in the drawing and modelling of the face, hands and arm; the firm colour that appears about the lower part of the throat and its adjuncts, the right hand and draperies.[4]

Medea was begun in 1866 when Sandys was lodging with Rossetti at his house in Cheyne Walk, and includes some of their shared studio props, such as the coral necklace, which appears in Rossetti's oil painting *Monna Vanna* (1866; Tate Gallery, London).[5] Aiming to instil an atmosphere of barbaric splendour, Sandys has, perhaps quite consciously, incorporated motifs from Japanese decorative art (an interest of Rossetti's), such as the flying cranes and the dragon that appears behind Medea's left shoulder.[6] The model for Medea, again probably the gypsy Keomi (see cat. no. 77), also sat for the head of one of the bridesmaids in Rossetti's painting *The Beloved* (1865–1866; Tate Gallery, London).[7] Whether or not as a result of his treatment at the hands of the Royal Academy, Sandys virtually ceased to paint in oils from this date, and instead reverted to chalk drawing.

1. Esther Wood, "A Consideration of the Art of Frederick Sandys", *Artist*, vol. 18, November 1896, p. 31.
2. Quoted in Wood, "Consideration of Sandys", 1896, p. 31. Swinburne had already prepared a notice for publication, also proclaiming Medea the artist's "masterpiece": "Pale as from poison, with the blood drawn back from her very lips, agonized in face and limbs with the labour and the fierce contention of old love with new" ("Notes on Some Pictures of 1868", reprinted in *Essays and Studies*, London, 1875, p. 372; quoted in Kestner, 1989, p. 171).
3. *Art Journal*, vol. 8, June 1869, p. 164.
4. *Athenaeum*, 15 May 1869, p. 675.
5. Surtees, 1971, no. 191, pl. 281; London, Tate, 1984 (136, repr.).
6. See London, Barbican Art Gallery, *Japan and Britain: An Aesthetic Dialogue 1850–1930*, 1991, p. 109.
7. Surtees, 1971, no. 182, pl. 263; London, Tate, 1984 (133, repr.).

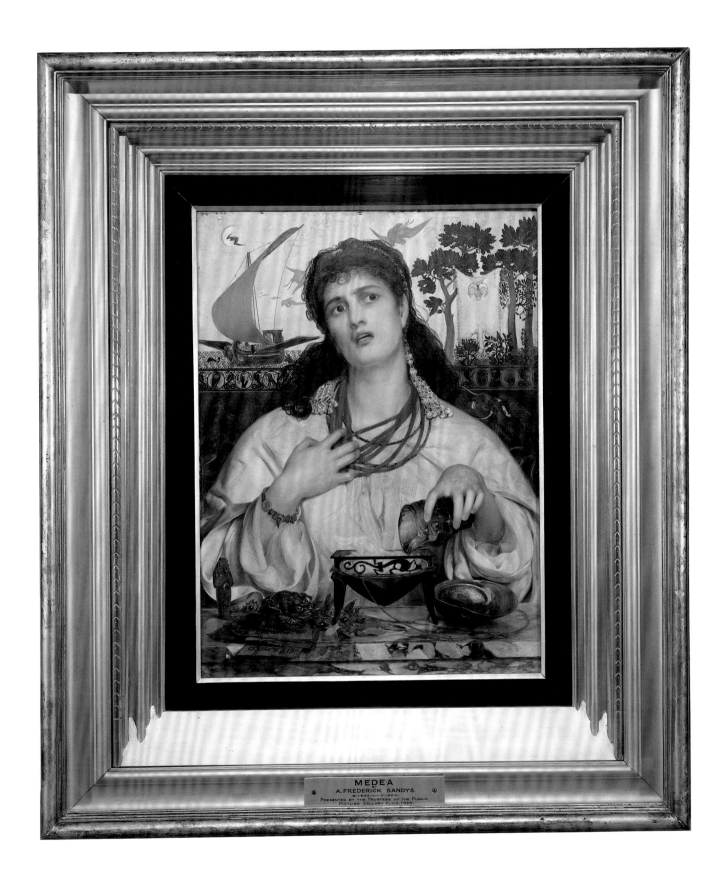

MEDEA
BY
A. FREDERICK SANDYS.
B. 1832. — D. 1904.
PRESENTED BY THE TRUSTEES OF THE PUBLIC
PICTURE GALLERY FUND, 1925.

263

89

DANTE GABRIEL ROSSETTI

Fanny Cornforth

1868
Red chalk
19 5/8 x 13 3/8 in.; 50.0 x 34.0 cm.
Signed and dated, centre right: DGR / 1868 (initials in monogram)
In original frame
Presented by subscribers, 1904 (486'04)

PROVENANCE: Cyril Flower (Lord Battersea); Charles Fairfax Murray

REFERENCES: Birmingham, *Drawings*, 1939, p. 366 (as *Study of a Girl's Head);* Baum (ed.), 1940, frontispiece; Surtees, 1971, no. 304; Tokyo, 1990 (55, repr.)

Fanny Cornforth (see cat. nos. 35, 78) reached her zenith as Rossetti's model in the oil painting *The Blue Bower* (1865; Barber Institute of Fine Arts, University of Birmingham).[1] Like many of Rossetti's most effective works, this masterpiece of harmonious colour and mood has no 'subject' other than a celebration of sensuous female beauty, although the likely reference to his poem "The Song of the Bower" may have been intended as an additional tribute to Fanny's physical attributes, not least her "large lovely arms and a neck like a tower".

Visitors to Cheyne Walk in the mid-1860s regularly encountered Fanny, who was generally known to be Rossetti's mistress, and to be living close by (in Royal Avenue, Chelsea) in an apartment rented by the artist.[2] Her company was of vital importance to Rossetti in the years after Elizabeth Siddal's death, and his brother William Michael recognised her as "a pre-eminently fine woman", even allowing for her lack of "breeding, education, or intellect".[3] Many of Rossetti's friends were captivated by her friendliness and sense of humour. The poet William Allingham recorded her comment on the hair loss, through illness, of William Bell Scott: "'O my, Mr Scott is changed!' she exclaimed. 'He ain't got a hye-brow or a hye-lash – not an 'air on his 'ead!' At this Gabriel laughed immoderately, so that poor F., good-natured as she is, pouted at last: 'Well, I know I don't say it right'."[4]

Always on the lookout for a striking new model, Rossetti earlier had met the beautiful Alexa (Alice) Wilding in 1865, and she soon supplanted Fanny as the face most often used by the artist for paintings and drawings. Of the same size and date as this portrait is a chalk study (predominantly in red) of Alexa Wilding (Bristol Museum and Art Gallery):[5] the pair might perhaps stand as tokens of valediction and welcome. This portrait of Fanny, however, is an outstanding piece of deliquescent draughtsmanship, and remains in its original frame (by Foord and Dickinson, 90 Wardour Street, London).[6]

1. Surtees, 1971, no. 178, pl. 259; London, Tate, 1984 (132, repr.).
2. Marsh, 1985, p. 237.
3. Quoted in Baum (ed.), 1940, p. 3.
4. Quoted in Marsh, 1985, pp. 238–239.
5. Surtees, 1971, no. 534; Tokyo, 1990 (57, repr.). Rossetti was not, it seems, emotionally involved with Alexa Wilding: "although he liked [her] and paid her a regular retainer of 30s a week to be sure of her services, Gabriel found her dull company" (Marsh, 1985, p. 248).
6. The backboard of the frame bears a printed label signifying Rossetti's awareness of the popularity of this kind of highly finished work:

> DRAWN IN CHALK
> BY
> DANTE G. ROSSETTI.
> AS THIS DRAWING IS NOT SET, IT WOULD REQUIRE
> GREAT CARE IF EVER REMOVED FROM ITS FRAME.
> N.B. – The Copyright of this Drawing is the exclusive
> property of the Artist

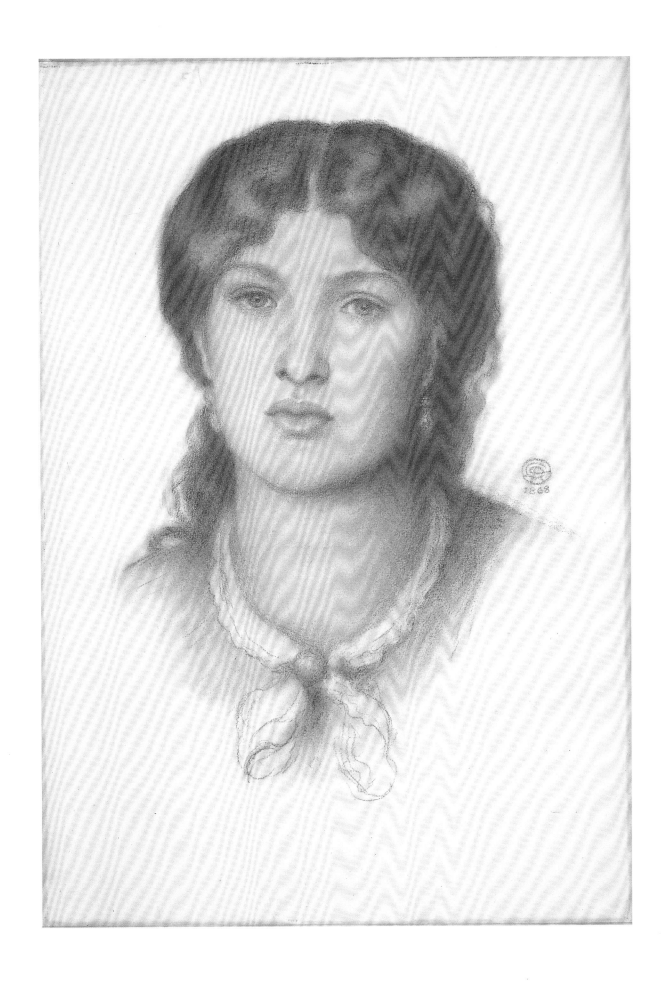

265

DANTE GABRIEL ROSSETTI

Woman with a Fan

1870
Coloured chalks
37 3/4 x 28 in.; 95.8 x 71.1 cm.
Signed and dated, top left: DGR 1870 (initials in monogram)
In original frame
Presented by subscribers, 1904 (414'04)

PROVENANCE: Fanny Cornforth?; Constantine Alexander Ionides; Charles Fairfax Murray

REFERENCES: Birmingham, *Paintings &c.*, [1930], p. 176; Surtees, 1971, no. 217, pl. 310; Tokyo, 1990 (56, repr.)

One of Rossetti's final likenesses of Fanny Cornforth (see cat. no. 89),[1] this spectacular drawing may have been meant as a subject picture – perhaps with an appropriate text on the scroll at top left – but instead was probably given to the sitter out of affection and gratitude. It is surely identifiable as the "portrait" whose sale, along with other pictures, Rossetti was trying to arrange on her behalf in the winter of 1872–1873. A letter from Charles Augustus Howell to Rossetti, dated 6 January 1873, describes the negotiations:

> I have been to see Fanny and had a very long chat with her. She says she would rather I did not take Parsons [a dealer]. . . . I will give £150 for her portrait and the *Margaret*, £200 for *Lucretia* when finished, and a fair price for *Loving Cup*. This, with the £100 she has, should buy her a nice house, and I am going to look about and help her, that nothing may be done in a hurry. You must not be surprised at my offering only £150 for the two drawings. Her portrait is truly splendid but it is so full of *individuality*, such a very *living portrait*, that I fear I shall never be able to sell it as a picture.[2]

It is not known whether this sale occurred, although it was not for another four years that Fanny finally moved out of the Royal Avenue house, settling down as the proprietor of the Rose Tavern in Jermyn Street, after having married a widower, John Bernhard Schott.[3] During that time Rossetti, emotionally pre-occupied with Jane Morris, had remained a friend and regular correspondent, often teasing Fanny about her (and indeed, his own) increasing corpulence: in the many letters addressed to his 'good elephant' he calls himself the 'old rhinoceros'.[4]

Rossetti's serious breakdown of health in 1877 effectively permitted his family, who had never approved of the relationship, to sever connections with Fanny, even to the extent of excluding her from attending his funeral.[5] Her only surviving letter to Rossetti, dated 24 September 1877, poignantly reassures him that "I have *none of your* pictures in any part of the house excepting my bedroom and private sitting room".[6] Fanny and her husband went on to amass a large collection of Rossetti's drawings (over a hundred are listed in Surtees's catalogue raisonné), which were exhibited in 1883 as "The Rossetti Gallery" at 1a Old Bond Street.[7] Almost all of these works are now in the Birmingham collection, having been acquired by Charles Fairfax Murray before Fanny's death in 1905.

1. Two coloured chalk portraits, dated 1874, are also at Birmingham (Surtees, 1971, nos. 308, 309); one of these is reproduced in Rose, 1981, p. 110.
2. Doughty and Wahl, 1965–1967, vol. 3, p. 1112.
3. Marsh, 1985, p. 326.
4. Baum (ed.), 1940, pp. 104–106.
5. Marsh, 1985, p. 329.
6. Baum (ed.), 1940, p. 95.
7. The exhibition was titled *Pictures, Drawings, Designs and Studies by the late Dante Gabriel Rossetti*. This rival to the memorial exhibitions of 1883 at the Burlington Fine Arts Club and at the Royal Academy of Arts (a joint homage to Rossetti and John Linnell) is said to have caused great annoyance to the Rossetti family.

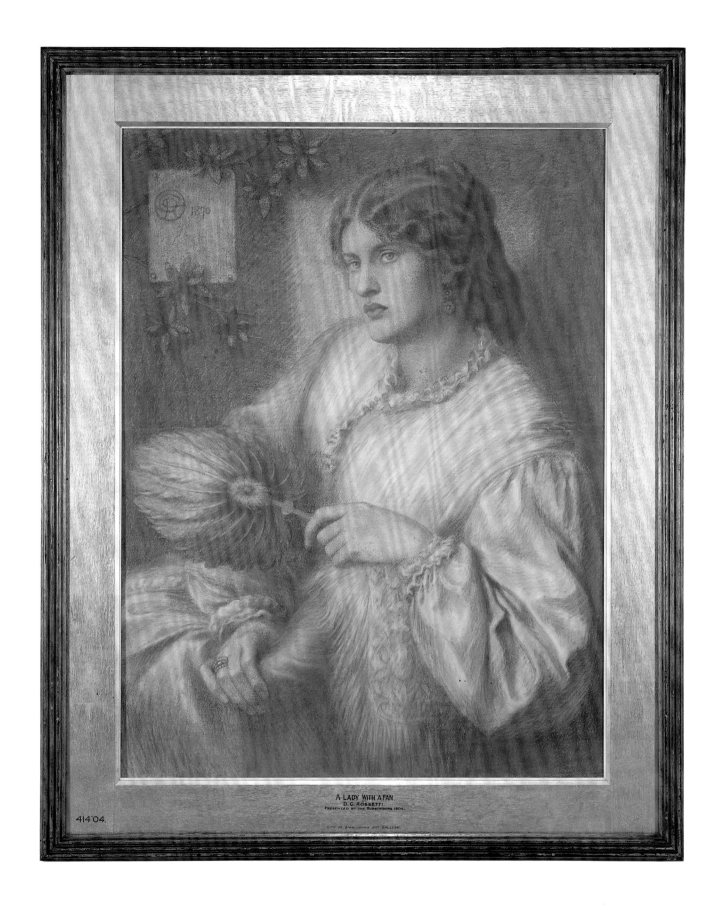

A LADY WITH A FAN.
D. G. ROSSETTI.
PRESENTED BY THE SUBSCRIBERS 1904.

CITY OF BIRMINGHAM ART GALLERY.

414'04.

91

JOHN WILLIAM INCHBOLD

Springtime in Spain, near Gordella

1866, re-touched 1869
Oil on canvas
12 x 18 in.; 30.5 x 46.0 cm.
Signed and dated, bottom right: I. W. INCHBOLD / 1869 /
IN SPAIN
Inscribed in ink, on label formerly attached to back of
frame: Inchbold / Springtime in Spain / near Gordella
Presented by Miss Hipkins, in memory of her brother W.E.
Hipkins, 1913 (25'13)

PROVENANCE: Bought from the artist by James Leathart,
April 1869; returned to Inchbold, November 1869

REFERENCES: Birmingham, *Paintings*, 1960, p. 80; Newcastle
upon Tyne, 1968 (52); Staley, 1973, p. 120; Newcastle upon
Tyne, 1989–1990 (63, repr.); Leeds, 1993 (25, repr.)

*I*nchbold was an enigmatic and solitary man, sharing the
perfectionism of Ford Madox Brown but without his capacity
to compromise with the commercial art world. He could be
difficult, even with his closest friends (Rossetti once de-
scribed him as "less a bore than a curse"), and he suffered from
ill health as well as a constant shortage of money.[1] Initially
encouraged by Ruskin, not least through a shared love of the
Swiss Alps, Inchbold joined the Hogarth Club (see cat. no.
44) and contributed to the exhibition despatched to America
in 1857, at which time William Michael Rossetti described
him as "perhaps highest of the strictly Pre-Raphaelite land-
scape painters".[2]

As had happened with Brett, however (see cat. no. 82),
Ruskin's enthusiasm for Inchbold's work cooled. In the early
1860s, the artist's style underwent a change from a hard-edged
observation of detail to a more ethereal concentration on light
and atmosphere, yet he retained a fondness for brilliant and
boldly juxtaposed colours. Inchbold spent long periods abroad,
living in Venice probably from early 1862 until spring 1864,
and travelling in Spain throughout the winter of 1865–1866.

Springtime in Spain is the most important of the few works
that so far have been identified as deriving from this journey.
An oil of the same size, dated 1865 (Private Collection), gives
a view of Cordelia in Valencia as the background to a simple
sun-drenched landscape seen from the terrace of a villa.[3] The
Birmingham painting, presumably from the same area in east-
ern Spain, combines far more detail – including farm build-
ings similar to those in a watercolour also of 1865 (Private
Collection)[4] – with a thinly painted but very subtle rendering
of earth, trees and sky. While the tiniest of brushes has been
used to delineate the bare branches of the olive trees and the
cluttered farmhouse wall, the immediate foreground of freshly
turned earth is treated in a rich but complex scumbling, a
very un-Pre-Raphaelite technique.

Inchbold was delighted when the collector James
Leathart offered forty guineas for the painting early in 1869,
and he may have brought the work to a further state of com-
pletion before then signing and dating it. A letter of 1 April to
Leathart, written from Brown's house, confirms that "the
small Spanish picture is complete & I think you will be
pleased with it".[5] Unfortunately, Leathart was not satisfied and
after a few months decided to return it to the artist. Inchbold
was disappointed, stating in a letter of 9 November that this
was "the first time I have known a picture of mine to abate
the force of the pleasure giving qualities once felt", at the
same time expressing "no reluctance to receive again the
spring time in Spain on account of its art deficiencies or pecu-
liarity of art qualities".[6] He went on to outline the effects he
was trying to capture in the painting, including "the sky, that
has to me a special charm, & is rare in Spain, even in Spring
time coupled with the line of Cyprus trees & the still leafless
olive trees, & the Spanish farmhouse & the springing corn",
but he finally conceded that all this might still "touch a dif-
ferent chord in those who knew not this land of strange and
intense extremes". Unable to be dissuaded, Leathart exchanged
the picture for *Venice from the Public Gardens* (circa 1862–
1864; Private Collection), with a compensatory payment of an
additional ten guineas.[7]

1. The best account of Inchbold's life and work is now Christopher
Newall's introduction in Leeds, 1993.
2. Quoted in Staley, 1973, p. 117.
3. Leeds, 1993 (24, repr.).
4. Leeds, 1993 (23, repr.).
5. Quoted in Leeds, 1993, p. 58.
6. Quoted in Leeds, 1993, p. 58.
7. Leeds, 1993, p. 59 and no. 18 (repr.).

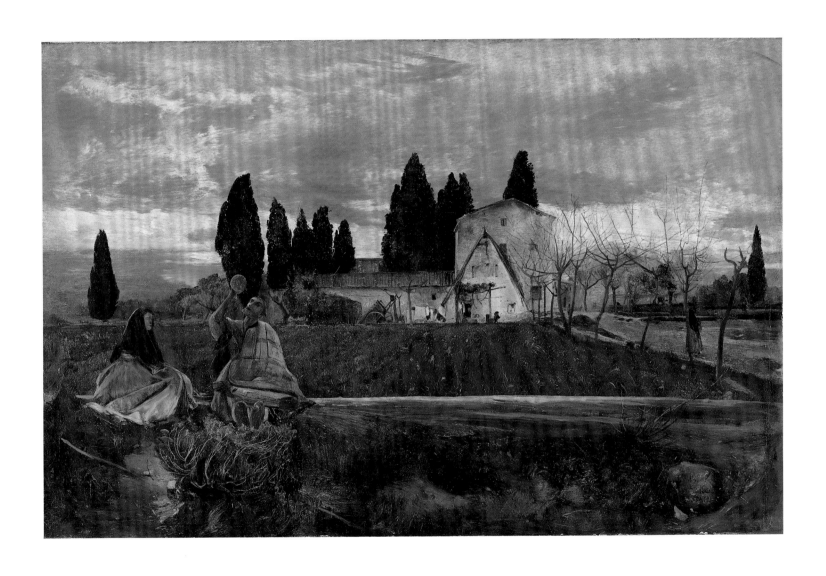

92

HENRY WALLIS

Corner of an Eastern Courtyard

1870s?
Oil on canvas
24 x 18 1/2 in.; 61.0 x 47.0 cm.
Presented by Harold Wallis, 1918 (17'18)
REFERENCE: Birmingham, *Paintings*, 1960, p. 148

*N*o research seems to have been undertaken yet which might shed light on the later work of Henry Wallis. After noting that the influence of Pre-Raphaelitism came to both a peak and a conclusion in 1858 with *The Stonebreaker* (cat. no. 40), most commentators repeat the summary of an obituarist in 1917, stating that Wallis "continued to exhibit at the R.A. at intervals until 1877, but in later life he devoted himself chiefly to travel and to the study and collection of Persian and Italian ceramics, preparing monumental text-books upon these subjects".[1]

The destination of his 'elopement' in 1858 with Ellen, wife of George Meredith (see cat. no. 39), was the island of Capri. *Winnowing corn, Capri*, shown at the Royal Academy in 1864, may have resulted from a subsequent visit, since Wallis is known to have spent much time in Italy, including Sicily. Another picture exhibited at the Royal Academy in 1876 was *Outside a prison in Southern Italy*. His large oil painting of 1873, *A despatch from Trebizond*, is set in the Piazza San Marco at Venice.[2] Although carrying an accompanying quotation from Shakespeare's *Merchant of Venice*, it has exaggeratedly theatrical figures of a kind that recall the early Victorian paintings against which the Pre-Raphaelite Brotherhood revolted, posed against a rendering of figured marble which Lawrence Alma-Tadema could hardly have bettered. In the Birmingham collection is a large related study in black chalk of two Venetian senators: while it is a bold and powerful piece of chiaroscuro, it is equally far removed from Pre-Raphaelite practice.[3]

Corner of an Eastern Courtyard is a more informal type of work whose date and setting are impossible to determine precisely in the absence of documentary evidence. The very basic building materials and obviously hot climate suggest the eastern Mediterranean, possibly Egypt; again at Birmingham is a rather abstract chalk study by Wallis identified as an Egyptian village.[4] A comparable canvas, described just as vaguely as a *Mediterranean Landscape seen from the Terrace of a Villa*, appeared on the art market in 1973 (fig. 81).[5] Conceivably, both could be of Capri, and in their relaxed naturalism and joyous colour they distinctly echo the oil sketches made by Frederic Leighton on the island in 1859, which in Richard Ormond's description celebrate "the narrow streets, brilliant white walls, and the semi-Eastern appearance of the town".[6] The more elaborate of two larger landscape oils by Leighton, *Garden of an Inn, Capri* (exhibited at the Royal Academy in 1861), is also at Birmingham, and acts as a regular companion to the Wallis on the Museum's walls.[7]

1. *Burlington Magazine*, vol. 30, March 1917, p. 124.
2. Sold at Christie's, 2 November 1990, lot 196, repr.
3. Birmingham, *Drawings*, 1939, p. 414 (1'18).
4. Birmingham, *Drawings*, 1939, p. 415 (15'18).
5. Norham House Gallery, Cockermouth, *The Pre-Raphaelite Fringe: Nineteenth-Century Drawings and Paintings*, 1973, no. 14, repr.
6. Leonée and Richard Ormond, *Lord Leighton*, London, 1975, p. 43.
7. Birmingham, *Paintings*, 1960, p. 89 (P41'60); Ormond, *Lord Leighton*, 1975, p. 44, pl. 65.

Fig. 81 HENRY WALLIS, *Mediterranean Landscape seen from the Terrace of a Villa*, 1870s; oil on canvas, 11 5/8 x 15 1/4 in. (28.5 x 38.7 cm.). Private Collection.

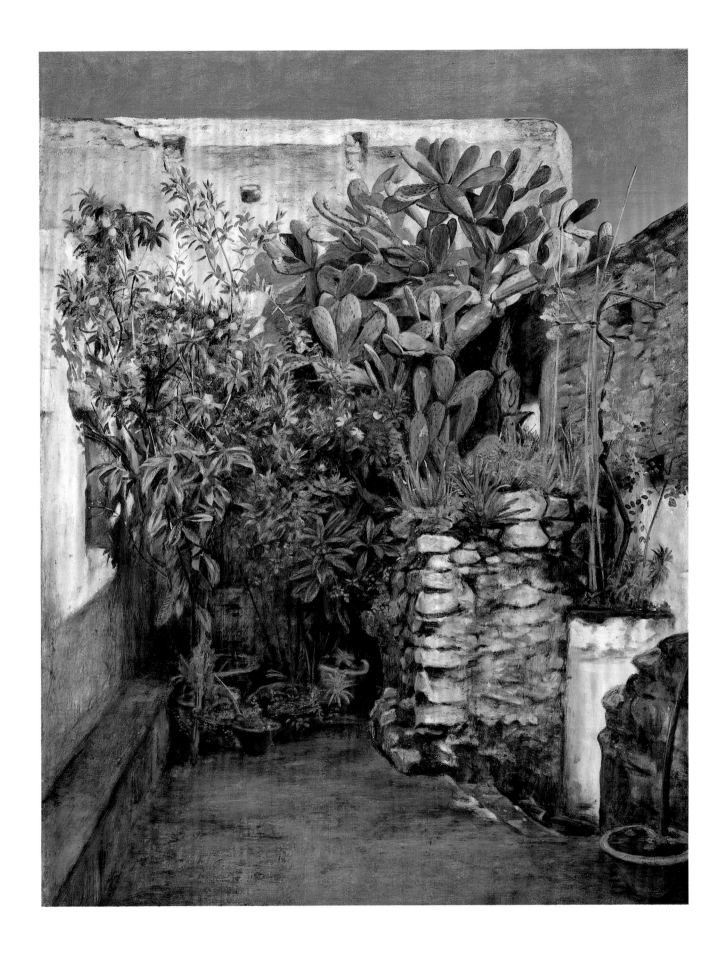

93

CHARLES FAIRFAX MURRAY

Head of a Young Man

1869
Brush and brown ink
14 x 10 in.; 35.6 x 25.5 cm.
Dated, bottom right of image: 8.69.
Inscribed in pencil, bottom right of sheet: C F Murray
[probably in the artist's handwriting]
Transferred from Birmingham Reference Library, 1983
(P77'83)

PROVENANCE: Unrecorded, but possibly bequeathed by J.R.
Holliday, 1927

Murray's name appears frequently in these pages as the chief source of the Birmingham collection of Pre-Raphaelite drawings, and it is as a connoisseur and dealer that he is best remembered, especially for the sale to American financier John Pierpoint Morgan (1867–1943) in 1910 of his vast collection of Old Master drawings, books and autograph letters.[1] This was a remarkable achievement for "little Murray", the Irish shop-boy first taken up as a protégé by Ruskin in 1866.[2] Backing the great critic's judgement – "that boy's sketches are marvellous"[3] – first Burne-Jones and then Rossetti began to employ Murray as a studio assistant. He also became friendly with Morris, painting a portrait of Jane Morris on commission in 1868 for the publisher F.S. Ellis. Murray then collaborated on a number of Morris's early illustrated manuscripts, beginning with the *Book of Verse*, and by 1872 was working for Morris, Marshall, Faulkner and Company, converting Burne-Jones's designs into working cartoons for stained glass.[4]

Henry Treffry Dunn (1838–1899), Rossetti's more permanent assistant, remarked in 1869 that "young Murray has now started as an artist on his own account",[5] although the first of his two pictures exhibited at the Royal Academy had appeared in 1867 (the second, in 1871, was a study of a head). The scale of Murray's output as a painter remains obscure, since few works are to be found in major public collections: the Walker Art Gallery, Liverpool, owns *The Violin Player*,[6] and the Dulwich Picture Gallery, London, to which Murray was an important benefactor, holds *Kings' Daughters*, of about 1875.[7] The Delaware Art Museum, Wilmington, has a group of works, including the oil *The Last Parting of Helga and Gunnlaug* (which perhaps dates as late as 1880–1885, and illustrates one of Morris's Icelandic sagas). All these pictures demonstrate inevitable influences on his style, which Rowland Elzea has described as "a combination of Rossetti's colour, Burne-Jones's rhythmical composition, and Italian Renaissance figure types".[8]

Murray's drawings share this range of inspiration, although he adopted one style of 'decorative' draughtsmanship, using heavy white chalk highlights on coloured papers, which is quite idiosyncratic.[9] A cache of fine figure drawings, mostly in pencil and black chalk, appeared on the art market in 1962.[10] In addition to the present confident head in yet another medium, the Birmingham collection holds eighteen figure or costume studies, including some good female heads in black chalk (fig. 82).[11] Of our three watercolours, two are interesting copies: a small replica of Rossetti's watercolour *A Christmas Carol*, and a large transcription, dating from 1885, of *St George and the Dragon* after Carpaccio, presumably made for Ruskin, who regarded Murray as a "heaven-born copyist".[12]

1. See Charles Fairfax Murray, *A Selection from the Collection of Drawings by the Old Masters formed by C. Fairfax Murray*, [n.d.].
2. See Carole Cable, "Charles Fairfax Murray, Assistant to Dante Gabriel Rossetti", *Library Chronicle of the University of Texas at Austin*, n.s., no. 10, 1978, pp. 81–89.
3. Letter to Charles Augustus Howell, 14 September 1866; Ruskin, *Works*, 1909, vol. 36, p. 669.
4. See Sewter, 1975, *Plates*, pp. 47, 48.
5. Quoted in Cable, "Charles Fairfax Murray", p. 84.
6. Walker Art Gallery, Liverpool, *The Taste of Yesterday*, 1970 (68, repr.).
7. London, Barbican, 1989 (42).
8. Elzea, 1984, p. 90.
9. A good example of this technique is the study for *The Last Parting of Helga and Gunnlaug*, also at Wilmington; Elzea, 1984, p. 88, repr.
10. "Charles Fairfax Murray: drawings", *Connoisseur*, vol. 150, July 1962, pp. 158ff.
11. Birmingham, P143'70–P157'70, P75'83–P76'83; none of these drawings has a provenance, but all are presumed to have formed part of the Holliday bequest.
12. Whitworth Art Gallery, Manchester, *Ruskin and the English Watercolour*, 1984 (138, repr.); also Phoenix and Indianapolis, 1993, pp. 184–185, fig. 140.

Fig. 82 CHARLES FAIRFAX MURRAY, *Head of a Young Woman*, circa 1870; black chalk, 10 x 7 3/8 in. (25.4 x 18.8 cm.). Birmingham Museums and Art Gallery (P153'70).

8.69.

C.T. Murray

94

SIMEON SOLOMON

Dawn

1871
Watercolour and bodycolour
13 7/8 x 19 7/8 in.; 35.3 x 50.7 cm.
Signed and dated, bottom left: SS / 1871 (initials in monogram)
In original frame
Presented by the Trustees of the Public Pictures Gallery Fund, 1909 (57'09)

PROVENANCE: C. Rowley; Henry Boddington, by 1891

EXHIBITED: London, Dudley Gallery, 1872; Birmingham, 1891 (154)

REFERENCES: Birmingham, *Paintings &c.*, [1930], p. 189; Reynolds, 1984, p. 20, pl. 58; Seymour, 1987, pp. 187–189, fig. 176

*W*hile Solomon completed very few oil paintings (of which *Bacchus* [cat. no. 86] is one of the most important), he produced many watercolours during the 1860s. The most elaborate of these were of subjects from the Bible, such as *Shadrach, Meshach and Abednego in the Fiery Furnace* (1863; Private Collection),[1] or from classical sources, such as *Sappho and Erinna in a Garden at Mytelene* (1864; Tate Gallery, London).[2]

His friendship with a circle of writers which included Swinburne, Pater and Oscar Browning, all aesthetes with an interest in homoerotic literature, led Solomon to compose his own quasi-mystical prose poem "A Vision of Love Revealed in Sleep", printed for the author in 1871 by F.S. Ellis, Rossetti's publisher.[3] Bearing a dedication to Burne-Jones, this strange text consists of a dream-like narrative in which the artist, engaging in sporadic dialogue with his soul, encounters Love, Hope, Despair and other of the personified emotions of which he was beginning to make allegorical drawings.

Dawn, arguably Solomon's most subtle and carefully executed watercolour, is one of the works painted in and around 1871 which complement the mood of "A Vision of Love". It may have been intended as a visual evocation of the passage in which the narrator encounters an "unseen and mysterious presence":

> There lay upon him yet the shadow of the Night, but his face had upon it the radiance of an unexpected glory, the light of glad things to come. . . . With one hand he cast away his dim and heavy mantle from him, and with the other he put aside the poppies that had clustered thickly about him; as he turned his head to the East, the poppies fell from his hair, and the light rested upon his face; the smile it kindled made the East to glow, and Dawn spread forth his wings to meet the new-born Day.[4]

Interestingly, in the spring of 1871 Solomon discovered the poetry of Walt Whitman (1819–1892), with which he felt an immediate rapport. There is evidence that he was acquainted with these lines from Whitman's "Leaves of Grass", which are indeed a perfect accompaniment to such images as *Dawn*:

> This is the hour O soul, thy free flight into
> the wordless,
> Away from books, away from art, the day erased,
> the lesson done,
> Thee fully forth emerging, silent, gazing, pondering
> the themes thou lovest best,
> Night, sleep, death and the stars.[5]

Dawn was one of several watercolours which Solomon exhibited at the Dudley Gallery in 1872: these included a similar composition, *Love dreaming by the Sea* (1871; University College of Wales, Aberystwyth).[6] *Dawn* remains in its original frame, which bears the label of Joseph Green (Carving and Gilding Manufactory, 14 Charles Street, Middlesex Hospital), Rossetti's frame-maker in the 1860s.[7] One of the previous known owners of the watercolour may have been another framer and Pre-Raphaelite associate, Charles Rowley of Manchester.[8]

1. London and Birmingham, 1985–1986 (46, repr.); sold at Christie's, 5 November 1993 (lot 128, repr.).
2. London and Birmingham, 1985–1986 (48, repr.).
3. London and Birmingham, 1985–1986, pp. 74–76.
4. Simeon Solomon, *A Vision of Love Revealed in Sleep*, 1871, pp. 25–26 (reprinted in Reynolds, 1984, pp. 67–68).
5. "A Clear Midnight", in the section "From Noon to Starry Night"; see Reynolds, 1984, p. 92.
6. Reynolds, 1984, pl. 59.
7. See Grieve, 1973C, p. 19.
8. Grieve, 1973C, p. 19.

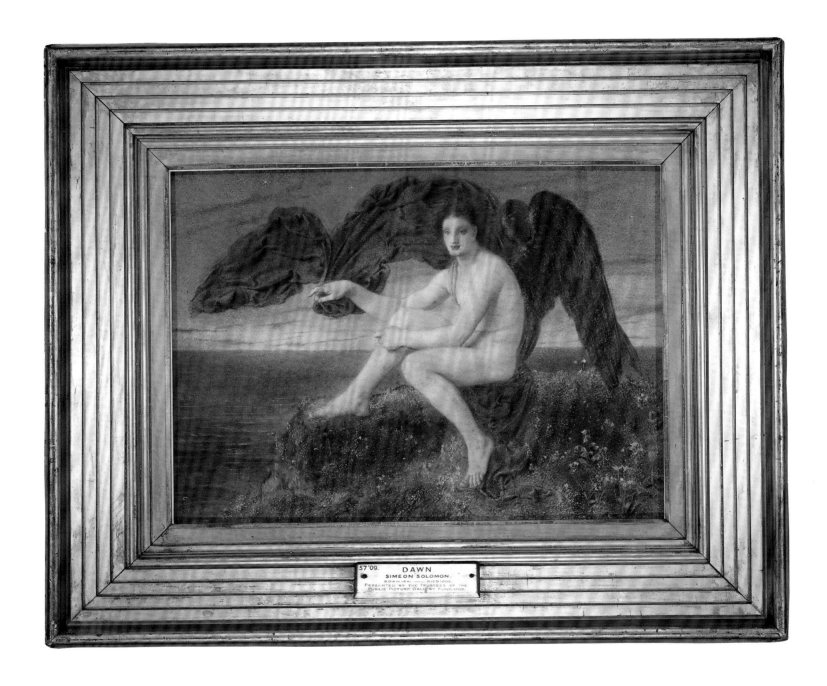

57'09.　DAWN
SIMEON SOLOMON.
BORN 1841 — DIED 1905.
PRESENTED BY THE TRUSTEES OF THE
PUBLIC PICTURE GALLERY FUND 1705.

95

DANTE GABRIEL ROSSETTI
Study for "Water Willow"

1871
Black, brown and red chalk on pale green paper
13 3/8 x 10 3/4 in.; 34.0 x 27.2 cm.
Signed and dated, top right: DGR / 1871 (initials in
monogram)
Presented by subscribers, 1904 (39'04)

PROVENANCE: Fanny Cornforth; Cornelius Cox; Charles
Fairfax Murray

REFERENCES: Birmingham, *Paintings &c.*, [1930], p. 175;
Surtees, 1971, no. 226A; Rose, 1981, p. 108, repr.; Tokyo,
1990 (53, repr.)

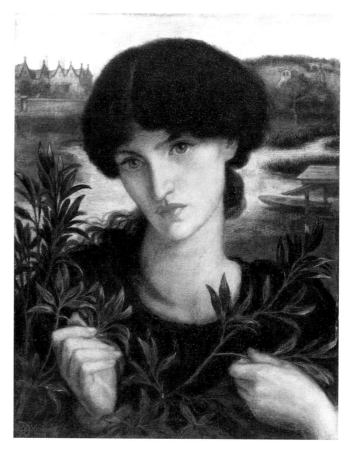

Fig. 83 DANTE GABRIEL ROSSETTI, *Water Willow*, 1871; oil on canvas,
13 x 10 1/2 in. (33.0 x 26.6 cm.). Delaware Art Museum, Wilmington
(Samuel and Mary R. Bancroft Memorial).

Rossetti had been physically attracted to Jane Burden
(1839–1914) from the moment of her introduction to the circle
of artists engaged on the Oxford Union mural campaign in
1857 (see cat. no. 42). She married William Morris in April
1859 and bore him two daughters – Jenny in 1861, and May in
1862 – but by 1866–1867 their relationship had become
strained.[1] The renewed attentions of Rossetti, who was find-
ing the company of Fanny Cornforth less and less stimulat-
ing, became irresistible, and Jane began to sit for him as a
model. Rossetti's oil painting known as *The Blue Silk Dress*
(Society of Antiquaries, Kelmscott Manor) was completed in
1868 and bears the enigmatic inscription (translated from the
Latin): "Famous for her poet-husband, and famous for her
face, may my picture add to her fame".[2] This uneasy mixture
of respect for a friend's wife, romantic love, and self-flattery in
finding his affections reciprocated colours all Rossetti's pic-
tures of Jane Morris. It also runs through his often passionate
poetry that is clearly inspired by and addressed to her, as well
as their touching and often frank correspondence. Passages
such as the following, from a letter of February 1870, express
the frustration felt by Rossetti at seeing Jane only within the
confines of the studio (since she was reluctant to leave her
husband and children):

> I suppose this has come into my head because I feel so
> badly the want of speaking to you. No one else seems
> alive at all to me now, and places that are empty of you
> are empty of all life. . . . But more than all for me, dear
> Janey, is the fact that you exist, that I can yet look for-
> ward to seeing you and speaking to you again, and know
> for certain that at that moment I shall forget all my own
> troubles nor even be able to remember yours.[3]

It cannot fail to be noticed that in what the artist himself
called his 'Janey pictures', Rossetti chose subjects redolent of
loveless marriage and misdirected passion. *Mariana* (1868–

1870; Aberdeen Art Gallery) from Shakespeare's *Measure for
Measure,* and *La Pia de' Tolemei* (1868–1880; Museum of Art,
University of Kansas, Lawrence), from Dante's *Purgatory*, are
both wives doomed by jealous husbands, while *Pandora* (1871;
Private Collection) disastrously sealed the fate of all man-
kind.[4] Janey later became *Beatrice* (1872; watercolour; Private
Collection), to Rossetti the ultimate symbol of unrequited
love, and finally *Proserpine* (see cat. no. 111), another heroine
rendered unattainable by misfortune.[5]

In the spring of 1871, Morris and Rossetti took joint ten-
ancy of Kelmscott Manor, a romantic sixteenth-century house
of grey stone in a remote corner of Oxfordshire, by the river
Thames (at that point called the Isis). Both artists wanted a
peaceful summer residence away from London, Morris chiefly
thinking of the benefit to his wife and children. Morris, how-
ever, immediately went on an extended trip to Iceland, leaving
Rossetti and Jane to spend the summer of 1871 together at
Kelmscott. "It is hard", Jan Marsh has concluded, "to believe that
the arrangement was not deliberate".[6] On the other hand, with
the two young Morris girls and a number of servants in the
house, Rossetti's opportunities for a sexual liaison with Jane
must have been limited, and Jane later told her friend Wilfred
Scawen Blunt that she "never quite gave herself to Gabriel".[7]

Whatever the details of the affair may have been, the two spent a happy and productive few months together. In addition to the larger pictures that had already been begun, Rossetti painted a small oil, *Water Willow* (Delaware Art Museum, Wilmington; fig. 83),[8] to commemorate the occasion. Despite being a serene portrait, Jane holds branches of willow, a traditional symbol of sorrow, with the house, church and river at Kelmscott in the background. In this simplified version in chalks, Jane bears an even more soulful expression, and carries, with no little irony, a pansy – conventionally a token of fidelity and remembrance.

1. See Marsh, 1985, pp. 246ff.
2. Surtees, 1971, no. 372, pl. 408.
3. Bryson (ed.), 1976, p. 34.
4. Surtees, 1971, no. 213, pl. 303; no. 207, pl. 300; and no. 224, pl. 318, respectively.
5. For *Beatrice*, see Tokyo, 1990 (54, repr.); there is also an oil, dated 1879 (Surtees, 1971, no. 256).
6. Marsh, 1985, p. 294.
7. Quoted in Marsh, 1985, p. 295.
8. Elzea, 1984, pp. 118–119, repr.

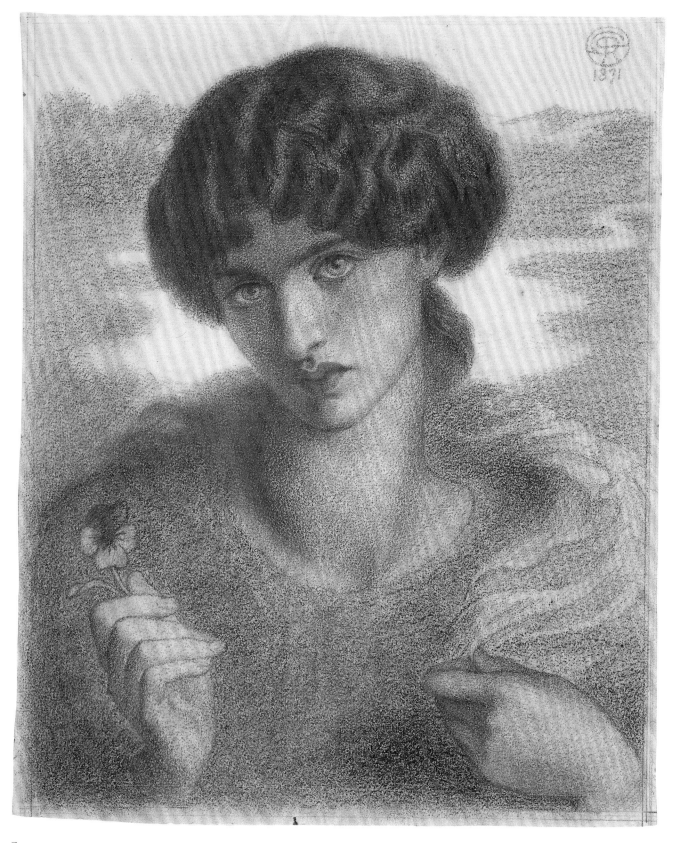

Cat. no. 95

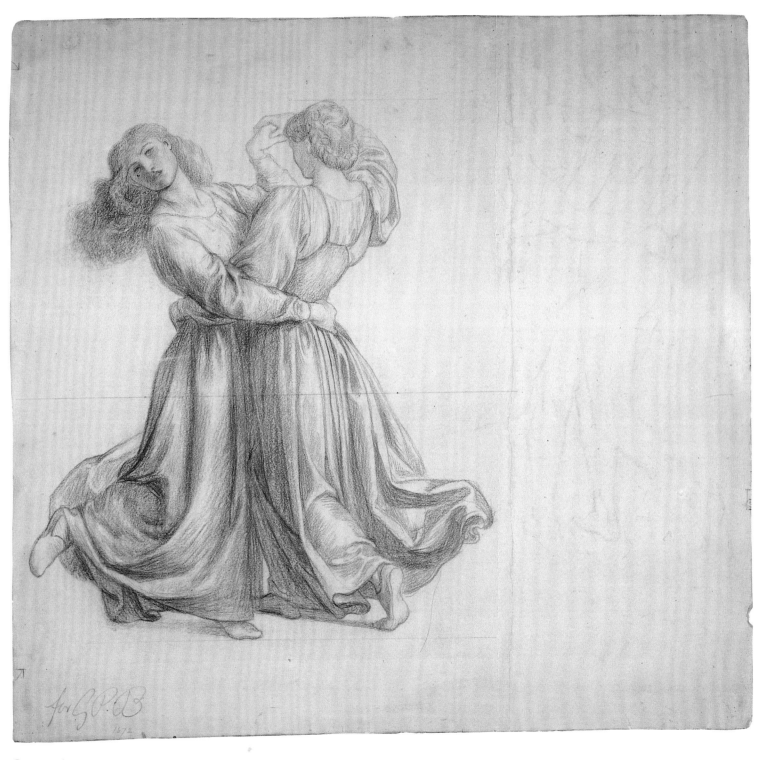

Cat. no. 96

96

DANTE GABRIEL ROSSETTI

The Bower Meadow: study of dancing girls

1872
Black and red chalk on pale green paper
19 7/8 x 20 7/8 in.; 50.5 x 53.0 cm.
Inscribed in pencil, bottom left: for GPB
Dated below, in pencil: 1872 [probably added by G.P. Boyce]
Presented by subscribers, 1904 (475'04)

PROVENANCE: George Price Boyce; his sale, Christie's, 1 July 1897, lot 160 (17 guineas); Charles Fairfax Murray

REFERENCES: Birmingham, *Drawings*, 1939, p. 337; Surtees, 1971, no. 229D, pl. 327 (main figures only); Tokyo, 1990 (75, repr.)

Soon after his return from Kelmscott in October 1871, Rossetti began work (in a studio newly refurbished by Philip Webb) on an oil painting to be called *The Bower Meadow* (Manchester City Art Gallery; fig. 84).[1] Using a canvas which already bore a landscape background painted in the company of Hunt at Sevenoaks, Kent, in 1850 (see cat. no. 17) – his only attempt at the Pre-Raphaelite outdoor method – Rossetti devised a clever composition, balancing seated and dancing female figures in a rhythmic harmony of complementary reds and greens. An early study in pen and ink (Ashmolean Museum, Oxford)[2] shows a winged child between the two musicians, holding a bird. This may suggest a more symbolic concept of music, earthly and heavenly, and perhaps by implication also of love, human and divine, in whose absence the women find solace through their playing. The term 'bower meadow' was presumably meant to convey the kind of seclusion within a country setting that Rossetti had recently enjoyed at Kelmscott. The figure running across the distant meadow strikes an additionally enigmatic note.

Alexa Wilding (see cat. no. 89) sat for the woman on the right, and her companion (in the absence of Jane Morris) was Marie Spartali (1844–1927), daughter of the Greek Consul-General in London. She and two other members of the Greek community, Aglaia Coronio and Maria (Mary) Zambaco (née Cassavetti), were known as the Three Graces.[3] In 1871, Marie Spartali married the artist and writer William James Stillman (1828–1901), the co-founder in 1855 of the magazine *The Crayon* and the leading American supporter of Pre-Raphaelitism. The writer and aesthete W. Graham Robertson amusingly described her as "Mrs Morris for Beginners".[4]

For the figures of the dancing girls, Rossetti made one of his rare nude studies, in black chalk:[5] a tracing of this in red chalk, now rather faint after long being folded beneath the stronger image, appears at the right side of the present sheet. From this Rossetti made one of his liveliest groups in coloured chalk; both drawings bear inscriptions of gift to his friend G.P. Boyce, who eventually came to own nearly fifty Rossetti drawings.

An entry in Boyce's diary for 12 June 1872 records his receipt of the news "that poor Gabriel Rossetti was seriously unwell, in fact had for the time quite lost his head".[6] Rossetti had indeed struggled to complete *The Bower Meadow*, which he sold on 2 June 1872 for £735, during the shock of seeing a vicious personal attack on his verse, which had first been published by Robert Buchanan in a magazine article of October 1871, unexpectedly reprinted as a pamphlet (*The Fleshly School of Poetry*) the following May. Suffering a nervous breakdown, Rossetti left London for Scotland to recuperate in the house of his patron William Graham, and returned to Kelmscott in September.

1. Surtees, 1971, no. 229, pl. 330; Treuherz, 1993, p. 91, pl. 71.
2. Surtees, 1971, no. 229B, pl. 328.
3. See Rose, 1981, pp. 27, 106, 107.
4. W. Graham Robertson, *Time Was*, London, 1931; quoted in Rose, 1981, p. 106.
5. Surtees, 1971, no. 229E (Private Collection).
6. Surtees, 1980, p. 54.

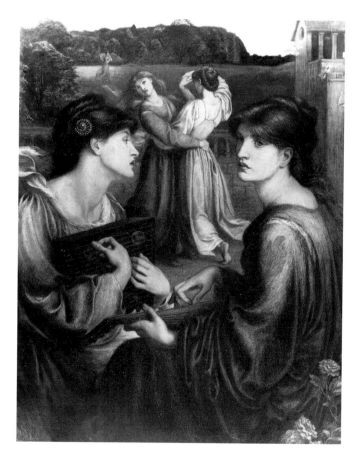

Fig. 84 DANTE GABRIEL ROSSETTI, *The Bower Meadow*, 1871–1872; oil on canvas, 34 x 26 3/4 in. (86.3 x 68.0 cm.). Manchester City Art Gallery.

97

FORD MADOX BROWN

Convalescent (Emma Madox Brown)

1872
Pastel
19 x 17 1/4 in.; 48.2 x 43.8 cm.
Signed and dated, bottom left: FMB Octr – 72 (initials in monogram)
Presented by subscribers, 1906 (793'06)

PROVENANCE: Harry Quilter, by 1896; his sale, Christie's, 7 April 1906, lot 2, bought by Whitworth Wallis (27 guineas) on behalf of J.R. Holliday [1]

REFERENCES: Hueffer, 1896, pp. 271, 442; Birmingham, *Paintings &c.*, [1930], p. 22; Rose, 1981, p. 24, repr.; Newman and Watkinson, 1991, p. 165, pl. 141

For both Ford and Emma Madox Brown, 1872 was a year "broken in upon by distressing illnesses and harassing cares".[2] Work on a large version in oil of a subject from Byron, *The Finding of Don Juan by Haidee* (1870–1873; in the Birmingham collection [22'12]), was disrupted by a summons to the aid of Rossetti (see cat. no. 96). "I was some days at Cheyne Walk with him", Brown wrote to their mutual artist friend Frederick Shields (1833–1911), "some days we brought him here, and then at last I got him off to Scotland and went with him".[3]

Brown himself suffered severe attacks of gout ("or, as he preferred to call it, rheumatism"),[4] recovering in the autumn just in time to celebrate the wedding in September of his younger daughter Catherine to the German musicologist Franz Hueffer. Within eighteen months, her elder sister Lucy would also be married, to Rossetti's brother William Michael. Emma, bearing the brunt of all this domestic upheaval, succumbed to a feverish illness, and was convalescent for the rest of the year. In October, Brown made this touching study of Emma clutching a posy of violets, a notable addition to the many portrait drawings of his family.[5]

According to his grandson, Brown contributed *Convalescent* to a sale of pictures on behalf of the widow of the young Manchester artist Henry James Holding, who died suddenly in Paris in the autumn of 1872.[6] Brown assisted Frederick Shields, who instigated the fund, by canvassing further contributions from his friends, including Rossetti, Burne-Jones, Hughes and Boyce. Such generosity was typical of Brown – he acted as fund-raiser again after the death in 1885 of his old student colleague Daniel Casey – but must equally reflect his relief at Emma's recovery. Hueffer also states, however, that Brown made a duplicate drawing of *Convalescent* in February 1873, and it is not clear which he donated.[7] One version was shown in the Birmingham Pre-Raphaelite exhibition of 1891 as a loan by Henry Boddington of Manchester.[8] Since Boddington outlived Harry Quilter, this loan was probably the duplicate and not the present work.

1. Although the work is numbered among the Brown drawings purchased from Charles Fairfax Murray, its provenance implies that it cannot have belonged to him; the inference is that Holliday made an (anonymous) addition to the collection bought by the subscribers.
2. Hueffer, 1896, p. 271.
3. Letter of 17 July 1872, quoted in Hueffer, 1896, p. 272.
4. Hueffer, 1896, p. 275.
5. See Mary Bennett, "Family Drawings of Ford Madox Brown", *National Art Collections Fund Review*, London, 1985, pp. 128–132.
6. Hueffer, 1896, pp. 275–276.
7. Hueffer, 1896, p. 281.
8. Birmingham, 1891 (157).

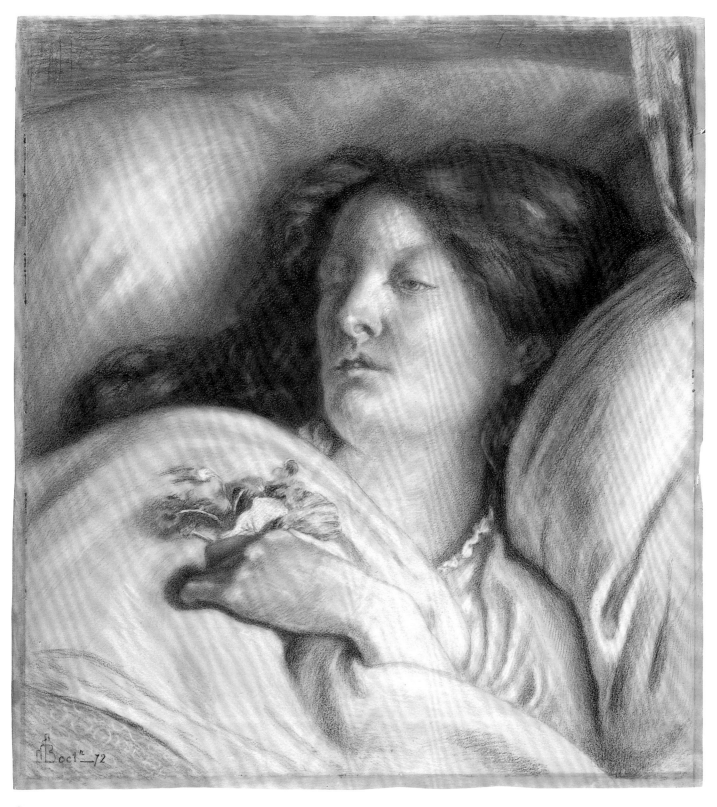

Cat. no. 97

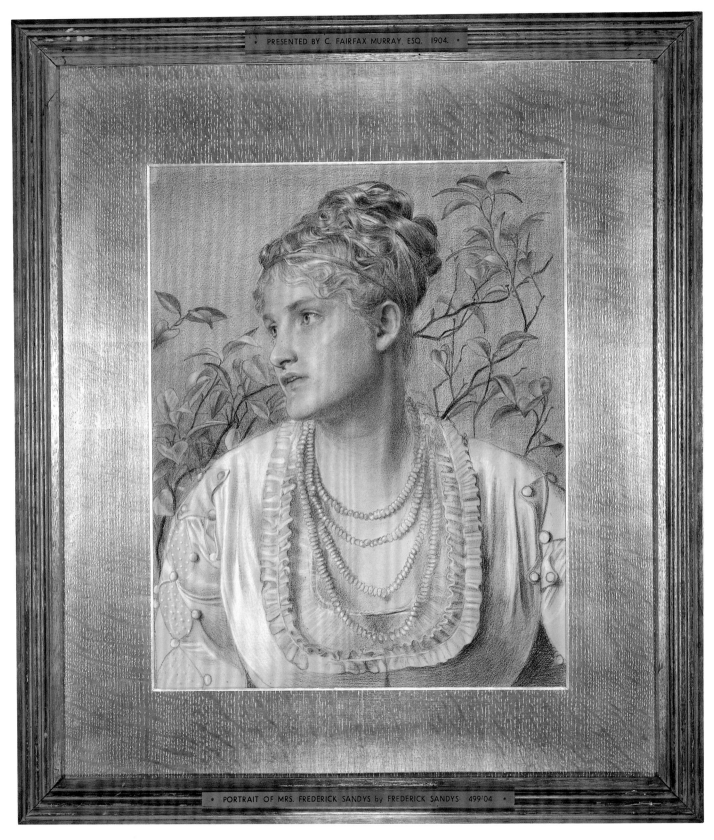

PRESENTED BY C. FAIRFAX MURRAY, ESQ. 1904.

• PORTRAIT OF MRS. FREDERICK SANDYS by FREDERICK SANDYS· 499'04 •

Cat. no. 98

98

FREDERICK SANDYS
Mary Sandys

Circa 1871–1873
Coloured chalks on buff paper
21 7/8 x 19 1/4 in.; 55.5 x 49.0 cm.
In original frame
Presented by Charles Fairfax Murray, 1904 (499'04)

REFERENCES: Birmingham, *Paintings &c.*, [1930], p. 182;
Brighton and Sheffield, 1974 (113, pl. 77); Rose, 1981,
p. 117, repr.

The actress Miss Clive, whose brief success on the public
stage owed much to her striking beauty, first sat to Sandys in
Norwich as early as 1862.[1] She appears as the model for two
chalk drawings with the title *Love's Shadow*, both dated 1867;[2]
a refinement of this head-and-shoulders profile portrait, sub-
stituting a strand of hair for the posy held to her lips, became
Proud Maisie, one of the artist's most celebrated and sensual
images (see cat. no. 83).[3]

Her real name was Mary Emma Jones, and she was born
in Hull on 26 May 1845.[4] A chalk portrait of 1871, known as
The Coral Necklace,[5] is very similar to the present drawing.
The position of the head is identical, and Mary wears the
same dress, although it is more elaborately detailed in the
Birmingham portrait, which substitutes a necklace of rough-
cut turquoises for the red coral one. By this date, Frederick
and Mary seem to have been regarded by friends as man and
wife, even though they never married (Mary used the name
Mrs Neville). She bore him ten known children (six daugh-

ters and two sons survived infancy), of whom the eldest,
Winifred, was born in 1873. A memorial poem by Gordon
Bottomley, published after her death in 1920, celebrates
Mary's role as a late Pre-Raphaelite icon:

> Now she is deathless by her lover's hand,
> To move our hearts and those of men not born,
> With famous ladies by her living hair –
> Helen and Rosamund and Mary Sandys.[6]

Although Sandys's chalk drawings are in a lighter, more
linear, style, Rossetti felt that the younger artist was imitating
his work, and a rift developed between them in 1869 that was
fully healed only six years later. During this time, they
retained a mutual friend in Charles Augustus Howell (see cat.
no. 62), and Sandys executed one of his largest and most spec-
tacular drawings in a portrait of Howell's wife Catherine
(Kitty), also in the Birmingham collection but now sadly dis-
coloured by fading (fig. 85).[7]

1. Information kindly supplied by Betty Elzea; see also Anthony Crane,
"The Pater", in Brighton and Sheffield, 1974, p. 14.
2. Brighton and Sheffield, 1974 (140, 141, pls. 100, 101; Private
Collections).
3. Brighton and Sheffield, 1974 (142, 143, pls. 102, 103; both are in the
Victoria and Albert Museum, London).
4. Information supplied by Betty Elzea.
5. Brighton and Sheffield, 1974 (146, pl. 106); sold at Sotheby's, 12
November 1992, lot 157, repr.
6. Quoted by Crane, "Pater", p. 15.
7. Birmingham, *Paintings &c.*, [1930], p. 183 (97'25); Brighton and
Sheffield, 1974 (114, pl. 78), and Rose, 1981, p. 121, repr. Kitty Howell
is depicted wearing what is probably the same long, single-strand
necklace of turquoises; see Shirley Bury, *Jewellery 1789–1910*, vol. 2
(*1862–1910*), Woodbridge, Suffolk, 1991, p. 472, pl. 250.

Fig. 85 FREDERICK SANDYS, *Mrs Charles Augustus Howell*,
1873; coloured chalks on buff paper, 27 3/8 x 35 7/8 in.
(69.5 x 91.1 cm.). Birmingham Museums and Art
Gallery (97'25).

99

EDWARD BURNE-JONES

Designs for the "Cupid and Psyche" Frieze

1872
Presented by the daughters of George Howard, 9th Earl of Carlisle, 1922 (199'22–209'22)

I *Cupid finding Psyche asleep by a Fountain*
 Pencil, sepia, watercolour and bodycolour
 6 x 6 1/4 in.; 15.2 x 15.8 cm.

II *The King and other Mourners, preceded by Trumpeters, accompanying Psyche to the Mountain, where she is to be abandoned to the Monster*
 Watercolour and bodycolour
 6 x 16 1/4 in.; 15.2 x 41.2 cm.

III *Zephyrus bearing Psyche from the Mountain to Cupid's Valley: Psyche asleep outside the house: Psyche entering Cupid's house*
 Watercolour and bodycolour
 6 x 6 1/2 in.; 15.2 x 16.5 cm.

IV *Psyche's sisters visit her at Cupid's house: Psyche unrobing, Cupid flying to her through the night: Psyche's sisters bidding her farewell after their second visit*
 Watercolour and bodycolour
 6 x 13 3/8 in.; 15.2 x 34.0 cm.

V *Psyche, holding the Lamp, gazes enraptured on the face of sleeping Cupid: Psyche kneels, with arms held out in supplication, as Cupid flies away through the doorway*
 Watercolour and bodycolour
 6 x 16 1/4 in.; 15.2 x 41.2 cm.

VI *Psyche gazes in despair at Cupid flying away into the night*
 Watercolour and bodycolour
 6 x 1 1/4 in.; 15.2 x 3.2 cm.

VII *Cupid flying away from Psyche*
 Watercolour and bodycolour
 6 x 1 1/4 in.; 15.2 x 3.2 cm.

VIII *Psyche at the Shrine of Ceres: Psyche at the Shrine of Juno*
 Watercolour and bodycolour
 6 x 6 1/4 in.; 15.2 x 15.8 cm.

IX *Psyche, set by Venus the task of collecting the Golden Fleece from her flocks, is helped by a voice from the river reeds: Psyche, sent by Venus to the Black Mountain to fill a ewer at the fountain guarded by dragons, is aided by Jupiter's eagle*
 Watercolour and bodycolour
 6 x 10 1/4 in.; 15.2 x 26.0 cm.

X *Psyche giving the Coin to the Ferryman of the Styx: The Dead Man rising from the Water as Psyche is ferried across to Hades*
 Watercolour and bodycolour
 6 x 13 1/2 in.; 15.2 x 34.3 cm.

XI *Psyche receiving the Casket from Proserpine: Psyche, brought back to the upper regions by Charon, having opened the Casket, lies unconscious on the ground: Cupid, warned by the Phoenix of Psyche's danger, flies to her rescue*
 Watercolour and bodycolour
 6 x 9 1/2 in.; 15.2 x 24.1 cm.

REFERENCES: Birmingham, *Paintings &c.*, [1930], pp. 35–36; Rome, 1986 (48, repr.)

By 1865, William Morris had completed "The Story of Cupid and Psyche", the first in a cycle of long narrative poems conceived under the title *The Earthly Paradise;* parts I and II were published in 1868, part III in 1869, and part IV in 1870. More or less following the classical tale popularised by Apuleius in *The Golden Ass*, Morris sought to re-interpret the story as it foreshadowed later legends, such as that of St George and the Dragon, intending the whole of *The Earthly Paradise* to represent "a continued thread of living Greek tradition coming down almost to the end of the Middle Ages among Greek-speaking people, and overlapping the full development of romanticism in Western Europe".[1] Accordingly, and in keeping with his own tastes, he gave his poem a medieval – or more specifically, a Chaucerian – atmosphere and treatment.

This perfectly suited Burne-Jones, whom Morris asked in 1865 to provide designs, with the intention of publishing a lavish folio edition illustrated with woodcuts.[2] In the Birmingham collection is a bound volume containing eighty-six preliminary sketches for *Cupid and Psyche*, in which many of his final ideas can be seen germinating (fig. 86).[3] Forty-seven more finished pencil designs survive in a group given by Burne-Jones to Ruskin, and by him to the Ashmolean Museum, Oxford;[4] forty-five of these were transferred to wood blocks by George Wardle (later manager of Morris and Company). These were then cut (Morris undertaking thirty-five of them himself, according to Sydney Cockerell), and proofs taken; a set, given by Morris to the Birmingham architect John Henry

Fig. 86 EDWARD BURNE-JONES, *Psyche and Charon; two sketches for Cupid delivering Psyche*, 1865; pencil, each 4 x 6 1/4 in. (10.2 x 16.0 cm.). Birmingham Museums and Art Gallery (648'27).

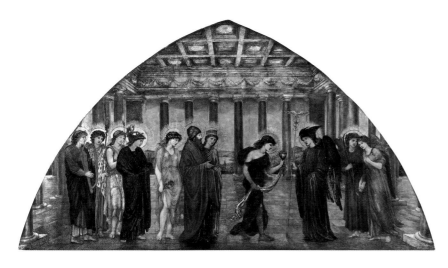

Fig. 87 EDWARD BURNE-JONES and WALTER CRANE, *Psyche entering the Portals of Olympus*, 1872–1881; oil on canvas, 78 x 129 1/2 in. (198.0 x 328.8 cm.). Birmingham Museums and Art Gallery (198'22).

Chamberlain, is now at Birmingham.[5] Unfortunately, trial sheets printed at the Chiswick Press were considered unsuccessful as a union of text and image, and the project was abandoned. Morris and Burne-Jones did achieve a collaboration in print over twenty years later through the Kelmscott Press.

In 1872, George Howard (1843–1911), the future 9th Earl of Carlisle and a painter with Pre-Raphaelite sympathies, commissioned the Morris firm to decorate his substantial new house at 1 Palace Green, Kensington (London's 'Millionaires' Row'), built by Philip Webb.[6] Burne-Jones was asked to decorate the dining-room with a frieze of canvases, and he decided to condense his many designs for *Cupid and Psyche* into twelve sections. Although 1872 proved to be an exceptionally busy year, he was able to record in his retrospective list of work: "arranged the story of Cupid and Psyche for Howard's dining room, and drew in the figures on canvas and painted some time at them".[7] This set of watercolour sketches must represent his 'arrangement', lacking only the final large lunette (for an alcove below the frieze), of *Psyche entering the portals of Olympus* (fig. 87). The titles of each image (given above) offer an explanation of the narrative, which is described thus in *The Earthly Paradise:*

> Psyche, a king's daughter, by her exceeding beauty caused the people to forget Venus; therefore the goddess would fain have destroyed her: nevertheless she became the bride of Love [Cupid], yet in an unhappy moment lost him by her own fault, and wandering through the world suffered many evils at the hands of Venus, for whom she must accomplish fearful tasks. But the gods and all nature helped her, and in process of time she was reunited to Love, forgiven by Venus, and made immortal by the Father of gods and men.[8]

After his initial burst of inspiration, Burne-Jones made only sporadic progress on the paintings. As with other hugely ambitious schemes, such as *The Story of Troy* (begun in 1870 and never completed [see cat. no. 116]), he was tempted into reworking favourite elements as independent pictures. Having already painted large watercolours of the first and last com-

positions of the figures of Cupid and Psyche,[9] he translated the latter into an oil for F.R. Leyland, and turned the processional musicians from the second panel into one of his most powerful late paintings, *The Challenge in the Wilderness.*[10] While staying with the Howards in 1876, the painter Walter Crane (1845–1915) agreed to take on the completion of the cycle, and with a little help from Burne-Jones and his studio assistant T.M. Rooke (1842–1942), all the canvases were in place by 1881.[11] They were there for only forty years: when the Howard family gave up the house in 1922, the paintings were taken down and presented (along with the watercolours) by the Earl's daughters to Birmingham Museum and Art Gallery (fig. 87), where they await conservation and display.[12]

1. Mackail, 1899, vol. 1, pp. 178–179.
2. The full story of this project is related in Joseph R. Dunlap, *The Book that Never Was*, New York, 1971, and A.R. Dufty, *The Story of Cupid and Psyche by William Morris*, London and Cambridge, 1974.
3. Birmingham, *Drawings*, 1939, pp. 81–87 (648'27, bequeathed by J.R. Holliday in 1927); London, Southampton and Birmingham, 1975–1976 (267). A further volume of sketches, including other subjects from *The Earthly Paradise*, is in the Pierpont Morgan Library, New York.
4. London, Southampton and Birmingham, 1975–1976 (264).
5. Presented by Mrs William Harris, 1913 (155'13–198'13); see also London, Southampton and Birmingham, 1975–1976 (268).
6. See Bill Waters, "Painter and Patron: The Palace Green Murals", *Apollo*, vol. 102, November 1975, pp. 338–341; also Rome, 1986, pp. 168–171.
7. Quoted in Burne-Jones, *Memorials*, 1904, vol. 1, p. 30.
8. Quoted in Birmingham, *Paintings &c.*, [1930], p. 33.
9. *Cupid finding Psyche asleep*, begun 1865, watercolour and bodycolour, 25 1/2 x 19 1/2 in. (64.9 x 49.4 cm.), Manchester City Art Gallery; *Cupid delivering Psyche*, 1867, watercolour and bodycolour, 31 1/2 x 36 in. (80.0 x 91.5 cm.), Hammersmith Public Libraries, London. London, Southampton and Birmingham, 1975–1976 (98, 99, repr.).
10. Harrison and Waters, 1973, col. pl. 39: sold at Christie's, 11 June 1993, lot 105, repr. The rest of the procession was also converted into an oil painting, *The Wedding of Psyche* (1895; Musées Royaux des Beaux Arts, Brussels); Rome, 1986 (82, repr.).
11. See Isobel Spencer, *Walter Crane*, London, 1975, pp. 73–74. The only substantial alteration to the cycle was Crane's substitution of a simplified subject, *Psyche passes safely through the Shadowy Meads*, for the ninth canvas, the composition being taken from one of the 1865 woodcuts; this is illustrated in Waters, "Painter and Patron", 1975, fig. 7.
12. Birmingham, *Paintings &c.*, [1930], pp. 32–35 (187'22–198'22).

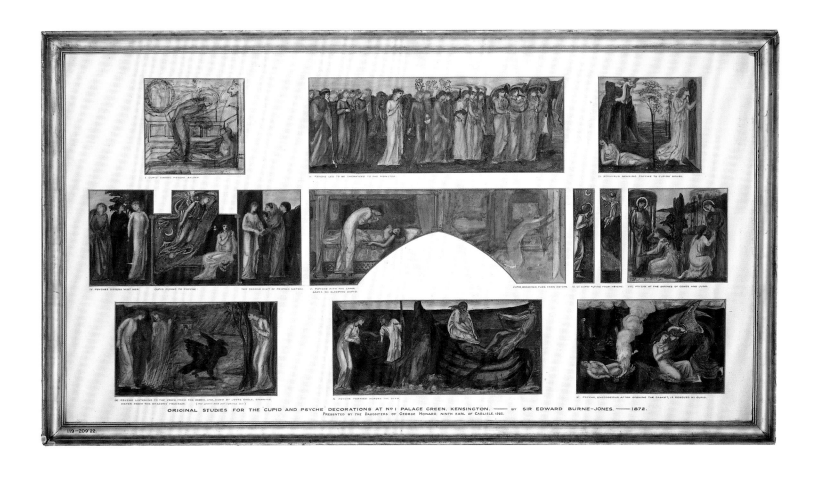

ORIGINAL STUDIES FOR THE CUPID AND PSYCHE DECORATIONS AT N° I PALACE GREEN, KENSINGTON. —— BY SIR EDWARD BURNE-JONES. —— 1872.
Presented by the Daughters of George Howard, ninth Earl of Carlisle, 1922.

119—209'22.

100

EDWARD BURNE-JONES

The Tiburtine Sibyl

1875
Pencil, black chalk and pastel, heightened with gold paint, on buff paper
43 7/8 x 17 3/4 in.; 111.6 x 45.3 cm.
Bequeathed by J.R. Holliday, 1927 (424'27)

EXHIBITED: Grosvenor Gallery, Winter 1881 (346)

REFERENCES: Birmingham, *Drawings*, 1939, p. 143; Sewter, 1975, *Text*, p. 44, *Plates*, pl. 438; London, Southampton and Birmingham, 1975–1976 (198); Cambridge, 1980 (67)

Although Morris, Marshall, Faulkner and Company could undertake interior decoration on quite a large scale (see cat. no. 99), the firm was most prolific and acclaimed for its stained glass. The remarkable achievements of its first few years (see cat. nos. 58–66) had resulted in a steady flow of commissions for ecclesiastical windows. The appointment of George Warington Taylor as manager in 1865, and a move from 8 Red Lion Square to larger premises at 26 Queen Square, Bloomsbury, enabled Morris to spend more of his time on the business, which began to grow dramatically and gain profit in the early 1870s.[1] Its very success led to an inevitable re-shaping: in 1875, the rather amateur association of friends was disbanded, and the firm was re-constituted as Morris and Company, with Burne-Jones becoming effectively its sole designer of stained glass. Unfortunately, this caused a rift between Morris and Ford Madox Brown which never healed, although Brown and Burne-Jones were reconciled later in life.

Burne-Jones's productivity in designs for glass is astonishing. It has been calculated that between 1872 and 1878 – when he was occupied with many major paintings – he made more than two hundred and seventy cartoons, an average of nearly forty a year. "Such an output", Sewter has observed, "would be remarkable for an artist occupied solely with designing for stained glass. In the case of Burne-Jones it implies not only fierce and sustained application, but also a well-organized studio system".[2] For the eleven windows in the chapel at Jesus College, Cambridge, arguably the finest single scheme of Morris stained glass, such a system is evident in the variety of surviving designs. Between March 1872 and July 1877, Burne-Jones produced fifty-five entirely new designs for these windows, whose accompanying preparatory drawings range from male nude studies in pencil to full-scale figures.[3] Some of the working cartoons are clearly by Burne-Jones himself, although others – including, notably, the ten *Angels of the Hierarchy*, now at Birmingham[4] – are more likely to have been worked up by the firm's studio assistants, including Charles Fairfax Murray.[5]

The present 'cartoon' is a piece of draughtsmanship taken far further than would have been necessary or useful for the glass painter to utilise. Burne-Jones either found himself carried away in enthusiasm or, as so often occurs in his decorative work, he deliberately continued to a degree of finish appropriate for an independent easel picture. While an equally big but slightly less elaborate cartoon for the matching figure of *The Erythraean Sibyl* exists,[6] it comes as no surprise to find that the artist did indeed go on to reproduce *The Tiburtine Sibyl* in 1877 as a large watercolour.[7]

The focal point of Morris and Company's work at Jesus College is the great five-light south transept window, with its four tiers of powerful single figures by Burne-Jones and Morris, and minstrel angels in the tracery above. In each of the adjoining three-light windows, two on the north side and two on the south, the glass depicts the four Evangelists flanked by Sibyls. Brown designed some of the smaller panels below each of these figures, but the rest is all work by Burne-Jones. Although rooted in pagan classical mythology, the Sibyls – ten women chosen to convey divine wisdom to mankind – were adopted by the early Christians, and the so-called Sibylline verses were amended to accommodate Christian philosophy. In Renaissance art, they were painted most famously by Michelangelo on the ceiling of the Sistine Chapel in the Vatican at Rome.

On his third visit to Italy in 1871, Burne-Jones followed an itinerary that took in many of the treasures of early Renaissance painting at Florence, Pisa, Siena, Orvieto, Assisi, Perugia and Rome. Each of the great artists had something to teach him: Burne-Jones was always capable of assimilating qualities of colour, line, composition and expression into his own style. Looking back on his journey, he enthused that "Giotto at Sante Croce [Florence], and Botticelli everywhere, and Orcagna in the Inferno at Santa Maria Novella, and Luca Signorelli at Orvieto, and Michel Angelo always . . . seemed full of the inspiration that I went to look for".[8] In the Sistine Chapel, according to Lady Burne-Jones, "he was made happy by finding the ruin of the frescoes, as well as their obscurity, much exaggerated by report. So he bought the best opera-glass he could find, folded his railway rug thickly, and, lying down on his back, read the ceiling from beginning to end, peering into every corner and revelling in its execution".[9] Burne-Jones's subsequent homage to Michelangelo is evident not only in the mighty draped figures such as here in his own Sibyls, but also in such powerful drawings of the male nude as those in his *Perseus* sketchbook of 1875 (in the Birmingham collection).[10] He was all the more saddened and disappointed, therefore, by Ruskin's denunciation of Michelangelo – "physical instead of mental interest" – in one of his Oxford lectures of 1871.[11]

1. See John Press and Charles Harvey, "William Morris, Warington Taylor and the firm, 1865–1875", *Journal of the William Morris Society*, vol. 7, no. 1, Autumn 1986, pp. 41–44.

2. Sewter, 1975, *Plates*, p. 46.

3. See Sewter, 1975, *Text*, pp. 42–44, and Cambridge, 1980, pp. 39–43. Burne-Jones charged £15 for each Sibyl cartoon, as in this relevant entry in his account book: 1 April 1875, Day of Dissolution: "2 Sibyls – to wit Erythrea & Tiburtina £30" (Sewter, 1975, *Text*, p. 44).

4. Birmingham, *Drawings*, 1939, pp. 140–141 (411'27–1 to 10); Cambridge, 1980 (59, i–x).

5. Sewter, 1975, *Plates*, pp. 47–48.

6. Sold at Christie's, 17 June 1975, lot 149, repr.

7. Sold at Christie's, 13 March 1990, lot 185, repr. (18 1/8 x 9 5/8 in.; 46.2 x 24.4 cm.).

8. Burne-Jones, *Memorials*, 1904, vol. 2, p. 27.

9. Burne-Jones, *Memorials*, 1904, vol. 2, pp. 25–26.

10. Birmingham Museums and Art Gallery (P5'52); London, Southampton and Birmingham, 1975–1976 (176).

11. "The Relation between Michael Angelo and Tintoret", in Ruskin, *Works*, 1906, vol. 22, p. 86. Writing to Charles Eliot Norton, Burne-Jones recorded evidence, in a letter from Ruskin, showing the critic to be "without that love of the human form which to an artist makes each fold of drapery that clothes it alive" (Burne-Jones, *Memorials*, 1904, vol. 2, p. 18).

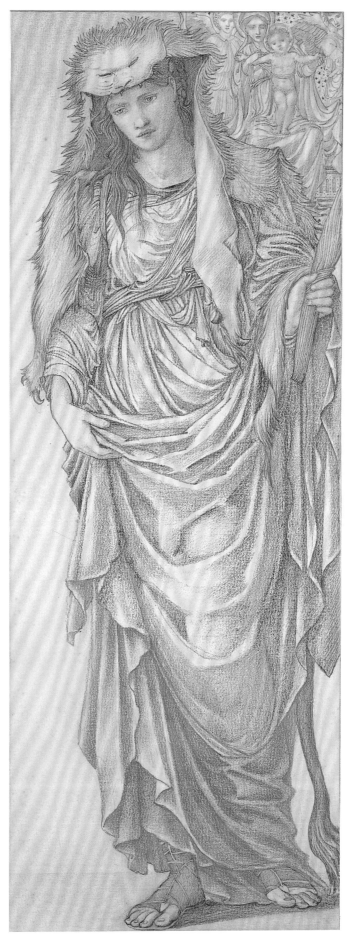

Cat. no. 100

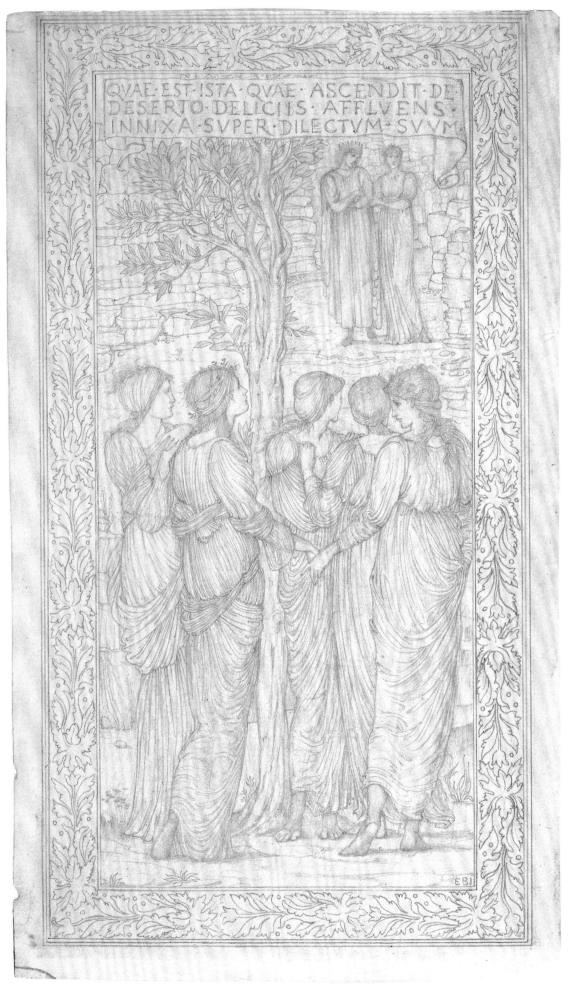

Cat. no. 101

101

EDWARD BURNE-JONES

The Song of Solomon

Circa 1876
Pencil
13 3/4 x 8 in.; 35.0 x 20.3 cm.
Signed, bottom right: EBJ
Inscribed on cartouche, top: QVAE EST ISTA ASCENDIT DE /
DESERTO DELICIIS AFFLVENS / INNIXA SVPER DILECTVM SVVM
["Who is this that cometh out of the wilderness leaning
upon her beloved?"]
Presented by Mrs G.F. Watts, 1924 (92'24)

PROVENANCE: George Frederic Watts

REFERENCES: Bell, 1892, p. 56; Birmingham, *Drawings*, 1939,
p. 98; Rome, 1986 (148, repr.)

*B*urne-Jones's absorbing interest in the linear patterns
created by heavy swathes of drapery (see cat. no. 100) is even
more apparent in his smaller-scale decorative work of the
mid-1870s. In 1873–1874 he worked on a series of initials and
marginal decorations for one of Morris's most ambitious
handwritten books, a copy on vellum of Virgil's *Aeneid*.[1] This
was abandoned, but not before Burne-Jones had made dozens
of intricate pencil drawings: twenty-nine of these, now at the
Fitzwilliam Museum, Cambridge, possess a wiry energy that
would finally be released onto the pages of the Kelmscott
Chaucer twenty years later.[2]

A similar power of linear invention was diverted into
another project of 1876. Described by the artist as "five designs
from the Song of Solomon – for paintings on panel some day",[3]
this set of large pencil drawings has also been associated with
his support of the Royal School of Needlework, which opened
in 1872. Through its foundress, his friend Madeline Wyndham,
Burne-Jones provided two designs, *Poesis* and *Musica*, to be
worked in outline with brown crewel on linen.[4] These proving
both successful and popular, the *Song of Solomon* series was then
taken up, although only one full-size embroidery is known.[5]
This is of the third composition, depicting Solomon's bride of
Lebanon, which is now better known as *Sponsa di Libano*, the
large watercolour version of 1891 at the Walker Art Gallery,
Liverpool. Also in the Birmingham collection is the equiva-
lent drawing of 1876 for that subject (fig. 88).[6]

Burne-Jones's first chronicler, Malcolm Bell, describes all
five designs, of which the present drawing is the last: "Five
slender girlish figures grouped around a young tree, gazing out
upon a rocky gorge from which Solomon, crowned, emerges
supporting the spouse of Lebanon".[7] The text is from the
Vulgate, chapter VIII, verse 5. In a later edition of his book,
Bell identifies the likely sources of these highly formalized,
hieratic compositions as being the engravings by Baldini and

Pollaiuolo after Botticelli, and especially the edition of Dante
published by Niccolo di Lorenzo della Magra in 1481. The
animation of *Sponsa di Libano* (fig. 88) is a welcome relief to
the otherwise rather solemn groups of figures in the rest of the
series: even with the sharp, bright draughtsmanship of these
sheets, one can understand why in 1878 the *Art Journal* ex-
pressed the hope that Burne-Jones would one day discover
"that all mankind, especially womankind, do not walk around
the world like hired mutes at a funeral".[9]

1. See Anna Cox Brinton, *A Pre-Raphaelite Aeneid*, Los Angeles, 1934.
2. Cambridge, 1980 (122, i–ix).
3. Burne-Jones, *List of my designs drawings and pictures* [etc.] (see cat.
no. 67, note 2).
4. See Caroline Dakers, *Clouds: The Biography of a Country House*,
New Haven and London, 1993, p. 40. A pencil design for *Poesis* is at
Birmingham (*Drawings*, 1939, p. 131 [190'04]). Both large cartoons were
sold in the Clouds sale of 1933, with *Poesis* re-appearing at Sotheby's on
23 June 1981, lot 94, repr.
5. Harrison and Waters, 1973, p. 118.
6. Birmingham, *Drawings*, 1939, p. 98 (463'27); Rome, 1986 (147, repr.).
In addition, Birmingham has a pencil sketch for *The Song of Solomon*
(cat. no. 101), which is close to the final composition (189'04).
7. Bell, 1892, p. 56. Two further illustrations to *The Song of Solomon*,
including a putative frontispiece, appear in Burne-Jones's *"Secret Book
of Designs"* (British Museum, London); see Aymer Vallance, "The
Decorative Art of Sir Edward Burne-Jones, Bart.", *Easter Art Annual
(Art Journal)*, 1900, p. 21, figs. 28–29.
8. Bell, 1898, pp. 96–97.
9. *Art Journal*, n.s., vol. 17, July 1878, p. 155.

Fig. 88 EDWARD BURNE-JONES, *The Song of Solomon* (chapter IV, verse
16: "Awake, O North Wind, and come thou South, blow upon my
garden that the spices thereof may flow out"), 1876; pencil, 14 x 8 3/8
in. (35.5 x 21.2 cm.). Birmingham Museums and Art Gallery (463'27).

102

DANTE GABRIEL ROSSETTI

The Question

1875
Pencil
18 7/8 x 16 1/4 in.; 48.0 x 41.5 cm., including strip of paper
18 7/8 x 2 1/2 in. (48.0 x 6.4 cm.) added at right
Signed and dated, bottom right: DGR / 1875 (initials in
monogram)
Presented by subscribers, 1904 (239'04)

PROVENANCE: Rossetti sale, Christie's, 12 May 1883, lot 197
(32 guineas); Charles Fairfax Murray

REFERENCES: Birmingham, *Drawings*, 1939, p. 338; Peterson,
1967; Surtees, 1971, no. 241, pl. 350; London, Tate, 1984
(248, repr.)

The Question is one of Rossetti's oddest yet most accomplished works. As a sophisticated exercise in brilliantly gradated pencil drawing, nothing quite like it appears in nineteenth-century British art, and in terms of technical achievement it represents an extraordinary contrast with the artist's naïve and awkward early draughtsmanship. The only comparable drawings by Rossetti are *The Death of Lady Macbeth* (circa 1875; Carlisle Museum and Art Gallery) and *Orpheus and Eurydice* (1875; British Museum, London), both of which are on the same scale but neither taken to an equivalent degree of finish.[1] All three compositions were meant to be turned into oil paintings, as Rossetti wrote to Jane Morris in March 1875:

> I have been finishing the Sphinx design I spoke of. . . . The idea is that of Man questioning the Unknown and I shall call it either "The Question" or "The Sphinx & her Questioner", but I think on the whole the shorter title is the better. I have made the design nude, but propose to drape it in some degree when I paint it, which I fancy must be on rather a small scale, for 2 reasons; one being that to sell a big picture without women in it wd. be a double difficulty, and the other that a moonlight subject on a large scale is always monotonous.[2]

A further letter to F.G. Stephens, written to assist his forthcoming article on Rossetti's work in the *Athenaeum* (published on 14 August 1875), describes the details of the composition in rather poetic terms – the Sphinx's eyes "are turned upward and fixed without response on the unseen sky which is out of the picture & only shows in the locked bay of quivering sea a cold reflection of the moon" – and offers a personal variation on the traditional meaning of the riddle of the Sphinx.[3] While the answer to her question, "What walks on four legs in the morning, two at noon, and three in the

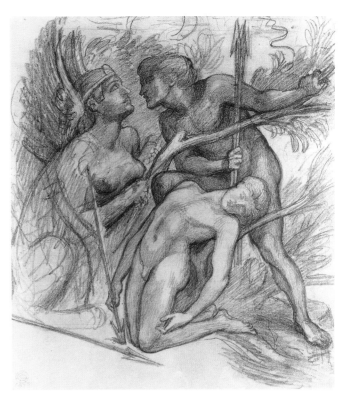

Fig. 89 DANTE GABRIEL ROSSETTI, *Study for "The Question"*, 1875;
pencil, 15 1/2 x 13 1/2 in. (39.4 x 34.3 cm.). Fogg Art Museum, Harvard
University, Cambridge, Massachusetts; Gift of Miss Ellen Bullard.

evening?", remains Man (in infancy, adulthood and old age, walking with a stick), Rossetti adds this gloss:

> In the symbolism of the picture (which is clear and gives its title founded on Shakespeare's great line To be or not to be, that is the question) the swoon of the youth may be taken to shadow forth the mystery of early death, one of the hardest of all impenetrable dooms.[4]

Although the artist himself is not recorded as having made the association, his brother William Michael stated in 1889 that "in representing the dying stripling, Rossetti was thinking of the premature fate of Oliver Madox Brown, the youth of singular promise, who had ended his twenty years in the November of 1874 – a bitter grief to his father, Rossetti's lifelong friend, Ford Madox Brown".[5]

It may well have been this specific impetus towards finding an appropriate symbolic theme that led Rossetti to an unmistakable plagiarism of *Oedipus and the Sphinx*, the large oil painting of 1808 by Jean-Auguste-Dominique Ingres (1780–1867) now in the Louvre, Paris, which he would have seen at the 1855 Exposition Universelle.[6] As Carl Peterson has argued in his thorough account of *The Question*, Rossetti was at pains to defend the "originality" of his mature work, and it seems more likely that this is an instance of deliberate, even witty, quotation in pursuit of expressing a broader theme.[7] Apart

from Oedipus and the Sphinx, Ingres's painting includes only a small subsidiary figure. Rossetti could have considered his interpretation legitimate both in its fuller treatment of the elements of the riddle and in its secondary discourse on the mysteries of life and death. Ironically, in the last weeks of his own life Rossetti wrote two sonnets to accompany the drawing, the first concluding:

> Ah, when those everlasting lips unlock
> And the old riddle of the world is read,
> What shall man find? or seeks he evermore?[8]

A large but loose pencil sketch, also dated 1875, is at the Fogg Art Museum, Harvard University (fig. 89). Peterson speculates that this might be "a simplification and revision" of *The Question*, "done to play down the indebtedness to Ingres",[9] but he equally acknowledges that the sizeable enlargement of the Birmingham sheet, done chiefly to incorporate the figure of the old man who is absent in the sketch, encourages the more probable suggestion that it is indeed a preliminary work. The motif of the archaic 'swan-neck' boat was one Rossetti had used before, in the background of the large coloured chalk drawing *Ligeia Siren* (1873; Private Collection).[10]

1. Surtees, 1971, nos. 242, 243, pls. 352, 364.
2. Bryson (ed.), 1976, pp. 37–39; also quoted in Surtees, 1971, p. 140.
3. Quoted in Surtees, 1971, p. 140, and in London, Tate, 1984, p. 307.
4. Quoted in Surtees, 1971, p. 140, and in London, Tate, 1984, p. 307.
5. Quoted in Peterson, 1967, p. 50.
6. See Peterson, 1967, pp. 48–50.
7. Peterson, 1967, pp. 51–52.
8. Doughty and Wahl, 1965–1967, vol. 4, p. 1953 (enclosure in letter to Theodore Watts-Dunton, 5 April 1882); the sonnets are printed in Surtees, 1971, pp. 139–140.
9. Peterson, 1967, p. 52.
10. Surtees, 1971, no. 234; Tokyo, 1990 (76, repr.).

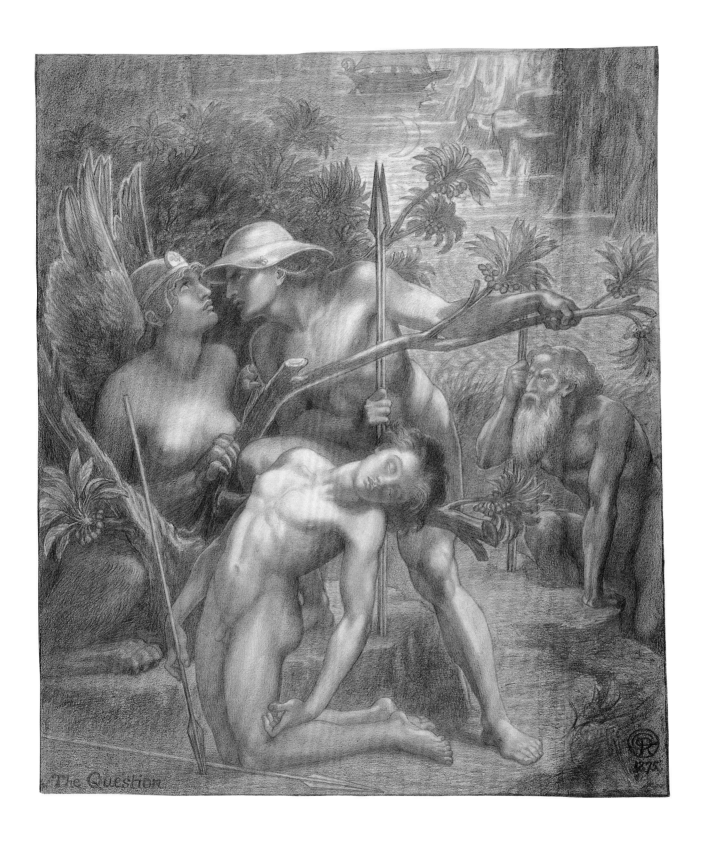

The Question

JOHN BRETT

Southern Coast of Guernsey

1875
Oil on canvas
24 x 42 1/2 in.; 61.2 x 108.2 cm.
Signed and dated, bottom right: John Brett 1875
Inscribed in ink, on label formerly attached to stretcher:
Southern Coast of Guernsey / from the Cliff over Moulin
Huet / July 1875
In original frame
Presented by the Council of Birmingham University, 1927
(275'27)

PROVENANCE: Mrs Osler

EXHIBITED: ?Royal Birmingham Society of Artists, Autumn
1875 (361, as *On the Coast of Guernsey*)

REFERENCE: Birmingham, *Paintings*, 1960, p. 15 (as *Coast Scene*)

*F*rom 1865 onwards, John Brett focused his work on the depiction of the coasts of England and Wales, with occasional forays to Scotland and France. He married in 1870, and spent a honeymoon winter in Sicily, but thereafter he habitually spent each summer with his family on board a yacht, chiefly cruising and painting along the English Channel.

Favoured haunts were Cornwall and the Channel Islands, which offered Brett the irresistible combination of rugged rocks and restless sea. In both places he made on-the-spot oil sketches, usually no larger than 7 x 14 inches (18.0 x 36.0 cm.), that were intended to capture "a single observation unadulterated".[1] These, with a few small oils brought to some degree of finish, would assist him during his winter's work in his London studio to produce paintings for exhibition, often of huge dimensions. Some are pure seascapes, tranquil – as in *The British Channel seen from the Dorsetshire Cliffs* (Tate Gallery, London)[2] – or tempestuous, such as *A North-West Gale off the Longships Lighthouse* (Land's End) (fig. 90)[3]; both are of a favourite larger size, 42 x 84 inches (106.5 x 213.0 cm.).

Southern Coast of Guernsey represents a more typical example of Brett's coastal landscapes. It is possibly identifiable as *On the Coast of Guernsey*, one of three scenes of the island which were exhibited at Birmingham in 1875: these and his single Royal Academy exhibit of that year, *Spires and Steeples of the Channel Islands*, are his earliest documented views of the archipelago. The brilliance and luminosity of the colours (restored to their full strength by recent cleaning), together with a loving observation of the rock formations, are the most obvious legacy of Brett's Pre-Raphaelite apprenticeship, although the clever brushwork used to indicate lichen and grass would not have met with Ruskin's approval. The combination of rocks, greensward and turquoise sea strangely

echoes the identical elements in a group of Cornish watercolours painted by Hunt in 1860, of which the best known is *Asparagus Island, Kynance Cove* (Private Collection).[4]

Brett never lacked admirers (nor purchasers), but even in the 1870s the critics' praises were still mitigated by the same doubts that Ruskin had expressed in 1859 over *Val d'Aosta* (see cat. no. 82). In 1874, for instance, the *Art Journal* extolled Brett's "love of the solid forms and real surfaces of the outward world. . . . The skill with which he interprets these facts of nature is always extraordinary".[5] Still seen to be lacking, however, was "the expression of some phase of sentiment", for which "no amount of mere literal fidelity" could compensate. In an essay for the catalogue to an exhibition of his work in 1886, Brett countered such criticism with the terse statement that "sentiment in landscape is chiefly dependent on meteorology", and concluded his remarks by observing that "the out-of-doors world is entirely at the command of the landscape painter, and if he does not depict it accurately it is not because of the imperfection of the means and appliances, or the inherent weakness of his art, but merely because he lacks intelligence and information".[6] The icy intellectual rigour of this assertion, a curious *reductio ad absurdum* of Ruskin's forty-year-old exhortation to "go to Nature . . . rejecting nothing, selecting nothing, and scorning nothing",[7] is belied by the warmth of feeling and affection for place evident in Brett's finest later landscapes, which remain an important but sadly neglected body of work.

1. Staley, 1973, p. 136. One such oil sketch, given the title *Off the Coast, Guernsey*, and depicting a headland similar to that seen here, was sold at Christie's, 13 March 1992, lot 123, repr.
2. Staley, 1973, pp. 135–136, pl. 73b. *The British Channel* was included in the Royal Academy exhibition of 1871 (522).
3. Birmingham, *Paintings*, 1960, p. 15 (2471'85). *A North-West Gale off the Longships Lighthouse* was purchased for the Birmingham collection from the Royal Birmingham Society of Artists' autumn exhibition of 1873 (128), having been shown at the Royal Academy in the summer (945).
4. London, Tate, 1984 (232, repr.).
5. *Art Journal*, n.s., vol. 13, July 1874, p. 199.
6. *Three Months on the Scottish Coast*, Fine Art Society, London, 1886; quoted in Staley, 1973, pp. 136–137.
7. From Ruskin, *Modern Painters*, 1843, vol. 1; see Staley, 1973, p. 8.

Fig. 90 JOHN BRETT, *A North-West Gale off the Longships Lighthouse*, 1873; oil on canvas, 42 x 84 in. (106.5 x 213.0 cm.). Birmingham Museums and Art Gallery (2471'85).

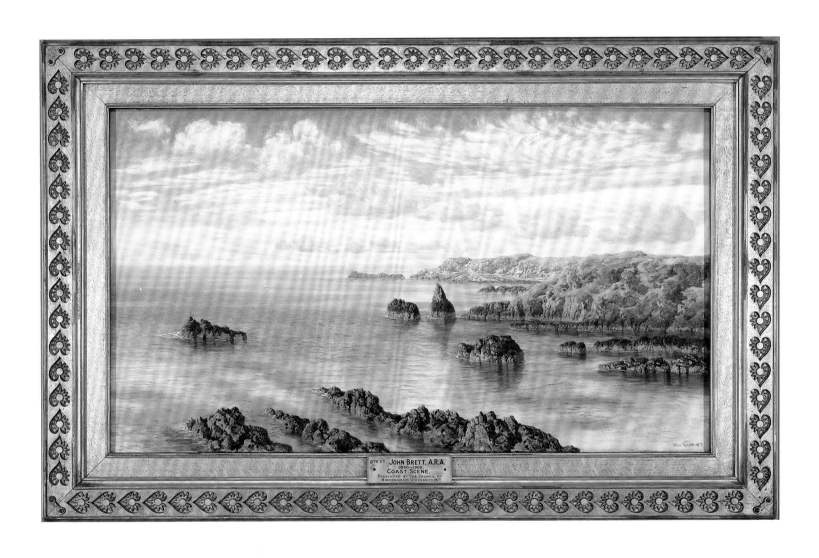

JOHN BRETT. A.R.A.
1830–1902.
COAST SCENE.
PRESENTED BY THE COUNCIL OF
BIRMINGHAM UNIVERSITY.1977

104

DANTE GABRIEL ROSSETTI

Beata Beatrix

Begun in 1877 (left unfinished in 1882)
Oil on canvas
34 1/8 x 26 7/8 in.; 86.8 x 68.3 cm.
Inscribed on the frame, top: Quomodo sedet sola Civitas! /
Veni, Sponsa, de Libano
Bottom: "Quella beata Beatrix, la quale vive in cielo cogli
angioli e in terra colla mia anima" / Dante: Convito
In original frame
Purchased, 1891 (25'91)

PROVENANCE: Given by the artist to Mrs W.M. Rossetti

EXHIBITED: Birmingham, 1891 (175)

REFERENCES: Birmingham, *Paintings*, 1960, p. 127; Surtees,
1971, no. 168.R.5; Tokyo, 1990 (27, repr.)

Beata Beatrix is an idealised portrait of Elizabeth Siddal
in the role of Beatrice, the focus of Dante's unrequited love in
the *Vita Nuova*. Although the painting is often described as a
posthumous token of love, poignantly assuaging Rossetti's
guilt over his wife's unhappiness and tragic death in 1862, the
composition was conceived in the 1850s. A pencil sketch of
Lizzie holding this pose (William Morris Gallery, Walthamstow,
London; fig. 91) and a more precise study of her hands (in the
Birmingham collection; fig. 92) probably date from about
1854, when Rossetti was making many drawings of her.[1] In
December 1863 the artist wrote to Ellen Heaton that he had
re-discovered "a life size head of my wife in oil, begun many
years ago as a picture of Beatrice",[2] and this formed the basis
for the first *Beata Beatrix*, completed in 1870 for the Hon.
William Cowper (Tate Gallery, London).[3]

The substantial offer of nine hundred guineas from
William Graham, one of the artist's best patrons, tempted
Rossetti into undertaking an oil replica, with the addition of
an elaborate predella representing the meeting of Dante and
Beatrice in Paradise (The Art Institute of Chicago).[4] Rossetti
found this a chore – "a beastly job, but lucre was the lure"[5] – not
least on account of the mixed emotions he must have experi-
enced while painting it at Kelmscott in the summer of 1871 in
the company of Jane Morris. Finished in 1872, it joined a full-
size version in red chalk which Rossetti had done in 1869 to
keep Graham happy while he waited (Fogg Art Museum,
Harvard University).[6] At the same time, Rossetti made two fur-
ther replicas, a watercolour in 1871 (also at the Fogg)[7] and a
coloured chalk drawing in 1872 (Private Collection)[8]; the latter
was for the collector Leonard Valpy, who also commissioned
a version in oil (dated 1880; National Gallery of Scotland,
Edinburgh).[9] The Birmingham version of *Beata Beatrix* is
said to date from 1877, and to have been left unfinished when

given by the artist to his sister-in-law Lucy; after Rossetti's
death, it was completed by her father, Ford Madox Brown.[10]

Rossetti provided two of his patrons with a detailed
explanation of the image. In a letter of 1871 to Cowper's wife
(now Mrs Cowper-Temple), he describes the picture as
"embodying, symbolically, the death of Beatrice", continuing:

It must of course be remembered, in looking at the pic-
ture, that it is not at all intended to represent Death . . .
but to render it under the resemblance of a trance, in
which Beatrice seated at the balcony over-looking the City
[Florence] is suddenly rapt from Earth to Heaven. You
will remember how much Dante dwells on the desola-
tion of the city in connection with the incident of her
death, & for this reason I have introduced it, as my back-
ground, & made the figure of Dante and Love passing
through the street & gazing ominously on one another,
conscious of the event, whilst the bird, a messenger of
death, drops a poppy between the hands of Beatrice.[11]

Writing to William Graham two years later, Rossetti
again emphasises that the subject was not to be viewed "as a
representation of the incident of the death of Beatrice, but as

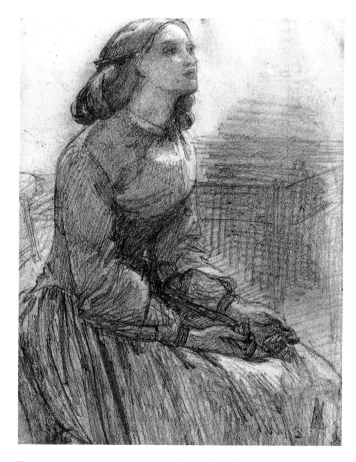

Fig. 91 DANTE GABRIEL ROSSETTI, *Elizabeth Siddal, in the pose of
"Beata Beatrix"*, circa 1854; pencil, 5 7/8 x 4 5/8 in. (15.0 x 11.9 cm.).
William Morris Gallery, Walthamstow, London.

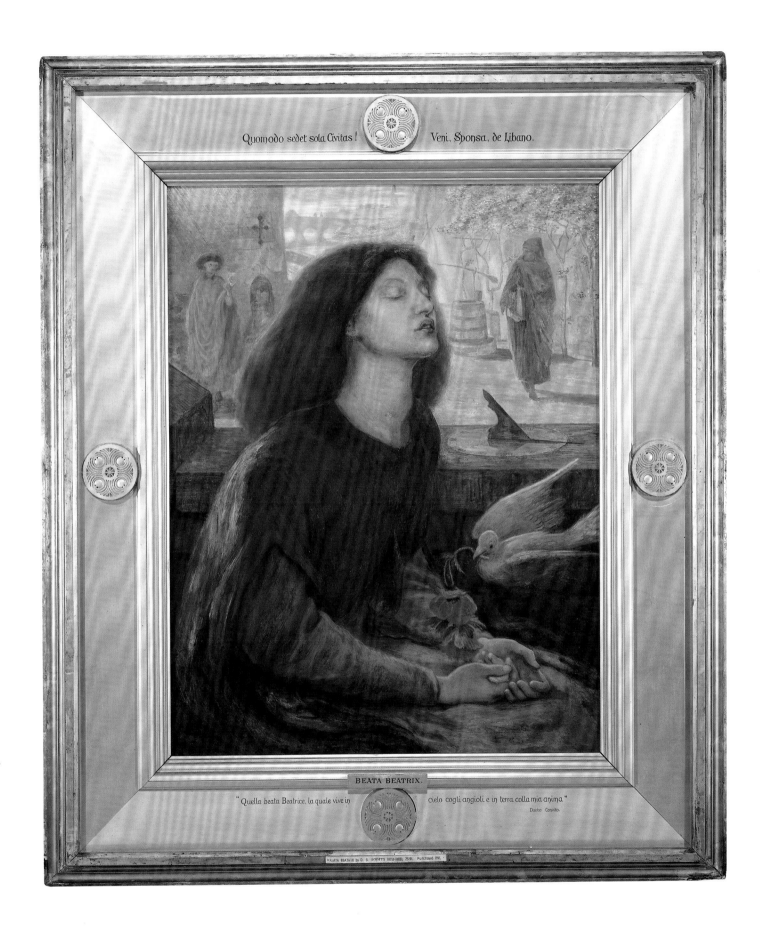

299

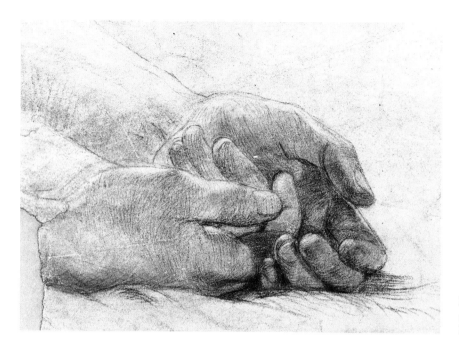

Fig. 92 DANTE GABRIEL ROSSETTI, *Study of hands*, circa 1854; black chalk, 5 1/2 x 7 5/8 in. (14.0 x 19.3 cm.). Birmingham Museums and Art Gallery (300'04).

an ideal of the subject, symbolized by a trance or spiritual transfiguration".[12] Two of the texts which appear on the Birmingham frame were then explained: 'Quomodo sedet sola Civitas!', a biblical quotation from Lamentations I:1, refers to the City of Florence, "which, as Dante says, 'sat solitary' in mourning for her death"; and "The words, 'Veni, Sponsa De Libano' are sung at the meeting [of Dante and Beatrice, after death] by the women in the train of Beatrice"; the reference to the Bride of Lebanon comes from *The Song of Solomon* (see cat. no. 101). The third text on the frame is a quotation from Dante: "that blessed Beatrice, who lives in heaven among the angels, and on earth within my soul".

A symbolic use of colour was attested by F.G. Stephens, who was at pains to check his descriptions of Rossetti's work with the artist. In an essay of 1891 he noted that Beatrice's costume, of green and purple, represented "the colours of hope and sorrow as well as of life and death".[13] The colours of the red bird and white poppy, in the Tate, Chicago, and Edinburgh oils, are reversed in the Birmingham version, where the bird (more closely resembling a dove) bears no halo. The background cityscape is also treated differently, presumably having been painted by Brown from photographs of the other pictures.[14]

The frame of *Beata Beatrix* is consistent with other Rossetti frames of the 1870s, although its roundel decorations lack the representations of sun, moon and stars (a further Dante reference) that appear on the three other frames.[15]

1. Surtees, 1971, nos. 168B, 168C, pls. 239, 240.
2. Letter of 22 December 1863, quoted in Surtees, 1971, p. 94.
3. Surtees, 1971, no. 168, pl. 238; this was presented to the nation in 1889 by Lady Mount Temple, the widow of William Cowper, who had become Lord Mount Temple in 1880.
4. Surtees, 1971, no. 168.R.3.
5. Letter of 10 September 1871 to William Michael Rossetti, quoted in Surtees, 1971, p. 95.
6. Surtees, 1971, no. 168.R.1.
7. Surtees, 1971, no. 168.R.2.
8. Surtees, 1971, no. 168.R.4; sold at Sotheby's, 20 June 1989, lot 68, repr.
9. Surtees, 1971, no. 168.R.6.
10. The catalogue to the 1891 Pre-Raphaelite exhibition at Birmingham states that "the background was left unfinished by Rossetti, and after his death was completed by Ford Madox Brown" (Birmingham, 1891, p. 53).
11. Letter of 26 March 1871, quoted in Surtees, 1971, p. 94.
12. Letter of 11 March 1873, quoted in Surtees, 1971, p. 96.
13. "*Beata Beatrix* by Dante Gabriel Rossetti", *Portfolio*, vol. 22, 1891, p. 46; quoted by Alastair Grieve in London, Tate, 1984, p. 209.
14. See note 10.
15. See Grieve, 1973C, p. 23; fig. 15 illustrates, as typical of these later frames, the one for *Proserpine* (1873–1877) in the Tate Gallery, London.

105

EDWARD BURNE-JONES

Pygmalion and the Image: I The Heart Desires

1875–1878
Oil on canvas
39 x 30 in.; 99.0 x 76.3 cm.
Signed and dated on scroll, bottom left: E. BURNE-JONES /
inv. 1868 / pinxit 1878.
In original frame
Presented by Sir J.T. Middlemore, Bt., 1903 (23'03)

PROVENANCE (for cat. nos. 105–108): Bought from the artist
by Frederick Craven; his sale, Christie's, 18 May 1895, lots
60–63, bought Agnew's (3,500 guineas for the series); Sir
John Throgmorton Middlemore

EXHIBITED (cat. nos. 105–108): London, Grosvenor Gallery,
1879 (167–170); Manchester, Royal Jubilee Exhibition, 1887
(199–202); London, New Gallery, 1892–1893 (47–50)

REFERENCES: Birmingham, *Paintings*, 1960, pp. 23–24;
London, Southampton and Birmingham, 1975–1976 (137a);
Rome, 1986 (33, repr.)

The four *Pygmalion* paintings share with the *Cupid and Psyche* frieze (cat. no. 99) an origin in illustrations to *The Earthly Paradise* by William Morris. Deriving from the story in Ovid's *Metamorphoses*, Morris's poem tells how the sculptor Pygmalion, disgusted by the immorality of the young women of Cyprus, resolves to remain celibate. Falling in love, however, with the image of perfection he creates in marble, he prays to Venus: she brings the sculpture to life as Galatea, whom Pygmalion marries.

Burne-Jones lists "12 subjects from Pygmalion" among work undertaken in 1867.[1] Twenty-two preparatory pencil drawings and tracings in the Birmingham collection, together with three more drawings at the William Morris Gallery, Walthamstow, London, show Burne-Jones working out these compositions, which were clearly intended as woodblock illustrations (as for *Cupid and Psyche*).[2] Only the first subject (*The Heart Desires*) is known to have been cut (an impression is in the William Morris Gallery), although two others were engraved on copper plate (impressions are in the William Morris Gallery and the Pierpont Morgan Library, New York).[3] On the abandonment of an illustrated *Earthly Paradise*, Burne-Jones embarked on a set of four small oil paintings of *Pygmalion and the Image* (Private Collection), refining the most vivid ideas from the wider narrative. These were completed in 1870: the last two bear that date while the first only is inscribed 1868, although Burne-Jones himself listed this under 1869.[4] Five years later he began the larger cycle now in Birmingham, and conveniently finished them, as doubtless intended, for exhibition at the newly founded Grosvenor Gallery.[5]

The first set was painted for Euphrosyne Cassavetti, who had come to London from Greece in 1858 on the death of her husband, a wealthy cotton merchant. In the social circle of Alexander Ionides, the Greek Consul-General and an enthusiastic patron of the arts, Burne-Jones also met her daughter Maria (Mary), who had married Demetrius Zambaco in 1861 but had left him in Paris and returned to London in 1866. A love affair between Burne-Jones and Maria followed, which came to a head in February 1869 with Maria's attempt at suicide, and lasted until 1872, when Burne-Jones ended the relationship.[6] While the choice of Pygmalion, with its Mediterranean setting, was fitting enough for a Greek patron, the theme is even more appropriately coincident with Maria Zambaco's own talent as a sculptor (she later became an outstanding medallist). This further colours an inescapable psychological interpretation of the paintings, as an expression of the failure of a cerebral concept of beauty, which the artist may try to preserve, when faced with a physical reality which is impossible to resist.

Comparisons between the two cycles are instructive: the earlier set has a sombre romantic atmosphere of suffused colour, recalling the Pre-Raphaelite medievalism both of Rossetti's

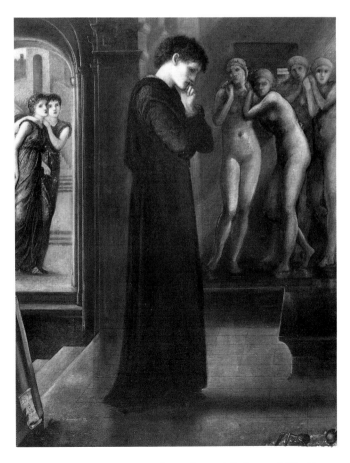

Fig. 93 EDWARD BURNE-JONES, *Pygmalion and the Image: I The Heart Desires*, 1868–1869; oil on canvas, 26 x 20 in. (66.0 x 51.0 cm.). Private Collection.

watercolours and of Burne-Jones's own watercolours, such as *The Merciful Knight* (cat. no. 73). The dark figure of the pensive sculptor in the 1868–1869 canvas (fig. 93), for example, displays very little modelling; in contrast, the *Pygmalion* of 1878 is given crisp, brightly illuminated drapery over a body of altogether more weight. Surviving pencil drawings demonstrate that the artist returned to the live model to correct such weaknesses and strengthen the stylistic consistency of the second cycle.[7] In *The Heart Desires*, the background sculpture group has also become a more classical depiction of the Three Graces, mirrored in an almost abstract pattern of reflections on the now polished marble floor.

The critical reception of *Pygmalion and the Image* at the third Grosvenor Gallery exhibition was not ecstatic, although it added significantly to Burne-Jones's hugely growing reputation for what the *Art Journal* called "creations of a mind specially gifted, and, in right of that uncommon gift of form and colour, entitled to consideration . . . how cold soever at first may be the glance of the questioning and doubting connoisseur, the genius of Burne-Jones will in the end make of him an enthusiastic partisan".[8] Henry James, wondering a little at this adulation of Burne-Jones – "what is called in London a 'craze'" – nevertheless found *Pygmalion* to have "as much as ever the great merit – the merit of having a great charm".[9]

1. *List of my designs drawings and pictures* [etc.] (see cat. no. 67, note 2).
2. Birmingham, *Drawings*, 1939, pp. 90–92 (612'27); London, Southampton and Birmingham, 1975–1976 (269, four exhibited). An annotated list of all the studies appears in Andreas Blühm, "Pygmalion: Die Ikonographie einer Künstlermythos zwischen 1500 und 1900", *Europäische Hochschulschriften* (European University Studies), vol. 90, 1988, pp. 261–264; this overlooks three additional drawings in an album sold at Sotheby's, 10 November 1981, lot 26, repr.
3. Blühm, "Pygmalion", nos. 129 Ic, 129 IIb and 129 IIIb, respectively. A further engraved image commonly confused with *The Heart Desires* – as in Birmingham, *Drawings*, 1939, p. 90 (612'27-A, 1030'27, 1031'27) – is for *The Ring Given to Venus*, another *Earthly Paradise* subject.
4. Harrison and Waters, 1973, col. pls. 20–23; sold at Sotheby's, 8–9 June 1993, lot 24, repr.
5. Under 1875, Burne-Jones lists work "at Laus Veneris, at Troy [*The Story of Troy*, now at Birmingham], at the large set of Pygmalion, at a small picture of two girls with a viol and a roll of music – and at Love's Temple"; see note 1. The last entry for 1878 is: "worked on the large Pygmalions till the end of the year".
6. See Marsh, 1985, pp. 269–288, and Philip Attwood, "Maria Zambaco: Femme Fatale of the Pre-Raphaelites", *Apollo*, vol. 124, July 1986, pp. 31–37.
7. For example, a female nude study, dated 1875, for the statue (Galatea) in *The Hand Refrains*, was sold at Christie's, 5 March 1993, lot 43, repr.
8. *Art Journal*, n.s., vol. 18, July 1879, p. 135.
9. *Nation*, 29 May 1879; reprinted in John L. Sweeney (ed.), *The Painter's Eye: Notes and Essays on the Pictorial Arts by Henry James*, London, 1956, p. 182.

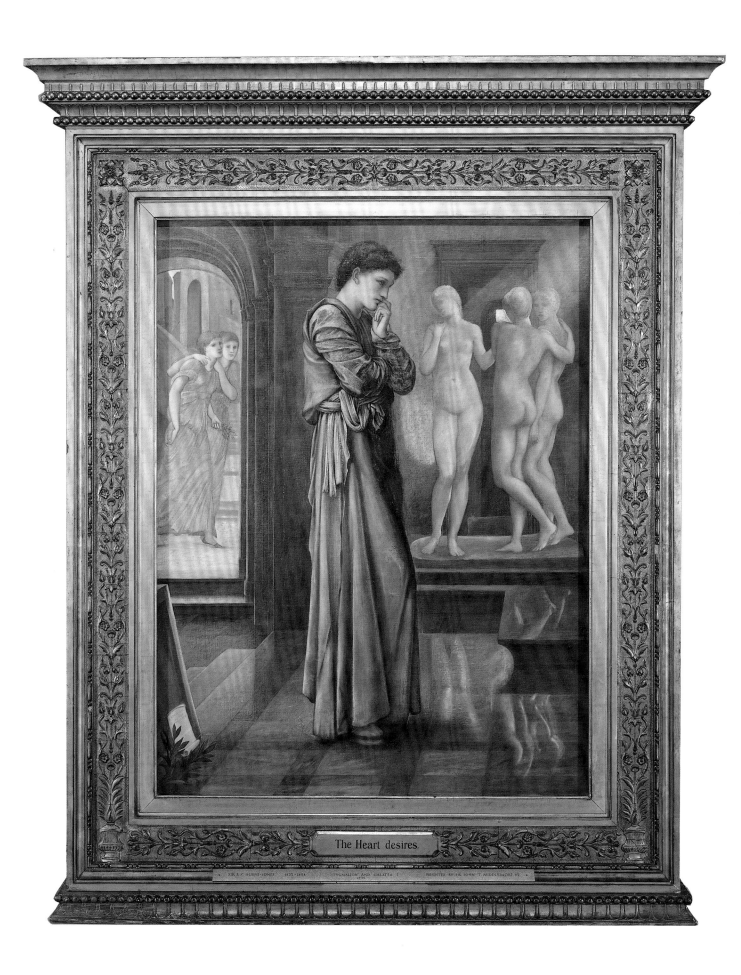

The Heart desires.

SIR E. C. BURNE-JONES 1833-1898 PYGMALION AND GALATEA, I PAINTED BY SIR JOHN T. MIDDLEMORE, BT.
1870

106

EDWARD BURNE-JONES

Pygmalion and the Image: II The Hand Refrains

1875–1878
Oil on canvas
39 x 30 in.; 99.0 x 76.3 cm.
In original frame
Presented by Sir J.T. Middlemore, Bt., 1903 (24'03)

PROVENANCE: As for cat. no. 105

EXHIBITED: As for cat. no. 105

REFERENCES: Birmingham, *Paintings,* 1960, pp. 23–24; London, Southampton and Birmingham, 1975–1976 (137b); Rome, 1986 (34, repr.); London and Birmingham, 1991–1992 (5, repr.)

Fig. 96 EDWARD BURNE-JONES, *Pygmalion and the Image: II The Hand Refrains,* circa 1869; oil on canvas, 26 x 20 in. (66.0 x 51.0 cm.). Private Collection.

*T*wo of the pencil drawings from 1867 show the development of this image.[1] Probably intended to be sequential, the first (fig. 94) shows Pygmalion chipping away at the marble in what is perhaps a basement studio. The following scene (fig. 95), with the sculptor musing over the perfection of his finished work, became the second painting, although again there are differences between the early and later oils. The statue stands on a fairly tidy plinth in the first oil (fig. 96), as in its related drawing, while in the second Burne-Jones returns the loose stone chippings that appear in the preceding sketch. These act as a foil to the smooth surfaces of Galatea's body, and emphasise the sculptor's skill in drawing life out of inanimate material. A *pentimento* is clearly visible between the two figures, where Burne-Jones has painted out a large jar standing on the floor.

1. Birmingham, *Drawings,* 1939, p. 90 (613'27 and 614'27).

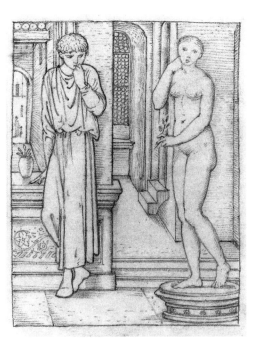

Fig. 94 EDWARD BURNE-JONES, *Pygmalion fashioning the Image,* 1867; pencil on tracing paper, 4 5/8 x 3 1/2 in. (11.7 x 8.9 cm.). Birmingham Museums and Art Gallery (613'27).

Fig. 95 EDWARD BURNE-JONES, *The Hand Refrains,* 1867; pencil on tracing paper, 4 1/2 x 3 1/2 in. (11.5 x 8.9 cm.). Birmingham Museums and Art Gallery (614'27).

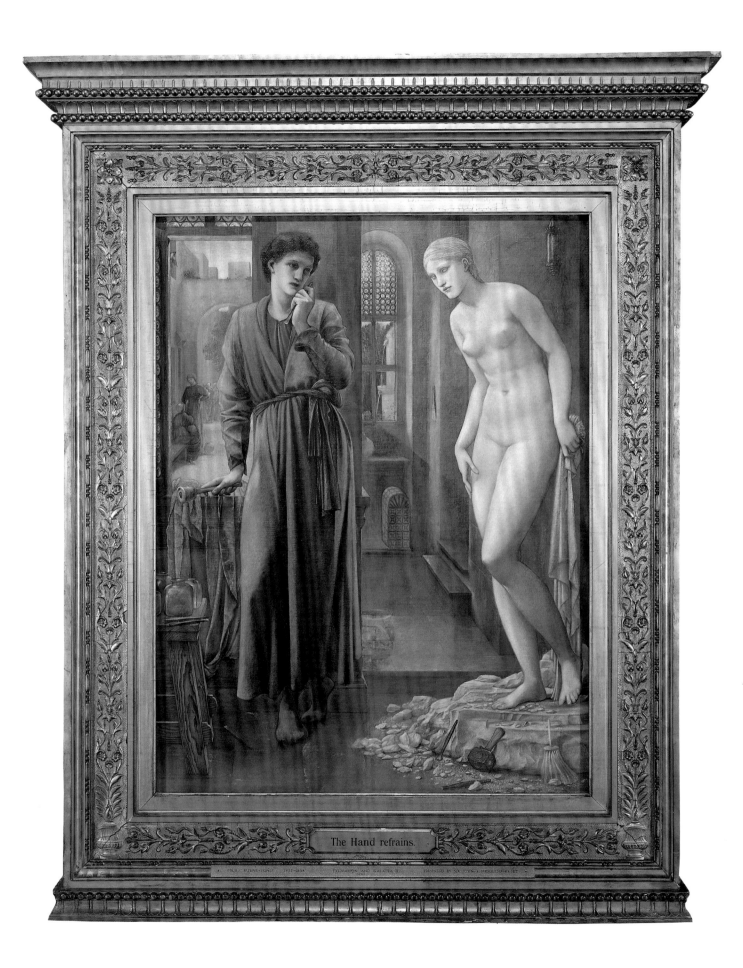

The Hand refrains.

305

107

EDWARD BURNE-JONES

Pygmalion and the Image: III The Godhead Fires

1875–1878
Oil on canvas
39 x 30 in.; 99.0 x 76.3 cm.
Signed and dated, bottom right: 18 EBJ 78
In original frame
Presented by Sir J.T. Middlemore, Bt., 1903 (25'03)

PROVENANCE: As for cat. no. 105

EXHIBITED: As for cat. no. 105

REFERENCES: Birmingham, *Paintings*, 1960, pp. 23–24;
London, Southampton and Birmingham, 1975–1976 (137c);
Rome, 1986 (35, repr.)

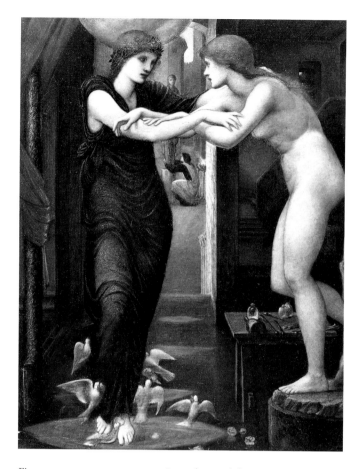

Fig. 97 EDWARD BURNE-JONES, *Pygmalion and the Image: III The Godhead Fires,* 1870; oil on canvas, 26 x 20 in. (66.0 x 51.0 cm.). Private Collection.

*I*n a quite radical change from the earlier oil (fig. 97), Burne-Jones has eliminated the figure of Pygmalion praying to a statue of Venus in the background. Instead, he makes the figure of the goddess appear more unearthly by substituting diaphanous material for her former heavy green drapery. Her left arm is now held in a pose less distracting to the languid intertwining of her right arm with those of Galatea. Such amendments add to the overall limpid brilliance of this scene, the most effective of all the Pygmalion paintings. "We can scarcely imagine the story of Pygmalion being told more beautifully", wrote the critic of the *Art Journal* in 1879, "and the canvas on which we see Venus imparting to Galatea the gift of life is worthy of Raphael".[1]

In the Birmingham collection is a delicate female profile in pencil, identified in an inscription by the artist as a "study for GALATEA in the series of PYGMALION" (fig. 98), and evidently used for *The Godhead Fires*.[2] Although dated 1870, it is closer to the head as painted in the Birmingham version; the model was almost certainly Maria Zambaco,[3] but Burne-Jones may have thought it prudent to dilute the resemblance in both versions.

1. *Art Journal*, n.s., vol. 18, July 1879, p. 135.
2. Birmingham, *Drawings*, 1939, p. 94 (61'24). A similar drawing (60'24), of the same model's right profile, is also dated 1870 and inscribed "study for VENUS in series of PYGMALION", but it does not conform with the head in either oil. Both are reproduced in Rome, 1986 (37–38).
3. There is a decided resemblance to the pencil drawing of Maria Zambaco, dated 1871, reproduced in Rose, 1981, p. 27 (Private Collection).

Fig. 98 EDWARD BURNE-JONES, *"The Godhead Fires": study for Galatea,* 1870; pencil, 6 3/4 x 7 3/4 in. (17.3 x 19.8 cm.). Birmingham Museums and Art Gallery (61'24).

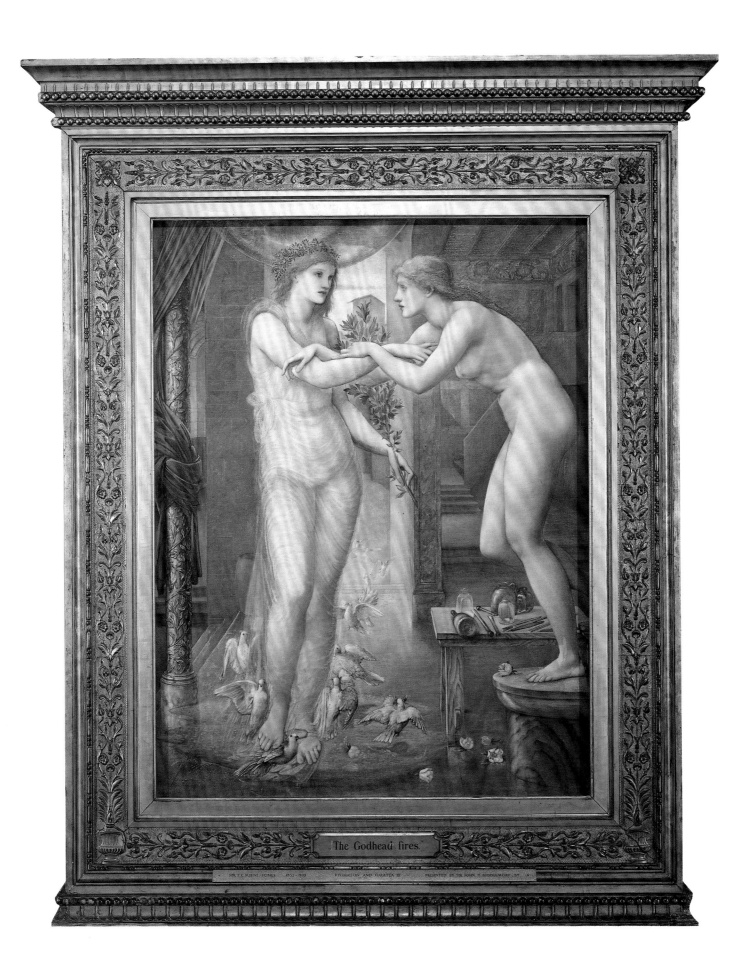

The Godhead fires.

SIR E. C. BURNE-JONES 1833-1898 PYGMALION AND GALATEA III PRESENTED BY SIR JOHN T. MIDDLEMORE, BT.

108

EDWARD BURNE-JONES

Pygmalion and the Image: IV The Soul Attains

1875–1878
Oil on canvas
39 x 30 in.; 99.0 x 76.3 cm.
In original frame
Presented by Sir J.T. Middlemore, Bt., 1903 (26'03)

PROVENANCE: As for cat. no. 105

EXHIBITED: As for cat. no. 105

REFERENCES: Birmingham, *Paintings*, 1960, pp. 23–24;
London, Southampton and Birmingham, 1975–1976 (137d);
Rome, 1986 (36, repr.)

*T*he second version of *The Soul Attains* shows the least variation from its earlier counterpart (fig. 99). Apart from a few decorative details, the chief difference lies in the brighter, harder colour and tone which pervade the later series.

The figures remain essentially unaltered, although Galatea's features have been re-modelled. Burne-Jones has slightly simplified the rich, angular folds of Pygmalion's robe and cloak, for which a splendid pencil study exists at Birmingham, presumably of circa 1870 (fig. 100).[1] Georgiana Burne-Jones states that the head of Pygmalion was drawn from W.A.S. Benson (1854–1924), later a designer and metal-worker who assisted both Burne-Jones (making studio props) and Morris.[2] They met only in about 1877, however, and there is not much difference between the 1878 head of Pygmalion and its 1870 predecessor: presumably Benson bore a resemblance to the artist's original model.

1. Birmingham, *Drawings*, 1939, p. 94, repr. p. 430 (476'27); Rome, 1986 (39, repr.).
2. Burne-Jones, *Memorials*, 1904, vol. 2, p. 81. See Rosalind Dépas, "The Bensons: A Family in the Arts and Crafts Movement", *Journal of Pre-Raphaelite and Aesthetic Studies*, vol. 1, no. 2, Fall 1988, pp. 75–85.

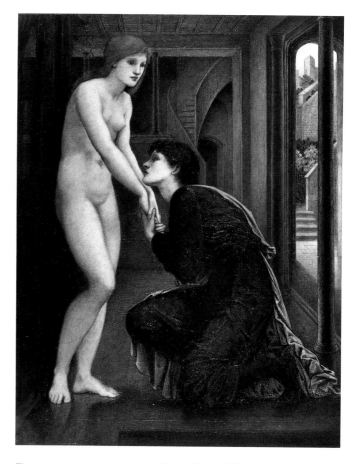

Fig. 99 EDWARD BURNE-JONES, *Pygmalion and the Image: IV The Soul Attains,* 1870; oil on canvas, 26 x 20 in. (66.0 x 51.0 cm.). Private Collection.

Fig. 100 EDWARD BURNE-JONES, *"The Soul Attains": study for Pygmalion,* circa 1870; pencil, 8 7/8 x 11 1/4 in. (22.6 x 28.6 cm.). Birmingham Museums and Art Gallery (476'27).

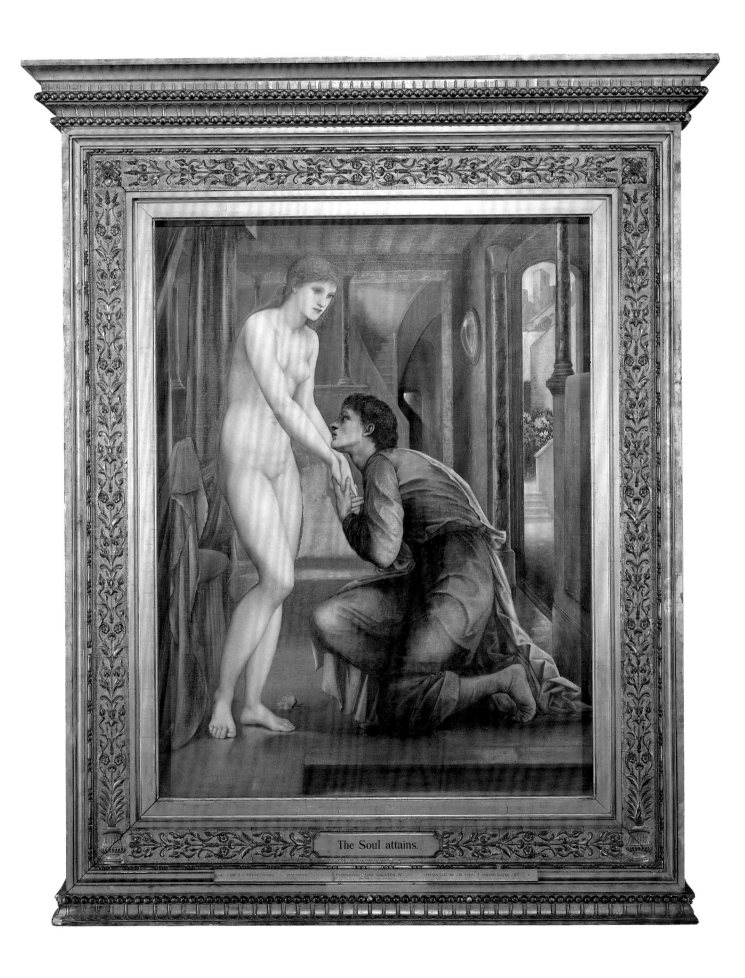

The Soul attains.

309

GEORGE PRICE BOYCE

Thorpe, Derbyshire

1879–1880
Watercolour
11 1/4 x 16 1/4 in.; 28.5 x 42.2 cm.
Signed and dated, bottom right: G.P. Boyce. 1879.'80
Inscribed in ink on label, formerly on old frame: Thorpe,
Derbyshire / G.P. Boyce / West House, Glebe Place / Chelsea.
Annotated in pencil: Light from the left hand!
Presented by Charles Fairfax Murray, 1903 (497'04)

REFERENCES: Birmingham, *Paintings &c.*, [1930], pp. 18–19;
London, Tate, 1987 (61, repr.); Tokyo, 1990 (104, repr.)

Having endured a desultory period in an architect's office, Boyce decided to become an artist after twice, in 1849 and 1851, encountering the painter David Cox (1783–1859) at Bettws-y-Coed in North Wales. On the second occasion, Boyce confided in his celebrated diary – an important source of information on artistic circles of the mid-nineteenth century – that he had "completed drawing from Church, which Mr Cox said looked like a Pre-Raffaelite drawing".[1]

Probably through Thomas Seddon (see cat. no. 28), Boyce was introduced to Rossetti, who became a lifelong friend. As a collector of Rossetti's drawings, he was visited by Ruskin, who took an interest in his early watercolours. The only other work by Boyce in the Birmingham collection is a small watercolour of *The Church of the Frari, Venice, from the Campiello San Rocco*, one of many painted during an enjoyable stay in the city prompted by Ruskin's enthusiasm.[2] Although Boyce was a founder member of the Hogarth Club in 1858 (see cat. no. 44) and had participated in the 1857 Exhibition at Russell Place, as a painter he did not immediately follow the same Pre-Raphaelite path as other Ruskin protégés such as Brett and Inchbold; his relative financial independence, resulting from his father's successful business interests, allowed him this freedom.

His earliest important watercolours date from 1859 and after. A series of unobtrusive but brilliantly composed views along the Thames Valley, such as *Streatley Mill at Sunset* (1859; Private Collection)[3] and *At Binsey, near Oxford* (1862; Cecil Higgins Art Gallery, Bedford),[4] are recognised as masterpieces in a variation of understated Pre-Raphaelite technique, emphasising flat, bright colour and quirky observation of detail. These works and others done in Egypt in the winter of 1861–1862 were well enough received to gain Boyce election as an Associate of the Old Water Colour Society in February 1864, at the same time as Burne-Jones. For many years thereafter, he puzzled and delighted critics and collectors with watercolours which never failed to avoid the obvious view or conventional composition. "Mr Boyce", the *Art Journal* opined, "is singular in the choice of his subjects, inasmuch as he loves to plant his sketching stool just where there is no subject",[5] while F.G. Stephens, in the *Athenaeum*, acknowledged that "he has the power . . . of making a common thing show grandly and gravely".[6]

Thorpe, Derbyshire is just such a deceptively simple subject, painted soon after Boyce was elected a full Member of the Old Water Colour Society in 1878. It is now a little faded, but still displays the artist's innate feeling for the quiet golden harmonies of an English autumn landscape; the setting is a village just north of Ashbourne, in the Peak District. Reviewing the Society's summer exhibition of 1880, where this work was shown, Stephens considered the handling of the gate in the foreground "rather thin", but was otherwise much taken with "a picture of sloping meadows, woodland, an ivy-clad church tower, a lane ending in a farm gate and a rough hedge. The whole is suffused by warm grey light, and the tenderness of the subtly graded local colouring of the sky, field and foliage is exquisite".[7]

1. Surtees, 1980, p. 3 (entry for 27 August 1851).
2. Birmingham, *Paintings &c.*, [1930], p. 19 (345'27).
3. London, Tate, 1987 (24, repr.).
4. London, Tate, 1987 (35, repr.).
5. *Art Journal*, n.s., vol. 5, July 1866, pp. 174–175.
6. *Athenaeum*, 30 April 1864, p. 618.
7. *Athenaeum*, 1 May 1880, p. 573.

110

DANTE GABRIEL ROSSETTI

La Donna della Finestra

Circa 1881 (left unfinished in 1882)
Oil on canvas, over black chalk under-drawing
37 3/4 x 24 2/4 in.; 95.9 x 87.0 cm.
Purchased, 1882 (2465'85)

PROVENANCE: Rossetti sale, Christie's, 12 May 1883, lot 101
(45 guineas), bought for the Birmingham collection

REFERENCES: Surtees, 1971, no. 255.R.1; London and
Birmingham, 1973 (361, shown in Birmingham only); Tokyo,
1990 (88, repr.)

The first two major Pre-Raphaelite pictures to enter the
Birmingham collection were both unfinished oils by Rossetti,
bought directly from the artist's studio sale in May 1883. Each
provides an interesting insight into Rossetti's later painting
methods. *The Boat of Love*, whose fragile surface now pre-
cludes travel, is a large canvas painted in brown monochrome,
begun in 1874 but abandoned in 1881.[1] Rossetti wanted to
experiment on a large subject with multiple figures, and
brought the composition to a considerable degree of detail
and modelling, even directing his studio assistant H.T. Dunn
to construct a model of a medieval ship.[2] Finding no patron
to commission its completion, the artist went no further with
the work, yet it gives some idea of the likely development of
his style had he lived beyond the age of only fifty-four.

La Donna della Finestra is a replica, begun around 1881,
of an oil dating from 1879, which itself derives from a pastel
of 1870. In its half-finished state, however, the Birmingham
painting is rather more striking than some of the completed
replica oils which occupied Rossetti in the last years of his life
and provided him with a steady income. The outline of the
body is roughly sketched in beneath a vigorously applied layer
of Indian red, with the details of head and hands carefully put
in first, from the 1870 drawing or a similar likeness.

The sitter is Jane Morris, and the two earliest drawings of
her in this pose, both dated 1870 and in pastel, are among
Rossetti's most powerful portraits of her, stemming from the
period of a growing affection between them. Rossetti never
parted with the version now at the Whitworth Art Gallery,
University of Manchester (fig. 101).[3] Another more elaborate
design, given an inscription from Dante's *Vita Nuova*, and
now at Bradford Art Gallery and Museums,[4] tilts the head to
the angle used for the subsequent oil and the present replica;
this drawing Rossetti sold to his solicitor friend Henry Vertue
Tebbs in 1881.[5]

The oil which Rossetti completed in 1879 is now at the
Fogg Art Museum, Harvard University (fig. 102).[6] Its twin

foci remain Jane's head and hands, united by the shimmering
gold robe which Rossetti used in several of his late works; its
translucence picks up the green of the full silk dress beneath,
which was chosen again to clothe Jane Morris in his last two
important paintings, *The Day Dream* (1879–1880; Victoria
and Albert Museum, London)[7] and *The Salutation of Beatrice*
(1880–1881; The Toledo Museum of Art, Ohio).[8] The exag-
gerated foliage and rose blooms give the picture a literal 'hot-
house' atmosphere, enhanced by a broad gold frame similar to
that for Birmingham's version of *Beata Beatrix* (cat. no. 104).[9]
A long inscription on the Fogg frame, both in the original
Italian of the *Vita Nuova* and Rossetti's translation, identifies
the subject as the woman who looks down from her window
with pity upon the poet Dante as he grieves for Beatrice.
Symbolically, she represents Philosophy (in the modern sense
of the acceptance of events), but Rossetti also chose to iden-
tify her as Gemma Donati, whom Dante was eventually to
marry. William Michael Rossetti offered this analysis of what
he considered one of his brother's most important works:

> Humanely she is the Lady at the window; mentally she
> is the Lady of Pity. This interpretation of soul and body
> – this sense of an equal and indefeasible reality of the
> thing symbolised, and of the form which conveys the
> symbol – this externalism and internalism – are constantly
> to be understood as the keynote of Rossetti's aim and
> performance in art.[10]

1. Birmingham, *Paintings,* 1960, pp. 126–127 (2476'85); Surtees, 1971,
no. 239, pl. 344.
2. Surtees, 1971, p. 137.
3. Surtees, 1971, no. 255D, pl. 385.
4. Surtees, 1971, no. 255A, pl. 384; Tokyo, 1990 (89, repr.).
5. See Bryson (ed.), 1976, pp. 174–175.
6. Surtees, 1971, no. 255, pl. 383. Rossetti wrote to Jane Morris on 26
August 1879: "Every one is specially delighted with the Donna della
Finestra done from your cartoon. It is certainly now my very best"
(Bryson (ed.), 1976, p. 117).
7. Surtees, 1971, no. 259, pl. 388.
8. Surtees, 1971, no. 250, pl. 390.
9. The picture in its frame is reproduced, in colour, in Faxon, 1989,
pl. 10.
10. Rossetti, 1889, p. 108; quoted in Surtees, 1971, p. 151.

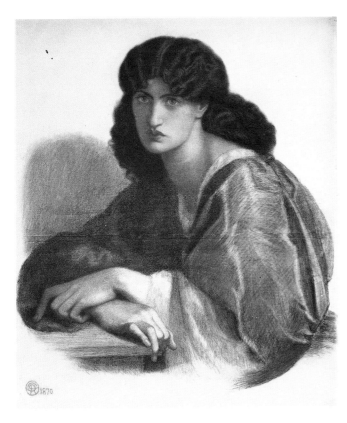

Fig. 101 DANTE GABRIEL ROSSETTI, *La Donna della Finestra*, 1870; pastel, 33 3/8 x 28 3/8 in. (84.8 x 72.0 cm.). Whitworth Art Gallery, University of Manchester.

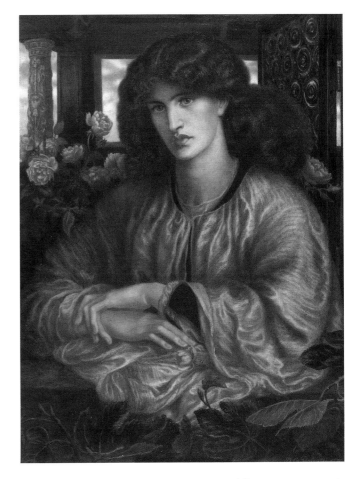

Fig. 102 DANTE GABRIEL ROSSETTI, *La Donna della Finestra*, 1879; oil on canvas, 39 3/4 x 29 1/4 in. (101.7 x 4.3 cm.). Fogg Art Museum, Harvard University, Cambridge, Massachusetts.

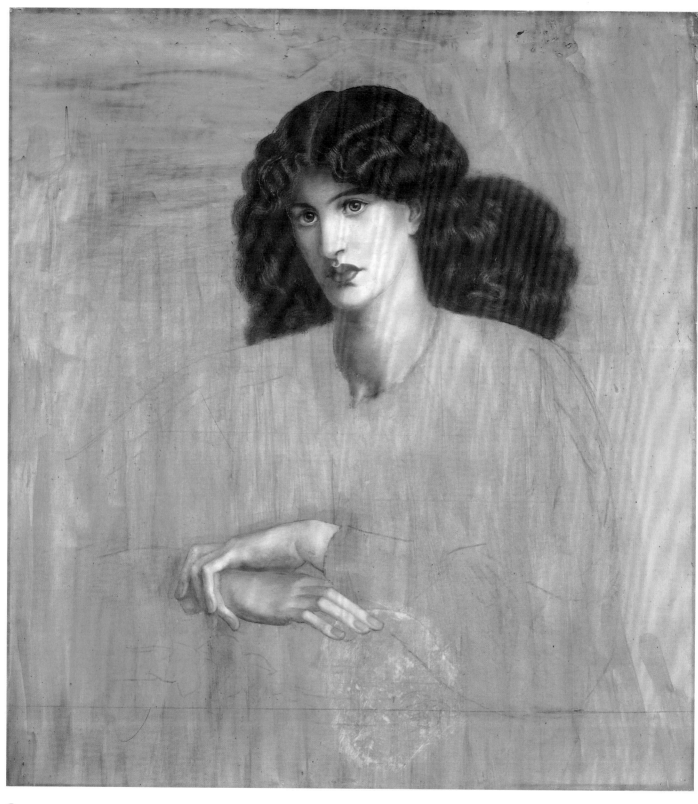

Cat. no. 110

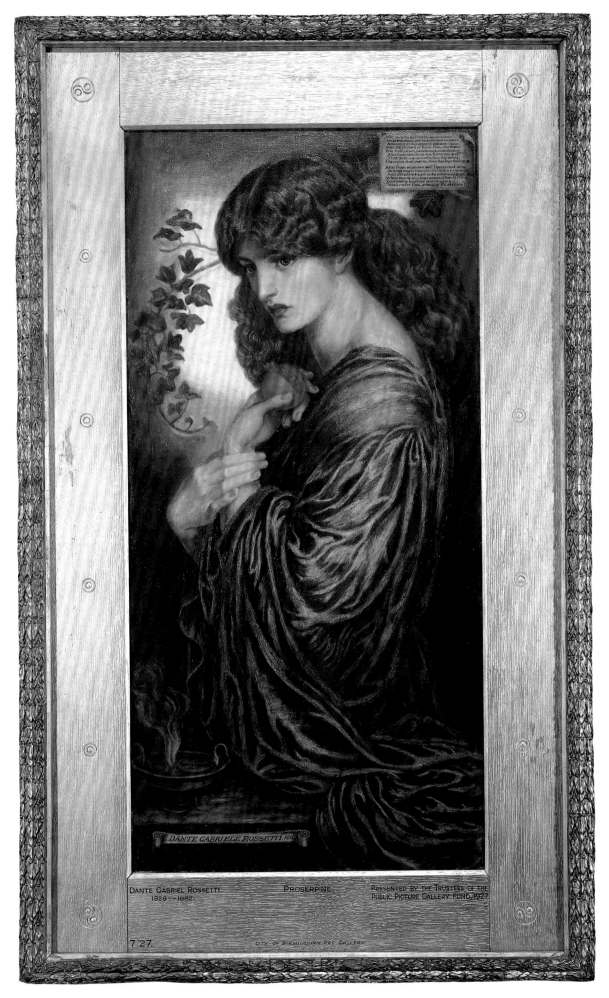

Cat. no. III

111

DANTE GABRIEL ROSSETTI

Proserpine

1881–1882
Oil on canvas
31 x 15 3/8 in.; 78.7 x 39.2 cm.
Signed and dated, on scroll, bottom left: DANTE GABRIELE
ROSSETTI 1882
Inscribed on cartouche, top right, with Rossetti's sonnet,
"Proserpine":

> Afar away the light that brings cold cheer
> Unto this wall, – one instant and no more
> Admitted at my distant palace-door.
> Afar the flowers of Enna from this cheer
> Dire fruit, which, tasted once, must thrall me here.
> Afar those skies from this Tartarean gray
> That chills me: and afar, how far away,
> The nights that shall be from the days that were.
>
> Afar from mine own self I seem and wing
> Strange ways in thought, and listen for a sign:
> And still some heart unto some soul doth pine,
> (Whose sounds mine inner sense is fain to bring,
> Continually together murmuring,)
> "Woe's me for thee, unhappy Proserpine"!

In original frame
Presented by the Trustees of the Public Picture Gallery Fund,
1927 (7'27)

PROVENANCE: L.R. Valpy; William Imrie; his sale, Christie's,
28 June 1907, lot 135 (440 guineas); Christie's, 29 May 1908,
lot 477 (450 guineas); Colonel James B. Gaskell, by 1913;
Christie's, 30 April 1926, lot 150 (340 guineas), bought
Sampson, from whom acquired (525 guineas)

REFERENCES: Birmingham, *Paintings*, 1960, p. 128; Surtees,
1971, no. 233.R.3; Tokyo, 1990 (91, repr.)

As with *La Donna della Finestra* (cat. no. 110), *Proserpine*
is another depiction of Jane Morris, this time as a doomed
classical heroine. In a letter to the first owner of the prime ver-
sion, Rossetti described the picture thus:

> The figure represents Proserpine as Empress of Hades.
> After she was conveyed by Pluto to his realm, and became
> his bride, her mother Ceres importuned Jupiter for her
> return to earth, and he was prevailed on to consent to
> this, provided only she had not partaken of any of the
> fruits of Hades. It was found, however, that she had eaten
> one grain of a pomegranate, and this enchained her to
> her new empire and destiny. She is represented in a
> gloomy corridor of her palace, with the fatal fruit in her
> hand. As she passes, a gleam strikes on the wall behind
> her from some inlet suddenly opened, and admitting
> for a moment the light of the upper world; and she
> glances furtively towards it, immersed in thought. The

incense-burner stands beside her as the attribute of a
goddess. The ivy-branch in the background (a decorative
appendage to the sonnet inscribed on the label) may be
taken as a symbol of clinging memory.[1]

This was one of Rossetti's favourite images of Jane, and
was first drawn as a large pastel at Kelmscott in the summer
of 1871 (Ashmolean Museum, Oxford).[2] As Virginia Surtees
observes, "The subject of Proserpine bound to her husband
except for a few short periods of escape would seem to bear
an analogy to the circumstance of their own two lives"[3]; the
sexual symbolism of the half-opened fruit can also hardly be
overlooked.

The first oil painting derived from the 1871 pastel caused
Rossetti severe problems: although completed in the spring of
1873, it had to be repainted, and was then damaged during
delivery to F.R. Leyland in Liverpool. Finally repaired and
sold in 1877, it was one of his few late oils to appear in pub-
lic, at the Manchester Royal Institution Art Treasures
Exhibition of 1878. Later bought by the painter L.S. Lowry, it
is now in the J. Paul Getty Museum, Malibu, California.[4]
Leyland received a replacement oil in 1874 (now in the Tate
Gallery, London),[5] and in 1880 Rossetti reluctantly made a
replica in coloured chalks for William Graham, "to meet a
debt which he proved (to my surprise) of £100 . . . and which
had got quite overlooked for years".[6]

All these versions of *Proserpine* are about 46 x 22 inches
(117 x 56 cm.), and bear Rossetti's sonnet in Italian (beginning
"Lungi è la luce che in sù questo muro"). The Birmingham
version is smaller in size, and carries the English text: both
poems appear in *Ballads and Sonnets*, which was published in
October 1881 along with *Poems* (mostly a re-printing of older
work). In a curious variation, Rossetti has substituted auburn
hair for Jane Morris's black tresses (although William Michael
Rossetti did describe her hair as "tending to black, yet not
without some deep-sunken glow"). Otherwise, the likeness
can be compared with one of the photographs taken for
Rossetti by John R. Parsons in July 1865 (fig. 103).[7] The paint-
ing was done to fulfil a bargain with the collector Leonard
Valpy, as one of a number of small oils to compensate him for
relinquishing the massive *Dante's Dream at the Time of the
Death of Beatrice* (1869–1871), which was purchased by
Liverpool Corporation in 1881 and is now in the Walker Art
Gallery, Liverpool.[8] Rossetti began this final *Proserpine* in
September 1881: certain areas of hasty execution conform with
the belief that this was the last picture finished by the artist,
just a few days before his death at Birchington-on-Sea on
Easter Sunday 1882.

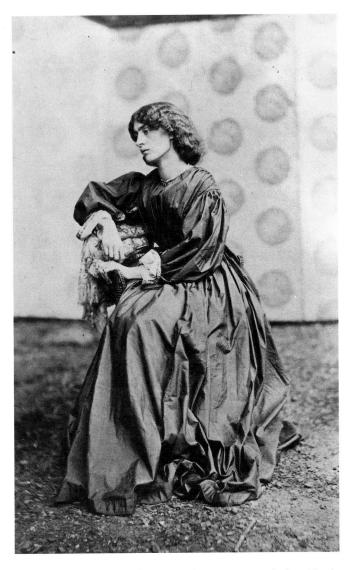

Fig. 103 JOHN R. PARSONS (copy print by EMERY WALKER), *Jane Morris*, 1865; collodion photograph, 7 7/8 x 4 3/4 in. (19.8 x 12.2 cm.). Birmingham Museums and Art Gallery (359'41A).

1. Letter to W.A. Turner, quoted in Surtees, 1971, p. 131.

2. Surtees, 1971, no. 233A; reproduced in Jon Whiteley, *Oxford and the Pre-Raphaelites*, Oxford, 1989 (20).

3. Surtees, 1971, p. 131.

4. Surtees, 1971, no. 233; London, Tate, 1984 (151, repr.). Sold at Christie's, 27 November 1987, lot 140, repr., where bought by the J. Paul Getty Museum.

5. Surtees, 1971, no. 233.R.2

6. Surtees, 1971, no. 233C; presumably the drawing sold at Christie's, 20 October 1970, lot 165, repr.

7. See Tokyo, 1990 (147–153, repr.) for the seven copy prints by Emery Walker now at Birmingham; an album containing the most complete set of these photographs is at the Victoria and Albert Museum, London.

8. Surtees, 1971, no. 81.R.1, pl. 97.

112

EDWARD BURNE-JONES

The Rape of Proserpine

Circa 1883–1884
Pencil, touched with red chalk
8 1/8 x 12 7/8 in.; 20.7 x 32.7 cm.
Signed, bottom right: EBJ
Bequeathed by J.R. Holliday, 1927 (446'27)

REFERENCES: Birmingham, *Drawings*, 1939, p. 115; London, Southampton and Birmingham, 1975–1976 (323)

A picture on the subject of Proserpine (see cat. no. 111) was apparently commissioned from Burne-Jones by Ruskin some time before the critic wrote to "darling Ned" on 2 February 1883: "Also, if my Proserpine isn't begun, *please* begin it; and if it is stopped, go on again; and if it is going on again, do a nice little bit as the Spring comes".[1] Burne-Jones's immediate response was that "Proserpine bides, my dear, I haven't begun her yet, I am practising my art; one day I mean to paint a picture".[2] According to Georgiana Burne-Jones, Ruskin had to wait "more than a year" before receiving news from Ned: "I have designed what should look beautiful and awful if it were well done, Pluto going down with Proserpine into the earth, and a nice garden, a real one, all broken to bits, and fire breaking out amongst the anemones; and Pluto is an awful thing, shadowy and beautiful".[3]

Evidently, Ruskin received what must be the earlier of two pencil drawings matching this description; now at the Montreal Museum of Fine Arts, this has the energetic strength of a first design (fig. 104).[4] The Birmingham drawing is a more precise and detailed replica of the composition, with some substantial refinements: the sky is all but eliminated in favour of a raised horizon and additional groups of female attendants. A more careful delineation of the clinging, swirling drapery of this animated mass of jostling figures emphasises what one recent commentator has called the "proto-Art Nouveau character" of Burne-Jones's work, which indeed led to his esteem among such European Symbolists as Fernand Khnopff and Jan Toorop.[5] The touches of red chalk over areas of the drawing suggest possible intentions for further alteration or translation into another medium, perhaps even engraving: the whole design is in the spirit of prints by early Italian artists such as Marcantonio Raimondi.[6] No finished related work is known, although a large drawing of the subject exists in coloured chalks and bodycolour, one of the artist's strange, later experimental pieces.[7]

Burne-Jones may have been aware of a number of allusions to the story of Proserpine (or Persephone) in Ruskin's writings. In the fifth and final volume of *Modern Painters,* reprinted in 1873, Ruskin muses on "the goddess of the flower":

That of the Greeks is set forth by the fable of the Rape of Proserpine. The Greeks had no goddess Flora correspondent to the Flora of the Romans. The Greek Flora is Persephone, the "bringer of death", because they saw that the force and use of the flower was only in its death. For a few hours Proserpine plays in the Sicilian fields; but, snatched away by Pluto, her destiny is accomplished in the Shades, and she is crowned in the grave.[8]

Both Edward and Georgiana Burne-Jones also knew that Proserpine was an affectionate name used by Ruskin for Rose La Touche, the young woman who had turned down his offer of marriage and then died in 1875 aged only twenty-seven. "A design of Proserpine", listed in Burne-Jones's retrospective record of his work under 1875, may have been the result of an earlier proposition by Ruskin for a memorial picture, for which the subject of young womanhood suddenly snatched from mortal life would have been poignantly appropriate.[9]

1. Ruskin, *Works*, 1909, vol. 37, p. 437.
2. Burne-Jones, *Memorials*, 1904, vol. 2, p. 129.
3. Burne-Jones, *Memorials*, 1904, vol. 2, p. 129.
4. *The Earthly Paradise: Arts and Crafts by William Morris and his Circle from Canadian Collections,* Toronto and tour, 1993–1994 (A39, repr.).
5. Douglas Schoenherr, in *Earthly Paradise: Arts and Crafts by Morris,* 1993, p. 91. For Burne-Jones's influence on the Symbolists, see Laurent Busine, "From Edward Burne-Jones to Fernand Khnopff", in *Burne-Jones 1833–1898: Dessins du Fitzwilliam Museum de Cambridge*, Nantes, Charleroi and Nancy, 1992, pp. 59–68.
6. Burne-Jones is known to have made a partial copy of *The Rape of Proserpine*, a drawing attributed to Maso Finiguerra, from the so-called *Florentine Picture-Chronicle* (an album of fifteenth-century Florentine drawings) acquired by Ruskin in 1873 and subsequently sold by him to the British Museum; see London, Southampton and Birmingham, 1975–1976 (354).
7. London, Southampton and Birmingham, 1975–1976 (324).
8. Ruskin, *Works,* 1905, vol. 5, p. 474.
9. See *Earthly Paradise: Arts and Crafts by Morris,* 1993, p. 90.

Fig. 104 EDWARD BURNE-JONES, *The Rape of Proserpine*, circa 1883; graphite on paper, 10 x 14 in. (25.2 x 36.0 cm.). The Montreal Museum of Fine Arts; Gift of Mr and Mrs F.J. Berryman.

113

SIMEON SOLOMON

Night and Sleep

1888
Blue and red crayon
14 1/8 x 11 5/8 in.; 36.0 x 29.5 cm.
Signed and dated, bottom left: SS / 1888 (initials in monogram)
Inscribed, at bottom: NIGHT AND SLEEP
Presented by Cecil F. Crofton, 1908 (306'08)

REFERENCES: Birmingham, *Paintings &c.*, [1930], p. 188; Reynolds, 1984, pl. 71; London and Birmingham, 1985–1986 (68, repr.); Raymond Lister, *British Romantic Painting*, Cambridge, 1989 (75, repr.).

Only two years after his *succès d'estime* in 1871 with "A Vision of Love Revealed in Sleep" (see cat. no. 94), Solomon suffered the catastrophe of being arrested in a public lavatory off Oxford Street, in the company of a sixty-year-old stableman by the name of George Roberts. Charged with gross indecency, Solomon was found guilty at the Clerkenwell Petty Sessions on 24 February 1873, fined £100, and sentenced to six weeks in the Clerkenwell House of Correction (his unfortunate companion Roberts was given eighteen months).[1]

Although his public reputation was irreparably damaged – the author of the Birmingham exhibition catalogue of 1891 could only bring himself to declare that "in dealing with art, as with life, the Oriental notions were natural to him"[2] – Solomon's later artistic career may not necessarily have been thrown much off course. *Night and Sleep* is typical of the heady, febrile allegorical depictions of abstract concepts which Solomon had been producing before 1873, but which became his staple work in the 1880s and 1890s. By 1884 he was a resident in the St Giles Workhouse, Seven Dials, where he was apparently quite content, supposedly claiming that "I like it here, it's so central".[3]

Night and Sleep is one of seven late Solomon drawings presented to Birmingham by Cecil Crofton in 1908. The juxtaposition of profile heads is a compositional device used as early as 1867 in *The Two Sleepers and the One that Watcheth*.[4] A similar drawing of *Sleep*, along with another entitled *"I Sleep: My Hearth Waketh"*, dates from 1886,[5] and at least two variants of the present design are seen in *Night and her Child Sleep* of 1889, and *Night looking upon Sleep – her Beloved Child* of 1893.[6] The critic and aesthete Arthur Symons provided an acute commentary on these ethereal images:

> These faces, with their spectral pallor . . . are full of morbid delicacy like the painting of a perfume. Here as always there is weakness, insecurity, but also a very personal sense of beauty. . . . These faces are without sex; they have brooded among ghosts of passions till they have become the ghosts of themselves; the energy of virtue or of sin has gone out of them, and they hang in space, dry, rattling, the husks of desire.[7]

1. See Gayle Seymour, "The Trial and its Aftermath", in London and Birmingham, 1985–1986, pp. 28–30.
2. Birmingham, 1891, p. 41.
3. Reynolds, 1984, p. 89.
4. T. Earl Welby, *The Victorian Romantics 1850–70*, London, 1966, frontispiece.
5. Christie's, 16 February 1984, lots 103, 104, repr.
6. Phillips, 21 November 1988, lot 80, repr., and London and Birmingham, 1985–1986 (72, repr.), respectively.
7. *Studies in Seven Arts*, 1906, quoted in Reynolds, 1984, pp. 24–25.

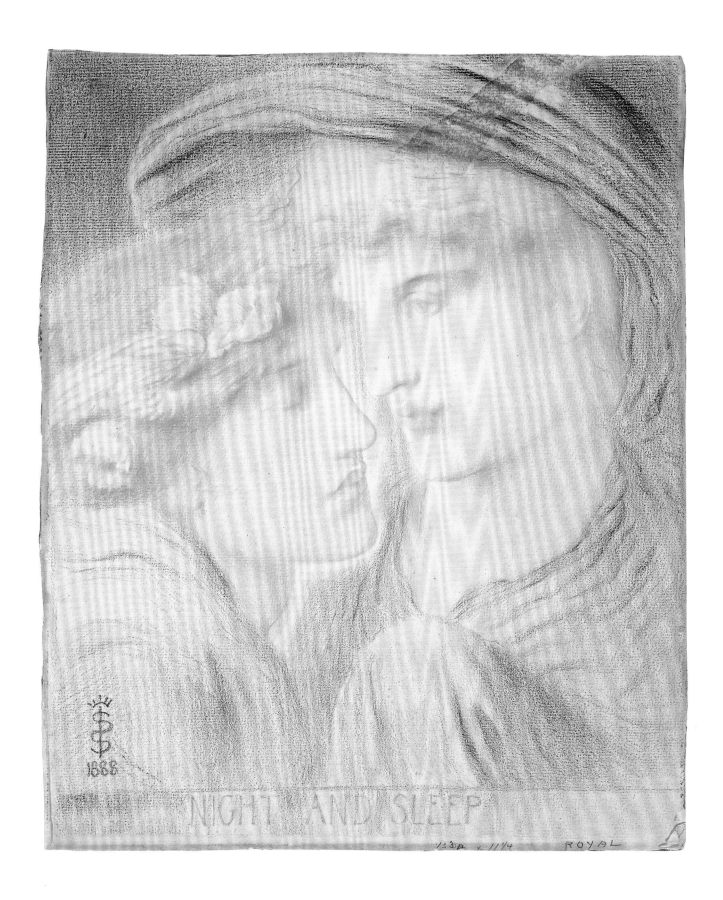

NIGHT AND SLEEP

114

WILLIAM HOLMAN HUNT

May Morning on Magdalen Tower, Oxford

1888–1893
Oil on canvas
15 1/4 x 19 1/4 in.; 38.8 x 48.8 cm.
Frame of copper repoussé, designed by the artist and
executed by the Guild of Handicraft, incorporates scrolls
that are inscribed, top: MAY MORNING / MAGDALEN TOWER
Bottom: AND FYRY PHEBVS RYSETH VP SO BRIGHTE / that al
the orient lavgheth of the lighte
Presented by Mr and Mrs Barrow Cadbury, 1907 (132'07)

EXHIBITED: Kensington Church Education Board, Campden
House Loan Exhibition, 9–11 June 1896; Royal Birmingham
Society of Artists, 1897 (292); London, Leicester Galleries,
1906 (2); Manchester, 1906 (18); Liverpool, 1907 (59)

FRAME EXHIBITED: London, Armourers' and Brasiers' Hall,
Exhibition of Metalwork, 1890 (34)

REFERENCES: Birmingham, *Paintings*, 1960, pp. 79–80;
Liverpool and London, 1969 (60); Bennett, 1988, pp. 99,
103, fig. 45

A label on the back of the frame, in the artist's hand-
writing, explains the subject: "It is an ancient custom, observed
annually at Magdalen College, for the Fellows and President,
with the Choristers, to ascend the Tower, and sing a hymn as
the sun emerges above the horizon". A further description on
this label – "original study, finished, for the painting" – matches
Hunt's laconic account in his autobiography:

> On the morning I ascended the Tower, making observa-
> tions and sketches, and a few days later I returned to
> settle to work. For several weeks I mounted to the Tower
> roof about four in the morning with my small canvas to
> watch for the first rays of the rising sun, and to choose
> the sky which was most suitable for the subject. When
> all was settled I repeated the composition upon a larger
> canvas, the President obligingly placing at my disposal a
> studio in the new buildings of the College.[1]

Hunt's first ascent was on 1 May 1888,[2] and he had complet-
ed the large painting (Lady Lever Art Gallery, Port Sunlight;
fig. 105) by August 1890, when he invited Millais to see it.[3]
That picture was exhibited on its own at the Gainsborough
Gallery, 25 Old Bond Street, London, from 9 May to 1 August
1891, and was shown at the Ryman Gallery, High Street,
Oxford, in November of that year; a seven-page explanatory
pamphlet accompanied its exhibition. Hunt then returned
to this smaller, first version, completing it "with some last
touches" in June 1893.[4]

Mary Bennett's 1988 catalogue of Pre-Raphaelite paint-
ings at the National Museums on Merseyside includes an
exhaustive and illuminating account of the genesis, content
and critical reception of *May Morning*.[5] Hunt wrote in 1889
that he had long wanted to paint the subject, fearing that it
might since have been "snapped up, as interesting ideas will
be".[6] He had probably heard of the custom during a visit to
Oxford in 1851, when the ceremony, although rooted in tradi-
tion and first reliably recorded in the seventeenth century,
had been recently revived by Dr J.R. Bloxam (1807–1891).
Bloxam's portrait is included as the fourth figure from the
right; two figures further to the right is Sir John Stainer (1840–
1901), an organist and composer of the *Crucifixion*, first per-
formed in 1887, who was appointed Professor of Music at
Oxford in 1889. Other Fellows of the College are included,
along with some of the Magdalen choristers: "Among those
there at the time", Hunt wrote in 1906 to Barrow Cadbury,
the donor of this oil, "I selected some half dozen eminently
suitable for pictorial treatment, and I supplied the places of
the others from other chorister boys, my own son being at the
time one at Temple Grove School".[7] Hilary Lushington
Holman Hunt, born in 1879, is the first boy chorister from
the right, holding his music at waist level. The one major dif-
ference between the two paintings is the substitution in the
larger version of a bearded adult singer in this group, pre-
sumably to break up the repetitive line of boys' heads.

Hunt's picture was not meant, therefore, as a literal tran-
scription of a single event, but "rather to represent the spirit
of a beautiful, primitive, and in a large sense eternal service".[8]
In his letter to Barrow Cadbury, the artist similarly admitted
that "my treatment of the ceremony is rather abstract than of
prosaic fact, inasmuch as on May mornings nowadays half the
tower roof is crowded by undergraduates waiting the termi-
nation of the hymn to engage in youthful frolic".[9] Hunt
"used an artistic license [*sic*] to remove" these figures, together
with an "unsightly" handrail running across the roof.[10]
Instead he put in, on the extreme right, the figure of a Parsee:
as a sun worshipper, he represents the ancient origins of the
event, although it was reported that a Parsee member of the
Indian Institute at Oxford had attended the ceremony on at
least one occasion.[11] The silver monteith (a large bowl) in the
foreground is the oldest piece of the College's plate, dating
from the reign of William III. The flowers are appropriately
symbolic, with the lily serving as an emblem of St Mary the
Virgin and St Mary Magdalen; the fritillary was said to have
been brought from the East to England by the Crusaders.

The frames for both versions were designed by the artist
and executed in copper repoussé by John Williams of the
newly established Guild of Handicraft, which had been
founded in 1888 by C.R. Ashbee with the moral and financial

PRESENTED BY MR AND MRS BARROW CADBURY, 1907

MAY MORNING ON MAGDALEN TOWER, OXFORD by W. HOLMAN HUNT (1827-1910) 132/07

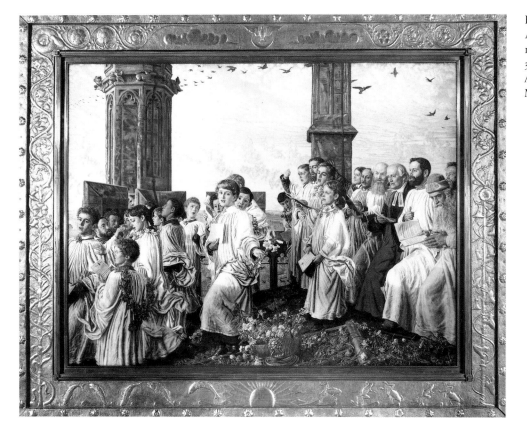

Fig. 105 WILLIAM HOLMAN HUNT, *May Morning on Magdalen Tower, Oxford,* 1888–1890; oil on canvas, 60 3/4 x 78 3/4 in. (154.5 x 200.0 cm.). Lady Lever Art Gallery, Port Sunlight (National Museums and Galleries on Merseyside).

support of friends such as Hunt.[12] The Port Sunlight frame (fig. 105) is rectangular, and carries motifs symbolising "creation . . . awakened to joyous life", including a rising lark at the top and convulvulus (also known as 'morning glory') at the sides.[13] The Birmingham frame is more dramatic and stylised, with another lark at the top of the outer rim and a central design of radiating sun-bursts, flames and arrow-heads. Cartouches bear the picture's title and an apposite quotation from Chaucer's *Knight's Tale.* This frame was shown, presumably on its own, at an exhibition in the Armourers' Company Hall in London in May 1890.[14]

1. Hunt, 1905, vol. 2, p. 378.
2. According to the Note Book of the President of Magdalen, Sir Herbert Warren; Bennett, 1988, p. 99.
3. Bennett, 1988, p. 102.
4. Bennett, 1988, p. 103.
5. Bennett, 1988, pp. 97–106.
6. Bennett, 1988, p. 98.
7. Letter to Barrow Cadbury, 19 November 1906; from a transcript in the Birmingham Museums and Art Gallery files. Bennett, 1988, gives full details of the known identification of each figure.
8. Letter to the *Pall Mall Gazette,* 4 November 1891, quoted in Bennett, 1988, p. 97.
9. Letter to Barrow Cadbury (see note 7); quoted in Birmingham, *Paintings,* 1960, pp. 79–80.
10. Letter to Barrow Cadbury (see note 7); quoted in Birmingham, *Paintings,* 1960, pp. 79–80.
11. Hunt identified him as "Mr Cama, Parsee of India. A merchant"; Bennett, 1988, pp. 101, 104. The magazine *John Bull,* 16 May 1891, considered that "some people will be disposed to question the propriety of introducing into the representation of an act of Christian worship the figure of one who is, after all, engaged in adoring the creature rather than the Creator"; quoted in Bennett, 1988, p. 103.
12. See Alan Crawford, *C.R. Ashbee: Architect, Designer & Romantic Socialist,* London, 1985, pp. 34–35.
13. Bennett, 1988, p. 102. "I wish Ruskin could see the work", Hunt wrote on 19 May 1869 to Fred Hubbard, Secretary of the Guild, "for I feel sure that he would be much pleased with it, and even be encouraged to hope better for the artistic life of the country by seeing it" (Guild of Handicraft archives, Library of the Victoria and Albert Museum; quoted in part in Crawford, *Ashbee,* 1985, p. 35).
14. *The Builder,* 24 May 1890, p. 375, and 31 May 1890, p. 397 (left side reproduced): these references were first brought to light by Shirley Bury (letter of 16 December 1966, Birmingham Museums and Art Gallery file).

115

EDWARD BURNE-JONES

The Briar Rose: study for "The Garden Court"

1889
Bodycolour
24 x 35 7/8 in.; 61.0 x 91.2 cm.
Signed and dated, bottom left: EBJ / for BRIAR ROSE / 1889
Inscribed on back of frame: 6 Sleeping Palace EB-J
In ink, on label (now detached): VI / Sketch for figure in / picture of Sleeping / Beauty
Frame bears label of Foord & Dickinson, 129 Wardour Street, London
Bequeathed by Miss K.E. Lewis, 1961 (P50'61–vi)

EXHIBITED: London, New Gallery, 1890 (339); London, Fine Art Society, April 1896 (173)

REFERENCES: Tokyo, 1990 (28–vi)

The Briar Rose was the last major series of oil paintings that Burne-Jones completed, although in succeeding years he spent much time on a number of paintings based on the Arthurian legend, which culminated in *The Sleep of King Arthur in Avalon* (unfinished, now in the Museo de Arte, Ponce, Puerto Rico). Burne-Jones first turned to the story of "The Sleeping Beauty", treated variously by Charles Perrault, the brothers Grimm and in Tennyson's poem "The Day-Dream", for the subject of a set of tiles commissioned by Birket Foster in 1863 to decorate The Hill, his house at Witley (see cat. no. 80).[1]

In 1871 Burne-Jones began a set of oils for William Graham (known as the 'small *Briar Rose* series'), and completed three canvases in 1873: *The Briar Wood*, showing the Prince and the sleeping knights; *The Council Chamber*, with

the King and his courtiers asleep; and *The Rose Bower*, depicting Sleeping Beauty and her attendants (these are also now at Ponce, Puerto Rico).[2] A fourth subject, *The Garden Court*, is not known to have been completed, although a half-size watercolour sketch may be of that date.[3] This composition, in many respects the most successful and appealing, is of servant girls asleep at a loom in the palace garden.

By 1874 Burne-Jones had begun work on a larger set of four oils, but as usual he was distracted by other commissions; he records finishing "the 1st of the Briar Rose" only in 1884, and was painting "the Sleeping Princess" in 1886.[4] In 1887 he "re-drew all the figures of the sleeping girls in the 3rd picture of the sleeping palace"[5] – presumably *The Garden Court* – but the six large studies dated 1889, of which this is one, may represent a further re-working of the theme. Their bold, deceptively loose style, which perfectly matches the languorous subject, is certainly a considerable development from the tight Albert Moore-like drapery style adopted in the earlier watercolour sketch. These six drawings were probably also intended as independent works, however, and were exhibited as such at the same time as the finished oils, though in a different gallery.[6]

The four paintings were completed in 1890 and exhibited in the summer at Agnew's, "to ever-increasing crowds of delighted visitors",[7] and subsequently at Toynbee Hall in the East End of London, "where many thousand people came to see them without entrance fee".[8] They were bought by the financier Alexander Henderson, later 1st Lord Faringdon, and were installed in the Saloon at Buscot Park in Oxfordshire (only two miles from Kelmscott); Burne-Jones painted ten additional strips of canvas (without figures) to fit into the panelling between them.[9] William Morris provided an

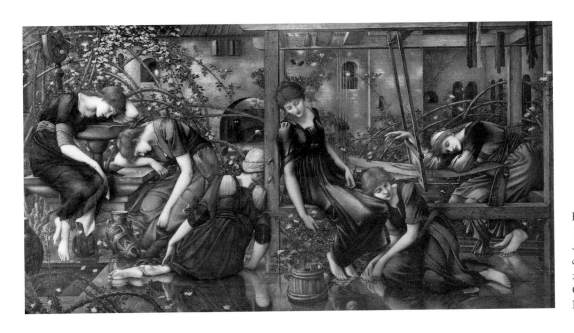

Fig. 106 EDWARD BURNE-JONES, *The Garden Court (Briar Rose Series)*, 1887–1890; oil on canvas, 49 1/4 x 91 in. (125.0 x 231.0 cm.). The Faringdon Collection, Buscot Park (The National Trust).

accompaniment in verse, to be inscribed beneath each of the four pictures; that for *The Garden Court* (fig. 106) reads:

> The maiden pleasance of the land
> Knoweth no stir of voice or hand;
> No cup the sleeping waters fill,
> The restless shuttle lieth still.[10]

Three further canvases, probably begun soon after 1874 and set aside, were re-worked between 1892 and 1894: *The Council Chamber* (1892; Delaware Art Museum, Wilmington)[11]; *The Garden Court* (1893; Bristol Museum and Art Gallery)[12]; and *The Rose Bower* (1894; Municipal Gallery of Modern Art, Dublin).[13]

1. Under January 1864, Burne-Jones lists "10 designs of 'Sleeping Beauty' in his account book with Morris, Marshall, Faulkner and Company (Fitzwilliam Museum, Cambridge; transcript at Birmingham). A tile panel of nine subjects is now at the Victoria and Albert Museum; for this and the subsequent paintings, see Kirsten Powell, "Burne-Jones and the Legend of the Briar Rose", *Journal of Pre-Raphaelite Studies*, vol. 6, no. 2, May 1986, pp. 15–28.
2. Each is approximately 24 x 50 inches (61.0 x 127.0 cm.); reproduced in Harrison and Waters, 1973, pls. 139–141.
3. Sold at Christie's, 11 June 1993, lot 93, repr.
4. Burne-Jones, *List of my designs drawings and pictures* [etc.], (Fitzwilliam Museum, Cambridge; transcript at Birmingham).
5. Burne-Jones, *List of my designs* (see note 4).
6. New Gallery, London, summer 1890, where they were described in the catalogue as "coloured designs for sleeping girls in the third picture of the [Briar Rose] series".
7. Bell, 1892, p. 63.
8. Burne-Jones, *Memorials*, 1904, vol. 2, p. 205.
9. See St John Gore, *The Faringdon Collection, Buscot Park*, The National Trust, 1982, pp. 38–39.
10. Gore, *Faringdon Collection*, 1982, pp. 38–39; the verses were published by Morris in *Poems by the Way*, 1891.
11. Elzea, 1984, pp. 44–45, repr.
12. Powell, "Legend of the Briar Rose", fig. 5.
13. Rome, 1986 (32, repr.). A version of *The Briar Wood*, sold at Christie's, 27 November 1987 (lot 143, repr.), is probably not related to these last paintings; in the accompanying catalogue note, John Christian suggests that it may even be the artist's earliest large-scale attempt at a *Briar Rose* subject, putatively of 1869.

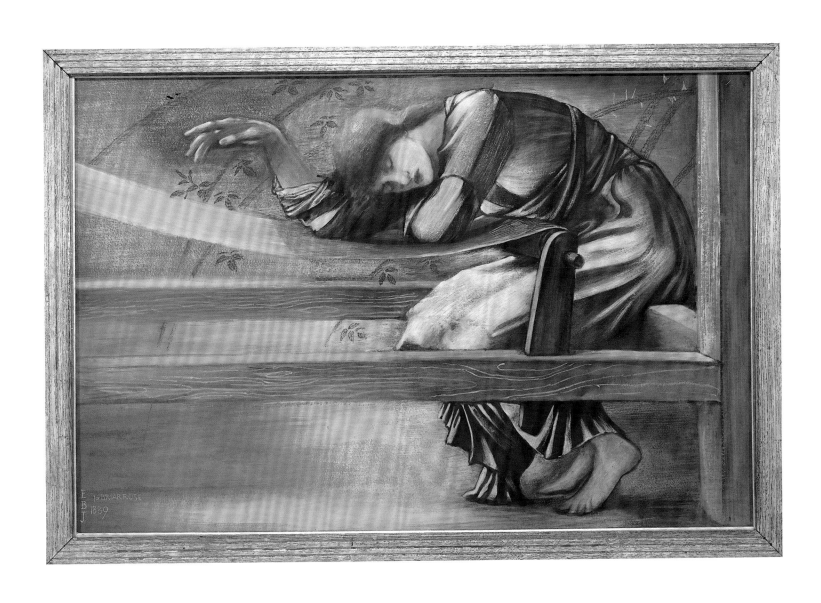

116

EDWARD BURNE-JONES

The Three Graces

Circa 1890–1896
Charcoal and pastel on brown paper
53 1/4 x 27 1/2 in.; 139.0 x 69.5 cm.
Purchased, 1898 (22'98)

PROVENANCE: Burne-Jones sale, Christie's, 16 July 1898, lot 31, where purchased (75 guineas)

REFERENCES: Birmingham, *Drawings*, 1939, pp. 94–95; Rome, 1986 (25, repr.)

The Three Graces is a motif with which Burne-Jones would have been familiar from its regular appearance in Antique, Renaissance and Neo-classical art. It was a natural choice for an artist who drew routinely from the live model, and the motif appears in several variations in his paintings. A sculpture group features in the background of *The Heart Desires* in the second *Pygmalion* series (cat. no. 105), and the three sea-nymphs in *The Arming of Perseus* (1877; Southampton Art Gallery)[1] have the character of a Three Graces composition, the central figure having her back to the viewer.

Burne-Jones's most direct use of the group, however, occurs in one of the predella panels of *The Story of Troy*, the huge triptych subject begun in 1870. The great canvas now in

Birmingham (fig. 107) remained in his studio for the rest of his life. It was probably never intended to be finished as a single work in its own right, but instead was designed to simulate a three-dimensional scheme that combined architecture, painting and sculpture, which Burne-Jones doubtless knew was unlikely ever to be achieved.[2] Indeed, it acted as a laboratory for ideas, to which he returned again and again over the next twenty-five years. The central predella panel is *The Feast of Peleus*, worked up in oil in 1879–1881 and now also at Birmingham.[3] This depicts the wedding feast of Peleus and Thetis, at which Discord casts an apple, inscribed 'For the Fairest', whose deserved possession leads to the outbreak of the Trojan War. On either side are *Venus Concordia* and *Venus Discordia*, emblematic of peaceful love and disruptive jealousy.

For each of these two compositions Burne-Jones made exquisite drawings in hard pencil, both dated 1871. They formerly belonged to Sir Edward Poynter (1836–1919), Burne-Jones's brother-in-law, and are now at the Whitworth Art Gallery, University of Manchester.[4] The *Venus Concordia* (fig. 108) features the Three Graces group, which is balanced in the *Venus Discordia* by the figures of the Four Vices (Anger, Envy, Suspicion and Strife), appropriately standing separate from each other. A large oil of *Venus Discordia* was begun in 1873, but never completed (National Museum of Wales, Cardiff).[5] An equivalent painting of *Venus Concordia* (Plymouth City Museum and Art Gallery) may only have been taken up

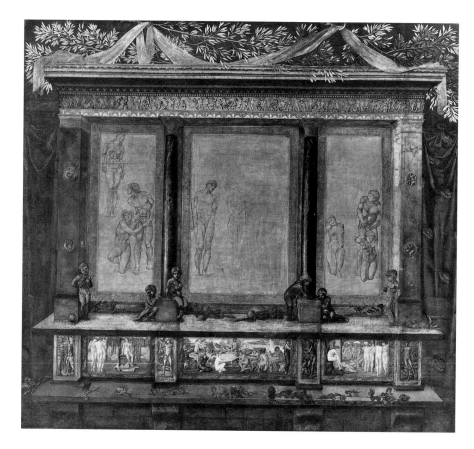

Fig. 107 EDWARD BURNE-JONES, *The Story of Troy (The Troy Triptych)*, begun 1870; oil on canvas, 107 1/2 x 116 in. (275.0 x 298.5 cm.). Birmingham Museums and Art Gallery (178'22).

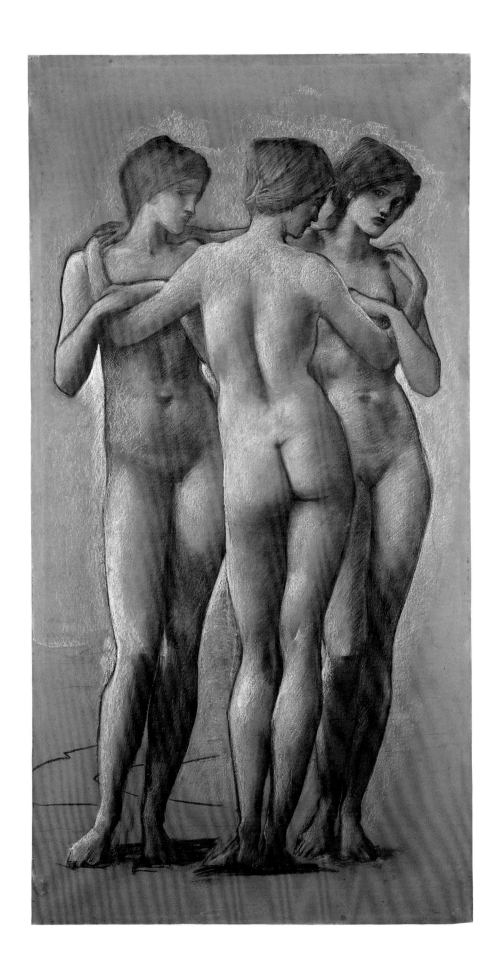

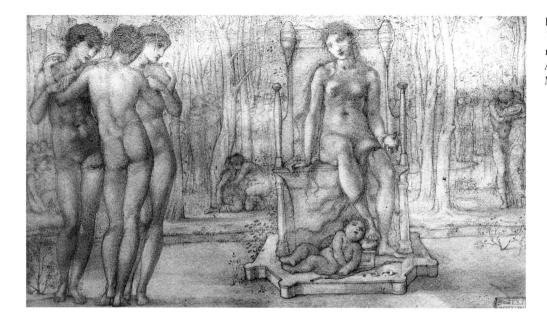

Fig. 108 EDWARD BURNE-JONES, *Venus Concordia*, 1871; pencil, 12 x 19 in. (30.3 x 48.4 cm.). Whitworth Art Gallery, University of Manchester.

much later. T.M. Rooke, the artist's assistant, records a conversation in the studio on 23 January 1896:

> EB-J (altering outermost of 3 Graces in *Venus Concordia*): In my anxiety to make it a good figure in itself I've made it too independent of the others, and it's become an isolated figure instead of part of the group, and that won't do. We mustn't indulge in favourite passages of a work. . . .[6]

Burne-Jones's anxiety over the figure group may have instigated the two large drawings of *The Three Graces*, of which this is one. The other, now at Carlisle City Museum and Art Gallery,[7] is identical in size and form but is more richly coloured, in a prevailing tone of steely blue; it might have been intended as a more saleable replica, although both remained in the studio.[8] Stylistically, these drawings must date from the 1890s: the rather stiff, dry treatment of the hair is typical of Burne-Jones's very late draughtsmanship (see cat. no. 117).

1. London, Southampton and Birmingham, 1975–1976 (162, repr.).
2. London, Southampton and Birmingham, 1975–1976, p. 48, fig. 2; Birmingham, *Paintings*, 1960, p. 27 (178'22).
3. Birmingham, *Paintings*, 1960, p. 26 (P8'56); 14 3/4 x 43 in. (37.5 x 109.2 cm.). A much larger version, begun in 1881, is at the Victoria and Albert Museum, London; Harrison and Waters, 1973, pl. 170.
4. *The Pre-Raphaelites and their Associates in the Whitworth Art Gallery, Manchester*, Manchester, 1972, nos. 77, 78 (*Venus Discordia*, pl. 38); Rome, 1986 (22–23, repr.).
5. London, Southampton and Birmingham, 1975–1976 (123, repr.).
6. Lago, 1982, p. 86.
7. Harrison and Waters, 1973, col. pl. 40; London, Southampton and Birmingham, 1975–1976 (122).
8. The Carlisle version also appeared in the Burne-Jones sale, Christie's, 16 July 1898, lot 30.

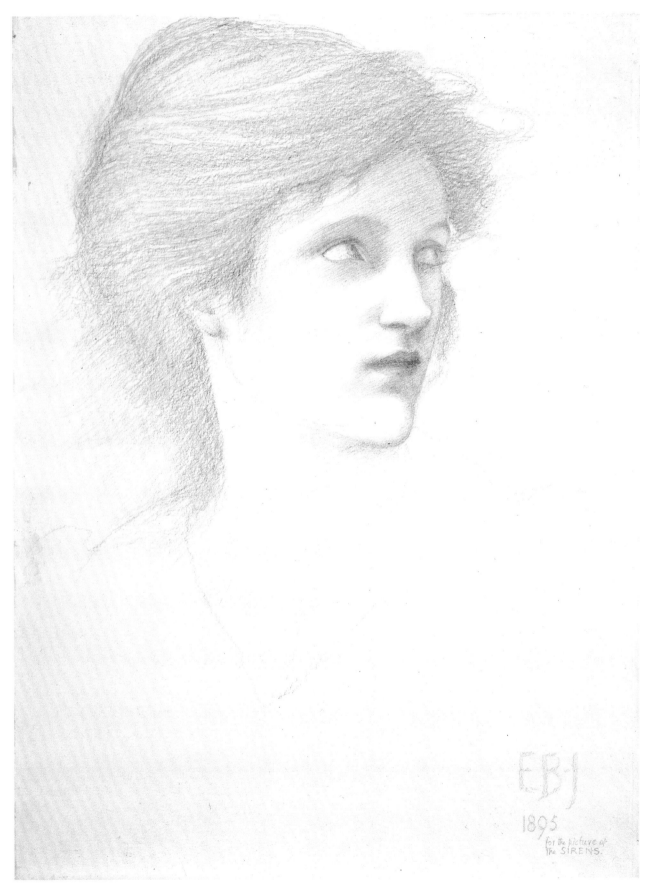

Cat. no. 117

117

EDWARD BURNE-JONES

The Sirens: study of a female head

1895
Pencil
17 3/8 x 13 in.; 44.3 x 33.0 cm.
Signed and dated, bottom right: EB-J / 1895 / for the picture
of / the SIRENS.
Presented by Arthur S. Dixon, 1898 (45'98)

REFERENCES: Birmingham, *Drawings*, 1939, p. 101; Rome,
1986 (80, repr.)

*B*urne-Jones had the first idea for yet another major
painting, *The Sirens*, during the eventful year of 1870.[1] It may
not have been coincidental that Rossetti was also considering
a 'lyrical drama' at that time, under the title *The Doom of the
Sirens;* a prose outline had been composed while he was stay-
ing at Penkill, Scotland, in 1869, but the project came to
nothing.[2] The subject is listed again, under 1872, in Burne-
Jones's retrospective list of work, as one of the subjects "which
above all others I desire to paint", although a first design is
not mentioned until 1880.[3]

By 1891 he had begun in earnest, writing to his patron
Frederick Leyland:

> I am making a plan for a picture that will not be very
> big and will need to be very pretty. It is a sort of Siren-
> land – I don't know when or where – not Greek Sirens,
> but any sirens, anywhere, that lure on men to destruction.
> There will be a shore full of them, looking out from
> rocks and crannies in the rocks at a boat full of armed
> men, and the time will be sunset. The men shall look at
> the women and the women at the men, but what hap-
> pens afterwards is more than I care to tell.[4]

Burne-Jones may have been describing the substantial sketch
in bodycolour which re-appeared recently on the art market.[5]
Two larger and more detailed designs in pastel[6] preceded the
huge oil painting, which was never completed, and is now at
the Ringling Museum of Art, Sarasota, Florida (fig. 109).[7]

The Sirens is a static and ghostly composition, its twenty-
odd female figures exuding tangible sexual tension despite (or
perhaps as a result of) their frozen, rigid poses. Both the
designs and the large oil are painted in the idiosyncratic tones
of deep blue, green and yellow that reinforce Burne-Jones's
expressed wish to convey in his pictures "a beautiful romantic
dream of something that never was, never will be – in a light
better than any light that ever shone – in a land no one can
define or remember, only desire".[8] As so often occurred in the
course of his grand projects, Burne-Jones was tempted into
making many striking independent studies of individual ele-
ments. The present drawing is one of at least a half-dozen
female heads in meltingly soft pencil, inscribed or otherwise
identifiable as studies for *The Sirens*, all dated 1895 or 1896.[9]

1. "Designed the triptych of Troy and the Sirens and began the oil
picture of the Mill, and made studies for the Hours, & Pygmalion" is
only one of the entries for 1870 in Burne-Jones's *List of my designs
drawings and pictures* [etc.] (Fitzwilliam Museum, Cambridge; tran-
script at Birmingham).
2. Bornand, 1977, p. 36.
3. See note 1.
4. Burne-Jones, *Memorials*, 1904, vol. 2, p. 222.
5. Sotheby's, 3 November 1993, lot 201, repr.
6. Harrison and Waters, 1973, col. pl. 41 (Private Collection), and
National Gallery of South Africa, Cape Town; both approximately
67 x 92 inches (170.0 x 230.0 cm.).
7. Indianapolis and New York, 1964 (14, repr.); Rome, 1986 (83, repr.).
8. Quoted in London, Southampton and Birmingham, 1975–1976, p. 11.
9. London, Burlington Fine Arts Club, 1899, nos. 31 (1896), 96 (1895)
and 109 (1896); Fogg Art Museum, Harvard University (1896);
Indianapolis and New York, 1964, no. 30 (1895).

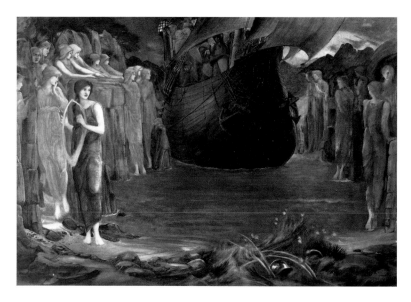

Fig. 109 EDWARD BURNE-JONES, *The Sirens*, circa 1870–1875;
oil on canvas, 84 x 120 7/16 in. (213.4 x 305.9 cm.). The John
and Mable Ringling Museum of Art, Sarasota, Florida.

118

MAX BEERBOHM

Dante Gabriel Rossetti, in his back garden

Circa 1904
Watercolour over pencil, pen and ink
7 7/8 x 12 1/2 in.; 20.1 x 31.3 cm.
Signed in ink, lower right: Max
Inscribed in ink, bottom left: Dante Gabriel / Rossetti / in his back-garden
Purchased, with grant aid administered by Victoria and Albert Museum, London, 1981 (P2'81)

PROVENANCE: Miss Gladys Curry?; Langton Gallery, London, from whom purchased

EXHIBITED: London, The Carfax Gallery, May 1904

REFERENCES: Max Beerbohm, *The Poets' Corner*, London, 1904, pl. 19; Rupert Hart-Davies, *A Catalogue of the Caricatures of Max Beerbohm*, London, 1972, p. 119, no. 1268; Tokyo, 1990 (7, repr.)

The most famous caricaturist of his time, Max Beerbohm found a rich source of subjects in the Pre-Raphaelite circle, with its wide variety of artists, writers and their friends. "Somehow", he recalled, "one doesn't feel sentimental about a period in which oneself has footed it. It is the period that one *didn't* quite know, the period just before oneself, the period of which in earliest days one knew the actual survivors, that lays a really strong hold on one's heart".[1] He confessed that Rossetti "'to my gaze was ne'er vouchsafed.' Nor did I ever set eyes on Coventry Patmore or Ford Madox Brown or John Ruskin or Robert Browning. Nor did I see any one of the others until he had long passed the age at which he knew Rossetti".[2] Yet Beerbohm was fascinated by this "complex and elusive" figure, who was all the more interesting for having been born "outside his proper time and place": such a man might have seemed less remarkable "in the Quattrocento and by the Arno. But in London, in the great days of a deep, smug, thick, drab, industrial complacency, Rossetti shone, for the men and women who knew him, with the ambiguous light of a red torch somewhere in a dense fog".[3]

The present caricature was included in Beerbohm's second book of caricature drawings, *The Poets' Corner*, published in 1904. In the winter of 1916–1917, when he had returned to England from his home in Rapallo, Beerbohm drew an additional set of twenty-two watercolours (now in the Tate Gallery, London) which appeared in 1922 as *Rossetti and His Circle*. These include such comic gems as *Ford Madox Brown being patronised by Holman Hunt* and *The Sole Remark likely to have been made by Benjamin Jowett about the Mural Paintings at the Oxford Union* ("And what were they going to do with the Grail when they found it, Mr Rossetti?"). It also contains a simplified version of the scene in Rossetti's back garden, under the title *Mr William Bell Scott wondering what it is these Fellows seem to see in Gabriel.*

The Birmingham watercolour is not, of course, intended to represent any actual occasion, but to highlight the incongruous mixture of Rossetti's circle of friends and his fondness for keeping exotic animals in the garden of Tudor House, Chelsea. At various times he owned (among others) at least one deer, kangaroo, armadillo, chameleon, Japanese salamander, Chinese horned owl and a talking parrot. The most celebrated of these creatures was an Australian wombat, of which Rossetti made several affectionate drawings in 1869.[4] His studio assistant Henry Treffy Dunn commented that Rossetti "had not any great love for animals, nor knew much about their habits. It was simply a passion he had for collecting, just as he had for books, pictures and china, which compelled him to convert his house into a sort of miniature South Kensington Museum and Zoo combined".[5]

The figures are identified thus in *The Poets' Corner:*

Background from left to right: Swinburne, Theodore Watts [afterwards Watts-Dunton], Meredith, Hall Caine. In front of the wall on the left: Whistler. With the kangaroo: Burne-Jones. Upright and reciting: William Morris. On the right: Holman Hunt, and in front of him, in profile: Ruskin. In the foreground: Rossetti. The lady is no one in particular, just a vague synthesis.[6]

1. Max Beerbohm, *Rossetti and His Circle*, London, 1922; quoted in N. John Hall (ed.), *Rossetti and His Circle by Max Beerbohm*, New Haven and London, 1987, p. 6.
2. Hall, *Rossetti and Beerbohm*, 1987, pp. 48–49.
3. Hall, *Rossetti and Beerbohm*, 1987, p. 48.
4. See Michael Archer, "Rossetti and the Wombat", *Apollo*, vol. 81, March 1965, pp. 178–185.
5. Quoted in Hall, *Rossetti and Beerbohm*, 1987, p. 32.
6. The 1904 *Poets' Corner* contained no letterpress; this note seems to have been supplied by Beerbohm for the King Penguin edition, London and New York, 1943 (p. 16). The identifications are confirmed by a key, drawn in pencil on a sheet of paper that was formerly attached to the frame of the present drawing: this describes the female figure simply as 'The Model'.

Cat. no. 118

Artists' Biographies

MAX BEERBOHM
1872–1956

'The incomparable Max', as George Bernard Shaw described him, was a man of enormous charm and hugely varied talents. Of Baltic descent and the son of a prosperous corn merchant who published *Beerbohm's Morning Shipping List*, Max Beerbohm was born in London on 24 August 1872 and educated at Charterhouse and Merton College, Oxford, where he first gained a reputation as a writer. Through the artist William Rothenstein he made the acquaintance of a host of *fin-de-siècle* aesthetes, including Oscar Wilde and Aubrey Beardsley, and contributed to the first volume of *The Yellow Book* in 1894.

His early celebrity as an essayist, beginning with *The Works of Max Beerbohm* published by John Lane in 1896, increased with the publication in 1911 of the fantasy novel *Zuleika Dobson*, set in Oxford. He became equally famous as a caricaturist, with his first important book of cartoons, *The Poets' Corner*, appearing in 1904 (cat. no. 118); this was followed by eight further compilations between 1907 and 1937, including *Rossetti and his Circle* (1922). Beerbohm's original watercolours were exhibited from 1901, firstly at the Carfax Gallery and, from 1911 onwards, at the Leicester Galleries in Leicester Square: the catalogue raisonné by Rupert Hart-Davies (1972) lists just over two thousand known works.

In 1910, Beerbohm married the American actress Florence Kahn; they lived in Rapallo, Italy, returning to England only during the period of the two world wars. Long retaining an affectionate reputation as both dandy and humourist, Beerbohm became a regular radio broadcaster, and was knighted in 1939. He died in Rapallo on 20 May 1956.

Self-caricature by Max Beerbohm, circa 1909; Charterhouse School, Godalming

Cat. no. 118

GEORGE PRICE BOYCE
1826–1897

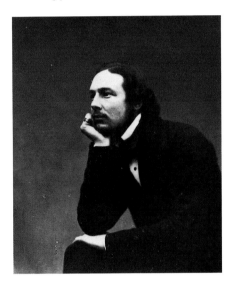

George Price Boyce's fame within the Pre-Raphaelite circle rests partly on his work as a painter of idiosyncratic watercolour landscapes, but it also derives from his gregarious character; his particular friendship with Rossetti is chronicled in the diaries he kept between 1851 and 1875. His younger sister Joanna was also an accomplished artist, one whose promise was sadly ended by her death in childbirth in 1861.

Boyce was born in London on 24 September 1826, the eldest of the five children of a city wine merchant who later became a prosperous pawnbroker. After travelling in Europe, Boyce joined the architects' office of Wyatt and Brandon as a draughtsman, but he found the work limiting; an encounter in 1849 with the painter David Cox (1783–1859) at Bettws-y-Coed, North Wales, convinced him to take up the career of a watercolourist. He met Thomas Seddon (1821–1856) in 1849, and through him may first have become aware of Pre-Raphaelitism; soon afterwards Boyce was introduced to Rossetti and began a lifelong friendship. John Ruskin took an interest in his work, and advised Boyce to visit Venice in 1854. Seemingly well off financially, he was later able to make painting trips to Switzerland (1856) and Egypt (1861–1862). A founder member of the Hogarth Club, Boyce occasionally exhibited works on its walls, and in 1864, along with Burne-Jones, he was elected an Associate of the Old Water Colour Society. In 1877 he was promoted to full Member.

He continued to exhibit watercolours until 1891, achieving a reputation for choosing and making the most from the unexpected viewpoint: in 1867 the *Art Journal* commended his "pictures which, as usual, please by their peculiarities". Having taken over Rossetti's studio at Chatham Place, Blackfriars, after the death of Elizabeth Siddal, Boyce commissioned a large new house and studio from the architect Philip Webb in 1868; West House, Glebe Place, Chelsea, was completed in 1871 and remains one of Webb's most important surviving buildings. Boyce married Caroline Subeiran in 1875, and died at West House on 9 February 1897.

Photograph of George Price Boyce; National Portrait Gallery, London

Cat. no. 109

JOHN BRETT
1831–1902

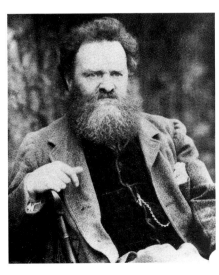

Born near Reigate, Surrey, on 8 December 1831, John Brett was the son of an army veterinary surgeon who served as a captain in the 12th Lancers. Having received sporadic art instruction, including lessons from the drawing-master J.D. Harding (1797–1863), Brett entered the Royal Academy Schools in 1853, at a comparatively late age. An affinity with the work of the Pre-Raphaelites, strengthened by his reading of Ruskin's writings, led to his friendship with the poet Coventry Patmore and an introduction to William Holman Hunt.

While in Switzerland in the summer of 1856, Brett encountered J.W. Inchbold, whose work was an immediate inspiration: "[I] there and then saw", he wrote, "that I had never painted in my life, but only fooled and slopped, and thenceforth attempted in a reasonable way to paint all I could see". Inchbold encouraged him to stay and complete his first major oil painting, *The Glacier of Rosenlaui* (Tate Gallery, London), which Rossetti took to show Ruskin later that year. Brett contributed to the 1857 Russell Place exhibition and was an early member of the Hogarth Club. In 1858 he exhibited *The Stonebreaker* (Walker Art Gallery, Liverpool; fig. 42) at the Royal Academy, and in the following year sent his masterpiece, *Val d'Aosta* (Private Collection). This received high praise from Ruskin in his *Academy Notes*, though it was tempered with the damning criticism that Brett's minutely detailed style was "Mirror's work, not Man's".

Brett was a prolific watercolourist in the 1860s, some of his best work deriving from visits to Italy and the Mediterranean. Around 1869 he met his future wife Mary Ann Howcraft, who bore the first of their seven children in 1870. Fond of the sea, the family spent their summers on board a yacht, chiefly cruising the English Channel: Brett's later paintings include many brilliantly coloured coastal views in Devon, Cornwall and the Channel Islands (cat. no. 103). In 1871 Brett was elected a Fellow of the Royal Astronomical Society, an honour reflecting his lifelong scientific interest. He died in Putney, London, on 7 January 1902.

Photograph of John Brett; National Portrait Gallery, London

Cat. nos. 82, 103

FORD MADOX BROWN
1821–1893

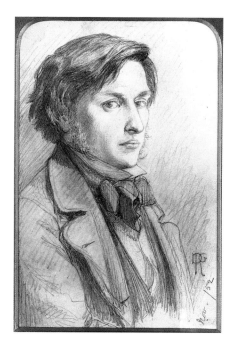

Although not a member of the Brotherhood, Ford Madox Brown was one of the leading figures in the development of Pre-Raphaelite painting. Born in Calais on 16 April 1821, the son of a ship's purser, he was a few years older than the young band of Pre-Raphaelites and to some degree acted as a father figure and mentor to them (Rossetti, who became a close friend, studied the practicalities of oil painting in his studio in March 1848). He contributed essays on historical painting to *The Germ* (1850), and was the only member of the circle with firsthand knowledge of the German 'Nazarene' painters, whose studios in Rome he had visited in the winter of 1845–1846.

Brown moved to Paris after training in Bruges, Ghent and at the Antwerp Academy between 1837 and 1839 under Gustave, Baron Wappers (1803–1874). He submitted cartoons to the Palace of Westminster fresco competitions of 1844 and 1845 (see cat. no. 4), by which time he had married his cousin Elisabeth Bromley and settled in London; she became ill and died in 1846, leaving an infant daughter.

During the years 1849 to 1853, Brown exhibited paintings alongside those of the Pre-Raphaelites, receiving much the same kind of criticism. A painstaking perfectionist, he spent much longer on each picture than his younger contemporaries, and his early achievements were rather eclipsed by theirs. Each of the three major paintings begun in 1852 – *Work* (cat. no. 74), *The Last of England* (fig. 30) and *English Autumn Afternoon* (fig. 1) – took years to complete, and Brown (who married Emma Hill in 1853) had to endure insecurity, depression and genuine hardship. His remarkable diary, running from 1847 to 1850 and from 1854 to 1858, is one of the most revealing and soul-searching ever kept by a painter.

A retrospective exhibition of his work in 1865 was a critical, if not financial, success. By this time Brown had become a valued designer of stained glass and furniture for Morris, Marshall, Faulkner and Company, although he was ousted in favour of Burne-Jones when the firm was re-constituted in 1875. In 1878, when he also visited Birmingham to lecture, Brown received the commission for six (later increased to twelve) large frescoes for the new Town Hall at Manchester. More than compensating for his lack of success at Westminster thirty years before, this massive undertaking was to occupy a large part of his remaining working life. With his family, he moved to Manchester in 1881, returning seven years later on account of his wife's health. The scheme was finally completed just a few months before his death in London on 6 October 1893.

A magazine article of 1891 – the year in which *The Last of England* was bought for Birmingham – unfortunately described Brown as "neglected and forgotten". This seemed to be his fate, and although on that occasion he was able to refute the suggestion vigorously, he has tended to remain the least fashionable of the Pre-Raphaelite painters – unfairly, in view of the great body of superb drawings and individual masterpieces of painting which are among the most memorable works of the School.

Drawing of Ford Madox Brown, by Dante Gabriel Rossetti, 1852; National Portrait Gallery, London

Cat. nos. 1, 2, 4, 5, 7, 8, 9, 18, 20, 21, 37, 57, 74, 75, 97

EDWARD BURNE-JONES
1833–1898

Burne-Jones is the chief artist associated with the 'second generation' of Pre-Raphaelites who were initially influenced by Rossetti. Edward Coley Burne Jones was born in Birmingham on 28 August 1833: his mother, Elizabeth Coley, died a few days after his birth, leaving the child in the care of his father, Edward Richard Jones, a gilder and frame-maker. After education at King Edward VI School, Birmingham, where he showed a talent for drawing (including caricatures of his teachers), he went up to Exeter College, Oxford, in 1853. There he met William Morris; both intended to enter the Church, but they decided to become artists after a tour of the northern French cathedrals in 1855. From November 1856 he and Morris shared rooms in London at 17 Red Lion Square, which previously had been occupied by Rossetti and Walter Deverell. Known to early friends simply as Jones, he adopted the name of Burne-Jones at about this time.

Apart from a few informal lessons from Rossetti, whom he had met in 1856, Burne-Jones was a self-taught artist, and his early work consisted largely of pen and ink drawings and watercolours, all of romantic or literary subjects. He took part in the Oxford Union mural campaign in 1857, joined the Hogarth Club in 1858, and in the following year made the first of four lengthy trips to Italy. On 9 June 1860 he married Georgiana Macdonald, the daughter of a Methodist minister; their first home was at 62 Great Russell Street, in rooms vacated by Henry Wallis, and they were regular guests of William and Jane Morris at Red House, which Burne-Jones helped to decorate. He designed stained glass for several manufacturers before becoming the principal designer for Morris's firm, especially after its re-constitution in 1875: between 1861 and his death he was responsible for well over five hundred individual figure subjects.

Enjoying the patronage of John Ruskin, who accompanied him and Georgiana on a second trip to Italy in 1862, Burne-Jones began to develop a personal style in which elements of Rossettian Pre-Raphaelitism were fused with the influence of classical art and Old Master painting. The discipline of drawing, preferably from the live model, was central to his art, and became a daily practice after he settled in The Grange, Fulham, in 1867. He had been elected an Associate of the Old Water Colour Society in 1864 – *The Merciful Knight* (cat. no. 73) was one of his first exhibits – but he resigned in 1870 after criticism of *Phyllis and Demophoön* (Birmingham Museums and Art Gallery; fig. 11), with its large nude male and female figures. In the same year he narrowly survived the scandal of an affair with Maria Zambaco.

Concentrating increasingly on oil painting, Burne-Jones was a major contributor to the first exhibition of the Grosvenor Gallery in 1877, at which he achieved sensational popular acclaim; this was echoed in France with works shown at the Exposition Universelle in 1878. An appearance later that year as a witness for Ruskin in the notorious libel case with James McNeill Whistler was a less happy event. His later work included many large oils, such as *The Golden Stairs* (1880) and *King Cophetua and the Beggar Maid* (1884, fig. 5; both in the Tate Gallery, London), and several series of paintings, notably *Pygmalion and the Image* (cat. nos. 105–108), *Perseus* (1875–1885) and *The Briar Rose* (cat. no. 115). The culminating masterpiece, a huge canvas begun in 1881 but left unfinished, was *The Sleep of King Arthur in Avalon* (Museo de Arte, Ponce, Puerto Rico). In bringing these works to fruition, he was greatly aided from 1869 by his studio assistant Thomas Matthews Rooke (1842–1942).

Burne-Jones habitually re-used preparatory drawings and designs for projects in different media, from decorated tiles and pianos to jewellery and theatrical costume. Two final collaborations with Morris led to outstanding designs for tapestries, dating from the late 1880s – of these, the finest are the *Holy Grail* series now in Birmingham – and a plethora of illustrations for the Kelmscott Press, founded in 1891, whose greatest achievement was the folio *Chaucer* of 1896. Reluctantly, Burne-Jones accepted election as an Associate of the Royal Academy in 1885, but exhibited only once and resigned in 1893. He was created a baronet in 1894, and died in Fulham on 16 June 1898; he was buried in the churchyard at Rottingdean, Sussex, where he had a country home.

Photograph of Edward Burne-Jones at work on *The Star of Bethlehem*, by Barbara Leighton, circa 1890

Cat. nos. 59, 66, 67, 68, 73, 79, 80, 81, 99, 100, 101, 105, 106, 107, 108, 112, 115, 116, 117

JAMES CAMPBELL
1828–1893

Born in Liverpool in 1828 (he was baptised on 30 March), James Campbell was one of a group of painters from that city, including William Davis (1812–1873), William Lindsay Windus (1822–1907) and Daniel Alexander Williamson (1823–1903), who came under Pre-Raphaelite influence in the 1850s. All became familiar with the movement through seeing paintings by Brown, Hunt and Millais exhibited at the Liverpool Academy from 1848 onwards.

The son of a bookkeeper for the Sun Insurance Company, Campbell was a student at the Liverpool Academy before entering the Royal Academy Schools in 1853. He had made sufficient contact with the Pre-Raphaelite circle to be included in the 1857 exhibition at Russell Place and to become a member of the Hogarth Club, although most of his paintings were shown at the Liverpool Academy, of which he was elected an Associate in 1854 and a Member in 1856. His best surviving works are narrative and genre paintings filled with much detail and restrained dramatic incident, such as *Waiting for Legal Advice* (1857; fig. 45) and *News from My Lad* (1858; both in the Walker Art Gallery, Liverpool).

Described as "a man below middle height, with pleasant, genial manners, [but] defective eyesight", Campbell moved back to London in 1864, making an unsuccessful attempt to maintain a painting career; he married a widow, by whom he had children, and for a time lived in Reigate, Surrey. His eyesight failing almost completely, he returned to Liverpool, and died in Birkenhead on 25 December 1893.

Cat. no. 45

JAMES COLLINSON
1825–1881

The least known painter member of the Pre-Raphaelite Brotherhood (excluding F.G. Stephens, who abandoned the practice of art in favour of writing about it), James Collinson would have met Millais, Rossetti and Hunt as fellow students at the Royal Academy Schools. Born on 9 May 1825 in Mansfield, Nottinghamshire, where his father was a bookseller and printer, Collinson was living in London by 1846, when he exhibited a study of a head at the Society of British Artists. He was a member of the Cyclographic Society in the summer of 1848, and was proposed by Rossetti as a member of the Brotherhood.

A quiet and nervous young man (nicknamed 'the dormouse'), he was teased by Hunt for his lack of camaraderie, needing "to be waked up at the conclusion of the noisy evenings to receive our salutations". A convert to Roman Catholicism, he returned to the Church of England in order to be accepted as Christina Rossetti's fiancé, having first proposed marriage in 1848; the engagement ended in the spring of 1850, when Collinson reverted to the Roman faith and resigned from the Brotherhood on the grounds that he could not, "as a Catholic, assist in spreading the artistic opinions of those

who are not". He produced *The Child Jesus*, one of the four etchings in *The Germ*, and his most important painting in the Pre-Raphaelite style was also of a religious subject, *An Incident in the Life of Queen Elizabeth of Hungary* (1850; Johannesburg Art Gallery; fig. 25).

In 1853 Collinson entered the Jesuit College at Stonyhurst as a novice, but abandoned training for the priesthood by early 1855. There is evidence that he continued to paint during this time, and he exhibited again at the Royal Academy from 1855. The domestic genre subjects on which his reputation as a painter still rests, such as *For Sale*, also known as *The Empty Purse* (1857; versions at Castle Museum, Nottingham, and Tate Gallery, London), or *To Let* and *To Sell* (1858; Philadelphia Museum of Art), show brilliant finish and dexterity but little intellectual Pre-Raphaelite purpose. In 1858 he married Eliza Wheeler, apparently the sister-in-law of the Catholic painter J.R. Herbert (1810–1890), and moved to Epsom, Surrey. Relations with William Michael Rossetti had been restored sufficiently for Collinson to provide pictures for the Exhibition of British Art which toured America in 1857–1858. Collinson was a regular exhibitor at the Society of British Artists, and is said to have acted as its secretary from 1861 until 1870. Occasional visits to France included an extended stay in Brittany in the late 1870s, where his son Robert was a student. He had returned to London by 1880 and died of pneumonia in Camberwell on 24 January 1881.

Cat. no. 14

WALTER HOWELL DEVERELL
1827–1854

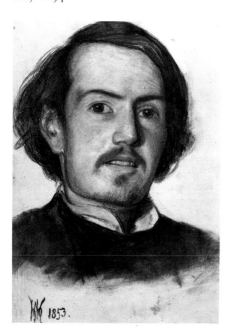

A member of the Pre-Raphaelite Brotherhood in all but name, Walter Howell Deverell was born on 1 October 1827 in Charlottesville, Virginia, where his English father Walter Ruding Deverell (who claimed descent from Jean d'Evrolle, a Norman follower of William the Conqueror) was a teacher. The family returned to England in 1829, with Walter Deverell senior finally becoming secretary-assistant to William Dyce at the Government School of Design in 1842.

An unwilling solicitor's clerk, young Walter persuaded his father to allow him to attend Sass's Academy in Bloomsbury, where he met Rossetti: they instantly became close friends. In 1846 he progressed to the Royal Academy Schools, and in the following year showed his first picture, *Reposing after the Ball*, at an Academy exhibition. A participant in the Cyclographic Society meetings of 1848, it is strange that Deverell was not included as a founder member of the Brotherhood, unless this may have sat uneasily with his appointment in September 1848 as an assistant master at the School of Design at Somerset House (where his father was still secretary). His name is mentioned frequently in the *P.R.B. Journal*, and he was suggested as a replacement after Collinson's resignation in 1850, but this was never ratified.

In the winter of 1850–1851, Deverell lodged at 17 Red Lion Square (in rooms later taken by Burne-Jones and Morris) and shared the studio with Rossetti. He showed *Twelfth Night* (FORBES Magazine Collection, New York) at the National Institution in 1850, and *The Banishment of Hamlet* in 1851 (later destroyed in a gas explosion); few other substantial paintings were ever completed. With his family (minus his mother, who had died in 1850), he moved to Kew in 1852, and assumed increased responsibility for the family income after the death of his father a year later, when he and his siblings were obliged to take a smaller house in Chelsea. By October 1853, Deverell was diagnosed as suffering from Bright's Disease, an ailment affecting the kidneys, and he died on 2 February 1854, three months after his twenty-sixth birthday.

Drawing of Walter Howell Deverell, by William Holman Hunt, 1853 (cat. no. 23)

Cat. nos. 15, 24, 25

WILLIAM DYCE
1806–1864

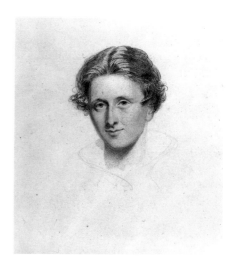

Considerably older than the Pre-Raphaelite painters, William Dyce was one of the more liberal-minded members of the artistic establishment in the late 1840s who recognised the Brotherhood's purpose and potential, and who adopted certain aspects of the group's style. The son of a distinguished physician and academic, Dyce was born in Aberdeen on 19 September 1806, and had gained a master's degree at Marischal College by the age of seventeen. After beginning studies in medicine and then theology, he turned to painting; travelling to London by boat, he obtained an introduction to Sir Thomas Lawrence (1769–1830), and entered the Royal Academy Schools in 1825. On impulse, he gave up the studentship and set off for Rome that autumn; despite the lack of supporting evidence, he probably encountered there the work of the German 'Nazarene' painters, as Brown was to do twenty years later.

Dyce returned to Aberdeen in 1829, pursuing a wide range of interests (even winning a £30 prize for an essay on electro-magnetism), and establishing a reputation in Edinburgh as a portrait painter. He returned to London in 1837 as Superintendent of the new School of Design, but he resigned six years later in frustration at its bureaucracy and ineffectiveness. In the 1844 competition to decorate the new Palace of Westminster, Dyce succeeded in gaining commissions for frescoes in the House of Lords, which were to occupy him for many years. These and such powerful easel paintings as *Joash shooting the Arrow of Deliverance* (1844; Kunsthalle, Hamburg) and *Jacob and Rachel* (1850–1853; Leicester Museum and Art Gallery) brought him the acquaintance and patronage of Prince Albert, for whom Dyce painted a fresco at Osborne House.

The combination of Dyce's interests in German and early Italian painting, together with his High Church background, made him

sympathetic to Pre-Raphaelitism, and led him to persuade Ruskin to look at paintings by Hunt and Millais at the Royal Academy exhibition of 1850. Already employing certain similar techniques, among them the use of canvases primed with white, Dyce showed the absorption of Pre-Raphaelite traits in paintings such as *Titian Preparing to Make his First Essay in Colouring* (1857; Aberdeen Art Gallery), and he produced a landscape masterpiece comparable to any of Brown's in *Pegwell Bay, Kent* (1858–1860; Tate Gallery, London): the figures in the latter work include the artist's young wife Jane and one of his sons. Dyce collapsed while still at work on a fresco in the Palace of Westminster in the winter of 1863, and he died in Streatham, London, on 15 February 1864.

Drawing of William Dyce, by John Partridge, 1825; National Portrait Gallery, London

Cat. no. 76

ARTHUR HUGHES
1832–1915

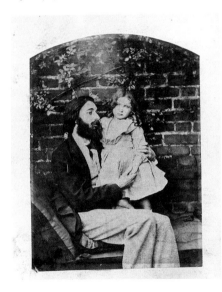

Arthur Hughes provides the classic example of a painter only a few years younger than the artists of the Pre-Raphaelite Brotherhood who was immediately moved to follow their example. In his case, the inspiration came from reading *The Germ* in 1850. Born in London on 27 January 1832 and of Welsh ancestry, Hughes studied at the School of Design under Alfred Stevens (1817–1875) before progressing to the Royal Academy Schools in 1847, where he won the silver medal for drawing from the antique.

While *Musidora*, his first exhibit at the Royal Academy in 1849, showed the influence of William Etty, his next submission three years later, *Ophelia* (1852; Manchester City Art Gallery), displays a lyrical Pre-Raphaelite nat-

uralism comparable with Millais's oil of the subject that was hung in the same exhibition. Hunt recalled that Millais mounted a ladder to examine Hughes's 'skied' picture and "expressed warm congratulation of the poetic younger artist". Used by Millais as a model for *The Proscribed Royalist* (1853; Private Collection), Hughes capitalised on the popular appeal of such meticulous romantic subjects with some memorable images of his own on the theme of lovers' meetings, including *April Love* (1855; Tate Gallery, London; originally bought by William Morris) and *The Long Engagement* (cat. no. 48). From 1852 to 1858 he shared a studio with the sculptor Alexander Munro.

Rossetti invited Hughes to participate in the 1857 Oxford Union mural scheme, for which he painted *The Death of Arthur*. Out of this experience came one of his most ambitious paintings, *Sir Galahad* (1870; Walker Art Gallery, Liverpool). From 1855 Hughes began to undertake book illustration, beginning with *The Music Master* by William Allingham, and embracing the work of Tennyson (*Enoch Arden*, 1866), George Macdonald (*At the Back of the North Wind*, 1871) and Christina Rossetti (*Sing Song*, 1872). In 1855 he married Tryphena Foord, who bore him five children; from 1858 they lived quietly in the London suburbs, and Hughes died in Kew on 23 December 1915. His nephew Edward Robert Hughes (1851–1914) acted for a time as Hunt's studio assistant, and became a well-known watercolourist.

Photograph of Arthur Hughes with his daughter Agnes, by Lewis Carroll, circa 1862; Tate Gallery Archives, London

Cat. nos. 46, 47, 48, 49, 58, 87

WILLIAM HOLMAN HUNT
1827–1910

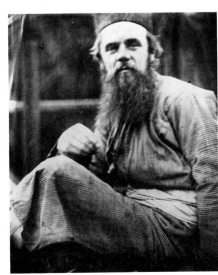

As the last surviving painter member of the Brotherhood (William Michael Rossetti died in 1919), William Holman Hunt was able to claim in his memoirs that he alone had maintained the original principles of Pre-Raphaelitism throughout his entire career. He was certainly the moving force in developing new painting techniques (such as the use of a 'wet white' ground), and as a devout Anglican provided the movement's moral earnestness. Born on 2 April 1827, the son of a London warehouse manager, Hunt worked as an office clerk before struggling for acceptance in 1844 as a student of the Royal Academy Schools, where he met Millais. He began to exhibit work from 1846, and sold his first entry at the Royal Academy in 1847.

Greatly impressed by John Ruskin's *Modern Painters* and equally inspired by the poetry of Keats, Hunt exhibited *The Eve of St Agnes* (Guildhall Art Gallery, London) at the Royal Academy in 1848, making it arguably the first Pre-Raphaelite painting despite its predating the foundation of the Brotherhood in September. He had met Rossetti earlier that year (and through him, Brown), and was a member of the Cyclographic Society. *Rienzi* (1849; Private Collection) had been begun out of doors, and Hunt stuck to this practice in painting *Valentine rescuing Sylvia from Proteus* (cat. no. 17), *The Hireling Shepherd* (1850–1851; Manchester City Art Gallery) and *The Light of the World* (1851–1853; Keble College, Oxford). His work received praise from Ruskin, and he found several patrons, including Thomas Combe, who commissioned *The Awakening Conscience* (1853; Tate Gallery, London). In 1852 he took Robert Martineau as a pupil, and also advised Edward Lear (1812–1888) on oil painting.

Deciding he needed experience of the Holy Land before undertaking a major religious painting, Hunt left London in January 1854, meeting up with Thomas Seddon in Cairo, and reaching Jerusalem by June. *The Scapegoat* (Lady Lever Art Gallery, Port Sunlight; fig. 2) was begun on the shore of the Dead Sea in November. He also visited Nazareth, Damascus and Beirut, and returned to England via Constantinople and the Crimea in February 1856. Initially sharing a studio with Martineau and Michael Halliday (1822–1869), he worked on *The Finding of the Saviour in the Temple* (Birmingham Museums and Art Gallery; fig. 37), whose hugely successful exhibition and sale in 1860 established his reputation and financial comfort. He contributed designs for the Moxon Tennyson in 1857, and was a member of the Hogarth Club from 1858 (see cat. no. 44). By 1859 he had abandoned the idea of marrying his protegée and model Annie Miller, and in 1865 he married Fanny Waugh, who died in Florence less than a year later

after the birth of their son Cyril. His second marriage, to Fanny's sister Edith in 1875, had to take place abroad (in Neufchâtel), since doing so was incompatible with English church law.

A regular watercolourist, Hunt was elected a Member of the Old Water Colour Society in 1869. He ceased to exhibit at the Royal Academy after 1874, showing instead at the Grosvenor and New Galleries, along with Burne-Jones. A move to Draycott Lodge, Fulham, in 1882 finally provided him with a large studio, in which he completed the thirty-two paintings shown at the Fine Art Society in 1886. His most important later works were *The Triumph of the Innocents* (1876–1887; Walker Art Gallery, Liverpool), *May Morning on Magdalen Tower, Oxford* (cat. no. 114) and *The Lady of Shalott* (Wadsworth Athenaeum, Hartford, Connecticut), begun in 1886 but completed only in 1905 with the aid of Edward Hughes. Hunt was awarded the Order of Merit in 1905, the same year his memoirs were published, and in 1906–1907 a retrospective exhibition was mounted in London, Manchester, Liverpool and Glasgow. He died in his final home in Melbury Road, Kensington, on 7 September 1910, and his ashes were interred in St Paul's Cathedral.

Photograph of William Holman Hunt in eastern dress, by Julia Margaret Cameron, 1864; National Portrait Gallery, London

Cat. nos. 6, 17, 23, 26, 28, 29, 30, 44, 114

JOHN WILLIAM INCHBOLD
1830–1888

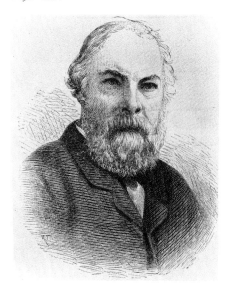

One of the more elusive figures within the Pre-Raphaelite circle, J.W. Inchbold was born in Leeds on 29 April 1830; his father had been joint proprietor of the *Leeds Intelligencer* newspaper, but may have reverted to his former profession as a bookseller. Very little is known of Inchbold's early life and education. He came to London around 1847 and had some connection, perhaps as an apprentice or pupil, with the lithographer Louis Haghe (1806–1885). The suggestion that he was a student at the Royal Academy Schools has been proved to have no foundation. His first exhibited work was a watercolour of Scarborough, shown at the Society of British Artists in 1849, and he sent two more watercolours to the Royal Academy in 1851.

A review in the *Spectator* of 1852 by William Michael Rossetti noted *A Study*, Inchbold's Royal Academy exhibit, as proof that "in landscape art . . . Pre-Raphaelitism is visibly making its way". The remarkably mature oil *The Chapel, Bolton* (1853; Northampton Museum and Art Gallery) shows a complete assimilation of Pre-Raphaelite technique, although it is only in 1854 that evidence supports Inchbold's personal contact with the group, at first probably with Millais, who was disgusted at the Royal Academy's rejection of *Anstey's Cove, Devon* (Fitzwilliam Museum, Cambridge). John Ruskin showed great interest in his work in 1855, and in *Academy Notes* praised Inchbold's meticulous attention to detail: "a single inch . . . is well worth all the rest of the landscapes in this room". Inchbold was apparently Ruskin's guest in Switzerland in the early summer of 1856, where he was painting when John Brett met him.

Like Brett, Inchbold was surprised and discouraged by Ruskin's impatience with a seeming lack of development from the minute Pre-Raphaelite landscape style. It is also clear that Inchbold had a spiky and difficult temperament (exacerbated by indifferent health), which allowed him few close friends. Leading an unsettled life, he travelled to Italy, Switzerland and Spain, broadening his style by the late 1860s while retaining a strong sense of colour and atmosphere. From about 1879 he lived in Switzerland, producing small oils and watercolours whose poetic charm had an appeal equal to Boyce's restrained English views; some of these works were shown at the Royal Academy and the Grosvenor Gallery. Inchbold died of heart disease on 23 January 1888 at his sister's house in Leeds. Woolner wrote to Stephens of "poor" Inchbold that "in truth he was rich, for his whole life was spent in doing exactly what he liked".

Wood engraving of J.W. Inchbold, from the *Illustrated London News*, 1888

Cat. no. 91

ROBERT BRAITHWAITE MARTINEAU
1826–1869

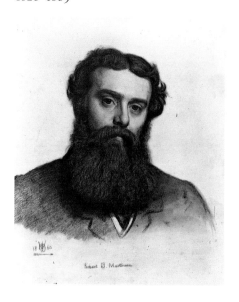

Born in London on 19 January 1826, Robert Martineau was the son of a taxing-master; the family, of Huguenot origin, included the writer Harriet (1820–1876) as well as the artists Gertrude (1837–1924) and Edith (1842–1909), who were his first cousins. His mother, Elizabeth Batty, was also a talented amateur watercolourist. Educated at University College, London, Martineau was articled to a firm of solicitors, but abandoned law in favour of art. After attending Cary's art school, he became a student at the Royal Academy in 1848, winning a silver medal for drawing from the antique.

Late in 1851 he approached Hunt, who agreed to take him as a pupil in painting, having ascertained that "to him the lucrativeness of the pursuit was not at first a vital question". They became close friends, and Hunt enjoyed painting at Fairlight Lodge, Hastings, the country house belonging to Martineau's father. In Hunt's studio Martineau painted his first important oil, *Kit's Writing Lesson* (Tate Gallery, London), which was well placed and sold at the Royal Academy in 1852.

Martineau essentially remained a competent genre painter with Pre-Raphaelite sympathies, and his pictures encompassed a similar range, from medieval and Shakespearean themes (*Katherine and Petruchio*, 1855, and *The Knight's Guerdon*, 1864; both at the Ashmolean Museum, Oxford) to modern-day subjects. His masterpiece is *The Last Day in the Old Home* (Tate Gallery, London), which proved such a popular success at the International Exhibition of 1862 that it was sent on a nationwide tour. In 1865 he married Maria Wheeler, who bore him three children. He died suddenly, of heart disease, on 13 February

1869, leaving unfinished the large oil *Christians and Christians* (Walker Art Gallery, Liverpool).

Drawing of Robert Martineau, by William Holman Hunt, 1860; Walker Art Gallery, Liverpool

Cat. nos. 69, 70

JOHN EVERETT MILLAIS
1829–1896

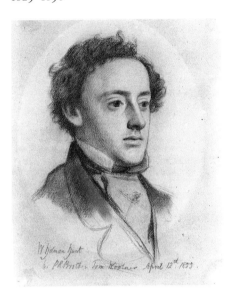

The most naturally gifted of the Pre-Raphaelite painters, John Everett Millais came from a well-to-do Jersey family, but was born in Southampton on 8 June 1829. Evidence of his precocious talent survives in drawings made before he was eight years old; following an introduction to Martin Archer Shee, P.R.A., and a brief attendance at Sass's art school, he entered the Royal Academy Schools in 1840 as its youngest ever student, winning several awards over the next six years. A substantial historical oil painting, *Pizarro seizing the Inca of Peru* (Victoria and Albert Museum, London) was shown at the Royal Academy in 1846, and he entered one of the last competitions to decorate the Palace of Westminster in 1847.

Millais had met Hunt at the Schools in 1844, and in 1848 encountered Rossetti, a fellow member of the Cyclographic Society. The founding of the Pre-Raphaelite Brotherhood in September 1848 followed a famous evening in Millais's studio in Gower Street, when he showed his friends engravings after the frescoes in the Campo Santo at Pisa. Willingly and easily adjusting his style of painting and draughtsmanship (see cat. nos. 11, 12), Millais produced two crucial early Pre-Raphaelite paintings: *Isabella* (Walker Art Gallery, Liverpool), which was well received at the Royal Academy in 1849, and *Christ in the House of his Parents*

(Tate Gallery, London; fig. 8), which provoked remarkably hostile criticism in 1850, including abusive remarks by Charles Dickens in *Household Words*.

Ophelia (Tate Gallery, London) and *A Huguenot* (Makins Collection) proved popular at the Academy exhibition of 1852, and led to a series of rather sentimental but memorable images painted in the 1850s, such as *The Order of Release* (1853; Tate Gallery, London), *The Blind Girl* (cat. no. 38) and *Autumn Leaves* (1856; Manchester City Art Gallery). Millais was befriended by John Ruskin, and he painted the critic's portrait at Glenfinlas, Scotland, in the summer of 1853; there he fell in love with Ruskin's wife Effie, marrying her in 1855 after her marriage to Ruskin was annulled.

The Moxon Tennyson (1857; see cat. no. 41) was only one of many projects for book illustration which supplemented Millais's steady income between 1855 and 1864. Having lived in Perth since their marriage, he and Effie returned to London in 1861, eventually moving to a grand house at 2 Palace Gate, South Kensington, in 1878. By then he had drifted away from a Pre-Raphaelite style towards a type of historical genre painting which brought him huge success with works such as *The Boyhood of Raleigh* (1870; Tate Gallery, London) and *Bubbles* (1886), whose copyright passed to the Pears soap company. A lingering affection for Scotland, where he loved to relax on shooting and fishing holidays, bore fruit in some mature landscape oils, of which the finest is *Chill October* (1870; Private Collection). Millais also became a celebrated portraitist, his sitters including the great and good of the day, such as Benjamin Disraeli, William Gladstone, Alfred Tennyson and Henry Irving.

Retrospective exhibitions of his work were held in 1881 at the Fine Art Society and in 1885 at the Grosvenor Gallery. Millais was the first artist to be created a baronet, in 1885, and on the death of Lord Leighton in 1896 he was elected President of the Royal Academy, an honour which might have come earlier but for his attachment to Effie Ruskin. He died only a few months later, on 13 August 1896, and was buried in St Paul's Cathedral.

Drawing of John Everett Millais, by William Holman Hunt, 1853; National Portrait Gallery, London

Cat. nos. 3, 11, 12, 22, 31, 32, 38, 41, 53

WILLIAM MORRIS
1834–1896

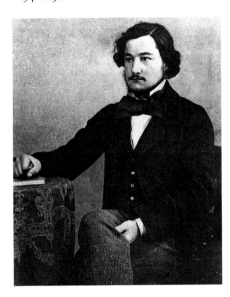

Starting out as a painter much influenced by Rossetti, William Morris may be said to have converted Pre-Raphaelitism into a recognisable decorative style through the work of his firm of craftsmen, and in collaboration with Burne-Jones as a designer, to have prolonged the life of the movement until the end of the nineteenth century. The son of a wealthy billbroker, Morris was born on 24 March 1834 at Walthamstow, then on the rural outskirts of London. From his early youth he was fascinated by the Middle Ages, and after schooling at Marlborough College it was a natural choice for him to enter the Church. At Exeter College, Oxford, in October 1853 he met Burne-Jones, who had the same intention and interests, and the two men became lifelong friends. A first visit to the continent in 1854 introduced Morris to the work of Jan van Eyck and Hans Memling in Belgium and to the treasures of medieval art in Paris. In the following year, he toured the cathedrals of northern France with Burne-Jones, and on their return both decided to leave the university and become artists.

In January 1856, Morris began work in the office of G.E. Street (1824–1881), then the diocesan architect for Oxford and a leading practitioner of the Gothic Revival. Through Burne-Jones, he met Rossetti a few months later and was persuaded to take up painting, moving to London to share his friend's rooms at 17 Red Lion Square. In 1857 he joined the group of artists assembled by Rossetti to decorate the Oxford Union building; Morris's first volume of poetry, *The Defence of Guenevere*, published in 1858, also drew on the Arthurian legend. Still in Oxford, he met Jane Burden, whom he married in 1859: she modelled for his only completed oil, *La Belle Iseult* (1858; Tate Gallery, London; fig. 6). Morris commissioned

Philip Webb to design their new home, Red House, at Bexleyheath in Kent. The site became a testing-ground for the firm of artist-craftsmen that was launched in April 1861 as Morris, Marshall, Faulkner and Company, in which Burne-Jones, Rossetti and Brown were also partners. A display of painted furniture and stained glass at the International Exhibition of 1862 brought immediate success.

Morris himself made many of the firm's early designs for textiles, wallpaper, and stained glass; the business did well enough to necessitate a move in 1865 from Red Lion Square to larger premises in Queen Square, Bloomsbury, which also became home for the Morrises and their two daughters, May and Jenny. In 1875 the original company was dissolved and re-constituted as Morris and Company, with Burne-Jones effectively its sole designer of stained glass – a practical arrangement which nonetheless deeply offended Brown. Showrooms at 499 Oxford Street were taken in 1877, and with an increasing demand for carpets and woven textiles, the firm's workshop moved again in 1881 to Merton Abbey, Surrey. The addition of manufacturing tapestries culminated in the *Holy Grail* series, designed by Burne-Jones in the 1890s (Birmingham Museums and Art Gallery).

A man of unbounded intellectual energy, Morris published a substantial cycle of narrative poems as *The Earthly Paradise* in 1868–1870, and followed this with a series of translations and illuminated manuscripts from the medieval sagas of Iceland, which he visited in 1871 and 1873. With Rossetti, he took a lease on Kelmscott Manor, Oxfordshire, in 1871, and he named his last London home in Hammersmith after Kelmscott. Both houses lay by the Thames, and Morris once rowed the length of the river between them. A founder of the Society for the Protection of Ancient Buildings in 1877, Morris also played a key role in the development of the Arts and Crafts movement, supporting both the Art Workers' Guild and the Arts and Crafts Exhibition Society. The ethic of the happy and well-educated workman, epitomised in his utopian fantasy *News from Nowhere* (1890), was central to his concept of socialism, which he vigorously supported, and he helped to found the Socialist League in 1884.

His last major undertaking was the Kelmscott Press, whose first book appeared in 1891; Morris lived just long enough to see its finest achievement, the folio *Chaucer* (1896). He died at Hammersmith on 3 October 1896, and his body was taken on a traditional farm cart to its resting place in Kelmscott churchyard, marked with a gravestone designed by Philip Webb.

Photograph of William Morris, 1857; William Morris Gallery, Walthamstow, London

Cat. nos. 51, 56, 60, 61, 62, 63, 64

ALEXANDER MUNRO
1825–1871

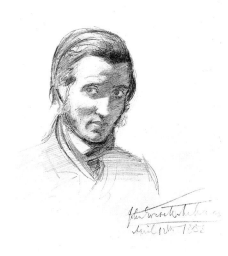

The son of a dyer in Inverness, Alexander Munro was born on 26 October 1825. He attended the local Academy, where he showed a precocious talent for modelling clay portraits of his friends. Through the patronage of the Duchess of Sutherland, he was employed by the architect Charles Barry as a decorative carver at the new Palace of Westminster, working under the leading sculptor John Thomas (1788–1867). Failing at first to enter the Royal Academy Schools in 1846, Munro was taken as a pupil by E.H. Baily (1788–1867), but was accepted for the Schools the next year. There he encountered Millais and Rossetti, the latter becoming a particularly close friend.

Munro became an intimate of the Pre-Raphaelite Brotherhood; his name is mentioned in its *Journal* as the likely, if inadvertent, source in revealing the meaning of the initials P.R.B. to the journalist Angus Reach in the summer of 1850. His first exhibits at the Royal Academy in 1849 were portrait busts – the inevitable staple work for a sculptor – but *Innocence* (1850; unlocated) was the first of many more genre subjects, often with a literary flavour, that complemented Pre-Raphaelite interests. *Paolo and Francesca* (cat. no. 19), shown in plaster at the Great Exhibition of 1851 and at the Royal Academy in 1852 as a marble group, is usually cited as the most important single piece of Pre-Raphaelite sculpture; it was bought by William Gladstone, who later became Prime Minister.

From 1852 to 1858 Munro shared a house and studio with Arthur Hughes, and remained on friendly terms with the Pre-Raphaelites, making medallion busts of Millais (1854), William Bell Scott (1854) and William Allingham (1855). In 1855 he accompanied Rossetti on a trip to Paris, and he visited Italy three times, in 1858, 1861 (with his new wife Mary Carruthers) and 1863, with Hughes. He executed a good deal of public sculpture, including a series of statues in Oxford University Museum (1856 onwards), and was involved in the Oxford Union scheme of 1857, carving a tympanum relief to Rossetti's design. His health deteriorated in 1865 and he went to live in the south of France; he died in Cannes on 1 January 1871.

Drawing of Alexander Munro, by John Everett Millais, 1853; William Morris Gallery, Walthamstow, London

Cat. no. 19

CHARLES FAIRFAX MURRAY
1849–1919

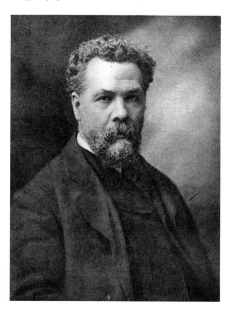

Charles Fairfax Murray was born in Bow, in the East End of London, on 30 September 1849. His father, a draper, may have been an amateur artist, and although the young Murray seems to have received no formal training, he showed enough promise as a draughtsman in an engineer's office in Westminster to attract attention. Through the art dealer Murray Marks he was introduced into Pre-Raphaelite circles, and was given work as a studio assistant in 1866–1867 by both Burne-Jones and Rossetti. In 1867 he painted a self-portrait and exhibited the first of two works at the Royal Academy (*The Children in the Wood*).

The extent of his oeuvre as a painter remains to be investigated, although he was working in oils well into the 1880s, and was an exhibitor at the Grosvenor and New Galleries.

By 1870 he was employed by Morris, Marshall, Faulkner and Company, chiefly in translating Burne-Jones's designs into working studio cartoons, although evidence indicates that he was also one of the glass painters: the Vyner Memorial window of 1872–1873 at Christ Church Cathedral, Oxford, apparently bears his initials. He also painted decorative panels for the firm's furniture, and is known to have carried out similar work for the furnishing company of Collinson and Lock.

Burne-Jones showed to John Ruskin copies made by Murray of the frescoes at the Campo Santa at Pisa, which the young man had painted during a first visit to Italy in 1871. The critic commissioned Murray to make similar watercolour copies in Siena and Rome in 1873. Italy became a second home to Murray, especially after his marriage to Angelica Collivichi in Pisa in 1875. Settling in Florence, they had six children, only three of whom survived infancy (on his death, it was revealed that Murray had maintained a family in England as well). He continued to work for Ruskin as a copyist, also providing photographs and information on Old Master paintings to him and other connoisseurs in England and America. In *Ariadne Florentina* (1875), Ruskin described Murray as someone "who already knows the minor secrets of Italian art better than I". This soon led to activity as a collector and dealer, both in Renaissance art and in the work of his contemporaries: his unique collection of Pre-Raphaelite drawings (mostly acquired by the shrewd purchase of minor lots at the artists' posthumous studio sales) was sold to Birmingham Museum between 1903 and 1906, while J. Pierpont Morgan bought his Old Master drawings *en bloc* in 1910. Murray died in Chiswick, London, on 25 January 1919.

Photograph of Charles Fairfax Murray, by F. Braun

Cat. no. 93

DANTE GABRIEL ROSSETTI
1828–1882

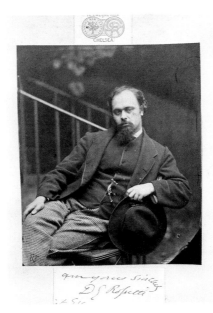

The driving force behind both phases of the Pre-Raphaelite movement, Rossetti was one of those rare British artists (including William Blake, a personal hero of his) who achieved fame both as a painter and as a poet. With his Italian background adding to a volatile and passionate temperament, he remained something of an outsider in the English art world, despite Ruskin's judgement (in *The Art of England* [1883]) that he "should be placed first in the list of men . . . who have raised and changed the spirit of Modern Art".

Gabriel Charles Dante Rossetti was born in London on 12 May 1828; his mother, Frances Polidori, was half-Italian, and his father Gabriele was a poet and Dante scholar (from 1831, Professor of Italian at King's College, London) who had fled Italy as a political refugee. In addition to an elder sister, Maria Francesca (1827–1876), Rossetti had a brother, William Michael (1829–1919), who became the chronicler of the Pre-Raphaelite Brotherhood, and a younger sister, the poet Christina (1830–1894). The reading and writing of poetry was a family pre-occupation, and by 1840 Gabriel (as he was usually known) was also drawing in pen and ink. In 1842 he enrolled at Sass's drawing academy and two years later entered the Royal Academy Schools as a probationer, becoming a full-time student in 1845, whereupon he immediately met Deverell. His early drawings (see cat. no. 10) betray an impatience with technique and practice: in 1847, when he was still undecided whether to become a painter or a poet, he sought the advice of Leigh Hunt and William Bell Scott (1811-1890), and wrote to Robert Browning as well.

In March 1848 he took lessons in painting from Brown, and became acquainted with

Hunt after admiring his *Eve of St Agnes* at the Royal Academy. Membership of the Cyclographic Society led to friendship with Millais and Woolner, and to the establishment of the Pre-Raphaelite Brotherhood in September (see cat. no. 13). With Hunt's technical advice, Rossetti completed two oil paintings, showing *The Girlhood of Mary Virgin* at the Free Exhibition, Hyde Park, in 1849 (the first work to be exhibited bearing the initials P.R.B.), and *Ecce Ancilla Domini!* at the National Institution, Portland Gallery, in 1850 (fig. 3; both now in the Tate Gallery, London).

A hostile reception similar to that which greeted pictures by Hunt and Millais at the Royal Academy discouraged Rossetti both from painting in oils and from exhibiting his work. He concentrated on watercolour, showing (and selling) two works at the Old Water Colour Society winter exhibition of 1852–1853, and he found the first of a series of loyal patrons in Francis MacCracken, who bought a third watercolour in 1853. All three scenes were taken from Dante's *Vita Nuova*, which Rossetti had finished translating in 1848: this and other translations would form his first published volume of poetry, *The Early Italian Poets* (1861). In the winter of 1849–1850, Rossetti visited France and Belgium with Hunt, and on his return he was introduced by Deverell to Elizabeth Siddal (see cat. no. 16). From November 1852 she was a constant presence at Rossetti's studio at 14 Chatham Place, Blackfriars (overlooking the river Thames), as model, pupil and eventually mistress.

An introduction to John Ruskin in 1854 led to patronage for both Rossetti and Siddal, allowing her to winter in the south of France in 1855–1856; Rossetti joined her briefly in Paris, where he visited the Exposition Universelle. In 1856 he met Morris and Burne-Jones, both admirers of his work, who were recruited with others to decorate the Oxford Union Society building in the summer of 1857; during the work Rossetti met the young poet Algernon Swinburne and the eighteen-year-old Jane Burden, Morris's future wife (see cat. no. 42). This was an *annus mirablis* for Rossetti, who contributed to the Moxon Tennyson and completed a remarkable series of watercolours on medieval themes (most are now in the Tate Gallery, London). *The Blue Closet*, bought by Morris, joined five other drawings in the Pre-Raphaelite Exhibition at Russell Place.

Rossetti's close friend Boyce records the appearance in 1859, during a lull in the relationship with Siddal, of a new model and mistress, Fanny Cornforth (see cat. nos. 35, 89). She sat for *Bocca Baciata* (1859; Museum of Fine Arts, Boston), the first in a long series of sensual half-length female subjects, in the

revived medium of oil, which were to establish his mature reputation. A reconciliation led to marriage with Lizzie Siddal in May 1860 and to one happy and productive year, in which Rossetti became a partner in Morris, Marshall, Faulkner and Company, and a lively member of a wide social circle in London. A stillbirth in 1861, however, was followed by a decline in Lizzie's health, and she took a fatal overdose of laudanum (liquid opium) on 10 February 1862; Rossetti placed the only manuscript of his poems in her coffin.

Deeply affected by this loss, Rossetti moved to Tudor House, Cheyne Walk, Chelsea, later in the year; by 1864 he had recovered, enjoying the company of artist friends such as Sandys and Whistler, and renewing his relationship with Fanny Cornforth, with whom he visited Paris in 1864, where he met Edouard Manet and visited Gustave Courbet's studio (see cat. no. 78). Turning to additional models such as Alexa Wilding and Marie Stillman, his major paintings included *The Beloved* (1865–1866; Tate Gallery, London), *The Bower Meadow* (1871–1872; Manchester City Art Gallery; fig. 84), and several versions of *Beata Beatrix* (cat. no. 104), a posthumous and haunting image of Lizzie. Patrons and dealers were eager for such works, as well as for watercolour replicas and chalk drawings, and in 1867 Rossetti found an able studio assistant in Henry Treffry Dunn (1838–1899), after previously employing Charles Fairfax Murray.

From 1869 until 1876 Rossetti enjoyed a close relationship with Jane Morris, which reached a height during the summer of 1871 at Kelmscott Manor, Oxfordshire, whose tenancy Rossetti had taken with Morris (he was travelling in Iceland). She inspired, and sat for, some of Rossetti's most powerful paintings, including *Pandora* (1871; Private Collection), *Astarte Syriaca* (1875–1877; Manchester City Art Gallery) and *Proserpine* (cat. no. 111). After the manuscript was retrieved from Lizzie's coffin, Rossetti's *Poems* were published in 1870; at first well received, they were later viciously attacked (along with Swinburne's poems) by Robert Buchanan in an article and pamphlet entitled *The Fleshly School of Poetry*. Rossetti suffered a nervous breakdown in 1872, and his health never really recovered, being further weakened by immoderate drinking and use of the drug chloral. He was able to complete *The Blessed Damozel* (Fogg Art Museum, Harvard University) in 1877, but decided against showing at the new Grosvenor Gallery, where Burne-Jones proved so successful.

His final creative work – as his first had been – was in poetry; in 1880 he returned to writing sonnets, many complementing his own paintings, and in October 1881 two volumes were published, *Poems* and *Ballads and Sonnets*. In worsening health, he went to live in Birchington-on-Sea, Kent, where he died on Easter Sunday, 9 April 1882; his grave in the local churchyard is marked by a cross designed by Brown.

Photograph of Dante Gabriel Rossetti, by Lewis Carroll, 1863; National Portrait Gallery, London

Cat. nos. 10, 13, 16, 27, 33, 34, 35, 36, 42, 50, 54, 55, 60, 61, 62, 63, 64, 78, 89, 90, 95, 96, 102, 104, 110, 111

FREDERICK SANDYS
1829–1904

Born in Norwich on 1 May 1829, Anthony Frederick Augustus Sandys was the son of Anthony Sands (the artist adopted the name Sandys after 1855), formerly a dyer who became a drawing master and then a professional painter. Frederick was educated at Norwich Grammar School, then attended the Government School of Design in the city; he exhibited drawings at the Norwich Union from an early age, and in 1846 won a Royal Society of Arts silver medal for a chalk portrait. Of crucial importance to his career was the patronage of a Norfolk clergyman, James Bulwer. A keen antiquarian and amateur artist (a former pupil of John Sell Cotman), from 1845 Bulwer commissioned numerous watercolours, drawings and etchings of archaeological objects and architectural details, affording Sandys continued experience in draughtsmanship and technique (see cat. no. 72).

Sandys first exhibited at the Royal Academy in 1851, when he was living in London; two years later he married Georgina Creed in Norwich. The publication in 1857 of the etching *A Nightmare*, a parody of *Sir Isumbras at the Ford* by Millais, brought him into contact with the Pre-Raphaelites, and he struck up a friendship with Rossetti, whose work he emulated in oil and chalk half-length female figure subjects, culminating in *Morgan le Fay* (cat. no. 77) and *Medea* (cat. no. 88). The latter painting, which became a *cause célèbre* when rejected by the Royal Academy in 1868, was begun in Rossetti's studio; the two artists fell out in 1869, but were reconciled by 1874. From the late 1860s onwards, Sandys lived with Mary Jones (the actress known as Miss Clive), whom he seems to have met in Norwich as early as 1862. Sandys did not remarry, yet the two lived as man and wife, with Mary bearing ten children, eight of whom survived infancy.

In 1860 Sandys made his first design for illustration, published in the *Cornhill Magazine;* he became a regular contributor to the magazines *Good Words* and *Once a Week* (see cat. no. 84). His natural gift for linear design and expressive composition earned him more acclaim than any of his Pre-Raphaelite contemporaries as a master of 'black and white'. After the scandal over *Medea*, he painted rarely in oils, turning instead to coloured chalks: his large-scale subject pictures, of which the most celebrated is *Proud Maisie* (the 1902 version, one of many, is in Ottawa), are comparable with works by Rossetti but have a greater delicacy of touch. He also used chalks for formal portraits, and was commissioned by the publishing firm of Macmillan's to undertake a series depicting its writers, including Tennyson, Matthew Arnold and James Russell Lowell, which the artist completed between 1881 and 1885. A notoriously slow worker, Sandys was often in financial difficulties (though he liked to spend each autumn in Venice), and was frequently aided by patrons such as Cyril Flower (Lord Battersea), who provided the artist with an allowance and studio expenses. In 1898 he was a founder member of the International Society of Sculptors, Painters and Gravers, where he renewed the acquaintance of Whistler, made over thirty years earlier through Rossetti. Sandys died in London on 25 June 1904.

Photograph of Frederick Sandys, circa 1900; Jeremy Maas

Cat. nos. 71, 72, 77, 83, 84, 85, 88, 98

ELIZABETH SIDDAL
1829–1862

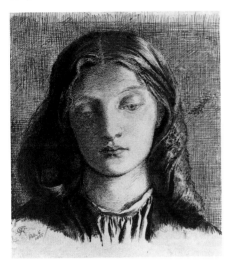

Long regarded merely as the romantic heroine of Pre-Raphaelitism, and remembered chiefly as Rossetti's model, mistress and victim (after her tragic death from an overdose of liquid opium), Elizabeth Siddal has emerged from recent biographical research as a woman of independent mind and considerable artistic ambition, and as the author of some impressive Pre-Raphaelite verse. The daughter of a Sheffield-born cutler, Elizabeth Eleanor Siddal (most often known as Lizzie) was born in London on 25 July 1829. Nothing is known of her early life until an encounter with the Deverell family, probably near the end of 1849, when she was working as a dressmaker. An obituary in the *Sheffield Telegraph* states that she showed some of her drawings and sketches to the elder Mr Deverell, then secretary of the Government School of Design, and was introduced to Walter Howell Deverell and the Pre-Raphaelite circle. A developing romantic attachment to Deverell has been suggested, though this cannot be confirmed.

Demure in manner but strikingly (if unconventionally) beautiful, with brilliant red hair, Siddal captivated the young Pre-Raphaelite artists and became a frequent model for their paintings, appearing as Sylvia in Hunt's *Valentine rescuing Sylvia from Proteus* (cat. no. 17), as Delia in Rossetti's watercolour *The Return of Tibullus* (cat. no. 27) and most famously as Ophelia for Millais (cat. no. 22). In 1852 she began to sit regularly to Rossetti, and was described by him in letters to his sister Christina as his pupil (although none of her drawings are dated earlier than 1853). He was soon in love with her, but they did not live together or become formally engaged, and although they were close friends with Ford and Emma Brown, Lizzie was not introduced to the Rossetti family for several years.

Her earliest drawings, such as *The Lady of Shalott* (1853; Private Collection), show considerable promise, and her best work materialised in a series of watercolours on romantic medieval themes, including *The Ladies' Lament* (1856; Tate Gallery, London) and *Clerk Saunders* (1857; Fitzwilliam Museum, Cambridge), which was one of five pieces by her included in the Russell Place exhibition of 1857. The completion of these works was assisted by an annuity from John Ruskin, which also enabled her to visit the south of France in 1855 for her health: her life was punctuated by bouts of a debilitating neuraesthenic illness.

Reconciled after a prolonged estrangement, Siddal and Rossetti married on 23 May 1860 in Hastings, and travelled to Boulogne and then Paris for their honeymoon. The succeeding year was among the happiest of Lizzie's life, spent in the stimulating company of the Brown, Burne-Jones and Morris families (she helped with the decorative painting at Red House), but it ended sadly after her pregnancy resulted in a stillbirth in May 1861. On 10 February 1862 she took an overdose of laudanum and died the following morning; rumours of a suicide note have never been confirmed, and the inquest delivered a verdict of accidental death. Before her burial in High-gate Cemetery, Rossetti laid a manuscript notebook of poems in her coffin (they were recovered by exhumation seven years later).

Drawing of Elizabeth Siddal, by Dante Gabriel Rossetti, 1855; Ashmolean Museum, Oxford

Cat. no. 43

SIMEON SOLOMON
1840–1905

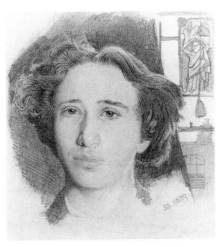

The son of a prosperous hat importer in the Jewish community, Simeon Solomon was born in the East End of London on 9 October 1840; Abraham (1823–1862) and Rebecca (1832–1886), two of his six siblings, also became painters. After initial study at Cary's art school, Solomon entered the Royal Academy Schools in 1856, exhibiting at the Academy for the first time in 1858. At the Schools he met Henry Holiday (1839–1927), Albert Moore (1841–1893), Marcus Stone (1840–1921) and Fred Walker (1840–1875), who together founded the Sketching Club, to some extent an imitation of the Pre-Raphaelite Brotherhood. Among the earliest work of Solomon and Holiday are drawings that parody Pre-Raphaelite subjects.

By 1859 Solomon had met Rossetti and Burne-Jones, and had begun the elaborate pen and ink drawing of *Dante's First Meeting with Beatrice* (Tate Gallery, London), which absorbs their style of that date. He received a commission for illustrations to Dalziels' *Bible Gallery* (see cat. no. 52), and most of his early oils and watercolours are of religious, especially Hebraic, subjects, such as *The Finding of Moses* (1862; Hugh Lane Gallery, Dublin). He also designed some stained-glass cartoons for Morris, Marshall, Faulkner and Company.

A close acquaintance with the poet Algernon Swinburne and Oscar Browning (with whom he visited Rome in 1867) led Solomon into aesthetic and homosexual circles – he illustrated Swinburne's (unpublished) pornographic novel *Lesbia Brandon* – and inspired his own enigmatic prose poem, *A Vision of Love revealed in Sleep*, published privately in 1871. His career and reputation suffered a disastrous reverse when in 1873 he was convicted of homosexual offences, receiving a suspended sentence. At first supported by his family, and to a limited extent by artist friends including Burne-Jones, Solomon accepted almost cheerfully the life of an impoverished recluse, eventually entering the St Giles Workhouse, Holborn, in 1884. Over the next twenty years Solomon produced hundreds of quasi-mystical chalk drawings, of which *Night and Sleep* (cat. no. 113) is typical; remarkably, he was awarded a gold medal at the Paris Exhibition of 1900. He died in the workhouse on 14 August 1905.

Self-portrait drawing by Simeon Solomon, 1859; Tate Gallery, London

Cat. nos. 52, 86, 94, 113

HENRY WALLIS
1830–1916

Although he remained on friendly terms with individual artists, Henry Wallis made only a limited contribution to Pre-Raphaelitism, through a few major oil paintings exhibited at the Royal Academy in the 1850s. He may otherwise be classified as a good genre and history painter, and an occasional landscapist.

His father's identity and profession remain unknown. Born in London on 21 February 1830, Wallis adopted the surname of a prosperous property owner whom his mother, Mary Anne Thomas, married in 1845. After training at Cary's academy, Wallis entered the Royal Academy Schools in 1848; he is also believed to have studied in Paris before 1853, both in the atelier of the orientalist painter Charles Gleyre (1806–1874) and at the Académie des Beaux-Arts. His first exhibited work in England was at the Manchester Institution in 1853, and he showed four paintings, including *The Room in which Shakespeare was born* (Tate Gallery, London), at the Royal Academy in 1854. By that year he was acquainted with Boyce, and also knew the poet George Meredith, who modelled for the head of Thomas Chatterton in the painting *Chatterton* (cat. no. 39), which caused a sensation at the Royal Academy in 1856 and received high praise from John Ruskin. Within a year, Wallis had formed a relationship with Meredith's wife Mary Ellen, who left her husband and bore Wallis a son in April 1858; she died in 1861, and Wallis never subsequently married.

Wallis was involved with the Hogarth Club in 1858, and in that year exhibited his masterpiece, *The Stonebreaker* (cat. no. 40), which has become one of the classic images of late Pre-Raphaelitism. On his stepfather's death in 1859, Wallis became financially independent. His subsequent paintings reverted largely to historical genre, from *Back from Marston Moor* (1859) to his last Royal Academy exhibit, *Louis XI and Cardinal Balue* (1877); he then became an Associate (in 1878) and Member (in 1880) of the Old Water Colour Society. His name appears many times in Boyce's diary in the company of Rossetti and Burne-Jones, and Hunt later recalled his presence in another circle of artists which included Stacy Marks (1829–1898) and George du Maurier (1834–1896).

Wealthy enough to travel abroad when he chose, Wallis made regular visits to Italy, the Mediterranean and Egypt, and from 1882 to 1890 he acted as honorary secretary to the committee for the preservation of St Mark's, Venice. His later life was dedicated to the collection and study of Italian and Near Eastern ceramics, on which he published some twenty monographs between 1885 and 1899. He died in Croydon on 20 December 1916.

Photograph of Henry Wallis in later life

Cat. nos. 39, 40, 92

PHILIP WEBB
1831–1915

One of eleven children, Philip Speakman Webb was born in Oxford on 12 January 1831, the son of a doctor; his grandfather was Thomas Webb, a well-known medallist in Birmingham. Showing an early interest in buildings, natural history and drawing, he was articled to the architect John Billing of Reading, before entering the office of George Edmund Street in Beaumont Street, Oxford, and eventually becoming his senior clerk. There Webb met William Morris, who joined the office in January 1856, and the two men formed an instant and lifelong friendship. Later that year, Webb began independent practice as an architect in London, firstly at 7 Great Ormond Street and later at 1 Raymond Buildings, Gray's Inn.

In August 1858 he joined Morris and Charles Faulkner in France, rowing down the Seine from Paris (in a boat sent over from Oxford). During this trip the plan was conceived for Red House, Morris's new home at Bexleyheath in Kent. Begun in 1859, this remarkable building, in red-brick vernacular style, established Webb's reputation – one of his obituarists wrote that it "marks the birth of modern domestic architecture". Webb also designed all its furniture and fittings, down to the candlesticks and table glass, and he played a crucial role in the early work of Morris, Marshall, Faulkner and Company from its establishment in April 1861. His contribution to the firm's stained glass was especially important, as he was responsible for the overall design of each commission (see cat. no. 65), as well as for nearly all the decorative details in the windows, from canopies and banners to pattern-work backgrounds and borders. When he renounced active participation after the re-constitution of Morris and Company in 1875, in A.C. Sewter's words "a certain irreplaceable quality was lost".

Webb's work as an architect consisted mostly of domestic, though often substantial, buildings, such as 1 Palace Green, Kensington, for George Howard (1868–1872; see cat. no. 99) and Clouds, Wiltshire, for the Wyndham family (1879–1886). He constructed new houses for several artists, including Val Prinsep (at 1 Holland Park Road, Kensington, in 1864), Boyce (Glebe Place, Chelsea, in 1868–1871) and G.F. Watts (Freshwater, Isle of Wight, in 1873); his only church, at Brampton in Cumberland (1875), was filled with some of Morris and Company's finest stained glass. In 1877 he helped Morris launch the Society for the Protection of Ancient Buildings, and shared his old friend's commitment to socialism in the 1880s; he also designed Morris's tombstone at Kelmscott. An able watercolourist, Webb remained a regular practitioner in the decorative arts: one of his last designs was for the ceremonial mace for the University of Birmingham (completed in 1902). He never married, and in 1900 retired from practice to live in a cottage at Worth, Sussex, where he died on 17 April 1915.

Drawing of Philip Webb, by Charles Fairfax Murray

Cat. no. 65

Chronology

LOUISE HAZEL

THE PRE-RAPHAELITES	CONTEMPORARY EVENTS
1819 John Ruskin born 8 February in London, son of a wine shipper	Future Queen Victoria and Prince Consort Albert born
	Opening of Burlington Arcade, Picadilly
	Gustave Courbet born
	Théodore Géricault: *The Raft of the Medusa*
1820	George III dies; succeeded by George IV
	John Keats: "Ode to a Nightingale" Walter Scott: *Ivanhoe* Percy Bysshe Shelley: "Prometheus Unbound"
	Friedrich Engels and Florence Nightingale born
	"Missouri Compromise": Maine enters Union as free state and Missouri as a slave state (in 1821)
1821 Ford Madox Brown born 16 April in Calais, son of a ship's purser	Greeks revolt against Turkish control
	Charles Baudelaire, Gustave Flaubert and Feodor Dostoevsky born
	John Keats dies
	Rosetta Stone deciphered
	Population in Great Britain, 20.8 million; in America, 9.6 million
1822	Royal Academy of Music founded in London
	Louis Pasteur and Heinrich Schliemann born
	Percy Bysshe Shelley dies
	Streets of Boston lit by gas
1823	Monroe Doctrine announces closing of American continent to European colonial settlement
	Oxford Union Society founded
	Charles Macintosh invents waterproof fabric
	George IV presents library of George III to British Museum, London
1824	National Gallery founded in London
	Lord George Byron dies at Missolonghi, supporting Greek war of independence
1825 James Collinson born 9 May in Mansfield, son of a bookseller and postmaster	First passenger railway line opens between Stockton and Darlington
Alexander Munro born 26 October in Inverness, son of a stone-mason	Completion of Erie Canal links Lake Erie with Hudson River
	Beethoven's *Symphony No. 9* first performed in England
Thomas Woolner born 17 December in Hadleigh, Suffolk	Tea roses from China introduced in Europe

	THE PRE-RAPHAELITES	CONTEMPORARY EVENTS
1826	Robert Braithwaite Martineau born 19 January in London, son of a taxing-master	Partial repeal of Combination Acts marks beginning of modern trade unions in England
	George Price Boyce born 24 September in London, son of a wine merchant	John Adams and Thomas Jefferson both die 4 July
	William Dyce visits Italy	James Fenimore Cooper: *The Last of the Mohicans*
		University College and Royal Zoological Society founded in London
1827	William Holman Hunt born 2 April in London, son of a warehouse manager	William Blake and Ludwig von Beethoven die
	Walter Howell Deverell born 1 October in Charlottesville, Virginia, to English parents; family returns to England, 1829	John Keble: *The Christian Year*
		George Ohm defines electrical current potential and resistance (Ohm's Law)
		Dr Richard Bright first describes Bright's Disease
		Karl Baedeker begins publishing his travel guides
1828	James Campbell born 17 February (?) in Liverpool, son of an insurance agent	Gilbert Stuart, Francisco de Goya, Jean Antoine Houdon and Franz Schubert die
	Dante Gabriel Rossetti born 12 May in London, son of an Italian political refugee and Dante scholar	George Meredith, Margaret Oliphant, Jules Verne, Leo Tolstoy and Henrik Ibsen born
	Frederic George Stephens born 10 October in London, son of a workhouse master	London publications *Athenaeum* and *Spectator* founded
		Henry Peter Brougham delivers the longest recorded speech (six hours) in the House of Commons
1829	Frederick Sandys born 1 May in Norwich, son of a dyer and drawing master	Andrew Jackson inaugurated as seventh President of the United States
	John Everett Millais born 8 June in Southampton, son of wealthy parents	Metropolitan police force established in London
	Elizabeth Siddal born 25 July in London, daughter of a cutler	Thomas Attwood founds the Birmingham Political Union to demand parliamentary reform
	William Michael Rossetti born 25 September in London	Catholic Emancipation Act allows Roman Catholics in Great Britain to hold public office
	Dyce returns from Rome to Aberdeen, then Edinburgh	First U.S. patent on a typewriter granted
		George Stephenson's railway engine *Rocket* succeeds at Rainhill Trials
1830	Henry Wallis born 21 February in London; born Henry Thomas, and later adopted stepfather's surname	George IV dies; succeeded by William IV
	John William Inchbold born 29 August in Leeds, son of a newspaper proprietor	Louis Philippe becomes "the Citizen King"; Talleyrand serves as French king's ambassador to London
	Christina Rossetti born 5 December in London	Emily Dickinson, Albert Bierstadt, Frederic Leighton and Camille Pissarro born
		Sir Thomas Lawrence dies
		Liverpool to Manchester railway formally opened
		James Smithson bequeaths £100,000 to found Smithsonian Institution
1831	Philip Speakman Webb born 12 January in Oxford, son of a doctor	Charles Darwin sails to South America, New Zealand and Australia
	John Brett born 8 December in Reigate, son of an army veterinary surgeon	Michael Faraday demonstrates his discovery of electromagnetic induction
		London Bridge opened
		Population of Great Britain: 13.9 million; United States: 12.8 million
		French Foreign Legion formed

1832	Arthur Hughes born 27 January in London	First Reform Act passed to enfranchise English middle classes
		Cholera epidemics spread to England, New York and New Orleans
		Alfred Tennyson: "The Lady of Shalott"
		Edouard Manet, Louisa May Alcott, Horatio Alger, Lewis Carroll and Theodore Watts-Dunton born
		Johann Wolfgang von Goethe and Sir Walter Scott die
1833	Edward Burne-Jones born 28 August in Birmingham, son of a gilder and frame-maker	Birmingham Town Hall is completed
	Brown moves to Belgium with his family; studies under Albert Gregorius, then in Ghent under Pieter van Hansel	Davy Crockett's autobiography is a best-seller
		Charity bazaars become popular in England
		First Venetian pictures by J.M.W. Turner shown at Royal Academy
		Factory Act limits work hours for women and boys, and provides a system of factory inspection in England
1834	William Morris born 24 March in Walthamstow, son of a wealthy bill broker	Palace of Westminster and Houses of Parliament destroyed by fire
		The Hunchback of Notre Dame by Victor Hugo is a best-seller
		Thomas Carlyle: *Sartor Resartus*
		James McNeill Whistler and Edgar Degas born
		Hansom cabs introduced in London
		End of Spanish Inquisition
		Poor Law Amendment Act establishes British workhouse system
1835		William Fox Talbot takes earliest negative photograph at Lacock Abbey, Wiltshire
		Hans Christian Andersen publishes first of his children's tales
		Madame Tussaud's Waxworks opens in Baker Street
1836		The People's Charter initiates first national working-class movement in Great Britain (Chartism), demanding universal suffrage and vote by ballot
		Davy Crockett dies at the Battle of the Alamo in Texas
		First cricket match held in London
		Joseph Chamberlain born
1837	Dyce is appointed Superintendent of the new School of Design, Somerset House (resigns 1843)	William IV dies; Victoria becomes Queen aged eighteen
	Brown attends Antwerp Academy, studying under Gustave, Baron Wappers	Martin Van Buren inaugurated as eighth President of the United States
	Brown: *Head of a Page Boy (?)* (cat. no. 1)	Algernon Charles Swinburne and J. Pierpont Morgan born
		John Constable dies
		England institutes official birth registration
1838		London to Birmingham railway opens
		National Gallery opens in London
		New York Herald is first American newspaper to employ European correspondents

1839	Millais enrols at Sass's Academy	Outbreak of First Opium War between Britain and China
	Sandys exhibits drawings at Norwich Art Union	First electric clock is built
		Charles Dickens's *Oliver Twist* and *Nicholas Nickleby* are best-selling books
		Abner Doubleday conducts first baseball game ever played
		Walter Pater, Paul Cézanne and Alfred Sisley born
		Chartists riot in Birmingham
1840	Simeon Solomon born 9 October in London, son of a hat importer who is a prominent member of the Jewish community	Queen Victoria marries her cousin, Prince Albert of Saxe-Coburg-Gotha
	Ruskin meets J.M.W. Turner	Penny postage established in Great Britain
	Brown marries his cousin Elisabeth Bromley; begins to exhibit at the Royal Academy	Claude Monet, Pierre Renoir, Auguste Rodin, Emile Zola, Thomas Hardy and Peter Ilyich Tchaikovsky born
	Millais enters the Royal Academy Schools, youngest student ever	Nelson's Column erected in Trafalgar Square
		2,816 miles of railway in use in the United States; 1,331 miles in England
1841	Rossetti enrols at Sass's Academy	Future King Edward VII born
		Edgar Allan Poe: "The Murders in the Rue Morgue" John Keats: *Poetical Works* (posthumous)
		Punch magazine launched
		Invention of the saxophone
1842	Woolner enters Royal Academy Schools	Great Britain and United States sign treaty defining Canadian frontier
	Brown: *Parisina's Sleep: study for the head of Parisina* (cat. no. 2)	Treaty of Nanking ends Opium War and confirms cession of Hong Kong to Great Britain
		Alfred Tennyson: *Poems*
		Queen Victoria makes her first railway journey
1843	Ruskin's *Modern Painters*, vol. 1, is published (vol. 2 in 1846)	Competition launched for decoration of new Houses of Parliament
	Woolner first exhibits at Royal Academy	Charles Dickens: *A Christmas Carol* Thomas Carlyle: *Past and Present*
	Millais: *Elgiva seized by order of Odo, Archbishop of Canterbury* (cat. no. 3)	Weekly financial paper, *The Economist*, launched
		World's first night club, "Le Bal des Anglais", opens in Paris
1844	Deverell attends Sass's Academy and meets Rossetti	James K. Polk elected eleventh President of the United States
	Hunt enters Royal Academy Schools at third attempt; meets Millais and Stephens	Samuel F.B. Morse sends first telegraph message between Washington, D.C., and Baltimore
	Brown and Woolner unsuccessful in Westminster competition; Dyce awarded commission for frescoes, Munro works as decorative carver	Coventry Patmore: *Poems* William Makepeace Thackeray: *Barry Lyndon* Elizabeth Barrett Browning: *Poems*
	Brown settles in London	YMCA founded in England
	Brown: *The Body of Harold brought before William the Conqueror* (cat. no. 4); *The Spirit of Justice* (cat. no. 5)	Thomas Eakins and Friedrich Nietzsche born
		Wood-pulp paper invented
1845	Rossetti enters Royal Academy Schools	Maori uprising against British rule in New Zealand
	Hunt: *Self-Portrait* (cat. no. 6)	First submarine cable laid under the English Channel
		U.S. Naval Academy opens in Annapolis, Maryland

	Brown travels to Italy for his wife's health; visits the studios of Nazarene painters Cornelius and Overbeck in Rome Brown: *Chaucer at the Court of Edward III* (cat. no. 7)	John Henry Newman converts to Roman Catholicism Benjamin Disraeli: *Sybil, or the Two Nations* Edgar Allan Poe: "The Raven" Friedrich Engels: *Conditions of the Working Class in England* Failure of potato crop in Ireland leads to famine and emigration
1846	Deverell enters Royal Academy Schools Hughes enrols at School of Design, taught by Alfred Stevens Sandys wins Royal Society of Arts medal Millais first exhibits at the Royal Academy; meets Effie Grey Ruskin Brown returns to England after the death of his wife in Paris	United States declares war on Mexico Edward Lear: *Book of Nonsense* Mendelssohn's oratorio *Elijah* first performed in the Birmingham Town Hall Sewing machine patented by Elias Howe Smithsonian Institution founded in Washington, D.C. Discovery of the planet Neptune
1847	Hughes and Munro enter Royal Academy Schools Collinson and Deverell first exhibit at Royal Academy Hunt reads Ruskin's *Modern Painters* and discovers poetry of Keats Millais is lent a book of engravings of the frescoes in the Campo Santo, Pisa Rossetti, undecided whether to be a poet or a painter, writes to Leigh Hunt and William Bell Scott	Thomas Edison and Alexander Graham Bell born Charlotte Brontë: *Jane Eyre* Emily Brontë: *Wuthering Heights* Henry Wadsworth Longfellow: *Evangeline* William Makepeace Thackeray: *Vanity Fair* Evaporated milk made for first time
1848	Deverell, Hunt, Millais, and Rossetti contribute to the Cyclographic Society Rossetti briefly becomes Brown's pupil Hunt works in Millais's studio, and later shares a studio with Rossetti Pre-Raphaelite Brotherhood is founded in September by Rossetti brothers, Millais, Hunt, Woolner, Collinson and Stephens Collinson renounces Roman Catholicism; becomes engaged to Christina Rossetti Deverell appointed Assistant Master, School of Design Rossetti finishes his translation of Dante's *Vita Nuova* Woolner visits Paris and meets Ingres Wallis enters Royal Academy Painting School Brown: *Wycliffe reading his Translation of the New Testament* (cat. no. 8); *The Young Mother* (cat. no. 9) Rossetti: *Ulalume* (cat. no. 10) Millais: *The Death of Romeo and Juliet* (cat. no. 11); *My Beautiful Lady* (cat. no. 12)	Year of turmoil in Europe, with revolutions in Paris, Vienna, Berlin, Venice, Milan, Parma and throughout Hungary; nationalist movement develops in Italy French Republic proclaimed; Louis Napoleon elected President *Communist Manifesto* issued by Karl Marx and Friedrich Engels Women's rights movement begins in the United States with a convention in Seneca Falls, New York Discovery of gold at Sutter's Mill leads to California gold rush of 1849 John Stuart Mill: *Principles of Political Economy* James Russell Lowell: *Biglow Papers* Last Chartist demonstration
1849	Charles Fairfax Murray born 30 September in Bow, East End of London, son of a draper Hughes first exhibits at Royal Academy First pictures inscribed with the initials P.R.B. are exhibited at the Royal Academy (Hunt: *Rienzi*; Millais: *Isabella*) Deverell meets Elizabeth Siddal, who works as a dressmaker Boyce, after meeting David Cox in Wales, decides to become a painter	European revolutions begin to subside Britain annexes Punjab Benjamin Disraeli becomes leader of Conservative Party John Ruskin: *The Seven Lamps of Architecture* Thomas Macaulay: *History of England* (–1861; 5 volumes) Charles Dickens: *David Copperfield* Edgar Allan Poe dies

Rossetti and Hunt visit Paris and Flanders together

Rossetti: *The First Anniversary of the Death of Beatrice* (cat. no. 13)

French physicist Armand Fizeau measures speed of light

Amelia Bloomer begins reform of American women's dress

1850

Founding of P.R.B. magazine *The Germ;* only four issues published

Meaning of P.R.B. is revealed to the press, generating hostile criticism

Dyce commends Pre-Raphaelite work to Ruskin

Collinson reverts to Roman Catholicism, breaks engagement to Christina Rossetti and resigns from Brotherhood; Deverell proposed in his place, but is not formally elected

Hunt paints in open air at Sevenoaks, with Rossetti and Stephens

Hughes reads *The Germ*, and meets Hunt, Rossetti and Brown

Collinson: *An Incident in the Life of St Elizabeth of Hungary* (cat. no. 14)
Deverell: *James II robbed by Fishermen* (cat. no. 15)
Rossetti: *Love's Mirror* (cat. no. 16)

Henry Clay's compromise slavery resolutions presented to U.S. Senate

Public Libraries Act passed in Britain

California becomes a state

Charles Dickens founds and edits *Household Words*, a weekly family magazine

Gustave Courbet: *The Stone Breakers*

Jenny Lind, the "Swedish Nightingale", tours America under the management of P.T. Barnum

Robert Louis Stevenson born

William Wordsworth dies; Alfred Tennyson appointed Poet Laureate

Herbert Spencer initiates the beginnings of sociology

Cast-iron railway bridge opened at Newcastle

1851

Campbell enters Royal Academy Schools

Martineau becomes Hunt's pupil and shares his studio

Sandys first exhibits at Royal Academy

Hunt's *Valentine rescuing Sylvia from Proteus* (cat. no. 17) is among Pre-Raphaelite paintings that are badly received at Royal Academy; reaction prompts Ruskin's letter to the *Times* and pamphlet *Pre-Raphaelitism*

Hunt and Millais paint in open air at Ewell

Brown begins *Pretty Baa-Lambs* (cat. no. 18)

Great Exhibition housed in the Crystal Palace; first international exhibition of manufactures and industrial art

J.M.W. Turner dies

John Ruskin: *The Stones of Venice* (vol. 1)
Nathaniel Hawthorne: *The House of Seven Gables*
Herman Melville: *Moby Dick*

Continuous stitch sewing machine invented

Introduction of first double-decker bus

Schooner "America" brings the America's Cup to the United States

Population of Great Britain: 20.8 million; United States: 23 million

Gold discovered in Victoria, New South Wales, Australia

1852

Inchbold and Martineau first exhibit at Royal Academy

Hughes meets Millais; shares studio with Munro

Woolner emigrates to Australia

Munro: *Paolo and Francesca* (cat. no. 19)
Brown: design and study for *The Last of England* (cat. nos. 20, 21)
Millais: study for *Ophelia* (cat. no. 22)

Franklin Pierce elected fourteenth President of the United States

Louis Napoleon proclaimed Emperor as Napoleon III

Duke of Wellington dies

Harriet Beecher Stowe: *Uncle Tom's Cabin*
Charles Dickens: *Bleak House*

1853

Burne-Jones and Morris meet at Exeter College, Oxford

Brett enters Royal Academy Schools

Boyce meets Hunt and Millais; first exhibits at Royal Academy and Old Water Colour Society

Brown marries Emma Hill; stops exhibiting at Royal Academy

Millais travels to Scotland with Ruskin and his wife Effie; elected Associate of Royal Academy

P.R.B. meets to draw portraits for Woolner

Hunt: *Deverell* (cat. no. 23); *Rossetti* (cat. no. 26)
Deverell: *"As You Like It"* (cat. no. 24); *Heads of two Women* (cat. no. 25)
Rossetti: *The Return of Tibullus* (cat. no. 27)

Peace established between Britain and Burma

World's Fair held in New York

Queen Victoria allows chloroform to be administered to her during the birth of her seventh child; anesthetic gains popularity in Britain

Levi Strauss sells jeans to miners in western United States

Uncle Tom's Cabin is a best-seller on both sides of the Atlantic

Vincent van Gogh born

Elizabeth Gaskell: *Cranford*

Vaccination against smallpox is compulsory in Great Britain

Henry Steinway and sons found a firm in New York to manufacture pianos

1854

Deverell dies of Bright's Disease on 2 February in London

Burne-Jones and Morris visit northern France, and decide to become painters

Campbell elected Associate of Liverpool Academy

Collinson leaves Stonyhurst College without completing noviatiate for priesthood

Rossetti meets Ruskin; spends summer at Hastings with Elizabeth Siddal

Woolner returns to England from Australia

Hunt begins two-year trip to Egypt and the Holy Land; *A Street Scene in Cairo* (cat. no. 28); study for *The Finding of the Saviour in the Temple* (cat. no. 29); *The Dead Sea from Siloam* (cat. no. 30)

Millais: *Waiting* (cat. no. 31)

Cimean War breaks out as Britain and France declare war on Russia; battles of Balaklava and Inkerman

Alfred Tennyson: "Charge of the Light Brigade"
Coventry Patmore: *The Angel in the House*
Henry David Thoreau: *Walden, or Life in the Woods*
Charles Dickens: *Hard Times*

Working Men's College, London, founded by F.D. Maurice; Ruskin and later Brown, Rossetti and Morris teach there

Commodore Matthew Perry negotiates first American-Japanese treaty

Crystal Palace re-assembled at Sydenham, South London

Republican Party founded in the United States

Britain and U.S. sign treaty on Canadian trade

1855

Solomon enters Royal Academy Schools

Campbell elected Member of Liverpool Academy

Burne-Jones and Morris discover Southey edition of *Morte d'Arthur*

Ruskin offers Siddal an annuity for exclusive supply of drawings; she travels to south of France for her health

Millais marries Effie Grey after her annulment from Ruskin; settle in Perth, Scotland, and return to London in 1861; cartoon for *The Rescue* (cat. no. 32)

Rossetti: study for *"Dante's Vision of Rachel and Leah"* (cat. no. 33); design for *Found* (cat. no. 34); *Tennyson reading "Maud"* (cat. no. 35)

Exposition Universelle held in Paris (Rossetti and the Brownings visit it)

Australian colonies become self-governing

The Crayon founded by W.J. Stillman and John Durand; *Daily Telegraph* founded in London

Anthony Trollope: *The Warden*
Walt Whitman: *Leaves of Grass*
Henry Wadsworth Longfellow: *The Song of Hiawatha*
Alfred Tennyson: *Maud*

David Livingstone discovers Victoria Falls of Zambezi River

Florence Nightingale introduces hygienic standards into military hospitals during Crimean War

Richard Wagner conducts a series of orchestral concerts in London

1856

Thomas Seddon, an associate of the Pre-Raphaelites, dies in Egypt

Burne-Jones receives lessons from Rossetti

Morris and friends launch *Oxford and Cambridge Magazine* (twelve issues published); meets Webb in office of architect G.E. Street; moves to London, where he shares rooms with Burne-Jones

Brett meets Inchbold and Ruskin in Switzerland

Hunt is unsuccessful as candidate for Associateship of Royal Academy

Brown: study for *The Prisoner of Chillon* (cat. no. 37)
Millais exhibits *The Blind Girl* (cat. no. 38)
Wallis: *Chatterton* (cat. no. 39)

Treaty of Paris ends Crimean War

Second Opium War breaks out between Britain and China

George Bernard Shaw, Oscar Wilde and Sigmund Freud born

Gustave Flaubert: *Madame Bovary*

Sir Henry Bessemer introduces converter into his steel-making process

Louis Pasteur discovers disease can be spread by airborne germs

"Big Ben", 13.5 ton bell at Houses of Parliament, cast at Whitechapel Bell Foundry

1857

Sandys's parody *A Nightmare* brings him into contact with Pre-Raphaelites

Brown organises Pre-Raphaelite exhibition at 4 Russell Place, Bloomsbury

Rossetti, Morris, Burne-Jones, Hughes and others decorate Oxford Union building

Moxon edition of Tennyson's *Poems* published with illustrations by Rossetti, Hunt and Millais (*Dora*; cat. no. 41)

Exhibition of British Art (largely Pre-Raphaelite) shown in New York; presented in Philadelphia and Boston following year

Royal Navy destroys Chinese fleet

Outbreak of Indian mutiny against British rule

Manchester Art Treasures Exhibition includes Pre-Raphaelite paintings

Victoria and Albert Museum, and National Portrait Gallery, London, open

Thomas Hughes: *Tom Brown's Schooldays*

Hallé concerts founded in Manchester

First safety elevator installed in America

	THE PRE-RAPHAELITES	CONTEMPORARY EVENTS
	Wallis: *The Stonebreaker* (cat. no. 40) Rossetti: *Sir Launcelot in the Queen's Chamber* (cat. no. 42) Siddal: study for *Jephtha's Daughter* (cat. no. 43)	Matrimonial Causes Act passed in Britain, easing process of divorce
1858	Solomon first exhibits at Royal Academy Hogarth Club founded by Brown, Rossetti, Hunt (*A Porter to the Hogarth Club*, cat. no. 44) and others; Burne-Jones first exhibits there Morris publishes first poetry, *The Defence of Guenevere* Campbell: *The Wife's Remonstrance* (cat. no. 45) Hughes: *The Annunciation* (cat. no. 46); *The Nativity* (cat. no. 47)	British proclaim peace with India Transatlantic telegraph cable links England and America Oliver Wendell Holmes: *The Autocrat of the Breakfast Table* Thomas Wright (ed.): *La Mort d'Arthur* Thomas Carlyle: *Frederick the Great* New York Symphony Orchestra gives its first public concert National Association of Baseball Players organized in America
1859	Morris marries Jane Burden and moves to Red House, Bexleyheath, built by Webb Burne-Jones visits Italy Wallis inherits property and becomes financially independent Hughes completes *The Long Engagement* (cat. nos. 48, 49) Rossetti: *Sir Galahad at the Ruined Chapel* (cat. no. 50) Morris: study for *"Tristram and Iseult"* (cat. no. 51) Solomon: *"Babylon hath been a golden cup"* (cat. no. 52)	Lord Palmerston becomes British Prime Minister John Brown hanged for leading slave uprising Charles Darwin: *On the Origin of Species by Natural Selection* Charles Dickens: *A Tale of Two Cities* Alfred Tennyson: *Idylls of the King* Edward Fitzgerald translates *Rubáiyát of Omar Khayyám* Arthur Conan Doyle, A.E. Housman and Georges Seurat born Leigh Hunt, Washington Irving, Thomas Macaulay and David Cox die First oil well drilled in Titusville, Pennsylvania Work on Suez Canal begins
1860	Rossetti marries Elizabeth Siddal Burne-Jones marries Georgiana Macdonald Hunt's *Finding of the Saviour in the Temple* is exhibited at German Gallery; sold for £5,500, the highest price then paid to a living artist Millais: *The Seamstress* (cat. no. 53) Dyce: *Christ and the Woman of Samaria* (cat. no. 76)	Abraham Lincoln elected sixteenth President of the United States; South Carolina secedes from Union in protest *Cornhill Magazine* founded, with William Thackeray as editor Invention of first practical internal-combustion engine British Open Golf Championships start During last decade, 424,000 people emigrated from England and 914,000 from Ireland to U.S.
1861	Collinson appointed Secretary, Society of British Artists (–1870) Stephens serves as art critic of *Athenaeum* magazine (–1901) Munro marries Mary Carruthers Hogarth Club dissolved Morris, Marshall, Faulkner and Company founded, with Brown, Burne-Jones and Rossetti also as partners Rossetti publishes *Early Italian Poets* Rossetti: *Self-Portrait* (cat. no. 54); study for *The Seed of David* (cat. no. 55) Brown: *King René's Honeymoon: Architecture* (cat. no. 57)	Prince Albert dies Confederate States of America formed with South Carolina, Georgia, Alabama, Mississippi, Florida, and Louisiana; outbreak of Civil War with Confederate attack on Fort Sumter; first battles of Union and Confederate troops Last issue of *The Crayon* George Eliot: *Silas Marner* Charles Dickens: *Great Expectations* Royal Academy of Music founded in London Daily weather forecasts begin in Britain First horse-drawn trams appear in London
1862	Elizabeth Siddal dies 11 February; Rossetti places manuscript poems in her coffin; he later moves to Cheyne Walk, Chelsea; Boyce takes his old studio at Chatham Place, Blackfriars Burne-Jones visits Italy with his wife and Ruskin Inchbold works in Venice (–1864?)	International Exhibition held in South Kensington; works by Morris's firm displayed in Medieval Court, Pre-Raphaelite paintings in Picture Galleries Lancashire Cotton Famine brought on by American Civil War Christina Rossetti: *Goblin Market* Herbert Spencer: *First Principles* Victor Hugo: *Les Misérables*

Morris: *The Ascension* (cat. no. 56)
Hughes: *The Birth of Tristram* (cat. no. 58)
Burne-Jones: *King Mark and La Belle Iseult* (cat. no. 59); *The Annunciation* (cat. no. 66); study for *An Idyll* (cat. no. 67)
Webb: *St Paul, with Scenes from his Life* (cat. no. 65)
Sandys: *Autumn* (cat. no. 71)

Sarah Bernhardt makes her stage debut in Paris

English cricket team tours Australia for first time

1863

Millais elected Royal Academician

Hunt, Ruskin and others give evidence before the Royal Commission on Fine Arts

Woolner: *My Beautiful Lady* (poems)

Martineau: *The Last Chapter* (cat. nos. 69, 70)
Sandys: *Study of Ivy* (cat. no. 72)
Burne-Jones: *The Merciful Knight* (cat. no. 73)
Brown: *Work* (cat. no. 74)

President Lincoln's Emancipation Proclamation goes into effect; Confederate defeat at Gettysburg shifts war in favour of Union; Lincoln presents Gettysburg Address

Edouard Manet's *Déjeuner sur l'herbe* outrages crowds at Salon des Refusés, Paris

Edward Everett Hale: *Man without a Country*
Henry Wadsworth Longfellow: *Tales of a Wayside Inn*

Construction begins on London underground railway

Association for Advancement of Truth in Art founded, with magazine *The New Path*

1864

Dyce dies, 15 February

Woolner marries Alice Waugh (later becomes Hunt's brother-in-law)

Boyce and Burne-Jones elected Associates of Old Water Colour Society

Hunt and Martineau hold their own exhibition, 16 Hanover Street

Rossetti visits Paris with Fanny Cornforth, where he meets Manet through introduction of Fatin-Latour

Burne-Jones: study for *Green Summer* (cat. no. 68)
Brown: *Elijah and the Widow's Son* (cat. no. 75)
Sandys: *Morgan le Fay* (cat. no. 77)
Rossetti: *Woman combing her Hair* (cat. no. 78)

Abraham Lincoln re-elected President

General Ulysses S. Grant becomes Commander-in-Chief of Union armies

First International Workingmen's Association founded by Karl Marx

Exhibition of Stained Glass held in South Kensington (Morris is represented)

John Newman: *Apologia pro Vita Sua*
Leo Tolstoy: *War and Peace*

Henri Toulouse-Latrec and Richard Strauss born

Louis Pasteur invents pasteurization for wine

"In God We Trust" first appears on U.S. coins

1865

Brown holds retrospective exhibition, 191 Picadilly

Hunt marries Fanny Waugh (she dies December 1866)

Munro moves to south of France for his health

Morris moves his home and workshop to Queen Square, Bloomsbury

Burne-Jones: *Two Female Heads* (cat. no. 79); *St George and the Dragon* (cat. no. 80); study for *"The Fates"* (cat. no. 81)

General Robert E. Lee becomes General-in-Chief of Confederate Army; Confederates surrender at Appomattox Courthouse in Virginia

Abraham Lincoln assassinated

American Civil War ends; Thirteenth Amendment to U.S. Constitution abolishes slavery

Future King George V born

Lewis Carroll: *Alice's Adventures in Wonderland*
Algernon Swinburne: *Atalanta in Calydon*
Mark Twain: "The Celebrated Jumping Frog of Calaveras County"

Rudyard Kipling and William Butler Yeats born

Carpet sweepers, ice machines and railway sleeping cars come into use

1866

Sandys lodges with Rossetti at Cheyne Walk

Morris and Webb decorate Green Dining Room, South Kensington Museum

Brett: *February in the Isle of Wight* (cat. no. 82)
Sandys: *If* (cat. no. 83); study for *Helen and Cassandra* (cat. no. 84)
Inchbold: *Springtime in Spain* (cat. no. 91)

"Black Friday" on London Stock Exchange

Last cholera epidemic in England

H.G. Wells and Vasily Kandinsky born

Feodor Dostoevsky: *Crime and Punishment*
Algernon Swinburne: *Poems and Ballads*, withdrawn due to public protest

Edgar Degas begins to paint ballet scenes

	THE PRE-RAPHAELITES	CONTEMPORARY EVENTS
1867	Sandys begins to use Mary Jones (Miss Clive) as a model	First Birmingham Art Gallery opens
	Burne-Jones moves to The Grange, Fulham	British Parliamentary Reform Act extends franchise
	Morris publishes *The Life of Jason*	Russia sells Alaska to U.S. for $7,200,000
	Sandys: *Helen of Troy* (cat. no. 85) Solomon: *Bacchus* (cat. no. 86) Hughes: *The Lost Child* (cat. no. 87)	Exposition Universelle held in Paris, with separate exhibition of paintings by Edouard Manet
		Arnold Bennett, John Galsworthy, Marie Curie and Arturo Toscanini born
		Oliver Wendell Holmes: *The Guardian Angel* Emile Zola: *Thérèse Raquin* Henrik Ibsen: *Peer Gynt* Karl Marx: *Das Kapital* (vol. 1)
		David Livingstone explores the Congo
1868	Sandys's *Medea* (cat. no. 88) is rejected by Royal Academy; Swinburne and others protest and write to the *Times*; painting shown in 1869	William Gladstone becomes British Prime Minister
	Morris publishes *The Earthly Paradise* (vols. 1 and 2)	Impeachment trial of U.S. President Andrew Johnson ends in acquittal by Senate
	Rossetti: *Fanny Cornforth* (cat. no. 89)	Royal Academy moves to Burlington House, Picadilly
		Louisa May Alcott: *Little Women* Robert Browning: *The Ring and the Book* Feodor Dostoevsky: *The Idiot*
		Skeleton of Cro-Magnon man found in France
1869	Martineau dies 13 February	Ulysses S. Grant inaugurated as eighteenth President of the United States
	Elizabeth Siddal's coffin is exhumed to recover Rossetti's manuscript poems	Opening of Suez Canal
	Rossetti falls out with Sandys; develops a relationship with Jane Morris	Britain abolishes debtors prisons
	Hunt elected to Old Water Colour Society; makes his second trip to Jerusalem	Frank Lloyd Wright, Henri Matisse and Mahatma Gandhi born
	Webb builds a house for Boyce at Glebe Place, Chelsea	Matthew Arnold: *Culture and Anarchy* R.D. Blackmore: *Lorna Doone* Bret Harte: *The Outcasts of Poker Flat*
	Murray: *Head of a Young Man* (cat. no. 93)	Formulation of periodic table for classification of elements
		Princeton and Rutgers Universities originate intercollegiate football
1870	Burne-Jones begins an affair with Maria Zambaco; resigns from Old Water Colour Society after criticism of *Phyllis and Demophoön*	Franco-Prussian War begins, with heavy defeats for French armies; formation of Third Republic
	Brett marries Mary Ann Howcraft	Lenin (Vladimir Ilyich Ulyanov) born
	Rossetti publishes *Poems*	Charles Dickens dies
	Rossetti: *Woman with a Fan* (cat. no. 90)	Jules Verne: *Twenty Thousand Leagues under the Sea*
		Keble College, Oxford, founded
		Metropolitan Museum of Art, New York, founded
		Heinrich Schliemann begins to excavate Troy
		John D. Rockefeller founds Standard Oil Company
1871	Munro dies 1 January	Paris Commune rules France for two months
	Morris and Rossetti share tenancy of Kelmscott Manor; Morris tours Iceland while Rossetti and Jane Morris spend summer at Kelmscott	Trade Unions Act legalises unions in Great Britain
		Slade School of Fine Art, London, established

Robert Buchanan attacks Rossetti in his article "The Fleshly School of Poetry", published in *Contemporary Review*

Brett elected Fellow of Royal Astronomical Society

Burne-Jones, on his third trip Italy, visits the Sistine Chapel in Rome

Solomon: *Dawn* (cat. no. 94); also writes "A Vision of Love revealed in Sleep"
Rossetti: study for *"Water Willow"* (cat. no. 95)

Charles Darwin: *The Descent of Man*
George Eliot: *Middlemarch*
Lewis Carroll: *Through the Looking Glass*

Stephen Crane, Theodore Dreiser and Marcel Proust born

James McNeill Whistler: *Arrangement in Grey and Black: Portrait of the Painter's Mother*

Giuseppe Verdi: *Aida*

The Royal Albert Hall opens in London

The Great Fire in Chicago destroys much of the city

P.T. Barnum opens his circus, "The Greatest Show on Earth"

1872

Beerbohm born 27 August in London, son of a prosperous corn merchant

Rossetti suffers a nervous breakdown after Buchanan's article is re-printed as a pamphlet; recuperates in Scotland

Rossetti and Morris: stained-glass windows on *St George and the Dragon* (cat. nos. 60–64)
Rossetti: study for *The Bower Meadow* (cat. no. 96)
Brown: *Convalescent* (cat. no. 97)
Burne-Jones: designs for *"Cupid and Psyche" Frieze* (cat. no. 99)

Ballot Act in Britain institutes voting by secret ballot

U.S. General Amnesty Act pardons most ex-Confederates

Christina Rossetti: *Sing Song: A Nursery Rhyme Book* (with illustrations by Hughes)
Jules Verne: *Around the World in Eighty Days*
Thomas Hardy: *Under the Greenwood Tree*

Brooklyn Bridge opens

Bertrand Russell and Sergei Diaghilev born

Ship *Marie Celeste* discovered empty and mysteriously abandoned at sea

First international soccer game, England vs Scotland

1873

Solomon convicted of homosexual offences; sentence subsequently suspended

Burne-Jones makes his fourth and last visit to Italy

Sandys: *Mary Sandys* (cat. no. 98)

Joseph Chamberlain elected Mayor of Birmingham

Financial panic in New York

Walter Pater: *Studies in the History of the Renaissance*
Herbert Spencer: *The Study of Sociology*
Leo Tolstoy: *Anna Karenina*

Enrico Caruso, Feodor Chaliapin and Sergei Rachmaninoff born

Vincent van Gogh lives in England (–1876)

Colour photographs first developed

1874

Brown's daughter Lucy marries William Michael Rossetti; his son Oliver dies aged twenty

Benjamin Disraeli becomes Prime Minister

Britain annexes Fiji Islands

First Impressionist exhibition held in Paris

Thomas Hardy: *Far from the Madding Crowd*

Winston Churchill, Guglielmo Marconi, Ernest Shackleton, G.K. Chesterton, Robert Frost, W. Somerset Maugham and Gertrude Stein born

1875

Hunt marries Edith Waugh, sister of his late wife, in Neuchâtel, Switzerland; makes his third trip to Jerusalem

Boyce marries Caroline Soubeiran

Morris, Marshall, Faulkner and Company dissolved; Morris and Company founded, with Morris in full control

Burne-Jones: *The Tiburtine Sibyl* (cat. no. 100)
Rossetti: *The Question* (cat. no. 102)
Brett: *Southern Coast of Guernsey* (cat. no. 103)

Housing and Public Health Acts passed in Britain

Albert Schweitzer, Samuel Coleridge-Taylor, Thomas Mann and Carl Jung born

Jean Baptiste Corot, Jean François Millet and Hans Christian Andersen die

Mark Twain: *The Adventures of Tom Sawyer*

"Trial by Jury", first Gilbert and Sullivan operetta, performed

London's main sewer system completed

Captain Matthew Webb is first man to swim the English Channel

	THE PRE-RAPHAELITES	CONTEMPORARY EVENTS
1876	Inchbold publishes his sonnets, *Annus Amoris*	Queen Victoria proclaimed Empress of India
	Morris publishes "Sigurd the Volsung", an epic poem inspired by his visits to Iceland	Centennial Exhibition held in Philadelphia to commemorate 100th anniversary of the Declaration of Independence
	Burne-Jones: *The Song of Solomon* (cat. no. 101)	Custer's Last Stand: George Custer and over 200 soldiers killed by Sioux Indians at Little Bighorn
		Alexander Graham Bell patents the telephone
		First U.S. tennis tournament
1877	Grosvenor Gallery, founded by Sir Coutts Lindsay, provides an alternative to Royal Academy; display of eight works by Burne-Jones causes a sensation	Third Impressionist exhibition held in Paris
	Morris helps found the Society for Protection of Ancient Buildings	Manchester Town Hall completed
		Gustave Courbet dies
	Rossetti: *Beata Beatrix* (cat. no. 104)	Henry James: *The American*
		First public telephones in U.S.
		Thomas Edison invents the phonograph
		All-England Lawn Tennis championship first played at Wimbledon
1878	Millais is awarded Légion d'Honneur; moves to 2 Palace Gate, Kensington	Exposition Universelle held in Paris
	Morris moves to Kelmscott House, Hammersmith	Ruskin vs Whistler libel suit over *Nocturne in Black and Gold: A Falling Rocket*; Ruskin wins damages of one farthing
	Brown begins murals for Manchester Town Hall, with Frederic Shields	Thomas Hardy: *Return of the Native*
	Burne-Jones: *Pygmalion and the Image* (cat. nos. 105–108)	Carl Sandburg and Upton Sinclair born
		Gilbert and Sullivan: *H.M.S. Pinafore*
		Invention of microphone
		Electric street lighting introduced in London
1879	Boyce: *Thorpe, Derbyshire* (cat. no. 109)	British Zulu War in southern Africa
		Henry James: *Daisy Miller*
		Albert Einstein, E.M. Forster and Joseph Stalin born
		London's first telephone exchange established
1880	Wallis elected to Old Water Colour Society	Metropolitan Museum of Art opens in New York
		Lytton Strachey and Helen Keller born
		Auguste Rodin: *The Thinker*
		New York streets first lit by electricity
		Game of bingo developed
1881	Collinson dies 24 January	Benjamin Disraeli and Thomas Carlyle die
	Morris and Company moves to Merton Abbey, Surrey	Pablo Picasso, P.G. Wodehouse and Alexander Fleming born
	Bible Gallery published by Dalziel brothers	Vatican archives open to scholars
	Rossetti publishes *Ballads and Sonnets* and *Poems*	Natural History Museum, South Kensington, London, opens
	Rossetti: *La Donna della Finestra* (cat. no. 110)	City populations: London, 3.3 million; New York, 1.2 million
1882	Rossetti dies 9 April; buried in churchyard at Birchington-on-Sea	British occupy Cairo
	Hunt moves to Draycott Lodge, Fulham	Franklin Delano Roosevelt, James Joyce, Virginia Woolf and Igor Stravinsky born

THE PRE-RAPHAELITES	CONTEMPORARY EVENTS

Morris joins Democratic Federation

Rossetti: *Proserpine* (cat. no. III)

Charles Darwin, Henry Wadsworth Longfellow, Anthony Trollope and Ralph Waldo Emerson die

Richard Wagner's *Tristan and Isolde* first performed in London

Tchaikovsky: *1812 Overture*

Beginnings of psychoanalysis

1883

Ruskin presents *The Art of England*, lectures on Pre-Raphaelitism

Burne-Jones: *The Rape of Proserpine* (cat. no. 112)

First skyscraper built in Chicago (ten stories high)

Clement Attlee, John Maynard Keynes and Franz Kafka born

Edouard Manet, Karl Marx and Richard Wagner die

Robert Louis Stevenson: *Treasure Island*

Metropolitan Opera House opens in New York

Orient Express makes its first run between Paris and Istanbul

"Buffalo Bill" Cody organises his "Wild West Show"

1884

Morris helps found Socialist League

International Meridian Conference, in Washington, D.C., establishes global time zones

Mark Twain: *Huckleberry Finn*

Oxford English Dictionary begins publication

First deep tube (underground railway) opens in London

1885

Millais created a Baronet, first British artist so honoured

Burne-Jones elected President of Royal Birmingham Society of Artists, and visits Birmingham; reluctantly accepts Associateship of Royal Academy

Inchbold exhibits at Royal Academy for last time

School of Art and Museum and Art Gallery open in Birmingham

General Charles Gordon killed at Khartoum in the Sudan, by followers of the Mahdi

Grover Cleveland inaugurated as twenty-second President of the United States

Washington Monument dedicated

George Meredith: *Diana of the Crossways*
Emile Zola: *Germinal*

Ezra Pound, Sinclair Lewis, D.H. Lawrence and Anna Pavlova born

Louis Pasteur develops rabies vaccine

Golf introduced to U.S. from Scotland

1886

Burne-Jones exhibits at Royal Academy for first and last time

Millais exhibits 159 works at Grosvenor Gallery; his picture *Bubbles* used to advertise Pear's soap

Hunt's articles on the Pre-Raphaelites appear in *Contemporary Review*

Statue of Liberty dedicated

William Gladstone introduces bill for Home Rule in Ireland

New English Art Club, London, founded

Robert Louis Stevenson: *The Strange Case of Dr Jekyll and Mr Hyde* and *Kidnapped*
Henry James: *The Bostonians*
Frances Hodgson Burnett: *Little Lord Fauntleroy*

Eighth and last Impressionist exhibition held in Paris

1887

Queen Victoria celebrates her Golden Jubilee

Arthur Conan Doyle: "A Study in Scarlet" (first Sherlock Holmes story)

Marc Chagall and Le Corbusier born

	THE PRE-RAPHAELITES	CONTEMPORARY EVENTS
1888	Inchbold dies 23 January	Arts and Crafts Exhibition Society with first presentation of works; Guild of Handicraft founded by C.R. Ashbee
	New Gallery breaks away from Grosvenor Gallery and opens exhibition space in Regent Street; Burne-Jones and Millais exhibit there	T.S. Eliot, Eugene O'Neill, Katherine Mansfield, Irving Berlin and T.E. Lawrence ("Lawrence of Arabia") born
	Solomon: *Night and Sleep* (cat. no. 113)	"Jack the Ripper" murders six women in the East End of London
	Hunt: *May Morning on Magdalen Tower, Oxford* (cat. no. 114)	*The Financial Times* first published in London
		George Eastman perfects "Kodak" box camera
		Football League and Lawn Tennis Association formed in U.S.
1889	Millais is instrumental in founding of National Portrait Gallery, London	Royal Charter gives Birmingham city status
	Ruskin suffers irreversible mental decline, and ceases to write	Eiffel Tower built for Exposition Universelle in Paris
	Burne-Jones is awarded Légion d'Honneur after his success in France	North Dakota, South Dakota, Montana and Washington become U.S. states
	Burne-Jones: *The Briar Rose* (cat. no. 115)	Charles Chaplin, Jean Cocteau, George S. Kaufman and Adolf Hitler born
		Robert Browning dies
		Henrik Ibsen's *A Doll's House* stirs controversy in London
		Barnum and Bailey's circus performs at Olympia in London
1890	Emma Brown dies	Birmingham Guild of Handicraft founded; Grosvenor Gallery closes in London
	Hunt begins his autobiography	Henrik Ibsen: *Hedda Gabler*
	Morris publishes *News from Nowhere*; establishes Kelmscott Press	Oscar Wilde: *The Picture of Dorian Gray*
	Burne-Jones's *Briar Rose* series exhibited to great acclaim at Agnew's and Toynbee Hall, London	William James: *The Principles of Psychology*
	Burne-Jones: *The Three Graces* (cat. no. 116)	Dwight D. Eisenhower and Charles de Gaulle born
		Vincent van Gogh, Cardinal Newman and Heinrich Schliemann die
		First moving-picture shows appear in New York
		Opening of Forth Railway Bridge in Scotland
		Global influenza epidemics
1891	Pre-Raphaelite Loan Exhibition, Birmingham; opening address given by Morris, in presence of Hunt and Stephens	Thomas Hardy: *Tess of the D'Urbervilles*
		Arthur Conan Doyle: "The Adventures of Sherlock Holmes" published in *Strand* magazine
		Paul Gauguin settles in Tahiti
		Invention of clothing zipper, though not in practical use until 1919
1892	Woolner dies 7 October	William Gladstone serves as British Prime Minister for fourth time
	Morris turns down position of Poet Laureate	Walt Whitman and Alfred, Lord Tennyson die
	Hunt visits Middle East for last time	Tchaikovsky: *The Nutcracker*
		Antonín Dvořák becomes director of New York National Conservatory of Music
1893	Brown dies 6 October	Revolt against British South Africa Company in Matabele is crushed
	Campbell dies 28 December	World's Columbian Exposition held in Chicago
	Burne-Jones resigns Associateship of Royal Academy	Art Nouveau appears in Europe
		Henry Ford builds his first automobile

1894	Christina Rossetti dies 29 December	Death duties (inheritance tax) introduced in Britain
	Burne-Jones accepts Baronetcy	Tower Bridge opens in London
	Morris publishes *How I Became a Socialist*	Beginnings of Dreyfus Affair in France
		Harold Macmillan, Nikita Khrushchev, James Thurber, Aldous Huxley and J.B. Priestley born
		George Bernard Shaw: *Arms and the Man* Rudyard Kipling: *The Jungle Book* George du Maurier: *Trilby* Anthony Hope: *The Prisoner of Zenda*
		Claude Debussy: *Prélude á l'après-midi d'un faune*
1895	Burne-Jones: study for *The Sirens* (cat. no. 117)	Future King George VI born
		London School of Economics and the National Trust founded
		First complete performance of Tchaikovsky's *Swan Lake*
		Oscar Wilde's *The Importance of Being Earnest* first performed; he is later convicted of homosexual offences and imprisoned
		H.G. Wells: *The Time Machine*
		Inventions of radio telegraphy, motion-picture camera and safety razor
1896	Millais elected President of Royal Academy on death of Lord Leighton	William McKinley elected twenty-fifth President of the United States
	Millais dies 8 August; buried in St Paul's Cathedral	Annual Nobel Prizes established in fields of physics, physiology and medicine, chemistry, literature and peace
	Kelmscott *Chaucer* designed by Morris and Burne-Jones	Giacomo Puccini: *La Bohème*
	Morris dies 3 October; buried in Kelmscott churchyard	First modern Olympics held in Athens
1897	Boyce dies 9 February	Queen Victoria's Diamond Jubilee
		Sir Henry Tate donates Tate Gallery to British people
		Rudyard Kipling: *Captains Courageous* H.G. Wells: *The Invisible Man* Edmond Rostand: *Cyrano de Bergerac* Bram Stoker: *Dracula*
		Discovery of the electron
1898	Burne-Jones dies 16 June; buried in Rottingdean churchyard	U.S. declares war on Spain over Cuba; Americans destroy Spanish fleet at Manila
	Kelmscott Press closes	Henry James: *The Turn of the Screw* H.G. Wells: *The War of the Worlds* Oscar Wilde: *The Ballad of Reading Gaol*
	Sandys is a founder member of International Society of Sculptors, Painters and Gravers	Ernest Hemingway and Bertolt Brecht born
		Aubrey Beardsley and William Gladstone die
		Glasgow School of Art opens; designed by Charles Rennie Mackintosh
1899		Boer War begins in South Africa between Britain and the Boers
		First Peace Conference at The Hague
		Humphrey Bogart, Charles Laughton and Noel Coward born

	THE PRE-RAPHAELITES	CONTEMPORARY EVENTS
1900	Ruskin dies 20 January; buried in Coniston churchyard	Boxer Rebellions in China against Europeans
		Exposition Universelle held in Paris, the largest of all international exhibitions
		Sigmund Freud: *The Interpretation of Dreams* Joseph Conrad: *Lord Jim*
		Thomas Wolfe, Kurt Weill and Aaron Copland born
		First performance of Edward Elgar's *Dream of Gerontius*, in Birmingham
		Max Planck formulates quantum theory
		W.G. Grace ends his cricket career with 54,000 lifetime runs
1901		Queen Victoria dies; succeeded by Edward VII
		Boers begin organised guerrilla warfare
		Enrico Fermi and Walt Disney born
		Boxing recognised as a legal sport in England
1902	Brett dies 7 January	Boer War ends, with casualties of 5,774 British and 4,000 Boers; Orange Free State becomes a British Crown Colony
		Arthur Conan Doyle: *The Hound of the Baskervilles* Anton Chekhov: *Three Sisters* Beatrix Potter: *The Tale of Peter Rabbit*
1903	Birmingham begins purchase of Pre-Raphaelite drawings from Murray (completed 1906)	Wilbur and Orville Wright successfully fly a powered airplane
		Jack London: *The Call of the Wild* George Bernard Shaw: *Man and Superman*
		James McNeill Whistler and Paul Gaughin die
		National Women's Political and Social Union (Suffrage Society) founded in England
		First Tour de France held
1904	Sandys dies 25 June	Russo-Japanese War breaks out; first use of trenches
	Beerbohm publishes *The Poets' Corner*	Christopher Isherwood, Graham Greene, Marlene Dietrich and Salvador Dali born
	Beerbohm: *Rossetti, in his back garden* (cat. no. 118)	James Barrie: *Peter Pan* Anton Chekhov: *The Cherry Orchard*
		London Symphony Orchestra gives its first concert
1905	Solomon dies 14 August	Theodore Roosevelt inaugurated as U.S. President for second term
	Hunt publishes *Pre-Raphaelitism and the Pre-Raphaelite Brotherhood;* awarded Order of Merit and honorary D.C.L. from Oxford	E.M. Forster: *Where Angels Fear to Tread* Baroness Orczy: *The Scarlet Pimpernel*
		Albert Einstein formulates Special Theory of Relativity
		Austin Motor Company formed in England
		First neon lights appear
1906		San Francisco earthquake kills 700 and causes $400 million in property losses
		Position of magnetic North Pole determined
		Samuel Beckett and Greta Garbo born
		Paul Cézanne and Henrik Ibsen die

1907	Stephens dies 9 March	First Cubist exhibition held in Paris
		Rudyard Kipling receives Nobel Prize for Literature
		First "Ziegfeld Follies" staged in New York
		Ivan Pavlov studies conditioned reflexes
1908	Hughes exhibits at Royal Academy for last time	H.H. Asquith becomes British Prime Minister
		Exhibition of realistic works by "The Eight" held at Macbeth Gallery in New York; artists soon dubbed "The Ashcan School"
		Ian Fleming, Simone de Beauvoir and Lyndon B. Johnson born
		E.M. Forster: *A Room with a View* Kenneth Grahame: *The Wind in the Willows*
		Production of first Model T Ford in Detroit
		Zeppelin disaster
		London hosts Olympic Games
1909		Algernon Swinburne and George Meredith die
		Sigmund Freud lectures in U.S. on psychoanalysis
		Mary Pickford becomes first film star
		H.G. Selfridge opens department store in Oxford Street
		First commercial manufacture of Bakelite marks beginning of Plastic Age
1910	Hunt dies 7 September; buried in St Paul's Cathedral	Edward VII dies; succeeded by George V
	Murray sells his collection of Old Master drawings to J. Pierpont Morgan	National Association for the Advancement of Colored People (NAACP) founded by W.E.B. DuBois
		E.M. Forster: *Howard's End*
		Leo Tolstoy, Mark Twain and Winslow Homer die
		Post-Impressionist exhibition of works by Cézanne, van Gogh and Matisse held in London
		Alfred Stieglitz exhibits modern American and European works at his 291 Gallery in New York
		Tango is latest rage
		The "week-end" becomes popular in U.S.
1911		Roald Amundsen reaches the South Pole
		Marie Curie receives Nobel Prize for Chemistry
		Max Beerbohm: *Zuleika Dobson*
		Mona Lisa stolen from the Louvre (found in Italy, 1913)
1912		S.S. *Titanic* sinks on her maiden voyage
		Extension to Birmingham Museum and Art Gallery opened
		London has 400 cinemas; approximately 5,000,000 people visit cinemas daily in U.S.
		Royal Flying Corps established in Britain (later R.A.F.)
		First successful parachute jump

1913		Suffragette demonstrations in London; Emmeline Pankhurst imprisoned
		Henry Ford pioneers assembly line techniques
		Willa Cather: *O Pioneers!* D.H. Lawrence: *Sons and Lovers*
		George Bernard Shaw's *Pygmalion* first performed in Vienna (in German); performed in London, 1914
		International Exhibition of Modern Art (better known as the Armory Show) introduces Post-Impressionism and Cubism to America
1914		World War I begins; Britain declares war on Germany, Austria and Turkey
		James Joyce: *Dubliners* Theodore Dreiser: *The Titan* Edgar Rice Burroughs: *Tarzan of the Apes*
		Almost 10.5 million immigrants entered U.S. from southern and eastern Europe (1905–1914)
1915	Webb dies 17 April	German blockade of England begins; English and French troops land at Gallipoli; first Zeppelin attack on London
	Hughes died 23 December	W. Somerset Maugham: *Of Human Bondage* Edgar Lee Masters: *A Spoon River Anthology*
		Marcel Duchamp creates first Dada-styled paintings
		First transcontinental telephone call (between New York and San Francisco)
1916	Wallis dies 20 December	Battle of the Somme; British first use tanks on Western Front
		Harold Wilson and Edward Heath born
		Dadaist cult arises in Zurich
		Daylight-saving time introduced in Britain
1917		U.S. declares war on Germany, Hungary and Austria; bread rationed in Britain
		John Fitzgerald Kennedy born
		T.S. Eliot: *Prufrock and Other Observations* Carl Jung: *Psychology of the Unconscious*
		Jazz sweeps U.S. as popular music, with Chicago at its center
1918		President Woodrow Wilson propounds Fourteen Points for world peace; Allied offensive on Western Front; end of World War I; approximately 8.5 million killed in war
		Booth Tarkington receives Pulitzer Prize for *The Magnificent Ambersons*
		Airmail postage instituted; first Chicago–New York airmail delivered
1919	Murray dies 24 January	Peace conference opens at Versailles; first League of Nations meeting in Paris; President Wilson is awarded Nobel Peace Prize
	William Michael Rossetti dies 5 February	Bauhaus founded by Walter Gropius in Weimar
		First nonstop flight across the Atlantic (Newfoundland to Ireland)

Select Bibliography

This bibliography is arranged chronologically. A shortened reference is given to works cited frequently in the catalogue text. Publications referred to only once within the essays and entries are not repeated here. The place of publication is London, except where specified.

PUBLICATIONS ON THE BIRMINGHAM COLLECTION

Birmingham, 1891
City of Birmingham, Museum and Art Gallery. Catalogue (with descriptive notes and illustrations) of the Permanent Collection of Paintings . . . compiled by Whitworth Wallis and Arthur Bensley Chamberlain, Birmingham, 1891; later editions of Permanent Collection catalogue only, 1899 (et seq.).

City of Birmingham Museum and Art Gallery. Catalogue of the Collection of Drawings and Studies by Sir Edward Burne-Jones and Dante Gabriel Rossetti, presented to the City in 1903, Birmingham, 1904.

London, Tate, 1911–1912
The National Gallery, British Art [later Tate Gallery]. Illustrated Catalogue of Works by English Pre-Raphaelite Painters lent by the Art Gallery Committee of the Birmingham Corporation. December, 1911 to March, 1912, 1912.

City of Birmingham. Museum and Art Gallery. Catalogue of the Collection of Drawings and Studies by Sir Edward Burne-Jones, Dante Gabriel Rossetti, Sir J.E. Millais, Ford Madox Brown, Frederick Sandys, John Ruskin, and others, exhibited in the Upper Galleries of the Museum, Birmingham, 1913.

Arthur B. Chamberlain, "Works by Frederick Sandys in the Birmingham Art Gallery", *Apollo,* vol. 4, November 1925.

Wallis, 1925
Twelve English Pre-Raphaelite Drawings reproduced from the Originals in the City of Birmingham Museum and Art Gallery. Selected and with a Foreword by Sir Whitworth Wallis, F.S.A., 1925.

Birmingham, *Paintings &c.,* [1930]
City of Birmingham Art Gallery. Catalogue of the Permanent Collection of Paintings in Oil, Tempera, Water-Colour, etc., Birmingham, n.d. [1930].
—— *Supplement,* Birmingham, n.d. [1935].
—— *Supplement II,* Birmingham, 1939.
—— *Supplement III,* Birmingham, 1951.

Randall Davies, "Water-Colours in the City Art Gallery, Birmingham; with a Summary Catalogue", *The Old Water-Colour Society's Club Sixteenth Annual Volume,* 1938, pp. 1–36.

Birmingham, *Drawings,* 1939
City of Birmingham Museum and Art Gallery. Catalogue of the Permanent Collection of Drawings in Pen, Pencil, Charcoal and Chalk, etc., including Cartoons for Stained Glass, Derby and Birmingham, 1939; compiled by A.E. Whitley.

Mary Woodall, *Some Pictures in the Birmingham Art Gallery: Eight Articles reprinted from the "Birmingham Weekly Post",* Birmingham, n.d. [1947].

"The Pre-Raphaelite Brotherhood". City of Birmingham Museum and Art Gallery, Picture Book No.1, Birmingham, n.d. [1949]; booklet by Kenneth Garlick.

City of Birmingham Museum and Art Gallery. Illustrations of One Hundred Oil Paintings in the permanent collection, Birmingham, n.d. [1952].

City of Birmingham Museum and Art Gallery. Illustrations of One Hundred Water Colours in the permanent collection, Birmingham, n.d. [1952].

Paintings & Drawings by British Artists from the City of Birmingham Art Gallery, National Library of Wales, Aberystwyth, 1956; catalogue by Mary Woodall and Brigid Bodkin.

Loan Exhibition of Pictures from the City Art Gallery, Birmingham, Thos. Agnew & Sons, Ltd., 1957; introduction by Trenchard Cox.

An Exhibition of the Decorative Art of Burne-Jones and Morris, Lent by the City of Birmingham Art Gallery, Midlands Federation of Museums and Art Galleries, 1957.

Birmingham, *Paintings,* 1960
City Museum and Art Gallery, Birmingham. Catalogue of Paintings, Birmingham, 1960; compiled by John Woodward, John Rowlands and Malcolm Cormack.

Ormond, 1965
The Pre-Raphaelites and their Circle, Birmingham, n.d. [1965], revised edition 1979; booklet by Richard Ormond.

Peintures et Aquarelles anglaises 1700–1900 du Musée de Birmingham, Musée des Beaux Arts, Lyon, 1966; catalogue by Peter Cannon-Brookes.

Richard Ormond, "Victorian Paintings and Patronage in Birmingham", *Apollo,* vol. 87, April 1968, pp. 240–251.

Birmingham Museums and Art Gallery. Pre-Raphaelite Drawings: Dante Gabriel Rossetti, Chicago and London, 1977; microfiche, with booklet by Andrea Rose.

British Watercolours 1760–1930 from the Birmingham Museum and Art Gallery, Arts Council, 1980–1981; catalogue by Richard Lockett.

British Nineteenth Century Drawings and Watercolours (from the Birmingham collection), British Council, 1982–1983; catalogue by Richard Lockett.

Pre-Raphaelite Art from the Birmingham Museum and Art Gallery, Hong Kong Museum of Art, 1984; catalogue by Richard Lockett.

The Holy Grail Tapestries designed by Edward Burne-Jones for Morris & Co, Birmingham, 1985; booklet by Emmeline Leary.

Pre-Raphaelite Women: A selection of drawings from Birmingham Museums and Art Gallery, Birmingham and Stoke-on-Trent, 1985–1986; booklet by Tessa Sidey.

Fifty Watercolours from Birmingham, Birmingham, 1987; booklet by Stephen Wildman.

Pre-Raphaelite Drawings: Exhibition Guide, Birmingham, 1989; booklet by Stephen Wildman, Jane Farrington and Tessa Sidey.

Pre-Raphaelite Paintings and Drawings in the Birmingham Museum and Art Gallery, Haslemere, 1990; microfiche with booklet, introduction by Stephen Wildman.

British Watercolours from Birmingham, Tokyo Station Gallery, Tokyo; Daimaru Museum of Art, Umeda (Osaka), and Yamanashi Prefectural Museum of Art, Kofu, 1991; Bankside Gallery (Royal Watercolour Society), 1992; catalogue by Stephen Wildman.

'Faithful and Able': Works by Thomas Matthews Rooke 1842–1942 in the Collections of Birmingham Museums and Art Gallery and the Ruskin Gallery, Collection of the Guild of St. George, Sheffield, Birmingham and Sheffield, 1993; catalogue by Janet Barnes and Stephen Wildman.

The following bibliography consists of books, articles and exhibition catalogues which make specific reference to works in the Birmingham collection. Biographies and general books on Victorian art which use Birmingham pictures as illustrations have not been included.

London, Piccadilly, 1865
The Exhibition of 'Work', and other paintings, by Ford Madox Brown, at the Gallery, 191, Piccadilly, 1865.

Rossetti, 1867
William Michael Rossetti, *Fine Art, Chiefly Contemporary: Notices reprinted, with Revisions,* 1867.

London, Burlington Fine Arts Club, 1883
Pictures, Drawings, Designs and Studies by the late Dante Gabriel Rossetti, Burlington Fine Arts Club, 1883.

London, Royal Academy, 1883
Works by the Old Masters, including a Special Selection from the Works of John Linnell and Dante Gabriel Rossetti, Royal Academy of Arts, 1883.

Pictures, Drawings, Designs and Studies by the late Dante Gabriel Rossetti, The Rossetti Gallery, 1a Old Bond Street, 1883.

Hunt, 1886
William Holman Hunt, "The Pre-Raphaelite Brotherhood: A Fight for Art", *Contemporary Review,* vol. 49, April, May and June 1886, pp. 471–488, 737–750, 820–833.

Rossetti, 1889
William Michael Rossetti, *D.G. Rossetti as a Designer and Writer,* 1889.

Bell, 1892
Malcolm Bell, *Edward Burne-Jones, A Record and Review,* 1892 (fourth edition, revised, 1898).

Exhibition of the Works of Edward Burne-Jones, New Gallery, 1892–1893.

Hueffer, 1896
Ford M. Hueffer, *Ford Madox Brown, A Record of his Life and Work,* 1896.

A Pre-Raphaelite Collection, Goupil Gallery, 1896 (collection of the late James Leathart); introduction by William Michael Rossetti.

London, Grafton, 1897
Exhibition of the Works of Ford Madox Brown, held at the Grafton Galleries, 8 Grafton Street, 1897; introductory note by Ford M. Hueffer.

London, Royal Academy, 1898
Works by the late Sir John Everett Millais, Bart., President of the Royal Academy, Royal Academy of Arts, 1898.

M.H. Spielmann, *Millais and his Works,* 1898.

London, New Gallery, 1898–1899
Exhibition of the Works by Sir Edward Burne-Jones, New Gallery, 1898–1899; introduction by J. Comyns Carr.

London, Burlington Fine Arts Club, 1899
Exhibition of Drawings and Studies by Sir Edward Burne-Jones, Bart., Burlington Fine Arts Club, 1899; introduction by Cosmo Monkhouse.

Bate, 1899
Percy Bate, *The English Pre-Raphaelite Painters, their Associates and Successors,* 1899 (second edition, revised, 1901; fourth edition, 1910).

Mackail, 1899
J.W. Mackail, *The Life of William Morris,* 2 vols., 1899 (second edition, 2 vols., 1901).

H.C. Marillier, *Dante Gabriel Rossetti, an illustrated Memorial of his Art and Life,* 1899.

Millais, 1899
John Guille Millais, *The Life and Letters of Sir John Everett Millais,* 2 vols., 1899 (second edition, 2 vols., 1900).

Catalogue of an Exhibition of Pictures, Drawings and Studies for Pictures made by the late Sir J.E. Millais, Bart., P.R.A., Fine Art Society, 1901; introductory note by J.G. Millais.

Dalziel, 1901
[George and Edward Dalziel], *The Brothers Dalziel, A Record of Fifty Years' Work in conjunction with many of the most distinguished artists of the Period 1840–1890,* 1901.

Ruskin, *Works*
E.T. Cook and Alexander Wedderburn (eds.), *The Works of John Ruskin,* 39 vols., 1903–1912.

Burne-Jones, *Memorials,* 1904
G B-J [Georgiana Burne-Jones], *Memorials of Edward Burne-Jones,* 2 vols., 1904 (second edition, 2 vols., 1906; new edition, 2 vols., 1993, with introduction by John Christian).

Fortunée de Lisle, *Burne-Jones,* 1904.

H.C. Marillier, *The Liverpool School of Painters,* 1904.

Pedrick, 1904
Gale Pedrick (ed.), *Recollections of Dante Gabriel Rossetti and his Circle (Cheyne Walk Life) by the late Henry Treffry Dunn,* 1904.

Hunt, 1905
William Holman Hunt, *Pre-Raphaelitism and the Pre-Raphaelite Brotherhood,* 2 vols., 1905 (second edition, 2 vols., 1913).

London, Whitechapel, 1905
British Art Fifty Years Ago, Whitechapel Art Gallery, Spring 1905; separate catalogue and illustrated booklet of thirty reproductions with descriptive letterpress.

Catalogue of an Exhibition of Paintings and Drawings by the late Simeon Solomon, Baillie Gallery, 1905–1906.

Rossetti, 1906
Some Reminiscences of William Michael Rossetti, 2 vols., 1906.

Catalogue of an Exhibition of Collected Works by Ford Madox Brown, Leicester Galleries, 1909; preface and notes by Ford Madox Hueffer.

London, Leicester Galleries, 1906
The Collected Works of W. Holman Hunt, O.M., D.C.L., Leicester Galleries, 1906; preparatory note by Sir W.B. Richmond.

Manchester, 1906
Handbook to the Exhibition of the Collected Works of W. Holman Hunt, O.M., D.C.L., City of Manchester Art Gallery, 1906; introduction by J. Ernest Phythian.

Liverpool, 1907
Collective Exhibition of the Art of W. Holman Hunt, O.M., D.C.L., Walker Art Gallery, Liverpool, 1907; introduction by E. Rimbault Dibdin.

Manchester, 1911
Loan Exhibition of Works by Ford Madox Brown and the Pre-Raphaelites, City of Manchester Art Gallery, 1911; introduction by J. Ernest Phythian.

Toynbee, 1912
Paget Toynbee, "Chronological list, with notes, of paintings and drawings from Dante by Dante Gabriel Rossetti", *Scritti Varii di Erudizione e di Critica in onore di Rodolfo Renier,* Turin, 1912, pp. 135–166.

Catalogue of Loan Exhibition of Works by Pre-Raphaelite Painters from Collections in Lancashire, National Gallery, British Art, 1913.

Catalogue of the Memorial Exhibition of some of the Works of the late Arthur Hughes, Walker's Galleries, 1916; preface by Albert Goodwin.

Catalogue, Loan Exhibition of Paintings and Drawings of the 1860 Period, National Gallery, Millbank, 1923.

Meisterwerke Englischer Malerei aus drei Jahrhunderten, Wiener Secession, Vienna, 1927.

Exposition Rétrospective de Peinture Anglaise (XVIIIe et XIXe Siècles), Musée Moderne, Brussels, 1929.

Centenary Exhibition of Paintings and Drawings by Sir Edward Burne-Jones, Bart. (1833–1898), Tate Gallery, Millbank, 1933; introduction by W. Rothenstein and note by T.M. Rooke.

Catalogue of an Exhibition in celebration of the Centenary of William Morris, Victoria and Albert Museum, 1934; introduction by J.W. Mackail.

Guide to the William Morris Centenary Exhibition, Walthamstow Museum, 1934; introductory essay by H.C. Marillier.

Commemorative Catalogue of the Exhibition of British Art, Royal Academy of Arts, London, January–March 1934, 1935.

English Prints and Drawings (Desenul si Gravura Engleza secolele XVIII–XX), Bucharest, Vienna and Prague, 1935–1936.

Twee Eeuwen Engelsche Kunst, Stedelijk Museum, Amsterdam, 1936.

La Peinture Anglaise, XVIIIe & XIXe Siècles, Louvre, Paris, 1938.

Baum (ed.), 1940
Paul Franklin Baum (ed.), *Dante Gabriel Rossetti's Letters to Fanny Cornforth,* Baltimore, 1940.

Paintings and Drawings of the Pre-Raphaelites and their Circle, Fogg Museum of Art, Harvard University, Cambridge, Massachusetts, 1946; introduction by Agnes Morgan.

Birmingham, 1947
"The Pre-Raphaelite Brotherhood" (1848–1862), City Museum & Art Gallery, Birmingham, 1947; catalogue by Trenchard Cox and Mary Woodall.

Pre-Raphaelite Drawings, Roland, Browse & Delbanco, 1947 (exhibition of drawings from the Birmingham collection, selected from the recent exhibition at Birmingham).

Robin Ironside and John Gere, *Pre-Raphaelite Painters,* Oxford, 1948.

Pre-Raphaelite Brotherhood 1848–1948, Catalogue of a Centenary Exhibition, Tate Gallery, 1948.

The Pre-Raphaelites, A Loan Exhibition of their Paintings and Drawings held in the Centenary Year of the Foundation of the Brotherhood, Whitechapel Art Gallery, 1948; introduction by J.A. Gere.

Pre-Raphaelite Masterpieces 1848–1862, City of Manchester Art Gallery, 1948; introduction by David Baxandall.

Centenary Exhibition of works by the Pre-Raphaelites – their Friends and Followers, Lady Lever Art Gallery, Port Sunlight, 1948.

Exhibition of Paintings and Drawings by the Pre-Raphaelites and their followers, Russell-Cotes Art Gallery, Bournemouth, 1951; introduction by Carlos Peacock.

The First Hundred Years of the Royal Academy, 1769–1868, Royal Academy of Arts, 1951–1952; separate catalogue and illustrated souvenir.

Pre-Raphaelite Drawings and Watercolours, Arts Council, 1953; catalogue by John Gere.

Some Pre-Raphaelite Paintings and Drawings, Arts Council (Welsh Committee), 1955.

British Portraits, Royal Academy of Arts, 1956–1957; separate catalogue and illustrated souvenir.

Masters of British Painting 1800–1950, New York (Museum of Modern Art), St. Louis and San Francisco, 1956–1957.

W.D. Paden, "'La Pia de' Tolomei' by Dante Gabriel Rossetti", *Register of the Museum of Art, University of Kansas, Lawrence,* vol. 2, no. 1, November 1958.

Exhibition of Victorian Painting, Nottingham University Art Gallery, 1959; catalogue by Alastair Smart and John Woodward.

Liverpool Academy of Arts, 150th Anniversary Exhibition: I The Liverpool Academy 1810–1867, II Liverpool Academy Open Exhibition 1960, Walker Art Gallery, Liverpool, 1960; catalogue by Mary Bennett and Hugh Macandrew.

Morris and Company 1861–1940, Arts Council, 1961; catalogue by Barbara Morris.

Victorian Paintings, Arts Council, 1962; catalogue by Graham Reynolds.

Primitives to Picasso: An Exhibition from Municipal and University Collections in Great Britain, Royal Academy of Arts, 1962; separate catalogue and illustrated souvenir.

Australia, 1962
Pre-Raphaelite Art, State Art Galleries of Australia (Adelaide, Perth, Hobart, Melbourne, Brisbane and Sydney), 1962; introduction by Daniel Thomas.

Bennett, 1962
Mary Bennett, "The Pre-Raphaelites and the Liverpool Prize", *Apollo,* vol. 77, December 1962, pp. 748–753.

Bennett, 1963
Mary Bennett, "A Check List of Pre-Raphaelite Pictures exhibited at Liverpool 1846–67, and some of their Northern Collectors", *Burlington Magazine,* vol. 105, November 1963, pp. 486–495.

Fredeman, 1963
William E. Fredeman, "Rossetti's Impromptu Portraits of Tennyson reading 'Maud'," *Burlington Magazine,* vol. 105, March 1963, pp. 116–118.

Gere, 1963
J.A. Gere, "Alexander Munro's 'Paolo and Francesca'," *Burlington Magazine,* vol. 105, November 1963, pp. 508–510.

Andrews, 1964
Keith Andrews, *The Nazarenes, A Brotherhood of German Painters in Rome,* Oxford, 1964.

Arts Council, 1964
Shakespeare in Art, Arts Council, 1964; introduction by W. Moelwyn Merchant.

Indianapolis and New York, 1964
The Pre-Raphaelites, A Loan Exhibition of Paintings and Drawings by Members of the Pre-Raphaelite Brotherhood and Their Associates, Herron Museum of Art, Indianapolis, and Gallery of Modern Art, including the Huntington Hartford Collection, New York, 1964; introduction by Curtis G. Coley.

Liverpool, 1964
Ford Madox Brown 1821–1893, Walker Art Gallery, Liverpool, 1964; catalogue by Mary Bennett.

Dale, 1965
William S.A. Dale, "A Portrait by Fred Sandys", *Burlington Magazine,* vol. 107, May 1965, pp. 250–263.

Doughty and Wahl, 1965–1967
Oswald Doughty and John Robert Wahl (eds.), *Letters of Dante Gabriel Rossetti,* 4 vols., Oxford, vols. 1 & 2, 1965, vols. 3 & 4, 1967.

19th Century English Art, New Metropole Arts Centre, Folkestone, 1965.

Artists of Victoria's England, Cummer Gallery of Art, Jacksonville, Florida, 1965.

An Exhibition of Paintings and Drawings by Victorian Artists in England, National Gallery of Canada, Ottawa, 1965; introduction by Allen Staley.

Lutyens, 1967
Mary Lutyens, "Selling the Missionary", *Apollo,* vol. 86, November 1967, pp. 380–387.

Ormond, 1967
Richard Ormond, "Portraits to Australia, a group of Pre-Raphaelite drawings", *Apollo,* vol. 85, January 1967, pp. 25–27.

Peterson, 1967
Carl A. Peterson, "Rossetti and the Sphinx", *Apollo,* vol. 85, January 1967, pp. 48–53.

Sir Edward Burne-Jones, Fulham Library, London Borough of Hammersmith, 1967; catalogue by John Gordon-Christian.

London and Liverpool, 1967
Millais, PRB, PRA, Royal Academy of Arts, London, and Walker Art Gallery, Liverpool, 1967; catalogue by Mary Bennett.

Bennett, 1967
Mary Bennett, "Footnotes to the Millais Exhibition", *Liverpool Bulletin* (Walker Art Gallery), vol. 12, 1967, pp. 33–59.

British Royal Family Exhibition, Seibu Department Store, Tokyo, 1967.

Romantic Art in Britain, Paintings and Drawings 1760–1860, Detroit Institute of Arts and Philadelphia Museum of Art, 1968; catalogue by Frederick Cummings and Allen Staley.

Art Nouveau in England und Schottland, Karl-Ernst-Osthaus-Museum, Hagen, 1968; introduction by Anna-Christa Funk.

The Victorian Vision of Italy 1825–1875, Leicester Museums and Art Gallery, 1968; catalogue by Lionel Lambourne, Luke Herrmann and Hamish Miles.

London, Royal Academy, 1968–1969
Bicentenary Exhibition, 1768–1968, Royal Academy of Arts, 1968–1969; separate catalogue and book of illustrations.

Newcastle upon Tyne, 1968
Paintings and drawings from the Leathart Collection, Laing Art Gallery, Newcastle upon Tyne, 1968; introduction by Gilbert Leathart, catalogue by Nerys Johnson.

Victorian Paintings 1837–1890, Mappin Art Gallery, Sheffield, 1968; catalogue by Michael Diamond.

Alastair Grieve, "A notice on illustrations to Charles Kingsley's 'The Saint's Tragedy' by three Pre-Raphaelite artists", *Burlington Magazine,* vol. 111, May 1969, pp. 290–293.

Grieve 1969
Alastair Grieve, "The Pre-Raphaelite Brotherhood and the Anglican High Church", *Burlington Magazine,* vol. 111, May 1969, pp. 294–295.

The Scared and Profane in Symbolist Art, Art Gallery of Ontario, Toronto, 1969; catalogue by Luigi Carluccio.

Liverpool and London, 1969
William Holman Hunt, Walker Art Gallery, Liverpool, and Victoria and Albert Museum, London, 1969; catalogue by Mary Bennett.

Bennett, 1970
Mary Bennett, "Footnotes to the Holman Hunt Exhibition", *Liverpool Bulletin* (Walker Art Gallery), vol.13, 1968–1970, pp. 27–64.

Robin Gibson, "Arthur Hughes: Arthurian and related subjects of the early 1860's", *Burlington Magazine,* vol. 112, July 1970, pp. 451–456.

Timothy Hilton, *The Pre-Raphaelites,* 1970.

John Nicoll, *The Pre-Raphaelites,* 1970.

Death, Heaven & the Victorians, Brighton Art Gallery and Museum, 1970; introduction by J.H. Morley.

Surtees, 1971
Virginia Surtees, *The Paintings and Drawings of Dante Gabriel Rossetti 1828–1882, A Catalogue Raisonné,* 2 vols., Oxford, 1971 (vol. 1 *Text,* vol. 2 *Plates*).

Cardiff and London, 1971
Arthur Hughes 1832–1915, Pre-Raphaelite Painter, National Museum of Wales, Cardiff, and Leighton House, London, 1971; catalogue by Leslie Cowan.

Dante Gabriel Rossetti 1828–1882, Laing Art Gallery, Newcastle upon Tyne, 1971; catalogue by Richard Green and Alastair Grieve.

Burne-Jones, Mappin Art Gallery, Sheffield, 1971; catalogue by W.S. Taylor.

Paris, 1972
La peinture romantique anglaise et les préraphaélites, Petit Palais, Paris, 1972; catalogue by John Christian, Alastair Grieve and others.

The Pre-Raphaelites, Whitechapel Art Gallery, 1972; introduction by John Gere.

The Pre-Raphaelites and their Associates in the Whitworth Art Gallery, Manchester, 1972; catalogue by David Jolley and Christopher Allen.

Bennett, 1973
Mary Bennett, "Ford Madox Brown at Southend in 1846: some lost paintings", *Burlington Magazine,* vol. 115, February 1973, pp. 74–78.

Christian, 1973
John Christian, "Early German sources for Pre-Raphaelite Designs", *Art Quarterly,* vol. 36, nos. 1 & 2, 1973, pp. 56–83.

Grieve, 1973A
A.I. Grieve, *The Art of Dante Gabriel Rossetti: The Pre-Raphaelite Period 1848–50,* Hingham, Norfolk, 1973.

Grieve, 1973B
Alastair Grieve, "Rossetti's Illustrations to Poe", *Apollo,* vol. 97, February 1973, pp. 142–145.

Grieve, 1973C
Alastair Grieve, "The Applied Art of D.G. Rossetti - I. His Picture-Frames", *Burlington Magazine,* vol. 115, January 1973, pp. 16–24.

Harrison and Waters, 1973
Martin Harrison and Bill Waters, *Burne-Jones,* 1973.

Kurt Löcher, *Der Perseus-Zyklus von Edward Burne-Jones,* Staatsgalerie, Stuttgart, 1973.

Smith, 1973
Roger Smith, "Bonnard's Costume Historique – a Pre-Raphaelite Source Book", *Costume,* vol. 7, 1973, pp. 28–37.

Staley, 1973
Allen Staley, *The Pre-Raphaelite Landscape,* Oxford, 1973.

Allen Staley, "Some Water-colours by John Brett", *Burlington Magazine,* vol. 115, February 1973, pp. 86–93.

W.S. Taylor, "King Cophetua and the Beggar Maid", *Apollo,* vol. 97, February 1973, pp. 148–155.

Präraffaeliten, Staatliche Kunsthalle, Baden-Baden, and Städtische Galerie, Frankfurt, 1973–1974.

London and Birmingham, 1973
Dante Gabriel Rossetti, Painter and Poet, Royal Academy of Arts, London, and City Museum and Art Gallery, Birmingham, 1973; introduction by John Gere, catalogue by Virginia Surtees and others.

Raymond Watkinson, *Pre-Raphaelite Art and Design,* 1974.

Brighton and Sheffield, 1974
Frederick Sandys 1829–1904, Brighton Museum and Art Gallery and Mappin Art Gallery, Sheffield, 1974; catalogue by Betty O'Looney.

Pre-Raphaelite Graphics and the Earthly Paradise woodcuts by Burne-Jones and Morris, Hartnoll & Eyre Ltd., 1974.

Fredeman, 1975
William E. Fredeman (ed.), *The P.R.B. Journal: William Michael Rossetti's Diary of the Pre-Raphaelite Brotherhood 1849–1853 together with other Pre-Raphaelite Documents,* Oxford, 1975.

John Nicoll, *Dante Gabriel Rossetti,* 1975.

Linda L.A. Parry, "The Tapestries of Edward Burne-Jones", *Apollo,* vol. 102, November 1975, pp. 324–328.

Sewter, 1975
A. Charles Sewter, *The Stained Glass of William Morris and his Circle,* New Haven and London, 2 vols., 1975 (*Text* and *Plates*).

Waters, 1975
Bill Waters, "Painter and Patron, The Palace Green Murals", *Apollo,* vol. 102, November 1975, pp. 338–341.

London, Southampton and Birmingham, 1975–1976
Burne-Jones: The paintings, graphic and decorative work by Sir Edward Burne-Jones 1833–98, Hayward Gallery, London, Southampton

Art Gallery, and City Museum and Art Gallery, Birmingham, 1975–1976; catalogue by John Christian.

Bryson (ed.), 1976
John Bryson (ed.), *Dante Gabriel Rossetti and Jane Morris, Their Correspondence,* Oxford, 1976.

Shirley Bury, "Rossetti and his Jewellery", *Burlington Magazine,* vol. 118, February 1976, pp. 94–102.

Grieve, 1976
A.I. Grieve, *The Art of Dante Gabriel Rossetti: 1. Found 2. The Pre-Raphaelite Modern-Life Subject,* Norwich, 1976.

Oberhausen, 1976
Judy Oberhausen, *Dante Gabriel Rossetti's "Found"* (Delaware Art Museum occasional paper, no. 1, December 1976), Wilmington, 1976.

The Pre-Raphaelite Era 1848–1914, Delaware Art Museum, Wilmington, 1976; catalogue by Rowland and Betty Elzea.

Pre-Raphaelite Drawings: An Exhibition of Drawings by William Holman Hunt, John Everett Millais, Dante Gabriel Rossetti, Ford Madox Brown, Portsmouth City Museum and Art Gallery, 1976; introduction by Alastair Grieve.

Dante Gabriel Rossetti and the Double Work of Art, Yale University Art Gallery, New Haven, 1976; catalogue by Maryann Wynn Ainsworth and others.

Bornand, 1977
Odette Bornand (ed.), *The Diary of W.M. Rossetti 1870–1873,* Oxford, 1977.

Andrea Rose, *The Pre-Raphaelites,* Oxford, 1977.

Brown, 1978
David Brown, "Pre-Raphaelite Drawings in the Bryson Bequest to the Ashmolean Museum", *Master Drawings,* vol. 16, no. 3, Autumn 1978, pp. 287–293.

Elzea, 1978/Elzea, 1984
Rowland Elzea, *The Samuel and Mary R. Bancroft, Jr. and Related Pre-Raphaelite Collections,* Delaware Art Museum, Wilmington, 1978; revised edition, 1984.

Grieve, 1978
A.I. Grieve, *The Art of Dante Gabriel Rossetti: The Watercolours and Drawings of 1850–1855,* Norwich, 1978.

Rabin, 1978
Lucy Rabin, *Ford Madox Brown and the Pre-Raphaelite History-Picture,* New York and London, 1978.

Raleigh Trevelyan, "Thomas Woolner, Pre-Raphaelite Sculptor: The Beginnings of Success", *Apollo,* vol. 107, March 1978, pp. 200–205.

The Pre-Raphaelites and the Circle in the National Gallery of Victoria, Melbourne, 1978; catalogue by Annette Dixon, Sonia Dean and Irena Zdanowicz.

George P. Landow, *William Holman Hunt and Typological Symbolism,* New Haven and London, 1979.

Pointon, 1979
Marcia Pointon, *William Dyce 1806–1864, A Critical Biography,* Oxford, 1979.

Vaughan, 1979
William Vaughan, *German Romanticism and English Art,* New Haven and London, 1979.

Arts Council, 1979
The Drawings of John Everett Millais, Arts Council touring exhibition, 1979; catalogue by Malcolm Warner.

Fantastic Illustration and Design in Britain 1850–1930, Museum of Art, Rhode Island School of Design, Providence, and Cooper-Hewitt Museum [New York], Smithsonian Institution, Washington, D.C., 1979, catalogue by Diana L. Johnson.

Zwei Jahrhunderte Englische Malerei: Britische Kunst und Europa 1680 bis 1880, Haus der Kunst, Munich, 1979–1980; catalogue edited by John Gage.

Cherry, 1980
Deborah Cherry, "The Hogarth Club: 1858–1861", *Burlington Magazine,* vol. 122, April 1980, pp. 236–244.

Rowland Elzea (ed.), *The Correspondence between Samuel Bancroft, Jr. and Charles Fairfax Murray 1892–1916* (Delaware Art Museum occasional paper, no. 2, February 1980), Wilmington, 1980.

Poulson, 1980
Christine Poulson, "A checklist of Pre-Raphaelite illustrations of Shakespeare's Plays", *Burlington Magazine,* vol. 122, April 1980, pp. 244–250.

Surtees, 1980
Virginia Surtees (ed.), *The Diaries of George Price Boyce,* Norwich, 1980.

Treuherz, 1980/Treuherz, 1993
Julian Treuherz, *Pre-Raphaelite Paintings from the Manchester City Art Gallery,* 1980; second edition, *Pre-Raphaelite Paintings from Manchester City Art Galleries,* Manchester, 1993.

Cambridge, 1980
Morris & Company in Cambridge, Fitzwilliam Museum, Cambridge, 1980; catalogue by Duncan Robinson and Stephen Wildman.

The Oxford Union Murals, Chicago and London, 1981; microfiche, with booklet by John Christian.

The Little Holland House Album by Edward Burne-Jones, North Berwick, 1981; introduction and notes by John Christian.

Oliver Fairclough and Emmeline Leary, *Textiles by William Morris and Morris & Co. 1961–1940,* 1981.

Rose, 1981
Andrea Rose, *Pre-Raphaelite Portraits,* Oxford, 1981.

Surtees, 1981
Virginia Surtees (ed.), *The Diary of Ford Madox Brown,* New Haven and London, 1981.

Wood, 1981
Christopher Wood, *The Pre-Raphaelites,* 1981.

William Morris & Kelmscott, Design Council and West Surrey College of Art and Design, Farnham, 1981; catalogue by A.R. Dufty and others.

Maria Teresa Benedetti, *Dante Gabriel Rossetti, Disegni,* Florence, 1982.

Lago, 1982
Mary Lago (ed.), *Burne-Jones Talking: His conversations 1895–1898 preserved by his studio assistant Thomas Rooke,* 1982.

MacDonald, 1982
Katharine Macdonald, "Alexander Munro, the Pre-Raphaelite Brotherhood and the 'Unmentionable'," *Apollo,* vol. 115, March 1982, pp. 190–197.

The Substance or the Shadow: Images of Victorian Womanhood, Yale Center for British Art, New Haven, 1982; catalogue by Susan P. Casteras.

Bronkhurst, 1983
Judith Bronkhurst, "Fruits of a Connoisseur's Friendship: Sir Thomas Fairbairn and William Holman Hunt", *Burlington Magazine,* vol. 125, October 1983, pp. 586–595.

Mary Lutyens and Malcolm Warner (eds.), *Rainy Days at Brig o'Turk: The Highland Sketchbooks of John Everett Millais 1853,* Westerham, 1983.

Pre-Raphaelite Photography, British Council, 1983; catalogue by Michael Bartram.

Maria Teresa Benedetti, *Dante Gabriel Rossetti,* Florence, 1984.

Bennett, 1984
Mary Bennett, "The Price of 'Work': the background to its first exhibition, 1865", in Parris (ed.), 1984, pp. 143–152.

Elzea, 1984
See Elzea, 1978

Grieve, 1984
Alastair Grieve, "Style and Content in Pre-Raphaelite Drawing 1848-50", in Parris (ed.), 1984, pp. 23–43.

Lutyens, 1984
Mary Lutyens, "Walter Howell Deverell (1827–1854)", in Parris (ed.), 1984, pp. 76–96.

Rosalie Mander (ed.), *Recollections of Dante Gabriel Rossetti & his Circle on Cheyne Walk Life [by] Henry Treffry Dunn,* Westerham, 1984.

Judith A. Neiswander, "Imaginative Beauty and Decorative Delight: Two American Collections of the Pre-Raphaelites", *Apollo,* vol. 119, March 1984, pp. 198–205.

Parkinson, 1984
Ronald Parkinson, "James Collinson", in Parris (ed.), 1984, pp. 61–75.

Parris (ed.), 1984
Leslie Parris (ed.), *Pre-Raphaelite Papers,* 1984.

Read, 1984
Benedict Read, "Was there Pre-Raphaelite Sculpture?", in Parris (ed.), 1984, pp. 97–110.

Reynolds, 1984
Simon Reynolds, *The Vision of Simeon Solomon,* Stroud, 1984.

London, Tate, 1984
The Pre-Raphaelites, Tate Gallery, London, 1984; catalogue edited by Leslie Parris.

Manchester, Whitworth, 1984
William Morris and the Middle Ages, Whitworth Art Gallery, University of Manchester, 1984; catalogue edited by Joanna Banham and Jennifer Harris.

Dante Gabriel Rossetti, Casa di Dante in Abruzzo, Torre de Passeri, and Accademia di Belle Arti, Milan, 1984–1985; catalogue edited by Corrado Gizzi.

Michael Bartram, *The Pre-Raphaelite Camera, Aspects of Victorian Photography,* 1985.

The Fairy Family by Archibald Maclaren, illustrated by Edward Burne-Jones, with an introduction by John Christian, Westerham, 1985.

Marsh, 1985
Jan Marsh, *Pre-Raphaelite Sisterhood,* London and New York, 1985.

Lynn Roberts, "Nineteenth Century English Picture Frames I: The Pre-Raphaelites", *International Journal of Museum Management and Curatorship,* vol. 4, June 1985, pp. 155–172.

London and Birmingham, 1985–1986
Solomon: A Family of Painters, Geffrye Museum, London, and Birmingham Museum and Art Gallery, 1985–1986; catalogue by Lionel Lambourne and others.

The New Path: Ruskin and the American Pre-Raphaelites, Brooklyn Museum, New York, and Museum of Fine Arts, Boston, 1985; catalogue edited by Linda S. Ferber and William H. Gerdts.

Ladies of Shalott: A Victorian Masterpiece and Its Contexts, List Art Center, Brown University, Providence, Rhode Island, 1985; catalogue edited by George P. Landow.

Jeffrey, 1986
Rebecca A. Jeffrey, "Walter H. Deverell: Some Observations and a Checklist", *Journal of Pre-Raphaelite Studies,* vol. 6, no. 2, May 1986, pp. 83–92.

Dianne Sachko Macleod, "F.G. Stephens, Pre-Raphaelite critic and art historian", *Burlington Magazine,* vol. 128, June 1986, pp. 398–406.

Marsh, 1986
Jan Marsh, "William Morris's Painting and Drawing", *Burlington Magazine,* vol. 128, August 1986, pp. 569–577.

Jan Marsh, *Jane and May Morris,* 1986.

Rome, 1986
Burne-Jones, dal preraffaellismo al simbolismo, Galleria Nazionale d'Arte Moderna, Rome, 1986; catalogue edited by Maria Teresa Benedetti and Gianna Piantoni.

London, Tate, 1987
George Price Boyce, Tate Gallery, London, 1987; catalogue by Christopher Newall and Judy Egerton.

Seymour, 1987
Gayle Seymour, *The Life and Work of Simeon Solomon (1840–1905),* University Microfilms International, Ann Arbor, Michigan, 1987.

Treuherz, 1987
Hard Times: Social Realism in Victorian art, Manchester City Art Gallery, Vincent van Gogh Museum, Amsterdam, and Yale Center for British Art, New Haven, 1987–1988; catalogue by Julian Treuherz and others.

Burne-Jones and his Followers, Isetan Museum of Art, Tokyo; Ishibashi Museum of Art, Kurume; Tochigi Prefectural Museum of Fine Arts, and Yamanashi Prefectural Museum of Art, 1987; catalogue by John Christian.

Bennett, 1988
Mary Bennett, *Artists of the Pre-Raphaelite Circle: The First Generation, Catalogue of Works in the Walker Art Gallery, Lady Lever Art Gallery and Sudley Art Gallery (National Museums and Galleries on Merseyside),* 1988.

Julian Hartnoll, *The Reproductive Engravings after Sir Edward Coley Burne-Jones,* 1988; with contributions from John Christian and Christopher Newall.

Gillian Naylor (ed.), *William Morris by himself, Designs and Writings,* 1988.

Faxon, 1989
Alicia Craig Faxon, *Dante Gabriel Rossetti,* Oxford, 1989.

Kestner, 1989
Joseph A. Kestner, *Mythology and Misogyny: The Social Discourse of Nineteenth-Century British Classical-Subject Painting,* Madison, Wisconsin, 1989.

Marsh, 1989
Jan Marsh, *The Legend of Elizabeth Siddal,* 1989.

Jan Marsh and Pamela Gerrish Nunn, *Women Artists and the Pre-Raphaelite Movement,* 1989.

London, Barbican, 1989
The Last Romantics: The Romantic Tradition in British Art, Burne-Jones to Stanley Spencer, Barbican Art Gallery, London, 1989; catalogue edited by John Christian.

Ruskin and the English Watercolour, from Turner to the Pre-Raphaelites, Whitworth Art Gallery, University of Manchester; Holburne Museum and Craft Centre, University of Bath, and Bankside Gallery, London, 1989; catalogue by Ann Sumner.

Newcastle upon Tyne, 1989-1990
Pre-Raphaelites: Painters and Patrons in the North East, Newcastle upon Tyne, 1989–1990; catalogue edited by Jane Vickers.

Casteras, 1990
Susan P. Casteras, *English Pre-Raphaelitism and its Reception in America in the Nineteenth Century,* London and Toronto, 1990.

Debra N. Mancoff, *The Arthurian Revival in Victorian Art,* New York and London, 1990.

Whisper of the Muse. The World of Julia Margaret Cameron, Colnaghi, 1990; catalogue by Jeremy Howard.

Tokyo, 1990–1991
Rossetti, Bunkamura Museum of Art, Tokyo, Aichi Prefectural Art Gallery, Nagoya, and Ishibashi Museum of Art, Kurume, 1990–1991; catalogue by Stephen Wildman.

Newman and Watkinson, 1991
Teresa Newman and Ray Watkinson, *Ford Madox Brown and the Pre-Raphaelite Circle,* 1991.

Surtees, 1991
Virginia Surtees, *Rossetti's Portraits of Elizabeth Siddal, A catalogue of the drawings and watercolours,* Aldershot and Oxford, 1991; exhibition held at Ashmolean Museum, Oxford, and Birmingham Museum and Art Gallery.

London and Birmingham, 1991–1992
Pre-Raphaelite Sculpture: Nature and Imagination in British Sculpture 1848–1914, Matthiesen Gallery, London, and Birmingham Museum and Art Gallery, 1991–1992; catalogue edited by Benedict Read and Joanna Barnes.

Casteras (ed.), 1991
Pocket Cathedrals: Pre-Raphaelite Book Illustration, Yale Center for British Art, New Haven, 1991; catalogue edited by Susan P. Casteras.

Sheffield, 1991
Elizabeth Siddal 1829–1862, Pre-Raphaelite Artist, Ruskin Gallery, Sheffield, 1991; catalogue by Jan Marsh.

The Pre-Raphaelites in Context, San Marino, California, 1992 (Huntington Library Quarterly, vol. 55, no. 1, Winter 1992); text by Shelley M. Bennett and others.

Grasmere and Lincoln, 1992
Tennyson 1809–1892, A Centenary Celebration, Wordsworth Trust, Grasmere, and Usher Art Gallery, Lincoln, 1992; catalogue by Robert Woof.

New Haven, Cleveland and Birmingham, 1992–1993
Victorian Landscape Watercolors, Yale Centre for British Art, New Haven, Cleveland Museum of Art, and Birmingham Museum and Art Gallery, 1992–1993; catalogue by Scott Wilcox and Christopher Newall.

Leeds, 1993
John William Inchbold, Pre-Raphaelite Landscape Artist, Leeds City Art Gallery, 1993; catalogue by Christopher Newall.

London, Tate, 1993
Burne-Jones, Watercolours and Drawings, Tate Gallery, 1993; booklet by Ian Warrell.

Treuherz, 1993
See Treuherz, 1980

Viktorianische Malerei von Turner bis Whistler (Pintura Victoriana de Turner a Whistler), Neue Pinakothek, Munich, and Prado, Madrid, 1993; catalogue by Robin Hamlyn and others.

Phoenix and Indianapolis, 1993
The Art of Seeing: John Ruskin and the Victorian Eye, Phoenix Art Museum and Indianapolis Museum of Art, 1993; catalogue edited by Susan Phelps Gordon and Anthony Lacy Gully.

The Earthly Paradise: Arts and Crafts by William Morris and his Circle from Canadian Collections, Art Gallery of Ontario, Toronto; National Gallery of Canada, Ottawa; Musée du Québec, Quebec City; and Winnipeg Art Gallery, Winnipeg, 1993–1994; catalogue edited by Katharine A. Lochnan, Douglas E. Schoenherr and Carole Silver.

John Ruskin and Victorian Art, Isetan Museum of Art, Tokyo; Ishibashi Museum of Art, Kurume; Nara Sogo Museum of Art, Nara; and Tochigi Prefectural Museum of Art, 1993; catalogue by James Dearden.

Pre-Raphaelite Drawings in the British Museum, British Museum, London, 1994; catalogue by J.A. Gere.

Nottingham, 1994
Heaven on Earth: The Religion of Beauty in Late Victorian Art, Djanogly Art Gallery, University of Nottingham, 1994; catalogue by Gail-Nina Anderson and Joanne Wright.

Jan Marsh, *Christina Rossetti: A Literary Biography,* 1994; New York, 1995.

PHOTOGRAPHIC CREDITS

Aberdeen Art Gallery, fig. 71; Bradford Art
Galleries and Museums, fig. 21; Charterhouse
School, photo of Beerbohm; Christie's, figs. 65,
66, 79, 80; Shipley Art Gallery, Gateshead, fig.
33; Harvard University Art Museums, figs. 89,
102; Johannesburg Art Gallery, fig. 25; Dean and
Chapter of Llandaff Cathedral (S.T.P. Photog-
raphy), fig. 52; British Architectural Library,
R.I.B.A., London (A.C. Cooper Ltd.), fig. 24;
Leger Galleries, London, figs. 93, 96, 97, 99;
Maas Gallery, London, fig. 29, photo of Sandys;
National Portrait Gallery, London, photos of
Boyce, Brett, Brown, Dyce, Hunt, Millais,
Rossetti; Tate Gallery, London, figs. 3, 5, 6, 8,
9, 32, 34, 39, 69, 70, 72, photos of Hughes,
Solomon; Manchester City Art Galleries, figs. 18,
19, 23, 84; Whitworth Art Gallery, University of
Manchester, figs. 101, 108; National Gallery of
Victoria, Melbourne, fig. 38; National Museums
and Galleries on Merseyside, figs. 2, 28, 42, 45,
78, 105, photo of Martineau; Montreal Museum
of Fine Arts, fig. 104; The National Trust, figs.
22, 106; National Gallery of Canada, Ottawa,
fig. 68; Ashmolean Museum, Oxford, figs. 4, 7,
10, photo of Siddal; Ringling Museum of Art,
Sarasota, fig. 109; Sotheby's, fig. 35; Art Gallery
of New South Wales, Sydney, fig. 20; William
Morris Gallery, Walthamstow, figs. 49, 91, pho-
tos of Morris, Munro; Delaware Art Museum,
Wilmington, figs. 40, 51, 83.